Bob Bartlett
NYC
2004

THE IMPRESSIONISTS

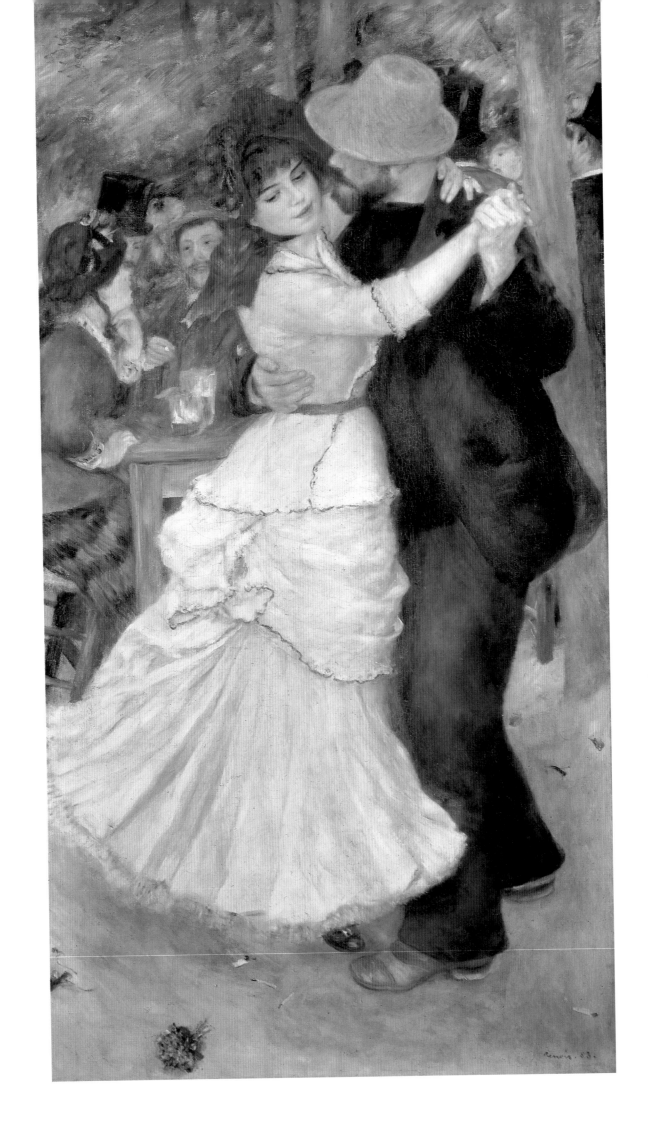

THE IMPRESSIONISTS

Gabriele Crepaldi

BARNES
&NOBLE
BOOKS
NEW YORK

For Matteo and Daniele

Frontispiece:

PIERRE-AUGUSTE RENOIR
Dance at Bougival
1882–83, oil on canvas,
182 × 98 cm
Museum of Fine Arts, Boston

ART DIRECTOR
Giorgio Seppi

MANAGING EDITOR
Tatjana Pauli

EDITORS
Adriana Savorani
Sergio Scardoni

DESIGN
Elena Dal Maso

TRANSLATION
Jay Hyams

This edition published by Barnes & Noble, Inc., by arrangement with
Mondadori Printing.
2002 Barnes & Noble Books
M 10 9 8 7 6 5 4 3
ISBN 0-7607-3527-1
English translation © 2002 Arnoldo Mondadori Editore, S.p.A., Milan.
All rights reserved.
Printed and bound in Spain by Artes Gráficas Toledo, S.A.
D.L.TO:942-2003

Photographic credits
Archivio Electa, Milan
Archivio Mondadori, Milan
Sergio Anelli, Milan
Diego Motto, Milan
With thanks to the museums and photo archives that kindly made material available.

Contents

7 Introduction

14 1850•1860 Masters and inspirations

38 1860•1870 Manet "Roi des Impressionnistes"

56 1860•1870 The formation of the Impressionists

82 France from 1848 to1871: The Second Empire,
 the Franco-Prussian War, and the commune

108 1872•1874 The first show of the Impressionists

148 1875•1876 Second show

174 1877 Third show

200 1878•1879 Fourth show

228 1880 Fifth show

254 1881•1882 Sixth and seventh shows

294 1883•1886 Eighth show

330 1886•1889 The shows in America and
 the universal exhibition in Paris

360 1853•1890 Vincent van Gogh

404 1890•1900 The consecration

442 1901•1920 The legacy of the Impressionists

468 References

469 Participants in the group shows

470 Biographies

473 Bibliography

474 Index of names and places

477 Index of works

PIERRE-AUGUSTE
RENOIR
Girl with Straw Hat
circa 1890,
oil on canvas,
55.9 × 46 cm
Private collection

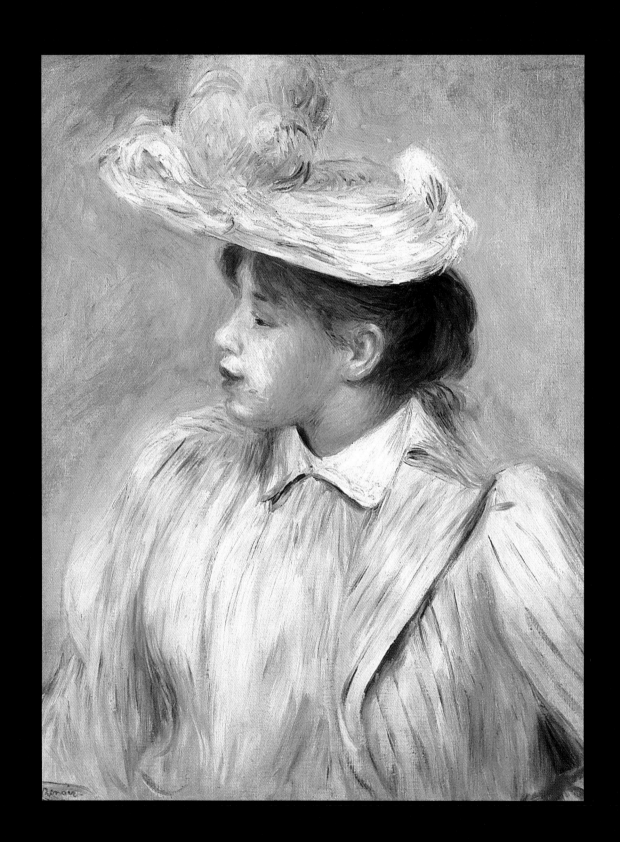

very year the major art magazines publish lists of the year's most popular exhibits throughout the world, and every year Impressionist painters occupy the top slots, followed closely by a few other artists, such as Caravaggio, Picasso, and the Venetian view painters of the eighteenth century. The same goes for the sales of reference works, biographies, critical essays, and coffeetable-book celebrations of art and artists: the lion's share goes to Impressionists. When the critic and journalist Louis Leroy coined the term *impressionism*, in 1874, he meant it to be sharp with scorn, and the first shows of the Impressionists attracted storms of protest and negative criticism, some of it rudely offensive, such that more than a few experts, or presumed experts, predicted the movement's rapid and quite inglorious demise. History has shown instead that the Impressionists' view of the world was

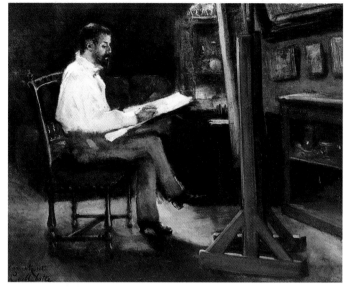

massive collection of correspondence, which also reveals the more private aspects of their lives and personalities. Everything seems to have been explained, with bright light cast on the smallest detail. Yet every time we approach one of their paintings we find ourselves once again surprised by the delicate poetry of their scenes, by the fresh magic of their colors; every time, we find ourselves discovering new details or new ways of interpreting them; every time we look, we see new reasons to admire and enjoy them.

This book brings together most of the studies done up to now to present the important information in a clear and straightforward manner; at the same time, it has the presumption of seeking to inform and inspire each reader to strive to work out his or her own personal opinion of the movement, the individual painters, and their art. The chronological arrangement of the book puts emphasis on the eight Impressionist shows, which were impor-

GUSTAVE CAILLEBOTTE
Aimé Nicolas Morot in His Studio
circa 1874,
oil on canvas,
46 × 55 cm
Private collection

Introduction

valid, and the fame they won has proved enduring. Over the decades the works of Impressionist painters have made their way into our collective imagination so deeply and so solidly that there is no one among us, no matter how well schooled or how ignorant, whether lover of art or completely indifferent to it, who cannot immediately recognize those works.

The Impressionists' undeniable and unequaled planetary fame has been examined from many angles, by no means limited to the aesthetic and the sociological. New studies at varying levels of expertise are published each year claiming to finally get to the bottom of the question, examining the most minuscule aspects of the artists' lives and art. By now we are in possession of such astonishingly detailed and in-depth documentation that finding out the sources the artists turned to during their apprenticeship, for example, is a relatively simple matter, as is learning who were their masters, or who their enemies. For almost every single one of the artists, we know the shows in which he or she participated, the pronouncements of the critics, and quite often the reactions of the public and colleagues. Their styles and techniques have been analyzed from nearly every conceivable point of view, which can also be said of the themes that show up in their works. The relationships among individual artists and art dealers, journalists, intellectuals, collectors, and friends are spelled out in a

tant moments of cohesion among the artists and which also had enormous effects on the academic culture that rejected them, on the critics who did not understand them, on the collectors who at first ignored them or even derided them but who over the years came to be the reason behind their success and fame. A large selection of the works of each artist is presented and described, showing how each approached the same basic themes, which can be divided into four broad categories: the world of nature, the city, the human figure, and the fascination of the exotic. Even the choice of these subjects is of enormous importance since it clearly demonstrates how the Impressionists broke free of academic restraints. Very nearly every one of the works shown during each of the annual Salons relentlessly repeated mythological or religious scenes or episodes from ancient history, almost always with a more or less obvious moralistic or edifying purpose. The young Impressionists wanted to be painters of modern life, they wanted to present the reality of the world in which they were living, and they struggled to do so in the most objective manner possible. Charles Baudelaire, who assumed the role of interpreting their aims, also wanted modern artists to paint modern themes. He wrote that "There is no lack of subjects, or of colors, to make epics. The painter, the true painter for whom we are looking, will be he who can snatch the epic quality from the life of

today and can make us see and understand, with brush or with pencil, how great and poetic we are in our cravats and our patent-leather boots."

Nature

One of the cornerstones of the Impressionist movement is painting outdoors, *en plein air*. The Impressionists rebel against the suffocating,

tedious lessons of the Ecole; they have no intention of staying shut-up inside the ateliers of their teachers, spending hour after hour and month after month copying the masterpieces of the past. Quite the contrary, they want to get outdoors and paint in the open air the same way Camille Corot and the painters of the Barbizon school have been doing for years. Their true objective is direct and authentic contact with nature. Moments of religious drama and historical events are swept from their landscapes; there are no nymphs, satyrs, or any of the other assorted personages from mythology; there is no room for classical ruins, whether real or imaginary; gone is even the idealized reading of nature so dear to the romantics, who saw it as a concrete representation of the spiritual life of the universe. The Impressionists' approach is spontaneous and immediate with importance given not to the details but to the whole, to the overall impression that reality awakens in the mind, free of reflections or second thoughts. To accomplish this, they get out of the city, leave their ateliers, and make their way to the real thing, a patch of ground right in the middle of nature. Thanks to the new system of rail lines there is no great difficulty in reaching the outskirts of Paris or even more distant regions of France, from Normandy to the Côte d'Azur, where they can spend as much time as they have available studying and working. Riverbanks and seasides are their favorite spots; almost all the Impressionists are fascinated by water

and strive to make their palette express the special effects of light on the surface of moving liquid. It is no coincidence that Claude Monet's *Impression: Sunrise*, the Impressionist painting par excellence, and the work that earned the movement its name, is a view of Le Havre with the rising sun brightening the sky and spreading its reflections across the sea.

Views along the Seine are among the most beautiful of the works created by Monet, Sisley, Renoir, and Caillebotte. There are also the many paintings of the countryside, of peasants and shepherds at work, the subject in which Pissarro specializes; there are the woods and rolling hills; there is Monet's garden, which inspires the marvelous water lilies series, or the mountain of Sainte-Victoire, which Cézanne never tires of painting; there are the picturesque villages of Provence and the snowy landscapes, endlessly evocative themes to which the Impressionists return again and again to show off their technical skills. When bad weather drives them indoors the Impressionists direct the same passion to the creation of still lifes. Splendid compositions with bunches of flowers offer them the opportunity to unleash the full force and energy of colors; at other times, when they want to express melancholy sentiments or atmospheres of

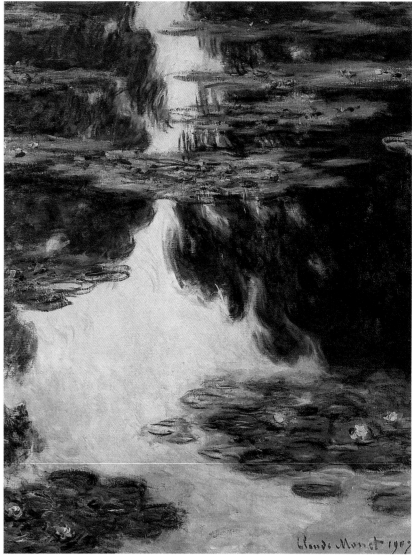

quiet intimacy, the colors they use are muted and delicate. Most often they amplify the intensity of the tints and emphasize the contrasts, following notions in Michel Eugène Chevreul's treatise *On the Law of the Simultaneous Contrast of Colors* (1839), the basic text of their chromatic experiments. Of all the Impressionist artists the most tirelessly devoted is Cézanne, creator of the most beautiful still lifes of the group,

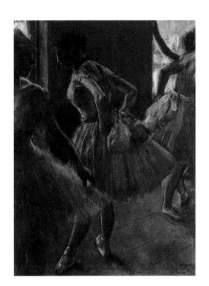

worthy of comparison to the Flemish and Italian masterpieces of the seventeenth and eighteenth centuries. With extreme patience he selects the objects to present, usually fruit; he carefully adjusts their arrangement, the relationships among their volumes, the way light falls on them, to create a perfect balance between the rhythm of the colors and the harmony of the design, bare but essential.

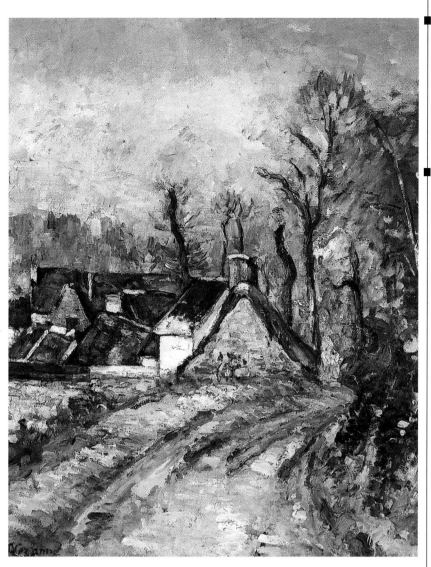

EDGAR DEGAS
Preparing for the Lesson
circa 1890,
pastel on paper,
64.8 × 49.7 cm
Private collection

PAUL CÉZANNE
View of Auvers
circa 1873,
oil on canvas,
46 × 55 cm
Private collection

The city

As we have seen, the Impressionists love nature and their hearts open when they can set up an easel on the banks of a river or in the open countryside. At the same time, however, they are also fascinated by the city of Paris, which in those very years is going through an astonishing period in its development. Under the direction of Baron Georges Haussmann, the old city, which still preserves much of its medieval appearance, is being transformed into a gigantic metropolis. Entire city quarters are being demolished to make room for enormous buildings inhabited by the new middle class and for other imposing public structures, including the monumental railway stations that are chosen by the Impressionist painters as the preeminent symbols of technological progress. The long tree-lined boulevards and the wide sidewalks lined with cafés and restaurants, theaters and dancehalls, crowded at every hour of the day by pedestrians and carriages, become images that show up in the paintings of the Impressionists, especially in the works of Gustave Caillebotte and Camille Pissarro. These painters also take on the theme of work, but do so only in a very limited number of

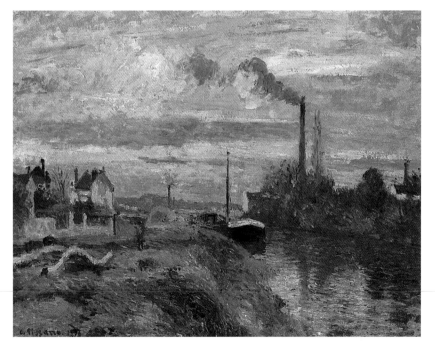

works, and they ignore almost completely the important social problems of the time (which are instead confronted head-on by other artists of the period, primarily in Italy and England). Although they come from different social classes, the Impressionist painters tend to feel most at ease with the middle class, sharing its tastes and mentality. They love to visit cafés and dancehalls, and such locales become the settings for their most exuberant works. Many of their paintings celebrate the city's exciting nightlife, from such simple and innocent pleasures as circus shows to more elaborate and sophisticated entertainments, such as Manet's *Bar at the Folies-Bergère*; from the cultured refinement of the opera-house or playhouse to the louder,

CAMILLE PISSARRO
View of Pontoise
1876, oil on canvas,
46 × 55 cm
Private collection

CAMILLE PISSARRO
The Gardens of the Tuileries and the Louvre
1900, oil on canvas,
27.3 × 35.3 cm
Private collection

more carefree spirit of the *café-concerts* and even to various more or less explicit allusions to the realities of prostitution, a world that is illuminated in the works of the contemporary artist Henri de Toulouse-Lautrec. On December 15, 1875, the new theater of the Opéra opens in a building designed by the architect Charles Garner; the enormous setting, one of the major cultural centers of those years, becomes another of the preferred subjects of the Impressionists. Some, such as Mary Cassatt and Pierre-Auguste Renoir, focus their attention on the public; others, and in particular Edgar Degas, choose the musicians of the orchestra and the dancers on the stage, which in fact become the primary subjects of many of his masterpieces. There are also the horse races on the new track at Longchamp, built in 1857 at the Bois de Boulogne, on the outskirts of Paris. The French middle class, in imitation of the longstanding English tradition, turns the sporting contests into important social events, as can be seen in paintings by Manet and Degas.

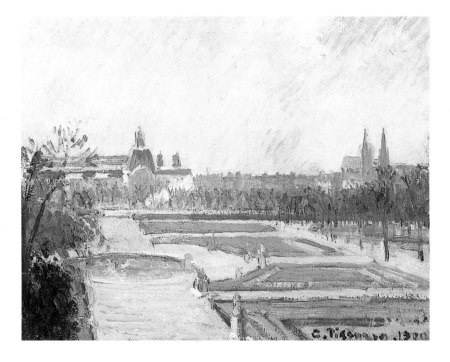

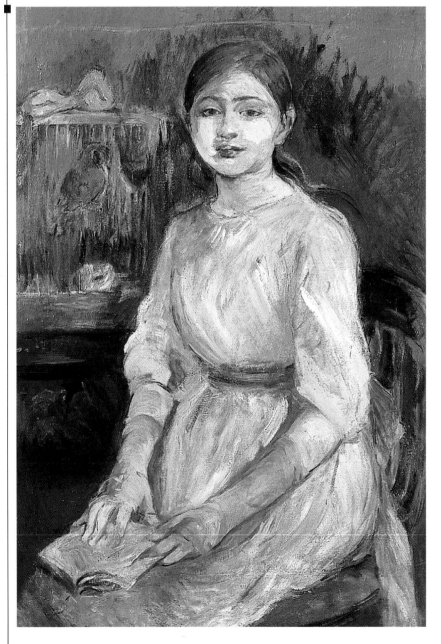

BERTHE MORISOT
Portrait of Julie Manet
1890, oil on canvas,
83.8 × 55.3 cm
Private collection

The human figure

The various Impressionist painters have differing relationships to the human figure, and for some of them, the relationship changes with the passage of time. Sisley and Pissarro show little interest in it, preferring to focus their attention on landscapes and city views. Manet, on the other hand, takes it as his principal source of inspiration, and the theme to which he dedicates almost all of his works. At the beginning of their careers, when they cannot afford the services of professional models, the Impressionists make portraits of relatives or friends. Thus, for example, Bazille portrays Renoir, Renoir portrays Monet; Manet makes use of Berthe Morisot, who in turn uses her mother and sister as models. They often make self-portraits, sometimes exchanging them as tokens of friendship, sometimes making them as a form of psychological introspection, searching for the human identity hidden behind the artistic one. The high technical quality of these works and their subtle revelations of personality and character convince several collectors of the value of Impressionist art and leads them to commission the artists to make their portraits, works that in many cases are only the first of a long and profitable relationship. Among the many examples is Victor Choquet, a customs official, who in 1875 orders two portraits from Renoir, one of himself and one of his wife; a little later he makes the same request of Cézanne. Pleased with their works, over the following years he continues to buy paintings from the Impressionists, such that at his death his collection numbers sixty of their works. Another example is Georges Charpentier. The portrait Renoir makes of his wife and two sons is the first of many Impressionist canvases in Charpentier's collection. Not only that; when the painter presents the work to the Salon, the rich and influential editor makes sure the jury accepts it, that it is displayed in a prestigious spot, and that it receives the right kind of

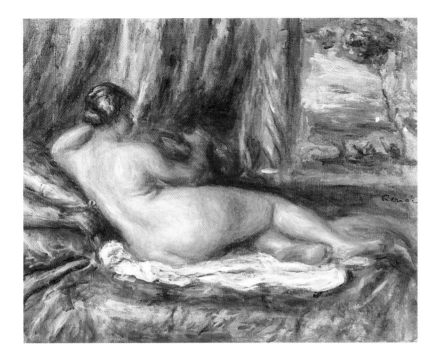

In terms of the human figure in painting, a subject of particular importance is the nude. The history of Impressionism begins and ends with nudes.

At its beginning are two famous nudes by Manet, the *Luncheon on the Grass (Déjuneur sur l'Herbe)* and *Olympia*—the appearance of which awakens scandal—and at its ending, at the beginning of the next century, is *The Large Bathers* by Cézanne, a work that inspired more than a few twentieth-century artists. Degas turns to the nude quite often, most of all when making his series of women bathing, and Renoir is famous for his many paintings of female bathers. In fact Renoir presents a striking example of what happens when Impressionists draw subjects from classical painting, for when they do so it is to revitalize and reinterpret them in a personal style. Renoir's women, with their ample, shapely bodies, recall the models of Titian and Rubens (and in their turn serve as models for Matisse and Picasso). In general, Impressionist nudes express a serene, reassuring, optimistic, almost maternal vision, with none of the sly suggestiveness of eighteenth-century versions, much less any of the troubled ambiguities of contemporary art. It is with joyous abandon that these models offer their bodies to the eyes of the viewer; showing neither reservation nor inhibition,

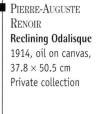

PIERRE-AUGUSTE RENOIR
Reclining Odalisque
1914, oil on canvas,
37.8 × 50.5 cm
Private collection

treatment from the critics. From then on the Charpentiers protect Renoir and other Impressionist artists, organizing shows in their gallery, easing relationships with the press, and introducing the artists to other rich collectors who in turn buy their works.

Scenes of domestic life warrant special attention. The outstanding artists here are Berthe Morisot, Marie Bracquemond, and Mary Cassatt. They are women, which means they are excluded from admission to the Ecole des Beaux-Arts. It also means they are the victims of further prejudice against their sex: it would be unseemly for them to do as their male colleagues do and paint in the open air or even on the streets of the city. They are therefore more or less forced to set their works within the four walls of homes—and so they are the artists we turn to for scenes of the private life of middle-class Parisian women. We are in the room as they climb out of bed and perform their morning toilette; we are on hand as they go about their domestic chores, drink tea with friends, pass a quiet hour reading. Finally, we admire them in their luxurious evening gowns as they prepare to go out for an evening at the theater or a dance party. Of course many other Impressionist painters dedicate works to scenes of modern life, captured with naturalism and immediate realism. There are the café interiors by Manet and Degas, the suburban festivities at the Grenouillère captured by Monet and Renoir; the boatmen of Caillebotte, the card players of Cézanne.

Left:
MARY CASSATT
A Kiss for Little Anna (N. 1)
circa 1897,
pastel on paper,
64 × 52.8 cm
Private collection

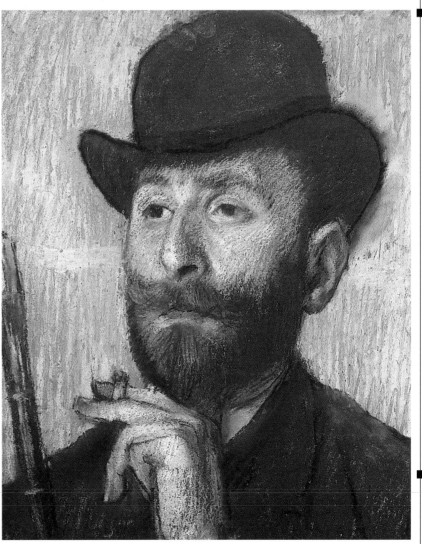

EDGAR DEGAS
Portrait of Zacharian
circa 1885,
pastel on paper,
Private collection

they let themselves be admired as though they were unaware of their own beauty. These are solar women, with no cares beyond that of filling and illuminating the space of the painting with their vibrant, bursting vitality.

Pictures of children are another traditional genre of painting that the Impressionists revitalize. Artists and poets have always taken children as symbols of purity and innocence. In antiquity they were presented as cherubs like Cupid, as fauns, satyrs, or young gods and heroes. Since the Middle Ages babies and children had appeared in paintings with sacred or mythological subjects, in scenes of court life, and in genre scenes based on daily life in the country or town. The subject reaches an apex of sorts in the nineteenth century, a period when, in reality, children are greatly mistreated, the victims of child-labor exploitation, even forced into prostitution at an early age. It is thus with more than a little hypocrisy that they become the leading figures in many paintings that are drenched in sentimentalism, both cloying and maudlin, rhetorical and false. Far different are the children painted by the Impressionists. A good example is the *Children of Martial Caillebotte* by Renoir, in which he presents his usual delicate, poetic sensitivity, treating the children with kindly attention and presenting them with fresh spontaneity, aspects that do not compare poorly to the works of English painters, the masters of this particular genre.

The fascination of the exotic

Almost all critics have emphasized and examined the important role played by foreign cultures in Impressionist painting. We have seen how, at the outset of their pictorial careers, the young artists turn away from the traditional teaching of the Ecole and the academy, and although they never renounce traditional Western culture, which they love and study, they constantly seek new models and new sources of inspiration. France's large-scale colonial expansion favors encounters with the cultures of other continents and permits comparisons with the thinking and art of faraway places. The first such encounter is with Islam, bringing Orientalism into being, begun by Delacroix and Ingres and widespread in Europe throughout the nineteenth century. The Impressionists

are also drawn to it, although to a far lesser degree, and they dedicate some of their best paintings to Orientalist subjects, such as the series of odalisques by Renoir. The art and culture of the Far East exercise a far greater influence on them, both in terms of subject matter and pictorial technique. The discovery of Japanese prints, which begin to be sold in Parisian galleries during these years, marks a truly fundamental turning point in their style. Since the period of Filippo Brunelleschi, the European tradition has been based on using perspective to define the pictorial space and give it the illusion of depth; the Japanese woodcuts reveal a new sense of space, almost completely two-dimensional, in which greater importance is given to color, creating new relationships and new visual effects. The Impressionists draw heavily on this great innovation in technique, which is destined to have an enormous impact on all twentieth-century art. Amid these theories there is also the human and artistic story of Paul Gauguin, who first encounters the ancient tribal cultures of the Pacific in the pavilions of the universal exhibition in Paris and then comes to know them firsthand on the islands themselves, where he spends the last years of his life, painting works recognized as masterpieces.

A hymn to the joy of life

That the language of the Impressionists is clear and easily understood is one of the primary reasons for their vast, enduring success. This simplicity at first causes confusion among critics, who misunderstand it and deride it, convinced that it results from a lack of training or values. With the passage of time, however, they come to change their minds and learn to see the wealth of content in Impressionist paintings. The art of the Impressionists can be read as a hymn to the joy of life, a life full of love and friendship in which the most ordinary events of daily life and the most banal objects are invested with their own special fascination and poetry. Emblematic of this vision of the world is *Dancing at the Moulin de la Galette* by Renoir, in which young friends pass happy, carefree hours dancing and talking. Unfortunately, life is not always like that, as the suicide of Van Gogh and the troubled pilgrimages of Gauguin remind us; and yet their paintings never tire of touching hearts and exemplify, yesterday as well as today, the desire for happiness, which is eternal and present in every human.

PAUL GAUGUIN
Hina
circa 1892–93,
wood,
height 38.7 cm
Private collection

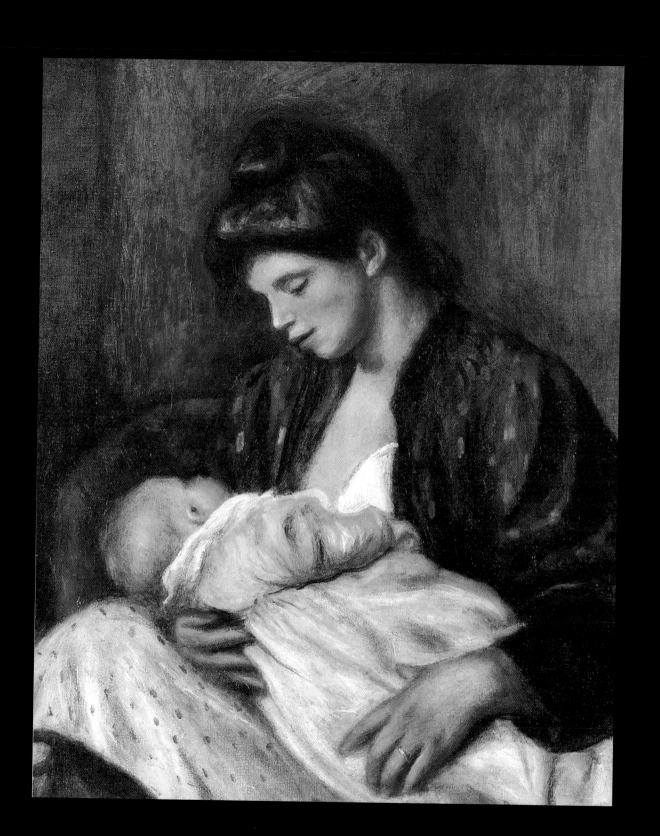

PIERRE-AUGUSTE
RENOIR
The Young Mother
1898, oil on canvas,
56 × 46.5 cm
Private collection

I n the years when the Impressionists begin their apprenticeship, the world of French painting is still ruled by the Académie des Beaux-Arts. Founded in 1664 and profoundly reorganized on the orders of Napoleon, the academy has become a section of the Institut de France, directed by forty members elected for life. These men select the young painters, assemble them in their private studios, and prepare them for the admission competition to the Ecole des Beaux-Arts, the cornerstone of the national educational system for artists. Created in 1648 by Jean-Baptiste Colbert to give the French state direct control over art and artists, the Ecole too underwent radical transformation under Napoleon and then during the Restoration, becoming an almost obligatory stop for any young artist serious about making a career in the arts. Those who succeed in passing the selective admission exam follow a program that is particularly strict and rigorous from a technical point of view but not very profound culturally and, most of all, hardly conducive to personal inventiveness and interpretation. The symbol of the Ecole is its grand atrium crowded with the Greek and Roman statues that serve as models for the drawing classes, without doubt the most important subject in the school's curriculum. Various contests of artistic ability are held every year, and the students who do best are awarded prizes, the most desired and prestigious being the Prix de Rome. In theory the contest is open to all Frenchmen between the ages of fifteen and thirty, but in reality only the Ecole students, exempted from the preliminary tests, have any hope of winning. The final test is the creation of a painting on canvas (about 1.5 by 1.2 meters in size) on a theme chosen by the members of the Institut de France and drawn from ancient history or the Bible. The candidates have 36 hours in which to make a highly detailed drawing and then 70 days to paint it on canvas. The winners spend five years at the French Academy at the Villa Medici in Rome: they study and copy Roman and Renaissance works of art

1850•1860

and periodically send their works to Paris to give the professors of the Ecole the opportunity to evaluate their progress. Official approval for any young student is admission to the Salon; while not the only way, it is by far the surest way for the aspiring artist to find potential buyers for his work. The Salon too is a creation of Colbert, dating to 1667; its name is from the Salon Carré of the Louvre, where the works by the most highly esteemed students in the academy are displayed. The Salon itself takes place in the Palais de l'Industrie. Since the French Revolution admittance to the Salon has been open to everyone, with a jury that chooses among the works submitted for consideration. Until 1833 it is held every two years, but beginning in that year, under Louis Philippe, it is made annual and remains that way except for the years 1852 to 1863, when it returns to the biennial schedule. The number of

works exhibited varies from year to year but runs from three to four thousand canvases, making the Salon the world's largest and most important market for contemporary art. People come from all over France as well as all over the world, with the number of visitors on some days reaching as many as four thousand, each paying about a franc for the admission ticket. Aside from the catalog, reproductions of almost all the works exhibited are on sale, giving them the widest possible diffusion. The press gives enormous importance to each exhibition, with many articles by famous critics and writers, such as Charles Baudelaire, Emile Zola, Alexandre Dumas, Théophile Gautier, and the Goncourt brothers, Edmond and Jules. Standing out among the publications of these decades is *Le Charivari*, a satirical magazine founded in 1832 by Charles Philipon (1800–62). Published on its pages are illustrations by Honoré Daumier, Grandville, vitriolic caricatures by Cham—pseudonym

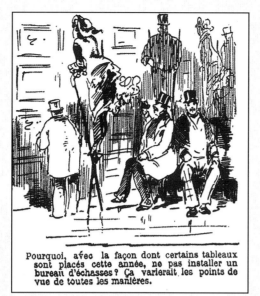

Pourquoi, avec la façon dont certains tableaux sont placés cette année, ne pas installer un bureau d'échasses ? Ça varierait les points de vue de toutes les manières.

of Amédée de Noé (1819–79)—and the often controversial articles by Louis Leroy, the writer destined to give the Impressionists their name.

To be among the prize-winners at the Salon signifies the highest kind of official recognition. It means to win or solidify fame, to increase the hope of finding buyers, or to receive commissions from state officials for the decoration of monuments, theaters, universities, courts, and churches. Even more fortunate are those artists whose works are chosen and purchased by the representatives of the ministry of fine arts to be set up in public buildings or even in the Musée du Luxembourg, the section of the Louvre dedicated to living artists. The increase in the number of works presented to the selection committee and the importance of the prizes given greatly increases the power of the jury, leading to disputes and bitter rivalries. Over the years various efforts are made to at least partially remedy this

Masters and inspirations

situation by altering the number of members of the jury and changing the criteria followed in the selection of the works. In general, however, throughout the first half of the century, the orientation of the jury remains rigidly conservative, so much so that the jury seems to deliberately ignore the most innovative trends or artists.

An important role is also performed by the universal exhibitions. The first of these is held in London at the Crystal Palace in 1851; it is followed by that of New York in 1853. The Paris exhibitions of 1855 and 1867 include true anthological art shows. For example, in 1855 Ingres is on hand with 40 paintings and Delacroix with 35, making an unprecedented opportunity to view works never before displayed, especially works commissioned by private collectors. Furthermore the public is given the chance to see, in many cases for the first time, works of art from foreign countries, in particular from countries outside Europe. For young artists this visual contact with such very different and distant cultures is a very important stimulus, offering them new sources of inspiration and also increasing their desire for

1850•1860

change. During the first half of the nineteenth century, French art is still in large part dominated by the classic revival that began during the last years of the eighteenth century, with such famous exponents as Jacques-Louis David. His spirit is passed on to one of his most gifted students, Jean-Auguste-Dominique Ingres. Born in Montauban in 1780 Ingres begins painting under the guidance of his father, then at the academy of Toulouse, and in 1797 he is taken into David's atelier in Paris. He wins the Prix de Rome in 1801, but the Napoleonic wars prevent him from leaving immediately for Italy. In 1806 he finally gets to Rome, where he stays until 1820, when he moves to Florence to study with the sculptor Bartolini. At the Salon of 1824 he presents the *Vow of Louis XIII*, a large canvas today in the cathedral of Notre Dame at Montauban; critics praise it highly, going so far as to compare it to the *Massacre at Chios*, one of Delacroix's first revolutionary works. Back in Paris, Ingres becomes a member of the academy and opens an atelier that becomes one of the most visited and highly esteemed in the city. Between 1834 and 1841 he returns to Rome as director of the French Academy, and his influence increases even more. In the following decades he receives many important commissions, both public and private, in particular for female portraits, considered among his masterpieces for the perfect balance struck between attention to the smallest detail and sharp psychological introspection.

The antagonist par excellence of Ingres' classicism is Eugène Delacroix, the foremost painter of the romantic movement in France. He is born in Charenton-Saint-Maurice in 1798 to a rich and influential middle-class family. He studies in the workshop of the neoclassical artist Guérin but is also influenced by Théodore Géricault, even posing for a figure in Géricault's *Raft of the Medusa*. He makes his debut at the Salon with the *Bark of Dante*, today in the Louvre, attracting the attention of critics with the scene's palpable dramatic tension, its forceful psychological characterization, and its luminous, brilliant colors. These aspects of his work are only reinforced over the coming years, most of all after his 1832 trip to Morocco and Spain, which seals his attraction to things exotic. His odalisques, with their languid but elegant eroticism, and his Arabian subjects in general—strongly marked by exotic elements—have a profound

influence on young artists, in particular the Impressionists, who see in him a master and an inspirer.

Another highly important person in the evolution of French art at the middle of the century is Jean-Baptiste-Camille Corot. Alongside works based on traditional classical themes, he makes more intimate and evocative paintings—fruit of his trips to Italy and his passion for nature—leading him to prefer painting *en plein air*, outdoors, in the open air. Critics long undervalue his realistic, naturalistic attitude, most of all because they still hold on to the conviction that landscape painting is only a minor pictorial genre, inferior in importance to canvases on historical, mythological, or religious subjects. They begin to change their minds and appreciate his art only after 1855, when Napoleon III buys one of his paintings, *Souvenir of Marcoussis*, at the universal exhibition in Paris. But the young Impressionists admire and closely study his works, which are notable for the simplicity and clarity of their forms and the use of delicate, suffused lighting. The Impressionists

Jean-Auguste-
Dominique Ingres
(1780–1867).

Exhibition of works
sent from Villa Medici
in Rome to the Ecole
des Beaux-Arts in
Paris in 1873.

often invite Corot to exhibit with them, and only his standoffish and solitary character prevents him from performing a more active role in their artistic formation.

The painters of the Barbizon school, identified by critics as the most direct forerunners of the Impressionists, showed much the same attitude toward nature. Far from being a true school, this was not even a homogeneous group. Its name comes from the small town of Barbizon near the forest of Fontainebleau, chosen as the ideal place to paint *en plein air* by Théodore Rousseau, who moves there in 1836. Soon enough he is being imitated by other landscapists who go to these outdoor settings in the hope of achieving a more spontaneous and direct relationship with nature. These artists include Constant Troyon, Jules Dupré, Charles-François Daubigny, Narcisse Virgile Diaz de la Peña, Antoine Louis Barye, and Alexandre Gabriel Décamps. Seeking emancipation from the backward and coercive teachings of the academy, they flee the confusion of the city with its false myths of technological progress to find new inspiration in woods and fields. At the same time, however, their return to nature is far different from the idealization of neoclassicism or the lyricism of the romantics. They do not transform reality, make no efforts to embellish it, and instead portray it as it presents itself to their eyes, however humble and banal as

The atrium of the Ecole des Beaux-Arts with its rows upon rows of copies of classical statues used as models by the students.

The courtyard of the Ecole des Beaux-Arts around 1860.

that may be. For this reason they leave their ateliers and prefer to paint *en plein air*. There is nothing new about the techniques used; landscape artists have long made quick sketches from life, preparatory drawings for the final painting, which is made later in the studio. Eager to emphasize their direct and spontaneous relationship with reality, the painters of the Barbizon school turn this arrangement around and transform what was considered the preliminary activity into the actual artistic creation. Daubigny is among the first to judge as finished what he has made out-

doors, without the need of further retouching or reworking, and in 1857 he builds a floating studio, named *Le Botin*, imitated several years later by Monet. Critics struggle to accept this method, and it is significant that the usual accusation leveled against these new artists is that of being superficial, satisfied with mere "impressions."

It should not be forgotten that this outdoor activity is facilitated by the invention, around 1840, of metallic tubes for oil paint, making paints more durable and easier to handle; also important is the widespread availability of portable easels and other pieces of equipment, all of them making painting outdoors far easier and more agreeable.

Corner of the Salon of 1861 in a photograph by Richebourg.

Jean-Auguste-
Dominique Ingres
**Oedipus and
the Sphinx**
1808, oil on canvas,
189 × 144 cm
Musée du Louvre,
Paris

In 1806, at the age
of twenty-six, Ingres
goes to Italy, where
he will remain for
fourteen years, first
in Rome, later in
Florence, closely
studying ancient art.
He soon adopts the
notion of "ideal
beauty," theorized by
Antonio Canova, and
endeavors to create
images of pure and
absolute beauty, out-
side both time and
space. Beginning in
his earliest works,
including this paint-
ing, he proves himself
capable of achieving
a perfect balance
between the design,
sharp and meticulous
in its smallest detail,
and the distribution
of light, used to give
the scene a sense of
depth and an almost
sculptural quality to
the characters.

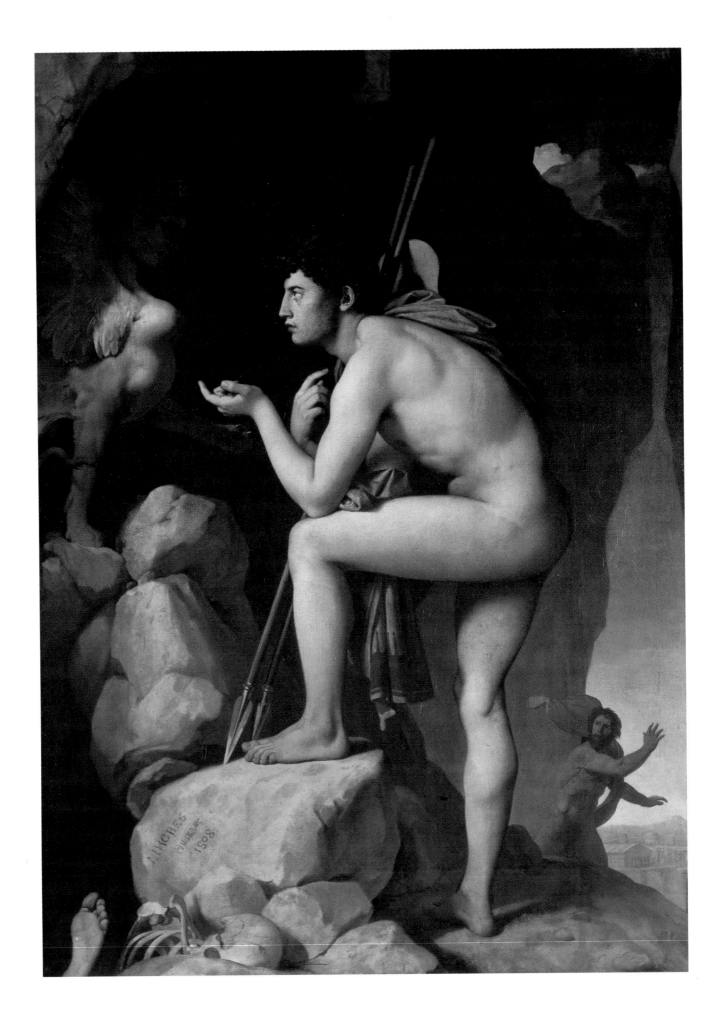

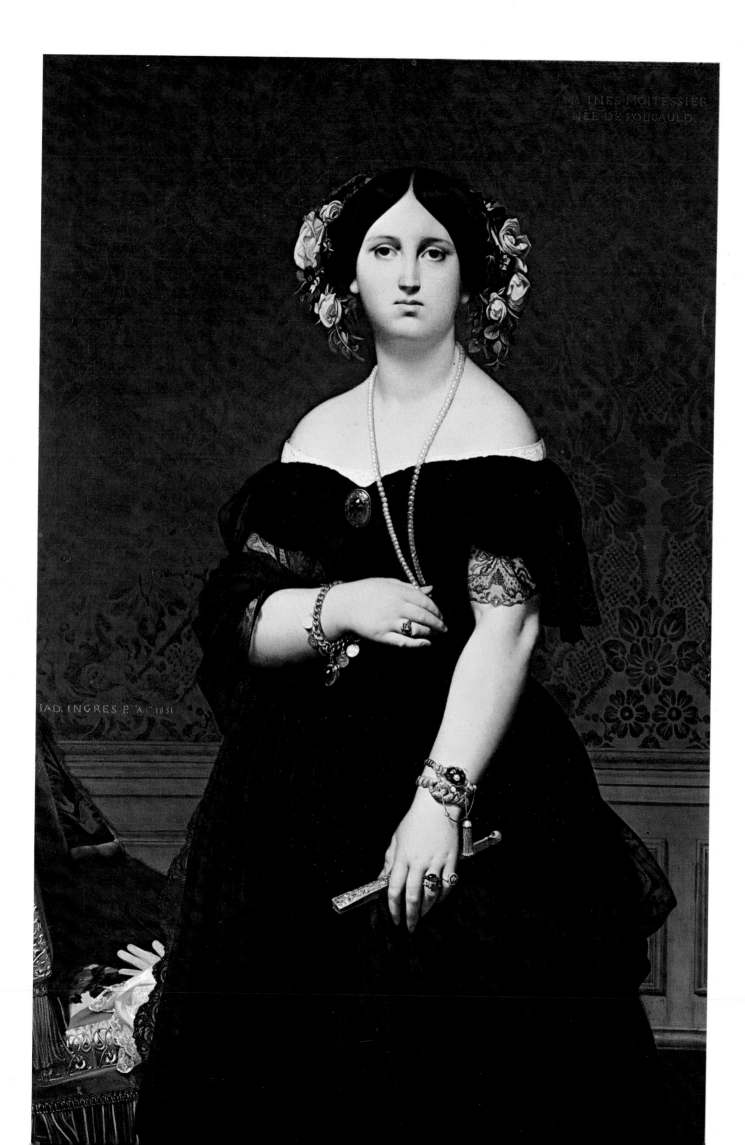

■ Jean-Auguste-
Dominique Ingres
Madame Moitessier
1851, oil
on canvas,
146 × 100 cm
National Gallery of
Art, Washington, D.C.

The end of the
1840s finds Ingres
specializing in female
portraits, both to
satisfy the growing
demand for them and,
most of all, because
they permit him in
explore his ideals of
beauty. The result
includes some of his
most famous works,
paintings character-
ized by a sophisticated
realism and great
attention to detail.
This can be seen in
this painting in the
complex decoration
of the woman's hair
and in the details of
her jewels. Some
critics find the same
faults in Ingres that
they find in Canova,
in particular, a certain
inexpressiveness in
the characters, who
seem to be without
any emotions or
sentiments.

JEAN-AUGUSTE-
DOMINIQUE INGRES
The Turkish Bath
1862, oil on panel,
108 cm in diameter
Musée du Louvre,
Paris

Unlike Delacroix, as in
his *Women of Algiers
in Their Apartment*
(page 22), Ingres
approaches Orientalist
themes only in a dis-
tant and superficial
way, making no
attempt to understand
their inner reality or
way of thought. He
is interested only in
the formal rendering,
the almost geometric
construction of space,
emphasized by the
use of the circular
format of the paint-
ing and the harmony
of the female bodies,
reminiscent of some
of his earliest studies.
In fact, the figure
seen from behind
in the foreground
repeats, with only
very few changes,
The Valpinçon Bather,
which Ingres had
made in 1808 during
his stay in Rome.

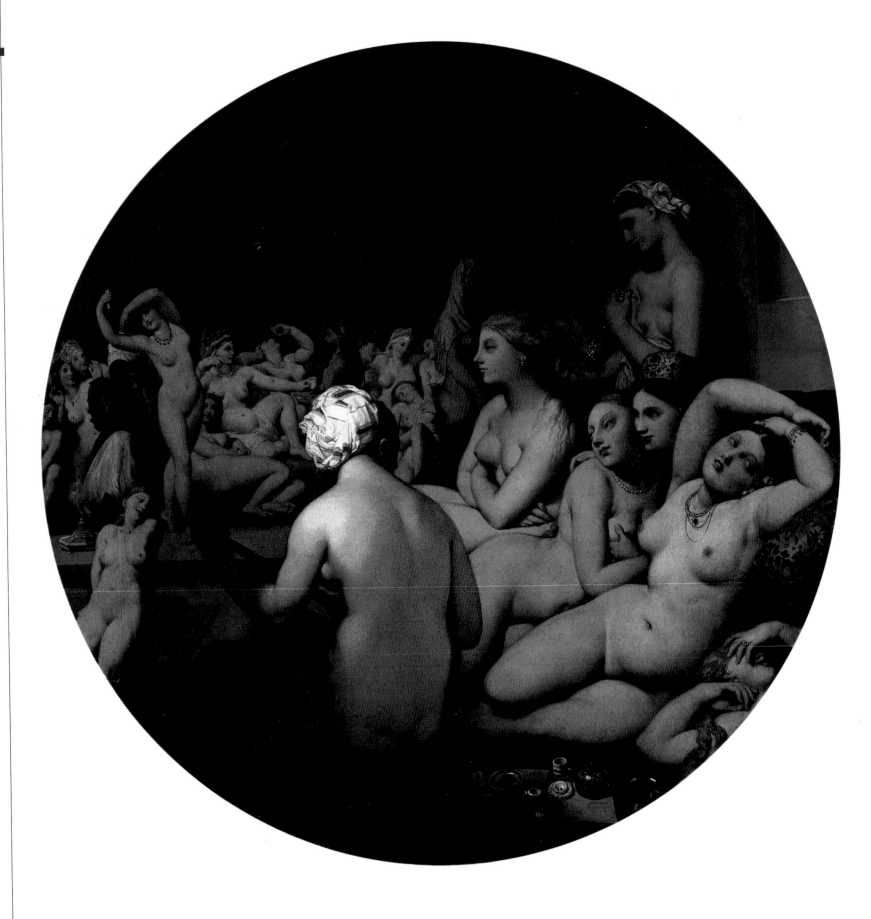

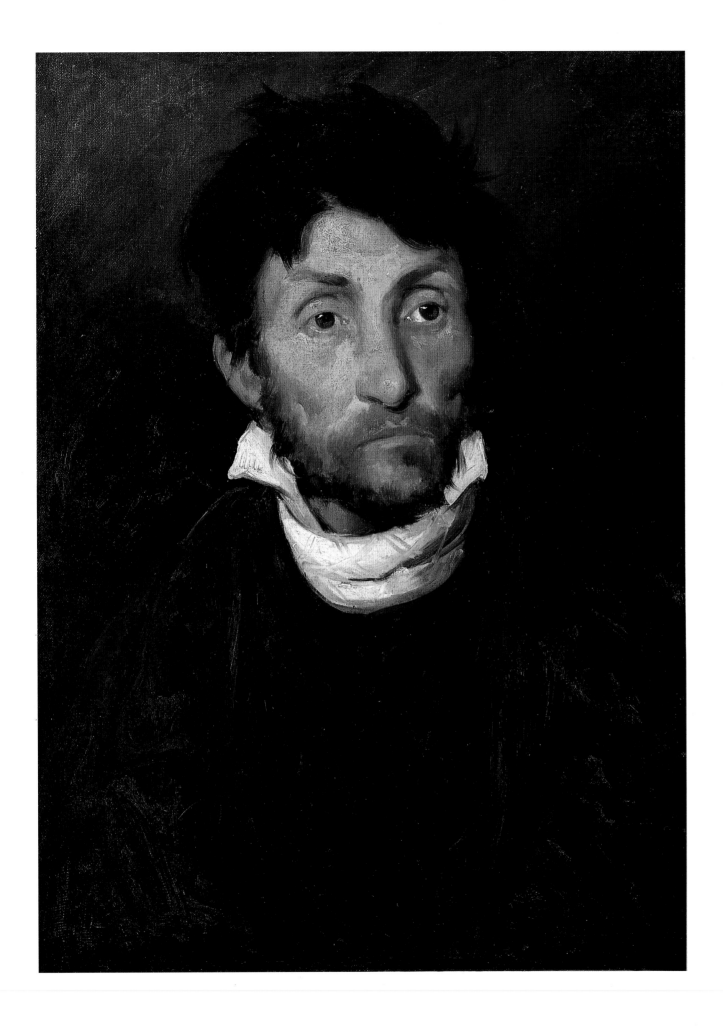

THÉODORE
GÉRICAULT
**Portrait of a
Kleptomaniac**
1821–24, oil
on canvas,
61 × 50 cm
Museum voor Schone
Kunsten, Ghent

This painting is one
of a series of five
canvases made
between 1820 and
1824 on the invitation
of Dr. Etienne-Jean
Georget, a pioneer in
psychiatric treatment,
in which Géricault
portrays the mentally
ill. These works are
among the first exam-
ples in nineteenth-
century painting of
an artist directing his
attention to the inner
feelings and emotions
of people, and the
sitters are presented
with stark, almost
scientific realism.
The dark tones of the
man's clothing and
the background con-
centrate the viewer's
attention on the
details of the face,
in particular the eyes,
evasive and at the
same time intense.

EUGÈNE DELACROIX ■
**Women of Algiers
in Their Apartment**
1834, oil on canvas,
180 × 229 cm
Musée du Louvre,
Paris

In 1832 Charles de
Mornay is sent on a
diplomatic mission to
the sultan of Morocco
and asks Delacroix if
he would like to come
along. Aside from
Morocco, they make
visits to Spain and
Algeria. The artist is
struck by what he
sees in these locales
and fills album after
album with sketches:
this canvas is based
on a sketch made
during a visit to a
harem, an opportunity
offered only rarely to
foreigners. The work
is immediately bought
by Louis Philippe,
and even Renoir
finds it fascinating:
"Approaching this
painting," he says,
"I smell the aroma
of the incense slowly
burning in the
narghile."

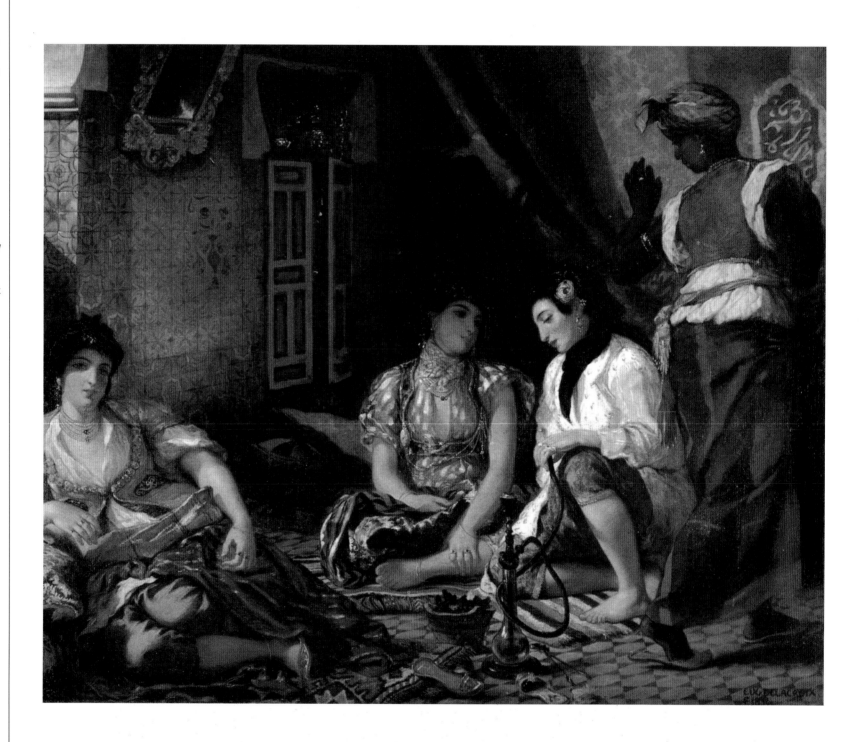

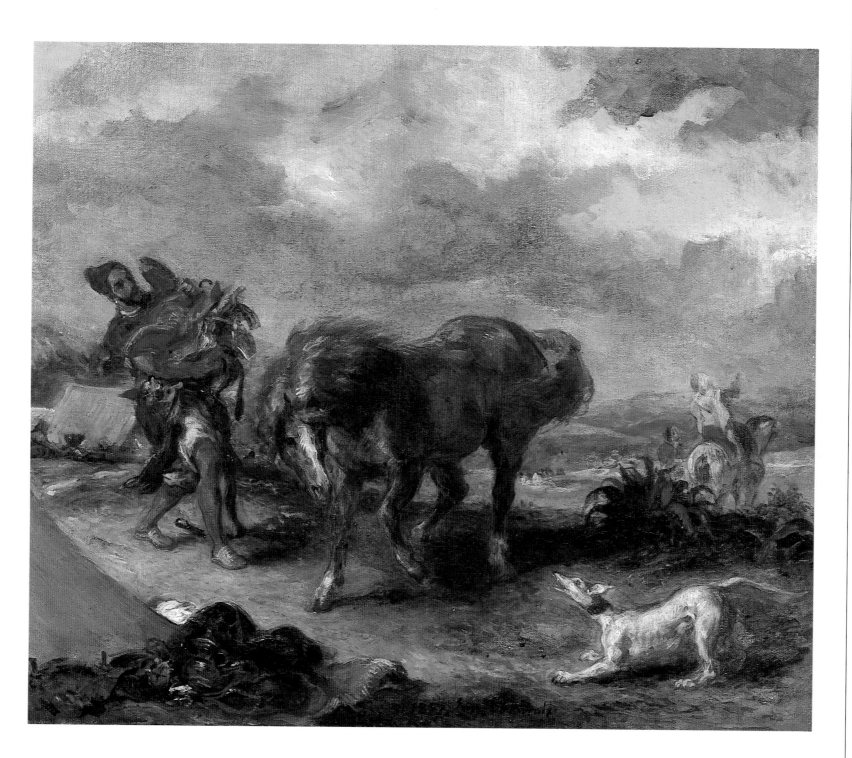

■ EUGÈNE DELACROIX
**Arab about to
Saddle His Horse**
1857, oil on canvas,
57 × 61 cm
Szépmüvészeti
Múzeum, Budapest

The trip to Morocco
proves a decisive
experience in
Delacroix's artistic
development, not
only because of his
adoption of Orientalist
themes, which in fact
show up in his work
for the rest of his
life, but most of all
because of the new
stylistic methods he
adopts. These mark a
true change in his art
and further accentu-
ate his detachment
from the classicism
of Ingres. In 1855
Delacroix presents a
dramatic *Lion Hunt*
at the universal exhi-
bition in Paris for
which he is awarded
the Legion of Honor.
This painting, made
two years later, testi-
fies to the energetic,
vital style of his
mature production.

1850•1860

EUGÈNE DELACROIX
**Jacob's Fight
with the Angel**
1854–61, oil and wax
medium on wall,
751 × 458 cm
Church of Saint-
Sulpice, Chapel of the
Saints-Anges, Paris

Between 1850 and
1861 Delacroix dedi-
cates himself almost
entirely to a single
ambitious project of
enormous scale, the
fresco decoration of
the chapel of the
Saints-Anges in the
Parisian church of
Saint-Sulpice. For the
scene of *Heliodorus
Driven from the Temple*
he draws inspiration
from Raphael's version
in the Stanze Vaticane
and from that of
Bertholet Flémalle
(1614–77). In this
large composition he
presents a personal
reworking of Titian's
*Death of St. Peter
Martyr*, of which he
has a copy that was
painted by Géricault.
From it comes much
of the work's flashing
luminosity as well as
its dramatic intensity.

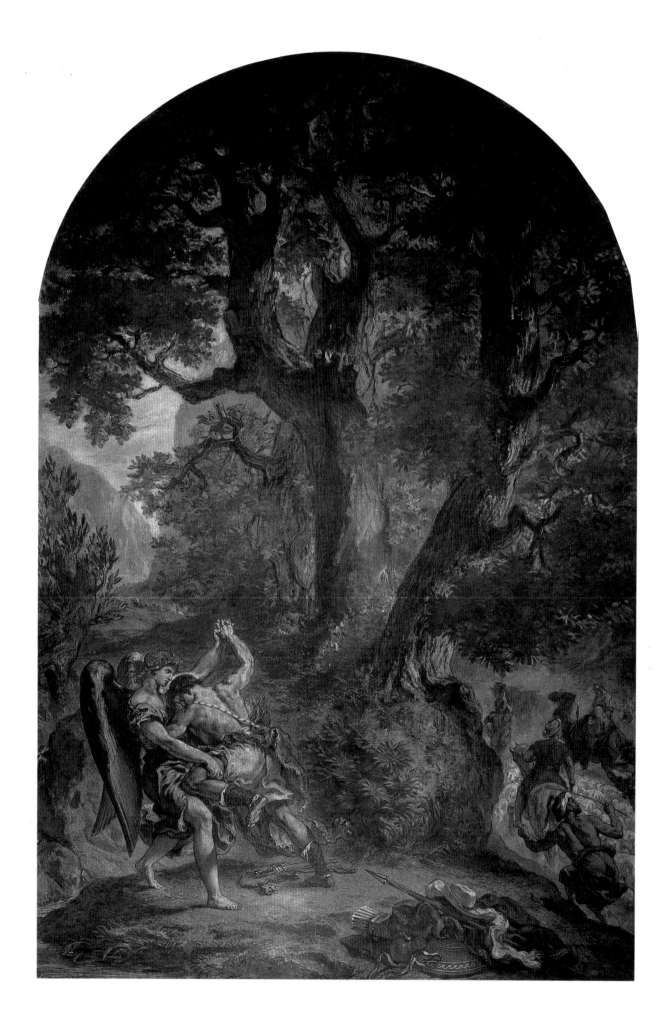

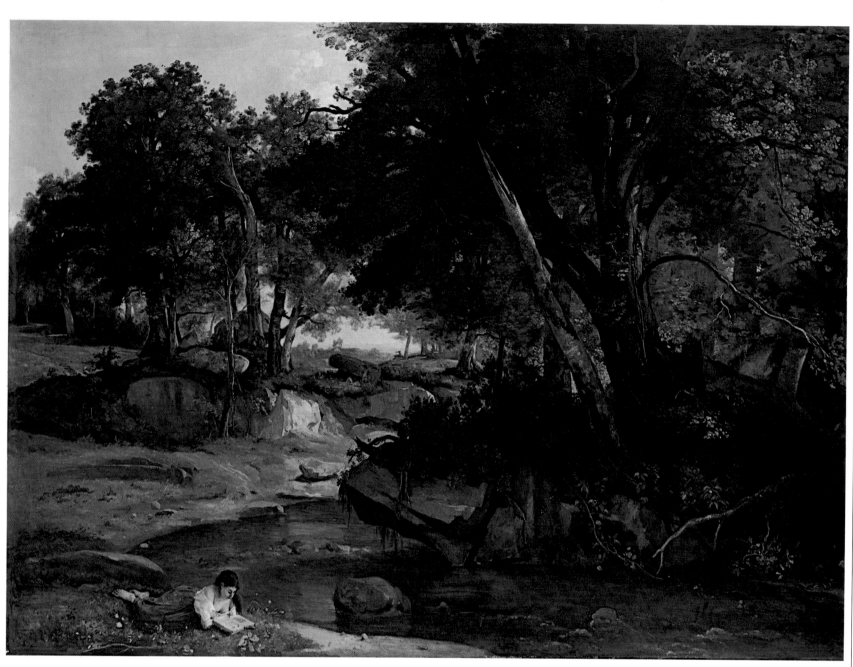

JEAN-BAPTISTE-
CAMILLE COROT
**The Forest of
Fontainebleau**
circa 1830, oil
on canvas,
175 × 242 cm
National Gallery of
Art, Washington, D.C.

In 1828 Corot returns
to Paris after three
years in Italy. During
the summer months
he begins to make
regular visits to the
nearby forest of
Fontainebleau to
make drawings and
sketches that he later
uses in his studio as
models for landscapes.
At times, however, he
completes entire land-
scapes outdoors, imi-
tated by the painters
of the Barbizon school
and, later, by the
Impressionists. The
role he performs is
particularly important
because he radically
transforms the genre
of landscape painting,
freeing it from the
rules codified during
the seventeenth cen-
tury by artists like
Poussin and Lorrain.

JEAN-BAPTISTE-
CAMILLE COROT
Chartres Cathedral
1830, oil on canvas,
65 × 50 cm
Musée du Louvre,
Paris

The Gothic cathedral
is a typical theme of
romantic painting;
there is, for example,
the series of the
cathedral of Salisbury
by John Constable.
The massive work of
architecture, symbolic
of human creativity,
is placed in a natural
setting that includes
more or less clearly
stated poetic or sym-
bolic images. Even the
sky in this painting,
scattered with clouds
and areas of light,
harkens back to works
by English land-
scapists, while the
figures among ruins
in the foreground are
reminiscent of works
by painters active in
Rome during the
seventeenth and
eighteenth centuries,
works that Corot had
occasion to study
during his first trip
to Italy.

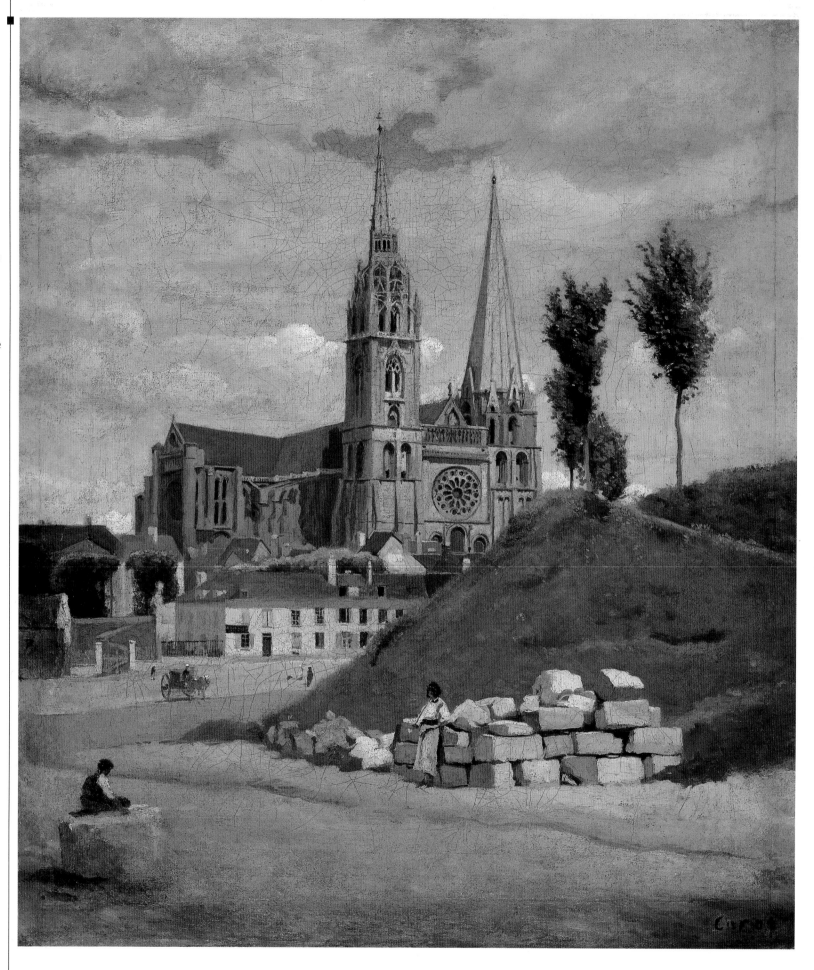

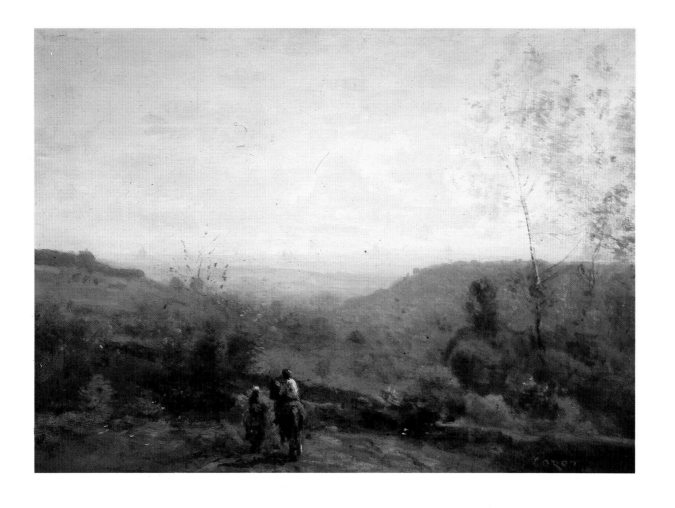

Jean-Baptiste-Camille Corot
**Horseman,
Setting Sun**
1853, oil on panel,
25 × 35 cm
Musée Fabre,
Montpellier

In 1834 Corot makes his second trip to Italy, this time visiting Florence, Genoa, Venice, and the Lombard lakes. He returns yet again in 1843, making this third trip to study ancient painting and also because he is drawn to the luminous Mediterranean landscapes. His palette grows lighter, enriched by new shadings that he uses to imbue his works with a soft, delicate atmosphere.

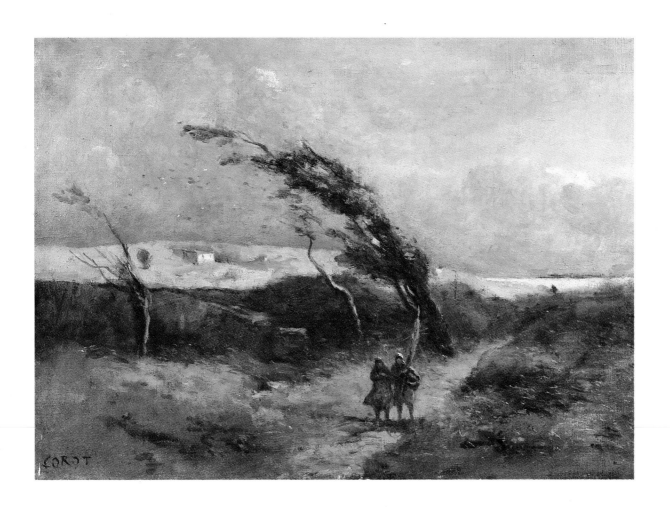

Jean-Baptiste-Camille Corot
**Windswept
Landscape**
1865–70, oil
on canvas,
40 × 56 cm
Musée du Louvre,
Paris

In the 1860s Corot receives his first official recognition and at the same time begins to enjoy increasing financial success. He intensifies his production such that he is calculated to have made as many as 5,000 paintings. In the landscapes of his mature years, such as this work, his forms become simpler and more casual, giving greater freedom to the colors.

JEAN-BAPTISTE-
CAMILLE COROT
Woman in Blue
1874, oil on canvas,
80 × 50.5 cm
Musée du Louvre,
Paris

In 1874, when he
paints this portrait,
Corot is seventy-eight
years old, but he is
still full of new ideas
and alert to new
sources of inspiration.
The unconventional
pose of the woman,
her attitude of
thoughtful absorption,
and the careful appli-
cation of light and
shadows have a great
influence on the
formation of the
Impressionists.

JEAN-BAPTISTE-
CAMILLE COROT
Agostina
1866, oil on canvas,
195 × 130 cm
National Gallery of
Art, Washington, D.C.

During his three trips
to Italy, Corot makes
various portraits of
people in local cos-
tume, of which this
is one of the most
representative. Corot
demonstrates only
superficial interest in
the more folkloristic
aspects of such works;
his objective is to
give the subject a
human dimension,
and his emphasis is
on the evocation of
feelings and emotions.

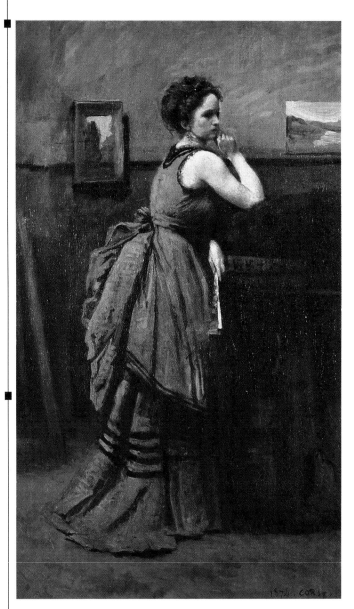

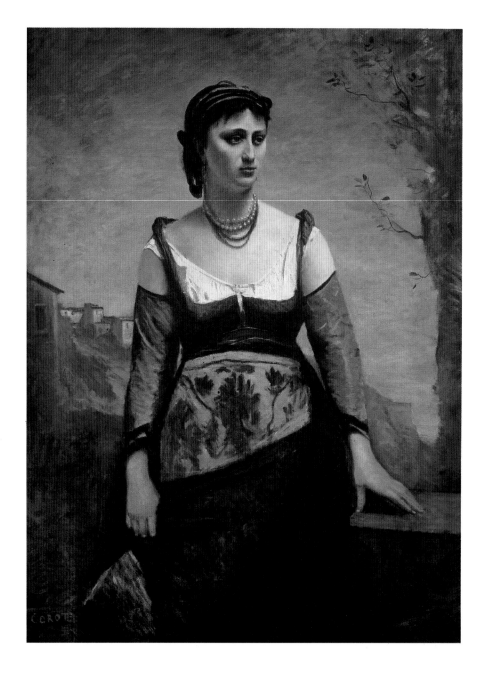

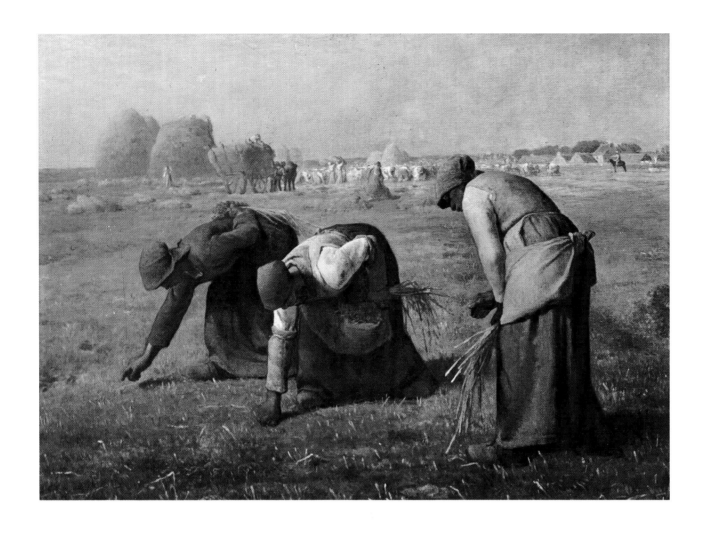

■ JEAN-FRANÇOIS
MILLET
Gleaners
1848, oil on canvas,
54 × 66 cm
Musée du Louvre,
Paris

Peasants are the
subjects of many of
Millet's works, usually
presented while per-
forming humble and
painstaking work in
fields. Unlike Daumier,
who used such social
themes as opportuni-
ties to make fiery
political statements,
Millet tones down or
avoids every possible
political reference and
uses the evocative
effects of light to
poetically transform
reality.

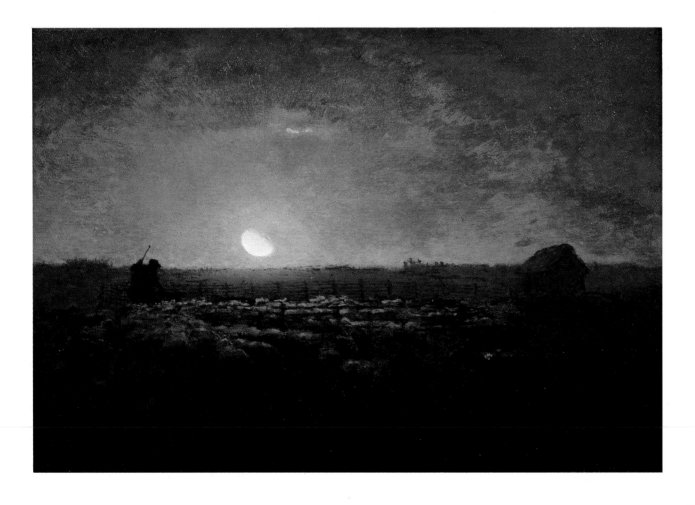

■ JEAN-FRANÇOIS
MILLET
**The Sheepfold,
Moonlight**
1861, oil on panel
39.5 × 57 cm
Musée d'Orsay, Paris

In 1848 Millet moves
to Barbizon, where he
stays, dying there in
1875. Although he is
friends with many of
the other landscape
artists who like him
visit the forest of
Fontainebleau, he
prefers to do his
pictorial research
alone. Above all,
he is faithful to his
own style, which
remains very much
his own, closer to the
lyrical and symbolic
reading of nature
typical of romanticism.

1850•1860

JEAN-FRANÇOIS
MILLET
Spring
1868–73, oil
on canvas,
86 × 111 cm
National Gallery of
Art, Washington. D.C.

Millet comes from a
family of reasonably
well-off peasants in
the Cotentin region of
northwest France. In
1837 a scholarship
award enables him to
go to Paris to study
painting in the atelier
of Delaroche. Inspired
by classical paintings
in the Louvre, Millet
is first drawn to
paintings with mytho-
logical subjects and
portraits. Soon,
however, following the
example of Honoré
Daumier, he abandons
such subjects to
dedicate himself to
themes with social
relevance, especially
the presentation of
life in the fields where
he spent his youth.

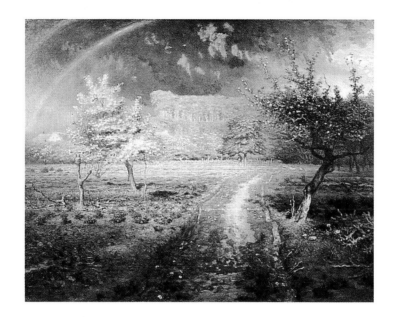

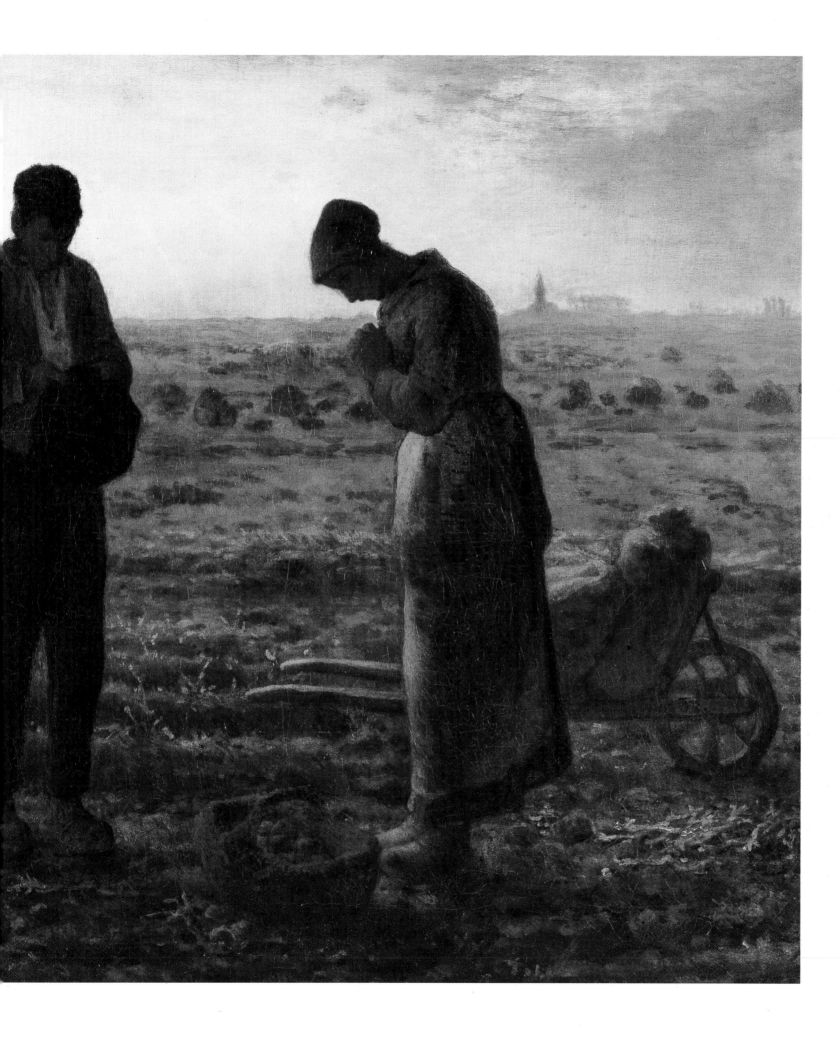

■ Jean-François
Millet
Angelus
1858–59, oil
on canvas,
55 × 66 cm
Musée du Louvre,
Paris

First exhibited in
1867, this painting
becomes an immedi-
ate, popular success
and reaches a wide-
spread and distant
audience when repro-
duced on calendars
and postcards. It is
interpreted as a
celebration of the
simple, pure life of the
peasant as opposed to
the excesses of Paris,
which in those years
was being transformed
into a great industrial
metropolis. In the
following decades
many artists, includ-
ing Vincent van Gogh,
look to this work for
inspiration, while
others set themselves
firmly against it,
among them Salvador
Dali, who creates his
own psychoanalytic
and surrealistic
interpretation.

Autumn

1865, oil on canvas,
106.5 × 93.5 cm
Rijksmuseum Hendrik
Willem Mesdag,
The Hague

Jules Dupré (1811–89)
begins his career as a
decorator of porcelain,
then studies painting
in Paris. Strongly
influenced by the
works of Constable and
Théodore Rousseau,
he dedicates himself
to landscapes, which
he makes *en plein
air* in the forest of
Fontainebleau and
at L'Isle-Adam, where
he moves in 1849.
His style, which is
halfway between the
dramatic tension of
romanticism and the
realism of the Barbizon
school, is not without
symbolic allusions, as
in this work.

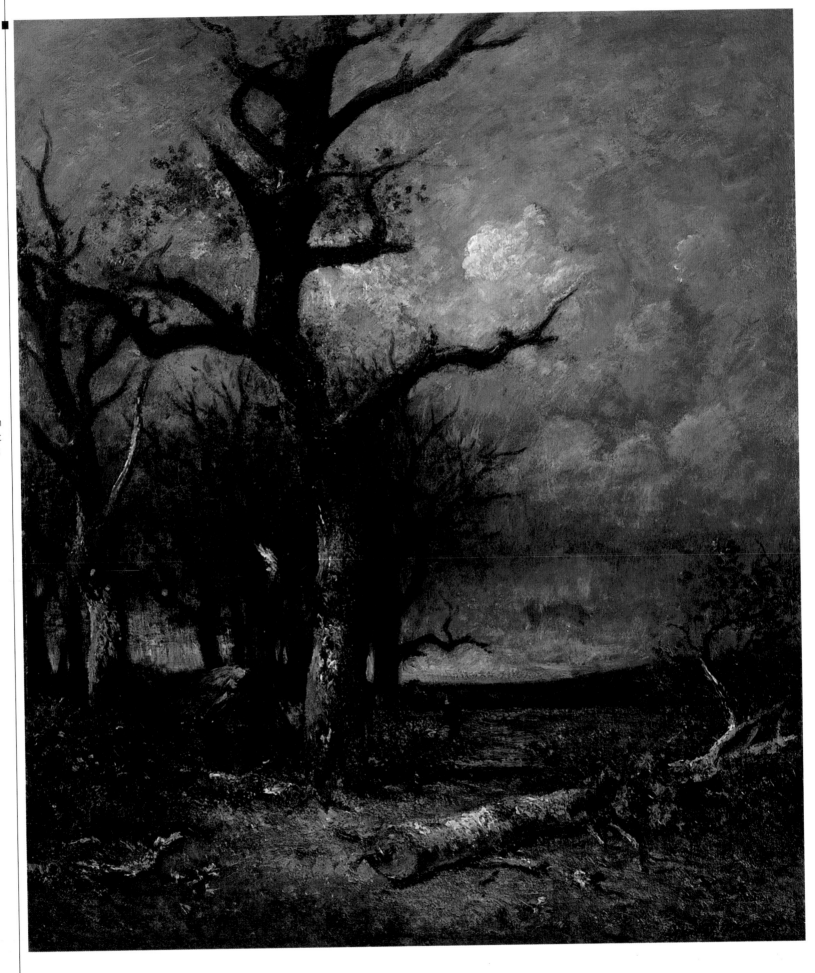

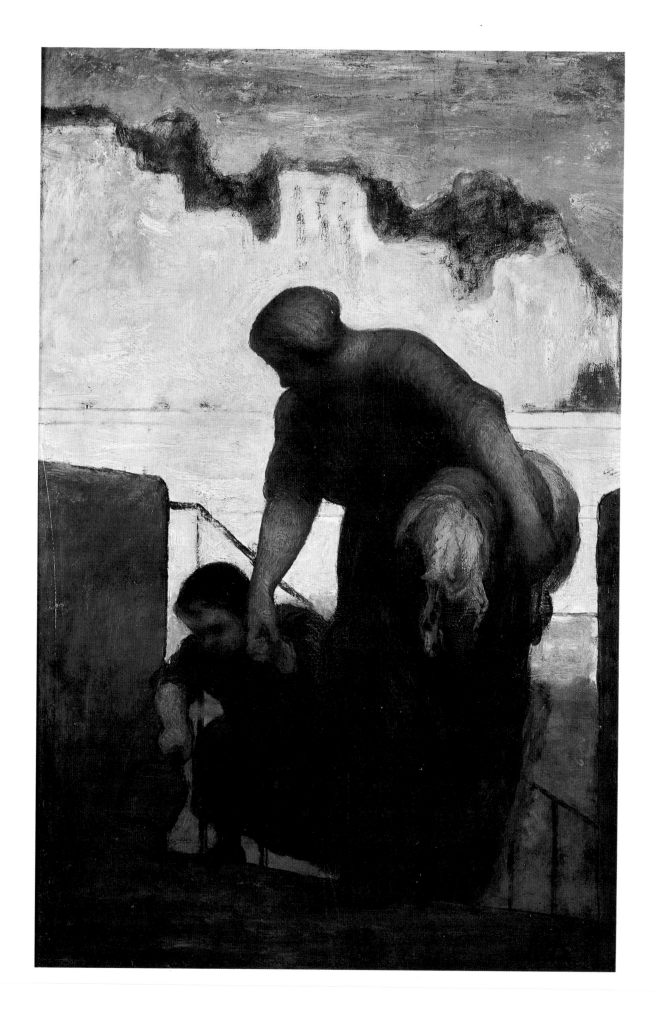

■ HONORÉ DAUMIER
The Washerwoman
1863, oil on panel,
49 × 33 cm
Musée d'Orsay, Paris

Honoré Daumier makes
a name for himself as
a social satirist. From
his earliest works
he is known for his
direct, incisive style,
but even more for his
irony and bold irrever-
ence, even getting
himself into legal
difficulties because
of several caricatures
of Louis Philippe.
An excellent engraver,
he regularly publishes
his lithographs in *Le
Charivari*, contributing
to that magazine's
success. He makes
comparatively few
paintings and sculp-
tures, but, as in this
example, they are
marked by a delicate
realism, with muted
tones and soft colors.

GUSTAVE COURBET
The Wave
1869, oil on canvas,
65 × 88 cm
Brooklyn Museum,
New York

This is one of a famous
series of paintings of
waves Courbet made
at Étretat on the
Channel coast between
1869 and 1872. He
makes clear the enor-
mous power of the
sea by presenting the
scene from very close
up and by his highly
expressive use of light.
His typically romantic
approach to nature is
destined to have a
notable impact on the
young Impressionists.

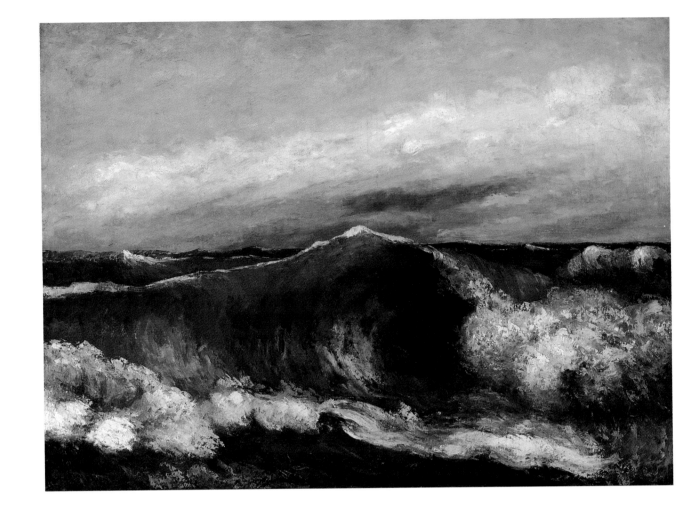

GUSTAVE COURBET
Small Seascape
1872, oil on canvas,
32 × 41 cm
Private collection

Courbet is an active
participant in the
events surrounding
the Paris Commune.
Arrested in the summer
of 1871 and accused
of having directed
the destruction of the
column in the Place
Vendôme, he is sen-
tenced to six months
in prison, which he
spends in the prison of
Sainte-Pélagie in Paris
and in the clinic of
Dr. Duval at Neuilly.
There he is able to
make several still lifes
and a dozen or so
seascapes, perhaps
including this one.

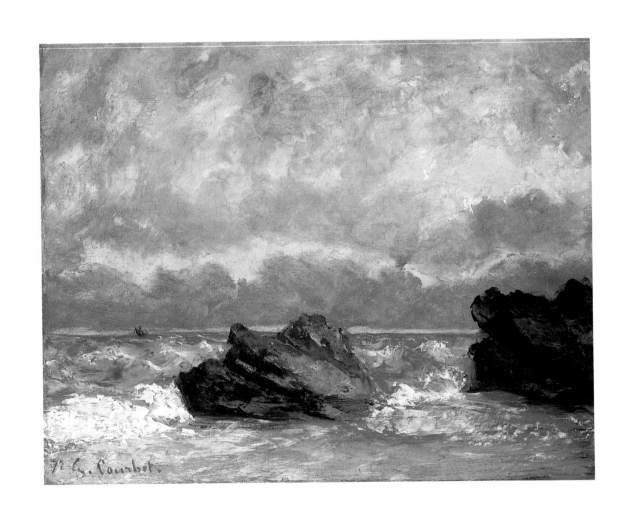

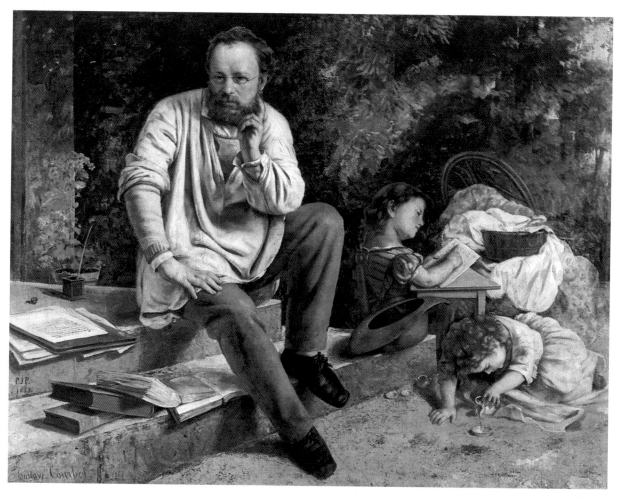

■ GUSTAVE COURBET
**The Proudhon
Family in 1853**
(Complete and detail)
1865, oil on canvas,
147 × 198 cm
Musée du Petit Palais,
Paris

Courbet shares the
socialistic and revolu-
tionary ideals of the
social theorist Pierre
Joseph Proudhon
(1809–65) and often
visits him during his
three years of impris-
onment for political
reasons between 1849
and 1852. In fact,
Courbet inspires his
essay *The Principle
of Art and Its Social
Function*. Courbet
often expresses the
wish to make a por-
trait of his friend,
but Proudhon refuses
to pose. This painting,
made after Proudhon's
death in January
1865, is based on
several photographs;
the detail shows
Proudhon's daughters,
Catherine and
Marcelle.

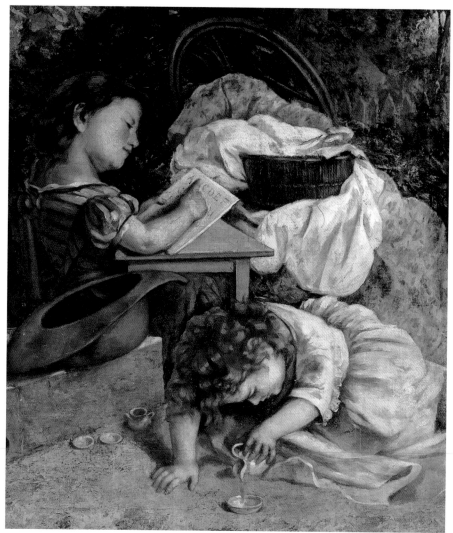

HENRI
FANTIN-LATOUR
**Scene from
Tannhäuser**
1864; oil on canvas,
97.5 × 130.2 cm
County Museum of
Art, Los Angeles

Born in Grenoble in
1836, Ignace-Henri-
Jean-Théodore
Fantin-Latour gets
his introduction to
painting from his
father, then contin-
ues his studies with
Courbet and Horace
Lecoq de Boisbaudran,
one of the most
famous drawing teach-
ers in Paris. After
time well spent at
the Ecole des Beaux-
Arts, he debuts at
the Salon in 1861.
He is the friend of
many writers, includ-
ing Baudelaire, Zola,
and Mallarmé, as
well as of most of
the Impressionist
painters, whom he
portrays in various
paintings. Even so, he
does not participate
in any of their shows,
and his style remains
faithful to the teach-
ings of the academy.

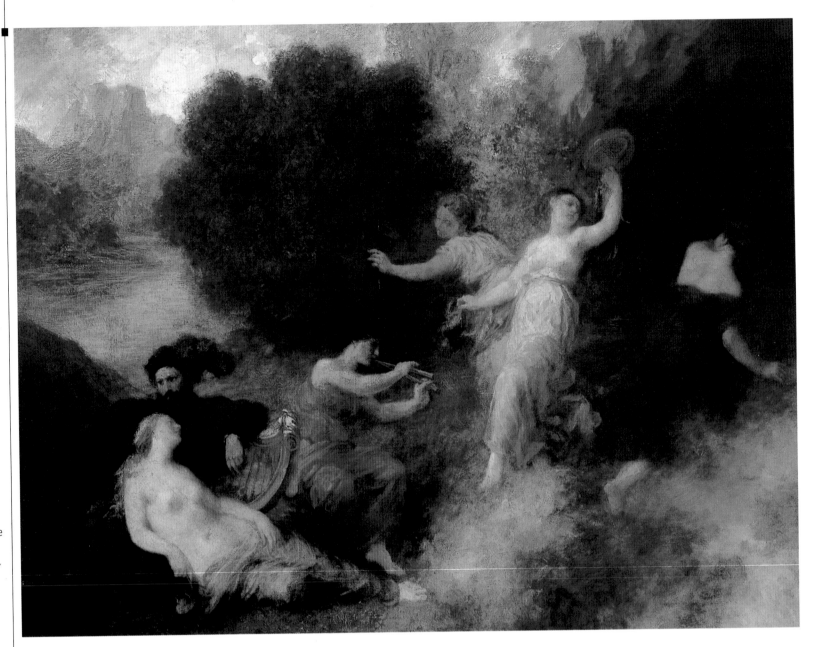

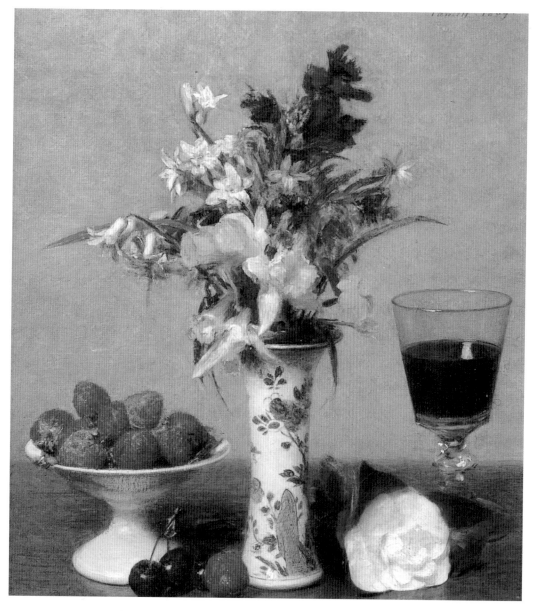

■ HENRI
FANTIN-LATOUR
**Strawberries and
Wine Glass**
1869, oil on canvas,
32 × 29 cm
Musée de Peinture,
Grenoble

In 1859, Fantin-
Latour, his school
friend Alphonse
Legros, and James
McNeill Whistler found
the Societé des Trois;
what the three have
in common is an
interest in realism.
In the following
decades Fantin-Latour
specializes in floral
still lifes, soon
becoming famous for
the fresh luminosity,
brilliant colors, and
delicate, intimist
atmosphere of his
work. His works gain
particular popularity
in England, where
Fantin-Latour settles
early in the 1870s;
in France they are
appreciated only
later, after 1879, the
year in which he is
awarded the Legion
of Honor.

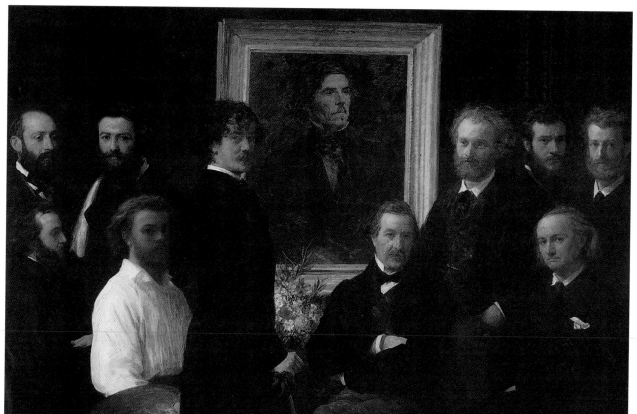

■ HENRI
FANTIN-LATOUR
Homage to Delacroix
1864, oil on canvas,
Musée d'Orsay, Paris

This painting expresses
the young painters'
admiration for the
great romantic master,
who had died in 1863.
Standing in front of a
portrait of Delacroix,
they are, from left to
right, Charles Cordier,
Louis-Edmond Duranty,
Alphonse Legros,
Fantin-Latour, James
Whistler, Jules Champ-
fleury, Edouard Manet,
Félix Bracquemond,
Charles Baudelaire,
and Albert, comte
de Balleroy.

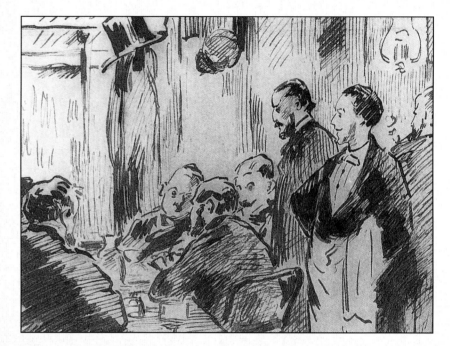

Café Guerbois, ink sketch by Manet, 1869, Fogg Art Museum, Harvard University, Cambridge.

Charles Baudelaire, Manet's friend, confidant, and defender.

Right: An "official" portrait of Manet from the 1870s.

D espite the fact that Edouard Manet does not participate in any of the eight Impressionist shows, critics have always agreed in considering him the Impressionists' guiding light, their principal source of inspiration.

He is born in Paris on January 23, 1832, so with the exception of Pissarro, born in 1830, Manet is the group's oldest member. He is two years older than Degas, seven older than Sisley and Cézanne, eight years older than Monet, and nine years older than Renoir, such that all of them come to look on him as an older brother. He comes from a well-to-do family; his father, Auguste, is the personnel director for the ministry of justice; his mother, Eugénie Désirée Fournier, is the daughter of a diplomat in Stockholm. He has two brothers, Eugène, born in 1833, and Gustave, born in 1835. He attends the Rollin College and begins studying drawing under the guidance of a maternal uncle, Edmond Edouard Fournier. In 1848 his attempt to make a career as an officer in the navy fails when he does not pass the admission exams. For a few months he serves as student helmsman aboard the ship *Le Havre e Guadeloupe*. Rejected in his

unhappy with the paintings he had made until then and discouraged at being unable to find new sources of inspiration that might help him to accomplish what he hoped, he saw an old beggar. This vision brought

1860•1870 Manet:

second attempt at the entrance exams for the naval school, he gets his father's permission to enroll in Thomas Couture's painting school, where he remains for six years. Meanwhile he meets a Dutch girl, Suzanne Leenhoof, from whom he takes piano lessons and with whom he almost certainly has a son, Léon, born January 29, 1852 (he marries her on October 28, 1863). Following a series of sharp quarrels with Couture he leaves his studio in 1856 and opens his own in Rue Lavoisier, together with a friend, Albert, comte de Balleroy, a painter of genre scenes. A few years later the critic Félicien Champsaur relates (or perhaps invents) an anecdote that explains young Manet's separation from the classicism of the academy: "One day, while the painter was walking through the streets of Paris,

about a kind of awakening in him that convinced him of the need to look at reality, just as it is, without making any attempts to embellish or deform it, and it led him to locate his paintings in the present, abandoning the intellectual flights into space and time so dear to paintings with historical or mythological subjects. He asked the beggar to come up to his atelier and pose for his portrait. And so, ladies and gentleman," concludes the critic, "this is the essence of impressionism; instead of imitating Praxiteles and Raphael, the new painters draw their inspiration from nature."

In 1857 Manet meets Fantin-Latour, with whom he is destined to share a friendship until the end of his life; the next year, at the Louvre, he meets Berthe Morisot, the young woman who

Manet: "Roi des Impressionnistes"

is one of the few female painters in the group of the Impressionists. For a while she poses for him, then, on December 12, 1874, she marries his brother Eugène, with whom she has a daughter, Julie, born in 1878. In 1859 Manet presents the Salon with a painting called the *Absinthe Drinker*, which is rejected; in 1861 his *Spanish Guitar Player* is accepted, earning him an honorable mention. Things Spanish are very much in vogue in Paris during those years, and many artists, including Manet, begin to study and imitate Iberian masters, chief among them Velázquez and Goya. Early in the 1870s Manet moves to a studio in Rue Douai and later to 8, Rue Guyot; he studies etching and shows he has good aptitude. He meets Victorine Meurent, then nineteen years old, who serves as his model in many famous paintings until 1875. On September 25, 1861, his father dies, leaving him a large inheritance. Early in 1863 Manet exhibits fourteen works in the gallery of Louis Martinent, among them *Music in the Tuileries Gardens*, today in the National Gallery in London. He submits three paintings for consideration by the Salon, *Youth in Costume of Majo, Mlle V.* [Victorine Meurent] *in the Costume of an Espada*, and *Luncheon on the Grass*, all three of which are refused. He is hardly the

"Roi des Impressionnistes"

only artist facing such rejection; the jury is particularly severe that year, and of the 5,000 works presented by 3,000 artists, only 2,217 by 988 painters are accepted (the year before, works by 1,289 artists had been accepted). When the protests of the rejected artists and the complaints of art critics threaten to get out of hand, Napoleon III himself is forced to intervene. At first the emperor tries to involve himself in the selection of the thirteen jury members, but this only offends the members, who threaten to quit en bloc. He then decides to offer the rejected artists the opportunity to show the public their works by providing them with rooms in another

wing of the Palais de l'Industrie. Thus is born the Salon des Refusés. The rooms provided are outfitted with the same decorations as those used by the Salon, although the works must be hung in a different order. All of this waiting greatly increases public interest, and when the show finally opens, on May 17, fully 7,000 people throng into the hall, and in fact for the entire duration of the show there are more visitors to the Salon des Refusés than to the official Salon. Even so, the judgment of the public and the critics is every bit as severe and biting as that of the Salon jury, and the newspapers take glee in publishing reams of satirical vignettes.

Manet's *Luncheon on the Grass*—considered an outrage to morals, logic, and the most elementary rules of painting—is among the works to receive the most negative criticism. Things don't go any better in the Salon of the following year, to which Manet presents two paintings, *Dead Christ and Angels* and *Corrida*. Once again the critics take aim in particular at Manet, pointing out supposed errors in perspective, his erroneous use of chiaroscuro, and other defects, sometimes making their point with sharp irony, sometimes with bitterness and rancor. The attacks seem to reach the level of true persecution, and following the publication in the magazine *Indépendance Belge* of a particularly scathing article by the critic Théophile Thoré (W. Bürger), on May 7, 1864, Charles Baudelaire writes a long, heartfelt letter in Manet's defense. Even more scandal and sharper criticism attend the appearance of another painting by Manet, *Olympia*, made in 1863 but not presented to the Salon until two years later. Mindful of the events of two years earlier, the jury does not have the courage to reject the painting, but critics and journalists, already unkind to Manet's *Luncheon*, unleash such a storm of criticism that during the last days of the exhibition the organizers move the painting from its original location to a higher spot where it is almost hidden from the eyes of spectators. In truth there is nothing about this nude to make it more provocative or lascivious than any of the hundreds of goddesses and nymphs crowding the paintings with mythological subjects that have been exhibited in the Salon over the years without comment. What disturbs the critics is the modern setting, which makes it look like what it is, without the (hypocritical) sublimation of a literary theme. And what it is, is one of Paris's many prostitutes about to receive a gift of flowers from a would-be sweetheart, probably waiting behind the green curtain of the anteroom. The pictorial style used by the young artist, so innovative and so unfaithful to the teachings of the Ecole des Beaux-Arts, contributes to the disorientation of the critics, revealing all the inadequacy of the aesthetic rules they use to judge art. In the belief that they are being confronted by an act of blatant and gratuitous provocation, they react with mockery and sarcasm—which in fact has not diminished many years later when the painting is put first in the Musée du Luxembourg and then, in January 1907, in the Louvre, alongside the *Odalisque* by Ingres. Badly shaken by the insults he has been forced to endure, Manet complains about his treatment to his friend Baudelaire. The writer, who has stood up for him in the past and who has inspired him with a long essay entitled *The Painter of Modern Life*, responds with unwavering support, urging him to hold firm and continue along his own road heedless of the incomprehension or insults of others. In 1867 Manet receives another bitter disappointment when his works are excluded from the art exhibit of the universal exhibition in Paris. With the support of Emile Zola and the help of a loan of 18,305 francs from his mother, he sets up his own personal show in a building in the garden of the marchese de Pomereux between Rue Montaigne and Rue De l'Alma. The show opens on May 24; entry costs 50 centimes and the catalog, with a preface written by Zacharie Astruc, presents 53 paintings and three etchings, the synthesis of the last eight years of his activity. The public is scarce, the critics particularly hostile. As if that were not enough, the authorities prevent him from showing the public his painting *Execution of Maximilian*, probably because they see in it unpleasant political allusions.

Meanwhile, Manet has begun frequenting the Café Guerbois at 11, Rue des Batignolles, near the large Place de Clichy. Right next door is

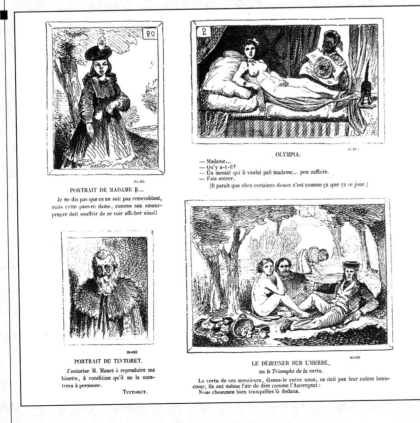

Manet: "Roi des Impressionnistes"

of enthusiasm that for weeks and weeks kept us up, until the final shaping of the idea. We left these meetings with greater determination, with our thoughts clearer and better defined." Manet is the group's intellectual guide and for some is also a financial support. The English author George Moore later recalls, "The glass door of the café grated upon the sanded floor, and Manet entered. Though by birth and by education essentially Parisian there was something in his appearance and manner of speaking that often suggested an Englishman. Perhaps it was his dress—his clean-cut clothes and figure. That figure! Those square shoulders that swaggered as he went across the room, and the thin waist; the face, the beard, and the nose, satyr-like shall I say? No, for I would evoke an idea of beauty of line united to that of intellectual expression—frank words, frank passion in his convictions, loyal and simple phrases, clear as well water, sometimes a little hard, sometimes as they flowed away bitter, but at the fountain head sweet and full of light." In the same way

the shop of Hannequin, where Manet goes to buy his paints. The café is in a somewhat out-of-the-way location. It has a nice garden with a pergola, well suited for banquets, but is hardly elegant. Even so, Manet soon finds himself joined by a crowd of young artists, writers, and painters who believe in his art and his new artistic ideas. Among the writers are Emile Zola, Louis Edmond Duranty, Armand Silvestre, Zacharie Astruc, and Théodore Duret. There are also the musician Edmond Maître and the photographer Nadar. The painters include Bazille, Monet, Degas, Bracquemond, Renoir, Alfred Stevens, and sometimes even Pissarro, Cézanne, and Sisley. Thursday is the favorite day for the meetings of these artists, first called the Batignolles group, then later the Impressionists. Their meetings are very often the occasion of much heated discussion, the subjects ranging from literature to modern art to music to politics. There is no lack of disagreements and fights, up to the point that on February 23, 1870, Manet challenges the critic Duranty to a duel in which he wounds him slightly. In an article in the magazine *Le Temps* of November 27, 1900, Manet recalls that "nothing could have been more interesting than these discussions, with their constant clash of opinions. They kept our wits sharpened, they encouraged us with stores

the Italian member of the group, Giuseppe De Nittis, in his book *Notes et Souvenirs* (1895), writes of Manet that "He radiates happiness, a happiness which is infectious, as is his whole good humored philosophy. I have always seen him thus. His spirit is infused with sunlight and I love him for it."

The group breaks up temporarily in the summer of 1870 because of the Franco-Prussian War. Some of them, such as Manet and Degas, enroll in the national guard, while Monet, Sisley, and Pissarro take shelter in England. Fréderic Bazille, the youngest of the group and often considered the most gifted, joins a regiment of Zouaves and dies in August 1870, the victim of a German sniper.

EDOUARD MANET
Boy with a Sword
1861, oil on canvas,
131.1 × 93.3 cm
Metropolitan Museum
of Art, New York

The model in this
painting is Léon
Edouard Koëlla
(1852–1927), son
of Suzanne Leenhoff
and, it is presumed,
Manet. Made in 1861,
it is first exhibited at
the Louis Martinet
gallery in Paris in a
show that opens
March 1, 1863. The
critic Ernest Chesneau
praises the painting
for its vivid colors and
for the expressiveness
of the boy, while Emile
Zola calls attention
to the work's stylistic
affinities with the
great masters of
Spanish painting,
most of all Velázquez
and Goya. Between
1861 and 1862 Manet
makes several etchings
of the same subject.

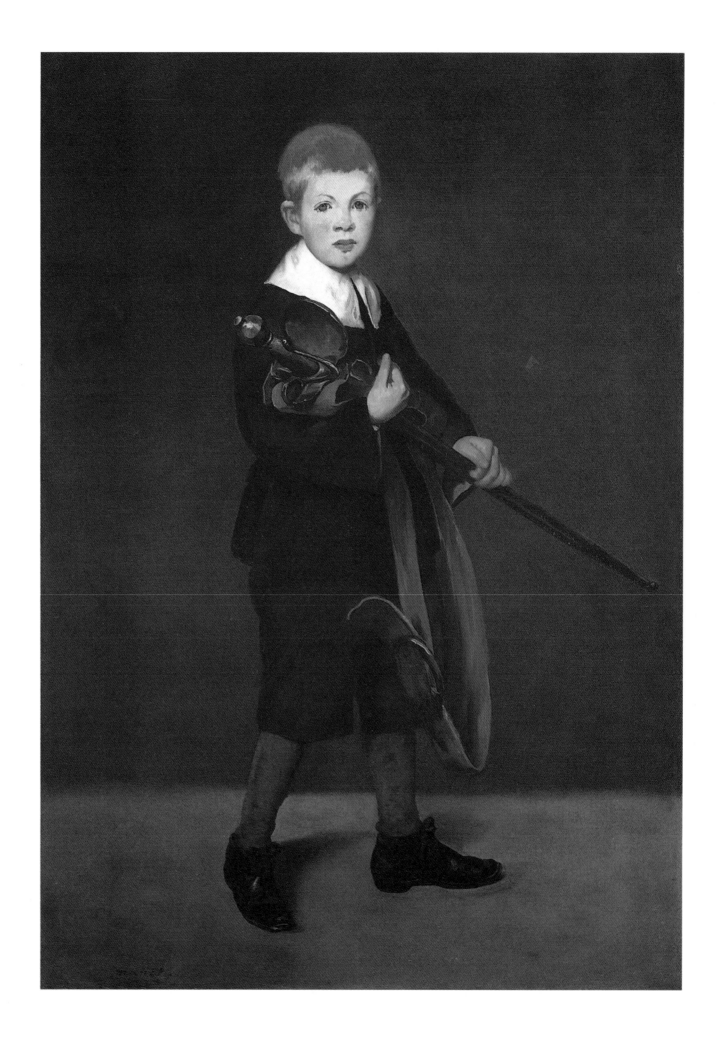

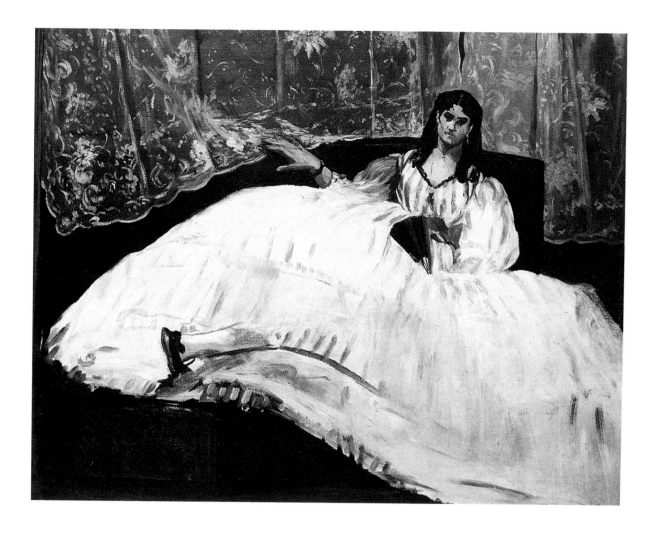

■ EDOUARD MANET
**Portrait of
Jeanne Duval**
1862, oil on canvas,
90 × 113 cm
Szépmüvészeti
Múzeum, Budapest

Jeanne Duval,
Baudelaire's lover
from 1842 to 1862,
suffered an attack of
hemiplegia, as can be
seen in the unnatural
position of the leg that
extends from beneath
the large gown. Since
the artist does nothing
to embellish this reality
there are those who
accuse him of being a
painter of ugliness.
According to some
accounts, Manet wants
to give the painting
to Baudelaire, who
refuses it, saying it
does not please him.
And in fact the paint-
ing remains unsold in
the painter's studio
until his death.

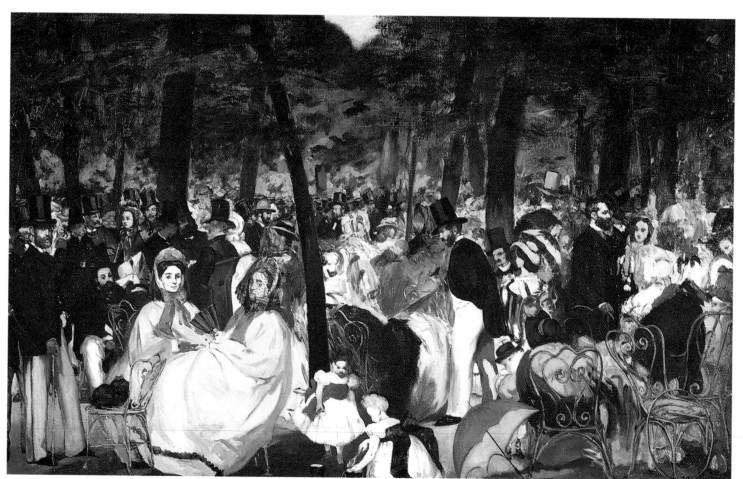

■ EDOUARD MANET
**Music in the
Tuileries Gardens**
1860–62, oil
on canvas,
76.2 × 118.1 cm
National Gallery,
London

Napoleon III is in the
habit of assembling his
court in the gardens of
the Tuileries, and two
concerts are held there
every week, attended
by stylish Parisians.
Manet includes himself
in this painting, stand-
ing at the far left; in
front of him is Albert
de Balleroy, with whom
he shared his first ate-
lier. Beneath the tree
at the left are Fantin-
Latour, Baudelaire in
profile, Théophile
Gautier, and the baron
Taylor.

EDOUARD MANET
**Luncheon on the
Grass (Le Dejèuner
sur l'Herbe)**
1863, oil on canvas,
208 × 26.5 cm
Musée d'Orsay, Paris

As is his habit, Manet
draws inspiration for
this work from classical
sources, the *Concerto
Campestre* by Titian
and a detail in the
Judgment of Paris, an
engraving by Marco-
antonio Raimondi,
based on a drawing by
Raphael. The painter
transforms the mytho-
logical theme into a
contemporary scene,
disorienting critics
and public alike. The
woman in the fore-
ground, whose shame-
less nudity was the
cause of so much
scandal, is Victorine
Meurent; beside her
is Manet's brother
Gustave, then there is
the Dutch sculptor
Ferdinand Leenhoff,
brother of Manet's
wife, Suzanne, who
in fact may have
posed for the woman
in the background.

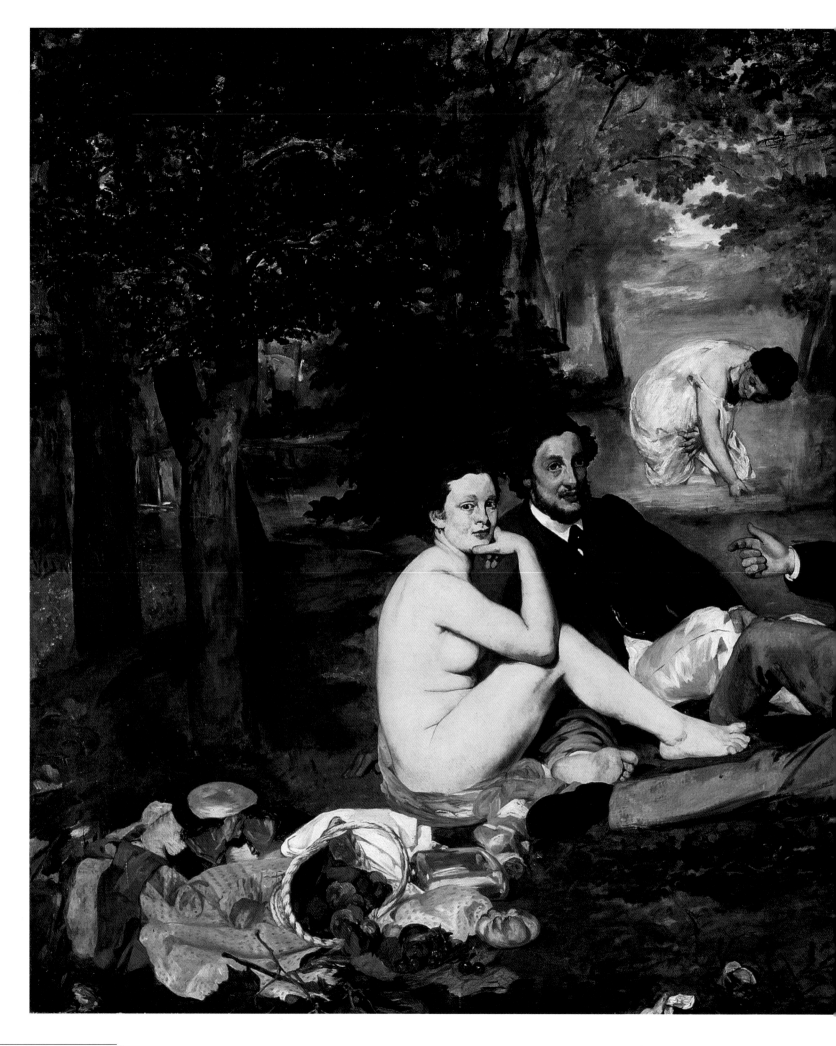

Manet: "Roi des Impressionnistes"

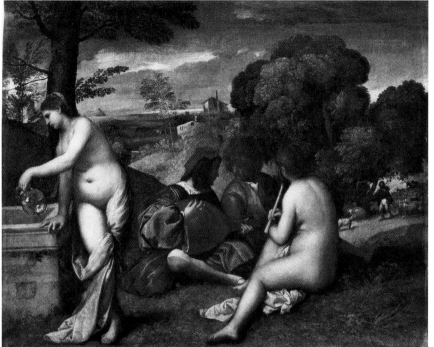

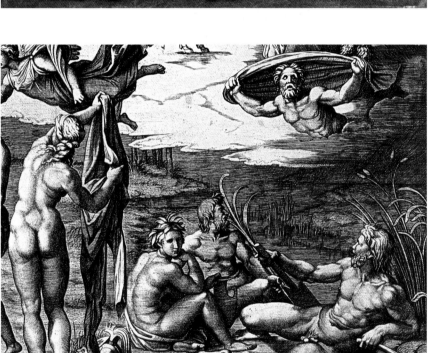

EDOUARD MANET
Street Singer
1862, oil on canvas,
175 × 118.5 cm
Museum of Fine Arts,
Boston

This is one of Manet's
first portraits of
Victorine Louise
Meurent, born in
1844. A professional
model, she had
worked in Couture's
atelier, and Manet
meets her in 1862,
the year in which he
makes this painting.
He is struck by her
particular beauty and
puts her in many
paintings until 1875.
This painting, one of
the fourteen works
exhibited in Louis
Martinet's gallery in
1863, is rejected by
the Salon that same
year: the jurists do
not appreciate the
choice of such a
"low-class" subject,
nor do they care for
the colors, which to
their way of thinking
create deathly, sinis-
ter effects.

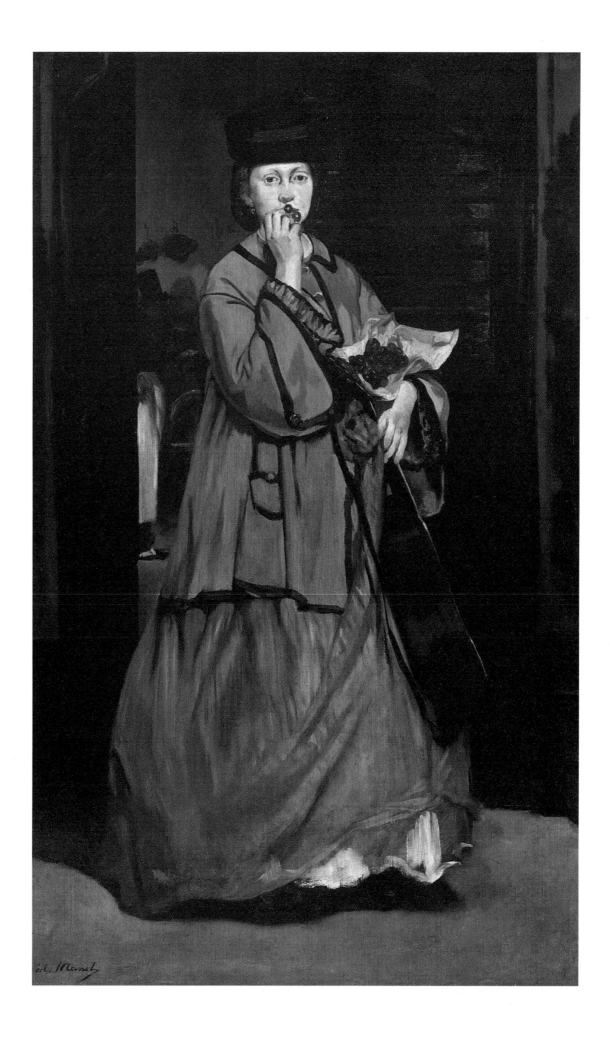

Manet: "Roi des Impressionnistes"

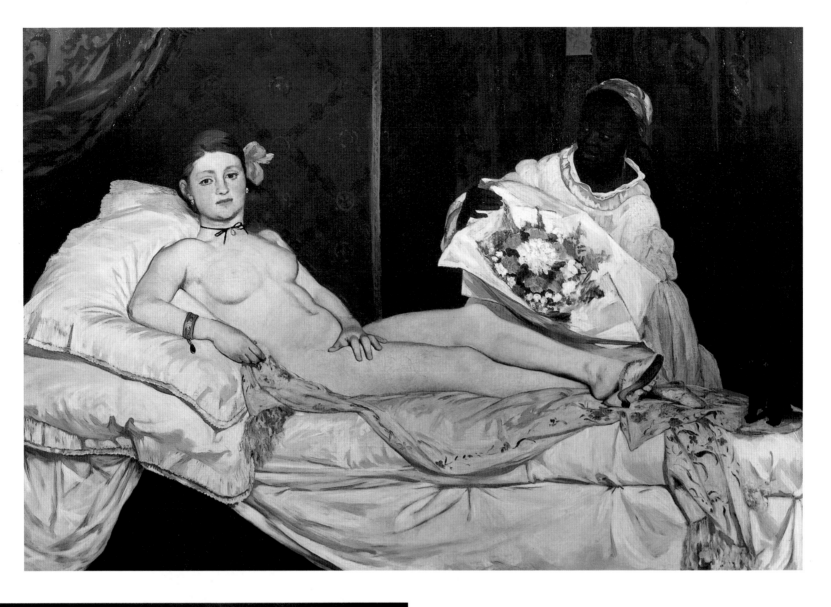

■ EDOUARD MANET
Olympia
1863, oil on canvas,
130 × 190 cm
Musée d'Orsay, Paris

For this painting, as controversial when it first appears as it is famous today, Manet turns for inspiration to Titian's *Venus of Urbino*, which he had copied in 1856, as well as to Goya's *Maya Naked* and Ingres' *Grand Odalisque*. The critics of the Salon do not understand his extreme modernity and cannot see beyond the most superficial and marginal aspects of the work, such as Manet's decision to replace the little dog at the feet of Titian's Venus with a black kitten, considered an erotic or demonic symbol. Even the figure of the servant holding the oversize bunch of flowers is the subject of a variety of interpretations, most of them morbid and malicious.

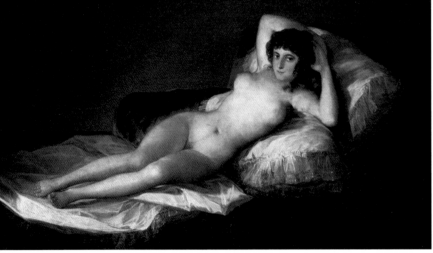

■ FRANCISCO GOYA
Maya Naked
1800
Prado Museum, Madrid

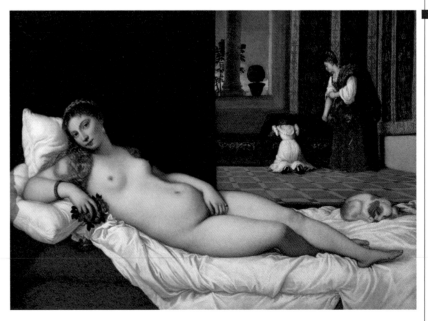

■ TITIAN
Venus of Urbino
1538
Galleria degli Uffizi,
Florence

EDOUARD MANET
Dead Toreador
1864–65, oil
on canvas,
75.9 × 153.3 cm
National Gallery of
Art, Washington, D.C.

This is the lower sec-
tion of a far larger
painting presented to
the Salon in 1864. The
jury accepts it, but the
critics find fault with
it, particularly in terms
of its perspective and
the difference in pro-
portions, in their opin-
ion mistaken, between
the figure in the fore-
ground and the bull in
the background. Manet
considers redoing the
painting but in the
end, in 1865, he sim-
ply cuts it in two parts.

EDOUARD MANET
**Dead Christ
and Angels**
1864, oil on canvas,
179 × 150 cm
Metropolitan Museum
of Art, New York

When the critics of
the Salon of 1864 see
this painting they
reproach Manet for
the excessive and
crude realism with
which he has present-
ed the body of Christ,
a realism they find
improper in a sacred
picture. Only Charles
Baudelaire stands up
for Manet, although
he does feel obliged
to point out that the
wound in Christ's
side should be on the
right, not on the left.
A few months later
Manet makes an etch-
ing and an aquatint
of the same subject.

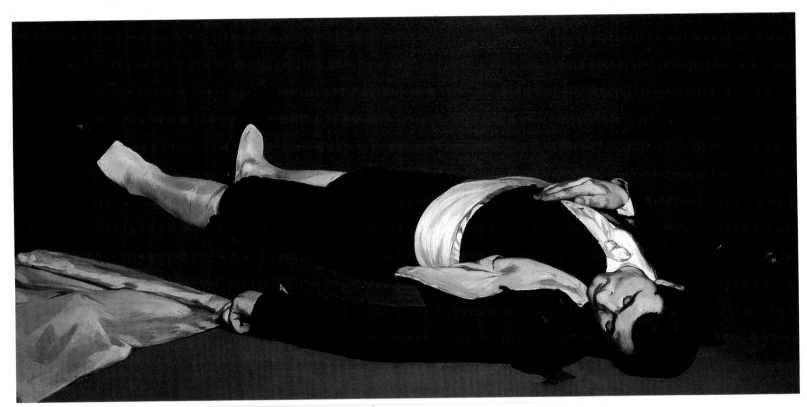

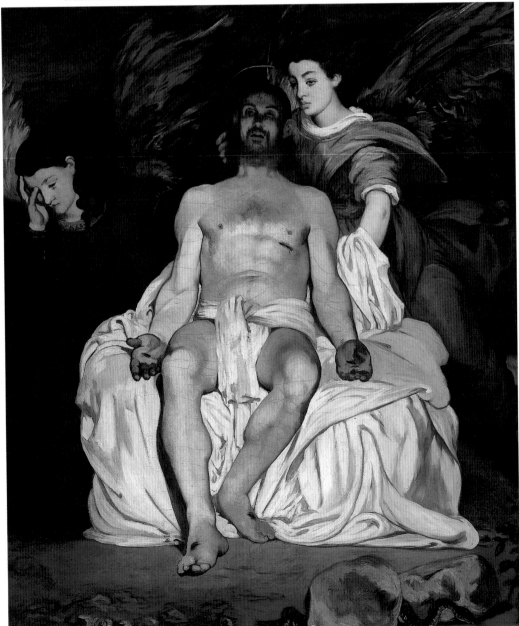

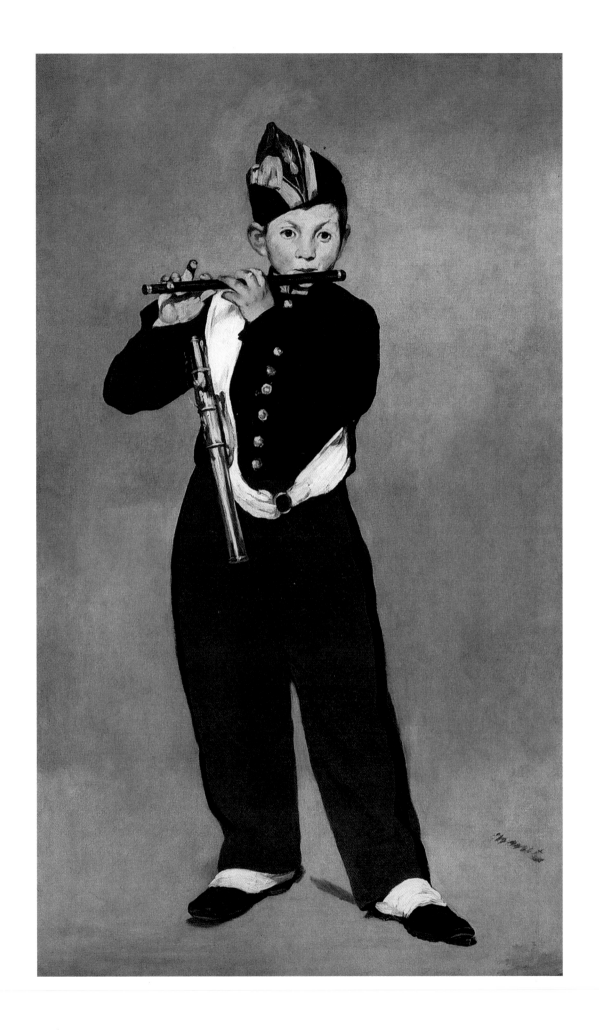

■ EDOUARD MANET
The Fifer
1866, oil on canvas,
160 × 97 cm
Musée d'Orsay, Paris

When he makes this portrait, Manet is still under the influence of the works of Velázquez. The model is a young fifer from the Pepinière barracks, brought to Manet's study by the commandant Lejosne, Bazille's uncle. Manet presents this work to the Salon jury together with the portrait of *Philibert Rouviére*. Both are rejected. It is at this time that Manet meets Emile Zola, who defends Manet from the ferocious attacks of his critics in an article published in *L'Evénement* on May 7, 1866. So many readers complain about this article that Zola's position with the magazine is altered.

EDOUARD MANET
**The Execution of the
Emperor Maximilian**
1867, oil on canvas,
252 × 305 cm
Kunsthalle, Mannheim

The painting presents
the death of Maximil-
ian, emperor of
Mexico, killed by firing
squad on June 19,
1867, at Querétaro,
along with two of his
generals, Mejía and
Miramón. Manet makes
his first version of the
scene in the month of
July. By the time he
makes this fourth ver-
sion he has had the
opportunity to get
better documentation,
having seen an illus-
tration published in
Figaro on August 11,
1867. In particular, he
changes the uniforms
of the soldiers and the
location of the scene.
The general arrange-
ment of the work is
based on Goya's
painting *May 3, 1808*;
Manet's work will in
turn inspire a later
work, the famous
painting by Picasso
entitled *Massacre in
Korea*, from 1951.

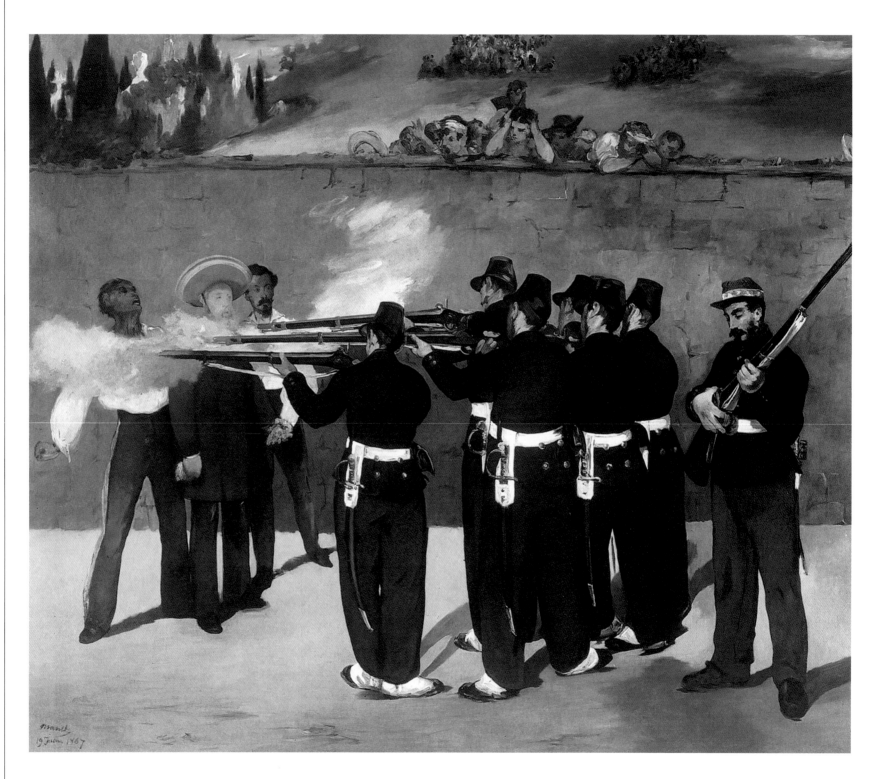

Manet: "Roi des Impressionnistes"

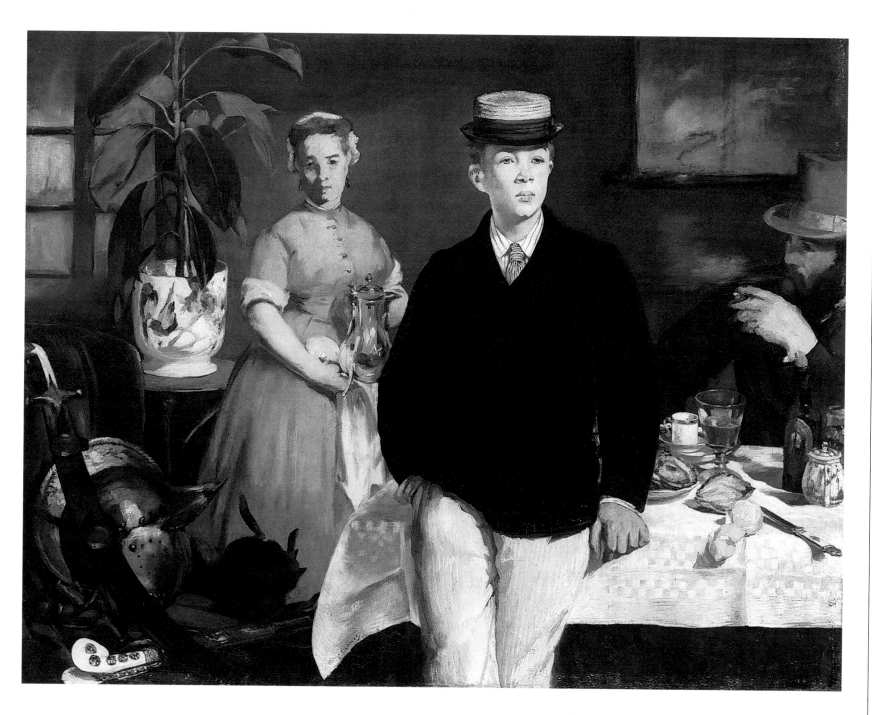

■ EDOUARD MANET
Lunch in the Studio
1868, oil on canvas,
118 × 153 cm
Neue Pinakothek,
Munich

The setting is the din-
ing room of the apart-
ment in Boulogne-
sur-Mer where Manet
spends six weeks in
the summer of 1868.
The boy in the fore-
ground is Léon
Edouard Koëlla, the
man with the cigar is
the painter Auguste
Rousselin, the woman
is a model from
Boulogne. The paint-
ing is exhibited at the
Salon of 1869. Critics
praise its pictorial
qualities, in particular
the left-hand corner
with its antique
weapons and armor
(loaned to Manet by
his friend Monginot).
Many critics do not
understand the
meaning of the scene
and heap upon it
the usual negative
judgments.

Manet gets the original
idea for this painting
during his stay in
Boulogne and makes
it in his studio in Rue
Guyot on his return
to Paris. The woman
seated in the fore-
ground is Berthe
Morisot, making her
first appearance in a
painting by Manet.
Beside her on the
balcony is the cellist
Fanny Claus (1846–69).
Immediately behind
them is the landscape
artist Antoine
Guillemet (1842–
1918), and half-hid-
den in the shadows of
the room is Léon
Edouard Koëlla. The
painting is exhibited
at the Salon of 1869;
Morisot writes to her
sister Edma that in
the painting "I am
strange rather than
ugly; its seems that
the epithet 'femme
fatale' is in circulation
among the curious."

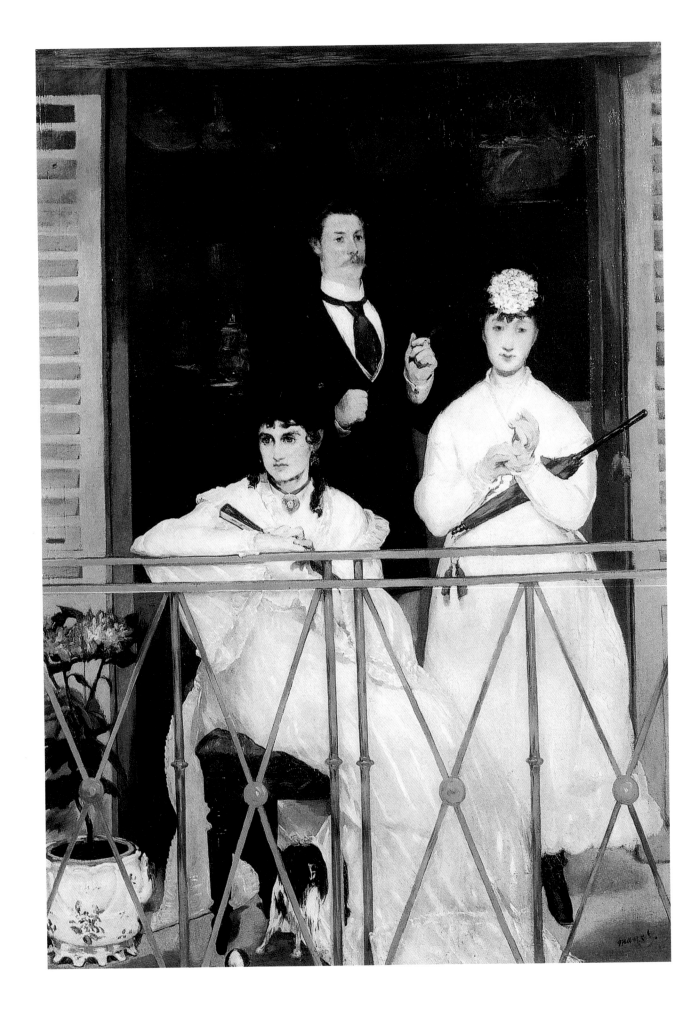

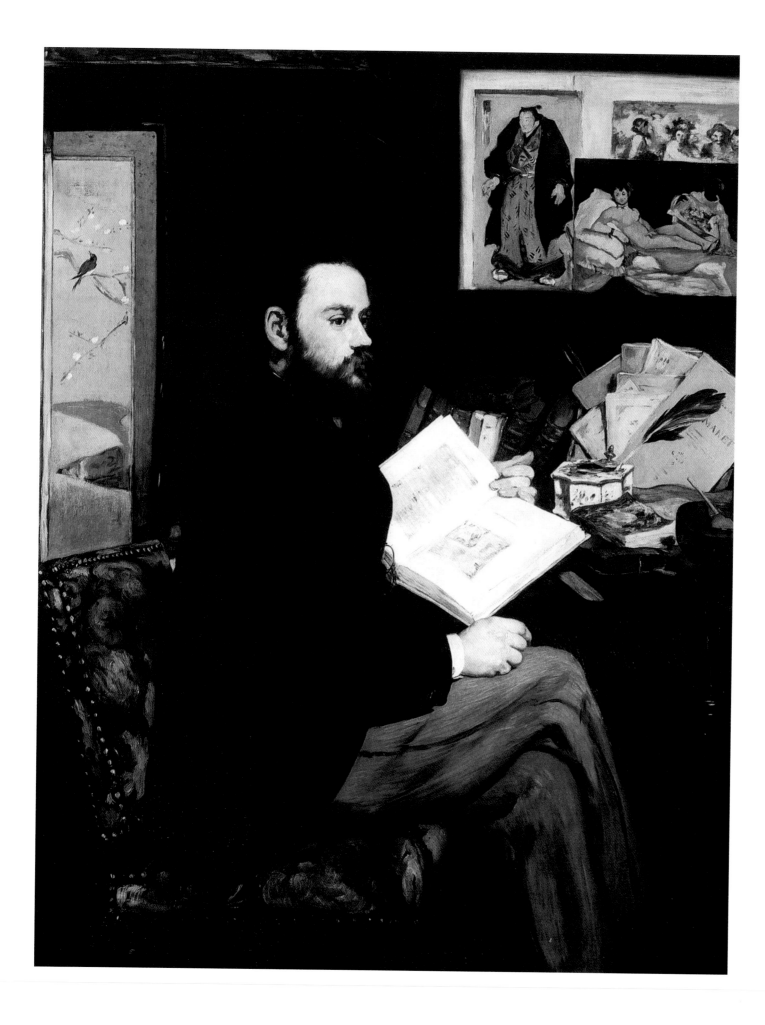

■ EDOUARD MANET
Portrait of Emile Zola
1868, oil on canvas,
146 × 114 cm
Musée d'Orsay, Paris

Zola, Manet's friend
and supporter, is here
shown in his study,
holding open a vol-
ume of the *History of
Painting* by Charles
Blanc. To the right on
the table, behind the
plume of the writer's
pen, one can see the
cover of the pamphlet
"A New Way of
Painting: Edouard
Manet," first published
in the magazine *Revue
du XIXème Siècle* in
January 1867 and
then reprinted as a
separate work on the
occasion of Manet's
personal show. On the
wall at right, along
with a reproduction
of the *Toppers* by
Velázquez and a
Japanese print, is a
photo of Manet's
Olympia, which Zola
had defended against
the heavy negative
criticism.

EDOUARD MANET
**Portrait of
Eva Gonzales**
1869–70, oil
on canvas,
198 × 135 cm
National Gallery,
London

Manet begins work
on this portrait in
February 1869 but
finishes it only on
March 12 of the next
year, the last day on
which it can be sub-
mitted to the Salon
jury. It is accepted,
and this time the
critics are far less
malicious than usual.
Satisfied, Manet gives
the painting to its
model, who is also his
student. Eva Gonzales,
born in 1849, daugh-
ter of the dramatist
Emmanuel Gonzales,
studies painting with
the academic Charles
Chaplin before enter-
ing Manet's atelier as
a student in February
1869 (attracting the
jealousy of Berthe
Morisot). In 1879 she
marries the engraver
Henri Guérard. She
dies of an embolism
on May 5, 1883, a few
days after giving birth
to a son.

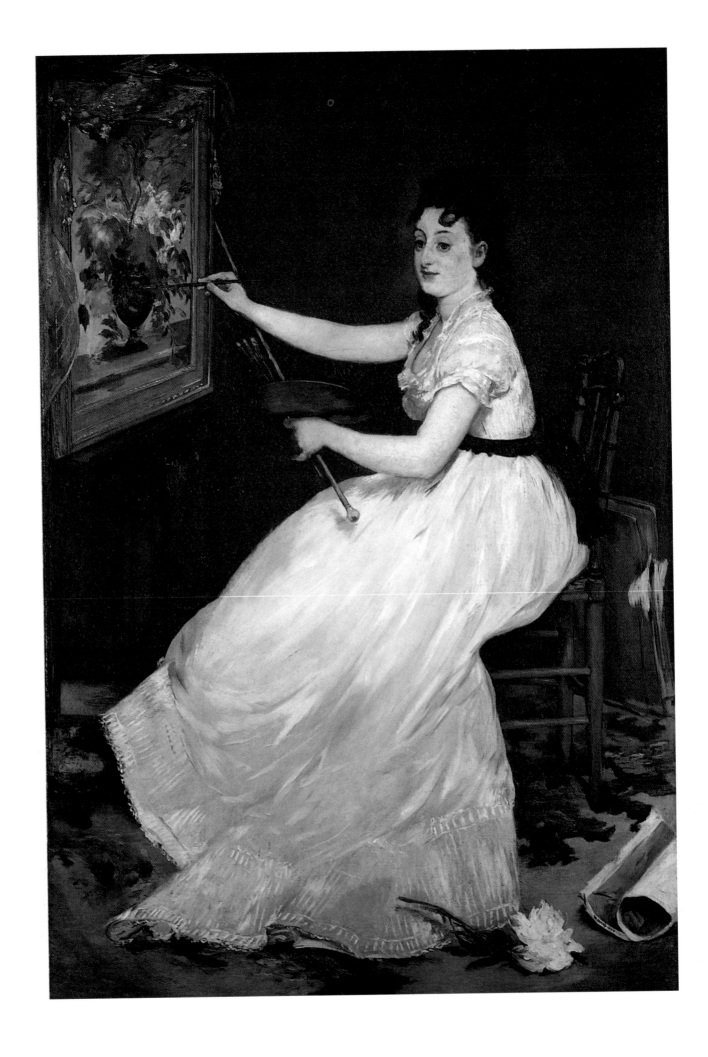

Manet: "Roi des Impressionnistes"

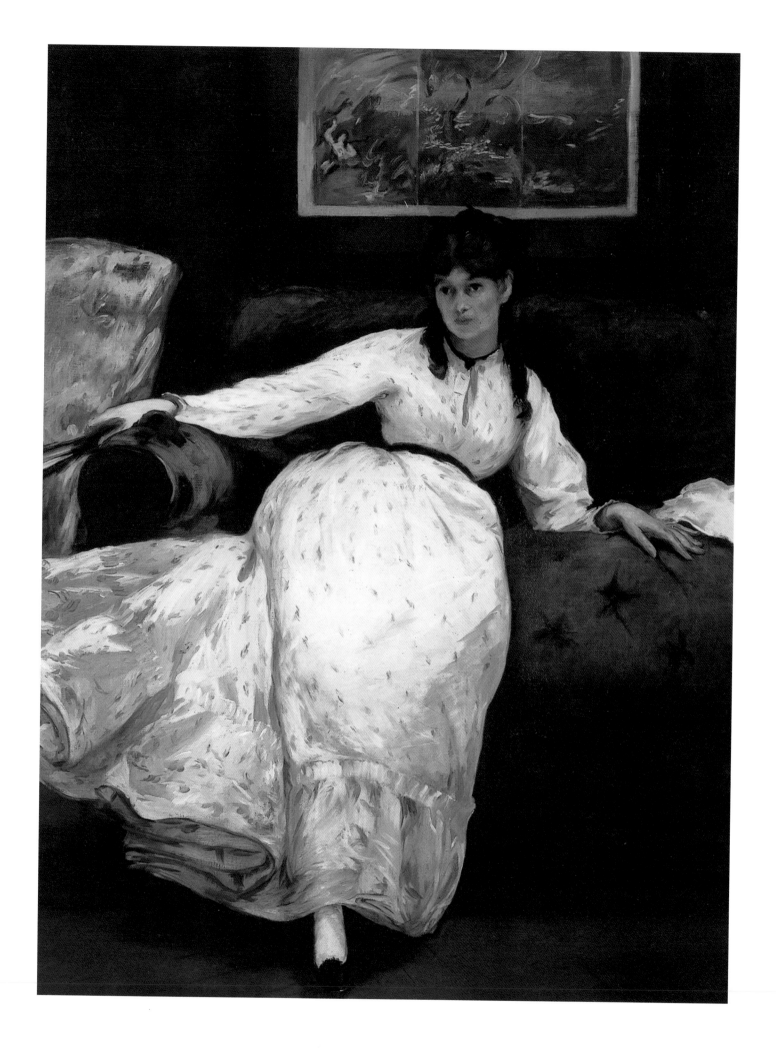

■ EDOUARD MANET
Repose
(Berthe Morisot)
1870, oil on canvas,
148 × 113 cm
Museum of Art, Rhode
Island School of
Design, Providence

In this portrait, as in
The Balcony (page 52),
Berthe Morisot holds a
fan and directs her
gaze not toward the
viewer but rather to
her right, in an atti-
tude at once thought-
ful and sad. In fact,
during these very
months the young
woman is going
through a particularly
difficult period of
doubts and uncertain-
ties, both personal
(at twenty-nine she is
not yet married) and
professional (she fears
she is not talented
enough to make a
career as a painter).
There is also the
matter of her jealousy
of Eva Gonzales, whom
Manet has recently
taken into his atelier
as both student and
model.

The pictorial formation of the Impressionists takes place in many ways, not only because of their varying relationships with the institutionalized schools of painting, sometimes cordial, sometimes negative, but also because they come from different social classes with different family backgrounds. Renoir's father is a modest tailor in Limoges, while Cézanne's father—formerly the owner of a hat factory—is a highly esteemed banker in Aix-en-Provence. Monet is the son of a pharmacist in Le Havre; Pissarro of a storekeeper in the Danish West Indies. Degas is the son of a Parisian banker of aristocratic origin; Manet of a magistrate; Berthe Morisot of an official at the state audit board; Sisley of a well-to-do English businessman who has decided to take up residence in France. For each of them, the decision to become an artist is not necessarily welcomed by parents and other relatives; a few are helped and encouraged, but others meet fierce resistance, everyone hoping they will change their minds and choose a more remunerative and "honor-

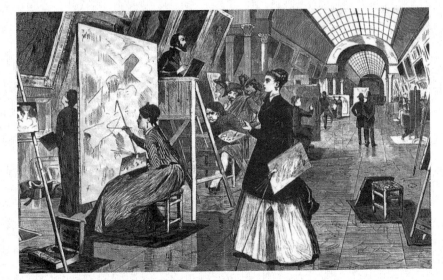

is the official Salon. Just being admitted among the exhibitors is an enormous victory, difficult to achieve; far harder is winning one of the awards, which offers the hope of being taken into consideration by state officials when they distribute commissions for the decorations of public buildings or churches. The final goal, reached by only a select few, is to

1860•1870 The formation

able" career. In fact, artists do not enjoy high social standing during the first half of the nineteenth century. Only the very best and most fortunate achieve fame, are taken into the palaces of nobles, or receive well-paying commissions from the church. These are but a small minority, however; for all the others, painting is a difficult and hardly rewarding career. Artists are poorly paid and live with the constant specter of poverty and hunger. As we saw in the first chapter, the dream of every youth who hopes to undertake an artistic career is to be accepted by the Ecole des Beaux-Arts. Once admitted they must do whatever they can to achieve recognition in one of the several artistic competitions, first among them the Prix de Rome, which opens the door to a long stay of study and training in Italy. The next stop

A street in Marlotte, the town on the outskirts of the forest of Fontainebleau where several of the Impressionists meet to paint.

earn a chair at the Ecole, or to be elected to the Académie des Beaux-Arts, or even to the Académie Française, the empyrean of the grand masters of official painting and for decades the true center of artistic and cultural power. Only near the end of the century does this situation change when the nobles and clergy are joined by members of the middle class, which has grown rich as a result of the commercial and industrial developments of that period. Thus is born the figure of the art dealer, a new point of reference for artists and collectors, a figure halfway between entrepreneur and patron, speculator and connoisseur. It is the art dealer who organizes art exhibits in private settings, sometimes in competition with the Salon, and it is the art dealer who makes the all-important contacts with potential buyers.

Over the course of these years art dealers permit many artists to break free of the official system and undertake artistic careers that free them of financial worry; and as artists they are increasingly well respected by others. This evolution has only just begun when the young Impressionists begin their apprenticeship. Renoir and Degas, for example, succeed in getting into the Ecole, attend the obligatory courses, and successfully complete the periodic examinations. Being a woman, Berthe Morisot cannot be admitted to the Ecole and instead takes private lessons in the atelier of the academic painter Joseph Guichard, who in turn introduces her to Corot, who teaches her painting in the open air. During these

drawing—which can take many months and sometimes many years of apprenticeship—can he move on to brushes and oil paints. Usually he is given permission to visit the Louvre to copy antique paintings and only later is he permitted to make works of his own invention.

One of the best known of these teachers is Thomas Couture (1815–79), creator of excellent portraits and historical scenes. In 1847, following the resounding success of his *Romans in the Decadence of the Empire*, today in the Musée d'Orsay in Paris, he opens a school that soon becomes famous. Among his students are Puvis de Chavannes and Manet. Manet takes lessons for six years, a troubling time for him of which he holds a somewhat negative memory. As he writes later: "Going to school I had the feeling I was entering a tomb; every object that met my eye seemed horribly ridiculous." Such judgments had an effect on Couture's later reputation—he came to be seen as the prototypical academic painter, obtuse and bereft

of the Impressionists

same years many teachers at the Ecole begin the custom of giving private lessons in their studios in addition to their institutional courses. Such lessons always begin with drawing exercises, the fundamental basis of the courses at the Ecole. The teachers make their students copy engravings, then three-dimensional models, usually plaster casts of ancient statues. During this early phase the student's attention is concentrated on proportions and the distribution of light and shadow. The next step takes the student from plaster casts to live models, first reproducing only details, and eventually moving on to the full figure, whether naked or clothed. Only when the student achieves complete mastery in

of inspiration. Such was not really the case. In his two books about teaching painting, *Méthodes et Entretiens d'Atelier* and *Entretiens d'Atelier: Paysage*, the latter dedicated to landscapes, he demonstrates a close understanding of the new trends in artistic expression and reveals an open mind responsive to new ideas, so much so that in the last years of his life he spends a good deal of time in the countryside, painting landscapes from life.

Another popular place for aspiring artists is the Académie Suisse, located at the Quai des Orfèvres. In reality the term *academy* is something of an exaggeration, since this is really no more than a large room in which young students, having paid a modest

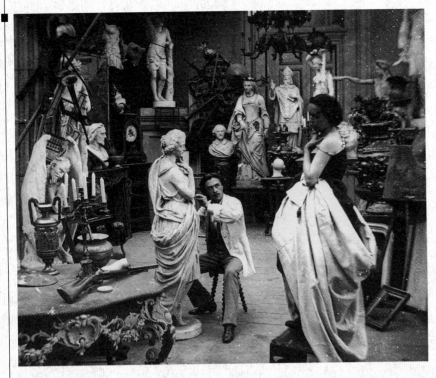

The atelier of a Parisian sculptor around the end of the 1860s.

Portrait photo of Frédéric Bazille, killed in the Franco-Prussian War of 1870 at the age of twenty-nine.

The Centre International des Beaux-Arts, one of Paris's many ateliers, in a photo from the end of the nineteenth century.

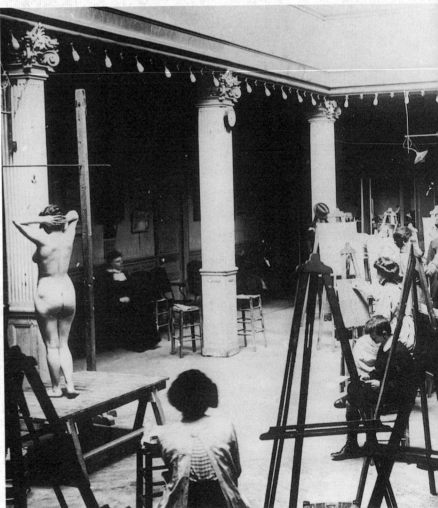

fee, can practice drawing and painting from live models. There are no admission exams, nor any strict rules to obey, but there is the opportunity to compare one's work with that of other artists and get their advice, suggestions, and opinions, which sometimes prove more useful than the tiresome lessons imparted by the professors at the Ecole. Beginning in 1855 the Académie Suisse numbers among its students Pissarro, and it is there, in 1859, that he meets Monet and, two years later, Cézanne and Guillaumin. There is also the Académie Julian, founded in 1873 by Rodolphe Julian in a former ball room on the third floor of an old building in the Passage des Panoramas. Admission costs forty francs per month; the teaching is flexible and open to new ideas. Indeed, by the end of the 1880s it has become one of the most crowded studios, with about six hundred more or less regular students. No less important, at least for the Impressionists, is the atelier of Charles Gleyre. Born in Switzerland in 1808, Gleyre sets himself up in Paris in 1838 and succeeds in becoming a teacher at the Ecole des Beaux-Arts. In his paintings, the most famous of which is *Evening: Lost Illusions*, made in 1843 and today in the Louvre, he attempts to fuse the teachings of classi-

cism to the new romantic trends. His studio becomes very well known because of his legendary patience as a teacher and because he asks only ten francs as contribution to the rent and fees for the models. His work method is technically excellent, and although he can be somewhat pedantic and is basically faithful to the traditional canons of the Ecole, he permits his students enough freedom of expression to satisfy them. In his 1894 novel *Trilby*, George du Maurier recalls Gleyre's studio: "We drew and painted from the nude model every day but Sunday from eight to noon, and for two hours in the afternoon, except on Saturdays, when it was time to clean the room. One week the model was male, the next week female, alternating throughout the entire year. A stove, a model-throne, stools, boxes, some fifty hefty chairs with backs, a couple of score of easels and many drawing boards completed the furnishings. The bare walls were adorned with endless caricatures in charcoal and white chalk, along with the scrapings of many palettes, a polychrome decoration that was not unpleasing." Among the artists who profit from studies in Gleyre's studio are Renoir, Monet, Sisley, Bazille, and Whistler. It is in this studio that they meet and become friends. In January 1864, for financial and health reasons, Gleyre is forced to close his studio. Bazille, Monet, Sisley, and Renoir leave for Chailly-en-Bière

near the forest of Fontainebleau to paint *en plein air*, much like Corot and the painters of the Barbizon school. While there they meet many other artists and make friends with Narcisse Virgile Diaz de la Peña, who teaches them how to achieve greater luminosity and brighter colors. The next year Pissarro joins the group, and together they again pass a long period at Marlotte, painting landscapes from life. Only an hour by train from Paris, the forest of Fontainebleau is popular not only with tourists but with painters, who go there to escape the traditional teachings of the Ecole by immersing themselves in nature. Weary of repeating ad nauseam historical events of ancient Rome or improbable, garish mythological scenes, they labor to fill their works with the ideals of spontaneity and freshness, with a sense of immediacy and freedom of inspiration, doing so with broad, swift brushstrokes and lively colors in clear, luminous tones.

Impressionism's true birthplace, however, is not the Ecole des Beaux-Arts, nor any of the many private ateliers, but rather a café, more precisely the Café Guerbois. During the years of Napoleon III's reign (1852–70) cafés become the new centers for social gatherings for Parisians at all levels. The number of cafés grows considerably following the radical alteration in the layout of the city directed by Baron Haussmann. Entire city sections are knocked down to make room for new buildings that face the long, tree-lined avenues—the boulevards—that the city becomes famous for. According to one estimation, by the end of the century there are roughly twenty-four thousand of these cafés in the city, each with its own character and matching clientele. Some have a strong regional or ethnic tone and are most popular with the numerous immigrants to the city who find in such places the food

and folklore of their birthplace. Others follow exotic trends in fashion, reflections of colonial enterprises, or inspirations based on universal exhibitions, leading to a triumph of *orientalisme, japonaiserie*, and *chinoiserie*. In the *café-concerts* celebrated in so many Impressionist paintings as well as in works by Toulouse-Lautrec, clients watch performances by singers, dancers, musicians, and comics. Other cafés are the sites of lively discussions of art, literature, and, as far is permissible in Third Empire France, even politics. Some of these are quite elegant and exclusive, as for example the Café de Bade, chosen for several years by Manet, and a habitual meeting place for Parisian dandies. Others are simple and cheap, but such traits do not prevent them from having their certain fascination and appeal. Among these is the Café Guerbois. As we saw in the second chapter, Manet begins going there regularly in 1866 to meet his friends, writers, poets, critics, musicians, and almost all of the artists destined to give life to the Impressionist movement: Bazille, Monet, Degas, Bracquemond, Renoir, Stevens, and sometimes Pissarro, Cézanne, and Sisley. Getting together to talk, often in a lively fashion, is extremely important to these men because it gives them the opportunity to sound out and perfect their ideas; it renews their spirit, helping them get through periods of discouragement, most of all the sharp disappointments caused by the repeated refusals of the Salon to show their work and the constant scarcity of buyers. This is a brief but extremely important moment of friendship and creativity, a forge of new ideas that are destined to radically change the traditional ways of painting, a melting pot of innovative notions that is interrupted, and then only briefly, by the outbreak of the Franco-Prussian War in the summer of 1870.

PIERRE-AUGUSTE
RENOIR
**Return from
a Boat Outing**
circa 1862
oil on canvas,
50.8 × 60.9 cm
Private collection

This is one of the first
larger-scale works
that the twenty-two-
year-old artist makes
while regularly
attending the lessons
at Gleyre's studio. One
can note how he has
tried to blend ele-
ments from classical
art, learned at the
Ecole and from visits
to the Louvre, with
the new methods of
en plein air painting
used by Eugène
Boudin and Johann
Barthold Jongkind.
The arrangement of
the figures and their
characterization are
still theatrical and
unnatural, but the sky
in the background,
swept by white and
gray clouds, already
reveals a striking free-
dom of expression.

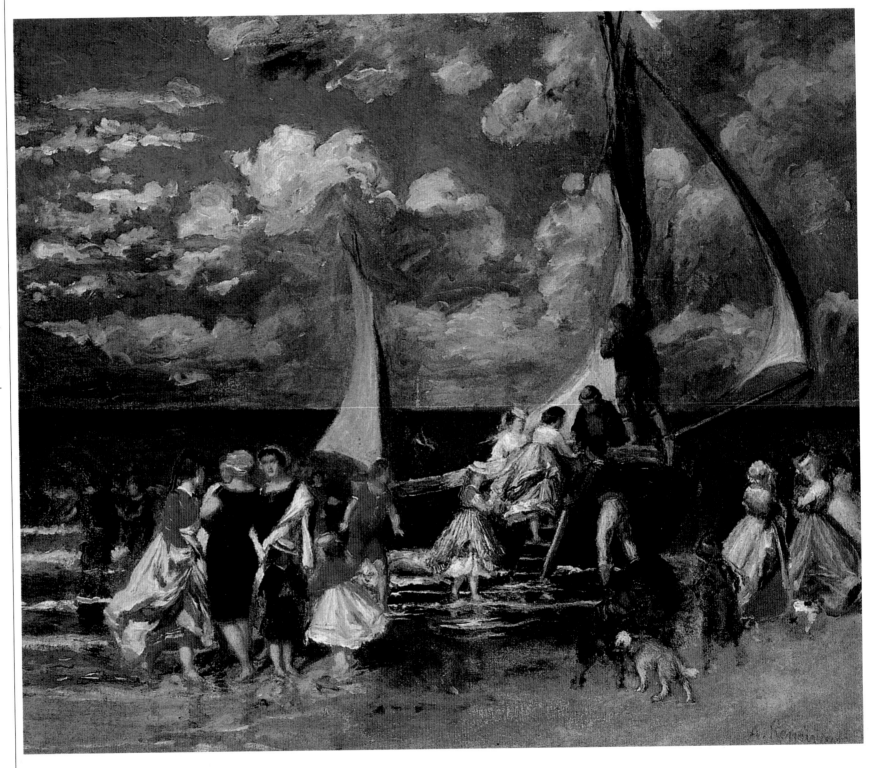

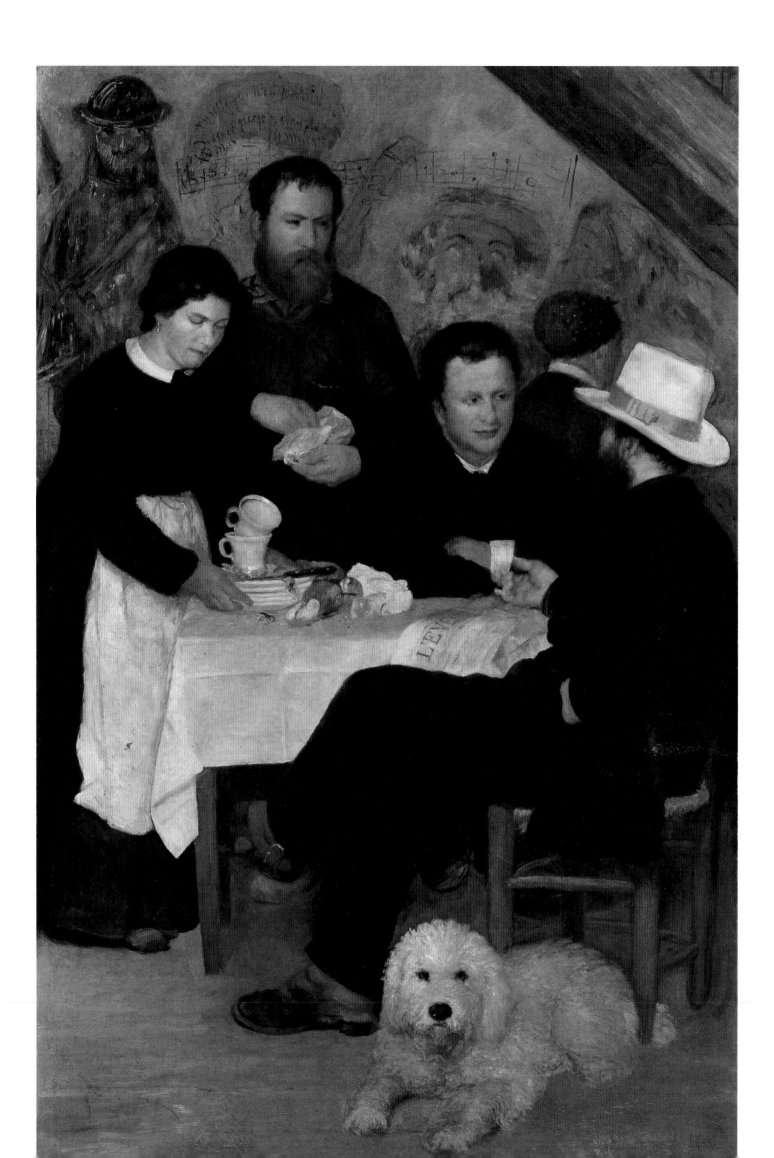

■ PIERRE-AUGUSTE RENOIR
At the Inn of Mother Anthony
1866, oil on canvas,
195 × 130 cm
Nationalmuseum,
Stockholm

In 1865 Renoir, his younger brother Edmond, Monet, Sisley, and Pissarro stay at the inn of "Mère" Anthony in Marlotte in the forest of Fontainebleau. The standing figure, preparing a cigarette, is Monet; beside him is Nana, daughter of the innkeeper (who is presented from behind, seated to the right). Seated at the table are Jules Le Coeur, and wearing the white hat, Sisley. Sisley holds a copy of *L'Evénement,* the newspaper in which Emile Zola published articles favorable to the Impressionists in April and May of 1866.

PIERRE-AUGUSTE
RENOIR
Bazille at His Easel
1867, oil on canvas,
105 × 73 cm
Musée d'Orsay, Paris

Frédéric Bazille is born
at Montpellier in 1841
to a well-to-do family
of winemakers. The
art collector Alfred
Bruyas, a friend of the
family, encourages
him to study art in
Paris. So it is that
Bazille enters Gleyre's
studio, where he
becomes friends
with Renoir, Sisley,
and Monet, soon to
form the so-called
Batignolles group.
Renoir portrays his
friend in his study,
at his easel, while
painting *Still Life
with Heron*, today in
a private collection.

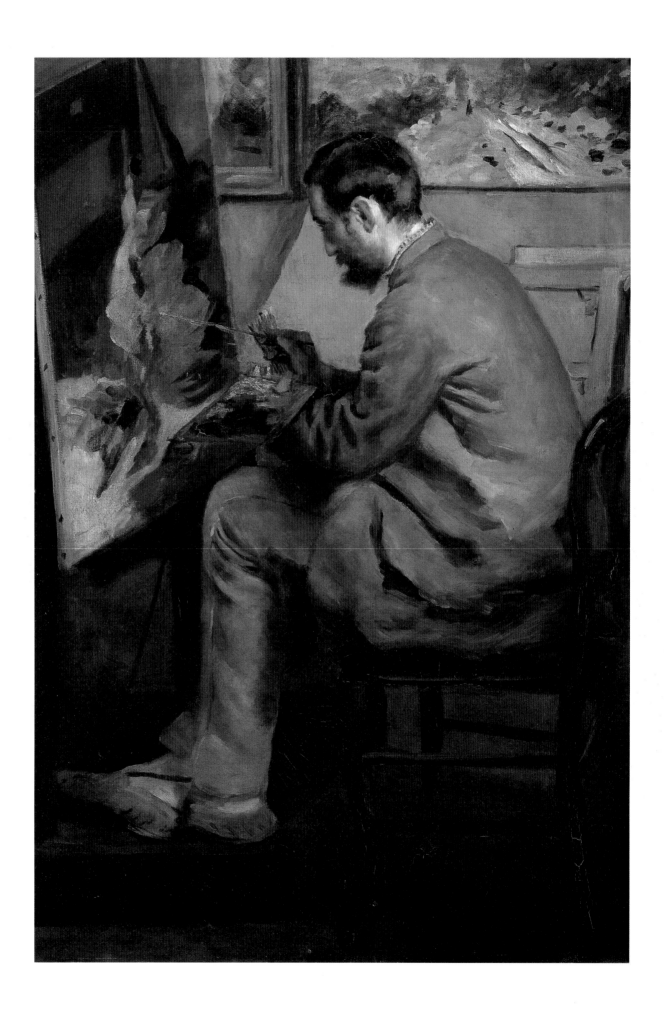

■ Frédéric Bazille
**The Studio in
Rue La Condamine**
1869–70, oil
on canvas,
98 × 128.5 cm
Musée d'Orsay, Paris

Seated at the piano to
the right is the musician
Edmond Maître; stand-
ing on the stairs is Emile
Zola; he is talking to a
seated Renoir. At the
center is Bazille, palette
in hand, showing his
View of the Village to
Manet (with the hat)
and Monet. It seems
that the figure of
Bazille was painted by
Manet. The studio in Rue
La Condamine becomes
a popular gathering
place for painters,
musicians, and writers
who get together there
to discuss cultural
matters and exchange
ideas. Bazille, often
considered the most
gifted of the Impres-
sionists, might well
have performed the
role of guide for the
new group had he not
been killed in the
Franco-Prussian War.

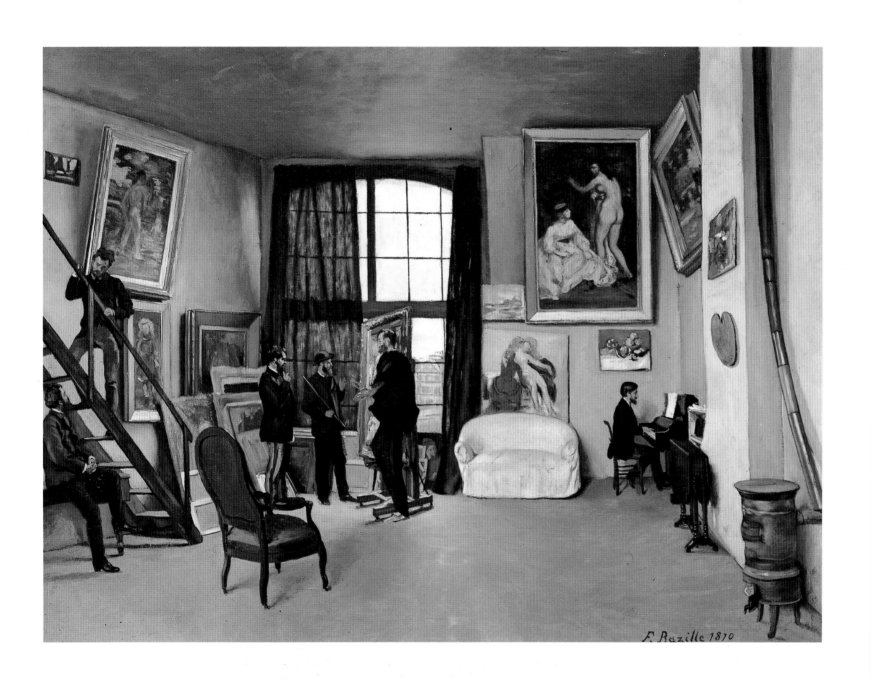

PIERRE-AUGUSTE
RENOIR
La Grenouillère
1869, oil on canvas,
66.5 × 81 cm
Nationalmuseum,
Stockholm

Between 1868 and
1870 Renoir and
Monet make numerous
trips along the Seine,
stopping at the more
picturesque locales to
paint in the open air.
They often paint the
same landscape or
scene from the same
point of view, later
comparing their works
and sharing sugges-
tions. In this instance
Renoir has chosen a
more close-up view,
while Monet's version
of the same scene
(below) has a sense
of greater breadth
and luminosity.

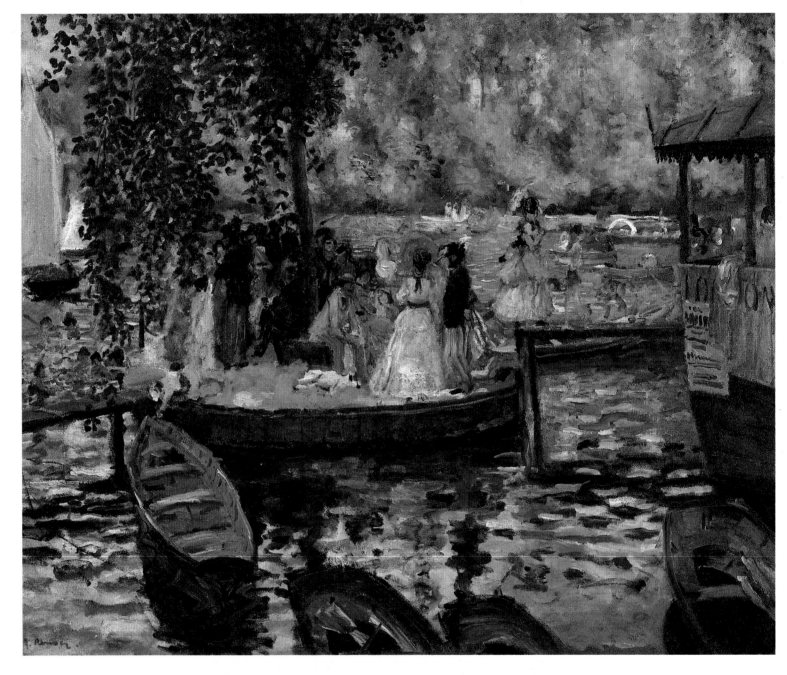

CLAUDE MONET
La Grenouillère
1869, oil on canvas,
74.6 × 99.7 cm
Metropolitan Museum
of Art, New York

La Grenouillère ("the
frog pond") is a styl-
ish restaurant on the
island of Croissy in
the Seine, between
Chatou and Bougival.
To reach it, Parisians
can use the rail line
between Paris and
Saint-Germain (the
first such line in
France), getting off
at Chatou.

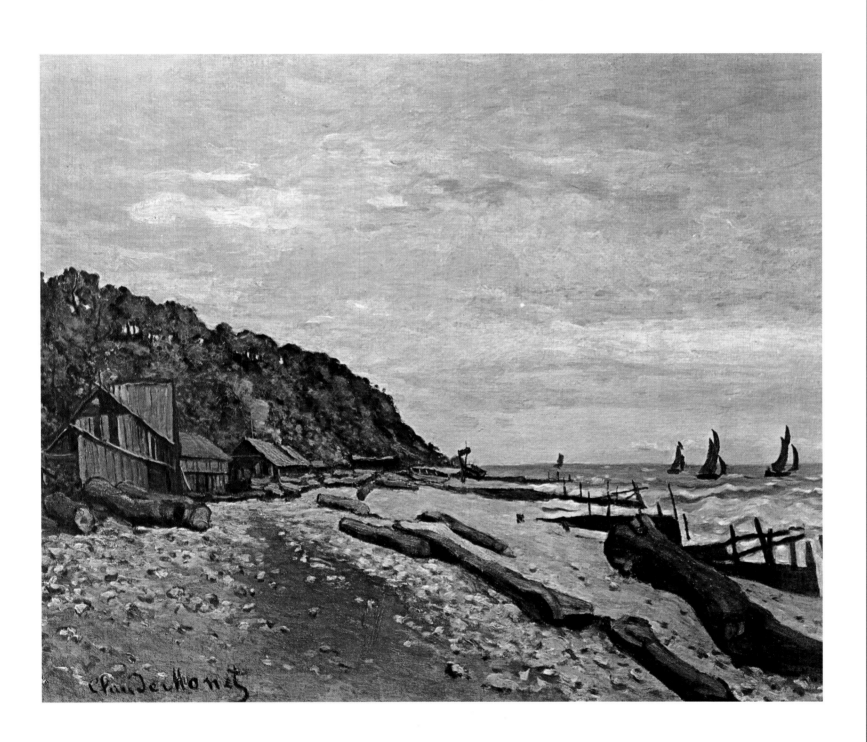

■ CLAUDE MONET
**Beach at Honfleur
(Shipyards near
Honfleur)**
1864, oil on canvas,
57 × 81 cm
Private collection

From his first works
Monet takes his inspi-
ration from the
natural realism of
Corot, Courbet, and
the Barbizon painters.
Unlike many of his
contemporaries, who
spend entire days in
the Louvre studying
classical art, Monet
prefers to seek inspi-
ration in contact
with nature. In 1862,
because of poor
health, he returns to
Le Havre, where he
spent his childhood
from the age of five
to nineteen. Here he
meets up with Boudin
and Jongkind, with
whom he makes
landscapes and from
whom he learns to use
pale, luminous colors,
as can be seen in this
painting.

CLAUDE MONET
**Luncheon on
the Grass**
1865, oil on canvas,
in two fragments,
418 × 150 cm and
248 × 217 cm
Musée d'Orsay, Paris

Monet begins work on
this painting in August
1865 at Chailly. His
future wife, Camille
Doncieux, and Frédéric
Bazille pose for all the
characters except the
bearded man seated
in the foreground,
almost certainly
Gustave Courbet.
Courbet criticizes the
painting, and Monet
makes changes but is
so unhappy with the
result that he leaves
the work unfinished.
He is then forced to
leave the painting
behind as security
when he can't pay
the rent in the hotel.
Several years go by
before he is able to
return and pay off the
debt, and he finds that
much of the canvas,
stored rolled up all
that time, has rotted;
he is able to save only
these two fragments.

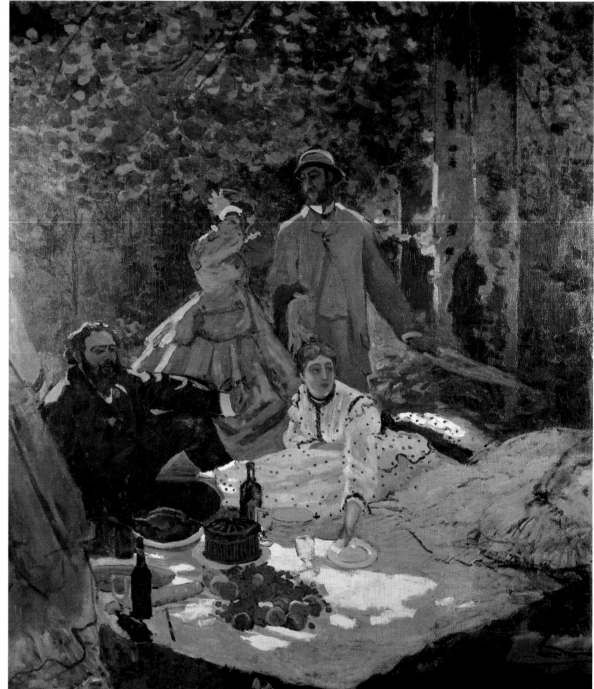

The formation of the Impressionists

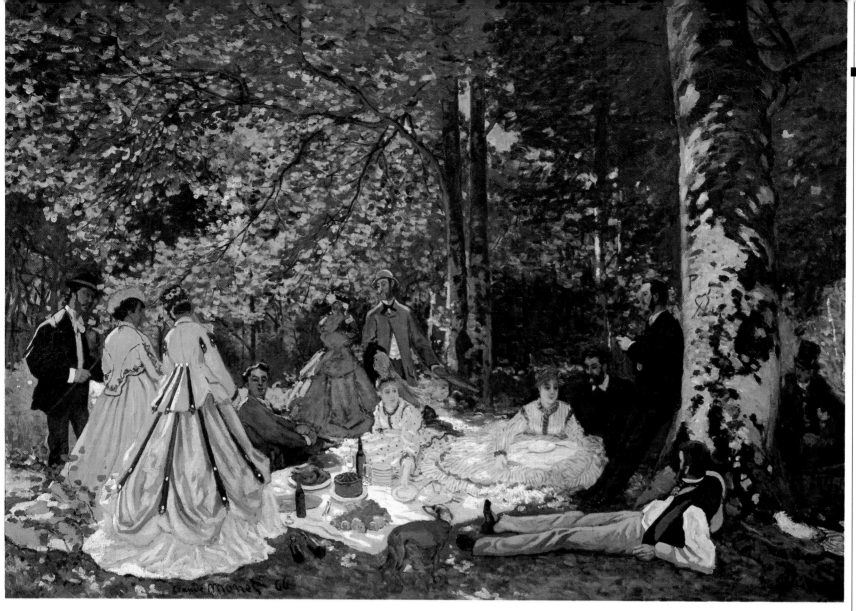

■ CLAUDE MONET
**Luncheon on
the Grass**
1865–66; oil
on canvas,
130 × 181 cm
Pushkin State Museum
of Fine Arts, Moscow

It is not clear whether
this work began with
a sketch made at
Chailly that was then
worked into the large
canvas or whether it
is a later version made
entirely in the Paris
studio. The theme of
the painting is drawn
from the *Luncheon on
the Grass* and, to a
lesser degree, the
*Music in the Tuileries
Gardens*, both by
Manet, although
Monet tries to give
the scene a more
realistic and collo-
quial feel.

■ CLAUDE MONET
**Bazille and Camille
(The Stroll)**
1865, oil
on canvas,
94 × 69 cm
National Gallery of
Art, Washington, D.C.

This work also serves
as a preliminary study
for the left corner of
the *Luncheon on the
Grass*. The man and
woman, Camille
Doncieux and Bazille,
are in the forest of
Fontainebleau. Monet
takes particular care
with the effects of the
light filtering through
the dense foliage to
fall upon the two fig-
ures in different ways.
Camille also serves as
the model for the
painting *Camille (The
Green Dress)*, exhibited
at the Salon of 1866.

1860•1870

The formation of the Impressionists

CLAUDE MONET
Camille on the Beach at Trouville
1870, oil on canvas,
45 × 36 cm
Private collection

The shadow cast over the woman by the parasol isolates her from the sunny landscape and locates her in a more intimate and reserved atmosphere. The expression on her face is nearly hidden by the veil attached to her peculiar hat, of a style every much in vogue at the time. All of the small-scale painting is made with short, quick brushstrokes, which in the lower area give the impression of an unfinished work, almost a sketch or preparatory drawing for a larger piece.

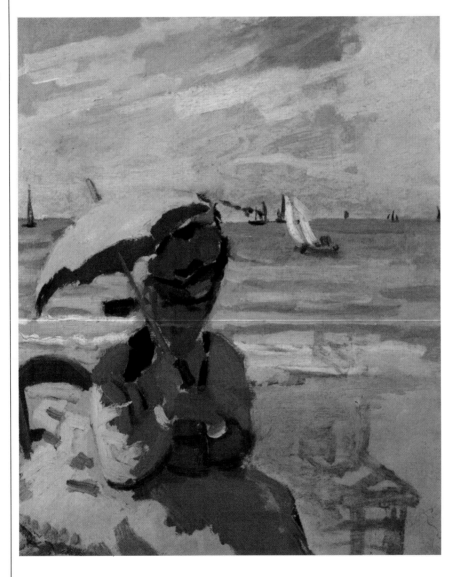

■ CLAUDE MONET
Woman in Garden
1867, oil on canvas,
80 × 99 cm
Hermitage,
St. Petersburg

This painting, made
in June 1867 at
Sainte-Adresse, a
suburb of Le Havre,
can be taken as both
a synthesis and the
highest achievement
of Monet's youthful
experiments with
light and its effects
on colors. The setting
is the garden of the
home of Monet's
cousin Paul Eugène
Lecadre, with whom
he was staying. The
woman in the picture
is Lecadre's wife,
Jeanne Marguerite.
X-ray examination of
the canvas reveals
that there were origi-
nally two male figures
in the picture, perhaps
part of a family por-
trait, but Monet
eventually painted
them over to concen-
trate his efforts on
the vegetation and
the many shadings of
green in the leaves.

CLAUDE MONET
**Women in
the Garden**
1866, oil on canvas,
255 × 205 cm
Musée d'Orsay, Paris

Except for a bit of
retouching done in
the studio at Honfleur,
Monet makes all of
this painting outdoors
at Ville d'Avray.
Camille Doncieux
serves as model for
all four of the women,
arranged asymmetri-
cally around a tree.
The work is composed
of striking chromatic
contrasts, most of all
between those areas
that are illuminated
and those that are in
shadow. In January
1867 Frédéric Bazille
buys the painting to
help Monet, who is
going through a
period of financial
difficulties. The work
is presented to the
Salon jury, who reject
it, deeming it too
revolutionary.

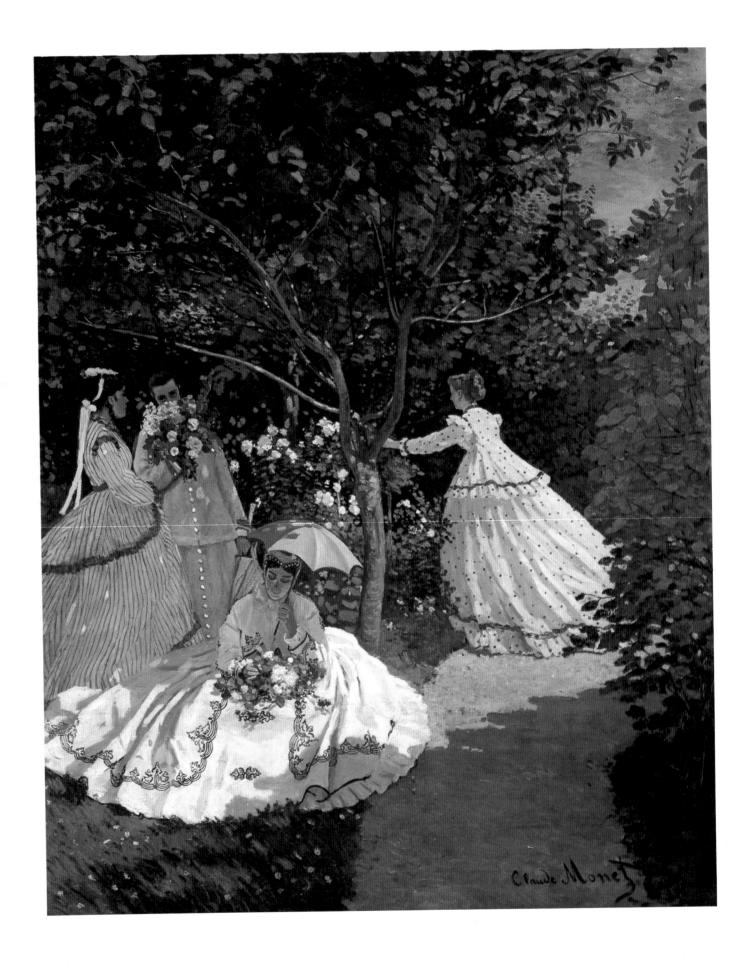

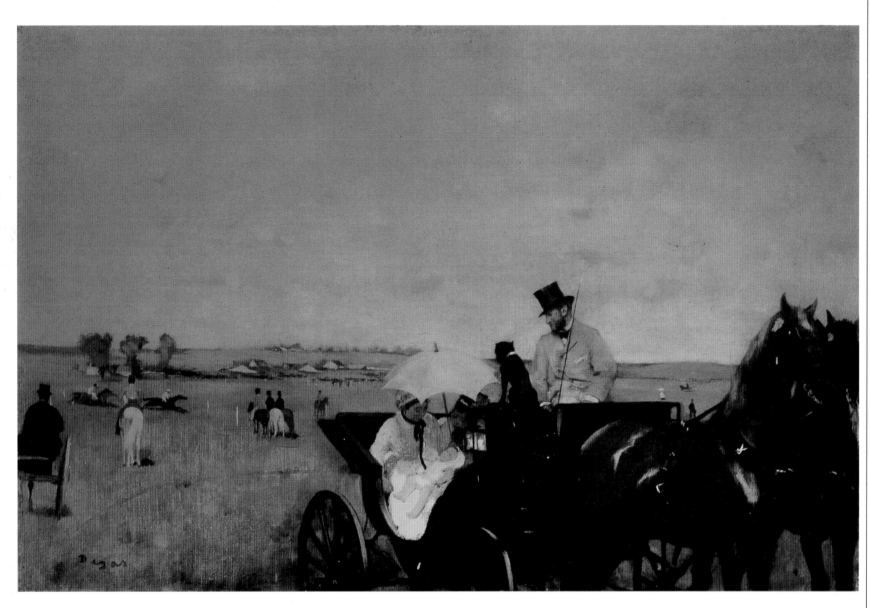

■ EDGAR DEGAS
At the Races in the Countryside
1869, oil on canvas,
36.5 × 55.9 cm
Museum of Fine Arts,
Boston

Between 1862 and
1870 Degas makes
fifty-odd works,
including drawings
and oil paintings,
dedicated to horses,
whether used in hunt-
ing or, more often, at
racecourses. In these
he is influenced by
Japanese prints, early
photographic repro-
ductions, and scientif-
ic studies of animal
locomotion. In fact, he
presents the elegant
anatomy of the horses
with great precision
and accurately renders
their dynamic move-
ments on canvas.
In this painting he
relegates the race to
the background and
uses the foreground
for the carriage of his
childhood friend Paul
Valpinçon, presented
with his family.

The formation of the Impressionists

JEAN-AUGUSTE-
DOMINIQUE INGRES
The Forestier Family
1806, lead pencil
on paper
26 × 34.5 cm
Musée Ingres,
Montauban

Comparison of this
drawing by Ingres,
part of the artist's
collection, with the
portrait of the Bellelli
family (right) reveals
how far Degas has
already distanced
himself from classical
schematics. The sev-
eral members of the
Forestier family are
arranged in a precise
order, and their gazes
seem to follow the
lines of perspective.
In Degas's work, the
poses of the figures
are far more natural
and spontaneous, and
instead of having a
single center, the
scene moves freely
in several directions
at once.

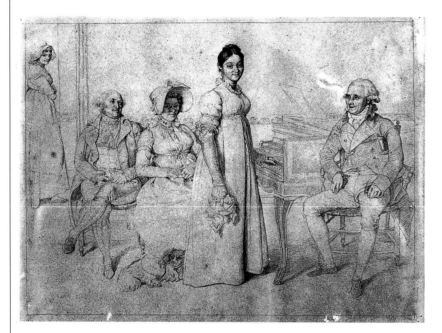

EDGAR DEGAS
**Family Portrait
(The Bellelli Family)**
1858–66, oil
on canvas,
200 × 250 cm
Musée d'Orsay, Paris

Degas makes the initial studies for this painting in 1858 in Florence while staying with the Bellelli family and completes it in Paris. The family members include Degas's maternal aunt Laura, her daughters Giovanna and Giulia (seated), and her husband, the Neapolitan baron Gennaro Bellelli. Bellelli had been forced to leave Naples because of his liberal politics and was in unhappy exile in Tuscany. The reason the mother and daughters are dressed in mourning is explained by the little red-chalk drawing on the wall, a portrait of the recently deceased Hilaire Degas, Laura's father and Edgar Degas's grandfather.

EDGAR DEGAS
Self-Portrait
1855, oil on canvas,
81 × 64 cm
Musée d'Orsay, Paris

In 1853, after graduating from the Louis-le-Grand secondary school, Degas obtains permission to copy at the Louvre. At the same time he participates in the studios of both Félix Barrias and Louis Lamothe; to please his father he also registers for law school. In 1855 he abandons his law studies and enters the Ecole des Beaux-Arts. In this self-portrait he presents himself as a model student, serious and concentrated, aware of his abilities and also aware of the examples set by the old masters of the academy: his pose is based on that of Ingres in a self-portrait from 1804, today in the Musée Condé at Chantilly.

■ EDGAR DEGAS
**Portrait of
Hilaire Degas**
1857, oil on canvas,
53.6 × 41 cm
Musée d'Orsay, Paris

In July 1856 and
the summer of 1857,
Degas is in Naples,
staying at the villa of
his paternal grand-
father, the banker
Hilaire Degas. Hilaire,
descendant of a noble
family of Breton ori-
gin, took refuge in
Naples during the
French Revolution.
In this work the
painter draws inspi-
ration from official
portraiture to give
his subject a noble,
austere expression.
At the same time,
however, he uses a
soft, uniformly glow-
ing light to imbue the
man with a sense of
intimacy and familiar-
ity that makes clear
the admiration and
great affection Degas
felt for him.

EDGAR DEGAS
Young Spartans Exercising
1860–62, oil
on canvas,
109 × 155 cm
National Gallery,
London

Unlike Monet, who
seeks inspiration in
contact with nature,
Degas follows the
traditional course of
academic studies,
which includes making
copies of classical
works and then creat-
ing compositions
with historical or
mythological subjects.
During his first five
years of study Degas
makes about a hun-
dred works inspired
by models from the
past, among them
this work, which is
based on a drawing
attributed to Jacopo
da Pontormo and a
similar version by
Delacroix. Already
apparent is an
uncommon technical
skill in the modeling
of bodies; in the group
of girls to the left
this skill is joined by
elegance and grace, a
combination destined
to show up later in
the famous series of
ballerinas.

PAUL CÉZANNE
**The Judgment
of Paris**
1862–64, oil
on canvas,
15 × 21 cm
Private collection

In 1861 Cézanne
convinces his father
to let him interrupt
his law studies at the
university of Aix-en-
Provence to go study
painting in Paris.
In Paris he enrolls at
the Académie Suisse,
where he meets
Monet, Pissarro, and
Guillaumin, and he
often visits the Louvre.
As preparation for the
entrance examination
to the Ecole he makes
copies of works by the
masters of antiquity;
this small painting is
among the first of
those exercises. In
1862 it is rejected,
and until 1882, every
painting he presents
to the Salon is
rejected.

1860•1870

78

The formation of the Impressionists

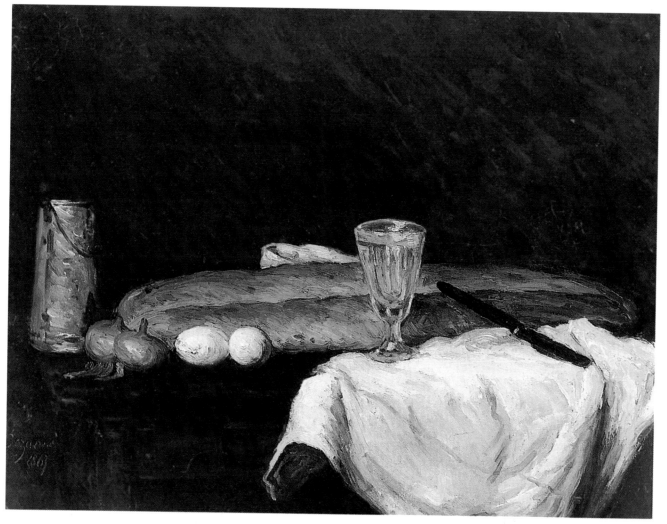

Cézanne makes much progress at the Académie Suisse, as indicated by this still life, in which he shows how in only a few years he has developed a sure technical hand and has learned how to apply light and color. The choice of everyday objects presented against a very dark background is reminiscent of Spanish painting, which was enjoying great popularity in that decade. The light strikes the objects frontally, making them stand out sharply against the background; the scene thus acquires notable depth and is given an unusual expressive force.

At the end of 1864, dissatisfied with the results he has achieved in Paris, Cézanne does what he will do many times in his life, he returns to Aix-en-Provence to paint on his own. The thick, broad brushstrokes of the white clouds and the green fronds of the vegetation recall the landscapes of Corot and the painters of the Barbizon school.

**Portrait of Ant
onin Valabrègue**
1866, oil on canvas,
116 × 98 cm
National Gallery of
Art, Washington, D.C.

Antonin Valabrègue
(1845-1900) is one of
Cézanne's friends in
Aix-en-Provence. He
too moves to Paris,
where he begins a
career as art critic and
writer, publishing,
among other works,
a volume of poetry
entitled *Petits Poèmes
Parisiens*. Cézanne
submits this canvas
to the jury of the
Salon, who refuse it.
In response he writes
two letters to Count
Emilien Nieuwerkerke,
superintendent of fine
arts, requesting that
he arrange another
Salon des Refusés,
as had been done
three years earlier.
His request falls of
deaf ears.

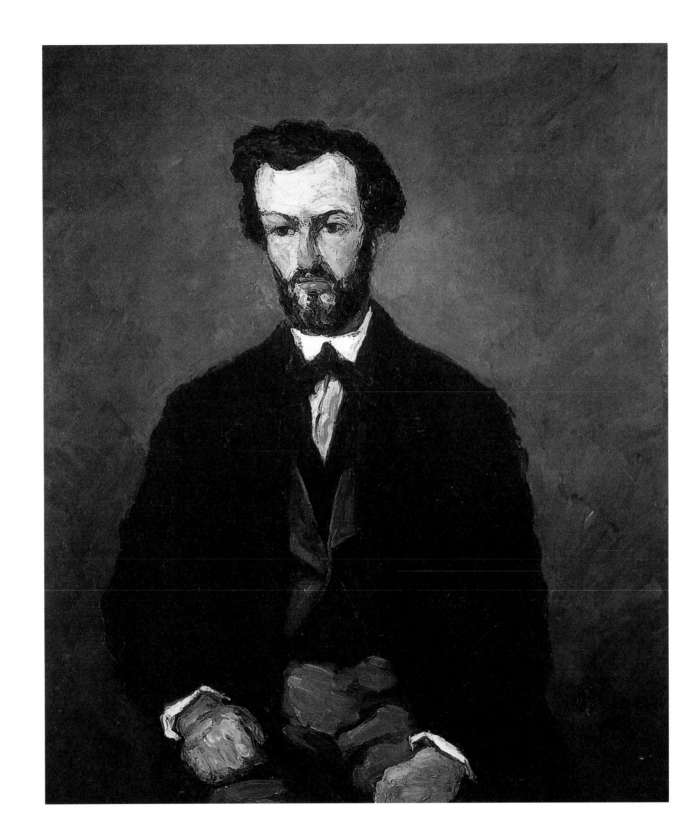

The formation of the Impressionists

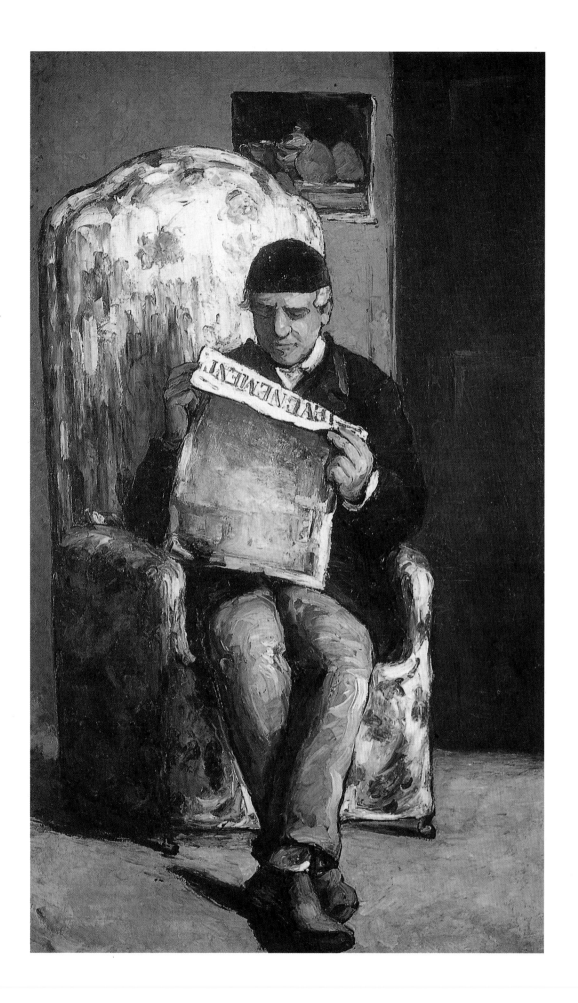

■ PAUL CÉZANNE
Portrait of Louis-Auguste Cézanne
1866, oil on canvas,
200 × 120 cm
National Gallery of
Art, Washington, D.C.

Cézanne's father owns
a hat factory in Aix-
en-Provence. In 1847
he saves the Banque
Barges from bankruptcy
and together with an
associate founds the
Cézanne & Cabassol
bank. He does every-
thing in his power
to convince his son
to complete his law
studies, and only the
unrelenting interces-
sion of his wife and
daughter Marie
convinces him to
permit him to go to
Paris to study painting.
Much as Renoir does
in *At the Inn of
Mother Anthony*
(page 61), Cézanne
here calls attention
to *L'Evénement*, the
newspaper for
which Zola writes
favorable reviews of
the paintings of the
Impressionists.

T he early years of the Impressionists fall within the reign of Napoleon III. Louis Napoleon Bonaparte, born in Paris in 1808, is the third child of Louis Bonaparte, king of Holland and brother of Napoleon I, and Hortense de Beauharnais. After the collapse of the empire of Napoleon I, defeated at Waterloo and exiled to St. Helena, Louis Napoleon Bonaparte lives with his mother, by then separated from her husband. He then moves to Italy, where he meets various leaders of the Carbonari movement, in particular Ciro Menotti. In February 1831 he participates in uprisings in Romagna against pontifical power. He then seeks refuge in Switzerland and Bavaria. During these years he matures in his political beliefs, which he sets forth in two books, *Political Fantasies* (1833) and *Idées Napoléoniennes* (1839). Following the death of his cousin, the duke of Reichstadt, in 1832, Louis Napoleon Bonaparte presents himself as the heir to Napoleon. In his opinion, the solution to

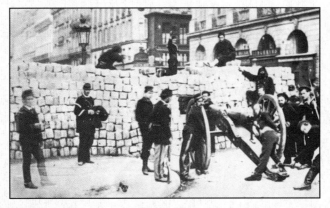

On December 10 he is elected president of the republic by an overwhelming majority, winning 5,434,000 votes out of 7,500,000. In 1849, to ensure himself the support of conservatives and the church, he sends a military expedition, led by General Oudinot, to Rome to deal with the republic set up by Mazzini and to reinstall Pope Pius IX in the Vatican. The next year he agrees to an educational bill, named for Frédéric Falloux, that gives the church control of primary and secondary instruction. At the end of his term, he tries to get the assembly to amend the constitution to permit his reelection as president. Failing that, he engineers a coup d'état, carried out during the night of December 2, 1851. A new constitution in January 1852 changes the republic into an empire, and he becomes emperor under the name Napoleon III. In 1853 he marries the Spanish countess Eugenia María de Montijo de Guzmán, with whom he has a son, Eugène Louis Napoleon. The press is closely controlled, the courts are put at the disposal of the

Photograph of a barricade put up in Rue de la Paix in 1871, during the period of the Paris Commune.

France from 1848 to 1871: the Franco-Prussian

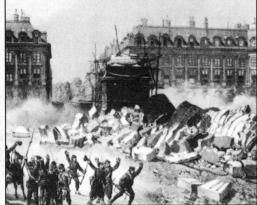

The statue of Napoleon in the Place Vendôme is knocked down on May 16, 1871, as shown in an engraving.

German soldiers at the ruins of Fort d'Issy on the outskirts of Paris.

the many problems afflicting France is the creation of a Second Empire, which under his guidance would restore France to prosperity and well-being. He makes his first attempt to dethrone Louis Philippe on October 30, 1836, at Strasbourg and is exiled to the United States; he tries a second time on April 6, 1840, at Boulogne-sur-Mer, after which he is locked up in the fortress of Ham. Six years later he effects an easy escape from prison, and in 1848, although legally barred from residing in France, he profits from revolutionary movements to get himself elected to the national assembly. On September 17, 1848, he is elected deputy, and on October 11, he obtains permission to return to his homeland.

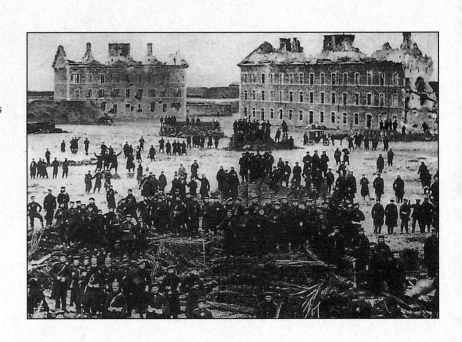

1848•1871

The Second Empire, the Franco-Prussian War, and the commune

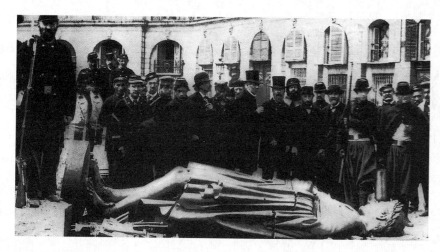

change, full of important transformations. In addition to the Louvre, many new galleries and museums are opened to the public. For example, there is the Palais du Luxembourg, the space dedicated to living French artists, there is a museum of French monuments, and a museum of French decorative arts. Every year the Salon presents about five thousand paintings by almost two thousand artists, viewed by no fewer than 200,000 visitors, many of them foreigners. In 1861, Paris has 104 private art galleries, each of which presents its own exhibits.

Napoleon III is also active in foreign affairs. He promotes French colonial expansion in Algeria, Senegal, Cochin China, Cambodia, and on the Red Sea, creating a zone of influence second in size only to that of Great Britain. He reaches political and economic accords with England and enters the Crimean War (1853–56) alongside England against Russia. Less fortunate is his intervention in Italy on the side of Savoy, and his attempt to replace Austrian hegemony with French control is skillfully deflected by Cavour and Victor

The insurrectional Paris Commune is proclaimed at the Hôtel de Ville on March 26, 1871.

ruler, the administration becomes more and more centralized. Political opposition is practically cancelled, with similar repression applied to the nascent workers' movement. The Second Empire lasts about twenty years during which the French nation undergoes profound economic and social transformations and enjoys notable prosperity. Agriculture, commerce, and industry make great progress, both quantitative and qualitative. The consolidation of France's first investment banks permits the

the Second Empire, War, and the commune

financing of new private undertakings and the building of large-scale public works. Outstanding among such public works is the radical rearrangement of Paris under the direction of Baron Georges Haussmann (1809–91), prefect of the department of the Seine, who has entire city districts destroyed, replacing them with new public and private buildings and giving the city the splendid avenues, boulevards, and parks for which it is famous. Strong support for the economy is provided by the new rail lines, which facilitate the movement of people and goods while also offering employment for many people. From a cultural point of view, these are decades of intense

Emmanuel II. He alienates the sympathies of French Catholics with his mixed politics toward the Vatican. Finally, the expedition to Mexico in 1862–67, with the aim of installing a monarchy faithful to France led by Maximilian, ends in failure. The final blow is delivered by Otto von Bismarck, who becomes premier of Prussia in 1862 and sets about unifying Germany. The Austro-Prussian War of 1866 reveals Napoleon III's diplomatic weakness and creates dangerous tension between France and Prussia. The 1867 universal exhibition in Paris is a triumphant display of imperial prestige, and the results of the election of May 8, 1870, in which he wins 7 million votes against 1.5 mil-

Georges Haussmann presents Napoleon III with his plans for the rebuilding of Paris.

The train station of Amiens in 1855. The railroad plays an important role in the economy of Second Empire France.

28, by which time the city is on the edge of famine, Paris surrenders. The war costs France about 300,000 in dead and wounded and more than 700,000 in prisoners; Prussian casualties number about 130,000. The French government signs a three-week armistice; elections are held on February 8. A new national assembly is elected and meets in Bordeaux to form a new government under Adolphe Thiers (1797–1877), who then begins working out the conditions of the peace treaty with Prussia. Among the members of the assembly is Victor Hugo, nominated president of the left. He arrives in Bordeaux on February 13, but hands in his resignation on March 8, following dissension within the assembly.

Meanwhile the Parisians, still suffering the results of the long siege, most of all famine, along with the general economic crisis, reject the outcome of the elections, which they claim have created an overly "rural" assembly, conservative and favorable to the return of the monarchy. Thiers attempts to disarm the national guard and requisition the rifles and cannon still in its possession. On March 18 the Parisians throw up barricades, throw out the regular forces, and elect a municipal council, the commune of 1871. On March 26 elections are held with universal suffrage, and representatives of the many and various revolutionary forces are elected, most of all Jacobins, followers of Proudhon, and radical socialists. This new assembly is granted legislative and executive powers on the model of the Convention of Robespierre. The ninety

lion for his opponent, mislead Napoleon III into believing he still has the entire nation behind him. The French emperor is unaware that Bismarck's skilled politics have isolated him; most of all he fails to realize that the French army is far less prepared and less numerous than the Prussian army led by Field Marshal von Moltke, which can field 800,000 men, with half in the front lines, against the 300,000 under Field Marshal MacMahon. On July 19, 1870, Napoleon III reacts ingenuously to Prussian provocations, and responding to public opinion he declares war on Prussia. Three Prussian forces cross the French border. General Bazaine is defeated in Lorraine at Spicheren, Marshal MacMahon at Wissembourg, threatening Strasbourg. The decisive engagement takes place on September 1 at Sedan, on the right bank of the Meuse River, northwest of Rheims. The defeat is total, and only Napoleon III's surrender to King William I of Prussia prevents the massacre of 100,000 French soldiers. Already seriously ill, the aging emperor exiles himself to Great Britain, where he dies in 1873.

Meanwhile, on September 4, 1870, Paris is proclaimed a republic, with a provisional government of ten members led by General Trochu (1815–96) and including Jules Favre (1809–80) and Léon Gambetta (1838–82). They decide to do everything possible to resist the Prussians. On October 27 General Bazaine surrenders a garrison of 180,000 men to the Prussians at Metz, and the Prussians move to besiege the city of Paris. Meanwhile Gambetta escapes Paris in a balloon and makes it to Tours, where he mobilizes about 600,000 men with the intention of freeing Paris and setting up a final desperate defense. Further help arrives in the form of a corps of international volunteers, mostly Italians, including Giuseppe Garibaldi, that defeats a Prussian force at Dijon in January 1871. The German forces, however, cannot be stopped, and on January

The Boulevard des Italiens, one of the wide avenues created in the Paris of Napoleon III, in 1860.

The Second Empire, the Franco-Prussian War, and the commune

elected members are divided in ten work commissions, coordinated by a five-member committee of public health, with the aim of reorganizing and reforming the state. Because of its symbolic importance, one of the most famous episodes of the commune is the knocking down of the column in Place Vendôme on May 16, 1871. This column was erected in 1810, on its top a statue of Napoleon Bonaparte, and it is considered an emblem of power and oppression. Gustave Courbet, who participates in the communal government as minister of culture, is later held responsible for the event. He is tried and condemned to pay for reconstruction. He flees to Switzerland, where he dies in poverty in 1877. Between March 22 and 28 similar revolts occur in Lyons, Marseilles, Toulouse, Narbonnne, and Saint-Étienne. At the same time, the government under Thiers, which has taken refuge at Versailles, concludes a preliminary peace agreement with Prussia that is then ratified at Frankfurt on May 10, 1871. France agrees to pay an indemnity of $1 billion within three years and to cede Alsace and much of Lorraine. Having resolved the

international situation, the Thiers government decides to use force to put down the commune and for the second time in three months Paris is under siege. The *communards* put up a furious defense of the city, fighting house by house, street by street, and destroying what they consider to be symbols of oppression, including the Tuileries palace, burned on May 21, and the city hall. Paris is the scene of chaotic fighting for a week, during which as many as 20,000 people die. On May 28 the last rebels are forced to surrender; the repression is cruel: 38,000 are arrested, more than 13,000 found guilty, with 270 condemned to death and another 7,500 to deportation. In the following months, the assembly constantly puts off the formation of a new republic, almost openly trying to prepare the country for the return of the Bourbon monarchy. The resignation of Thiers, in 1873, and the election of Field Marshal MacMahon seem to lead the way for a new sovereign. The favorable moment passes, however, the monarchists lose their chance, and the moderate republican forces under Gambetta win back their standing among the people. They succeed in having a new republican constitution adopted in 1875 and keep a republican majority in the elections of 1876 as well as those of 1877 and 1879. In 1880 MacMahon steps down

and Jules Grévy is elected the new president of the Third Republic. Under him the nation is reorganized, and new laws concerning elementary education are passed, taking the power from the church and entrusting it to the state. Also guaranteed are freedom of assembly and freedom of the press; the right to form workers' associations is guaranteed in 1884, permitting the rebirth of the workers' movement. For France a new period of development and prosperity begins, as indicated and celebrated by the great universal exhibitions.

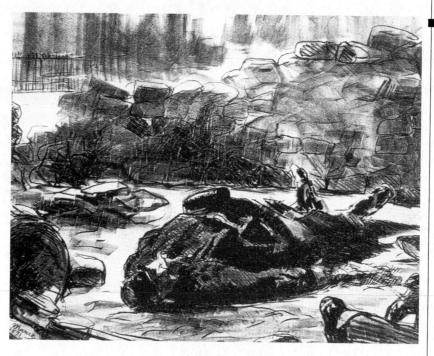

Bather with a Griffon
1870, oil on canvas,
184 × 115 cm
Museu de Arte,
São Paulo

The model for this painting is Lise Tréhot (1848–1924), Renoir's favorite model from 1865 to 1872. The arrangement of the composition is classical, recalling the positioning of the many Venuses that appear in classical art. The setting, however, is modern, as one notes immediately from the woman's dress, from the presence of a second person, visible to the right, and from the addition of the griffon, the little dog at her feet. The colors are not as bright as in other works of the same period and recall the soft tones used by Courbet. Renoir exhibited this painting at the Salon of 1870, obtaining much praise for it from critics.

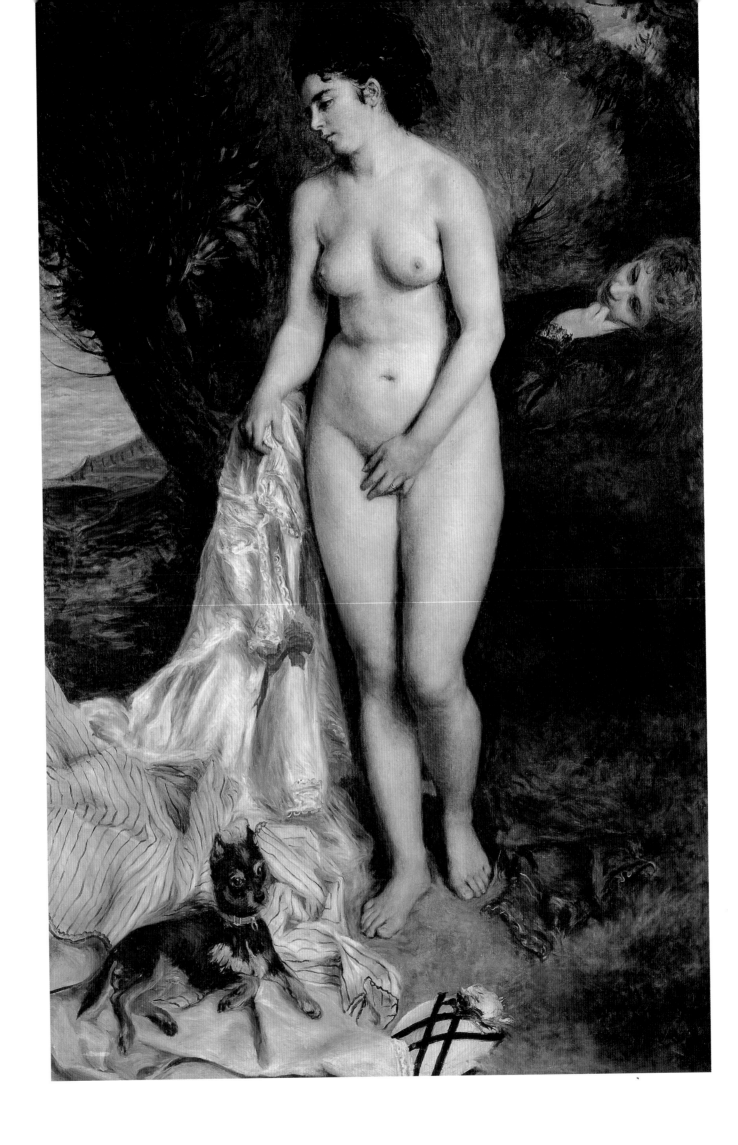

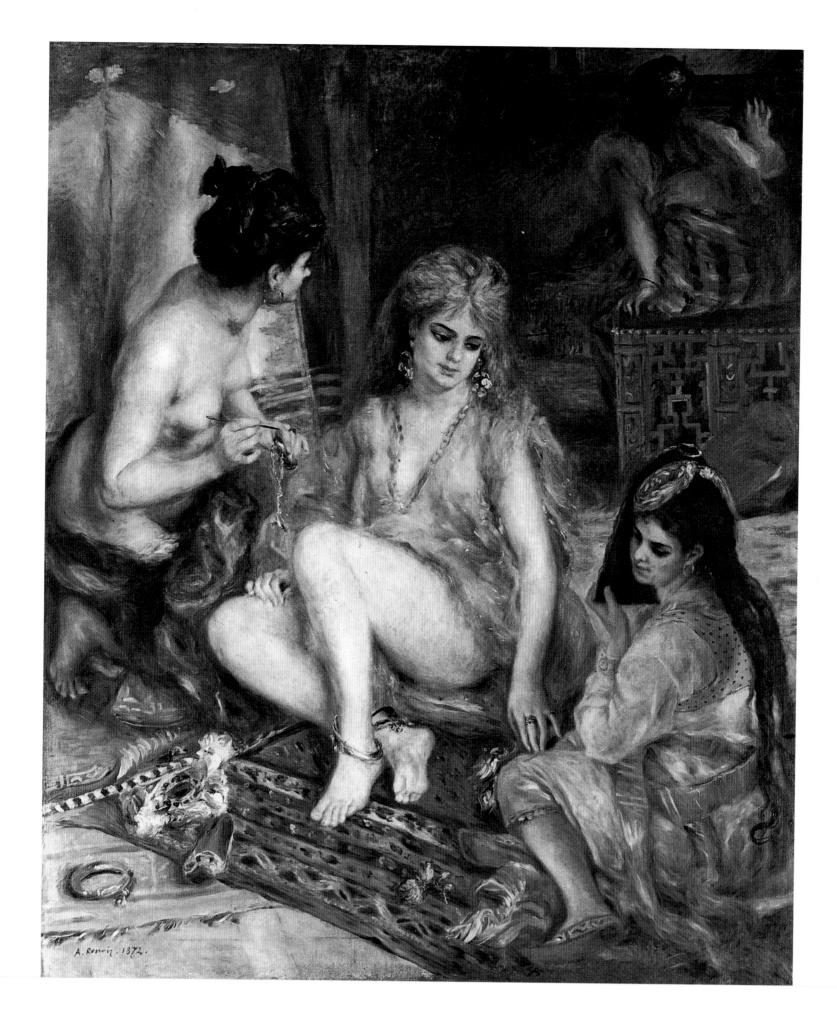

A. Renoir. 1872.

■ PIERRE-AUGUSTE
RENOIR
**Parisian Women
in Algerian Dress**
1871–72, oil
on canvas,
156 × 129 cm
National Museum of
Western Art, Tokyo

Here again the model
is Lise Tréhot, but this
is one of the last times
she poses for Renoir.
During this very period
she marries the Parisian
architect Georges
Brière de l'Isle, with
whom she will have
four children. The ref-
erence to the *Women
of Algiers* (page 22)
by Delacroix is made
clear by the arrange-
ment of the figures,
their poses, the use of
light, and the choice
of colors. The artist
begins this painting
in 1871, finishes it in
1872, and presents it
to the Salon. The jury
refuses it, and it is
later bought by the
restaurant owner and
art collector Eugène
Murer.

PIERRE-AUGUSTE
RENOIR
**Algerian Woman
(Odalisque)**
1870, oil on canvas,
69.2 × 122.6 cm
National Gallery of
Art, Washington, D.C.

Once again the model
is Lise Tréhot. This
work is accepted by
the jury and exhibited
at the Salon, where it
receives high praise.
The critics, including
Arsène Houssaye
(1825–96), writing in
the magazine *L'Artiste,*
note the work's strong
resemblance to the
Women of Algiers by
Delacroix, an artist
Renoir loves and
admires. Critics also
praise the intense
sensuality of the
model, emphasized by
the great variety of
colors in her clothes.
Another detail they
find worthy of atten-
tion is the still life
to the left marked
off with loose, easy
brushstrokes that add
a touch of naturalness
to the scene.

The Second Empire, the Franco-Prussian War, and the commune

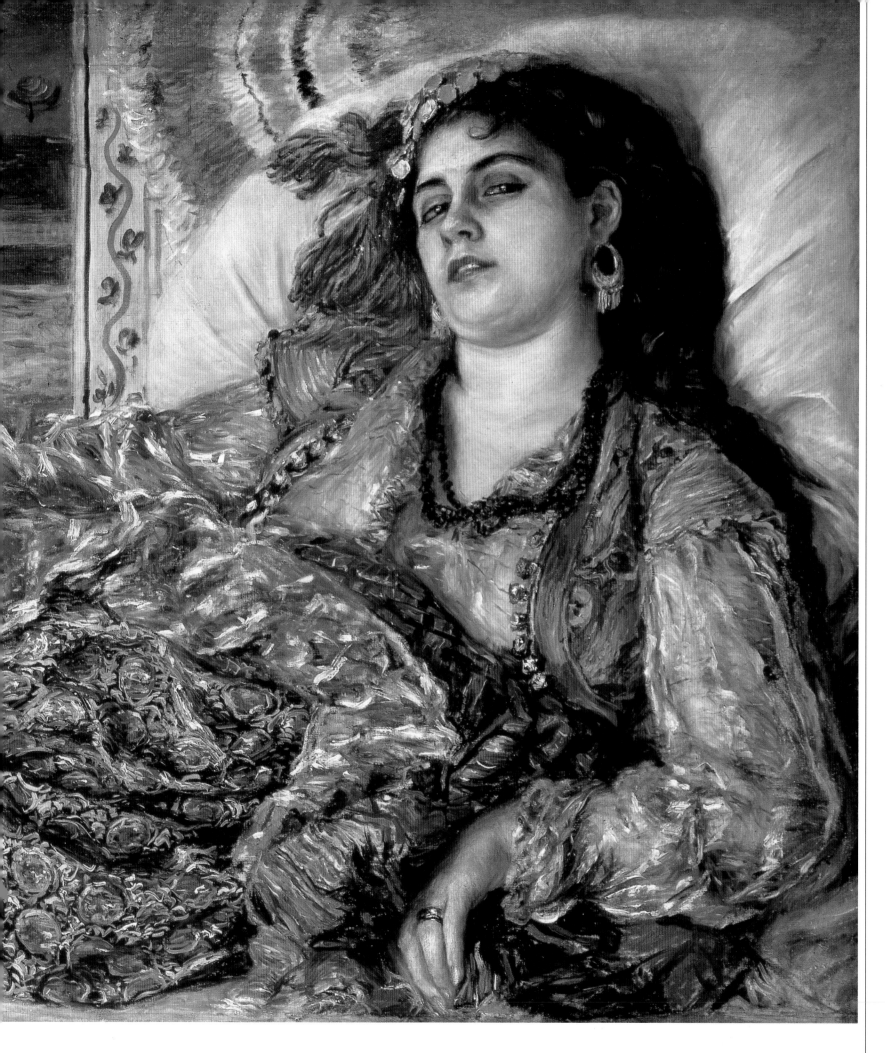

The Second Empire, the Franco-Prussian War, and the commune

PIERRE-AUGUSTE
RENOIR
The Stroll
1870, oil on canvas,
81.3 × 65 cm
J. Paul Getty Museum,
Malibu

The painting is loosely
based on the scenes of
amorous delights com-
mon to French paint-
ing in the seventeenth
century. Renoir, how-
ever, uses a modern
setting and a far more
realistic arrangement.
He also shows off his
technical skills, which
extend to near virtu-
osity in the subtle
chiaroscuro with
which he renders the
effects of light filter-
ing through the dense
foliage onto the cloth-
ing of the figures.

PIERRE-AUGUSTE
RENOIR
Woman with Parrot
1871, oil on canvas,
92.1 × 65.1 cm
Solomon R.
Guggenheim Museum,
New York

Although this scene
is set in an interior,
Renoir manages to
insert various "natur-
al" elements typical
of *plein air* painting,
most of all the plants
in front of the cage
and those behind the
woman. The woman's
expression and posture
seem so spontaneous
and natural that one
has the impression she
is not posing and has
instead been caught
by the artist in an
unguarded moment.

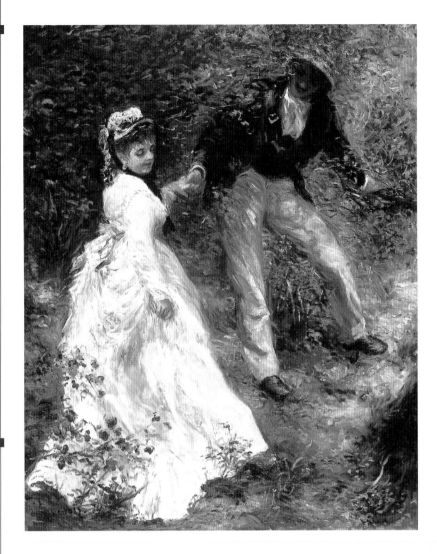

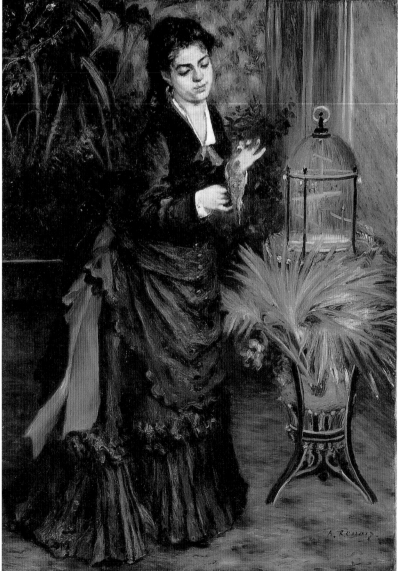

1848•1871
90
The Second Empire, the Franco-Prussian War, and the commune

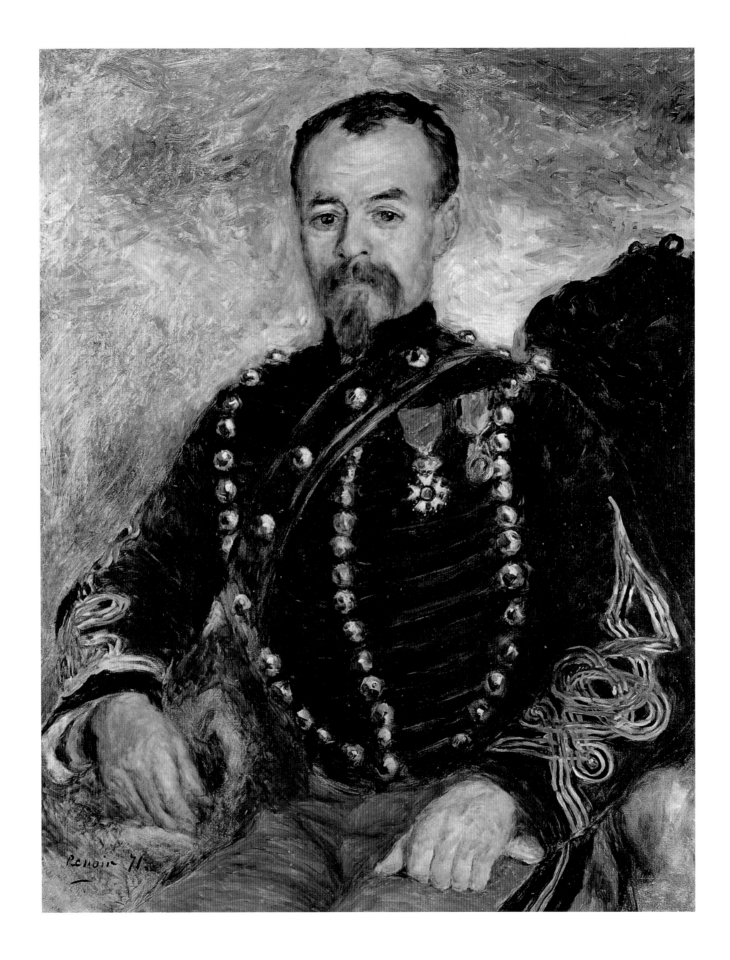

Renoir 71

■ PIERRE-AUGUSTE
RENOIR
Captain Darras
1871, oil on canvas,
81 × 65 cm
Gemäldegalerie,
Dresden

On October 28, 1870,
Renoir, like many
other Frenchmen, is
called to arms. He is
sent to Tarbes and to
Vic-en-Bigorre, near
Bordeaux, first among
the cuirassiers then in
the regular cavalry. By
way of his friend the
painter Jules Le Coeur
he meets Paul Darras
(born in Dijon in 1834,
he dies in Paris in
1903), who is a
captain at the time
of this portrait (and
later becomes a
brigadier and major
general). The painting
succeeds in giving a
sense of the sitter's
character and has a
powerful chromatic
vivacity supported by
the skillful application
of chiaroscuro effects.

CLAUDE MONET
**Hotel des Roches
Noires, Trouville**
1870, oil on canvas,
80 × 56 cm
Musée d'Orsay, Paris

On June 26, 1870,
Monet marries Camille
Léonie Doncieux;
among the witnesses
is Gustave Courbet.
The bride and groom
pass the summer at
Trouville in Normandy
where Monet makes
several paintings
based in part on simi-
lar scenes by Eugène
Boudin: there is the
same use of pale
colors to bring out
nuances of light and
atmosphere, and the
figures of people are
really just sketched
in, suggested by a few
simple touches of
paint. The enormous
flag in the foreground,
blown to one side by
the wind, is created
with quick brush-
strokes to give the
idea of movement.
In the same way,
even the clouds in the
background are highly
simplified, becoming
no more than broad
daubs of white.

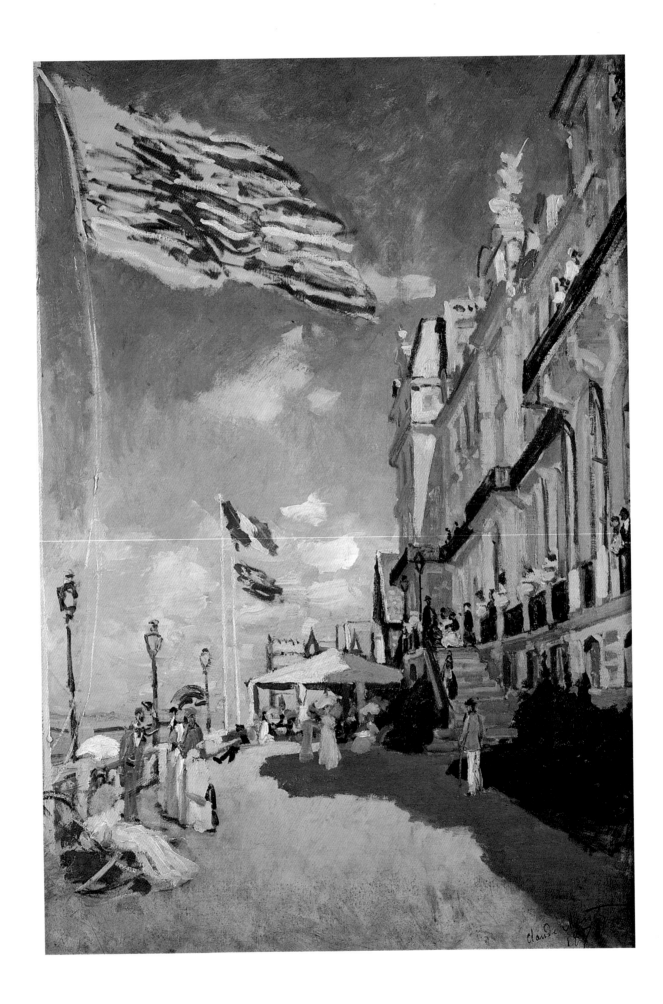

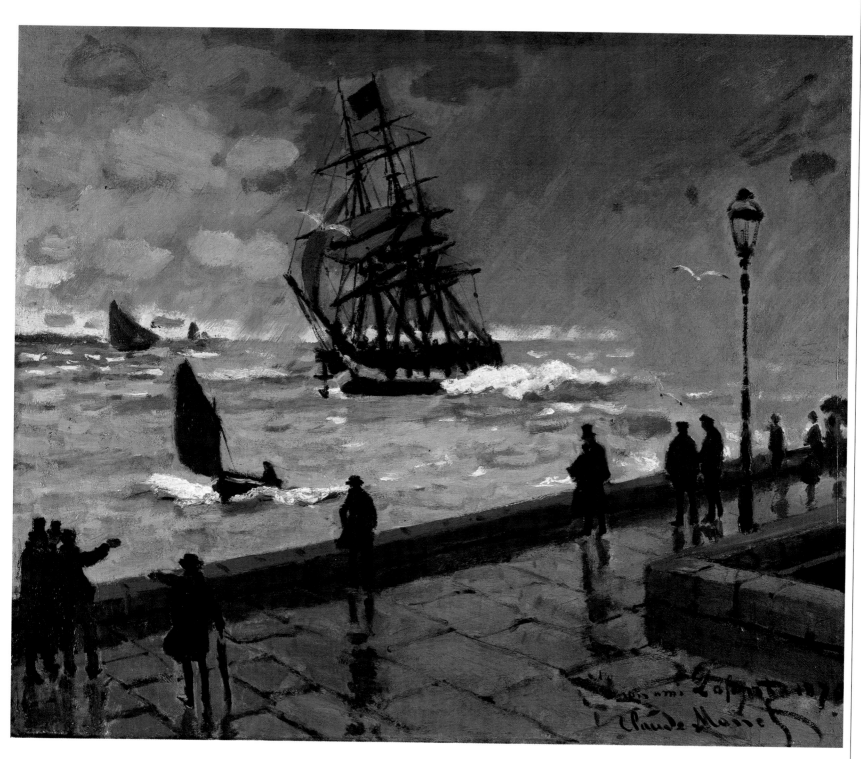

■ CLAUDE MONET
The Jetty at Le Havre
1870, oil on canvas,
50 × 60 cm
Private collection

This work's monochromatic chiaroscuro closely recalls paintings by Courbet. In the months he spends in Normandy Monet, still searching for his own pictorial language, experiments with various styles. Here nearly all colors have been banished, and the viewer's attention is captured by the striking contrast with which the artist presents the figures along the dock and the enormous sailing ship at the center of the painting. Using only various tones of gray he manages to render the sense of a sky full of rain, and the stormy sea is composed of alternating tones of green and white.

CLAUDE MONET
**The Thames and
Westminster**
1871, oil on canvas,
47 × 73 cm
National Gallery,
London

Although he is never
overly interested in
politics, Monet is a
republican at heart,
so when war breaks
out he refuses to
fight for the empire
and takes refuge in
London. While there
he meets Daubigny,
who has been in Great
Britain since 1867,
and Pissarro; together
they visit museums
and see works by
Turner and Constable,
and they often paint
along the banks of the
Thames, exchanging
opinions and advice.
Another very impor-
tant meeting in
London is that with
the art dealer Paul
Durand-Ruel, who has
opened a gallery at
168 New Bond Street.

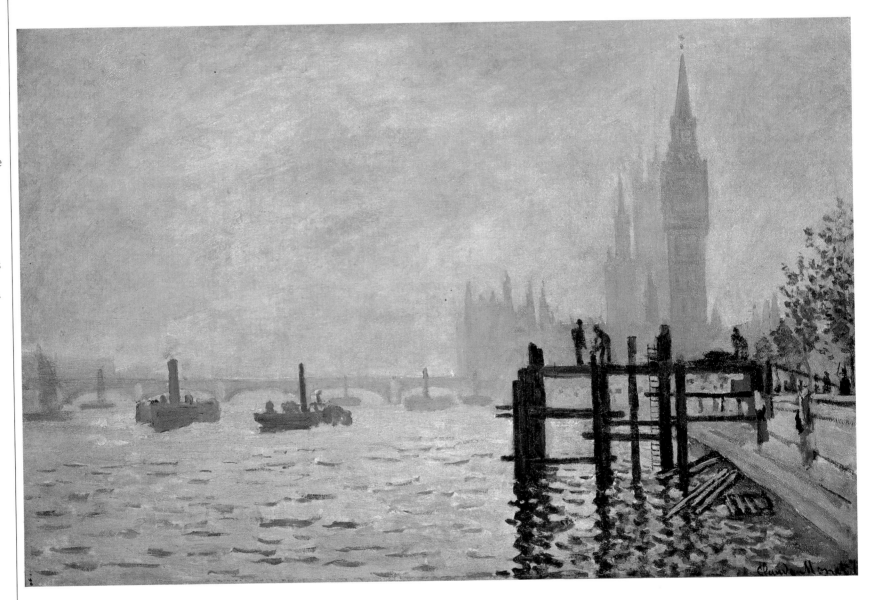

The Second Empire, the Franco-Prussian War, and the commune

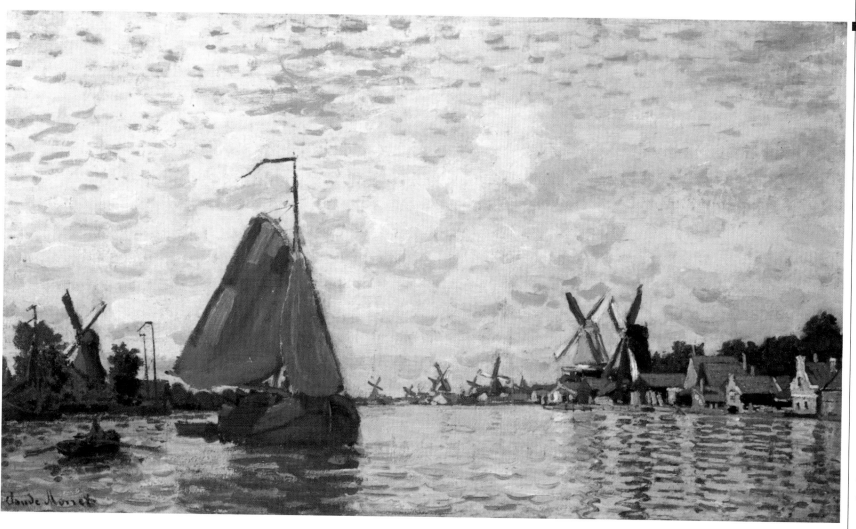

■ CLAUDE MONET
The Zaan at Zaandam
1871, oil on canvas,
42 × 73 cm
Private collection

On January 7, 1871, while Monet is in London, his father dies. The painter decides to return to France, but during the trip back he makes a short stop in Holland, at Zaandam. Here, drawn by the reflections of the houses and windmills on the water of the canals, he makes several landscapes inspired by those of Jongkind. Monet applies the paint in short, regular brushstrokes that have a rhythmic, almost musical cadence. The horizon line is low, giving more space to the sky, which is crowded with wispy, impalpable white clouds.

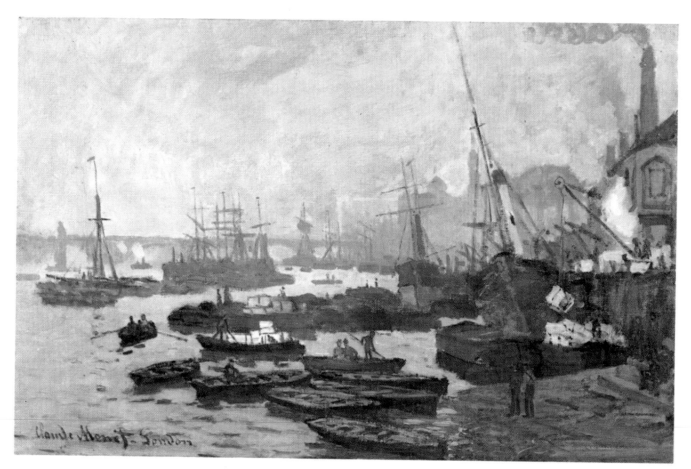

■ CLAUDE MONET
Boats in the Port of London
1871, oil on canvas,
47 × 73 cm
Private collection,
Paris

This painting (made in January 1871) and the other paintings from London show how Monet's palette is taking on new tones and shadings. His encounter with the English landscape tradition helps him improve his technical skills and refine the sensitivity of his drawing. The approach is still traditional, but various effects already reveal his lively attention to reality, which he expresses in a pleasantly original style.

The Second Empire, the Franco-Prussian War, and the commune

EDGAR DEGAS
Hortense Valpinçon
1871, oil on canvas,
76 × 110.8 cm
Institute of Arts,
Minneapolis

The little girl in this portrait, the older daughter of Degas's school friend Paul Valpinçon, has already been seen with her family in *At the Races in the Countryside* (page 71). Here she is caught with natural spontaneity, her lively gaze directed toward the viewer. With its limited range of colors, her dress contrasts with the elaborate richness of the shawl and the cloth draped over the table. The floral decoration of the wallpaper in the background is just barely indicated, recalling the Japanese prints that Degas is beginning to admire and collect in these very years.

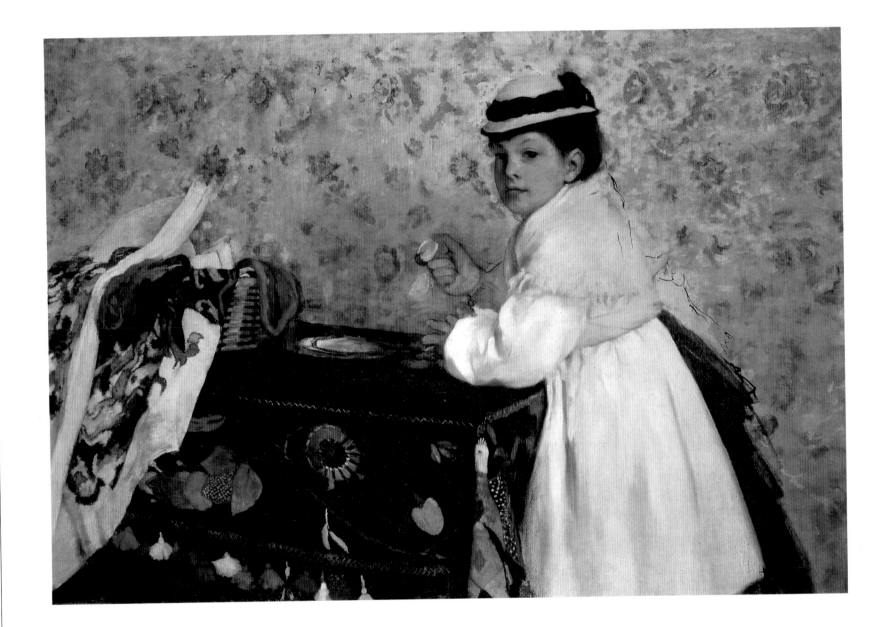

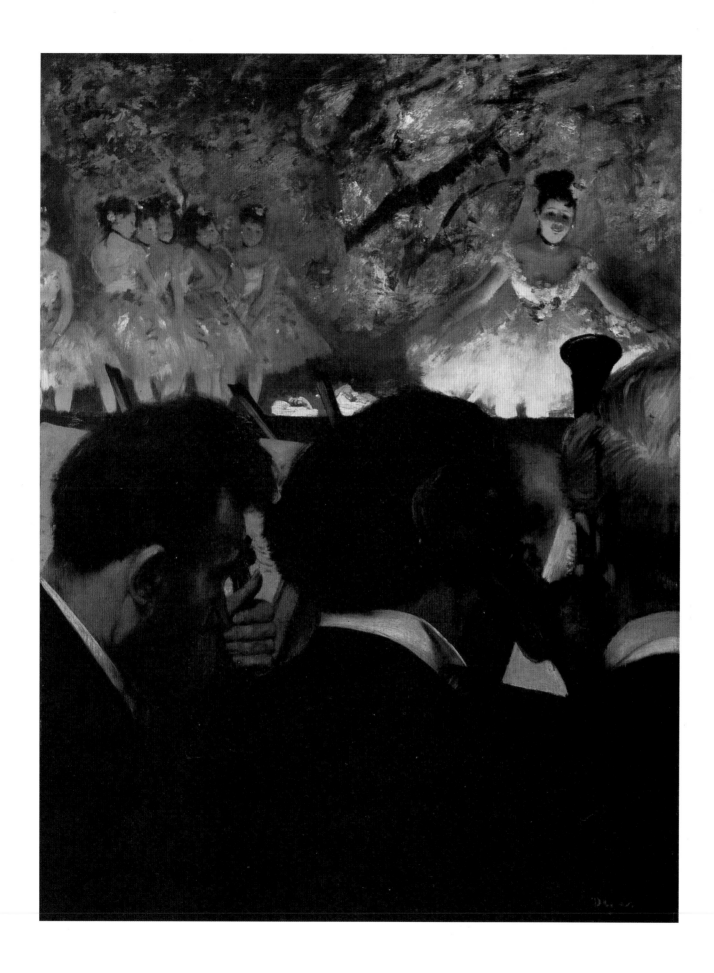

■ EDGAR DEGAS
Orchestra Musicians
1870-76, oil
on canvas,
69 × 49 cm
Städtische Galerie
im Städelschen
Kunstinstitut, Frankfurt

Degas begins this
work around 1870–71
but completes it only
several years later,
between 1874 and
1876. The composition
is divided in two dis-
tinct parts. In the
immediate foreground
are the musicians,
presented from such
an extremely close
point of view that the
viewer has the sense
of being a member of
the orchestra. On the
stage at left the artist
places a group of six
dancers in penumbra.
Our attention is con-
centrated on the
dancer to the right,
the true focal point
of the painting. Pink
flowers stand out
against her black
hair and the sharply
illuminated outlines
of her white tutu.

EDGAR DEGAS
**The Orchestra
of the Opéra**
circa 1870
oil on canvas,
56.5 × 46.2 cm
Musée d'Orsay, Paris

In 1868 Degas meets
Désiré Dihau, bassoon-
ist with the Paris
Opéra orchestra.
When Dihau asks him
to make his portrait,
Degas first considers
presenting him alone,
but then decides to
immortalize him along
with other members
of the orchestra,
including ballerinas in
the background, their
multicolored tutus
contrasting with the
somber blacks and
whites of the musi-
cians. Besides Dihau
playing his bassoon,
Degas presents por-
traits of other real-
life members of the
orchestra, but he uses
friends for the row of
violinists to the rear.
Far in the background
to the left, almost
hidden by the harp,
is the face of the
composer Emmanuel
Chabrier.

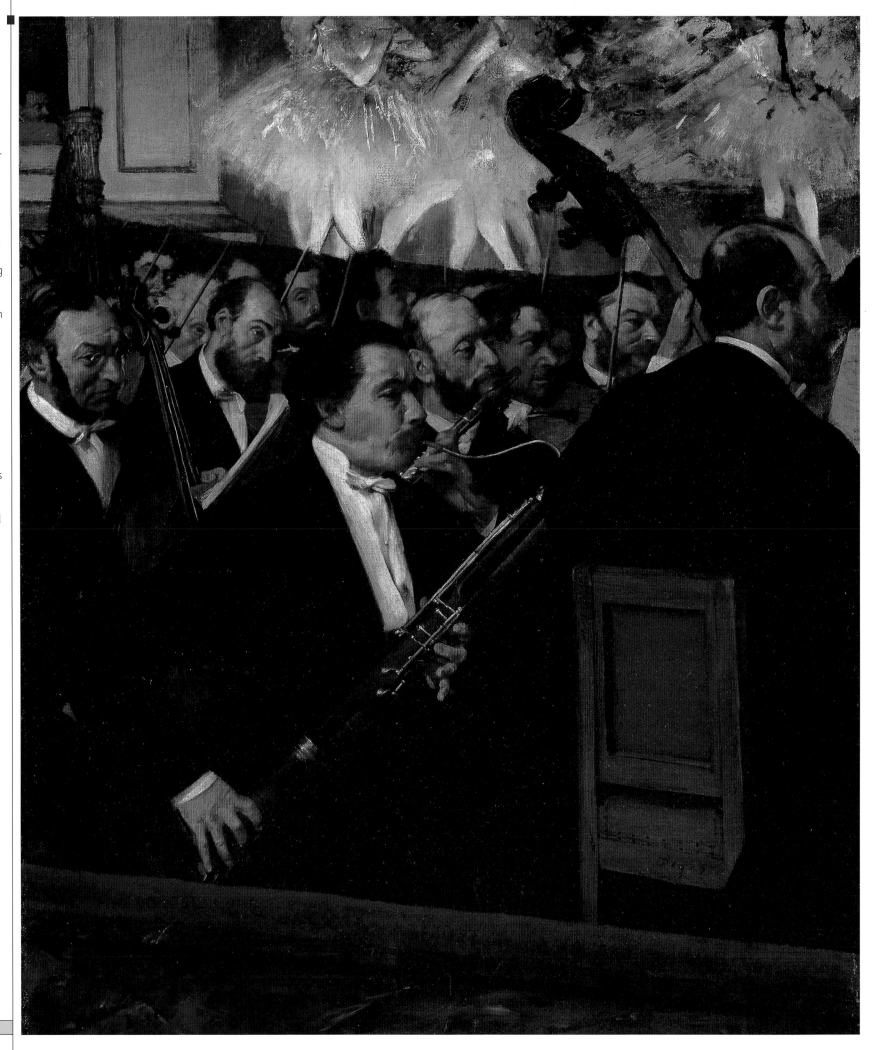

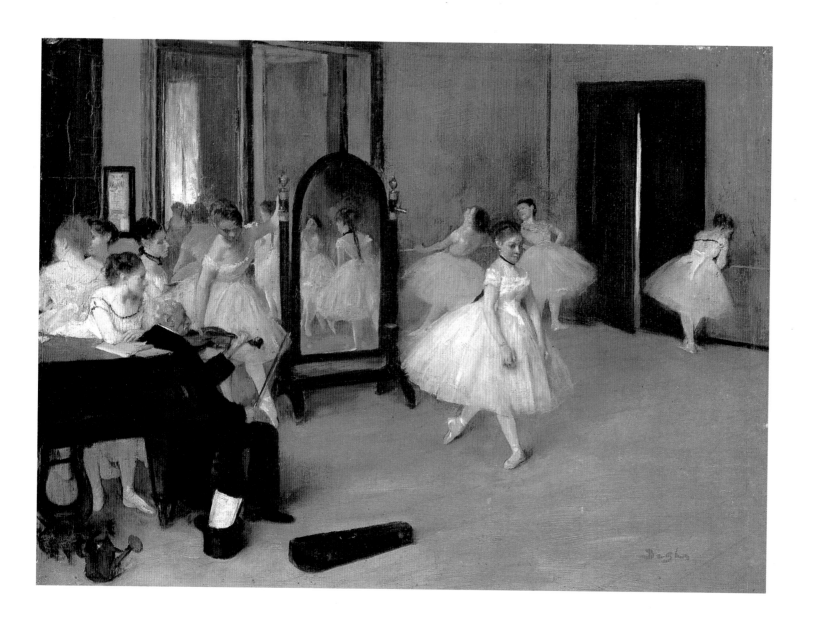

■ EDGAR DEGAS
The Dance Class
1871, oil on panel
19.7 × 27 cm
Metropolitan Museum
of Art, New York

At the outbreak of war
with Prussia, Degas
volunteers for service
in the national guard
and finds himself
under the command
of Henri Rouart, his
former school friend
from Louis-le-Grand.
The few paintings he
succeeds in making
during this period
include his first works
dedicated to balleri-
nas, a subject he will
return to with great
success in coming
years. The play of
mirrors amplifies
spaces and permits
him to alter the point
of view, to enliven
the scene, and to give
proof of his notable
stylistic virtuosity.
The aging violinist in
his black suit stands
out sharply among the
many girls dressed in
white, although he
does almost blend
into the piano.

EDGAR DEGAS
Lorenzo Pagans and Auguste De Gas
1871–72, oil
on canvas,
54 × 40 cm
Musée d'Orsay, Paris

Auguste De Gas, Edgar's father (he has split the last name in two to make it more chic), is an amateur organist and has handed on his love for music to his son. Together with Manet he organizes musical evenings during which he performs, accompanied by other musicians, many of them from the Opéra orchestra. The artist presents him, in a somewhat subordinate position, while listening to Lorenzo Pagans, a young Spanish guitarist and habitual participant at these soirées. The arrangement of the painting seems more conventional than in other works from this period, with the viewer's attention concentrated on the expressive elements of the two figures.

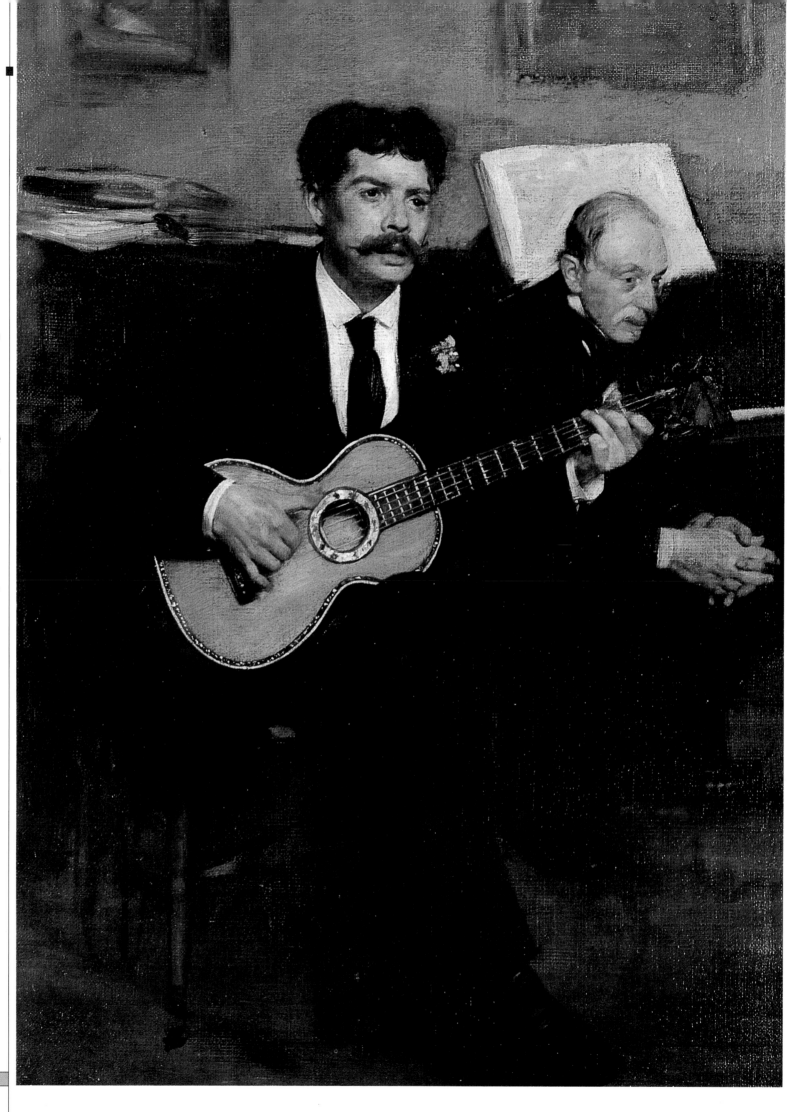

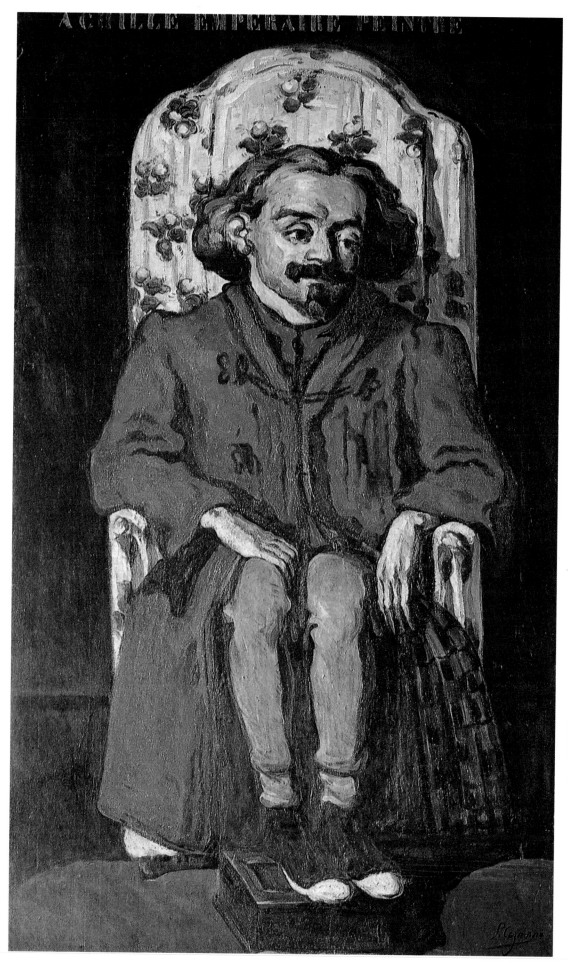

■ PAUL CÉZANNE
Portrait of Achille Emperaire
1868–70, oil
on canvas,
200 × 122 cm
Musée d'Orsay, Paris

Achille Emperaire (1829–1910) is a childhood friend of Paul Cézanne's; they went to school together in Aix-en-Provence. He too has come to Paris in the hope of making a career as a painter, but without success. Also working against him is a physical deformity: an overly large head, short body, and legs so short that Cézanne is forced to put a book under his feet to hold them up. The chair is the same as the one Cézanne used for the portrait of his father (page 81), but the lighting and colors are very different.

■ PAUL CÉZANNE
Portrait of Achille Emperaire
1868–70, charcoal
on paper,
49 × 31 cm
Musée du Louvre,
Paris

This preliminary study for the painting reveals Cézanne's extraordinary drawing skill as well as his psychological acuteness. Here, and in the painting, he makes no effort to disguise his friend's physical deformity and instead makes very much apparent his warm humanity and the uncommon nobility of his soul.

PAUL CÉZANNE
Pastoral (Idyll)
circa 1870
oil on canvas,
65 × 81 cm
Musée d'Orsay, Paris

Here is yet another
painting inspired by
Manet's *Luncheon on
the Grass* (pages
44–45). Cézanne
places himself inside
the painting: he is the
man dressed in black
at the center. The
brushstrokes are sharp
and decisive, but the
drawing is brisk and
nervous, most of all in
the rendering of the
background plants. The
dark colors still show
signs of seventeenth-
century Flemish and
Spanish masters, but
there is also some
of the sensibility of
Daumier and Courbet.
The resulting
atmosphere is far
more dreamlike than
realistic, with erotic
symbolism that is
far more conspicuous
than in Manet's
painting.

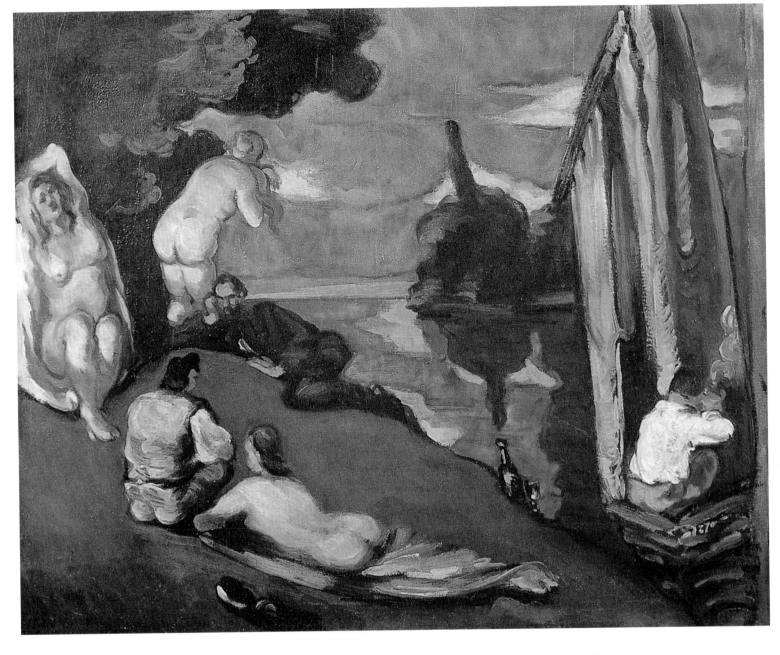

PAUL CÉZANNE
A Modern Olympia
1872, oil
on canvas,
46 × 55 cm
Musée d'Orsay, Paris

Yet another tribute to
Manet. In this case
Olympia, her servant
sweeping away her
final veil, appears
before a seated man
(Cézanne himself?)
and his small dog.

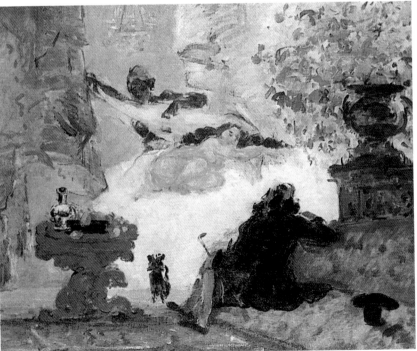

The Second Empire, the Franco-Prussian War, and the commune

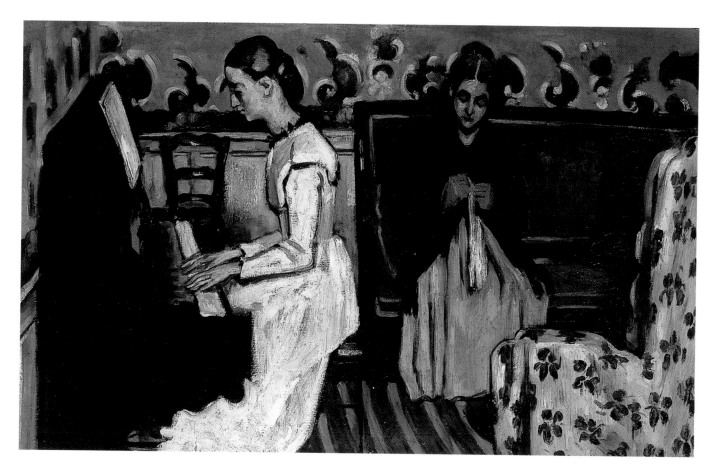

■ PAUL CÉZANNE
**Young Girl at the
Piano (Overture
to Tannhäuser)**
circa 1869,
oil on canvas,
57 × 92 cm
The Hermitage,
St. Petersburg

The girl at the piano
is probably Cézanne's
sister, Marie, born in
1841. The woman
busy sewing in the
background would then
be their mother, Anne
Elisabeth Honorine
Aubert, daughter of
a chair-maker and a
laborer in the factory
owned by Louis-
Auguste Cézanne.
These two women
encourage young
Cézanne in his
passion for painting,
interceding on his
behalf with his father.

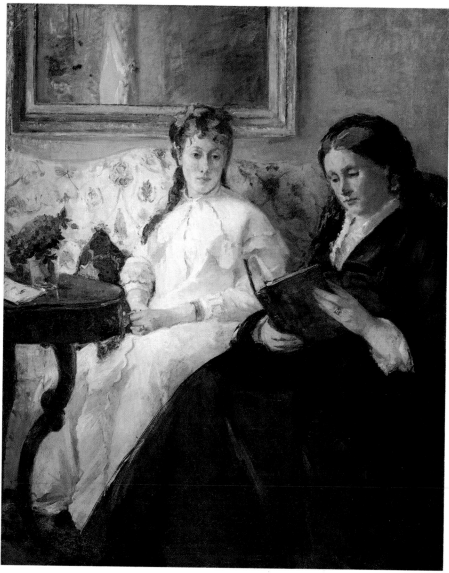

■ BERTHE MORISOT
**Reading: The Mother
and Sister Edma
of the Artist**
1870, oil on canvas,
101 × 81 cm
National Gallery of
Art, Washington. D.C.

In 1868 Morisot meets
Manet and begins an
association with the
other Impressionists,
who influence her pic-
torial style. When this
canvas, prepared for
the Salon of 1870,
is almost finished,
she asks Puvis de
Chavannes, who has
been courting her in
vain, for his advice.
He suggests several
stylistic improvements,
most of all to the
head of the mother;
most of these are made
by Manet himself. The
painting is accepted
by the Salon jury but
completely ignored
by the critics, who
perhaps discount it
because it is the work
of a woman.

1848•1871

PAUL CÉZANNE
Still Life with Green Pot and Pewter Jug
1870, oil on canvas,
63 × 80 cm
Musée d'Orsay, Paris

This is one of
Cézanne's first still
lifes, a genre that
will be of great
importance to him
in the years of his
maturity. The knife,
set down on the
shelf at an angle,
calls attention to
the depth of the
space, while the
white cloth that
occupies the middle-
ground creates a
sharp contrast to
the dark or dull
tones of the other
objects and the
background.

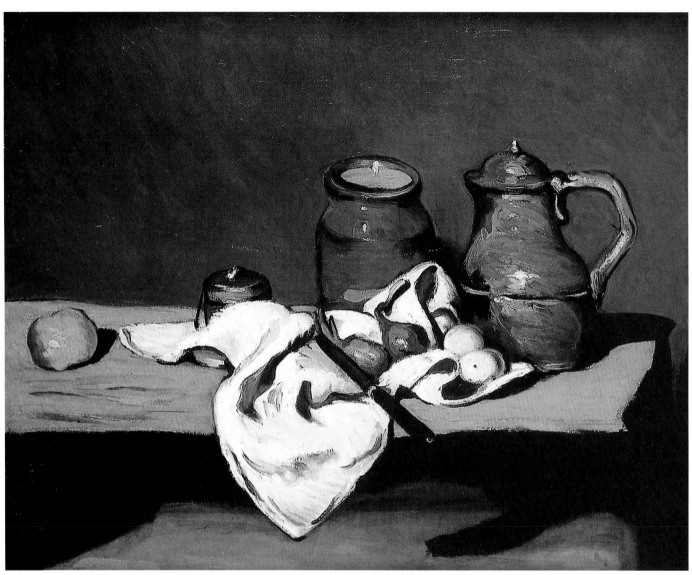

PAUL CÉZANNE
The Black Clock
1870, oil on canvas,
54 × 73 cm
Collection Stavros
Niarchos, Paris

Cézanne gets the idea
for this painting in
the home of Emile
Zola, for whom the
work is made. In it
he gives prominence
to a black marble pen-
dulum clock, strangely
without hands, which
he has saved in mem-
ory of his father. The
other objects, none
of which will ever be
repeated in a still life
by Cézanne, are prob-
ably also endowed
with special meanings
known only to the
painter and his writer
friend.

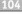

■ Paul Cézanne
**Vase, Bottle,
Cups, and Fruit**
1871, oil on canvas,
64 × 80 cm
Nationalgalerie, Berlin

In July 1870 Cézanne,
having failed to
respond to the call
to arms, finds himself
a wanted man and
must flee Paris. He
takes refuge in Aix-
en-Provence and
at Estaque, near
Marseilles. Here he
is able to continue
with his painting,
making landscapes
en plein air and still
lifes, including this
one, notable for its
muted, opaque colors,
its soft outlines, and
a luminosity that fills
the scene with an
atmosphere of silent
meditation. The depth
of the space is indi-
cated by the shadows
of the objects on the
wall and by the rela-
tionship between the
vertical lines of the
bottle and the hori-
zontal lines of the
small table.

JAMES WHISTLER
**Variations in Violet
and Green**
1871, oil on canvas,
61 × 35.5 cm
Musée d'Orsay, Paris

Whistler is born July
10, 1834, in Lowell,
Massachusetts. In
1855 he leaves the
United States for Paris,
where he takes lessons
with Charles Gleyre
and makes friends
with Degas. In 1859,
together with Fantin-
Latour and Legros, he
founds the Societé
des Trois; in 1864 and
1865 he visits Gustave
Courbet at Trouville
and assimilates some
of his pictorial real-
ism. He is close to
Baudelaire, Mallarmé,
Degas, and Manet,
with whom he com-
pletes his artistic
formation. With its
muted tones and
delicate lines, this
painting makes clear
the influence of
Oriental art on
Whistler, particularly
Japanese prints.

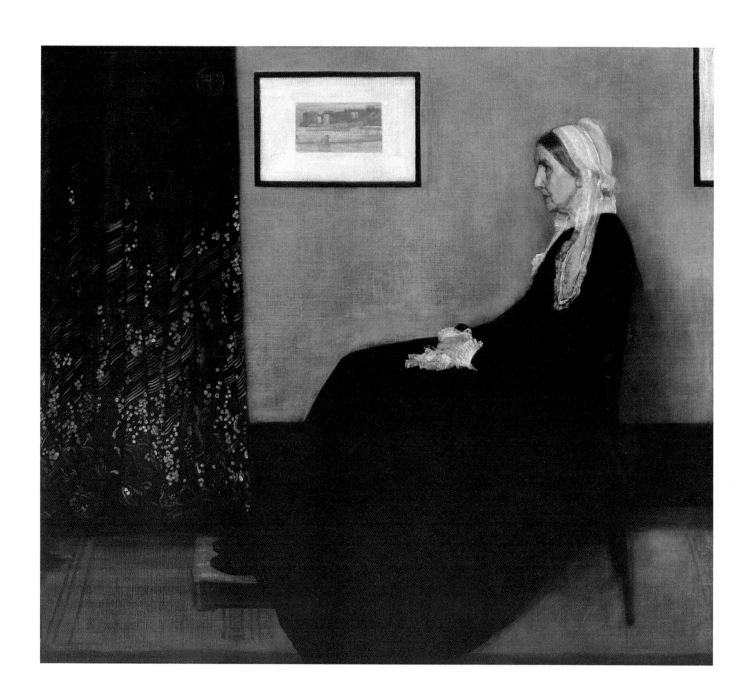

■ JAMES WHISTLER
**Arrangement in Gray
and Black No. 1
(The Artist's Mother)**
1871, oil on canvas,
144 × 162 cm
Musée d'Orsay, Paris

Whistler's mother,
Anna Matilda McNeill,
is born September 27,
1804, and dies January
31, 1881. This work is
made between August
and October of 1871
in the studio at 2,
Lindsey Row, in
London's Chelsea dis-
trict, where Whistler
moves to get away
from the war in France.
He originally wants to
present his mother
standing, but after
three days he decides
to let the elderly
woman pose in a
more comfortable
position. Even so,
the image is austere
and solemn, the
woman seated much
like a queen on her
throne. The framed
picture on the gray
wall behind her is an
etching by Whistler.

A fter being scattered far and wide by the Franco-Prussian War, the Impressionists slowly make their way back to their normal lives, including their regular meetings. On May 18, 1871, Manet finally manages to get back to Paris with his family only to find the city still in an upheaval because of the commune, and his atelier in Rue Guyot seriously damaged. He decides to head for Boulogne-sur-Mer, returning to the capital only at the end of September. He then sets up a new studio at 4, Rue de Saint Pétersbourg, and makes new paintings that he succeeds in having accepted by the Salon, among them *La Bon Bock* (page 134) and *The Railroad* (page 133). Less fortunate is Pissarro, who returns from Great Britain to find to his great distress that his home in Louveciennes, requisitioned by the Prussians, has been sacked. Of the 1,500 paintings he left there, the fruit of

from the army, has rented a room in Paris in Rue de Dragon as well as a small studio in Rue des Petits-Champs. Finally, Degas, having served in the artillery during the war and having spent the period of the Paris Commune in Normandy, spends most of 1872 in New Orleans, visiting various relatives of his mother and also his brother, Achille, who works in the cotton market. Back in Paris in April 1873, he sets up house in Rue Blanche in Montmartre and goes back to seeing his Impressionist friends at the Café Guerbois. There, in 1873, Pissarro and Monet make plans to form a cooperative association of painters based on the model on the mutual-assistance associations of workers, an association that would permit them to exhibit and sell their works without being forced to endure the decisions of the Salon jury. Over the coming months Renoir, too, supported by Pissarro, advances a similar proposal for an association to be called the Société des Irrégularistes, open not only to painters but to decorators, architects,

SOCIÉTÉ ANONYME
DES ARTISTES PEINTRES, SCULPTEURS, GRAVEURS, ETC.

PREMIÈRE

EXPOSITION
1874
35, Boulevard des Capucines, 35

CATALOGUE

Prix : 50 centimes

L'Exposition est ouverte du 15 avril au 15 mai 1874,
de 10 heures du matin à 6 h. du soir et de 8 h. à 10 heures du soir.
PRIX D'ENTRÉE : 1 FRANC

PARIS
IMPRIMERIE ALCAN-LÉVY
61, RUE DE LAFAYETTE

1874

1872•1874 The first

twenty years of work, he is able to save, thanks to the intervention of a neighbor (the town councilor Ollivon), only about forty. Adding insult to the injury is the miserly compensation he is offered for this war damage, 835 francs, against an estimated value made by the art dealer Durand-Ruel of more than 51,000 francs. Pissarro spends the summer of 1872 in Pontoise, where he paints *en plein air* together with Cézanne, who at the end of the war returned to Paris and Rue de Chevreuse, where he lives in the same house as his friend the sculptor Philippe Solari. In July 1873 Pissarro opens a studio in Paris at 21, Rue Berthe, in Montmartre. Monet, who also moved to London in 1871, has returned to France after hearing of the death of his father. Thanks to the efforts of Manet, he finds a house in Argenteuil, on the Seine, where he can dedicate himself to painting and gardening, his twin passions. His regular guests include Caillebotte and Renoir. The latter, having been discharged

The first show of the Impressionists

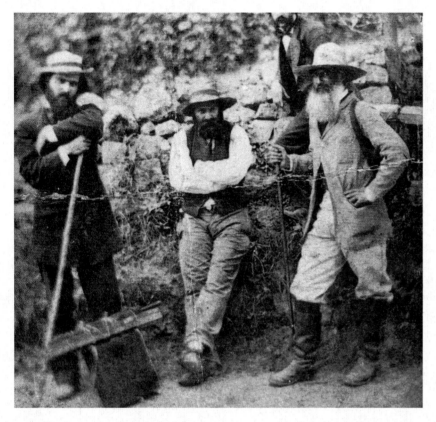

Ernest Hoschedé (1838–90), director of the Paris department store Au Gagne-Petit, are a few of their works, and they awaken a good deal of interest among collectors. For example, of the six works by Pissarro on offer, the art dealer Hagerman buys five, for a total of 1,850 francs.

The site chosen for the first Impressionist show is the studio at 35, Boulevard des Capucines, owned by Gaspar-Félix Tournachon (1820–1910), the photographer known only as Nadar. After a brief career as a caricaturist for the magazines *Le Charivari* and *Le Rire*, he has turned to photography, becoming over the period of a few years one of the best-known photographers in Paris. In 1864 he meets Bazille and begins spending time with the other painters at the Café Guerbois. At the end of 1873 he opens a new studio at 51, Rue d'Anjou, so when the associates of the new society ask if they can use the empty rooms in Boulevard des Capucines for their show, he lets them have them free of charge. The artists give thought to making up a name for their group, and among the many proposals put forward they seem most in favor of Degas's idea of calling the exhibition La Capucine ("The Nasturtium") and using the flower as their symbol. In the end, however, they can't

show of the Impressionists

and goldworkers; this is an idea whose time is to come several decades later, rediscovered by the leaders of Art Nouveau.

In the winter between 1873 and 1874 France is struck by a serious economic crisis, one result of which is that art collectors are reluctant to spend their money. The need to find new buyers makes the notion of forming an association seem far more appealing, and the idea is finally translated into reality. The society is founded on December 27, 1873. On January 17 of the next year, the magazine *Chronique des Arts* publishes the birth announcement of the Société Anonyme Coopérative d'Artistes Peintres, Sculpteurs, Graveurs et Lithographes. Its objective is to "organize open exhibitions without jury or prizes in which each member can exhibit his own creations." The first members, each paying a 60-franc fee, are Pissarro, Mattling, Rouart, Feyen-Perrin, Meyer, de Molins, Monet, Béliard, Ottin, Sisley, Degas, Morisot, Guillaumin, Lepic, Levert, and Renoir. An auction held at the Hôtel Drouot on January 13 has them convinced that the time may finally be favorable for the sale of their works. Among the paintings sold at the auction from the collection of

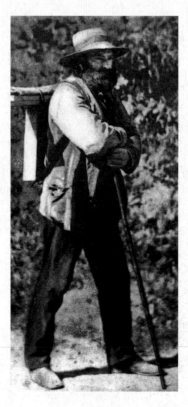

manage to agree and decide to present themselves with the neutral title of Société Anonyme. In the end, the show includes 165 works of art, including paintings, engravings, and drawings, by thirty artists (in alphabetical order): Zacharie Astruc, Antoine-Ferdinand Attendu, Edouard Béliard, Eugène Boudin, Félix Bracquemond, Emile Brandon, Pierre-Isidore Bureau, Adolphe-Félix Cals, Paul Cézanne, Gustave Colin, Louis Debras, Edgar Degas, Giuseppe De Nittis, Jean-Baptiste-Armand Guillaumin, Louis Latouche, Ludovic-Napoléon Lepic, Stanislas Lépine, Jean-Baptiste-Léopold Levert, Alfred Meyer, Auguste de Molins,

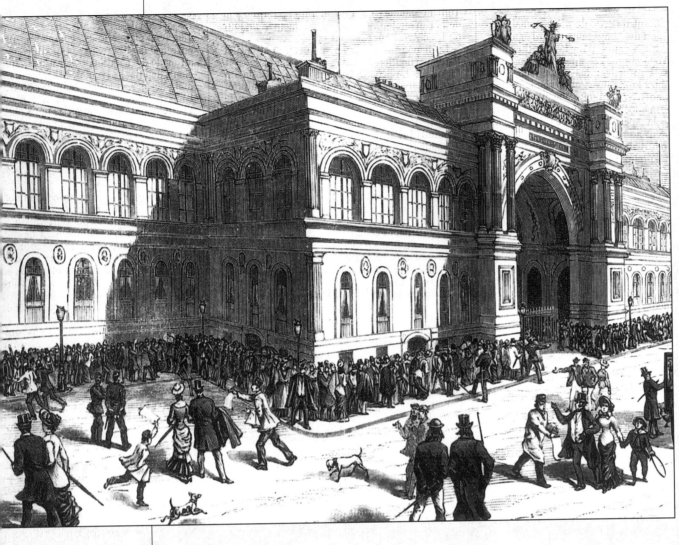

Renoir, the painter's brother, and printed by Alcan-Lévy, unfortunately in an incomplete and imprecise manner—is on sale for 50 centimes. The Parisian press dedicates no more than fifteen articles to the show, nothing in comparison to the lengthy, highly detailed reports it lavishes on the works exhibited at the Salon. Many critics simply refuse to acknowledge it, considering it a show of amateurs. The most important and famous among the articles published is that by Louis Leroy in *Le Charivari* on April 25. In it, the critic imagines paying a visit to the show in the company of a painter friend, a certain Joseph Vincent. The latter, a personification of the most reactionary mentality, lets himself go in searing criticism of the works on display, to which the journalist replies with his own opinions, efforts to bring to light the positive aspects of this new way of painting. The importance of the article is that Leroy uses the word *Impressionists* in its title, taking it from one of the paintings by Monet, *Impression: Sunrise*. This use leads to the word being applied to the style of painting and to the painters themselves. Although the artists are not pleased with the definition, which they find simplistic and belittling, the term catches on and

Nadar's studio in the Boulevard des Capucines.

Claude Monet, Berthe Morisot, Emilien Mulot-Durivage, Auguste-Louis-Marie Ottin, Léon Auguste Ottin, Camille Pissarro, Pierre-Auguste Renoir, Léon-Paul Robert, Henri Rouart, and Alfred Sisley. Other artists are invited but find various reasons to refuse, in particular Corot, Jongkind, Tissot, Legros, and most of all Manet. Unlike his colleagues, Manet is doing quite well financially and has no pressing need of new buyers; furthermore, despite the rejections and humiliations he has suffered, he still nurtures high regard for the official art of the Ecole and fears that participation in the Impressionists' show could cut off his access to the Salon. The show begins on April 15, 1874, fifteen days before the opening of the Salon to make certain no one thinks the paintings on display have been rejected by the Salon jury. The paintings are presented in a series of spacious rooms on two floors, the walls of the rooms a dark red, the rooms illuminated by large windows. To determine the placement of the individual works, they are divided into groups on the basis of measurement, and then the artists draw lots to avoid the disputes and rancor that always precede the opening of the Salon. The show runs until May 15 and is open every day, from ten to six and, in an unusual and innovative decision for the time, from eight to ten in the evening. Entrance is one franc and the catalog—edited by Edmond

is repeated by other critics, such as Jules Castagnary, who writes that "They are Impressionists in the sense that they render not the landscape but the sensation produced by the landscape." Within a few months the name has been unanimously accepted, and with it Impressionism officially comes into existence.

Not all of the reviews of the first show are biased and hostile. Writing in *La République Française* on April 16, Philippe Burty (1830–90) praises the artists' "good intentions" and expresses the hope that the show "will be crowned with a frank success and that a second exhibition will be organized next autumn." Ernest d'Hervilly in *Le Rappel* of April 17 confesses he felt "satisfied, in visiting the rooms of the exhibition, to see on those walls, well lit and at the proper height, works that were appealing and never banal." Almost all the other judgments,

however, are savagely negative, sometimes ironic, often sarcastic, at times almost insulting, such as those of Jean Prouvaire in *Le Rappel* on April 20, Marc de Montifaud in *L'Artiste* on May 1, Ernest Chesneau in *Paris-Journal* on May 7. Emile Cardon in *La Presse* of April 29 writes: "When the subject is the human body their painting is something else altogether. Their aim is no longer that of rendering the shapes, the model, the expression; to them it is enough to give an *impression*, without precise lines, without colors, without either shadows or light. Following such an extraordinary theory makes them fall into a senseless mess, inane, grotesque, fortunately without precedent in art since it is no

more than the negation of the most elementary rules of design and painting. The drawing of a child has a certain naïveté and sincerity that make us smile; the depravations of this school are nauseating and revolting. At the famous Salon des Refusés, which cannot be recalled without bursting into laughter, one saw girls with skin the color of Spanish tobacco riding yellow horses through forests of blue trees; and yet that show was a Louvre in comparison to the exhibition at the Boulevard des Capucines. Looking at the works on display one asks if this is an unseemly deception of the public or the result of some mental derangement, which we cannot help but deplore."

Over the course of the four weeks the show is open, it has 3,500 visitors (175 on its opening day and 54 the last day), truly trifling numbers if one compares them to the Salon of the same year, which gets 30,000 visitors on the Sunday it opens and overall attracts more than 400,000 visitors in the six weeks it is open. From an economic point of view, the results are also quite modest; sales are few despite the inviting prices. *Fishmonger at Fontarabie* by Colin is offered for 2,500 francs; De Nittis asks 2,000 francs for his

NOUVELLE ÉCOLE. — PEINTURE INDÉPENDANTE.
Indépendante de leur volonté. Espérons-le pour eux.

View of Vesuvius; Brandon wants 1,500 francs for *The First Reading of the Law*. Sisley accepts 1,000 francs for *The Seine at Port-Marly*, the same price Pissarro takes for *The Orchard*; Guillaumin asks 300 francs for *The Evening*, and Berthe Morisot 800 francs for *The Cradle* (page 140). Count Doria, one of the few buyers, pays 200 francs for *The House of the Hanged Man* by Cézanne, and Monet asks 1,000 francs for his *Impression: Sunrise* (put on the market today it would go for $100 million). The general expenses (setting up, lights, posters, guards, insurance, salaries, and so on) amount to 9,272 francs. The earnings, composed of the entrance fees, catalog sales, and a 10 percent commission on the sale of paintings, total 10,221 francs. Nearly all the participants are unhappy with the poor results, some even beginning to regret not having stuck to the traditional route of the Salon. The associates made a vain attempt to set up a second show in the fall. In the end, however, even the most optimistic among them has to give in to the evidence. On December 17, 1874, a general assembly is held in Renoir's house and the decision is made, by majority vote, to dissolve the society.

One of the many spoofs made of the Impressionists: "New school—independent painting. Independent from their will. At least let's hope so!"

Cartoon by Cham making fun of the Impressionists: the Turks use their paintings to scare off enemies.

The warehouse of "rejects" from a Salon in the early 1870s.

The first show of the Impressionists

PIERRE-AUGUSTE
RENOIR
Monet Reading
1872, oil on canvas,
61 × 50 cm
Musée Marmottan,
Paris

During the summer of
1872 Renoir is the
guest of Claude Monet
at Argenteuil. In this
particularly well done
portrait, he presents
his painter friend
not in any conven-
tional pose but in a
completely natural
moment, while reading
a newspaper. The scene
is presented from quite
nearby, making it feel
even more intimate
and colloquial. The
light is diffused, the
paint is applied with
even brushstrokes.
The only concession
to artistic virtuosity
is the smoke from the
pipe, which spirals
up to form elegant
arabesques against
the room's neutral
background.

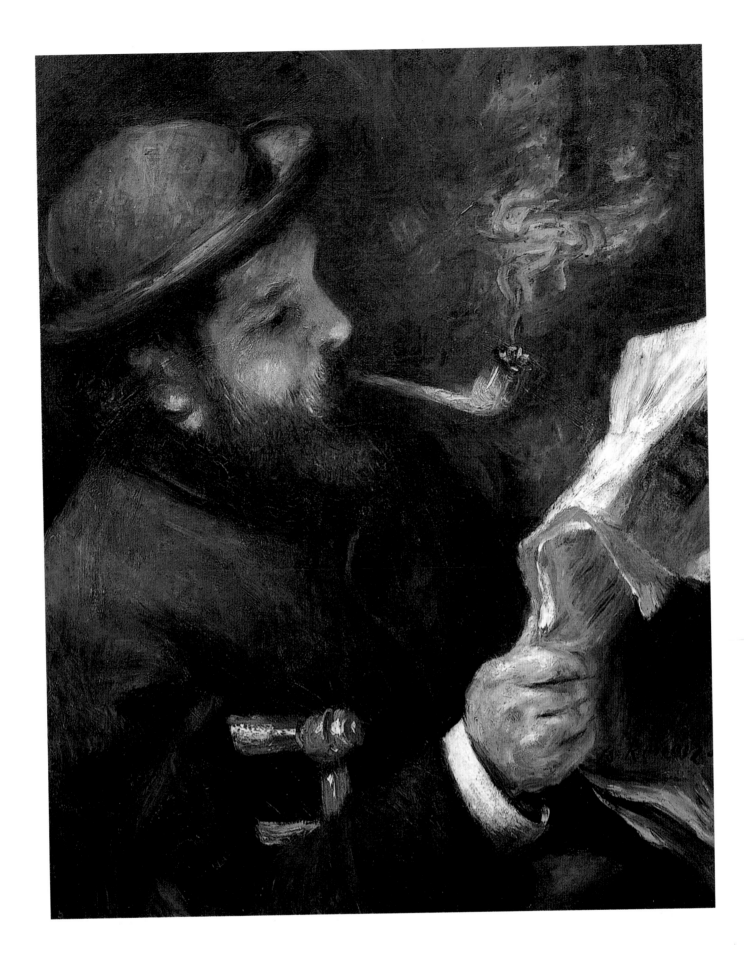

1872•1874

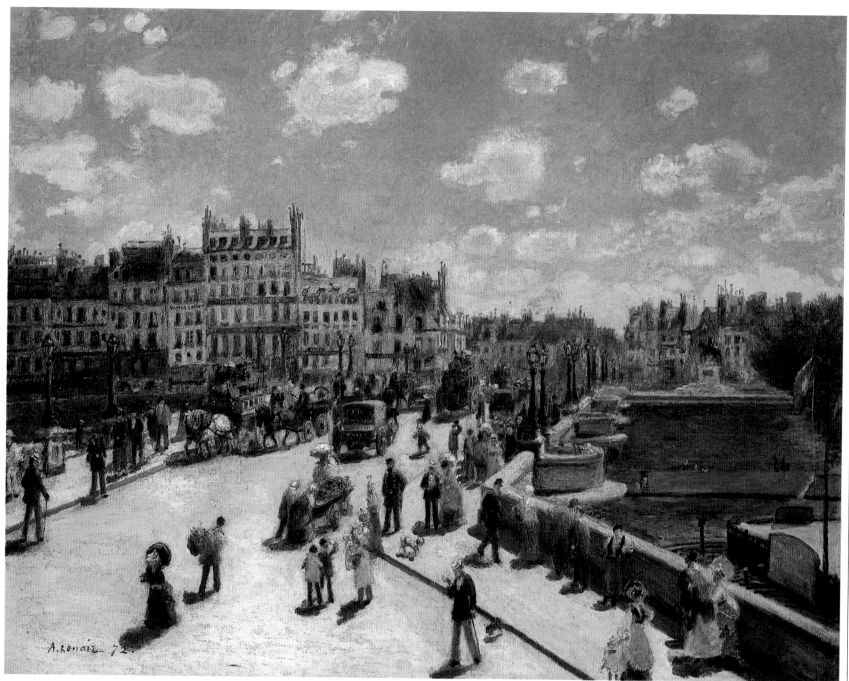

A. Renoir 72

■ PIERRE-AUGUSTE
RENOIR
The Pont Neuf
1872, oil on canvas,
75 × 94 cm
National Gallery of
Art, Washington, D.C.

According to a report
from John Rewald,
Renoir makes this
splendid view of Paris
from a window on the
second floor of a café
where he has found he
can paint for merely
ten centimes, that
being the price of two
coffees. His brother
Edmond uses various
excuses to make
passersby pause long
enough for Renoir to
quickly sketch in their
figures. The wall of
buildings becomes
nothing more than a
stage setting for the
comings and goings
of the pedestrians,
on whom the painter
concentrates his
attention. With a few,
astute brushstrokes
he transforms their
faces and clothes into
moving spots of pure
light embellished by
the pale, bright light
from above.

Renoir displays six
paintings at the show
in Nadar's space and
in the end is among
the lucky few since he
actually sells half of
them, including this
one, bought by the art
dealer "Père" Martin.
Renoir's younger
brother Edmond poses
as the gentleman,
aiming his opera glass
toward the spectators,
perhaps searching for
a familiar face. The
woman is Nini Lopez,
Renoir's new model.
Having put down her
opera glass she offers
herself, with a touch
of flirtatiousness, to
the view of others.
Worth noting is the
detail of the flowers
on her dress, a small
but marvelous frag-
ment of "still life."

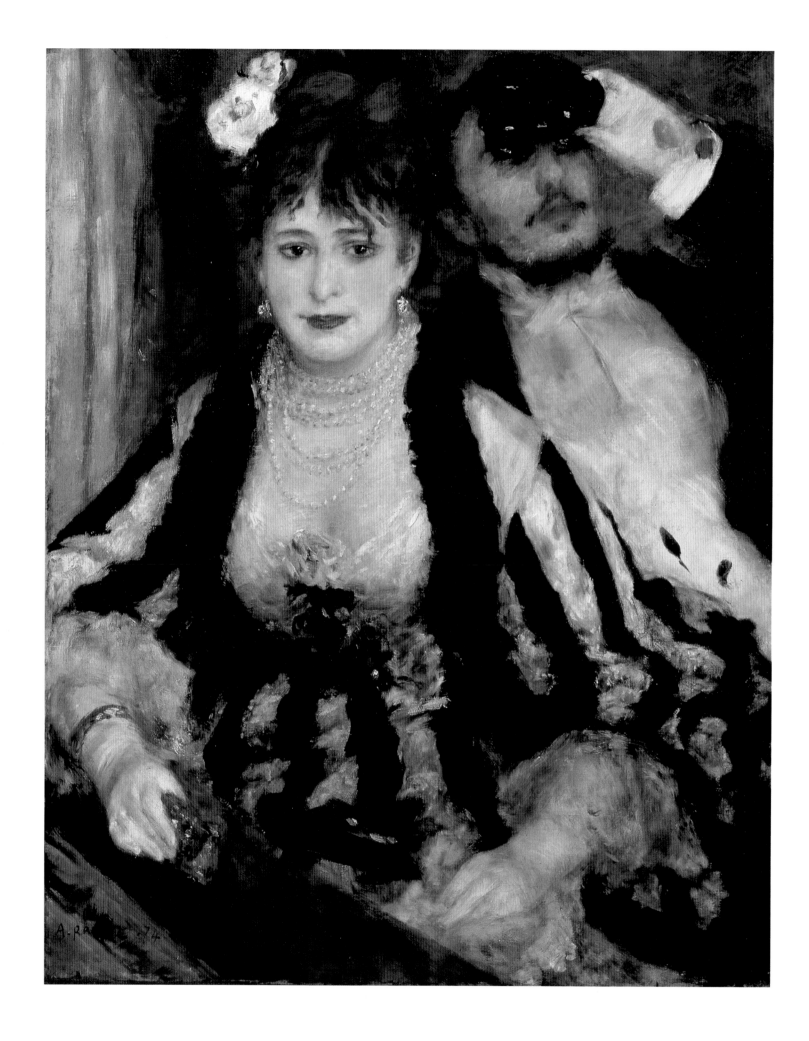

The first show of the Impressionists

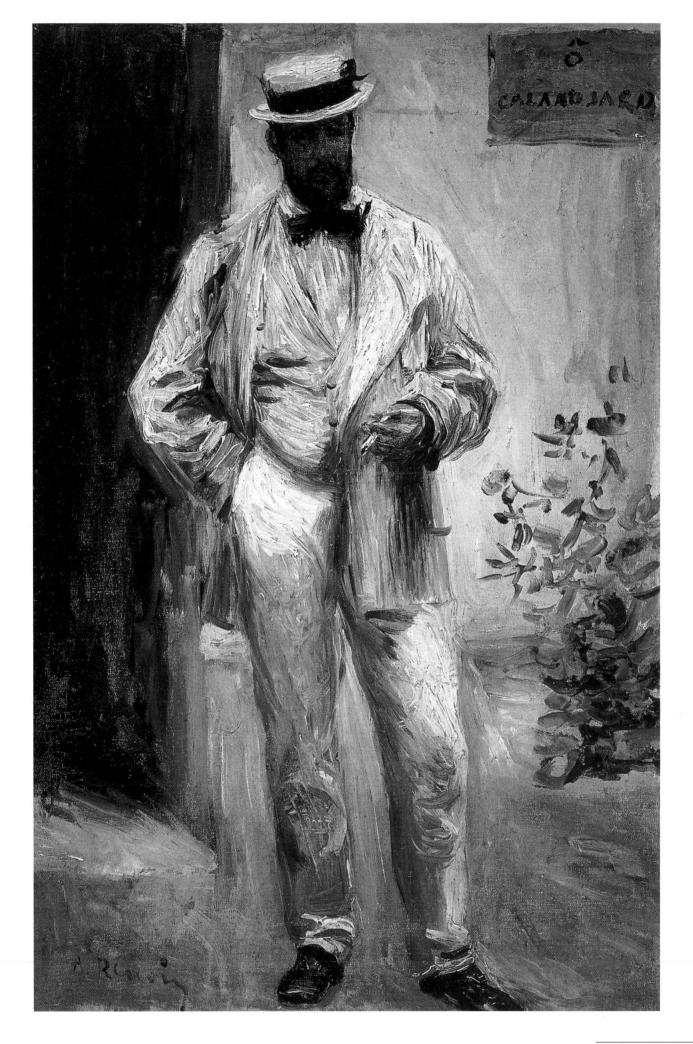

PIERRE-AUGUSTE
RENOIR
**Charles Le Coeur
in His Garden**
1874, oil on canvas,
42 × 30 cm
Musée d'Orsay, Paris

To the right above is
the dedication: *Ô
Galand Jard* ("To the
Gallant Gardener").
In 1865 Renoir
becomes friends with
the painter Jules Le
Coeur and his brother
Charles. The latter is
an architect, and in
1868 he gets Renoir
the commission to
make two large deco-
rative panels that he
has designed for the
home of Prince
Bibesco. Renoir is
often a guest at Le
Coeur's country home
over the years until
the friendship comes
to a sudden end in
1874: a love letter
addressed to the
painter by Marie,
adolescent daughter
of Charles, has been
intercepted by Jules.

CLAUDE MONET
Impression: Sunrise
1872–73, oil
on canvas,
48 × 63 cm
Musée Marmottan,
Paris

Monet begins this
painting in 1872
(the date beside the
signature at bottom
left) but finishes it
the next year. Its
fame has come to far
outstrip its objective
merits thanks to the
critic Louis Leroy, who
visits the show in
Nadar's studio in Boule-
vard des Capucines and
then writes a review
of it for the April 25,
1874, edition of *Le
Charivari*. He titles his
review "Exhibition of
the Impressionists."
Monet distributes the
brushstrokes with
extreme freedom, cre-
ating highly evocative
effects that awaken
the imagination and
poetic sensitivity of
the viewer. In the
fourth edition of his
*History of Impression-
ism* (1980) John
Rewald advances
the theory that this
painting, which origi-
nally belonged to the
collection of Georges
de Bellio and is today
in the Marmottan
Museum in Paris, is
not the work exhibited
in 1874 but instead
another version, the
one listed in the
catalog of the fourth
Impressionist show,
in 1879 as "Effect de
brouillard, impression,
owned by M. de
Bellio."

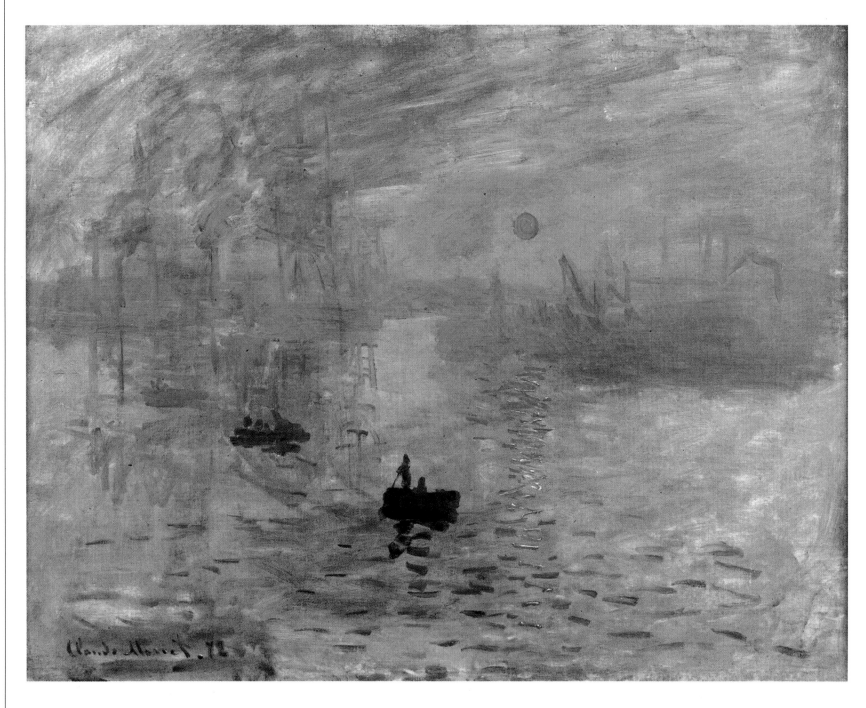

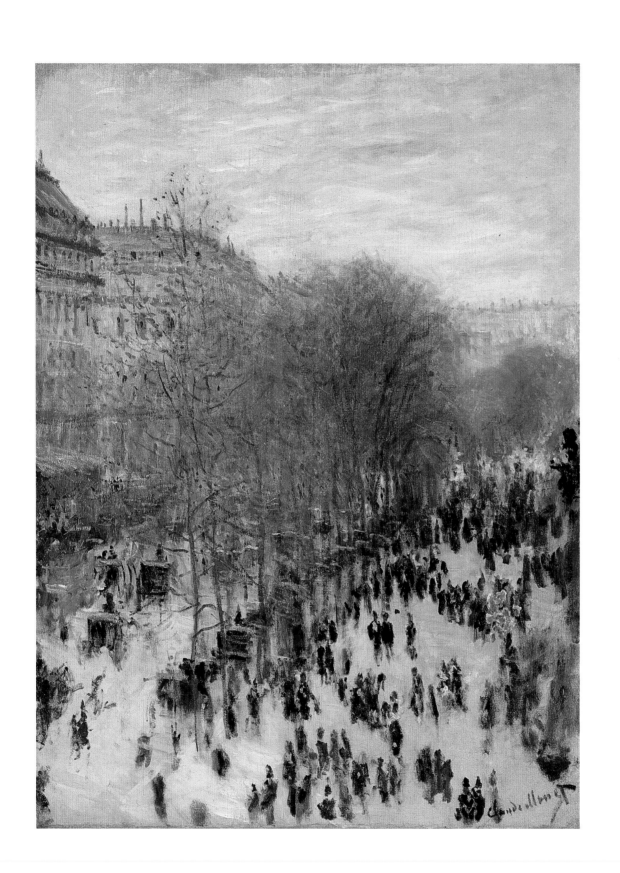

■ CLAUDE MONET
Boulevard des Capucines
1873, oil on canvas, 80 × 60 cm
The Nelson-Atkins Museum of Art, Kansas City

Monet presents nine works at the first Impressionist show: four pastel drawings and five paintings. In addition to this painting he shows *Impression: Sunrise* (opposite), *Field of Poppies, Argenteuil* (page 118), *Le Déjeuner*, and *Le Havre: Fishing Boats*. He uses rapid touches of the brush to indicate the tiny figures that crowd the broad avenue, seeking to visually recreate the sense of movement and the atmosphere of excited frenzy in the city. He seems to have meant to contrast this with the *Field of Poppies*, which presents the peace and quiet of life in the countryside in contact with nature.

CLAUDE MONET
**Field of Poppies,
Argenteuil**
1873, oil on canvas,
50 × 65 cm
Musée d'Orsay, Paris

In 1873 Monet goes
to Argenteuil, a small
village on the Seine
just outside of Paris.
In this painting he
reveals the spontane-
ity and freshness of
his artistic talent. His
models are his wife,
Camille, and their son
Jean, both of whom
he presents twice,
almost completely
immersed in the vast
field of poppies. The
features of their faces
are not defined and
seem confused, not
unlike the flowers,
which exist as little
more than reddish
smudges. The center
of the composition
is the house in the
background, surround-
ed by the dark green
shapes of trees and
dominated by white
clouds crossing a
blue sky.

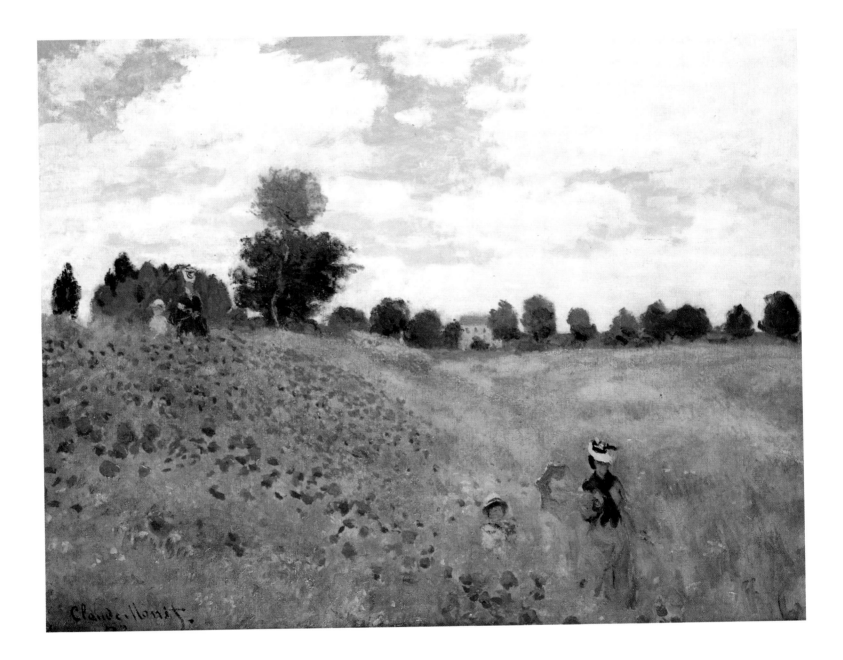

The first show of the Impressionists

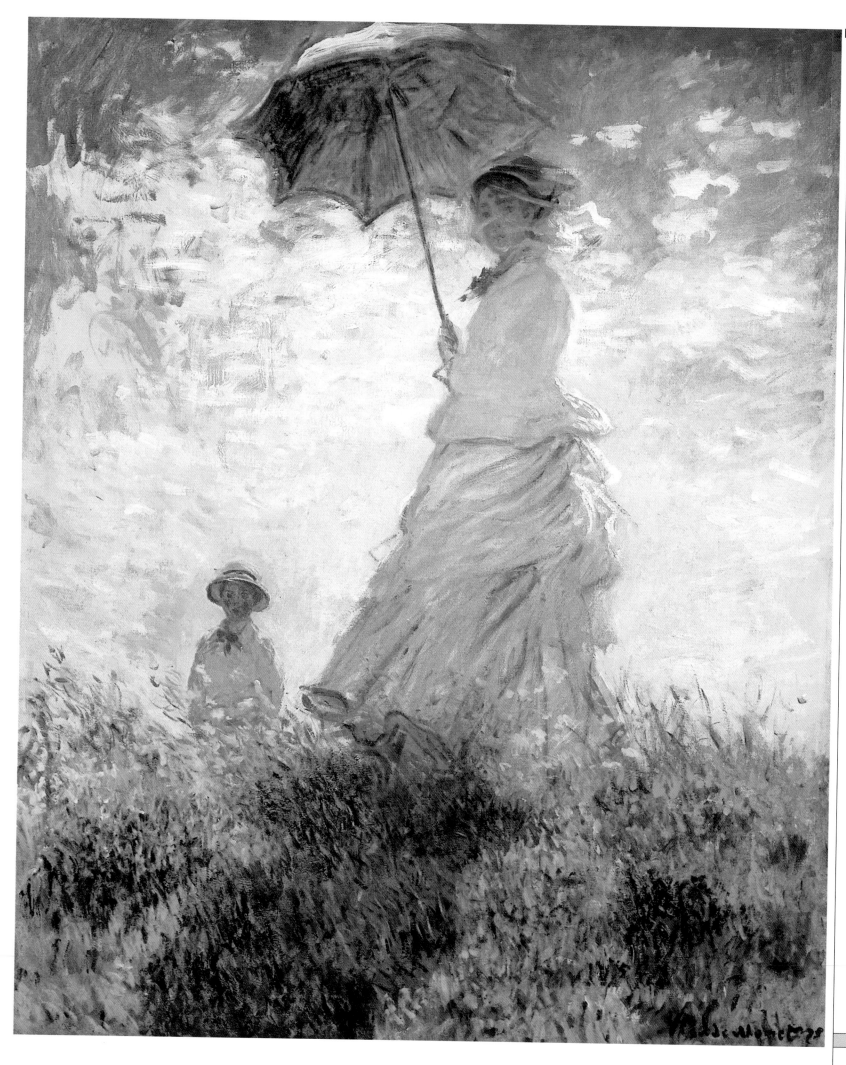

■ CLAUDE MONET
Woman with a Parasol—Madame Monet and Her Son
1873, oil on canvas,
100 × 81 cm
National Gallery of
Art, Washington, D.C.

By presenting the
scene from a very low
point of view, Monet
gives the two figures,
his son Jean and his
wife, Camille, a solemn
and statuelike
grandeur. The rapid,
nervous brushstrokes
perfectly render the
idea of wind moving
the grass, agitating
the clouds, lifting the
white skirt of the
woman's outfit. Unlike
the *Field of Poppies*,
here the features of
the two people are
well defined; they
direct their gazes at
the viewer, almost as
though trying to initi-
ate a silent dialogue.

CLAUDE MONET
**Railway Bridge
at Argenteuil**
1873, oil on canvas,
54 × 71 cm
Musée d'Orsay, Paris

The absolute protago-
nist of this painting
is the railroad bridge
over the Seine near
Asnières. Because the
point of view is so
very low, the viewer
cannot really see the
train on the bridge,
only the very tops of
a few cars and the
thick cloud from the
locomotive's smoke-
stack. The sky seems
almost serene, but
the colors of the water
and the vegetation
are dark, with large
areas in shadow.

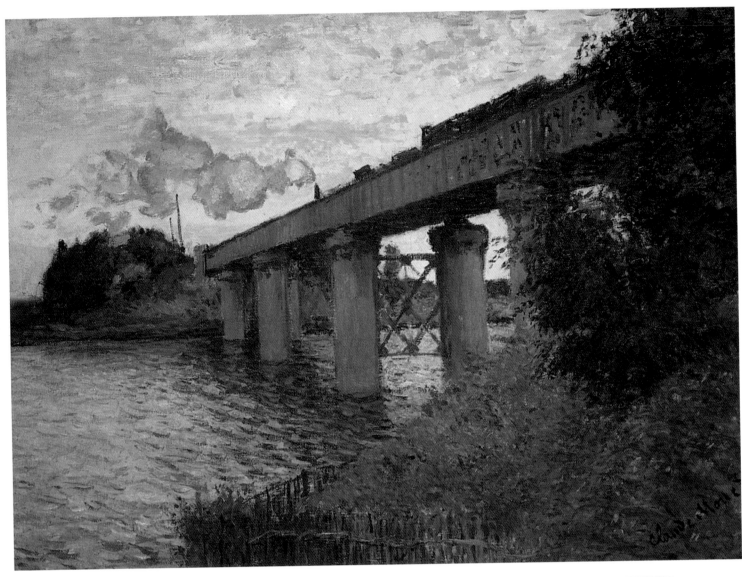

CLAUDE MONET
**Highway Bridge
at Argenteuil**
1874, oil
on canvas,
60 × 79.7 cm
National Gallery of
Art, Washington, D.C.

When not working in
his garden, Monet
spends many hours,
alone or with his wife,
on his "bateau-atelier,"
his floating studio,
from which he makes
dozens of river views.
The perspective from
which the bridge is
presented, with the
figures of people
quickly sketched in
along the side, gives
depth to the scene
and also encloses it
like a stage curtain.

1872•1874

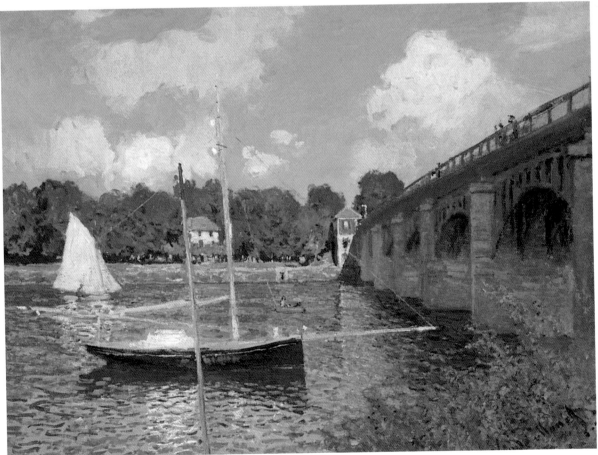

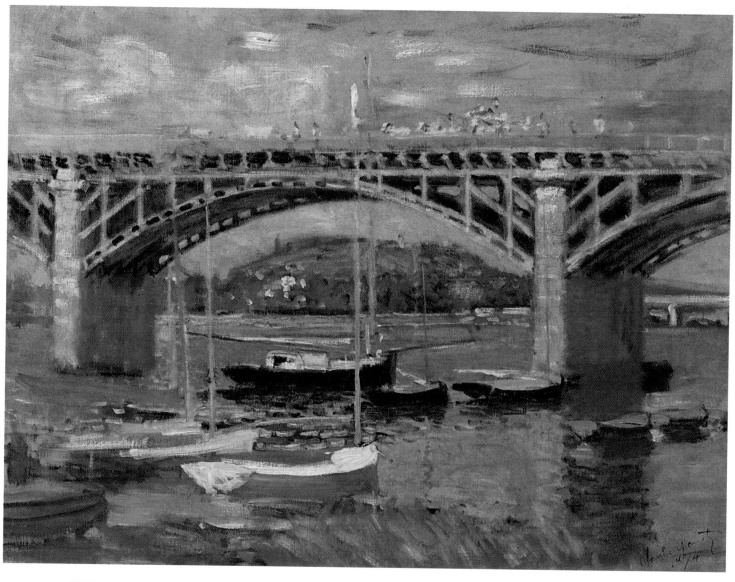

■ CLAUDE MONET
**The Bridge
at Argenteuil**
1874, oil on canvas,
60 × 81.3 cm
Neue Pinakothek,
Munich

Unlike the other works
on these two pages,
this painting presents
a bridge from the side,
facing the viewer and
thus accentuating the
horizontal line; Monet
compensates for this
in part with the pair
of pylons, and in part
with the masts of
the boats. The brush-
strokes, most of all
in the sky, are more
rapid and irregular; in
the same way the out-
lines of the boats are
summary, as though
this were a sketch or
preparatory study.

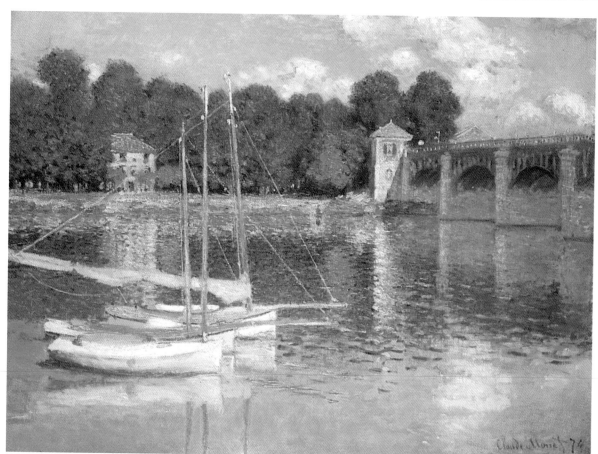

■ CLAUDE MONET
**The Bridge
at Argenteuil**
1874, oil
on canvas,
60 × 80 cm
Musée d'Orsay, Paris

This river view is
similar to the one on
the opposite page,
although the point of
view has been shifted.
The painter gives
importance to the
reflections on the
water of the boats and
the clouds, and the
entire composition is
dominated by a warm
luminosity. The masts
of the boats repeat
the verticality of the
bridge pylons and
are opposed by the
horizontal weight of
the row of trees on
the far shore.

EDGAR DEGAS
**Dance Class
at the Opéra**
1872, oil on canvas,
32 × 46 cm
Musée d'Orsay, Paris

Edgar Degas is a
devoted fan of the
musicians and balleri-
nas of the Opéra and
loves to portray them,
not only while per-
forming in the theater,
but even more while
they are practicing or
in the dressing room
changing. Here the
ballerina to the left
has just finished an
exercise, the violinist
has lowered his bow,
the dance master,
standing to the right
with one hand on
his cane, gives the
dancer instructions.
Some of her compan-
ions watch while
others go through
their exercises. The
large mirror multiplies
their images and
amplifies the space,
as does the half-open
door to the left.

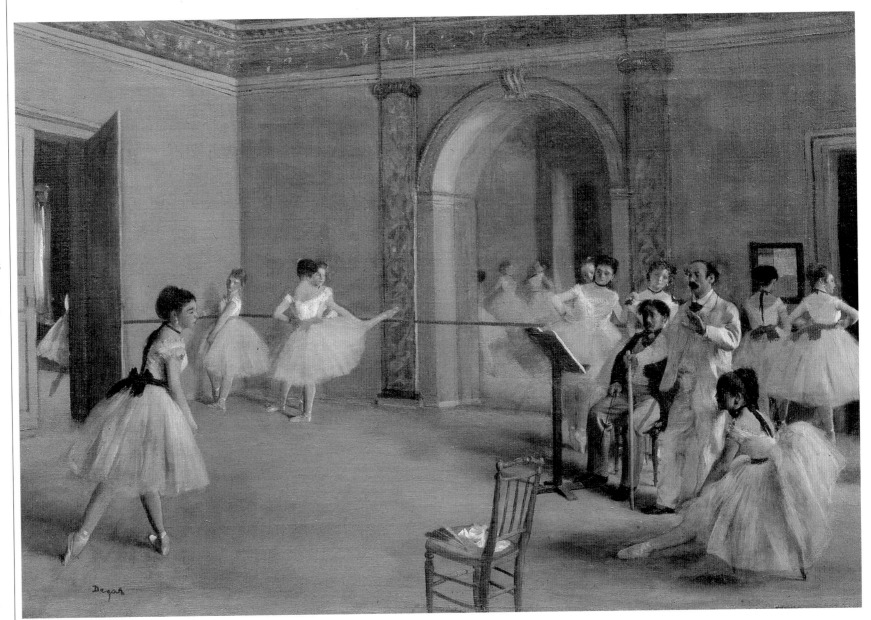

The first show of the Impressionists

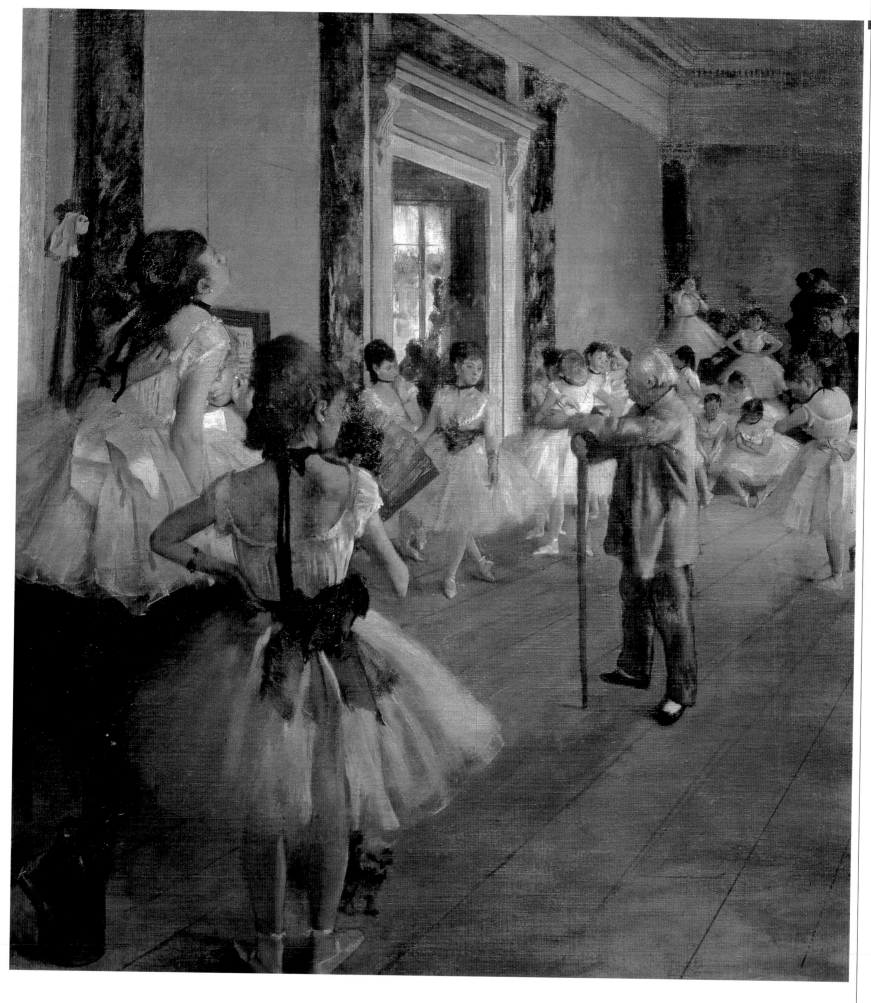

■ EDGAR DEGAS
The Dance Class
1873, oil on canvas,
85 × 75 cm
Musée d'Orsay, Paris

The scene is similar to that on the opposite page, although the arrangement of the dancers and the point of view are different. At the center of the painting is the dance master, leaning solidly on his cane. The ballerinas are around him, more or less attentive to him. The artist presents their various attitudes and gestures with a sharp eye for character, such as the girl to the left, seated atop the piano, scratching her back, or the girl near the center who, with a touch of flirtatiousness, adjusts the red ribbon in her hair.

EDGAR DEGAS
The Pedicure
1873, essence on
paper mounted
on canvas,
61 × 46 cm
Musée d'Orsay, Paris

Degas observes
everyday reality with
extreme sensitivity.
In his compositions
even the most appar-
ently commonplace
gesture acquires a
singular poetic sweet-
ness and a colloquial
intimacy of extraordi-
nary power. The set-
ting, so very humble
and simple, serves to
indicate that this is
a completely normal
situation. We are
worlds away from the
grandiose historical
evocations or the
mythological allegories
that triumph on the
walls of the Salon.
The use of essence
on paper permits the
artist to tone down
the light and to give
the colors even more
veiled and harmonious
shadings.

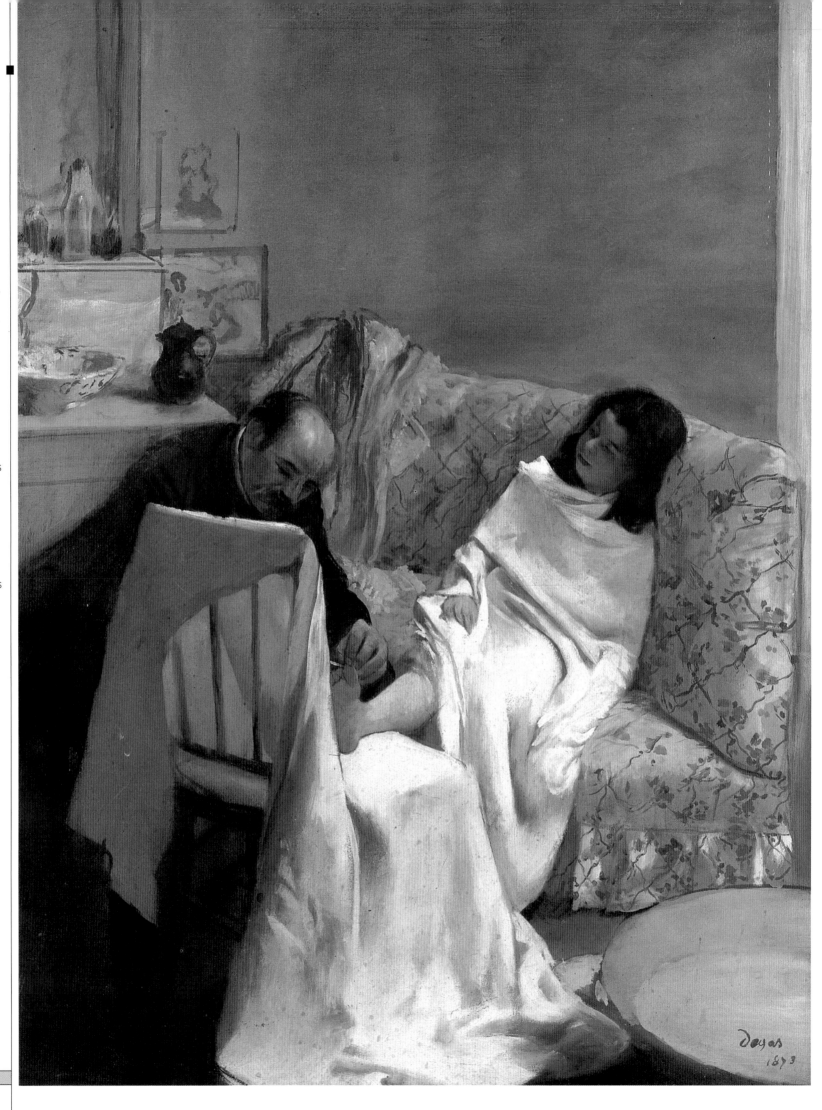

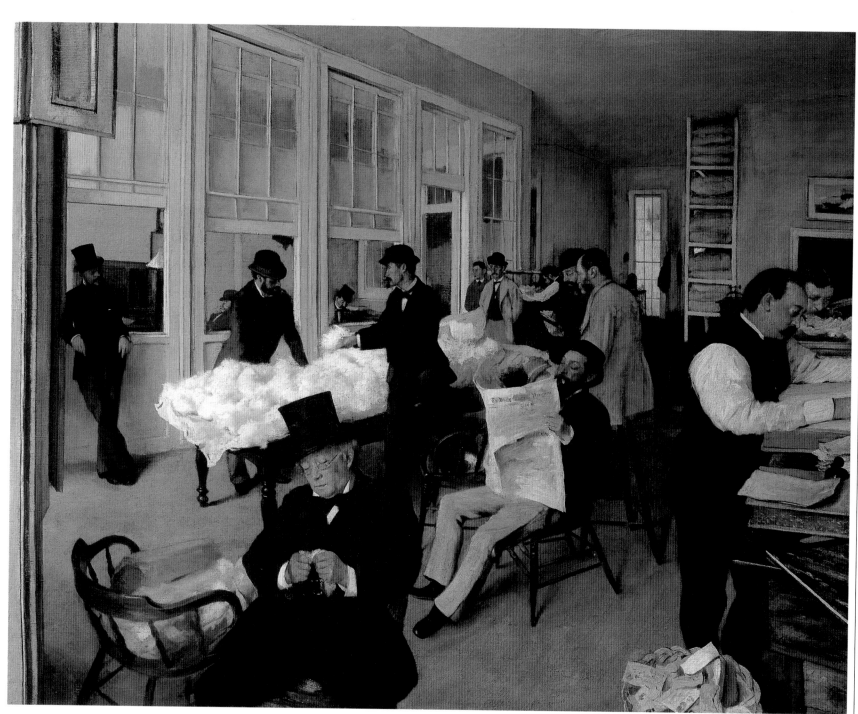

■ EDGAR DEGAS
**Portraits in an Office
(New Orleans)**
1873, oil on canvas,
73 × 92 cm
Musée des Beaux-Arts,
Pau

This is the most
famous of the paint-
ings Degas makes in
New Orleans. Seated
in the foreground is
Michel Musson, the
artist's uncle; to the
right, the cashier
Livandais leans on his
ledger books. Degas's
brother René is seated
at the center, reading
a copy of the *Times
Picayune*; his other
brother Achille is
standing off to the
left, leaning against
a window. The associ-
ate James Prestidge is
behind René, seated
on a stool while talk-
ing to a client. Seated
on the edge of the
table, gathering up
some cotton in his
hand to show it to
another client, is
William Bell, husband
of Mathilde Musson,
Michel's daughter,
and thus a cousin
of the artist.

PAUL CÉZANNE
Self-Portrait
1872–76, oil
on canvas,
64 × 52 cm
Musée d'Orsay, Paris

After the birth of his
son Paul, on January
4, 1872, Cézanne goes
to Pontoise, where he
finds Pissarro. The
two paint landscapes
together in the open
air in the nearby town
of Auvers-sur-Oise.
"We were always
together," recalls
Pissarro, "but what
cannot be denied is
that each of us kept
to the only thing that
counts: the unique
sensation." This is a
particularly important
period in Cézanne's
life because it marks
the attainment of his
mature style, permit-
ting him full use of
his expressive powers.

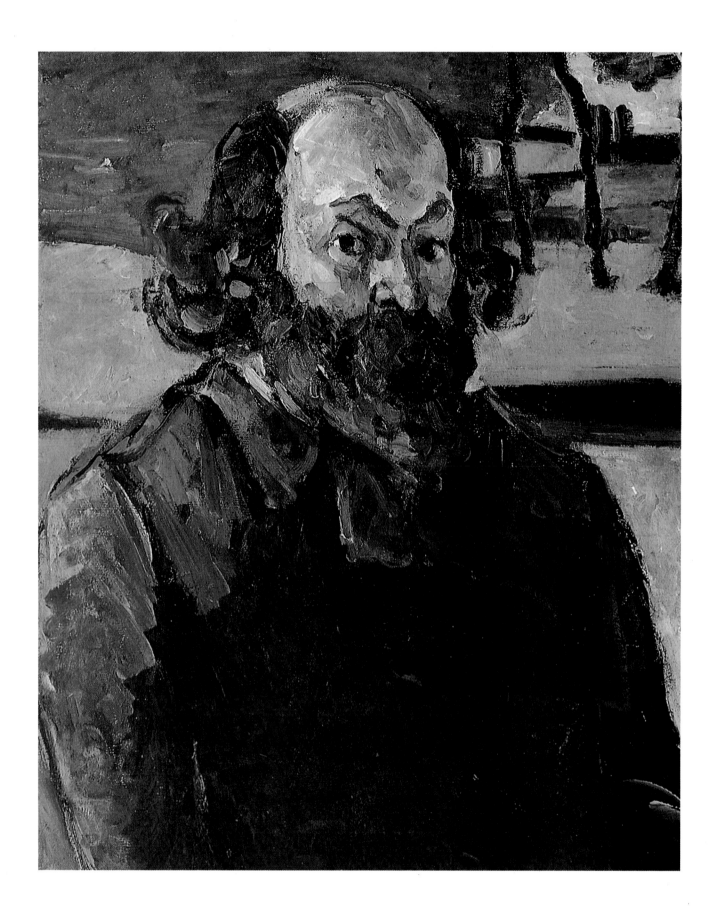

The first show of the Impressionists

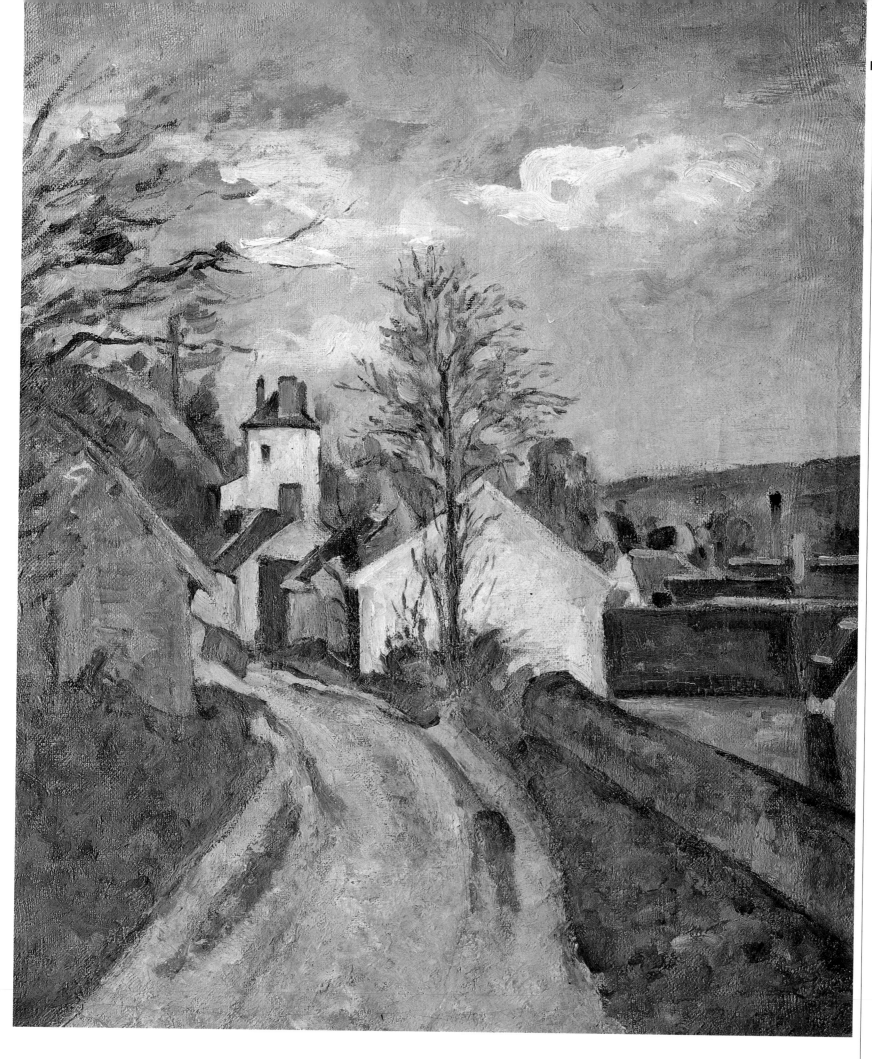

■ PAUL CÉZANNE
The House of Dr. Gachet at Auvers
1873, oil on canvas,
46 × 37.5 cm
Musée d'Orsay, Paris

Early in 1873 Cézanne goes to live in Auvers, near the home of Paul Gachet (1828–1909). A doctor specialized in homeopathy and psychiatry, Gachet loves art and is a friend to the artists who frequent the Café Guerbois. He has set up a studio in his home in Auvers where he makes engravings by way of a hobby. As an art collector he encourages Cézanne to paint landscapes *en plein air* and teaches him the technique of engraving, loaning him his tools so he can make an etching. In this same home the doctor will later be host to Vincent van Gogh, shortly before his suicide.

PAUL CÉZANNE
Dahlias
circa 1873, oil
on canvas,
73 × 54 cm
Musée d'Orsay, Paris

Together with his
abundant production
of landscapes, Cézanne
explores the genre of
the still life, in partic-
ular those with floral
subjects. In them he
reveals the influence
of Pissarro and shows
that he has come into
possession of the
palette of the Impres-
sionists. As can be
seen in this canvas,
these are bright,
luminous works, with
clear, brilliant colors,
very different from
the colors used in the
still lifes of the years
before the Franco-
Prussian War. They
create an atmosphere
of joyous serenity and
express the happy
creativity of the artist,
who passes some of
the happiest and most
carefree years of his
life in Auvers.

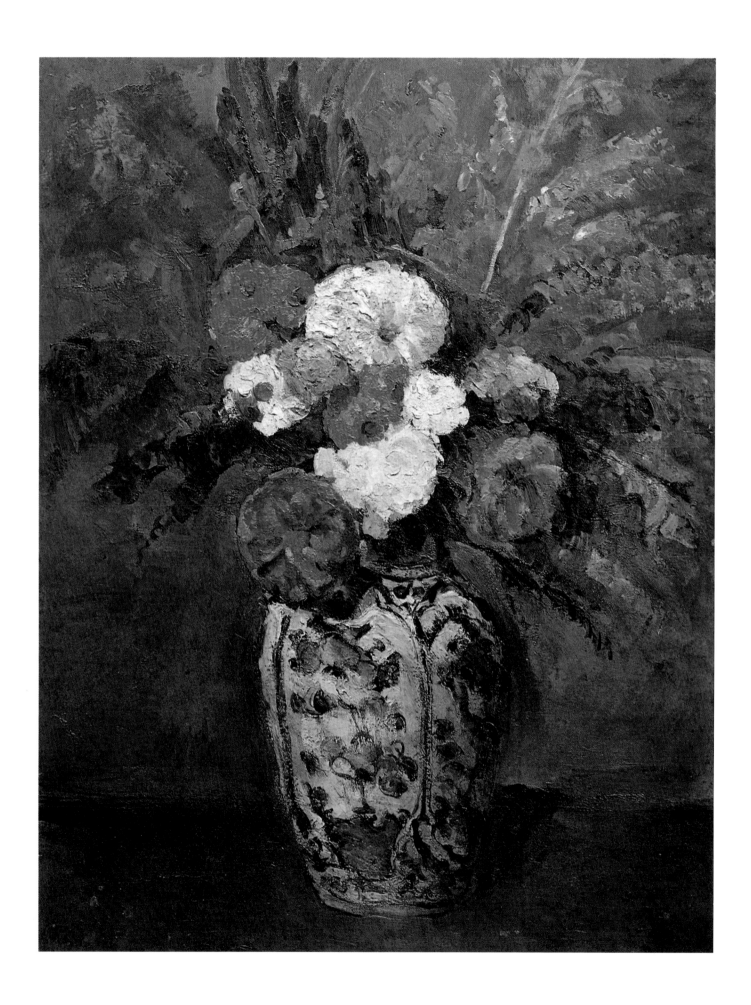

The first show of the Impressionists

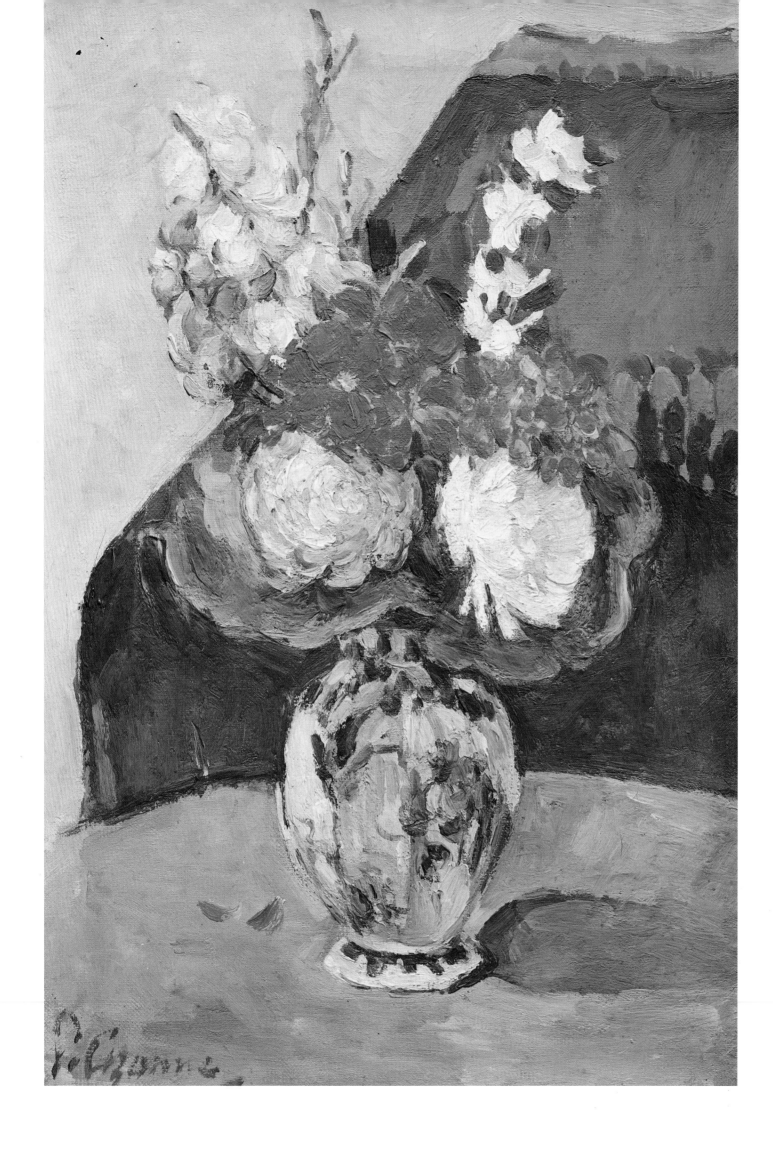

■ PAUL CÉZANNE
**Flowers in a Small
Delft Vase**
circa 1873,
oil on canvas,
41 × 27 cm
Musée d'Orsay, Paris

This painting shows
even more clearly
Cézanne's efforts to
use delicate tints and
soft, warm light that
sweetly caresses the
flowers. He makes
these paintings directly
on the canvas without
even a preparatory
drawing; their almost
total lack of spatial
depth and physical
solidity anticipates
the decomposition of
forms in the still lifes
of his artistic maturity.
The elegant decoration
on the vase recalls the
flowers the artist
painted on a few of
the porcelain vases
that Dr. Gachet's wife
made with her own
hands in their home
in Auvers.

PAUL CÉZANNE
The House of Père Lacroix at Auvers
1873, oil on canvas,
61 × 51 cm
National Gallery of
Art, Washington, D.C.

At Auvers, Cézanne and Pissarro paint together and exchange opinions and advice on how best to direct their energies. There is a certain calmness in the colors in this painting, and the relationship between the colors and the design strikes a kind of equilibrium. Although the artist tries to give the scene a sense of movement by adding touches of more intense color, overall the painting seems somewhat static and less original than his later landscapes, in which his contribution to the poetics of Impressionism is stated with greater clarity.

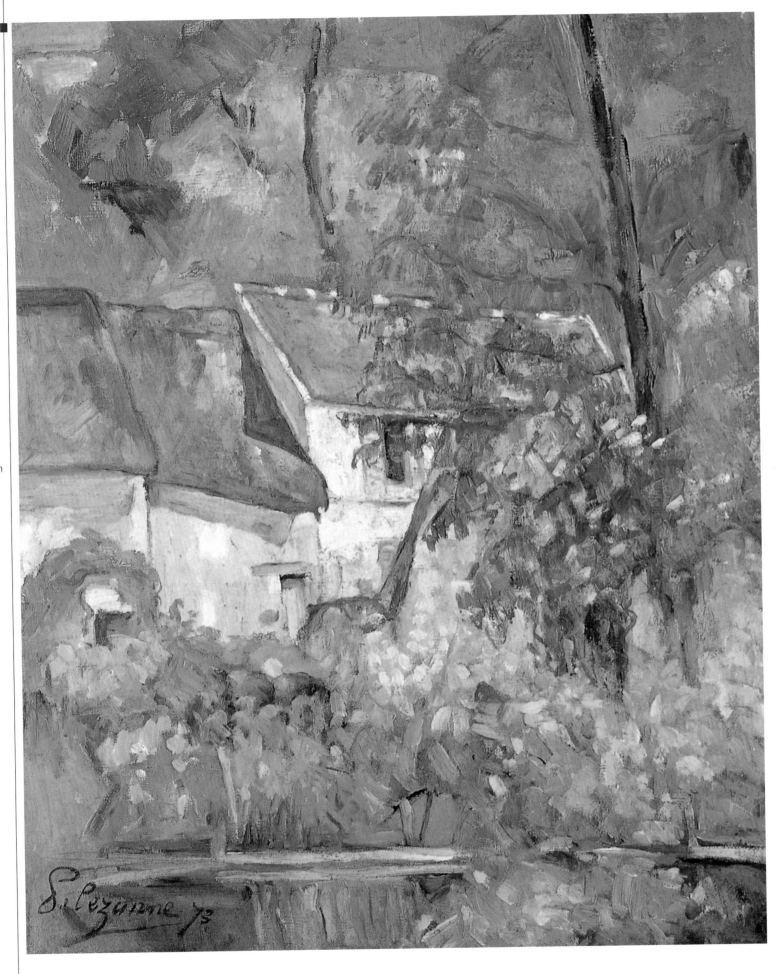

The first show of the Impressionists

■ EDOUARD MANET
**Racecourse in the
Bois de Boulogne**
1872, oil on canvas,
72.5 × 92.5 cm
Whitney Collection,
New York

In August 1872 Manet
takes a trip to Holland
with his wife. On his
return he makes this
canvas, commissioned
from him by the
sportsman and col-
lector M. Barret. The
jockeys are presented
seated solidly on their
saddles; only later
did the custom spread
of sitting upright
and forward on short-
ened spurs.

■ EDOUARD MANET
**Masked Ball
at the Opéra**
1873–74, oil
on canvas,
59 × 72.5 cm
National Gallery of
Art, Washington, D.C.

The compact and
irregular black mass of
the men's suits and
top hats is interrupted
by the vivacious colors
of the costumes, most
of all to the left, and
by the white columns
of the balcony. The
legs of several specta-
tors are visible over-
head, giving the scene
a touch of immediacy
and realism. These
members of the rich
middle class have cast
aside all memory of
the violence of the
Paris Commune and
have returned to their
amusements; dressed
in the elegant clothes
of grand occasions
they meet at the
Opéra, delighted to
celebrate again, freed
of any fear of social
revolts and bloodshed.

Among the many portraits that Manet makes of his student and model, this one stands out because of the vivacity and intensity of Morisot's gaze. The big black hat with its unusual shape acts as a frame for the face, from which the eyes stand out, particularly luminous and expressive. The tufts of hair that escape the hat to tumble over her forehead and neck give her a spontaneous, youthful look. A small bunch of violets is visible in the neckline of the dress, similar to a bunch of violets that Manet painted in a still life during these same months, a work he gave to Morisot as a token of their friendship.

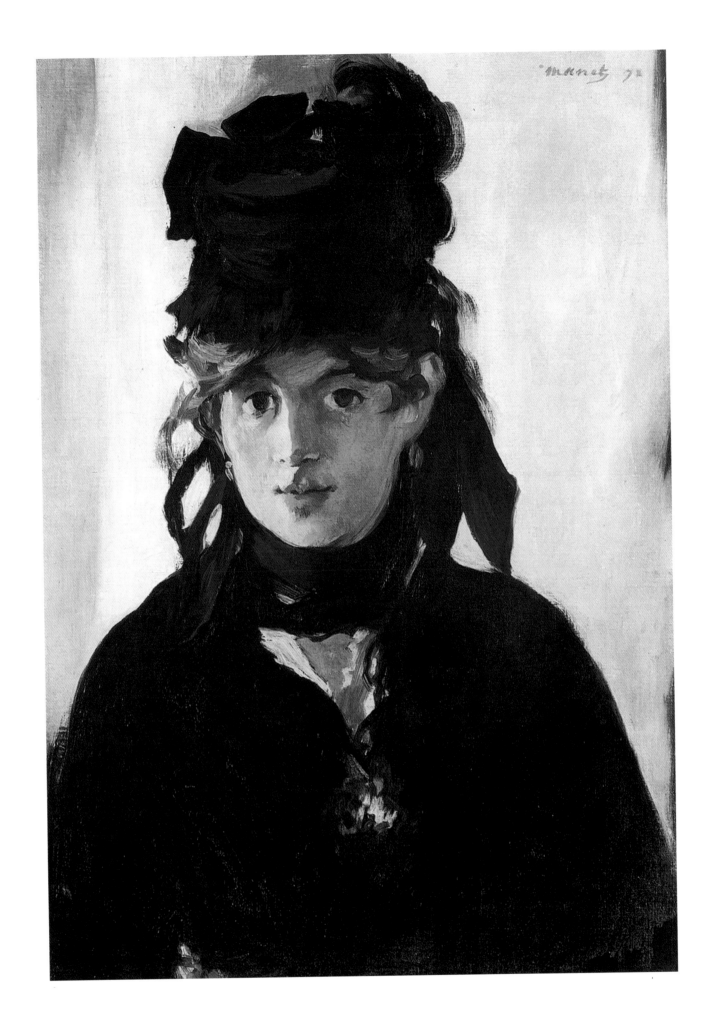

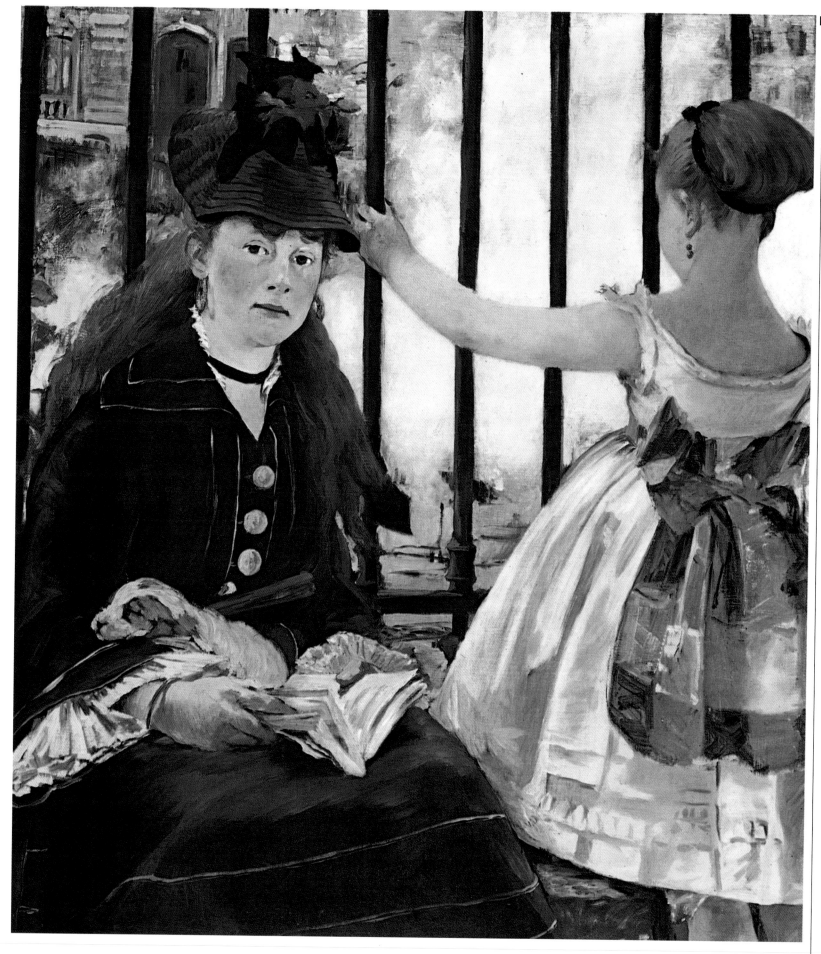

■ EDOUARD MANET
The Railway
1872–73, oil
on canvas,
93 × 114 cm
National Gallery of
Art, Washington, D.C.

The artist begins this
painting in his studio
and completes it in the
garden of the painter
Alphonse Hirsch. The
child seen from behind
is probably Hirsch's
daughter; the woman
is Victorine Meurent,
who had returned to
Paris after a short trip
to America connected
to a love affair. At the
time of the sitting she
was living with Alfred
Stevens (1823–1906),
a Belgian painter and
close friend of Manet's.
In the background
behind the bars can
be seen to the left a
house in Rue de Rome
and, to the right, the
Pont de l'Europe. The
painting is accepted
by the Salon of 1874;
critics are divided,
some praising it,
others expressing
comments that are
ironic or mocking.

1872•1874

EDOUARD MANET
La Bon Bock
1873, oil on canvas,
94 × 83 cm
Philadelphia Museum
of Art, Philadelphia

The sitter is Emile
Bellot, lithographer
and habitué of the
Café Guerbois. Manet
takes his inspiration
from Dutch art, in
particular that of
Frans Hals. Displayed
at the Salon of 1873
the work is very suc-
cessful with critics,
all of whom praise
Manet's technical
expertise and credit
him with sharp psy-
chological characteri-
zation. The canvas
is bought by Jean-
Baptiste Faure for
6,000 francs and
becomes popular: a
brasserie in the
Latin quarter uses it
as its sign, and Bellot
himself founds an
association and a
weekly with the same
name as the painting.

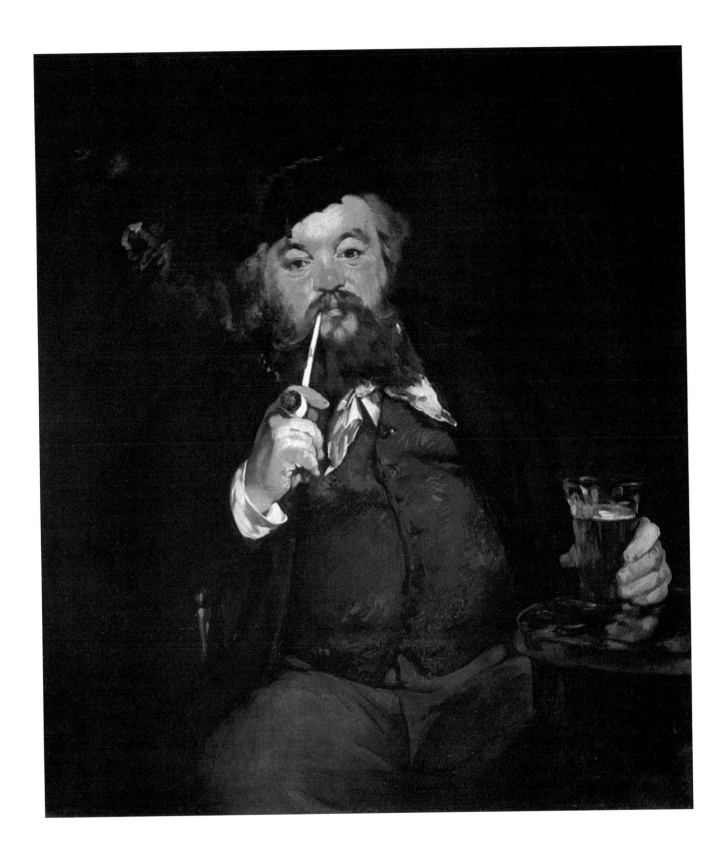

The first show of the Impressionists

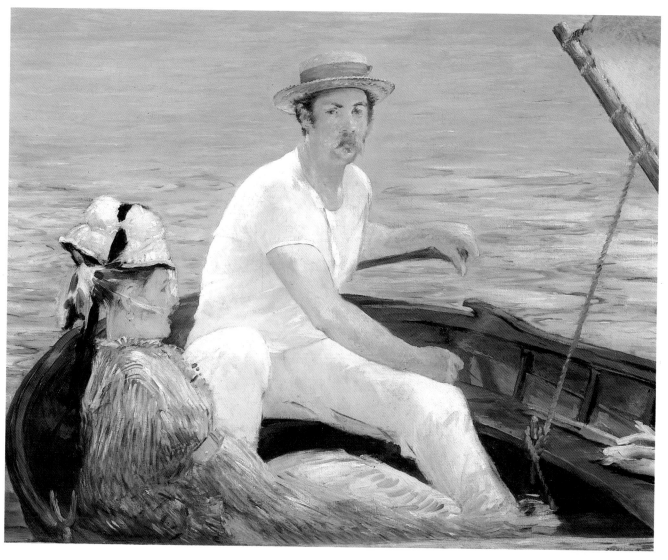

■ EDOUARD MANET
Boating
1874, oil on canvas,
97.2 × 130.2 cm
Metropolitan Museum
of Art, New York

The female is an
unidentified model,
but the man is Rudolph
Leenhoff, brother of
Manet's wife, Suzanne.
The presentation of
the scene, from above
and close-up, and the
pale colors of the
water indicate that
Manet was probably
drawing inspiration
from Japanese prints.
He illuminates the
scene with a uniformly
pale light that brings
out the broad areas of
the clothes of the two
figures. Their faces
are well defined if
not overly expressive,
especially that of the
woman, who seems
to be on the verge of
falling asleep, rocked
by the rhythmic
movement of the boat.

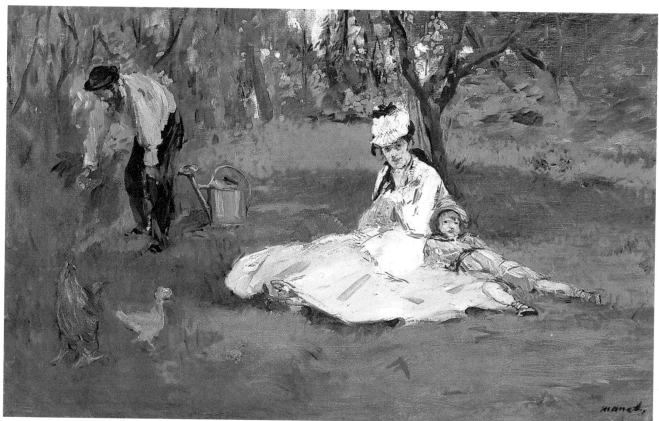

■ EDOUARD MANET
**The Monet Family
in Their Garden
at Argenteuil**
1874, oil on canvas,
61 × 99.7 cm
Metropolitan Museum
of Art, New York

So proud is Claude
Monet of the garden
he has created at
Argenteuil that
he declares it "my
greatest masterpiece."
Manet portrays him
tending to his beloved
plants in the company
of his wife, Camille,
and son, Jean (at the
time seven years old).
During these very
same days Renoir is
also a houseguest of
Monet, and he paints
a very similar painting
of Camille and Jean.

1872•1874

The first show of the Impressionists

EDOUARD MANET
Argenteuil
1874, oil on canvas,
149 × 131 cm
Musée des Beaux-Arts,
Tournai

The models in this
painting are the same
as in *Boating* (page
135) with slightly
different outfits and
a vertical rather than
horizontal arrange-
ment. The setting
of the scene is
Gennevilliers on
the Seine opposite
Argenteuil, where
Manet spends the
summer of 1874,
guest of his cousin
Jules de Jouy. This is
the sole work Manet
presents to the Salon
of 1875: nearly all of
the critics are fierce
in their criticism,
as for example Jean
Rousseau in the pages
of *Figaro*. In 1884
the painting is sold
for 12,500 francs;
resold five years later
it brings 14,000.

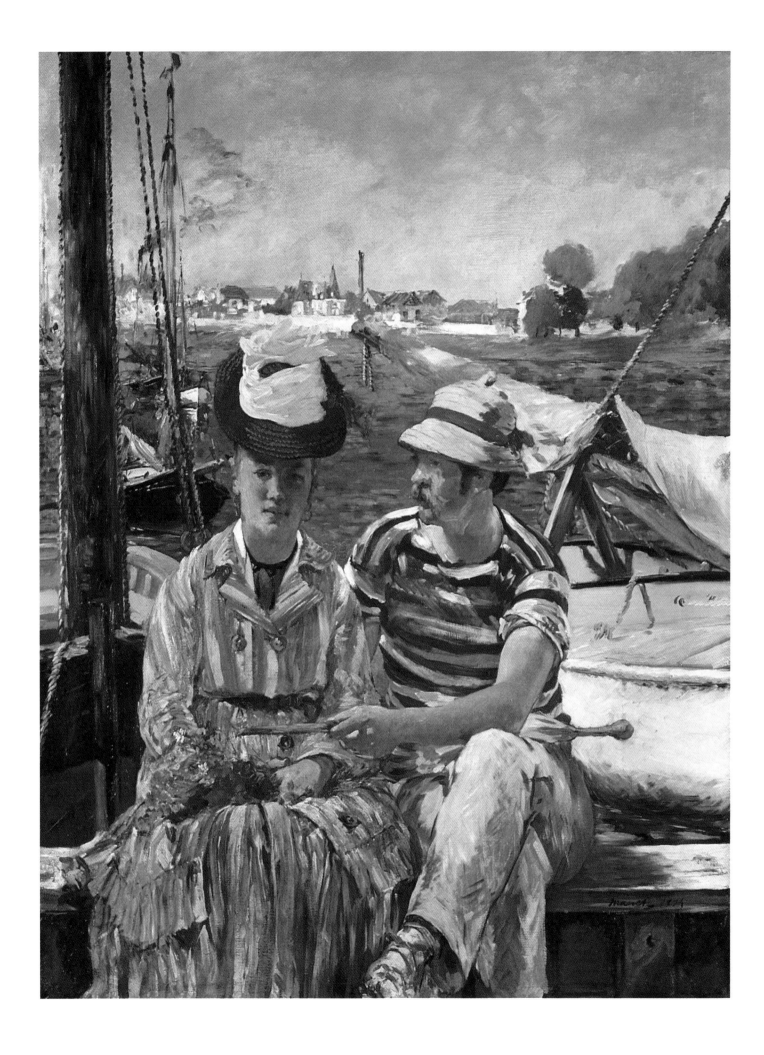

The first show of the Impressionists

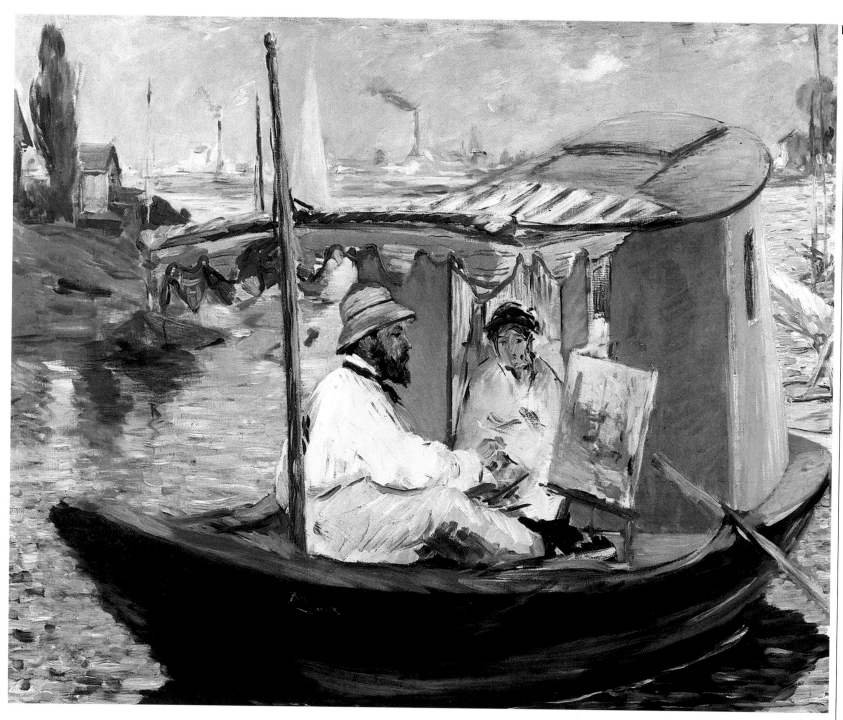

■ EDOUARD MANET
Monet Painting in His Floating Studio
1874, oil on canvas, 80 × 98 cm
Neue Pinakothek, Munich

With Manet's help, Monet manages to find a house in Argenteuil. In order to paint outdoors on the Seine more comfortably, he gets a boat and outfits it as a floating studio, much as Daubigny did in 1857. But whereas Daubigny moved around a great deal, making trips to places far from the Oise River and sometimes passing many days at a time in his *Le Botin*, Monet does very little wandering, preferring to ride at anchor among other recreation boats, as in this painting, in which he paints in the company of his wife.

PAUL GAUGUIN
Landscape
1873, oil on canvas,
50.5 × 81.5 cm
Fitzwilliam Museum,
Cambridge

Gauguin begins paint-
ing during the summer
of 1873, influenced by
Emile Schuffenecker,
a colleague of his in
the Bertin exchange
office. In November
of that same year he
marries the Danish
Mette Gad and, thanks
to stock-market earn-
ings, begins buying
works of modern art.
His first models are
the painters of the
Barbizon school,
whose works he is
able to study in the
collection of his tutor,
Gustave Arosa. Arosa
introduces him to
Pissarro, who teaches
him to use paints in
the Impressionist
style, with separate
brushstrokes and pale,
luminous colors.

The first show of the Impressionists

■ EUGÉNE BOUDIN
The Port of Portrieux
1874, oil on canvas,
48 × 85 cm
Szépmüvészeti
Múzeum, Budapest

In 1873 and 1874
Boudin goes to
Portrieux in Brittany
to paint. On the invi-
tation of his friend
Monet he participates
in the first Impres-
sionist show. That
same year, two of his
paintings are accepted
by the Salon, an
indication that the
members of the jury
did not see the exhi-
bition in the Boulevard
des Capucines as a
challenge and that,
all things considered,
Manet's fears were
unfounded.

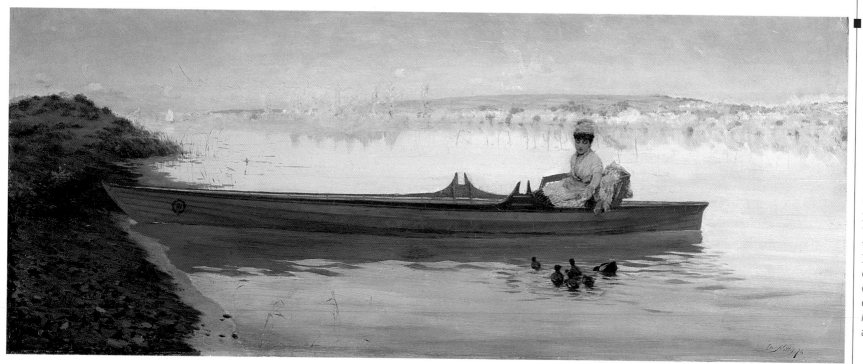

■ GIUSEPPE DE NITTIS
The Ducks' Repast
1874, oil on panel,
25 × 60 cm
Private collection

Born in Barletta, Italy,
in 1846, Giuseppe De
Nittis arrives in Paris in
1868 and studies at
the Ecole des Beaux-
Arts and at the studio
of Léon Gérôme. The
year 1874 is important
for him: he presents
five paintings at the
Impressionist show,
organizes a show of his
own paintings, and
one of his paintings,
How Cold It Is! is
accepted by the Salon.

1872•1874

The first show of the Impressionists

BERTHE MORISOT
The Cradle
1872, oil on canvas,
56 × 46 cm
Musée d'Orsay, Paris

Morisot exhibits nine
works at the first
Impressionist show:
four oils, two pastels,
and three watercolors.
Critics are less hostile
to her than to her
male colleagues,
perhaps because she
is the only female in
the show. In some
cases she receives
sincere praise for the
poetic content of her
creations. The models
for this tender,
delicate work are her
sister Edma, with the
sweet and thoughtful
expression, and her
little niece Blanche,
visible through the
pale transparency
of the veil.

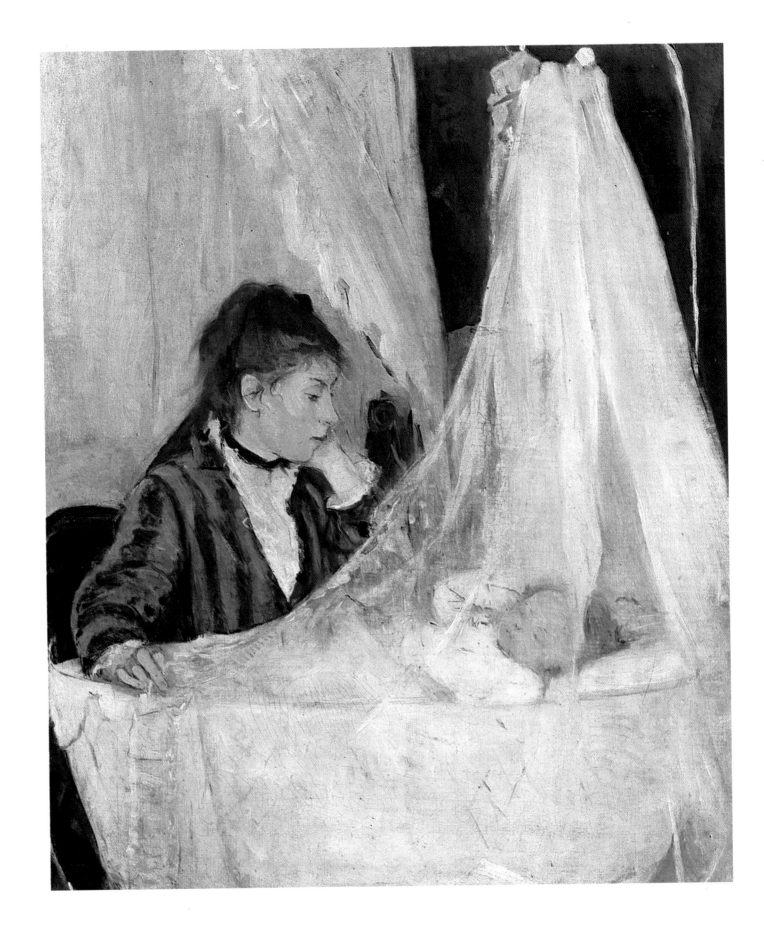

■ BERTHE MORISOT
Hide-and-Seek
1873, oil on canvas,
46.3 × 55.2 cm
Private collection

The first owner of this painting is Edouard Manet, Morisot's brother-in-law, who loans it back to her for the first Impressionist show, in 1874. The painting later enters the collection of John Hay Whitney and on May 10, 1999, is sold by Sotheby's, New York, for $3.8 million. Here, too, Morisot uses her sister Edma and Edma's daughter Blanche as models; their faces are only cursorily presented, with very little psychological depth. The artist's interest is instead devoted to the landscape, for which she uses oil paints but achieves the delicate transparency of watercolors.

■ BERTHE MORISOT
**In a Park
(On the Grass)**
1874, pastels on paper,
73 × 92 cm
Musée du Petit Palais,
Paris

Delicately muted pastels are made to mix, one blending into another to form a harmonious whole. The figures too, perfectly placed in the setting, are portrayed with great naturalness. The mother's tender position with her child recalls images of ideal maternity from ancient painting, though the scene here is enlivened by the presence of the little dog and the older child in the background.

1872•1874

The first show of the Impressionists

ALFRED SISLEY
**Villeneuve-la-
Garenne on the Seine**
1872, oil on canvas,
59 × 80.5 cm
The Hermitage,
St. Petersburg

The Franco-Prussian
War brings about the
financial ruin of
Sisley's father, an
English businessman.
To cope with the
economic difficulties,
Sisley intensifies his
activity as a painter,
helped by Monet and
Renoir, whom he met
during their days in
Gleyre's studio and
who, like him, frequent
the Café Guerbois.
Between 1871 and
1884 Sisley makes
regular visits to the
towns of Voisins and
Louveciennes and also
to spots on the out-
skirts of Paris, among
them Villeneuve-la-
Garenne, near Saint-
Denis, popular with
Parisians for Sunday
outings. As can be
seen in this painting,
Sisley uses pale,
luminous colors
with short, regular
brushstrokes.

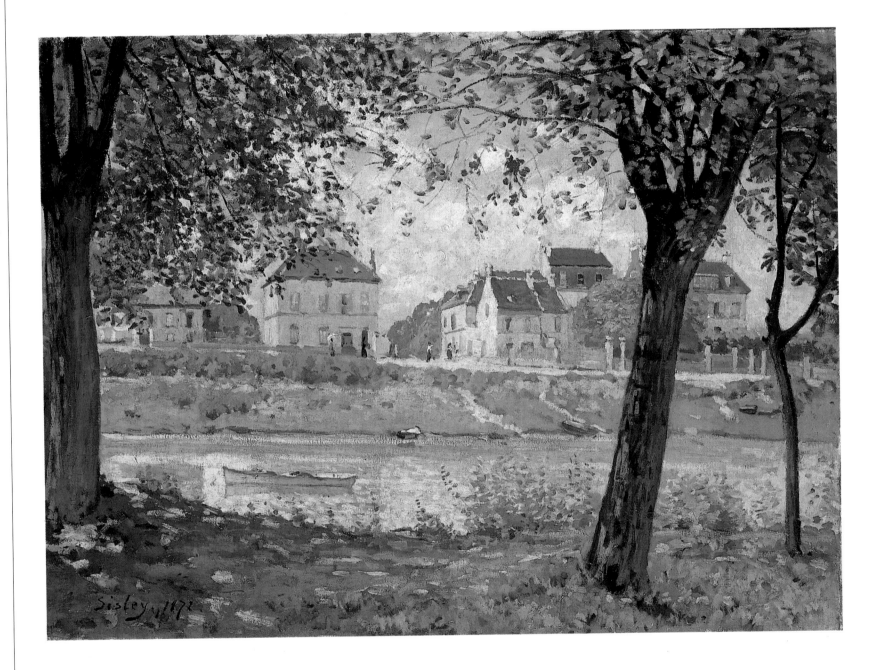

The first show of the Impressionists

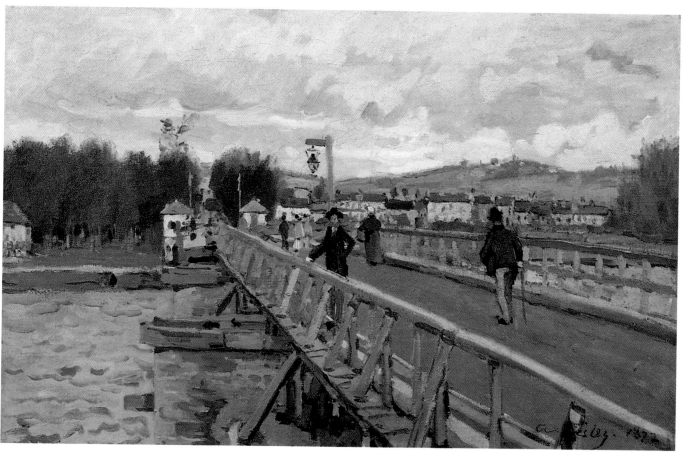

**Foot Bridge
at Argenteuil**
1872, oil on canvas,
39 × 60 cm
Musée d'Orsay, Paris

In 1872 Sisley is the guest of Monet at Argenteuil, along with Caillebotte and Renoir, and together they paint many views. The continuous interchange of ideas helps each of them mature his personal style. Here Sisley confirms his fondness for pale tones; the diagonal lines of the bridge interact with the horizontal weight of the landscape in the background, augmenting the illusion of a three-dimensional space.

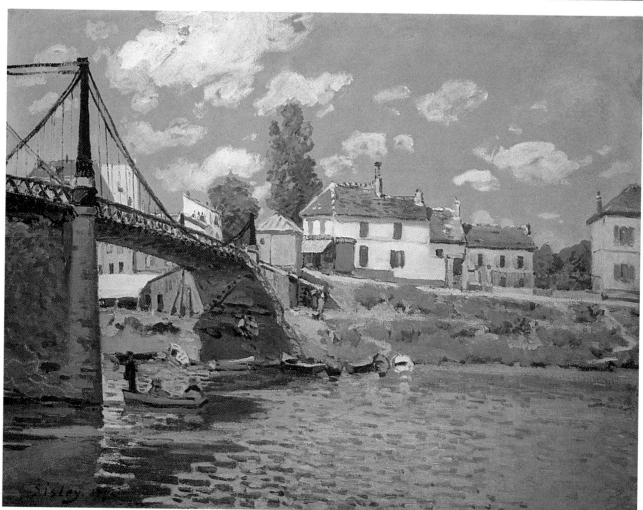

■ ALFRED SISLEY
**The Bridge at
Villeneuve-la-
Garenne**
1872, oil on canvas,
49.5 × 65.5 cm
Metropolitan Museum
of Art, New York

The composition is divided in three parts: the sky above, almost totally serene, with a few white clouds; the town and its bridge in the center, presented from a very effective perspective angle; the water in the lower area of the painting. The two upper sections are presented with thin, almost spare brushstrokes; the water of the river, however, is rendered with multiples of tiny brushstrokes of various colors that perfectly recreate the sense of the flowing current and distinguish the areas in shadow from those illuminated by the sun.

1872•1874

The first show of the Impressionists

ALFRED SISLEY
**The Road at Hampton
Court (detail)**
1874, oil on canvas,
Neue Pinakothek,
Munich

Struggling to make his
way out of his difficult
financial situation,
Sisley presents five
works at the first
Impressionist show.
Disappointed by the
poor outcome, he
goes to London for
four months and while
there paints several
views of the Thames.
At Hampton Court in
particular he finds an
atmosphere similar to
that of the landscapes
at Argenteuil on the
Seine. Furthermore,
the faded, cold tones
of the area are nearer
his pictorial sensibil-
ity. The outlines are
extremely simplified,
especially in terms of
the figures, which are
little more than quick,
light brushstrokes.

The first show of the Impressionists

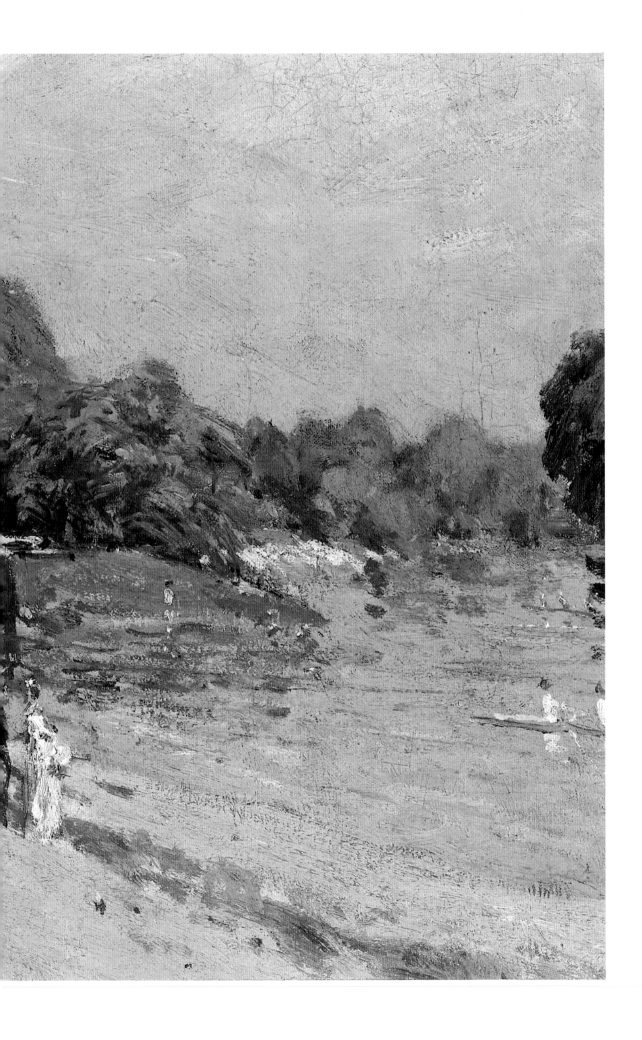

The first show of the Impressionists

ALFRED SISLEY
Misty Morning
1874, oil on canvas,
50 × 65 cm
Musée d'Orsay, Paris

During his stay in
England between 1870
and 1871 Sisley meets
Pissarro. Once back
in France the two get
together often to paint
in the areas of Louve-
ciennes and Voisins.
In this painting, Sisley
uses such a limited
range of colors that the
canvas seems almost
monochromatic. The
entire scene is filtered
through morning mist,
which softens outlines,
annuls details, and
puts the viewer in
a completely new
relationship with
nature, creating a
more intimate and
emotive bond.

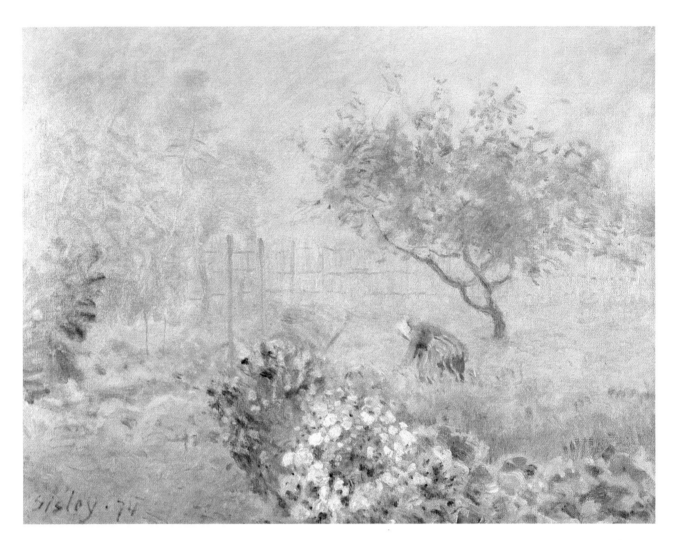

ALFRED SISLEY
Regatta at Molesey
1874, oil
on canvas,
66 × 91.5 cm
Musée d'Orsay, Paris

In July 1874 Sisley
arrives in London with
Jean-Baptiste Faure,
well-known baritone of
the Opéra and one of
the first collectors of
his work. In this river
view, attention is
drawn to the flags in
the wind, which give
vivacity to the scene.
In the background, the
boats are already near-
ing the finish line. The
artist has sketched in
the rowers with rapid
brushstrokes and with-
out the use of a pre-
liminary drawing: their
confused outlines sug-
gest the idea of speed.

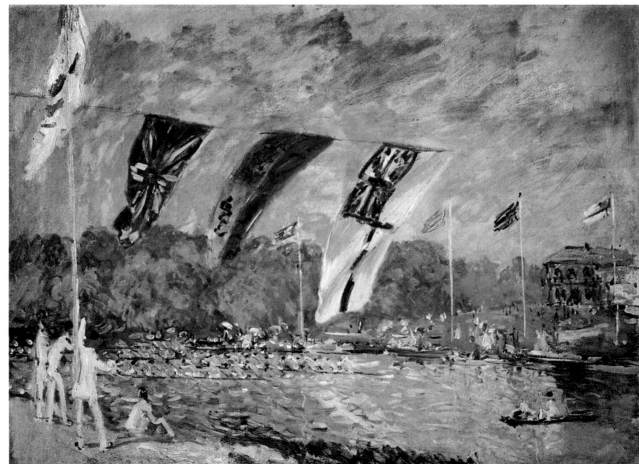

1872•1874

The first show of the Impressionists

■ CAMILLE PISSARRO
Self–Portrait
1873, oil on canvas,
56 × 46.7 cm
Musée d'Orsay, Paris

The thick, pale beard and calm, determined attitude give him the bearing of a man of authority and respect, not unlike a biblical patriarch. He is the one who encourages other painters when they're rejected by the Salon or when they fail to sell their paintings. Most of all, he is one of the major supporters of the idea of forming a group of painters who will paint and exhibit their works without any connection to the academy or the Ecole des Beaux-Arts.

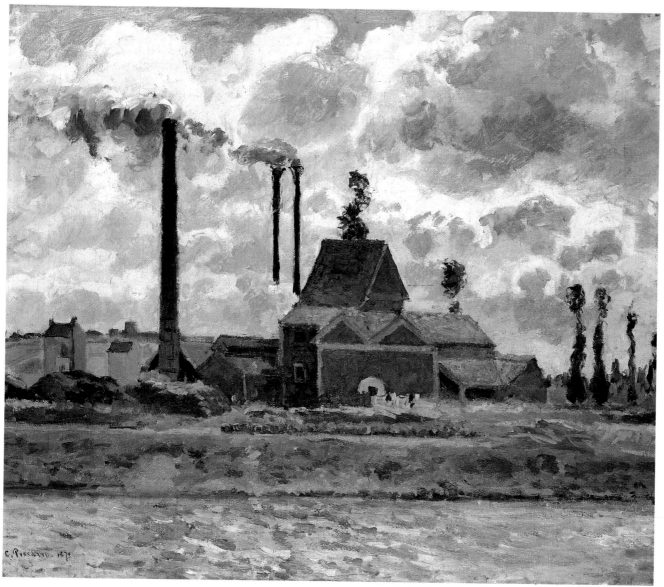

■ CAMILLE PISSARRO
Factory near Pontoise
1873, oil on canvas,
45.7 × 54.6 cm
Museum of Fine Arts,
Springfield

Socialist and anarchist, Camille Pissarro is highly aware of the social problems of day. Many of his paintings are dedicated to peasants and their difficult life in the fields. Pissarro is among the first artists to present the reality of factories, which in those very years were beginning to become part of the landscape of Paris and its immediate surroundings. From the stylistic point of view this painting shows clear traces of the colorist teachings of Corot, with whom Pissarro had studied for several years.

The first show of the Impressionists

I n 1875 the Impressionists rarely get together at the Café Guerbois, perhaps because, although none of them would say so out loud, they think it may not be bringing them luck. They move the location for their get-togethers to a similar spot, La Nouvelle-Athènes, in Place Pigalle in Montmartre. During the empire of Napoleon III, it was considered a place of "ill repute," frequented by political dissidents like Georges Clemenceau and Léon Gambetta, leaders of the Third Republic. It is popular with a few critics, among them Jules Castagnary, as well as with artists, including Courbet. Among the most dedicated regulars are Marcellin Desboutin, Manet, Degas, who uses it as the setting for one of his best-known works of the period (*In a Café*, page 162), Forain, Zandomeneghi, Raffaëlli, Caillebotte, and, a few years later, Gauguin. Every so often Cézanne, Pissarro, Monet, and Renoir drop by, busy with their efforts to find new solutions to the difficult period they're all living through. Admitting the disappointing outcome of the show in the Boulevard des Capucines, which led to the premature dissolution of their society, Renoir, whose father has recently died, convinces Monet, Sisley, and Berthe Morisot to try an

auction sale at the Hôtel Drouot, named for the Napoleonic general who lived in the building and chosen as the Paris headquarters of the state auctions, which are directed by public officials known as *commissaires priseurs*.

Influencing the artists' decision is the positive example set by Daubigny, who put some of his works up for sale in 1874 and got a favorable response from collectors. The auction of the Impressionists is

1875•1876

directed by the *Commissaire Priseur* Charles Pillet—whose studio is at 10, Rue de la Grange-Batelière—with the assistance of Paul Durand-Ruel, for some years now the recognized expert in the field of Impressionist art. The catalog includes a long, in-depth critical introduction by Philippe Burty, who defines their paintings as "little fragments of the mirror of universal life." There are 21 works by Sisley, 20 by Monet, the same number by Renoir, and 12 by Berthe Morisot, including seven pastels and watercolors. The preauction display is limited to just two days, Monday, March 22, and Tuesday, March 23, from one o'clock in the afternoon to five. The sale takes place on Wednesday, March 24, at two, in the main hall of the Hôtel Drouot. After the storm of criticism that surrounded the Salon des Refusés in 1863 and the even more bitterly sarcastic articles in response to the first show in Boulevard des Capucines, the public shows up in large numbers, but strongly prejudiced against the artists. Very few of those who come are interested in actually buying a painting, discouraged in part by the economic crisis in France; many greet the presentation of each painting with laughter, sarcastic com-

ments, and offensive jokes, the situation getting so bad at one point that the auctioneer is forced to call the police.

"We had good fun with the purple landscapes, red flowers, black rivers, yellow and green women, and blue children which the pontiffs of the new school presented to the admiration of the public," runs the review in the *Paris Journal* the next day. The outcome is truly miserable; the overall result, including the works bought back by the artists themselves, amounts to about 11,500 francs. The 21 paintings by Sisley go for 2,500 francs; those by Monet are sold for an average of a little more than 230 francs; the highest price goes to a painting by Berthe Morisot, which gets 480 francs, while many of those by Renoir do not get more than 100 and total just 2,251 francs. Time will prove those right who disregard the jokes and insults and have the courage to invest their money. For example, *The Pont Neuf* by Renoir sells for only 300 francs; quite a deal if one thinks that in December 1919 it will be resold for the then notable price of 100,000 francs.

One positive result of the auction is the strengthening of the relationship between the Impressionists and Paul Durand-Ruel. Born in 1811, the

sis forces him to close the London gallery, a loss that becomes one more reason the Impressionists, trying to find their own outlet for their works, put on the show in Boulevard des Capucines. Between 1875 and 1876 the dealer reopens the gallery, again exhibiting paintings by the Impressionists, and he gives new impetus to the Parisian store, enlarging the circle of his clients and presenting them with new works. A few years later Monet, in an interview with Thiebault-Sisson, says, "Durand-Ruel was our savior. For fifteen years and perhaps longer, my painting and that of Renoir, Sisley, and

■ Stephané Mallarmé with his lover Méry Laurent.

Second show

art dealer is the son of an art dealer. His father, Jean-Marie-Fortuné, was a promoter of the works of Delacroix and was among the first to believe in Corot, Daubigny, and Courbet. In 1865 Paul takes over control of his father's business, thus becoming the exclusive agent for many of the Barbizon artists. His first contact with the Impressionists comes in 1871 in the gallery he opens in London; first he meets Pissarro who introduces him to Monet and then, back in France, to the other painters. In 1872, in London, he exhibits 13 works by Manet, nine by Pissarro, six by Sisley, four by Monet, three by Degas, and a Renoir. In 1874, the economic cri-

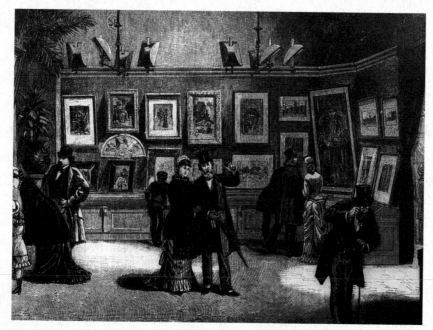

Pissarro had no other outlet than his." In August 1875 Pissarro tries to reanimate the group, founding a new artistic society called L'Union. He fails to attract interest from the other painters, and the project is soon abandoned. Early in 1876 Durand-Ruel is among the promoters of the second Impressionist exhibition, which takes place in three rooms of his gallery at 11, Rue Le Peletier. Once again the artists are unable to settle on a name or definition for their group, giving only the most generic description on their poster: "Exposition faite par un groupe d'artistes." The show is open from March 30 to April 30

■ One of Paul Durand-Ruel's galleries in an engraving of 1879 by E. Bichon.

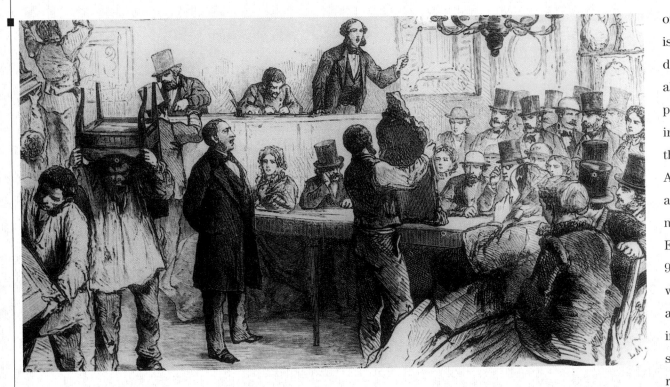

of contemporary life. His analysis is overall quite positive, but far different are the reviews in almost all the rest of the press, which pour an enormous quantity of ironic and sarcastic comments on the Impressionists and their art. Against any logic, their art is even accused of serving political motives. Following a review by Emile Blémont, published on April 9 in *Le Rappel*, other newspapers with monarchical leanings line up against the Impressionists, confusing their revolutionary artistic style and associating it with republican views. In *Le Soleil*, Emile Pocheron chides, "Who is an Impressionist? The question is delicate and calls for deep reflection. To us, an Impressionist is a man who, without really knowing why, senses the need to dedicate himself to the cult of the palette and, possessing neither the talent nor the necessary learning to achieve serious results, contents himself with tooting his horn in favor of his school, offering the public paintings that are not equal in value to the frames that hold them."

"Rue Le Peletier has bad luck. After the Opéra fire here is a new disaster," announces Albert Wolff in *Le Figaro*. "Five or six lunatics—including a woman—unfortunate creatures stricken with the mania of ambition have met there to exhibit their works. Some people burst out laughing in front of

1876, with hours from ten to six. The thirty participants in the first show have been cut down to only a dozen: Edouard Béliard, Adolphe-Félix Cals, Edgar Degas (with 24 works), Ludovic-Napoléon Lepic, Léopold Levert, Claude Monet (with 18), Berthe Morisot (with 17), Léon Ottin, Camille Pissarro (with 12), Auguste Renoir (15), Henri Rouart, and Alfred Sisley (nine). To these are joined six painters: Gustave Caillebotte (with eight works), Marcellin Desboutin, Jacques François, Alphonse Legros, Jean-François Millet, and Charles Tillot. Each exhibitor pays a fee of 120 francs to cover the expenses of the undertaking. On this occasion too, Manet is warmly invited to participate in the exhibit, but again he refuses: the Salon, which he persists in considering the only place where an artist can gain official recognition, has just rejected the two works he presented, *The Artist* (a portrait of Desboutin) and *Le Linge (The Wash)*. For this reason he prefers to organize a personal one-man show in his own studio, scheduled to coincide with the Impressionist show. On the occasion of the show, the critic Louis-Edmond Duranty publishes an essay, *The New Painting*, with the subtitle *On the group of artists exhibiting at the Durand-Ruel Gallery*. This is the first text by a critic dedicated entirely to the group, and it is worth noting that the term *impressionism* is never used. The writer, himself a regular at the Café Guerbois, discusses the stylistic innovations of the artists and provides detailed comments on the use each artist makes of drawing, light, and color. He insists that the painters do in fact respect the pictorial tradition of the great masters while at the same time explaining that they are seeking new subjects for their works in scenes

these things—my heart is oppressed by them. Those self-styled artists give themselves the title of noncompromisers, impressionists; they take up canvas, paint, and brush, throw on a few tones haphazardly, and sign the whole thing . . . It is a frightening spectacle of human vanity gone astray to the point of madness. Try to make Mr. Pissarro understand that trees are not violet, that the sky is not the same color as fresh butter, that in no country do we see the things he paints and that no intelligence can tolerate such aberrations! Try indeed to make Mr. Degas see reason. Tell him that in art there are certain qualities called drawing, color, execution, control, and he will laugh in your face and treat you as a reactionary. Or try to explain to Mr. Renoir that a woman's torso is not a mass of flesh in the process of decomposition with green and violet spots that denote the state of complete putrefaction of a corpse! There is also a woman in the group, as in most notorious gangs; her name is Berthe Morizot [*sic*] and she is curious to note. In her case, a feminine grace is maintained amid the outpourings of a delirious mind. . . . They have attached an old paint rag to a broomstick and made a flag of it." The article so upsets and infuriates Morisot that her husband wants to challenge the critic to a duel. More articulate but no less negative is the contribution from Henry James, entitled "Parisian Festivity," published on May 13, 1876, in *The New York Tribune*. The famous writer, at the time traveling and studying in Europe, writes that he found the show "decidedly interesting." At the same time, however, he has a series of reservations that he wants to put forward. In particular he notes that "[their] attitude has something in common with that of the English pre-Raphaelites, twenty years ago, but this little band is on all grounds less interesting than the group out of which Millais and Holman Hunt rose to fame. None of its members shows signs of possessing first-rate talent, and indeed the 'Impressionist' doctrines strike me as incompatible, in an artist's mind, with the existence of first-rate talent. To embrace them you must be provided with a plentiful absence of imagination." Finally, in September of the same year

A view of Rue Cortot in Montmartre where Renoir rents a studio in 1875.

Stéphane Mallarmé writes a long, detailed article called "The Impressionists and Edouard Manet," which appears in *The Art Monthly Review* of London. He analyzes the decisions of the artists to paint in the open air and to draw the inspiration for almost all their works from contemporary life rather than from history or myth.

CATALOGUE
DES
TABLEAUX
ET
AQUARELLES
PAR
CLAUDE MONET · A. RENOIR
BERTHE MORISOT · A. SISLEY

ET DONT LA VENTE AURA LIEU
HOTEL DROUOT, SALLE N° 3
Le Mercredi 24 Mars 1875,
À deux heures.

Title page of the catalog of the sale of Impressionist works at the Hôtel Drouot on March 24, 1875.

Satirical cartoon: displaying Impressionist paintings in front of government buildings (in this case the chamber of deputies) would be enough to deter miscreants.

PIERRE-AUGUSTE
RENOIR
**Portrait of
Victor Chocquet**
1875–76, oil
on canvas,
46 × 37 cm
Fogg Art Museum,
Cambridge

The customs official
Victor Chocquet is
passionate about art
and buys a canvas by
Monet at the 1875
auction at the Hôtel
Drouot. That very
evening he writes to
Renoir, asking him to
make a portrait of his
wife. The resulting
work is among the
most touching by the
artist because of its
human warmth and
serenity. Renoir intro-
duces him to his
Impressionist friends,
and from then on
the official buys only
their works, such that
at his death he owns
11 paintings by Renoir,
32 by Cézanne, 11 by
Monet, five by Manet,
and one each by
Sisley, Pissarro, and
Morisot. In this
portrait of Chocquet
himself, one of the
twenty works by
Delacroix in his
collection is visible
behind him.

■ PIERRE-AUGUSTE
RENOIR
The Reader
1874–76, oil
on canvas,
46 × 38.5 cm
Musée d'Orsay, Paris

The model for this
painting has never
been identified;
perhaps she is one of
the many women who
frequent the habitual
meeting-places of the
Impressionists, such
as the Café Guerbois or
La Nouvelle-Athènes.
Renoir uses soft light
and frames the scene
in a conventional
manner, but the
application of the
paint and the delicate
atmosphere of intima-
cy give the work a
special fascination.
Renoir uses only two
simple black lines to
create the angles of
the eyes turned toward
the open page of the
book; also striking is
the bright red of the
lips and the swift
brushstrokes of the
hair, making it blend
into the background.

PIERRE-AUGUSTE
RENOIR
**Study for Dancing
at the Moulin
de la Galette**
1876, oil on canvas,
64 × 75 cm
Ordrupgaardsamlingen,
Copenhagen

Renoir works about six
months on the large
painting of dancing
and conviviality at the
Moulin de la Galette.
He makes several
sketches and drawings
on the spot that he
then makes use of in
his nearby studio on
Rue Cortot, helped by
friends who pose for
him. This sketch comes
from an advanced
stage of the work.
Even so it differs in
many ways from the
final version, espe-
cially in the dress
of the figures, in
the arrangement of
the trees, and in the
diminished intensity
of the light from
the gas lamps, the
white globes of which
dominate the upper
part of the painting.

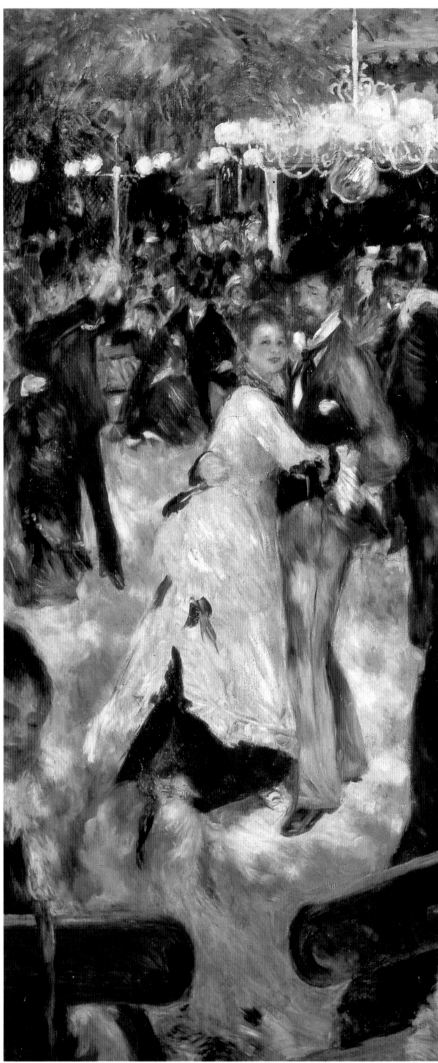

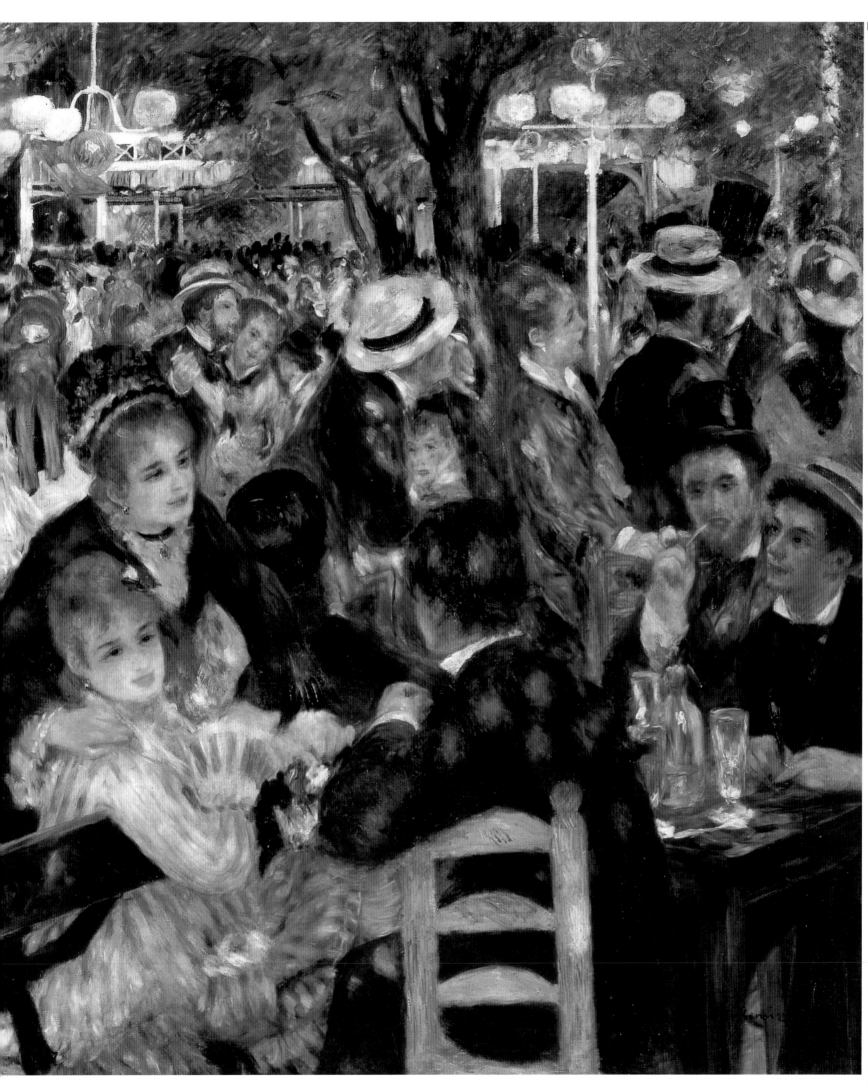

PIERRE-AUGUSTE
RENOIR
**Dancing at the
Moulin de la Galette**
1876, oil on canvas,
130 × 175 cm
Musée d'Orsay, Paris

Without a doubt, this
is the work that stands
as the absolute mas-
terpiece of Renoir's art;
it is also an enduring
manifesto of Impres-
sionist painting. With
extraordinary grace
and sensitivity the
artist celebrates the
happy, simple joys
of a Sunday dance,
a scene in which har-
mony and carefree
enjoyment of life
reign. Many of Renoir's
friends agree to pose
for him. Among those
who have been iden-
tified are the sisters
Estelle and Jeanne
Margot, Franc Lamy,
Georges Rivière,
Marguerite Legand,
and Pedro Vedel (the
last-named pair being
the two dancers to the
left). Another version
of the scene was
bought by the Japa-
nese paper magnate
Ryoei Saito from
Sotheby's in New York
on May 17, 1990, for
$78.1 million.

PIERRE-AUGUSTE
RENOIR
The Swing
1876, oil on canvas,
92 × 73 cm
Musée d'Orsay, Paris

Renoir uses the money
from the sale of his
paintings at the Hôtel
Drouot to rent a small
house with a garden
at 12, Rue Cortot, in
Montmartre. There
he begins painting
several scenes set at
the popular Moulin de
la Galette. He uses
friends as models for
this painting, includ-
ing sixteen-year-old
Jeanne Margot. The
critics of the Salon
do not think highly
of the way he renders
the effects of light
filtering through the
trees onto the figures.
In *L'Evénement*,
G. Vassy sarcastically
accuses him of having
"thrown handfuls of
grease on the clothes
of the models."

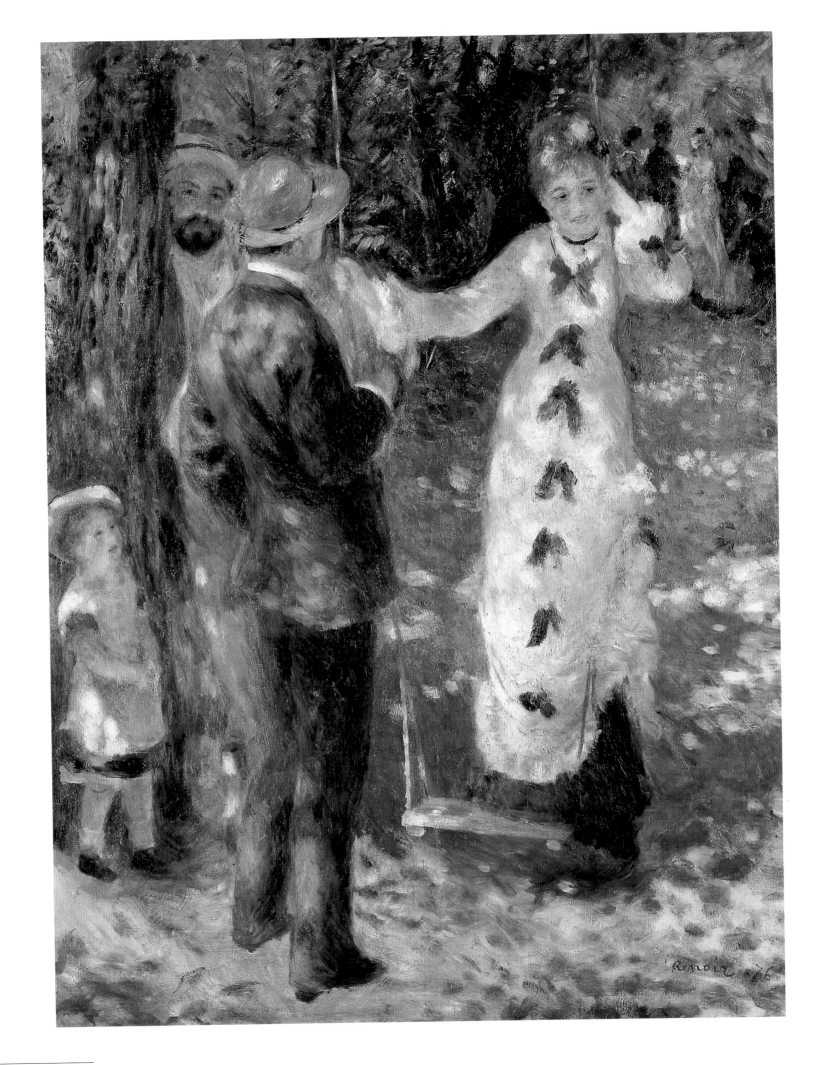

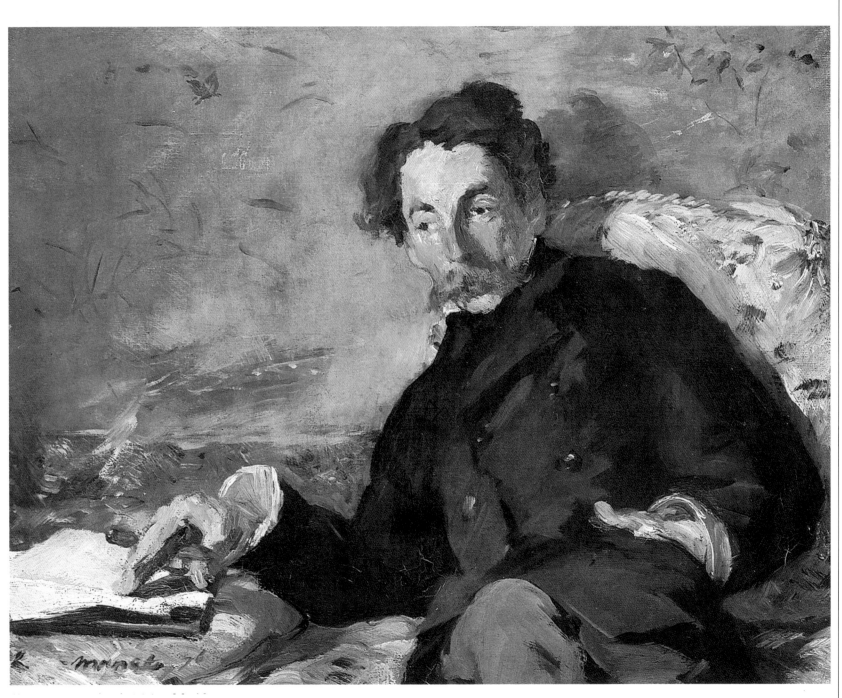

■ EDOUARD MANET
Portrait of
Stéphane Mallarmé
1876, oil on canvas,
65 × 92 cm
Musée d'Orsay, Paris

Stéphane Mallarmé
(1842–98) meets
Manet in 1874 and
asks him to make five
etchings to illustrate
his French translation
of Edgar Allan Poe's
"The Raven," published
on May 20, 1875. At
the time of this
portrait, the poet is
thirty-four, and his
apartment in Rue
de Rome in the
Batignolles quarter
is one of the cultural
centers of Paris, fre-
quented by writers,
musicians, and
painters. His article
in defense of Manet
and the Impression-
ists, published in the
English magazine *Art
Monthly Review,* is very
important precisely
because of his author-
ity, and it somewhat
blunts the force of
the negative criticism.

CLAUDE MONET
**Argenteuil under
the Snow**
1875, oil on canvas,
54.5 × 65 cm
The Nelson-Atkins
Museum of Art,
Kansas City

Monet is still at
Argenteuil in 1875,
but financial difficul-
ties have forced him
to move into a more
modest house. His
paintings find few
buyers, and he is able
to continue with his
work only because of
generous loans from
his friends Caillebotte
and Manet. In this
canvas he renders the
muffled silence of a
road covered in snow,
skillfully alternating
whites and grays with
slight shadings to
violet. The houses in
the background are
integrated into the
scene, becoming part
of the landscape, and
the human figures
seen from a distance
become nothing more
than spots of darker
color, just barely
indicated.

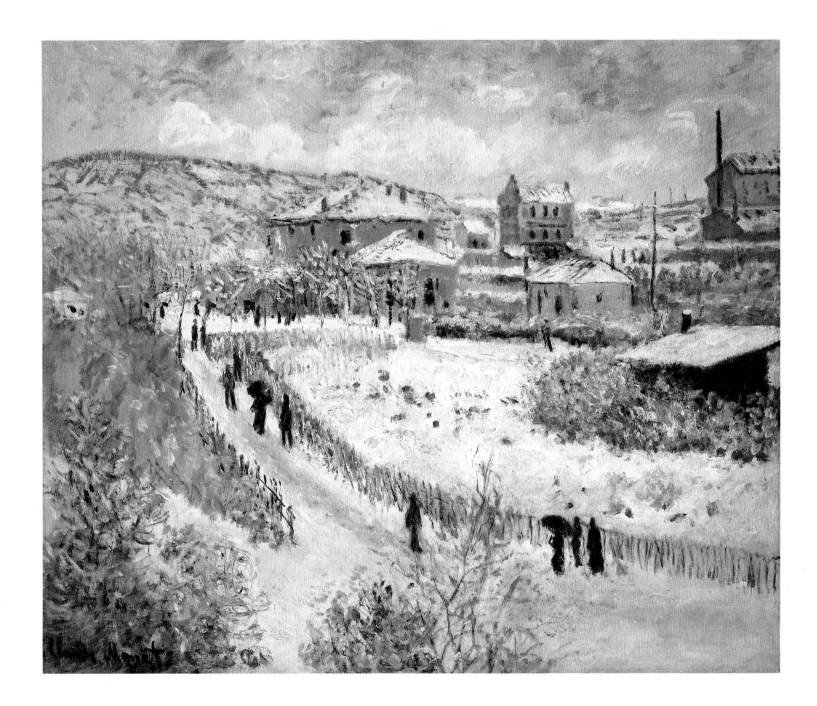

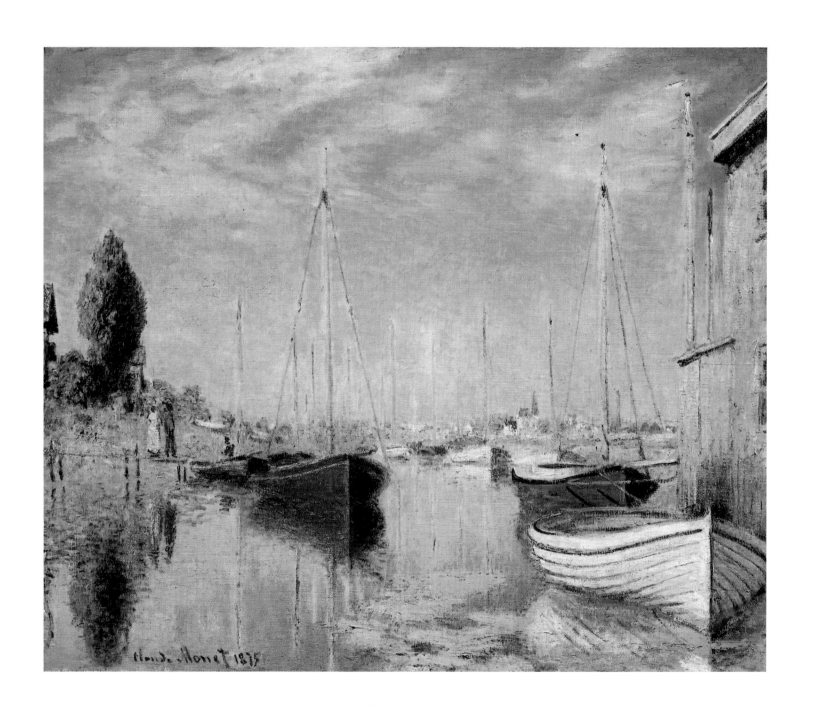

■ CLAUDE MONET
**Pleasure Boats
at Argenteuil**
1875, oil on canvas,
54 × 65 cm
Private collection

This is one of the
three versions Monet
makes of the same
subject over the peri-
od of a few months;
the other two are
today in the Fogg Art
Museum of Cambridge,
Mass., and the Musée
d'Orsay in Paris. The
artist uses highly
luminous, brilliant
colors, in particular
the bright red of the
boat at the center.
One notes the skill
with which he renders
the reflections of the
landscape on the
water. The composi-
tion is deftly balanced
on an alternating
rhythm of vertical and
horizontal lines, the
vertical masts of the
boats meeting the hor-
izontal lines of the
horizon, the hulls of
the boats, and the
landing stage.

**Madame Monet in a
Japanese Costume
(La Japonaise)**
1876, oil on canvas,
231 × 142 cm
Museum of Fine Arts,
Boston

So unrelated is this
painting to the rest
of Monet's pictorial
production that even
he has to admit, a few
years later, that it
was "only a caprice."
When it is displayed
in the second Impres-
sionist show the crit-
ics writing reviews
express surprise of
their own. For exam-
ple, Alexandre Pothey,
in *La Presse* of March
31, 1876, declares his
admiration for the
accuracy of the drafts-
manship and the
bright chromatics. In
reality, more than an
homage to Oriental
culture, the painting
should be taken as a
lighthearted jibe at
the style for all things
Japanese, then much
in vogue in Paris.

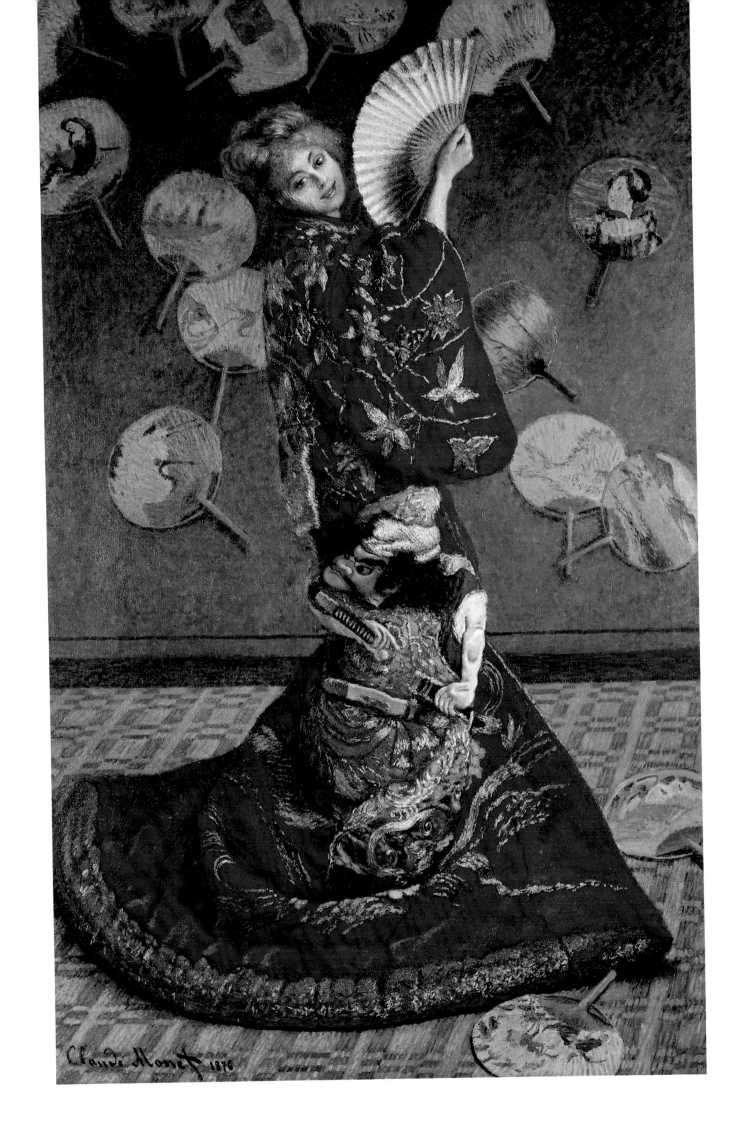

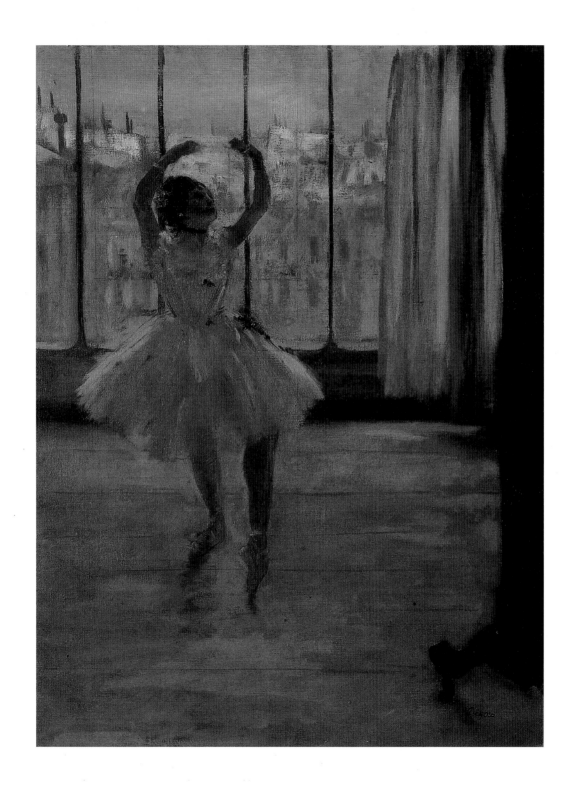

■ EDGAR DEGAS
**Ballerina in Pose
for a Photographer**
1875, oil on canvas,
65 × 50 cm
Pushkin State Museum
of Fine Arts, Moscow

This painting is part of
a series of paintings
of ballerinas Degas
makes between 1873
and 1879. The pres-
ence of the photogra-
pher referred to in
the title is limited to
the lower right cor-
ner, where part of his
camera stand is visi-
ble, but his presence
explains the ballerina's
static position, hold-
ing her breath to make
herself as motionless
as possible. Degas
uses a limited gamut
of colors but does so
with extreme skill,
most of all in the light
shadings of the tutu
and the intangible
transparency of the
curtains in the back-
ground to the right.

EDGAR DEGAS
**In a Café (The
Absinthe Drinker)**
1875–76, oil
on canvas,
92 × 68 cm
Musée d'Orsay, Paris

The setting is the
interior of La Nouvelle-
Athènes, the new
meeting-place of the
Impressionists. The
model for the man is
the painter and
engraver Marcellin
Desboutin; near him
is a glass of *mazagran*,
a popular hangover
remedy. The model
for the woman is the
well-known actress
Ellen Andrée; in front
of her is the typical
glass of absinthe. A
popular drink among
the Parisian working
class at the end of
the century, absinthe
is a mixture of anise
and mint with the
addition of an extract
of the plant with its
famous intoxicating
properties. On the
table in the fore-
ground are a match
holder and newspa-
per, available for
the use of clients
of the café.

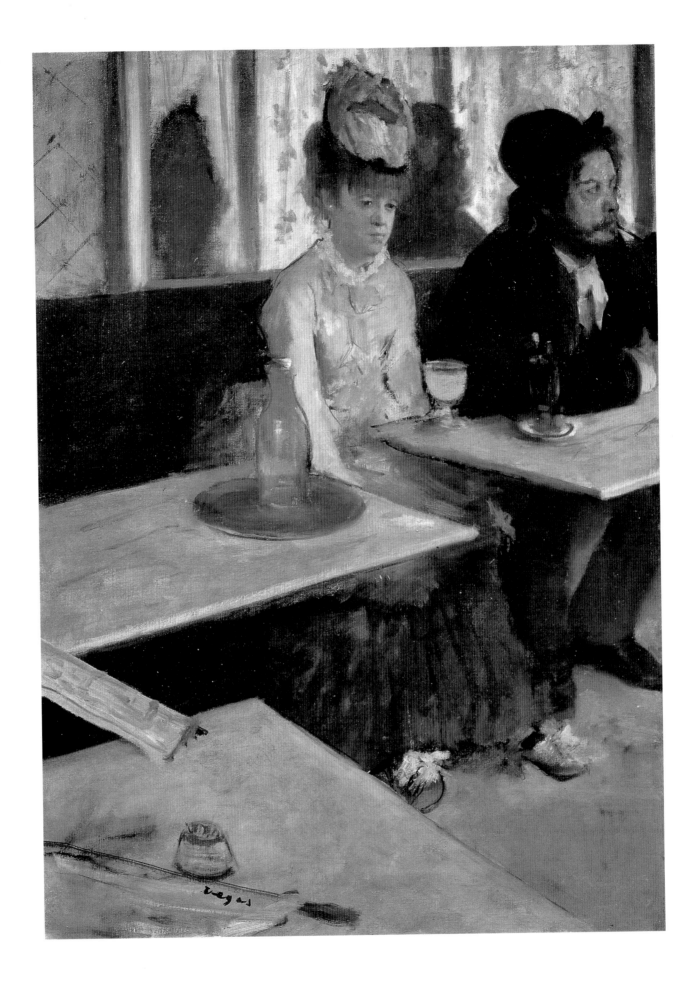

■ EDGAR DEGAS
The Duchessa di Montejasi with Her Daughters Elena and Camille
1876, oil on canvas,
66 × 98 cm
Private collection

The artist dedicates this painting to his cousins Elena and Camille, portrayed in the company of their mother, Stefanina de Gas, wife of Prince Primicili Carafa of Montejasi-Cicerale. The older woman looks at the viewer, but the two girls, pushed to the far corner of the image, are turned to the left as though on the point of leaving the room. The cold, dark shade of the background wall seems to match the black clothes of the three women and also suits their attitude of silence on the verge of emptiness.

EDGAR DEGAS
The Beach
1876, oil on paper,
46 × 81 cm
National Gallery,
London

The somewhat low
point of view creates
the sense that the
artist made the picture
while seated on the
beach at the same
height as the two
figures in the fore-
ground. Those figures
are presented with
casual naturalness,
their gestures reflect-
ing a moment of quiet
relaxation. The colors
are very pale, illumi-
nated by intense light,
as indicated by the
transparency of the
sea in the background.

EDOUARD MANET
On the Beach
1873, oil on paper,
59.6 × 73.2 cm
Musée d'Orsay, Paris

The setting is the
beach at Berck-sur-
Mer; the two charac-
ters are Manet's
wife, Suzanne, and
his brother Eugène.
Comparison with the
Degas painting on the
same subject reveals
the personal differ-
ences in the choice
of light and colors.
There is also the point
of view, which here is
far more close-up than
in the other painting,
almost hanging over
the two figures.

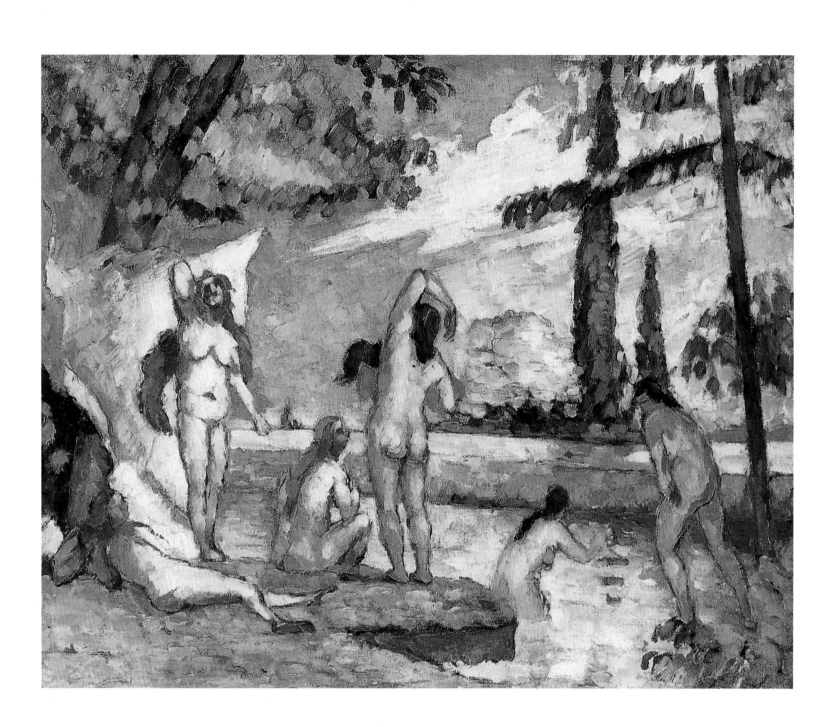

■ PAUL CÉZANNE
Bathers
circa 1874–75,
oil on canvas,
38.1 × 46 cm
Metropolitan Museum
of Art, New York

Between 1874 and
1876 Cézanne is living
in Paris, in Rue de
Vaugirard, but he
spends long periods
in the south of France.
In those months he
makes a series of
about twenty paint-
ings of male or female
nudes immersed in
nature. The artist gives
much importance to
this theme, returning
to it over and over
during the course of
his career. Some crit-
ics, calling attention
to the figures stand-
ing in the water and
the cross-shaped tree
in the background,
have found a religious
message in this work,
a symbol of the
redemption and
purification of sins.

PAUL CÉZANNE
**Self-Portrait
with Hat**
circa 1873–75,
oil on canvas,
55 × 38 cm
The Hermitage,
St. Petersburg

Cézanne gives in to
friendly persuasion
from Pissarro and
agrees to participate
in the first Impres-
sionist show, in 1874.
*The House of the
Hanged Man*, one of
the three works he
exhibits, receives
such negative criti-
cism that two years
later, disappointed
and offended, he
chooses not to partic-
ipate in the second
Impressionist show.
In this canvas he uses
very clear brushstrokes
and accentuates the
contrasts of the
unshaded colors to
create a highly effec-
tive rendering of his
expression, full of
strong character.

■ Paul Cézanne
The Road (The Boundary Wall)
circa 1875–76,
oil on canvas,
50 × 65 cm
Private collection

The intense, warm light that brightens and strengthens the colors of this delicate landscape is a clear demonstration of how well Cézanne assimilates the language and style of Pissarro, with whom he often paints in these years. The broad horizontal strip of the wall and the vertical lines of the trees create a frame for the buildings in the background, whose red roofs stand out so clearly. This is one of the first paintings by Cézanne in which Mont Sainte-Victoire appears, the mountain destined to become the focal point of so many works of his maturity.

GUSTAVE
CAILLEBOTTE
Floor Scrapers
1875, oil on canvas,
102 × 146.5 cm
Musée d'Orsay, Paris

By way of Degas,
Caillebotte meets the
other Impressionists
and displays eight of
his works, including
this one, at their sec-
ond show. In an arti-
cle of April 10, 1876,
in *Le Constitutionnel*,
the critic Louis Enault
admits that "Caille-
botte's scrapers are
not badly painted, and
the perspective is well
presented," but goes
on to regret that the
"artist couldn't do a
better job choosing his
subjects," since this,
in his eyes, is unwor-
thy of being presented
in a painting.

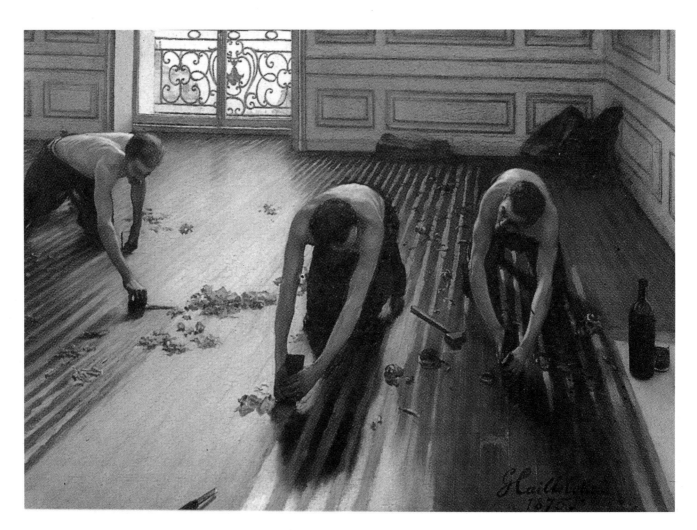

GUSTAVE
CAILLEBOTTE
Floor Scrapers
1876, oil on canvas,
80 × 100 cm
Private collection

This painting on the
same theme as the
above is also displayed
at the 1876 show.
Caillebotte changes
the orientation and
the angle of the
viewer, but maintains
the same illumination
and the same flat, cold
tones. The position
of the workers is the
result of careful study,
as indicated by many
preparatory drawings.
Some critics claim
that the artist also
made use of one or
more photographs,
but no documentation
exists to confirm this
hypothesis.

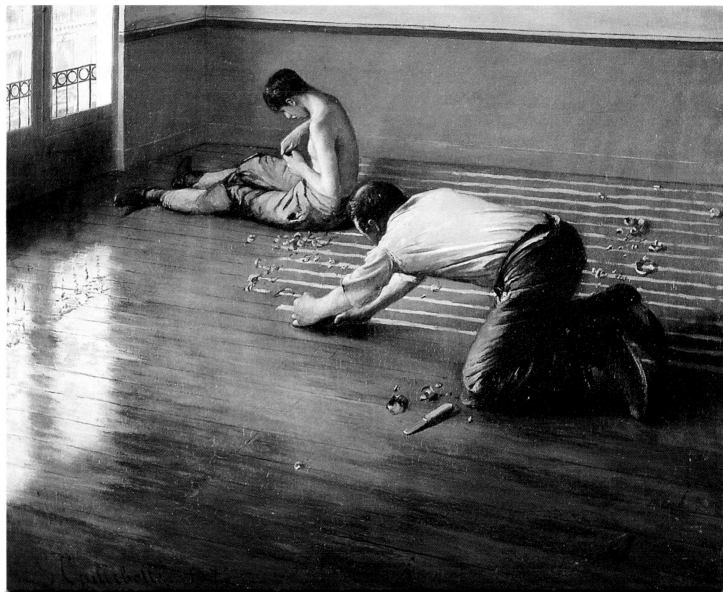

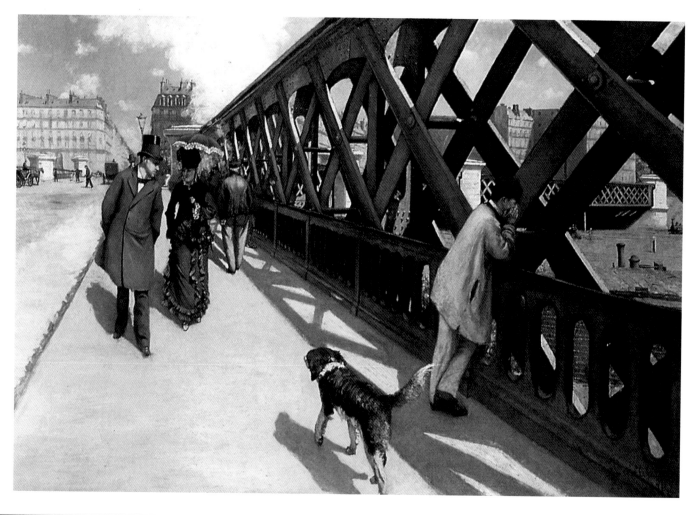

■ GUSTAVE
CAILLEBOTTE
The Pont de L'Europe
1876, oil on canvas,
124.7 × 180.6 cm
Petit Palais, Musée
d'Art Moderne, Geneva

Built a few years earlier, between 1865 and 1868, the Pont de L'Europe had already been painted by other artists, among them Manet, De Nittis, Monet, and Jean Béraud. Caillebotte makes a series of preparatory drawings on the spot and uses them to make the painting in his studio at 77, Rue de Miromesnil. Critics praise his daring perspective, accentuated by the rhythmic crossed-band structure of the metallic bridge.

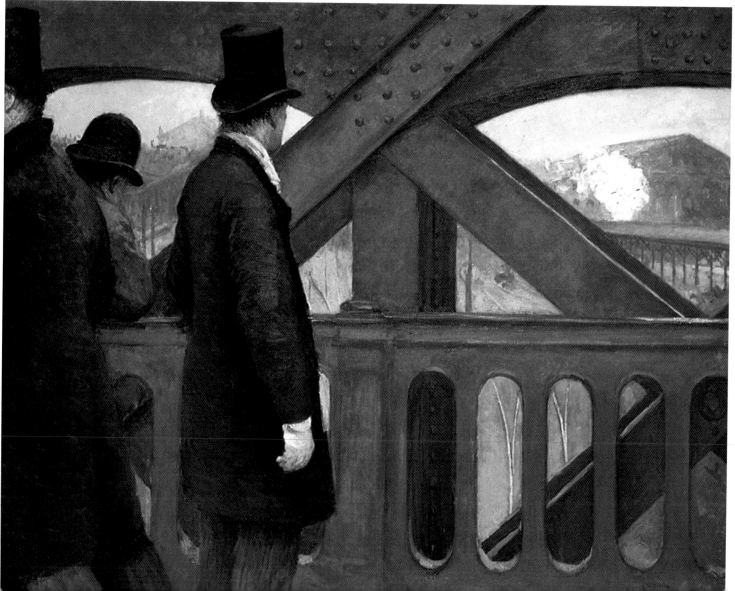

■ GUSTAVE
CAILLEBOTTE
The Pont de L'Europe
1876-77, oil
on canvas,
105 × 131 cm
Kimbell Art Museum,
Fort Worth

Caillebotte never exhibits this painting. It appears only in 1951 as part of a major retrospective in Paris. Critics note a certain resemblance to Manet's painting *The Railway* (page 133). In both works a figure looking toward the Saint-Lazare station is seen almost from behind; furthermore, the man's gaze in this work is directed at the precise spot on the opposite side of the tracks where the child is standing in Manet's painting.

PAUL GAUGUIN
**The Seine near
the Jena Bridge**
1875, oil on canvas,
65 × 92 cm
Musée d'Orsay, Paris

Gauguin is among the
few collectors paying
close attention to
the progress of the
Impressionists, and
he continues to use
the money he earns
on the stock market
to buy their paintings.
In his own landscapes,
both those he makes
together with the
daughter of Arosa,
his tutor, and those
he makes during eve-
ning classes at the
Colarossi academy,
he proves that he has
learned their methods,
although the darker
colors in this work
seem more akin to
works by the painters
of the Barbizon school.
His technique improves
so much that one
of his landscapes is
accepted by the Salon
jury in 1876.

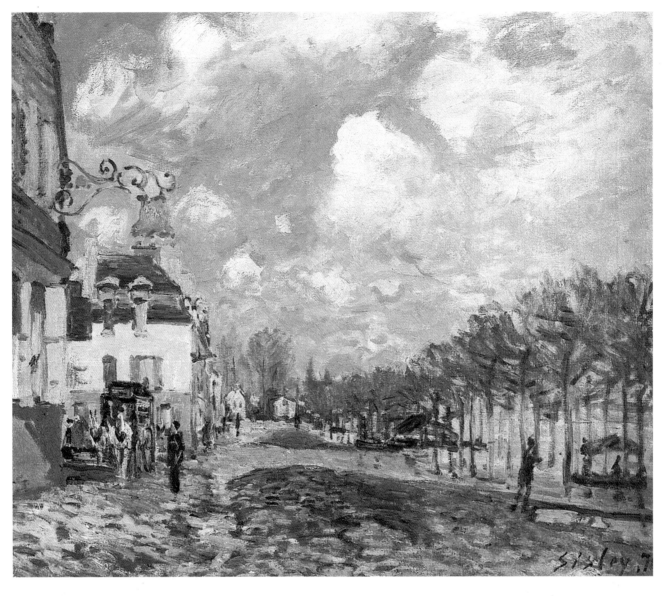

ALFRED SISLEY
Flood at Port-Marly
1876, oil on canvas,
50 × 61 cm
Thyssen-Bornemisza
Collection, Madrid

This is probably the
last of the three
canvases Sisley dedi-
cates to the flood at
Port-Marly; in fact the
water can be seen to
have receded, and
the inhabitants are
returning, although
with difficulty, to their
daily lives. In this
painting the artist
has diluted his paints
to give them increased
transparency and a
limpid luminosity.

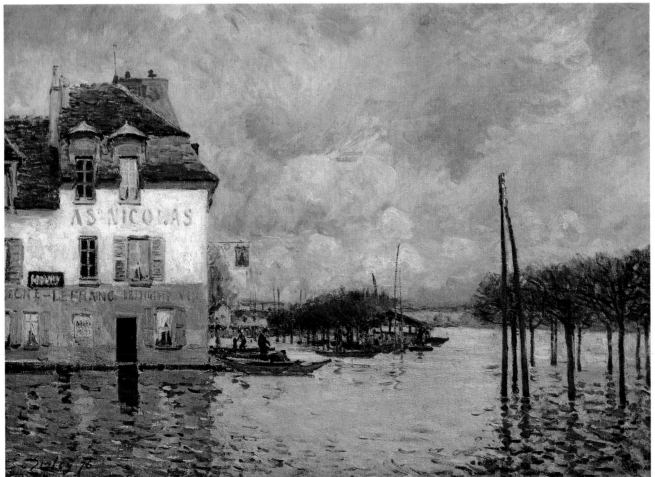

ALFRED SISLEY
Flood at Port-Marly
1876, oil on canvas,
60 × 81 cm
Musée d'Orsay, Paris

In 1876 Sisley is liv-
ing at Marly-le-Roi
and makes several
paintings at nearby
Port-Marly when it is
flooded by the Seine.
He does his best to
reproduce the effects
of light on water and
the reflections of the
gray, cloud-swept sky.
To do so he applies
his paint in small,
individual brush-
strokes, almost paral-
lel one to the next
and narrowing toward
the center.

Almost as though
taken by surprise,
the model is present-
ed in a natural and
at the same time very
intimate moment.
The features of her
face are not clearly
defined; Morisot shows
no interest in her
expression, her sole
desire being to create
an atmosphere of
delicate intimacy.
The dominate color is
white, although other
tints are distributed
with great freedom.
Morisot makes no
effort to correct
small smears or blurs,
as can be seen in the
black velvet ribbon at
the girl's neck or in
her left elbow.

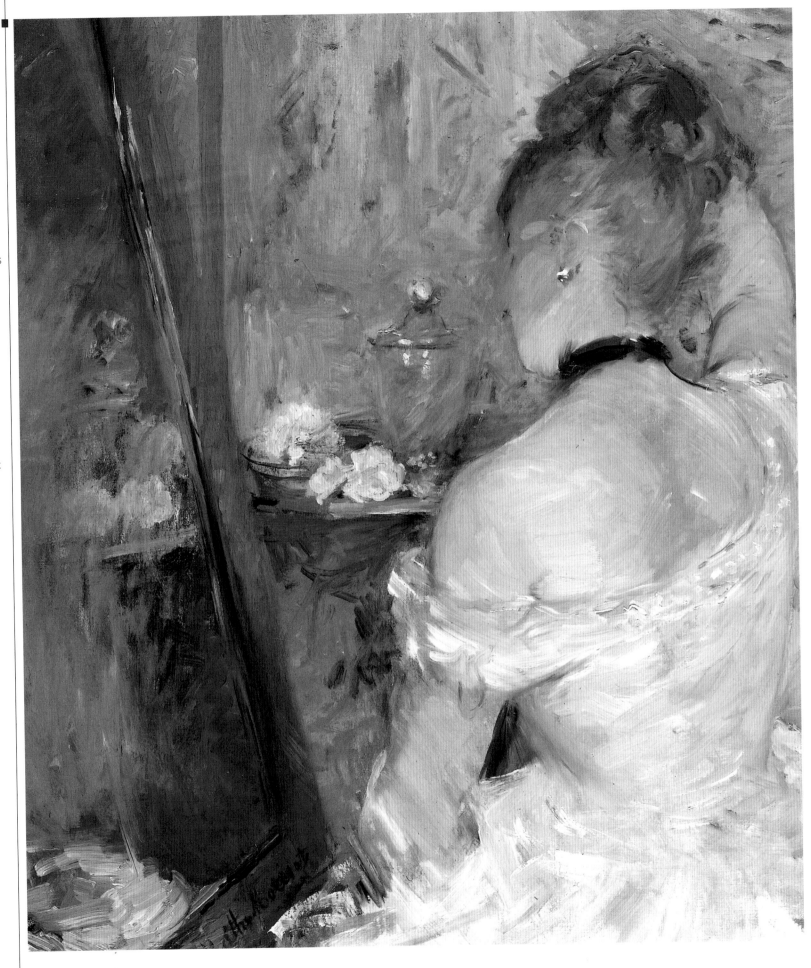

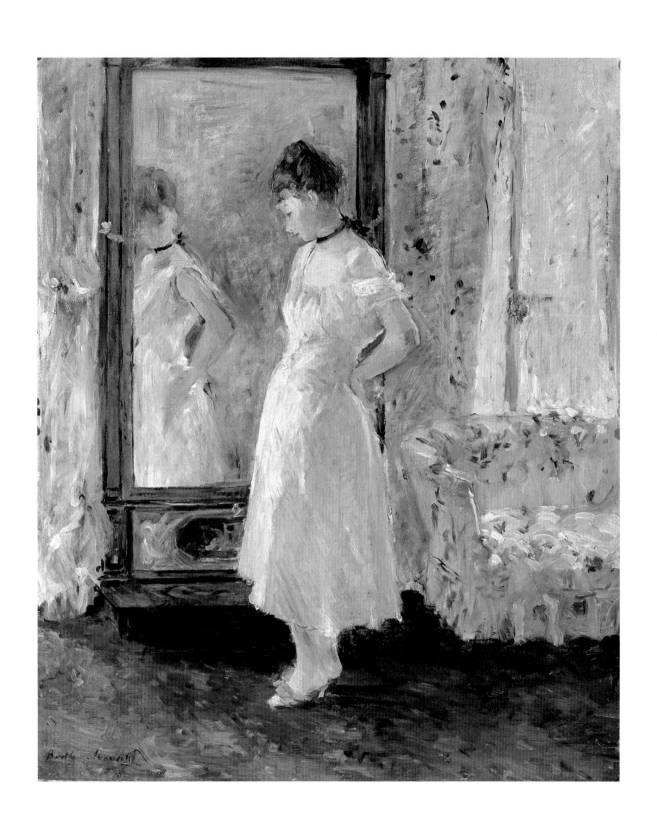

■ BERTHE MORISOT
The Psyche
(The Cheval Glass)
1876, oil on canvas,
76 × 54 cm
Thyssen-Bornemisza
Collection, Madrid

Morisot is enormously
fond of white, in this
case set off by spots
of bright color on the
sofa to the right that
multiply the effects
of the light. Most of
Morisot's paintings are
of similar interiors; as
models she uses her
sister or other relatives,
usually presenting
them in scenes of
daily intimacy.
Extraordinarily sensi-
tive to these images,
she presents them
without emphasis or
rhetoric, employing
instead a slow rhythm
of quiet tones,
closer to prose than
poetry, just barely
darkened by a veil
of melancholy.

Early in 1877 the Impressionists are still getting together at the Nouvelle-Athènes café. Far from discouraging them, the torrent of ferocious criticism leveled at them has only united them further and made them combative, such that they get busy organizing a new show. Since the rooms in Paul Durand-Ruel's gallery where they held their second show are no longer available, they set off in search of a new space. With the help of substantial financial assistance from Gustave Caillebotte, they are able to rent a large empty apartment on the third floor of 6, Rue Le Peletier, a short distance from Durand-Ruel's gallery. After long discussions, and despite Renoir's firm opposition, they decide to refer to themselves as Impressionists and use the name for the show. Of course, critics have long been calling them by that name, and even the public has learned to think of them in that way. It seems wiser to give in rather than risk allowing the journalists time to think up other names. The critics have already tried out a few, such as Intentionalists, Intransigents, Irreconcilables—the last-named coined by Henry James—and even Telegraph-stylists, as the critic Jules Claretie has proposed. On Degas's suggestion they decide not to submit their works to the Salon, for which reason Manet again refuses to join with them, stubbornly convinced of the need to obtain official recognition for his work. In the end there are 18 participants, presenting a total of 240 works, including paintings, watercolors, drawings, and etchings. Fourteen are artists who have participated in past shows: Gustave

Caillebotte (with six works), Adolphe-Félix Cals, Paul Cézanne (with 17), Edgar Degas (with 24), Jacques François, Armand Guillaumin, Léopold Levert, Claude Monet, Berthe Morisot, Camille Pissarro (with 22), Auguste Renoir (with 21), Henri Rouart, Alfred Sisley, and Charles Tillot. Four artists are taking part for the first time: Frédéric Corday and Franc Lamy, both of them friends of Renoir's; Alphonse Maureau, an acquaintance of Degas's; and Ludovic Piette, brought to the show from Pontoise by Pissarro. The show's curator is Alphonse Legrand, former employee of Durand-Ruel and now an art dealer at 22 bis, Rue Lafitte. Of the eight shows the Impressionists eventually give, this is the one that is today considered the most representative of their style, a kind of culmination point of the movement in its original, purest state. Unlike the Salon, where a great number of artists participate, but with a very limited number of works for each (no more than two or three canvases each), the

Impressionist show gives the public the opportunity to see and compare the separate stylistic personalities of the artists. In the Salon, the paintings are exhibited in alphabetical order, according to size, or even according to the amount of influence the individual artist is able to exert, such that visitors find themselves confronted with a chaotic mixture of differing subjects and styles. At the Impressionist show, on the other hand, the arrangement is carefully orchestrated, with the works of each painter set apart to offer a clear, understandable overview of the artist's development. The opening of the show gives the Impressionists

The collector Ernest May in his apartment in Faubourg Saint-Honoré.

the opportunity to bring to fruition an idea that dates back to the long, heated discussions they had in the Café Guerbois before the Franco-Prussian War: the plan to start their own newspaper in which to defend and promote their ideas. Using some of the money from Caillebotte, they entrust the task of coordinating the journal to Georges Rivière (1855–1943), a young official in the finance ministry, a writer, art critic, amateur journalist, and friend of Renoir's. Thus is born *L'Impressionniste, Journal d'Art*, four issues of which are published between April 6 and 28, the period the

show. Théodore Duret, in his column, focuses on the confused reaction of the public; according to him, the paintings displayed awaken nothing but "outbursts of laughter, contempt, indignation, and disgust." Another critic, Roger Ballu, writes, "One must see the paintings by Monet and Cézanne to get an idea of what they are: children playing with paper and paints must certainly do better!" On the pages of *Le Pays*, George Maillard writes (his exaggerated tone typical of critics writing about Impressionists): "Many of the paintings on display would throw the horses pulling omnibuses into panic. Their brushstrokes are brutal, their execution is without sense, and the absence of logic in their compositions makes them thoroughly revolting: one doesn't know whether to collapse in a state of desperation or to split one's sides from laughter." Attendance on the part of the public is poor, and from the financial point of view the

1877 Third Show

show is open. The publication's principal goal is to ward off the attacks of critics while also explaining the artists' true aesthetic and poetic ideals to the public. Rivière writes almost all of the articles himself, with the help of the painters, in particular Renoir. The first edition includes a letter to the editor of *Figaro*, protesting the openly hostile position taken by its art critic, Albert Wolff. Later issues take on the journalists of *Le Sportsman* and *La Petite République Française*, while expressing gratitude to the critic of *Petit Parisien*, who has the courage to stand up for the Impressionists. Sad to say, the paper reaches only a very limited number of readers and does nothing to hold back the tidal wave of negative criticism, including the enormous number of satirical, mocking, and derisive cartoons aimed at their

LE PEINTRE IMPRESSIONNISTE.
— Madame, pour votre portrait il manque quelques tons sur votre figure. Ne pourriez-vous avant passer quelques jours au fond d'une rivière?

result of the show is once again a failure. This is a serious blow to some of the participants, who find themselves in serious financial difficulties.

Renoir, Sisley, and Pissarro, with the assistance of Caillebotte, entrust some of their paintings to Alphonse Legrand and *Commissaire Priseur* Tual to try a second auction, held May 28, at the Hôtel Drouot. A report published in the satirical newspaper *Le Charivari* claims that the presentation of the works at the auction was disturbed by whistles and shouts from the public, and in fact many of the people who show up prove to be hostile. The journalist goes on to relate an episode, perhaps invented, in which one of the paintings was put on display upside-down, a story intended to prove that the landscapes of the Impressionists are so confused that no one can tell the water from the ground or the sky.

Les peintres impressionnistes pouvant doubler l'effet de leur exposition sur le public, en y faisant exécuter de la musique de Wagner.

LE PEINTRE IMPRESSIONNISTE.

— Mais ce sont des tons de cadavres?
— Oui, malheureusement je ne peux pas arriver à l'odeur!

This little tale, suitably rewritten and adapted, goes on to become one of the comedy skits presented in the *café-concerts*: a penniless painter—an unmistakable allusion to the Impressionists—struggles without success to sell his paintings, which are so poorly executed that even he cannot tell which side is up and which down. As happened following the previous show, the Impressionists again find themselves, very much against their will, in the middle of the ongoing political struggle between republicans and monarchists. Several monarchists show up in person during the auction, shouting that the Impressionists are "Communards!" At this auction too the prices are extremely low, the works going for an average price of just over 150 francs, with many works withdrawn for lack of buyers or bought back by the artists themselves because the offers are simply too low to be accepted. The 16 paintings by Renoir sell for a total of 2,500 francs, and all together the 45 works put up for auction bring the modest sum of 7,610 francs. The time has not yet come for an accurate financial assessment of their creations, but it is also true that in that same month of May, France is going through one of its most serious periods of crisis, and the public's attention is directed at far more pressing concerns. On May 16, President MacMahon, seeking to repress the growing republican trend affirmed in the elections of 1876, demands the resignation of the republican premier Jules Simon and puts in his place the monarchist Jacques-Victor Albert de Broglie. Broglie forms a government composed of right-wing businessmen, claiming they will guide the nation back to financial well-being, but the new government also makes possible the restoration of the monarchy. With this end in mind, on June 25, 1877, MacMahon decides to dissolve the chamber of deputies and hold new elections; the elections are held in October, and the republicans succeed in further strengthening their position, so much so that two years later MacMahon is forced to resign as head of state.

For the Impressionists, the closing months of 1877 are a particularly difficult time, not so much because of the national economic crisis as because of the lack of confidence and the discouragement, which begin to undermine their enthusiasm. Yet it is precisely in those months that they lay the groundwork for their eventual success. In a letter to Pissarro, Théodore Duret writes, "You have succeeded after quite a long time in acquiring a public of select and tasteful art lovers, but they are not the rich patrons who pay big prices. . . . I am afraid that before getting to where you will readily sell for 1,500 and 2,000 you will need to wait many years . . . People who know what it's all about and who defy ridicule and disdain are few, and very few of them are millionaires." The fate of the Impressionists is to be governed by collectors. They are the emerging figures of importance, the new leaders of the art market. The majority are well-to-do members of the middle class who have put together capital, sometimes after starting out with nothing, through hard work in business or industry. Their tastes and cultural interests are completely different from those of the nobility. Few of them are familiar with scholarly pursuits, and they do not recognize their world in the values and ideals championed by the official artists of the Salon; they are completely indifferent, if not actually hostile, to scenes set in antiquity, to mythological or biblical allegories. There is also the simple fact that those canvases are often quite large, far too large to fit the walls of the new middle-class homes built in accordance with the urban designs of Baron Haussmann. These new buyers want subjects drawn from their lives, they want a different pictorial style in a language they can understand and appreciate. So it is that they turn to the Impressionists, first to have portraits made but later because they have grown accustomed to their style, to their original use of light and color, to the simple poetry of their landscapes. While their style may well be somewhat ingenuous, it is also worlds away

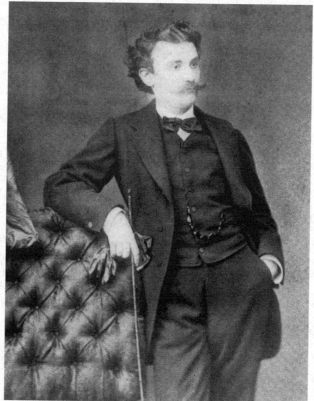

Georges Charpentier—a major collector of Impressionist paintings—and his wife, Marguerite. The photos were taken in 1875.

major collector of their works, such that he comes to possess 900, including drawings and paintings. There are also, among others, the rich businessman Ernest May, who proves a generous friend in times of need; Jean-Baptiste Faure, the celebrated baritone at the Opéra, who is a personal friend to many Impressionist painters; Paul-Octave Gauguin; Emile Blémont; and Félix-François Dépreaux.

from the tired, repetitive rhetoric of the Salon. Among the first collectors are Ernest Hoschedé, director of a chain of large stores; Victor Chocquet, customs official; the architect Jacques Le Coeur; and Eugène Murer, owner of a pastry shop and a restaurant where the Impressionists often meet. Another important figure is Georges de Bellio, born in Bucharest in 1828; in 1850, after getting a medical degree, he moves to Paris, where he specializes in homeopathic medicine and numbers Manet, Pissarro, Monet, Sisley, and Renoir among his patients. In 1874 he visits the first Impressionist show and buys Monet's *Seine at Argenteuil*. In 1878 he succeeds in buying Monet's *Impression: Sunrise* for only 210 francs, and at his death, in 1894, he is the owner of 150 Impressionist canvases, many of which his daughter, Dunop de Monchy, donates to the Musée Marmottan in Paris. Equally important is Georges Charpentier, son of Gervais, the well-known publisher who, since 1838, has been printing a series of books at particularly low prices, favoring their widespread popularity among all social classes. When Georges takes over direction of the publishing house from his father, he entrusts the literary side of it to Zola. He also opens his drawing room to leading writers, editors, musicians, actors, intellectuals, and artists, and beginning in 1875 he buys paintings by Renoir, Monet, and other Impressionists. In 1879 he publishes a magazine, *La Vie Moderne*, which dedicates much space to their works; he also opens a gallery that presents individual shows: for Renoir, his favorite painter, in 1879, for Monet and Manet in 1880, for Sisley in 1881. There is Henri Rouart, who takes part in seven Impressionist shows as a painter and becomes a

The apartment of Georges de Bellio. Passionate art collector, De Bellio is a homeopathic doctor who treats several Impressionist painters free of charge.

PIERRE-AUGUSTE
RENOIR
**Portrait of
Jeanne Samary**
1877, oil on canvas,
56 × 46 cm
Pushkin State Museum
of Fine Arts, Moscow

The famous actress
Jeanne Samary
debuted at age
eighteen at the
Comédie Française.
Renoir meets her in
the home of the
publisher Georges
Charpentier and for
several months they
enjoy an affectionate
friendship. This por-
trait is made striking
by its intensity, by
the sweetness and
depth of the sitter's
gaze as she looks
directly at the viewer.
The pale background
is well matched to the
color of the woman's
hair and brings out the
color of the elegant
evening gown. Several
years after the show,
the painting is bought
by the actress's hus-
band, Paul Lagarde.
In 1903 it is ceded
to Paul Durand-Ruel,
who the next year
sells it to the Russian
collector Ivan
Morozov.

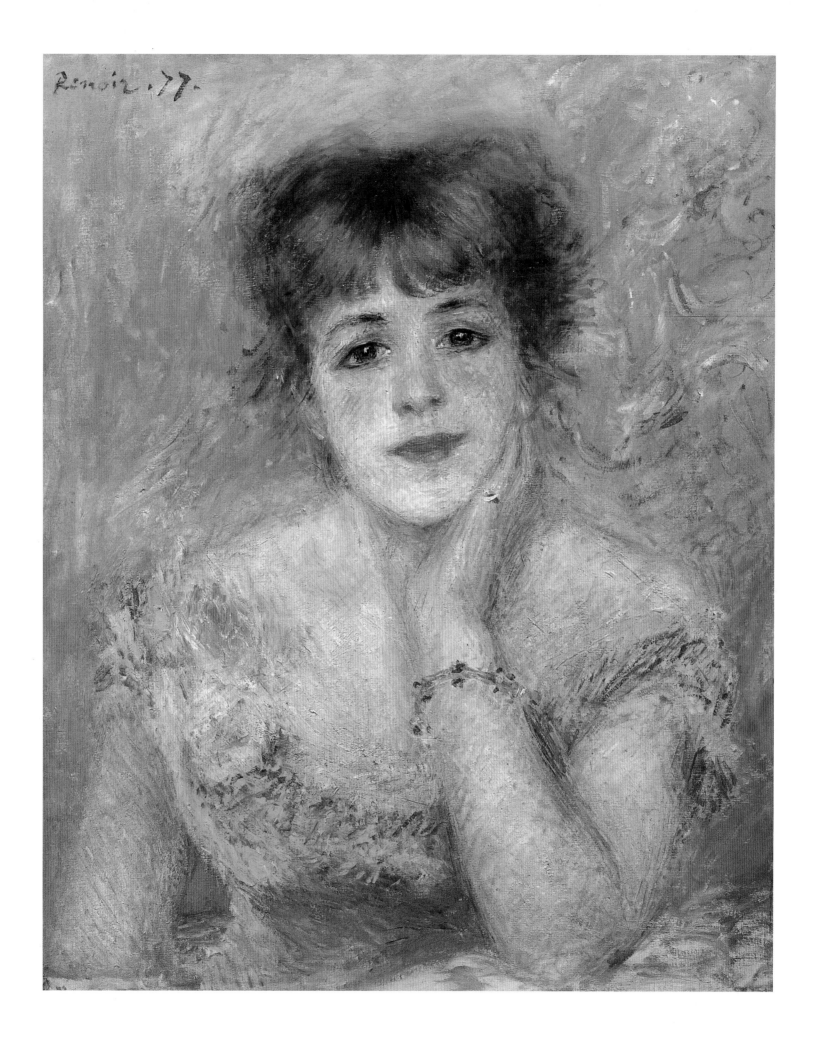

1877

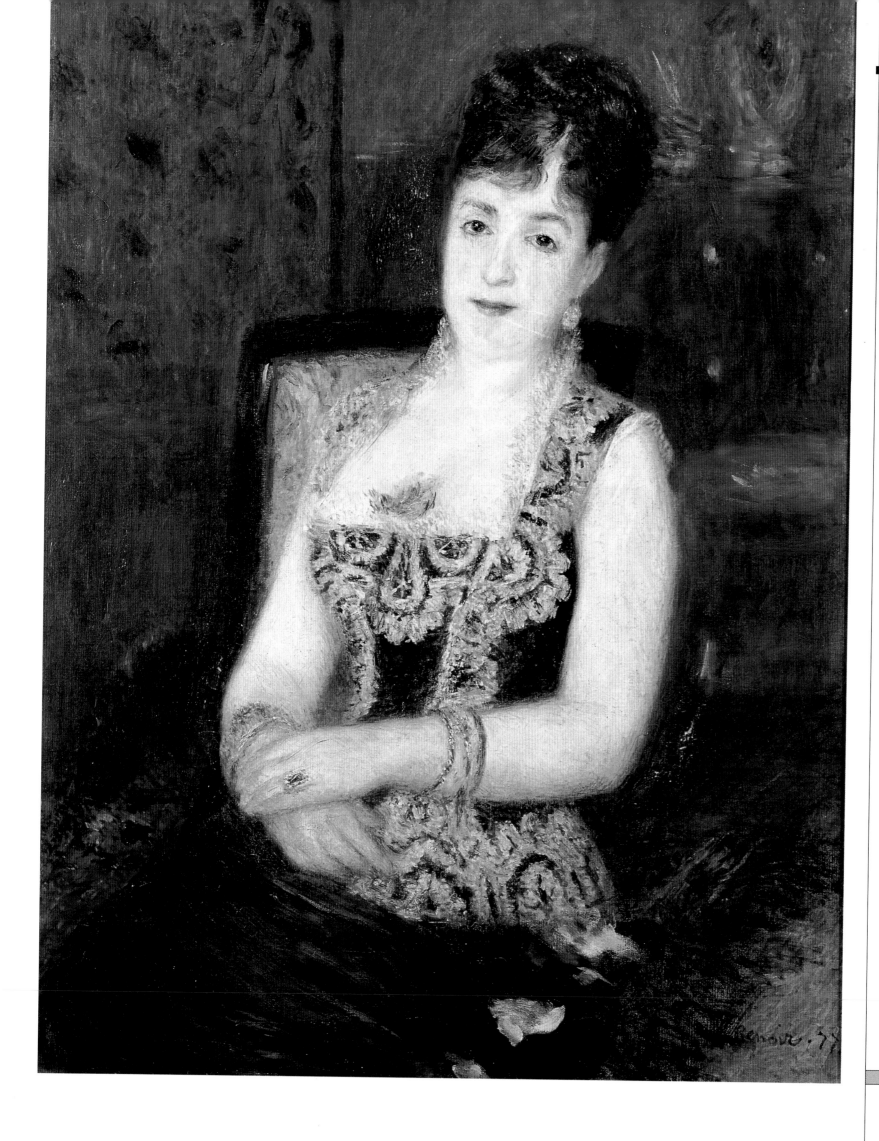

PIERRE-AUGUSTE
RENOIR
**Portrait of the
Countess of Pourtalès**
1877, oil on canvas,
95 × 72 cm
Museu de Arte,
São Paulo

The poor sales of
paintings at the third
show and then at the
auction at the Hôtel
Drouot are partly com-
pensated by a series
of portraits commis-
sioned of Renoir by
several major col-
lectors, helping to
mitigate his difficult
financial situation.
In this painting he
chooses a classic,
traditional arrange-
ment that brings to
mind the poses of
figures by Ingres. He
dedicates particular
attention to the com-
plex decoration of the
countess's dress and to
her expression, at once
sweet and maternal.

1877

PIERRE-AUGUSTE
RENOIR
**Portrait of
Eugène Murer**
1877, oil on canvas,
46 × 38 cm
Walter H. Annenberg
Collection, Rancho
Mirage, California

Eugène Murer (1845–
1906), owner of a
pastry shop and
restaurant at 95,
Boulevard Voltaire,
is a school friend
of Guillaumin, who
introduces him to the
other Impressionists.
He buys their paint-
ings, forming a col-
lection that comes
to include 15 works
by Renoir, eight by
Cézanne, 25 by
Pissarro, 10 by Monet,
28 by Sisley, and 22
by Guillaumin. Later
he buys a hotel in
Rouen where he is
host to Pissarro and
meets Monet, who
is living in nearby
Giverny. During the
last years of his life
he dedicates himself
to literature and
painting, enjoying a
modicum of success.

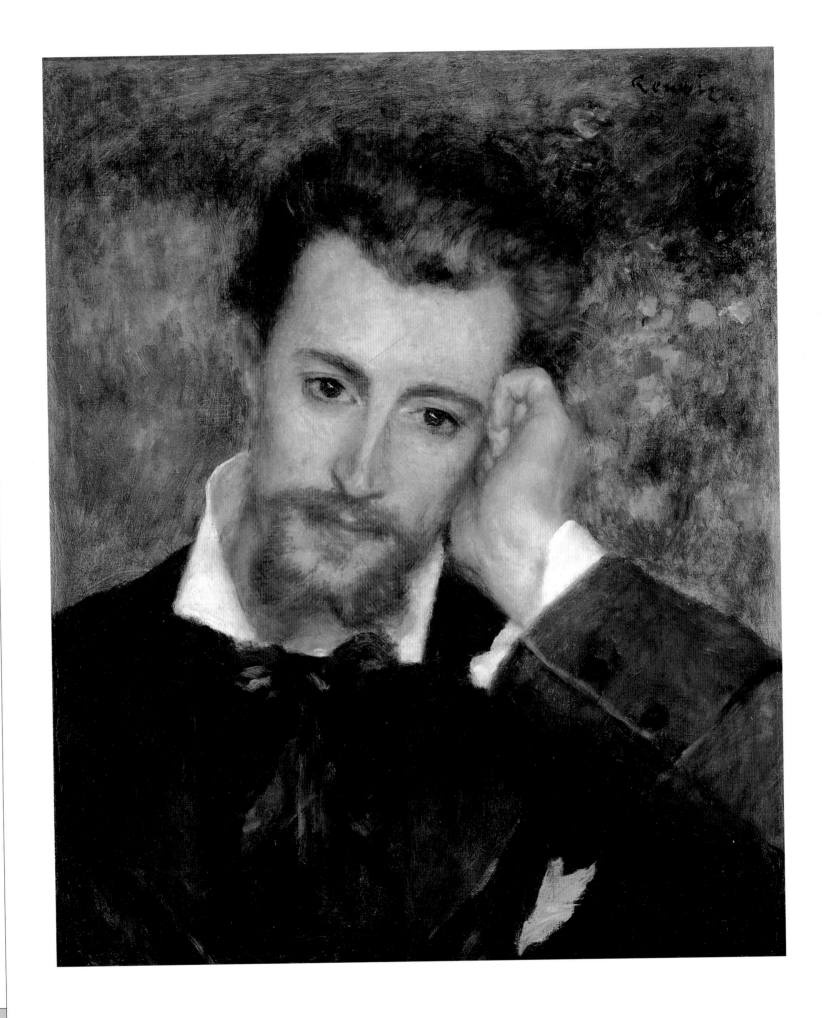

1877

180

Third show

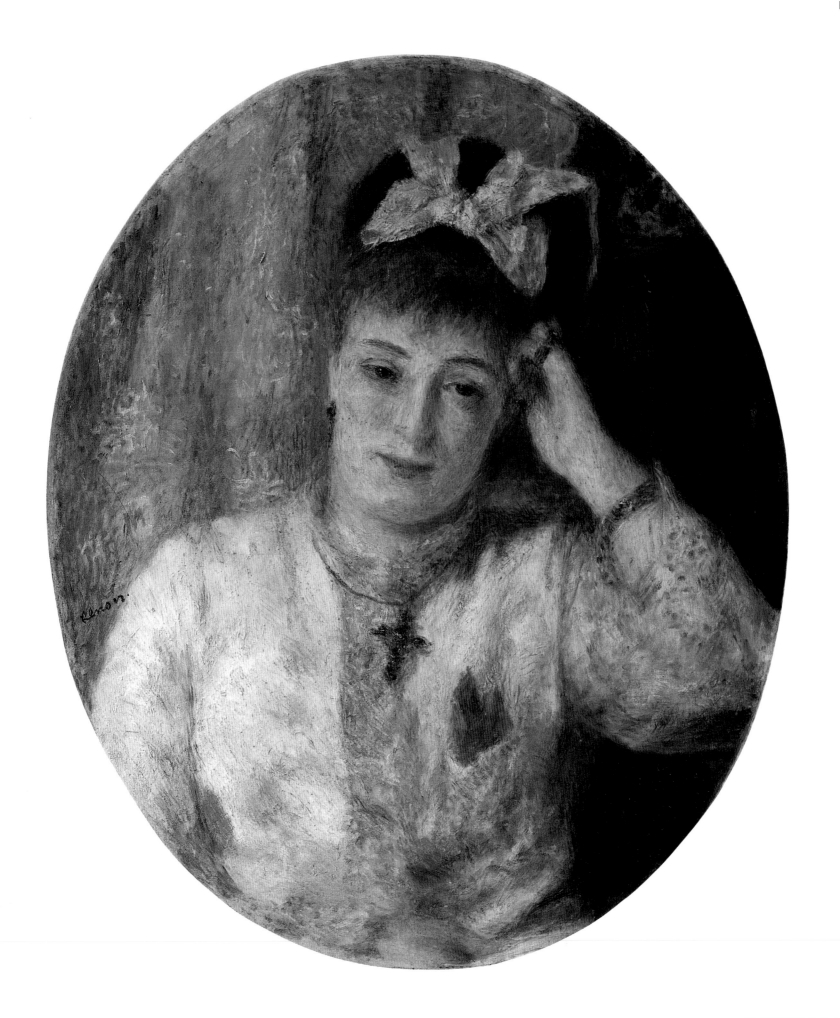

PIERRE-AUGUSTE
RENOIR
**Portrait of
Marie Murer**
1877, oil on canvas,
67 × 57 cm
National Gallery of
Art, Washington, D.C.

On Wednesday evenings the Impressionist painters have a standing invitation to dine at Eugène Murer's restaurant, where he is assisted by his sister Marie. In 1877 he commissions Pissarro and Renoir to decorate the restaurant with frescoes and also commissions them to make two portraits of his sister for 100 francs. Renoir presents her in the same thoughtful, melancholy pose he used for her brother. The point of view is less close-up, and he uses a slightly larger, oval canvas. The colors are less bright, and the illumination is softer.

CLAUDE MONET
**The Corner of
the Garden at
Montgeron**
1876–77, oil
on canvas,
172 × 192 cm
The Hermitage,
St. Petersburg

During the summer
of 1876, returning
to Argenteuil, Monet
meets the financier
and collector Ernest
Hoschedé (1839-90),
who invites him to
his residence at
Montgeron. Hoschedé
commissions Monet
to make several land-
scapes and a series
of decorative panels,
including this one,
which the painter
makes in later months.
The composition is
dominated by the
lively colors of the
flowers, which stand
out against the plant
background composed
of an enormous variety
of shadings of green.
The very pale sky con-
trasts with the dark
water of the pond.

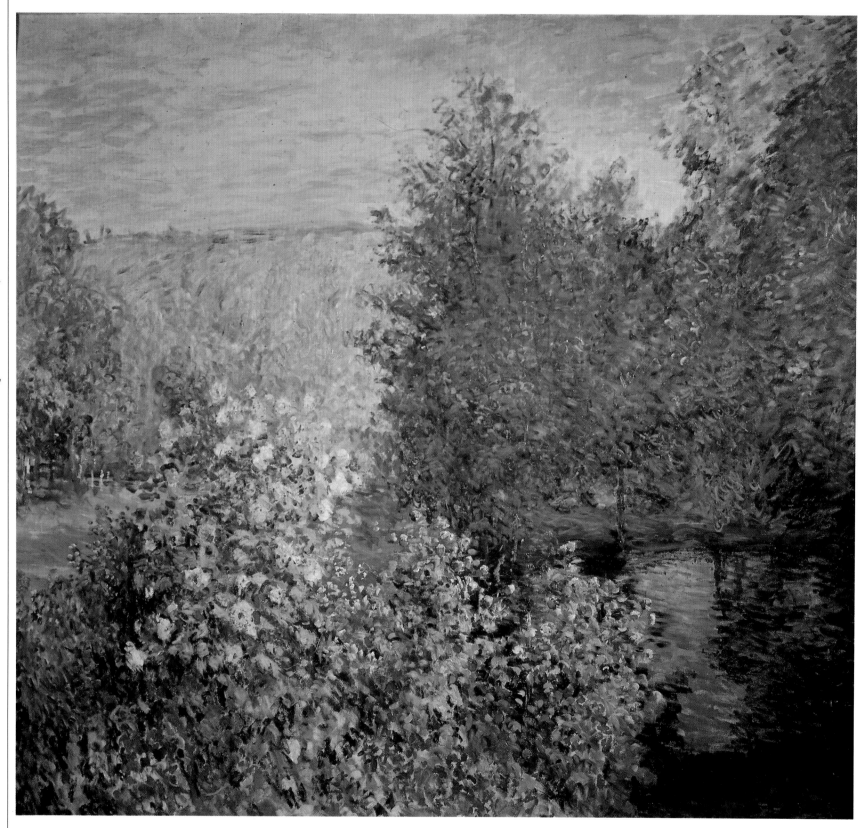

1877

Third show

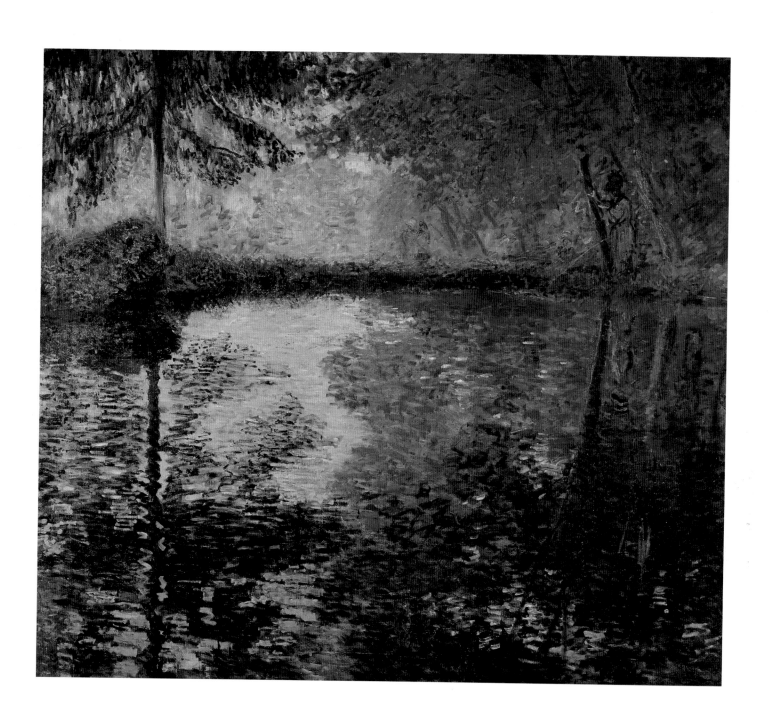

■ CLAUDE MONET
Pond at Montgeron
1876–77, oil
on canvas,
172 × 193 cm
The Hermitage,
St. Petersburg

This painting consti-
tutes a true artistic
accomplishment on
the part of Monet,
for the protagonist of
the work is the light,
which filters through
the dense foliage and
is reflected off the
motionless water
of the pond. Monet
applies the brush-
strokes in parallel
lines, at times super-
imposed one on the
next, at times slightly
separated, forming
areas of alternating
darkness and light.
Just visible in the
background, blending
into the trees, is a
female figure, per-
haps Alice, Ernest
Hoschedé's wife, who
becomes Monet's
friend and confidante,
then his lover, and
finally his second wife.

CLAUDE MONET
**Gare
Saint-Lazare**
1876–77, oil
on canvas,
60 × 80 cm
The Art Institute,
Chicago

The end of 1876 finds
Monet planning to
make a series of views
of Paris on foggy days;
he mentions his plans
to a critic friend and
is discouraged by his
objections. Even so,
he is fascinated by
the smoke of locomo-
tives. Having obtained
permission from the
station master, he sets
up his easel at Saint-
Lazare, one of Paris's
seven train stations,
which occupies a vast
area of the Batignolles
district. Here he makes
a dozen canvases,
from different points
of view and under
different conditions
of light; he exhibits
seven of these at the
third Impressionist
show and later sells
them to Durand-Ruel.

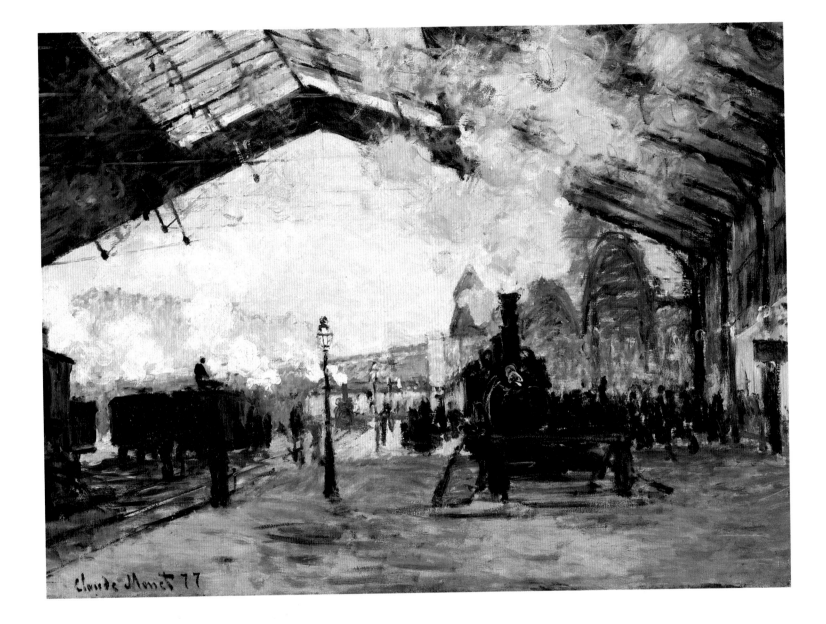

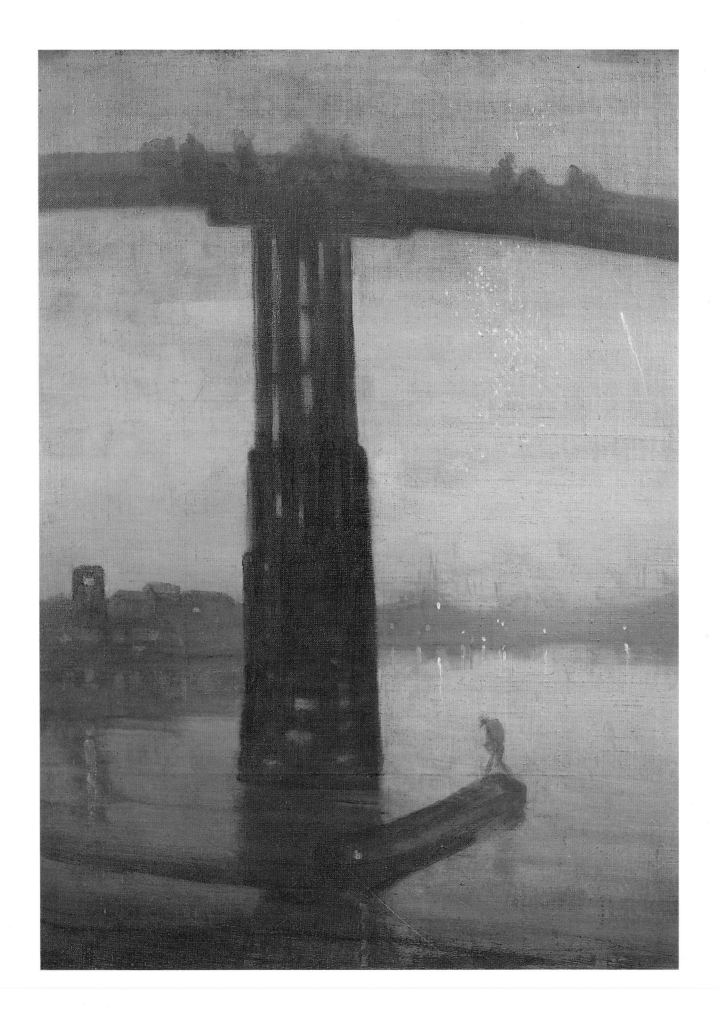

JAMES WHISTLER
Nocturne in Blue and Gold: The Old Bridge at Battersea
1872–77, oil on canvas, 68 × 50 cm
Tate Gallery, London

Begun in 1872 and finished in 1877, this canvas reveals Whistler's affinity with the Impressionists, particularly Monet. The painter presents this and other *Nocturnes* at the Grosvenor Gallery in London, but they are understood by neither the public nor the critics. Standing out among the most hostile of the critics is John Ruskin, who uses very strong words to condemn Whistler's work. Whistler takes the critic to court and wins, but only after a long legal process, the costs of which leave him bankrupt. He is forced to sell his own home and to put up at auction his paintings and collection of Oriental art.

1877

EDGAR DEGAS
L'Etoile (The Star; Dancer on Stage)
1876–77,
pastel on paper,
58 × 42 cm
Musée d'Orsay, Paris

Degas usually prefers to show groups of ballerinas while practicing or during moments of rest off-stage. Here instead he concentrates his attention, along with that of the viewer, on a prima ballerina presented alone in the foreground of the stage and transformed into a symbol of feminine beauty. The unusual presentation from above emphasizes the grace and elegance of the dancer's movements. One notes the skill with which Degas renders the airiness of the white tutu, set off by the black ribbon at her neck and by the delicate touches of yellow and red of the flowers.

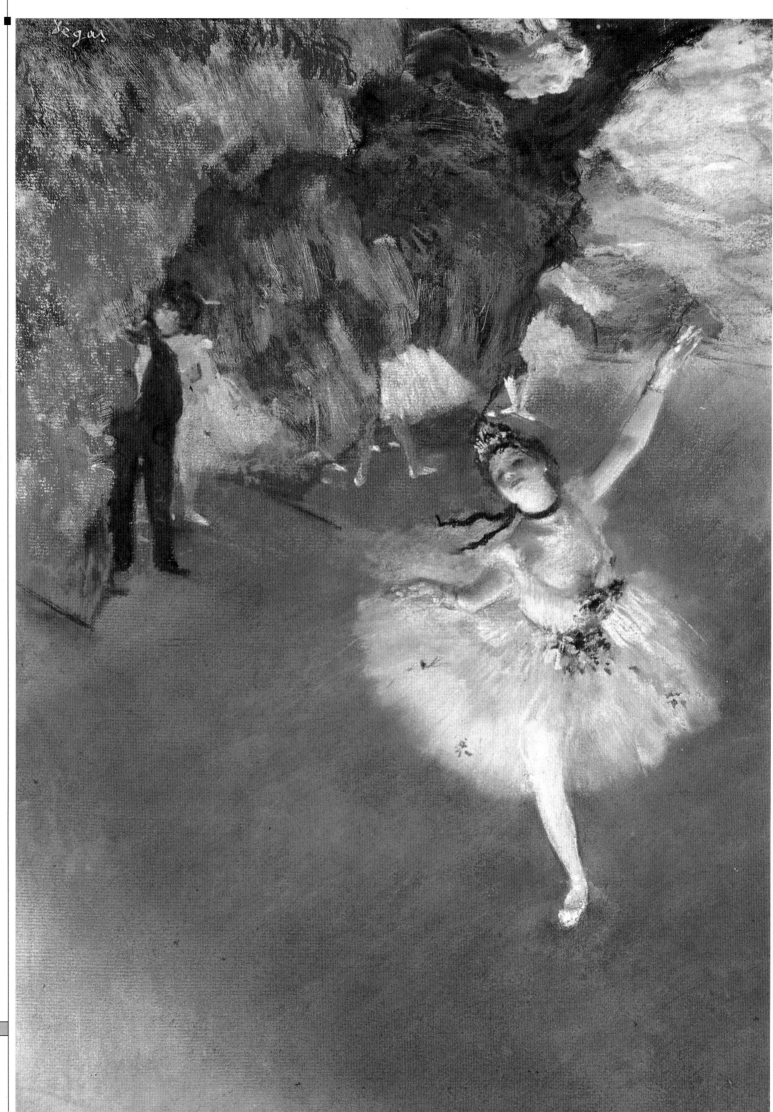

1877

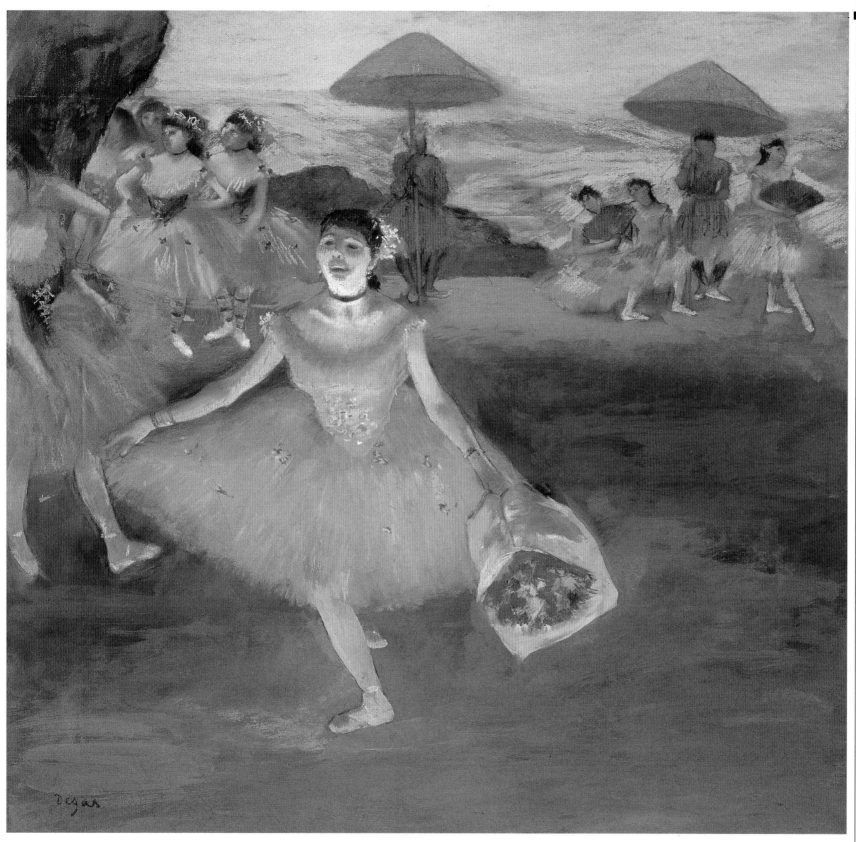

EDGAR DEGAS
Ballerina with Bouquet
circa 1877, pastel and gouache on monotype,
72 × 77.5 cm
Musée d'Orsay, Paris

Illuminated by theater spotlights, the ballerina, having finished her performance, curtsies to thank the applauding public. On her face can be read the satisfaction for the test she has passed, repaying the sacrifices made. Meanwhile behind her other ballerinas are leaving the stage, making room for others who begin setting up for the next scene. Degas captures them in this unguarded moment, communicating to the viewer their rapid, fleeting gestures, making skillful use of the shadings of pastels to fill in the areas of chiaroscuro.

Edgar Degas
The Song of the Dog
circa 1876–77, pastel
and gouache on
monotype,
57.5 × 45.4 cm
Private collection

The title of the paint-
ing is the title of the
song, then quite pop-
ular, being sung by the
singer, mimicking as
she does so the song's
hero by drooping her
hands like paws and
opening her mouth to
pant. The scene is
almost certainly the
Café des Ambassadeurs,
an open-air spot on
the Champs Elysées
frequented by the well-
to-do middle class and
loved by Degas. The
singer is Emilie Béchat,
known for the jerky
movements like those
of a marionette with
which she accompa-
nies her songs. The
bright light from
the Chinese lanterns
brings out her heavy
makeup, making her
face look much like a
grotesque mask.

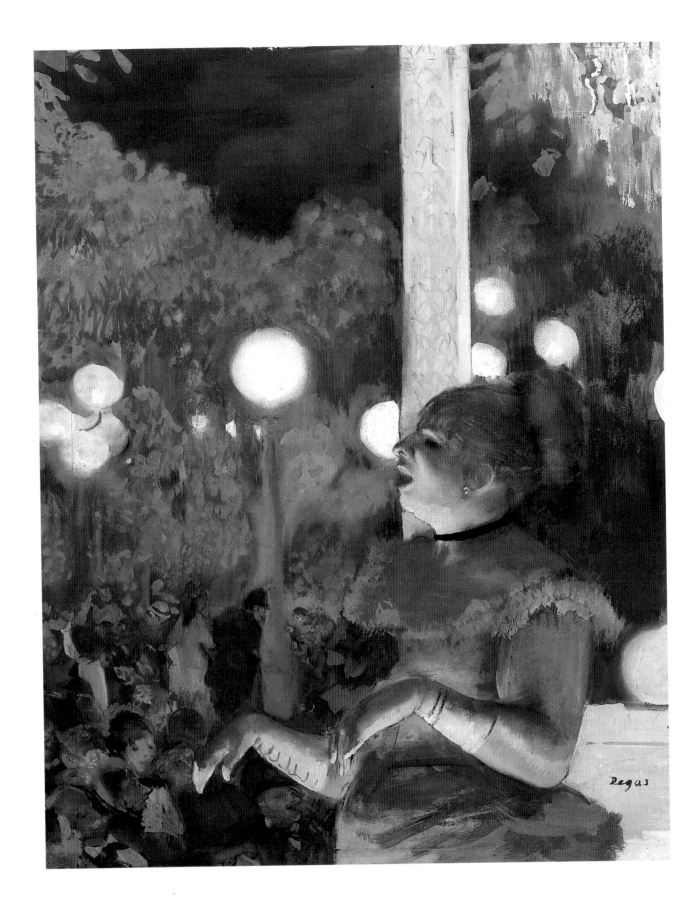

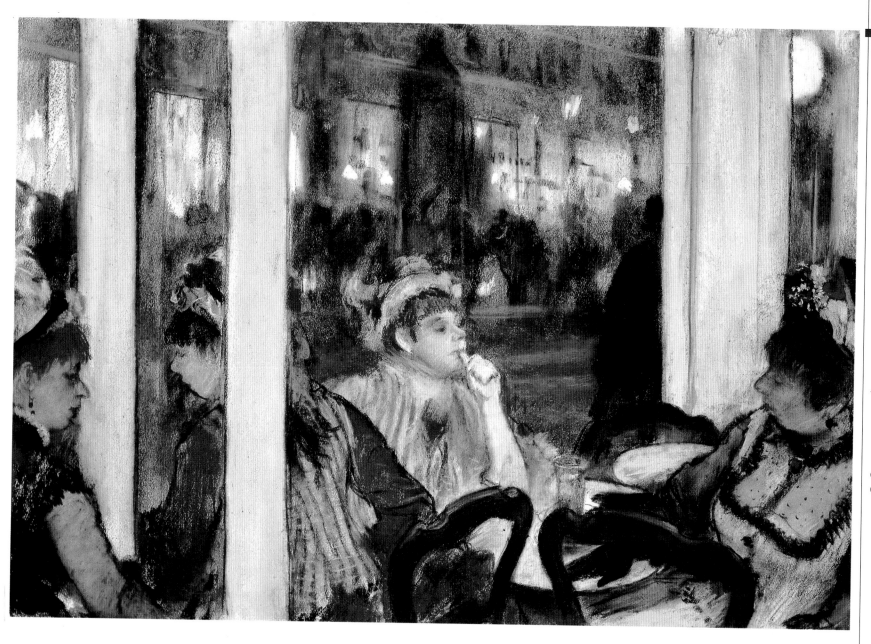

■ EDGAR DEGAS
Women on the Terrace of a Café in the Evening
1877, pastel on paper, 41 × 60 cm
Musée d'Orsay, Paris

Groups of figures in a café interior are one of Degas's favorite themes; he sees them as accurate mirrors of modern society. He observes his characters with close attention and presents them as he sees them, not posed but caught with spontaneous immediacy. Like the naturalistic novelists of the same years, he seeks to avoid moralistic judgments and limits himself to presenting reality. In this painting he uses a limited range of colors to render the special evening atmosphere of a café interior.

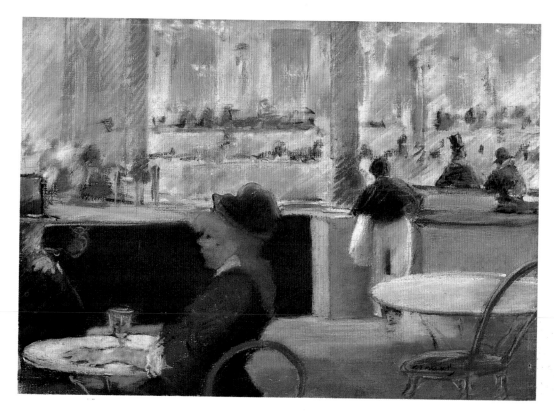

■ EDOUARD MANET
A Café in Place du Théâtre Français
1881, pastel on paper, 32.4 × 45.7 cm
Museum and Arts Galleries, Burrell Collection, Glasgow

In this pastel Manet traces the figures with a quick, incisive line. The structure of the interior is carefully reconstructed, with a balance struck between the vertical lines of the columns and the horizontal lines of the counters and tabletops.

1877

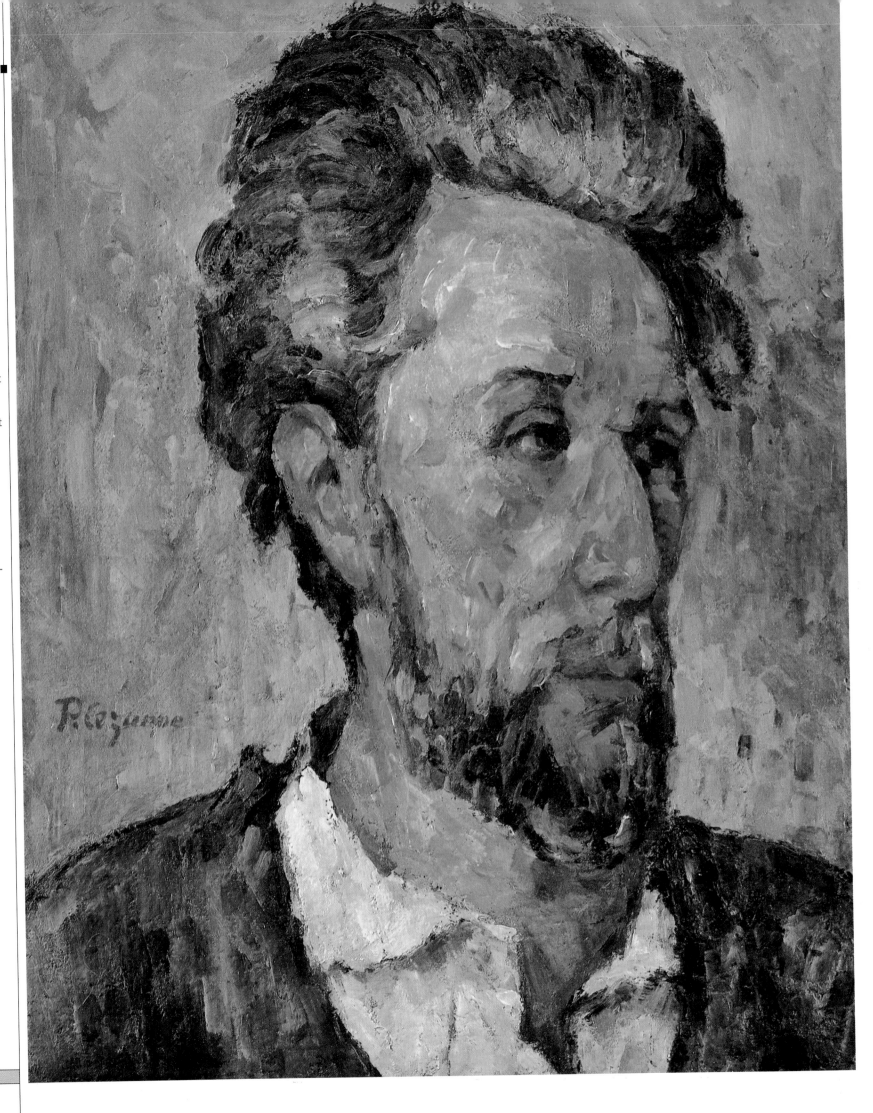

PAUL CÉZANNE
Victor Chocquet
1877, oil on canvas,
35 × 27 cm
Paul Mellon Collection,
Upperville, Virginia

In 1875 Renoir takes
Victor Chocquet to Père
Tanguy's shop to show
him the paintings by
Cézanne displayed
there. The customs
official is a collector
of art and one of the
first patrons of the
Impressionists. He is
enormously taken by
their paintings, and
Cézanne becomes his
favorite artist; by the
time he dies, Chocquet
will have bought 32
paintings by Cézanne.
The artist makes a first
portrait of Chocquet
in 1875 (today in the
Winterthur Museum),
then another two
between 1876 and
1877, the works
shown on this page
and opposite. Here
Cézanne reveals his
uncommon psycholog-
ical insight, giving
the character a noble
and austere bearing.

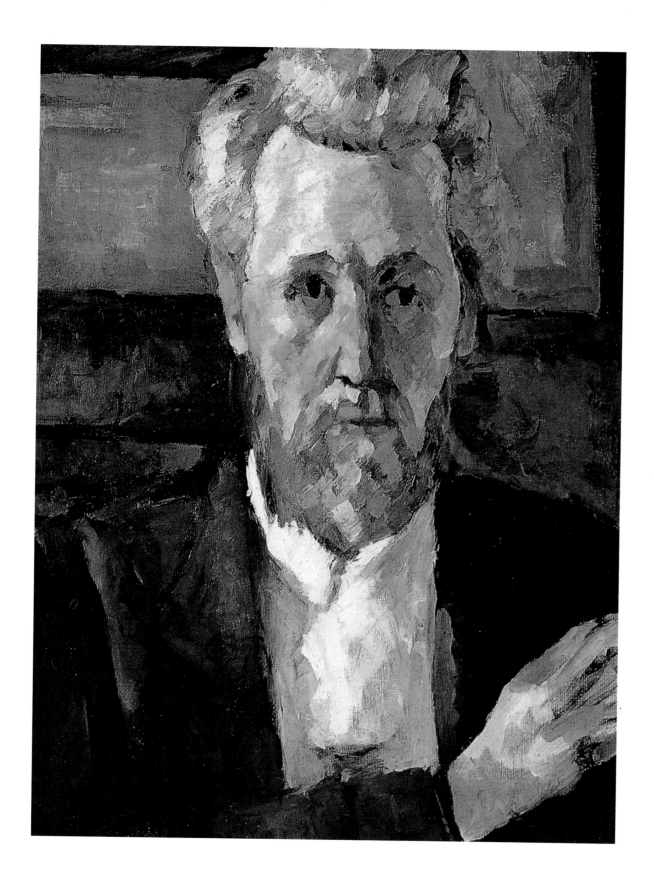

■ PAUL CÉZANNE
Victor Chocquet
1876–77, oil
on canvas,
46 × 36 cm
Private collection

This is almost certainly the portrait of Victor Chocquet that Cézanne exhibited at the third Impressionist show in 1877. The public was particularly impressed by the thick, vigorous brushstrokes, the strong colors, and the sitter's striking features, emphasized by the close-up point of view. Critics, however, once again took pains to point out presumed defects, nicknaming the work "Billoir in chocolate," a reference to a certain Billoir who in those same weeks was very much in the news, accused of having committed a savage murder.

PAUL CÉZANNE
Houses (Roofs)
1877, oil on canvas,
47 × 59 cm
Hahnloser Collection,
Berne

In 1877 the friendship
between Cézanne
and Pissarro grows
stronger. The two
painters often portray
the same subject or
make several varia-
tions on the same
theme. Doing so makes
it much easier for
them to make stylistic
comparisons, allowing
them to refine and
amplify their technical
skills. In this view,
somewhat unusual for
those years, Cézanne
can be seen carrying
out a study of volumes,
paying attention to
the relationships
among shapes while
seeking an illumination
capable of rendering a
sense of the depth of
space by means of
design and color.

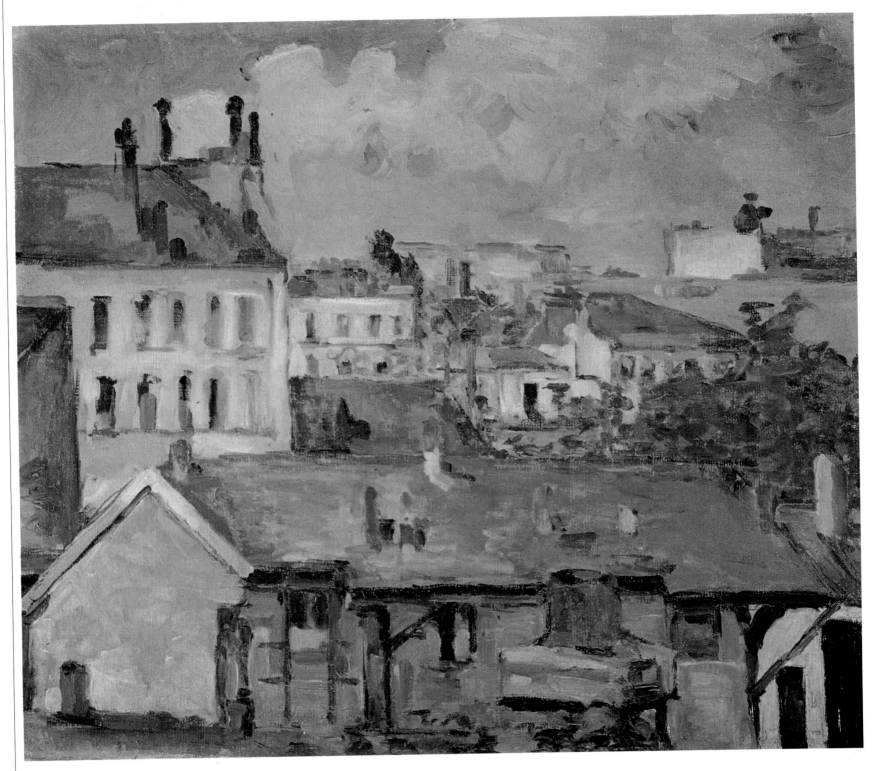

1877

Third show

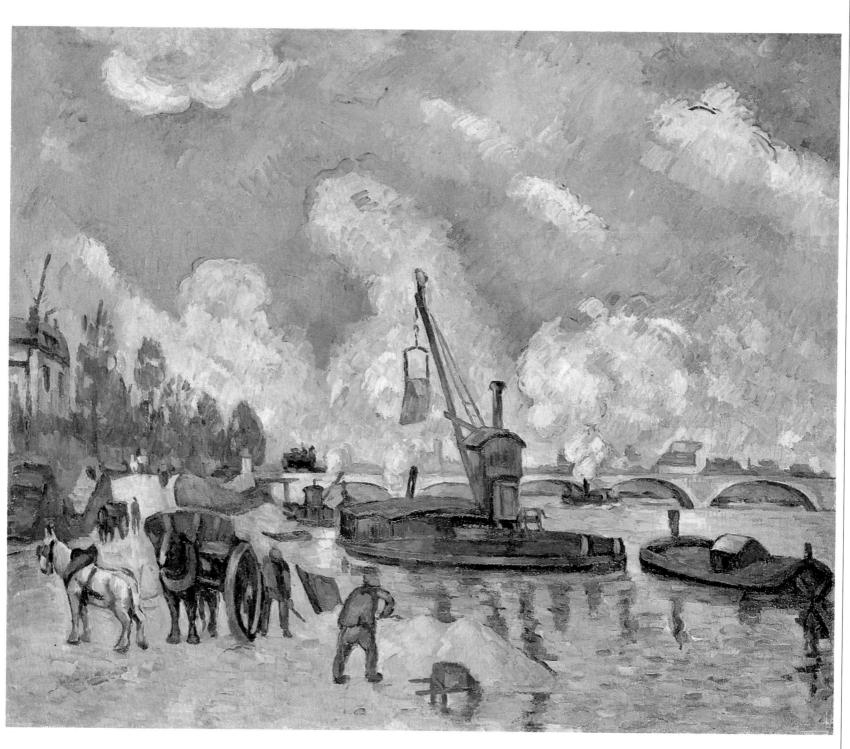

■ PAUL CÉZANNE
On the Banks of the Seine at Bercy
1876–78, oil
on canvas,
59 × 72 cm
Kunsthalle, Hamburg

This painting clearly displays how Cézanne's palette gradually liberated itself from the dark, opaque tints of his youthful production to take on the luminous, brilliant tones taught to him by Pissarro. Here he applies the paint in short, parallel brushstrokes, overlapping them until he has obtained the desired effects. In some areas he makes use of the wet-in-wet technique, applying a layer of paint atop or beside another layer before it has completely dried.

1877

193

Third show

PAUL CÉZANNE
**Apples, Bottle,
and Tureen**
1877, oil on canvas,
65 × 81.5 cm
Musée d'Orsay, Paris

The close attention
Cézanne applies to
reality and his desire
to transform the most
mundane objects of
daily life into poetry
are especially evident
in his still lifes, the
purpose and also the
culmination of his
experiments with
space. It is in still
lifes, more than in any
other genre, that he
most clearly reveals
his personal style and
establishes a perfect
harmony with the
viewer. The individual
elements of the com-
position are illumi-
nated by direct light
without shadow, which
sharply delineates the
colors one from the
next. Cézanne repro-
duces three paintings
in the background,
one of them, on the
farthest left, is a land-
scape by Pissarro, its
presence an obvious
homage to his friend
and mentor.

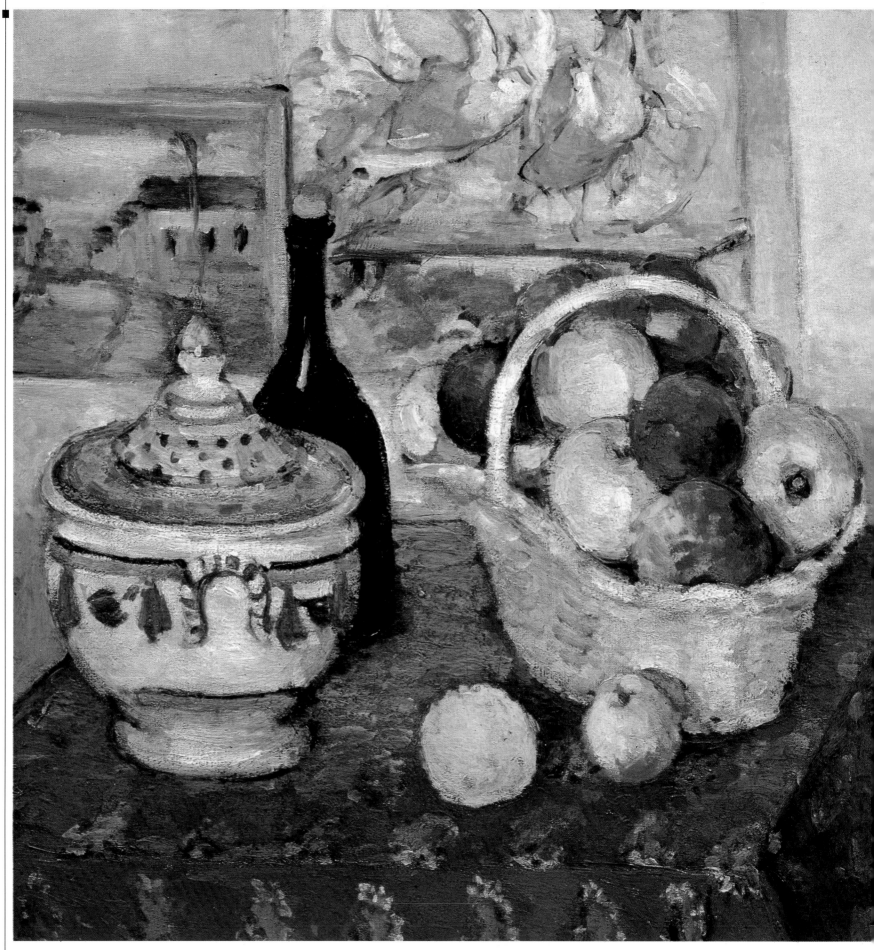

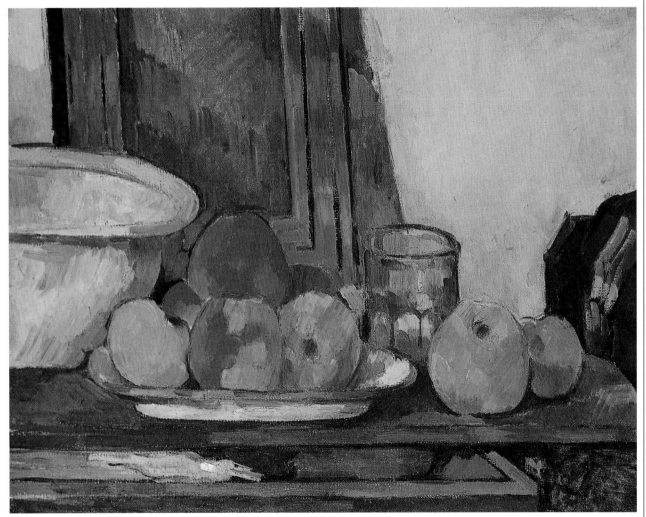

■ PAUL CÉZANNE
**Still Life with
Open Drawer**
1877–79, oil
on canvas,
33 × 41 cm
Private collection

In 1877 Cézanne lets Pissarro persuade him into presenting 17 works in the third Impressionist show. The public is indifferent, but the critics, with the single exception of his friend Georges Rivière, are openly hostile and unanimously reject him. Bitterly disappointed, he decides to never again take part in a group show and withdraws, almost to the point of isolation, to carry on his pictorial experiments alone. Most of all he dedicates himself to the effects of light on objects, as in this still life, made between 1877 and 1879.

PAUL CÉZANNE
**Madame Cézanne
Leaning on a Table**
1873–77, oil
on canvas,
61 × 50 cm
Private collection,
Geneva

This is one of the
many portraits
Cézanne makes of
his wife. He meets
Hortense Fiquet in
1869, perhaps when
she works for him as
a model, and they
begin living together,
a fact he hides
from his father. On
January 4, 1872, they
have a son, Paul, and
once again the painter
hides the fact from
his father. Six years
later, when the father
finally learns of the
relationship, he does
everything in his power
to end it, going so
far as to reduce the
monthly check that
permits Cézanne to
dedicate himself full-
time to painting. Only
a few months before
dying does Cézanne's
father finally consent
to the wedding,
which takes place on
April 28, 1886.

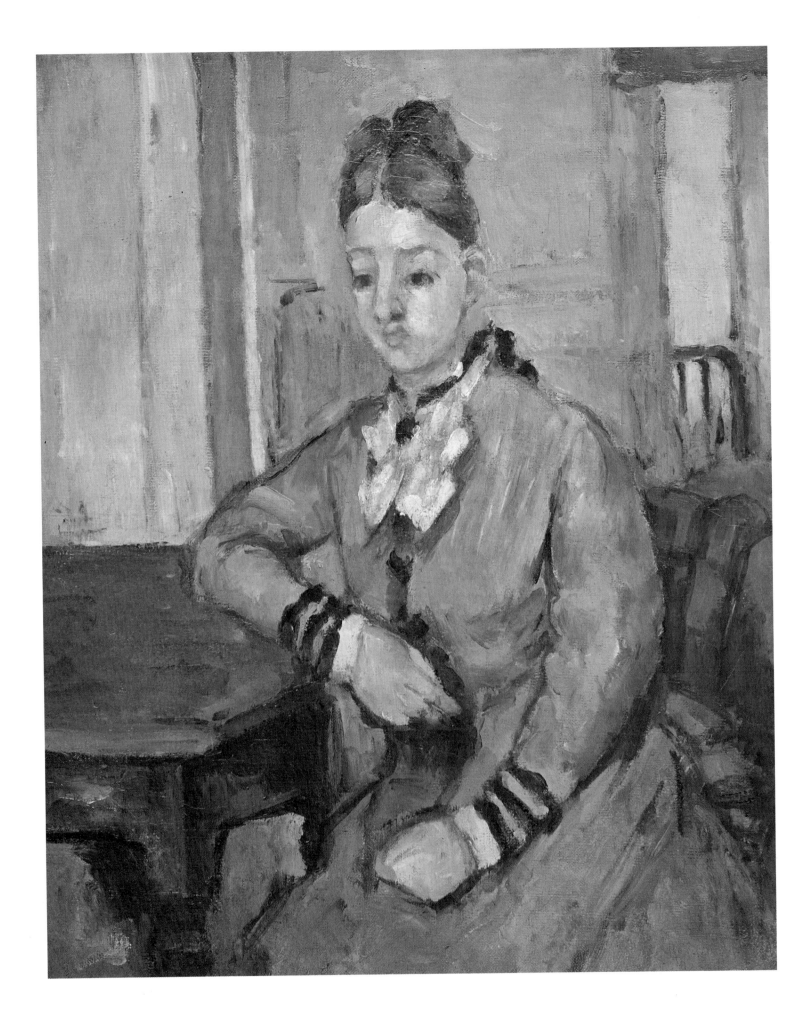

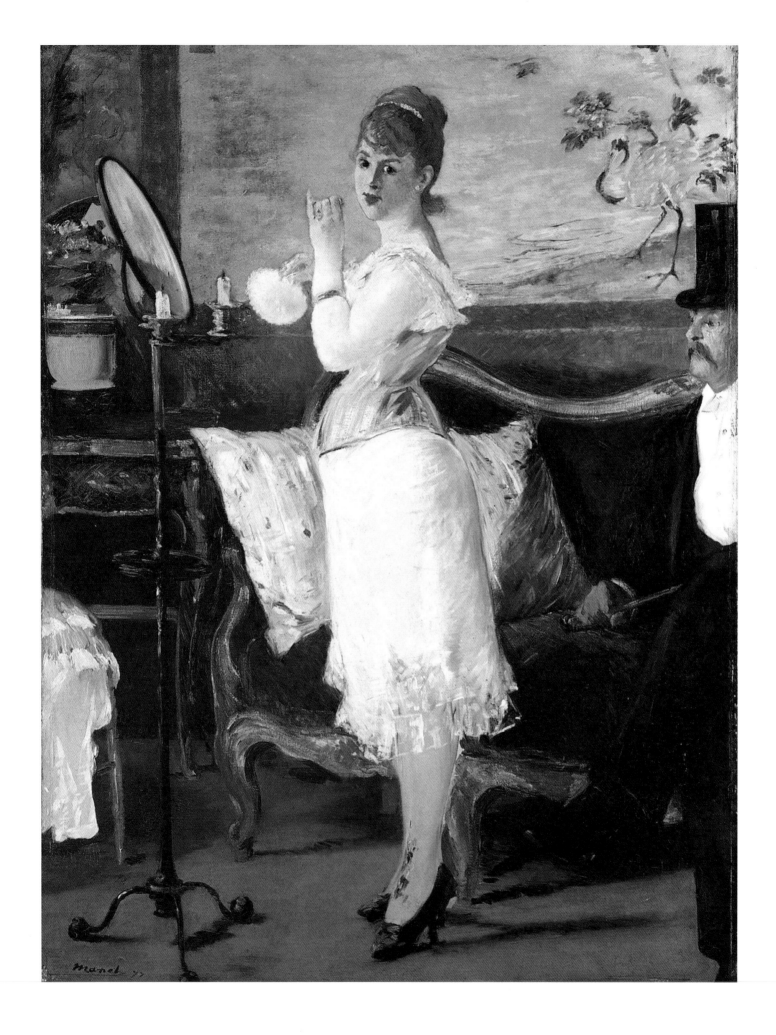

■ EDOUARD MANET
Nana
1877, oil on canvas,
150 × 116 cm
Kunsthalle, Hamburg

The model for the seated gentleman at right has never been identified, but the girl is Henriette Hauser, well known soubrette and paramour of the prince of Orange. The title of the painting is probably inspired by a character in Zola's *L'Assommoir*, published in installments in those months; the character was soon to have a novel of her own, *Nana*, published in 1879. The painting is rejected by the jury of the Salon, who consider it an outrage to morals. When the painter has it displayed in the window of Giroux's shop on the Boulevard des Capucines, several critics ask for the police to intervene and have it removed.

EDOUARD MANET
Portrait of
Antonin Proust
1877, oil on canvas,
183 × 110 cm
Pushkin State Museum
of Fine Arts, Moscow

The subject of this
splendid portrait is
Antonin Proust
(1832–1905), school
friend of Manet's at
the Rollin College in
1842 and friend for
life. He begins his
career as a journalist,
founding the peri-
odical *La Semaine*
Universelle, then
becomes involved
in politics, first as
secretary to Léon
Gambetta, then hold-
ing various posts in
the Third Republic,
including that of min-
ister of fine arts in
1881-82 and commis-
sioner of fine arts at
the universal exhibi-
tion in Paris in 1889.
He does whatever
he can to assist his
friend Manet, and in
1881 succeeds in
obtaining the Legion
of Honor for him.

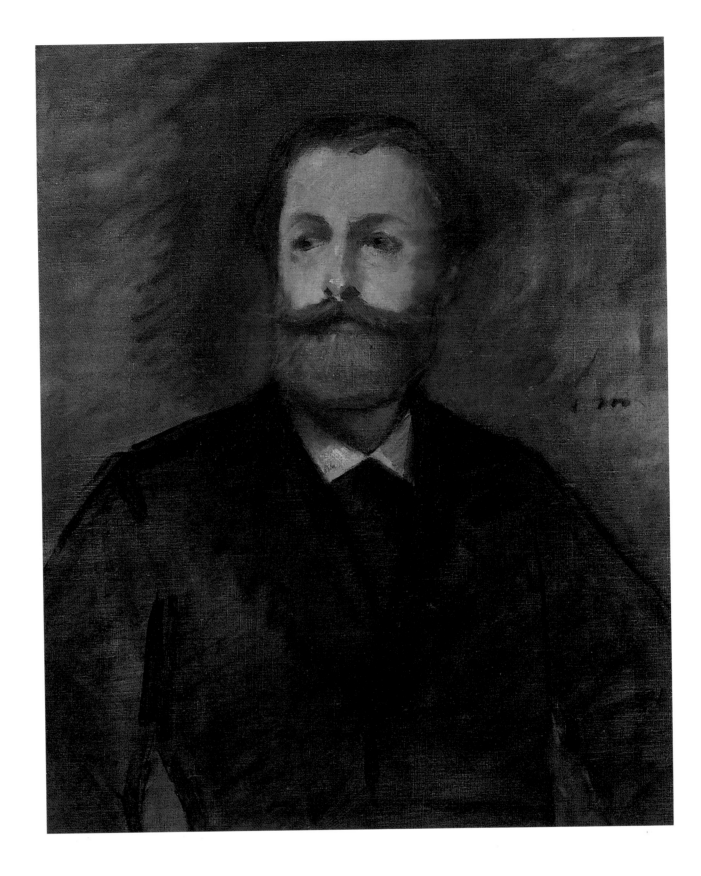

GUSTAVE
CAILLEBOTTE
Paris Street
1877, oil on canvas,
212.2 × 276.2 cm
The Art Institute,
Chicago

Large in size and large
in terms of its visual
impact, this painting
is the main attraction
of the third Impres-
sionist exhibition. The
painter makes many
preparatory drawings,
going over and over
even the smallest
detail, and the great
skill he displays is not
overlooked by critics,
who praise the work.
On one level the com-
position is broken
down into an alterna-
tion of triangles (the
slices of sky, shapes
of the umbrellas) and
rectangles (windows
and paving stones).
The street lamp
divides the scene in
two: to the left the
gaze is lost in the
distance, while to
the right it runs into
the pair of strollers,
who are projected off
the canvas into the
viewer.

1877

For France, the outstanding event of 1878 is almost certainly the universal exhibition held in Paris. The new republican government is eager to win back international prestige and to demonstrate to the world that the nation has fully recuperated from its humiliating defeat at the hands of the Prussians. To avoid controversy and useless, if not potentially damaging, rivalry with the Salon, the organizers of the exhibition decide not to exhibit paintings by living artists. Caillebotte does everything in his power to mount a new Impressionist show, scheduled to take place in the month of June, at the same time as the universal exhibition. But the disappointment and discouragement brought on by the failure of the previous year's show are still acute, and despite his

efforts the project is shelved. Cézanne has withdrawn alone to Estaque, his only ties with the world visits to his sick mother in Aix-en-Provence and stormy encounters with his father, who has discovered his secret relationship with Hortense Fiquet and the birth, in 1872, of his son, Paul. Manet too more or less keeps to himself and even decides against presenting works to the selection committee of the Salon, convinced that doing so would only mean a humiliating rejection. Renoir is more fortunate; his painting *The Cup of Chocolate* is accepted by the jury and exhibited at the Salon in May. So positive is the critical reception of this work that it attracts the attention of the publisher Georges Charpentier, who commissions several portraits from him. Monet is

Hiroshige II, *The Bridge of Kintaikyo at Iwakumi*, circa 1858. Takahashi Collection, Japan.

1878•1879

forced by a shortage of funds to leave Argenteuil and return to Paris, to 26, Rue d'Edimbourg; here, in the month of March, his wife, Camille, gives birth to a second son, Michel. On April 29, Jean-Baptiste Faure, one of the first collectors of Impressionist paintings, consigns 42 paintings to the *Commissaire Priseur* Pillet to be sold under the expert supervision of the critics Brame and Petit at an auction in the Hôtel Drouot: most of the works fail to find a buyer, and the few taken by bidders go for very low prices. In the same period Ernest Hoschedé is forced by his debts to declare bankruptcy. By order of the bankruptcy court he sells off his collection of paintings in an auction on June 5-6, again at the Hôtel Drouot. The sale is directed by the *Commissaire Priseur* Dubourg; the catalog, edited by Petit and George, covers 138 lots: 108 paintings, 13 watercolors, two sculptures, and 15 prints, including five works by Manet, 16 by Monet, 13 by Sisley, and nine by Pissarro. Once again the works are greeted by cries of derision from the public, and the few bidders courageous enough to stand up to the mocking pay only a few francs for the works. Faced with such a difficult situation, the

Impressionists seek help among their few faithful collectors as well as the paint merchants willing to take paintings in exchange for canvases, paints, and other artistic materials. One of these is "Père" Martin (1810–80), who begins his relationship with the Impressionists at the end of the 1860s, at which time he buys their works for 20 to 40 francs only to turn around and sell them for 60 to 80; his close relationship to them

continues through the next decade. His most important acquisition is *The Loge*, by Renoir, for which he pays 500 francs at auction at the Hôtel Drouot in 1874. Another important person in this regard is Julien Tanguy, best known as "Père" Tanguy (1825–94), who first encounters Impressionist painters in 1870 in the forest of Fontainebleau. A proud republican, he takes part in

shop, particularly Japanese woodcuts, which have a powerful influence on the art of the Impressionists. In 1854 the Japanese ports are reopened to international commerce, and in 1862 the first galleries of Oriental art open in Paris, La Porte Chinoise and L'Empire Chinoise, to be followed in the next decade by others. All of this is a great revelation to the Impressionists, who find themselves discovering a new way of presenting reality, different from the one imposed by the Ecole and nearer to their own sensibilities. In the second half of the 1870s, prints by such Japanese artists as Utamaro, Hiroshige, Hokusai, and their pupils are imported to France and enjoy immediate popularity. In

In 1876 Disdéri takes a series of photographs of the dancer Martha Muravieva; Degas later uses them as the models for paintings.

The amateur painter and photographer Charles Cross in a photo by Nadar.

Fourth show

the Paris Commune, is imprisoned during the repression under Thiers and deported to Brest, and finally, thanks to the intercession of Henri Rouart, obtains a pardon. He opens a paint store at 14, Rue Clauzel in Montmartre and becomes the supplier for many painters, especially the Impressionists. Gifted with fine business sense and a good eye for artistic talent, he establishes a protective, almost paternal relationship with the painters; he understands them and the difficulties they face; he encourages them and helps them by buying their paintings and displaying them in his shop, where he shows them to those of his clients who collect. He is among the first to display works of Oriental art in his

these works the Impressionists discover a new system of representation, a different use of perspective, of space and volumes, different ways of relating the figures in the foreground to those in the background, a wider range of colors, and the importance of the pictorial gesture. In 1893 Pissarro writes that "Hiroshige is a marvelous Impressionist," and the other artists, to greater or lesser degrees, admit the influence of Oriental art on their own art.

In the spring of 1879 the Impressionists organize their fourth show. It takes place from April 10 to May 11 in the rooms of an apartment at 28, Avenue de l'Opéra, with hours from ten to six. The show numbers 260 works by 16 artists. Nine of the artists

Women in a Garden, a photograph of 1865. The Impressionists drew inspiration for their artistic efforts from photographs like this.

the magazine *Nature* publishes several lithographs based on photographs by the English photographer Eadweard Muybridge showing the movements of humans and animals. Degas and the other artists are strongly influenced by these images. From then on they show increasing interest in the technical progress taking place in photography, making use of these innovations to more accurately define various stylistic aspects of their art. Photography comes into being in the first half of the nineteenth century most of all as a result of experiments by the Frenchmen Niepce and Daguerre and the Englishmen Talbot and Goddard. It took fourteen hours of exposure for Niepce to make his first photograph; thirty minutes were needed for the first daguerreotypes, in 1839; after 1850, thanks to the new collodion process (the "wet-plate" technique), the exposure time is reduced to a few minutes. Beginning in 1847, Blanquart-Evrard adopts Talbot's method of reproducing photographs from a paper negative to publish several photographs that

have already participated in at least one earlier show: Félix Bracquemond, Gustave Caillebotte (24 works), Adolphe-Phélix Cals, Edgar Degas (25), Claude Monet, Ludovic Piette, Camille Pissarro (38), Henri Rouart, and Charles Tillot. The seven participating for the first time are Marie Bracquemond (Félix's wife), Mary Cassatt, Jean-Louis Forain, Paul Gauguin (presenting a marble sculpture), Albert Lebourg, Henri Somm, and Federico Zandomeneghi. In addition to the usual absence of Manet there are the defections of Cézanne, Guillaumin, Renoir (who prefers to show his works at the Salon), Sisley, and Berthe Morisot, the latter because of the recent birth of her daughter, Julie. The driving force behind this show, as behind the previous one, is Degas. He comes into a sizable inheritance following the death of his father, in 1874, but over the course of just a few years he finds himself forced to spend it to pay off debts incurred by his brother René in New Orleans. He is thus forced to paint to earn money to get by, and after trying in vain to be accepted by the Salon, he has come to see the Impressionist shows as his only hope for finding new buyers. The clamor caused by the previous shows attracts a great many visitors, so many that when the show is over, Caillebotte, in a letter to Monet, is able to call it a success, with 15,400 admission tickets bought, four times the first show, making enough profit to pay each participating artist 439 francs. Almost all the critics persist in their attitude of mocking derision, but a few traces of calmer reflection are beginning to appear, a few critics are coming to realize that this is not a passing fad, it is not an ephemeral, inconsequential phenomena, but rather a new artistic movement destined to perform an important role.

Also in that year the relationship between Impressionist painting and photography is established with greater clarity. On December 14, 1878,

the theater or in a café, during picnics in parks or trips down the Seine outside Paris. Many photographic efforts seek to solve the problem of movement, which Nadar, Jouvin, and Jammes had dealt with in the 1860s. In 1873 Etienne-Jules Marey publishes *La Machine Animale*, a report of his studies on animal and human locomotion made using a special piece of photographic equipment that much resembles a rifle. In 1874, Muybridge, with support from the railroad magnate Leland Stanford, captures on film the series of movements of a running horse. He sets up a series of sequential still cameras (12, 24, or even 36 of them) and later (1881) invents his zoöpraxiscope, a device that projects the animated pictures on a screen. These studies enable painters to correct longstanding errors, like, for instance, the fact that an animal never lifts all four of its hooves off the ground at the same time, as had appeared in many paintings, such as *Derby at Epsom* by Géricault and Manet's *Racecourse in the Bois de Boulogne* (page 131). Many painters become interested in photography, and it is not a mere coincidence that the Impressionists' first show is held in the studio of Nadar, one of the best known photographers of those years. In 1865, for example, Manet uses a photo of Baudelaire taken by Nadar to make one of his most successful etchings. In much the same way, Degas, in 1861, uses a photo by Disdéri of the prince and Princess Pauline of Metternich as model for a portrait of the princess, today in the National Gallery of London; in 1865 he makes a portrait of Eugénie Fiocre of the Paris Opéra using as his base a photograph by Nadar. By the year 1880 Monet owns four cameras; Degas, who in 1896 will buy one of the first portable Kodak cameras, defines photography as "images of instantaneous magic." And Jean Renoir, in his biography of his father, writes, "The Impressionists believed the developments then taking place in photography would be of great importance to the world." Among their friends is Charles Cros (1842–88), amateur painter, passionate photographer, and author of studies of photography published between 1867 and 1869. Throughout the next decade the Impressionists are stimulated by photography not only in their experiments in light and shadow but in many cases in the new points of view they use in their paintings, held to be revolutionary for their time and often adaptations of a photograph's framing.

become very popular among painters, along with the landscapes by Edouard Baldus and the seascapes by Gustave Le Gray. As early as 1851 "animated photographs" composed of a series of frames each presenting a different phase of movement are in circulation. In 1854 A. E. Disdéri, a famous portraitist of the Second Empire, patents his "cartes-de-visite," small photographic portraits (6 x 9 cm) made in a series of 12 poses and glued to cardboard. One of the major attractions of the 1855 universal exhibition in Paris is the photochromy pavilion, whose thousands of visitors are amazed and astonished. By the 1860s, the photographic procedure has been perfected enough to make possible the large-scale distribution of numerous photographic views of train stations, trains rolling along tracks, landscapes, urban views, all of which offer inspiration to the Impressionists for their paintings. In the same way, their canvases suggest ideas to photographers, who turn to scenes from middle-class life: ladies and gentlemen in gardens or drawing rooms, at

CATALOGUE
DE LA
4ᴹᴱ EXPOSITION
DE PEINTURE

PAR

M. Bracquemond — Mᵐᵉ Bracquemond
M. Caillebotte — M. Cals — Mˡˡᵉ Cassatt
MM. Degas — Forain — Lebourg — Monet
Pissarro — Feu Piette
Rouart — H. Somm — Tillot et Zandomenighi.

Du 10 Avril au 11 Mai 1879

De 10 heures à 6 heures
28, AVENUE DE L'OPÉRA, 28
PARIS

■ Disdéri, *The Legs of the Opéra*, a photographic "carte-de-visite" from circa 1860.

■ Title page of the catalog of the sale of Impressionist works at the Hôtel Drouot on March 24, 1875.

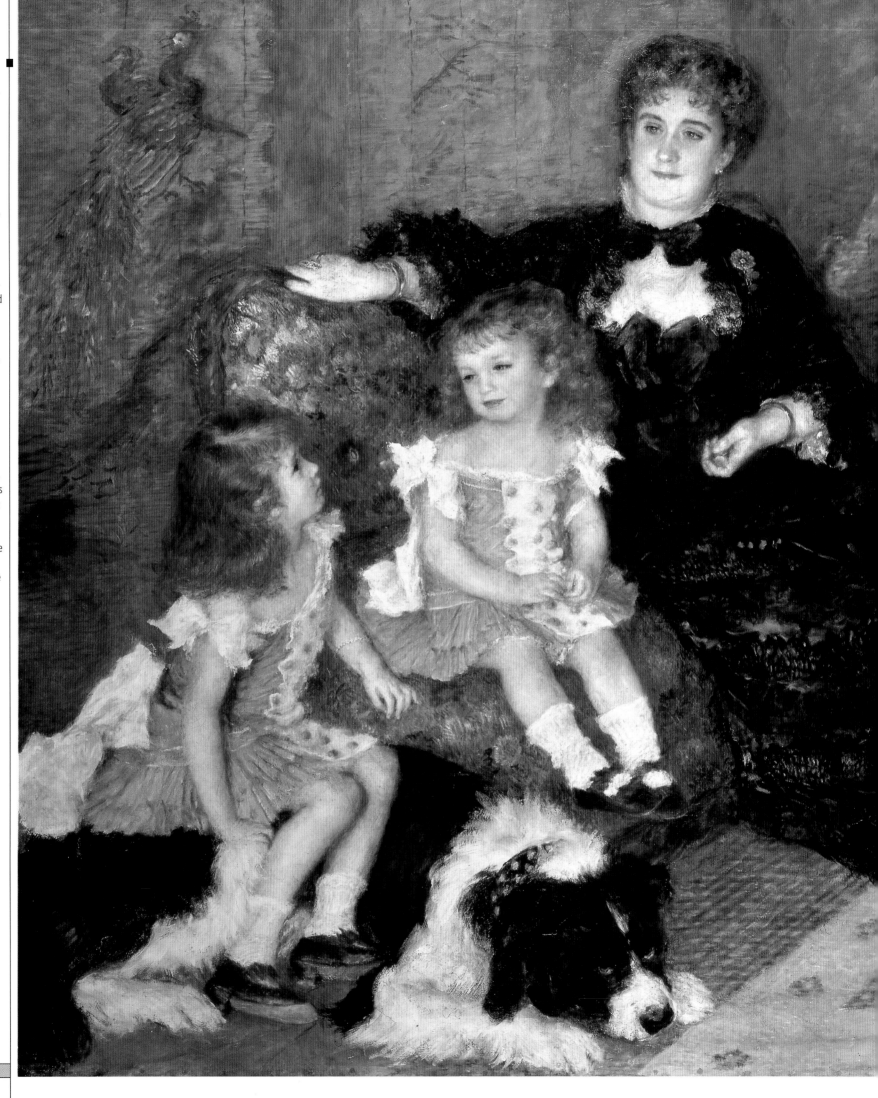

PIERRE-AUGUSTE
RENOIR
**Madame Charpentier
and Her Children**
1878, oil
on canvas,
153.6 × 190 cm
Metropolitan Museum
of Art, New York

Marguerite Lemonnier,
born in 1848, marries
the publisher Georges
Charpentier in 1872.
She is an educated
woman, and her draw-
ing room is frequented
by artists, intellectu-
als, and politicians.
Renoir portrays her
with her two children.
Seated on the dog is
Georgette, born in
1872; on the sofa is
her little brother,
Paul, born in 1875,
whose godfather is
Emile Zola. His long
blond locks and dress,
identical to that of his
older sister, make him
look more like a girl
than a little boy.
Thanks to the influence
of the Charpentiers,
husband and wife, the
painting is accepted
by the jury of the
Salon in 1879 and
receives much praise
from critics.

■ PIERRE-AUGUSTE
RENOIR
**Portrait of
Madame Charpentier**
1876–77, oil
on canvas,
46 × 38 cm
Musée d'Orsay, Paris

Marguerite Lemonnier
inherits a taste for
art from her father,
Gervais, a collector
and friend of romantic
painters. Renoir owes
much to her, for it is
only because of her
efforts that he gains
introductions to other
influential art collec-
tors, and thanks to
their business his
financial situation
improves enormously.

Renoir spends some of
the summer of 1879
as the guest of the
rich banker Paul Bérard
in the castle of Warge-
mont in Normandy.
While there he deco-
rates the dining room
with floral still lifes
and makes various
portraits of family
members, including
this one of the
daughter Marguerite.
Encouraged by the
eulogies received from
critics of the Salon,
Renoir is feeling surer
of himself. Here he
skillfully captures the
fresh spontaneity
in the young girl's
expression, concen-
trating the viewer's
attention on her
big, luminous eyes
and creating, all in
all, a work of grace
and extraordinary
sweetness.

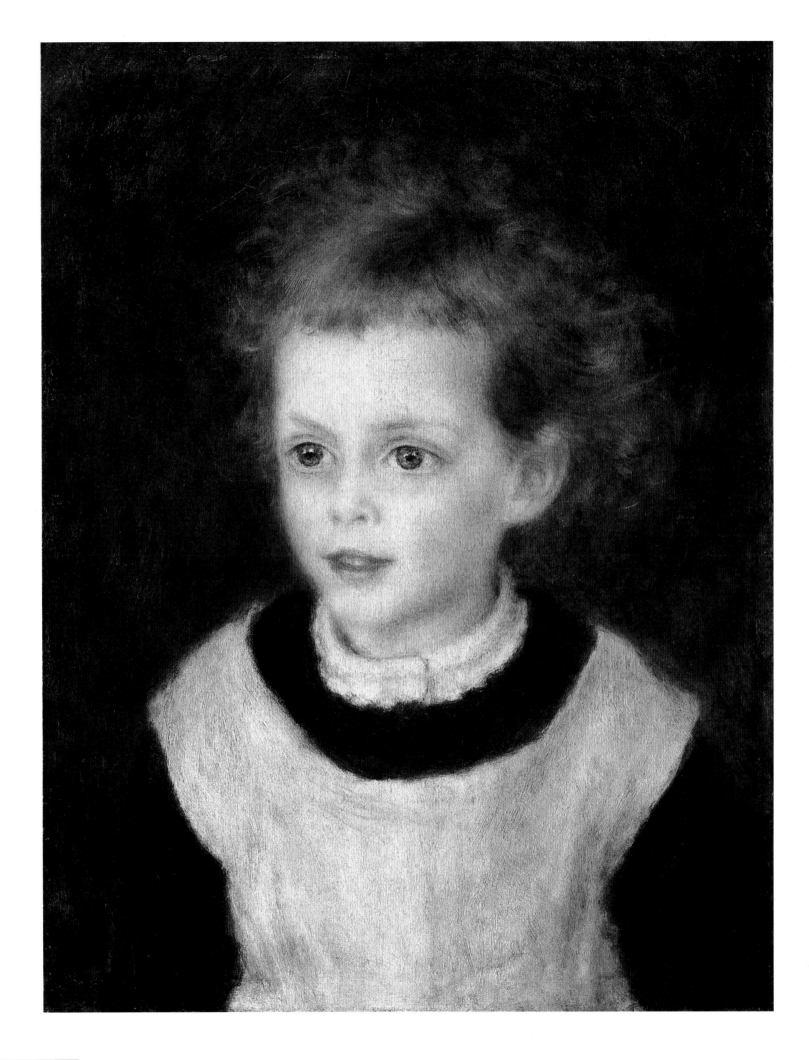

Fourth show

■ PIERRE-AUGUSTE
RENOIR
**Lunch on the
Banks of the River**
circa 1879, oil
on canvas,
55 × 66 cm
The Art Institute,
Chicago

This painting, almost
certainly made at
Chatou, can be taken
as a first version of
the famous *Luncheon
of the Boating Party*,
which Renoir will
make two years later.
The pictorial space is
divided in two parts
by the trellis. Visible
in the background are
boats on the river, the
water of which blends
with and mixes into
the sky. In the fore-
ground three people
are seated at a table,
two men and a woman
with her back to the
viewer. Worth noting
is the small still life
of the table setting,
created with only a
few brief brushstrokes
but endowed with
enormous effect.

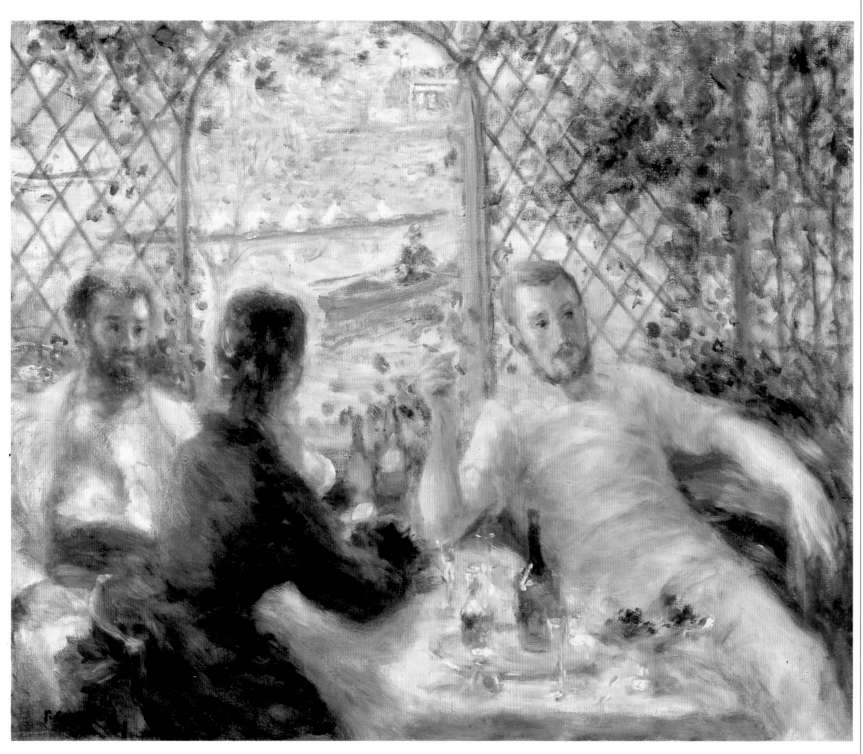

CLAUDE MONET
Rue Montorgueil, Paris, Festival of June 30, 1878
1878, oil on canvas,
81 × 50.5 cm
Musée d'Orsay, Paris

The scene most probably presents the festivities of June 30, 1878, for the universal exhibition, but it might also be the national celebration of July 14. In 1920 the painter himself explains: "I've always been very fond of flags. I was walking on Rue Montorgueil with my easel and paints. The street was decked out with flags and crawling with people. I spotted a balcony, climbed the stairs, and asked permission to paint: they said yes." The very bright colors and free use of brushstrokes to communicate the sense of movement anticipate characteristics typical of Fauvist painters.

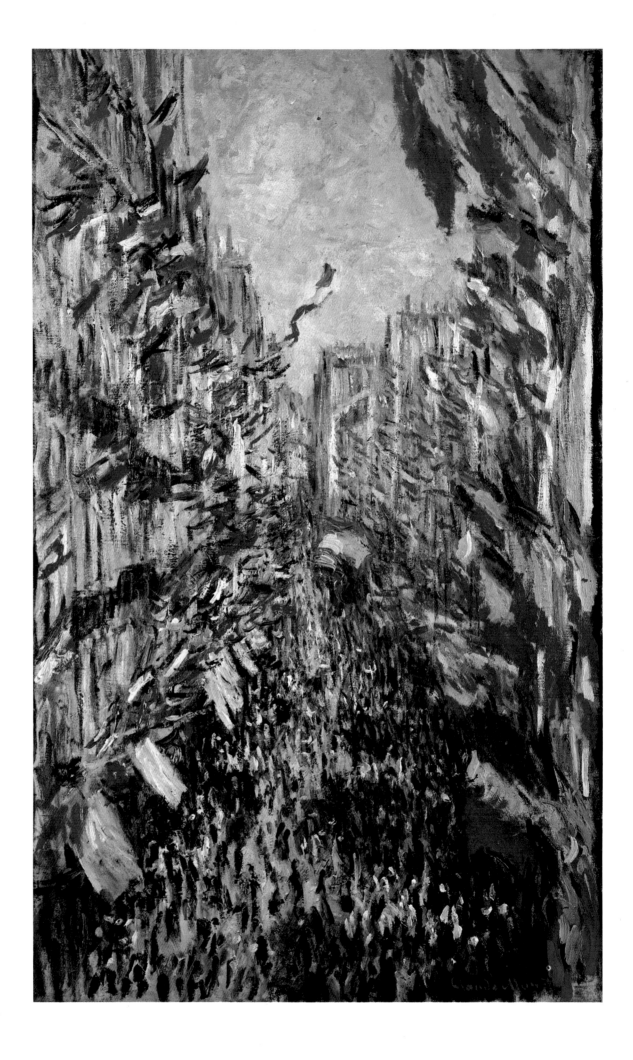

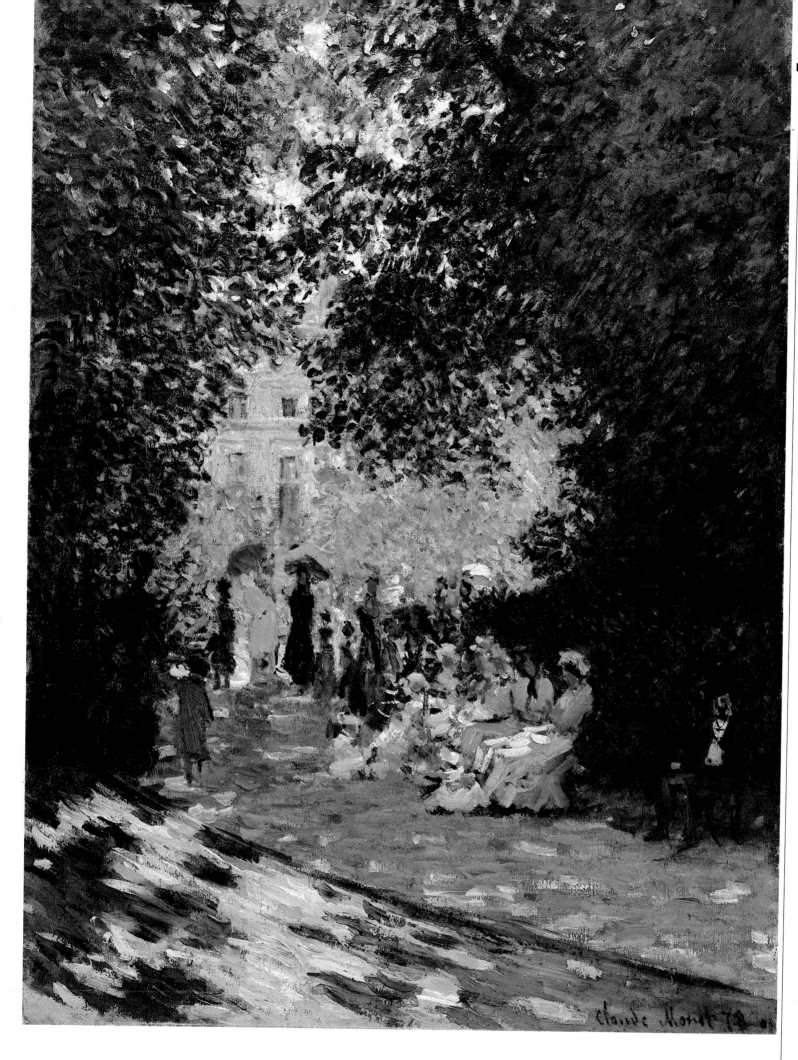

■ CLAUDE MONET
Monceau Park
1878, oil on canvas,
70 × 55 cm
Metropolitan Museum
of Art, New York

Monet had already
made a view of
Monceau Park, but
without people, in
1876, two years
before this painting.
In this version, gen-
tlemen stroll and
repose and mothers
look after their chil-
dren in the cool shad-
ows of trees on a
bright spring day. The
atmosphere is serene,
and the painter com-
municates a sense of
peace and quiet. The
brushstrokes in the
lower area of the can-
vas are wide and regu-
lar; farther up, they
grow dense and almost
seem to anticipate the
geometric decomposi-
tions of the Pointillists.

CLAUDE MONET
Road to Vétheuil in Winter
1879, oil on canvas,
53 × 72 cm
Konstmuseum,
Göteborg

On October 1, 1878, Monet moves his family to Vétheuil, a village on the Seine between Médan and Giverny. He takes into his home as guests the family of Ernest Hoschedé, made destitute by bankruptcy. Thus the five Hoschedé children are added to Monet's two sons. In 1879 Ernest Hoschedé returns to Paris in the hope of winning back some of his lost patrimony, leaving the painter in a difficult situation with his wife, Camille, and Alice Hoschedé, with whom he is secretly in love. During the summer of 1879 Camille falls ill, and on September 5 of that year, at only thirty-two years of age, she dies.

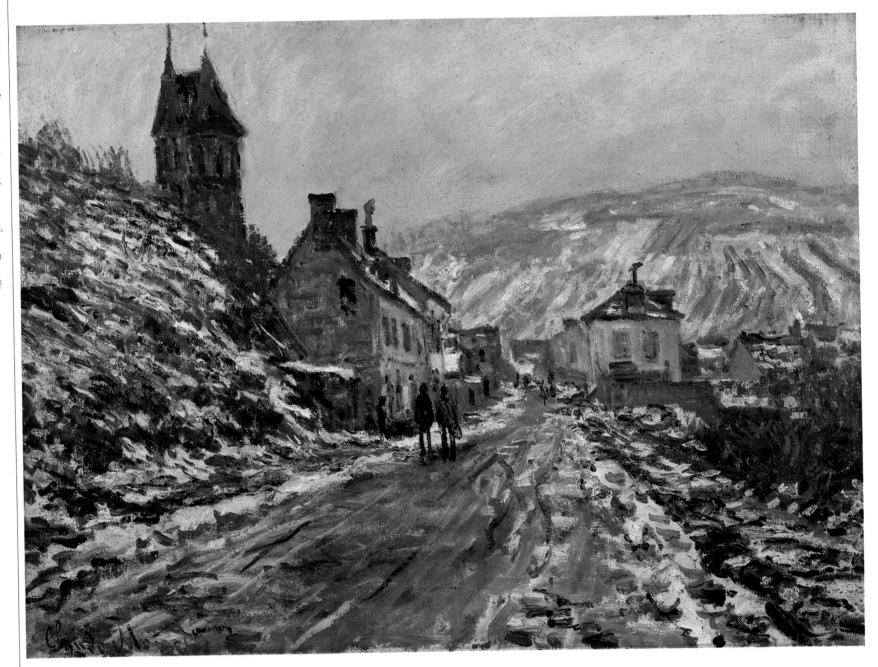

Fourth show

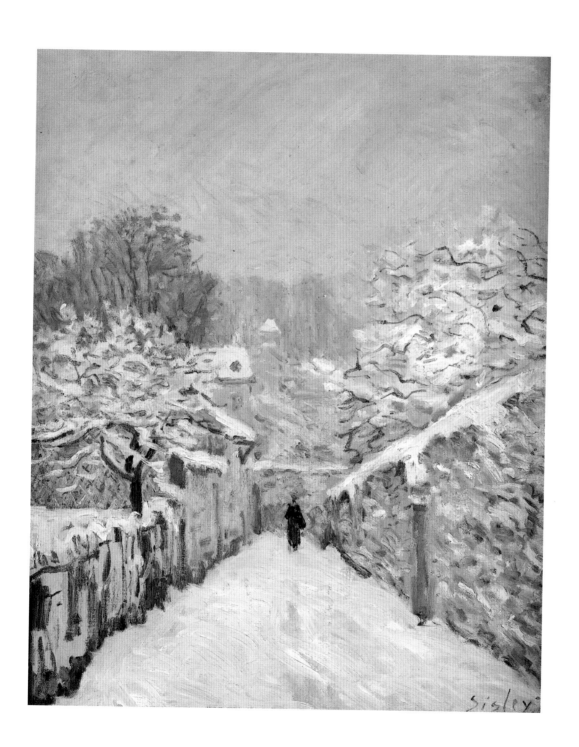

ALFRED SISLEY
Snow at
Louveciennes
1878, oil on canvas,
61 × 50.5 cm
Musée d'Orsay, Paris

The dominant colors of this painting are the white of the snow and the gray of the sky, together creating an atmosphere of muffled silence. The high walls running alongside the road are a device Sisley often uses to add clearly indicated perspective and depth to a scene; the same is true of the small figure in the background, similar to figures used by Boudin and Jongkind in their landscapes. The first owner of the painting is the playwright Georges Feydeau; in 1903 it is bought by Count Isaac de Camondo, and in 1912 it becomes part of the collections of the state of France.

EDGAR DEGAS
Café-Concert Singer
1878, pastel and mixed
media on canvas,
52.8 × 41.1 cm
Fogg Art Museum,
Harvard University,
Cambridge,
Massachusetts

Exhibited at the fourth
Impressionist show,
this pastel is part of a
series of works that
have *café-concert*
singers as their sub-
ject. Degas is an
habitué of those
places, especially the
Café des Ambassadeurs,
and he uses them as
the settings for many
of his best works. He
is drawn to the dra-
matic poses of per-
formers and singers,
epecially when pre-
sented, as here, from
very close up. He is
also fond of the spe-
cial effects of stage
lighting, the way it
increases the intensity
and vibrancy of colors.

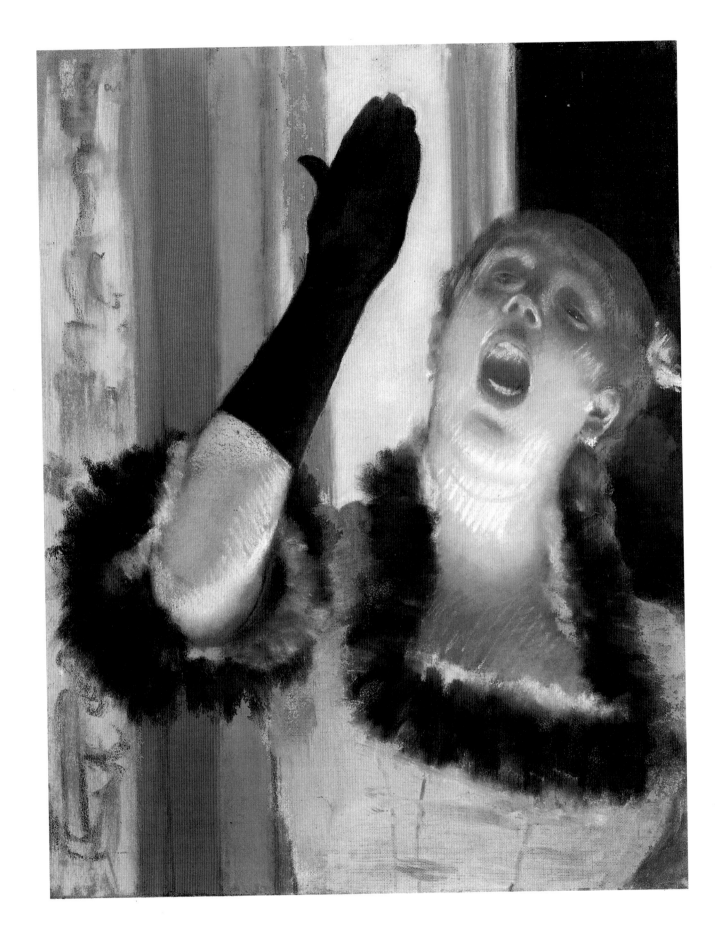

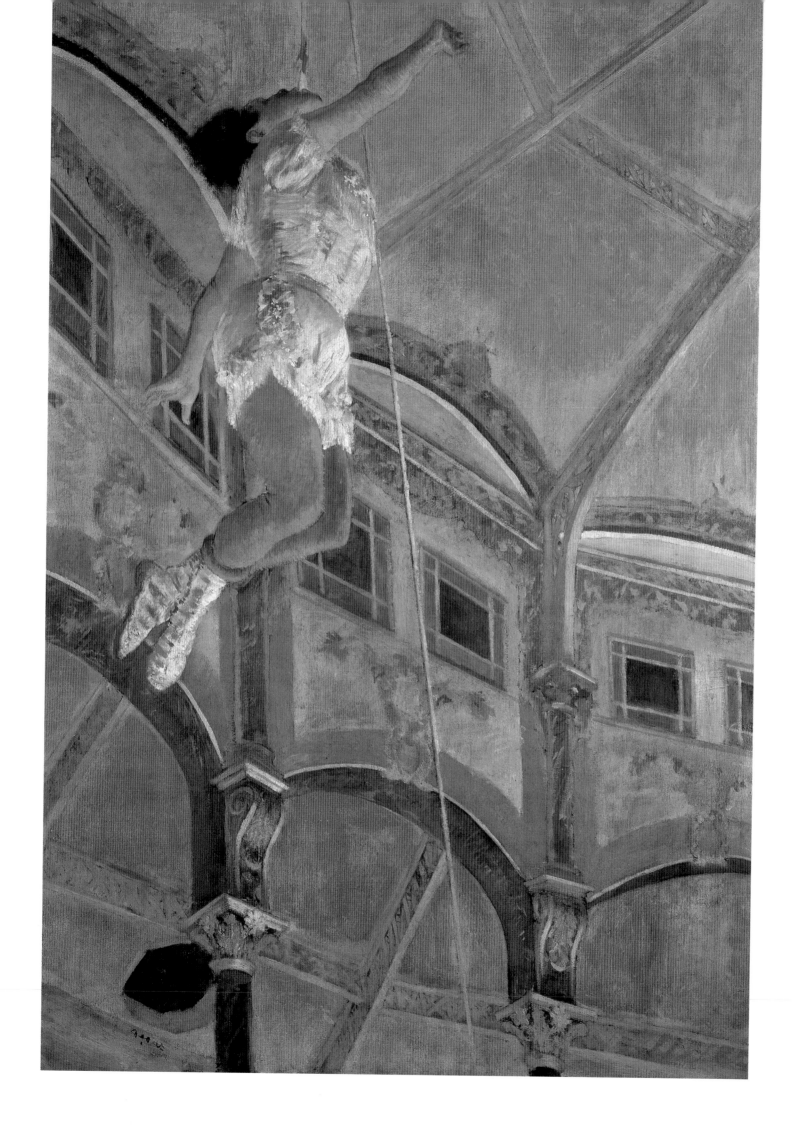

■ EDGAR DEGAS
Miss La La at the
Cirque Fernando
1879, oil on canvas,
117 × 77 cm
Tate Gallery, London

Degas is a friend of
Mallarmé and knows
the naturalist writers,
such as Louis-Edmond
Duranty, Emile Zola,
Edmond and Jules de
Goncourt, and Joris
Karl Huysmans. He is
fascinated by their
works, and his paint-
ings, in turn, serve
them as sources of
inspiration. For exam-
ple, many passages
in the youthful novels
of Huysmans read
like transcriptions
of images in Degas
paintings. One of his
Croquis Parisiens of
1880 includes the
description of an
acrobat at the Folies-
Bergère that perfectly
matches this painting.

EDGAR DEGAS
**Portrait of
Diego Martelli**
1879, oil on canvas,
110 × 11 cm
National Gallery of
Scotland, Edinburgh

Martelli (1838-96),
Italian painter and art
critic, is familiar with
the Macchiaioli group
of painters at the
Cafè Michelangelo in
Florence. In 1878 he
goes to Paris for the
universal exhibition
and meets Degas and
the other Impression-
ists. Back in Italy he
becomes one of the
first supporters and
heralds of their art.
In this portrait Degas
presents him in an
informal, unofficial
pose, seen from the
side and located
almost in the back-
ground; the scene
is dominated by the
disorderly arrange-
ment of papers and
engraver's tools atop
the desk.

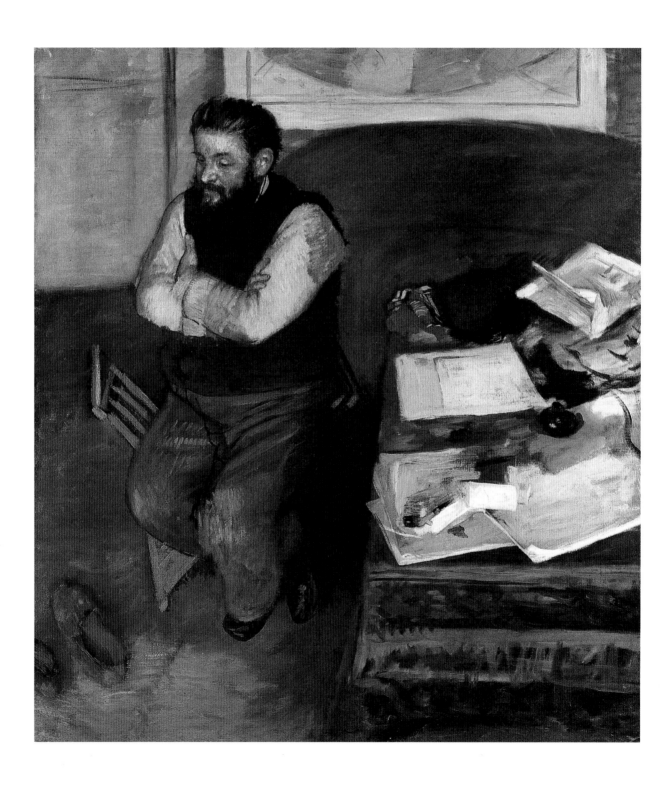

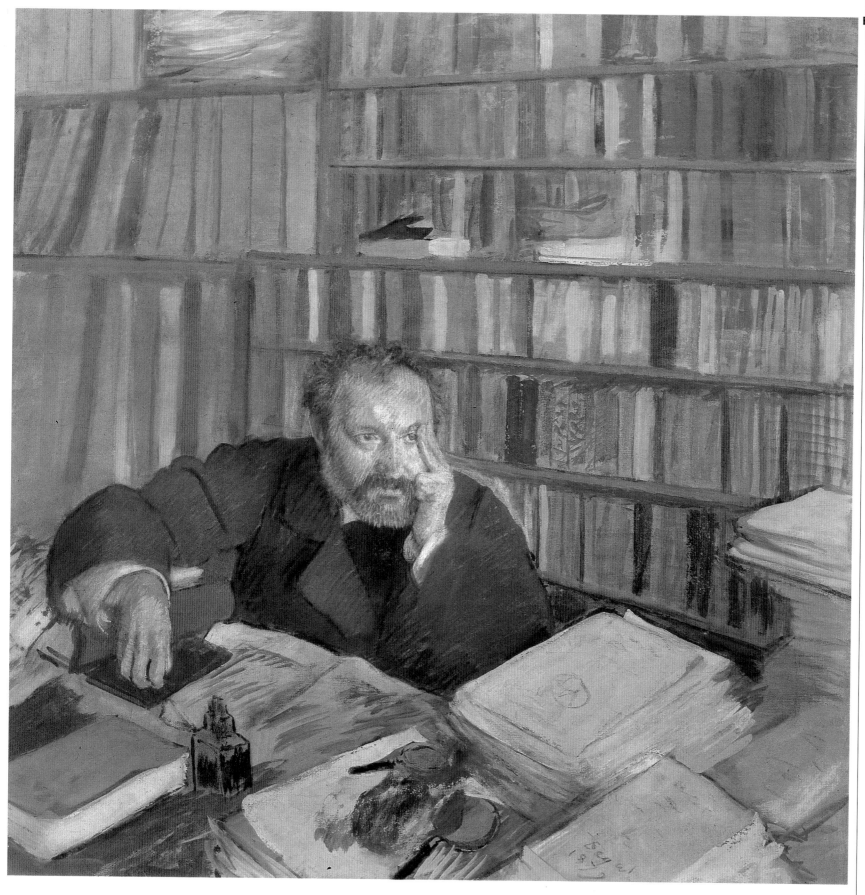

■ EDGAR DEGAS
Portrait of Louis-Edmond Duranty
1879, pastel and tempera on paper, 100.9 × 100.3 cm
Museums & Art Galleries, Burrell Collection, Glasgow

Louis-Edmond Duranty (1833–80) is one of the leading theoreticians of realist literature, which he promotes in the review *Réalisme*, of which he is founder. He frequents the Café Guerbois and meets the Impressionists; he defends them in the pages of the *Gazette des Beaux-Arts Illustré*. He reviews their second show in an important essay called *La Nouvelle Peinture*, published in 1876, and celebrates them in a book, *Le Pays des Arts*, published posthumously in 1881. He and Degas are good friends, and their lengthy discussions of drawing and color in some ways direct Degas's later works.

PAUL CÉZANNE
**Bather with
Raised Arm**
circa 1878, oil
on canvas,
33 × 24 cm
Private collection

The subject is one
Cézanne is very fond
of, and to which he
returns often. This
particular version is
one of the very few
vertical compositions,
and unlike almost all
of the others it has
a male protagonist
without the presence
of other figures more
or less related to one
another. The artist
uses short, regular
brushstrokes and pale
colors in a veiled light
to create an atmos-
phere of meditation
and reflection. The
man's pose is rendered
with natural spontane-
ity, free of any forced
stress or rhetoric.

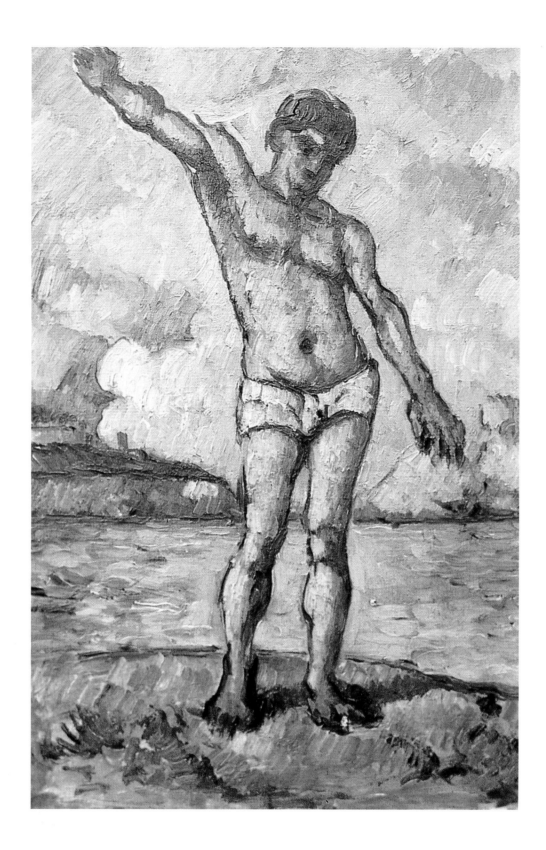

■ PAUL CÉZANNE
L'Estaque and the Gulf of Marseilles
1878–79, oil on canvas, 59 × 73 cm
Musée d'Orsay, Paris

Standing out among the most beautiful works of these years are several interesting views of the gulf of Marseilles seen from Estaque, and Estaque seen from across the sea. Cézanne uses these works to continue his experiments in volumes and to work out new stylistic methods. He is moving toward the eventual elimination of the traditional use of perspective, the spaces in his paintings becoming simplified to the point of appearing two-dimensional. Color assumes a greater importance because he uses it to mark off the rhythms of the entire composition.

PAUL CÉZANNE
**Self-Portrait with
Red Background**
circa 1878, oil
on canvas,
66 × 55 cm
Private collection

Disappointed by the
negative criticism he
received at the third
Impressionist show,
Cézanne decides to
stop exhibiting with
them and increasingly
isolates himself.
Writing to Octave
Maus on November 25,
1889, he explains, "I
made the decision to
work in silence on the
day I no longer felt
able to theoretically
defend the results of
my work." This self-
portrait seems to
express his state of
mind, determined
to exact revenge on
those who denigrate
him. The brushstrokes
are nervous, almost
tormented, and the
foreground contrasts
with the bright colors
of the background.

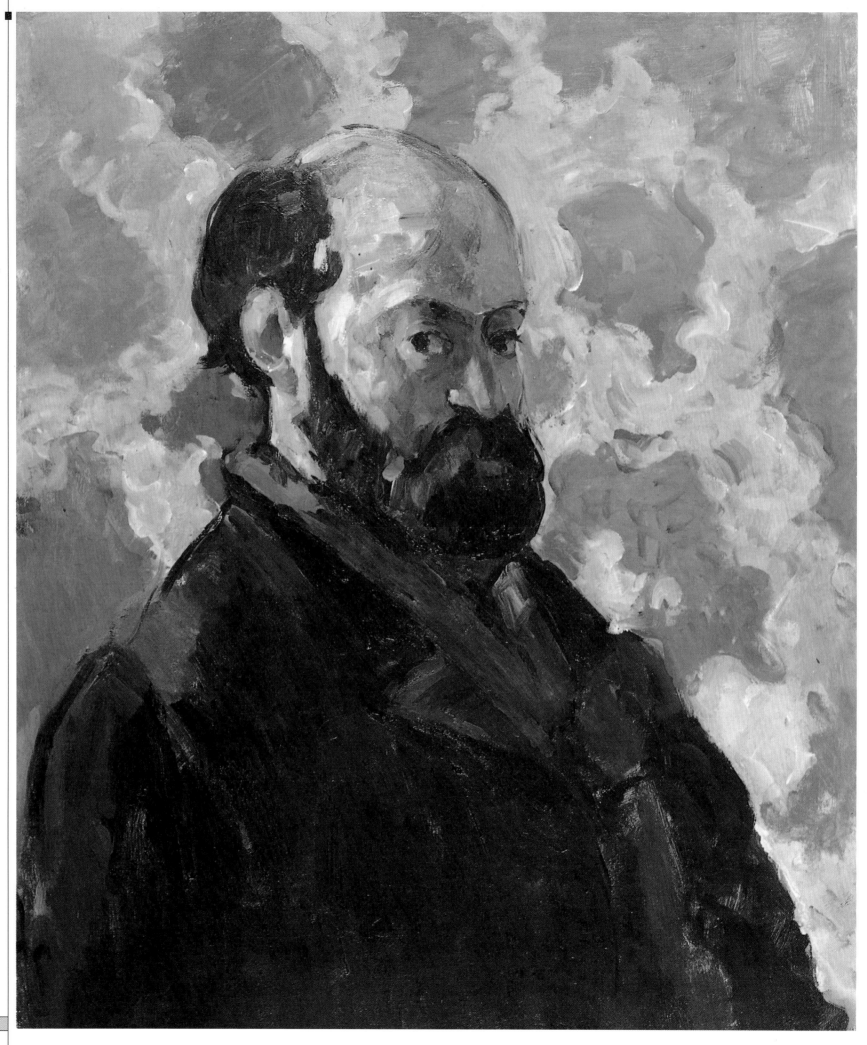

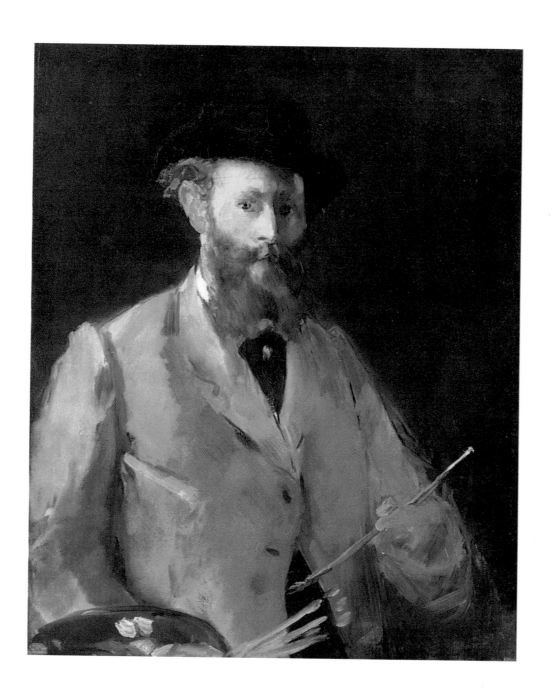

■ EDOUARD MANET
**Self-Portrait
with Palette**
1879, oil on canvas,
83 × 67 cm
Private collection

The artist makes this
painting in his new
Parisian studio at 77,
Rue d'Amsterdam by
looking at himself in
a mirror; in fact he
holds the palette in
his right hand, the
brush in his left. He
makes another, full-
figure self-portrait
that same year. Several
years after his death,
his widow finds her-
self forced to sell the
two canvases, along
with other paintings
by her husband, but
first, to preserve the
memory, she has copies
made by a nephew,
Edouard Vibert, the son
of her sister Marthe.
Early in the last cen-
tury they are passed
off as originals.

EDOUARD MANET
At the Café
1878, oil on canvas,
77 × 83 cm
Museum Stiftung Oskar
Reinhart, Winterthur

The setting of the
painting is the
Brasserie Reichshoffen
on Boulevard Roche-
chouart in Paris. The
man in the top hat is
the engraver Henri
Guérard, husband of
Eva Gonzales, Manet's
model and student.
The woman presented
in profile has not
been identified; the
woman in the hat is
Ellen Andrée, a very
popular actress, one
of the stars of the
Folies-Bergère. She
had already been used
as a model by Degas
in his *In a Café*
(page 162). On the
window can be read
an announcement of
the performance of
the Hanlon Lees,
famous acrobats who
performed at the
Folies-Bergère. In the
close foreground is a
match holder, one of
those used by the
clients of the café.

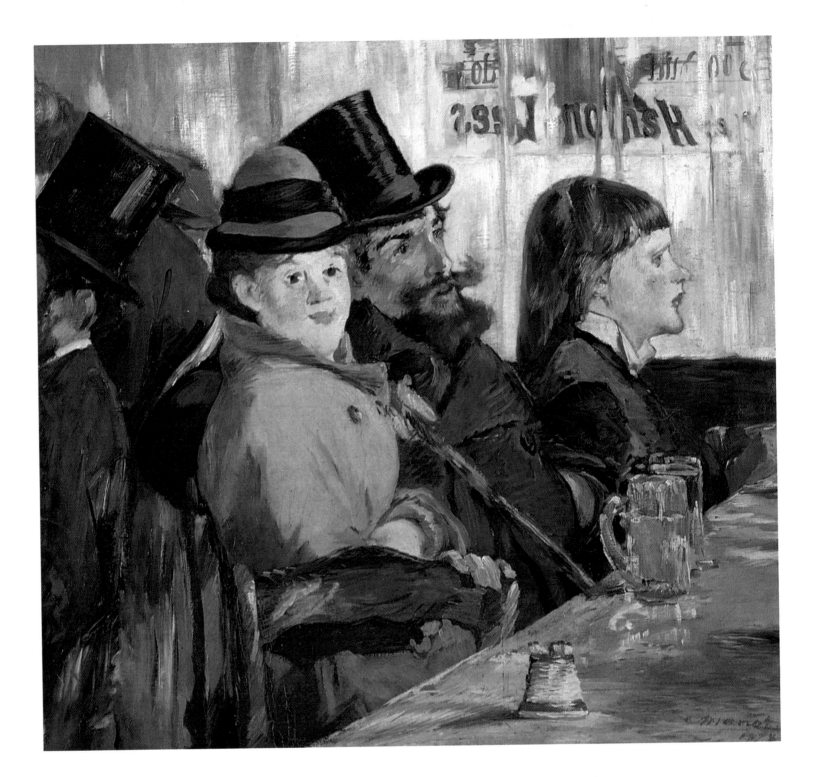

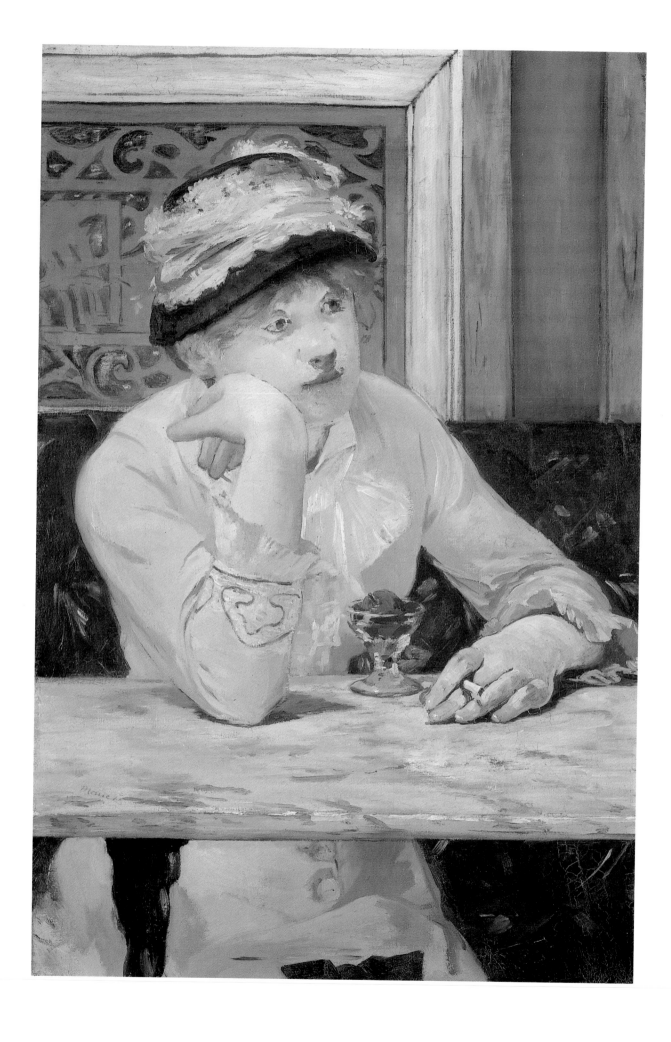

■ EDOUARD MANET
Plum Brandy
1878, oil on canvas,
73.6 × 50.2 cm
National Gallery of
Art, Washington, D.C.

The model for this
painting has not been
identified; she was
probably an occasional
client of the Nouvelle-
Athènes, the café
where the scene is
set. Her attitude and
expression closely
resemble those of the
girl who is the main
character in Degas's
In a Café (page 162).
Her face speaks of
boredom and melan-
choly; perhaps, after a
hard day of work, she
has come to the café
in the hope of having
a good time among
friends only to find
herself alone, with
only a cigarette and
her glass of brandy.

EDOUARD MANET
The Waitress
1879, oil on canvas,
77 × 65 cm
Musée d'Orsay, Paris

Like *At the Café* (page 220), this painting is set in the Brasserie Reichshoffen, leading several critics to suggest that the two paintings are really sections of a single work. The café is popular with clients of varying social classes, united by their shared passion for performances. The woman with the chignon and the man with the top hat seem to be members of the well-to-do middle class, while the man with the pipe wears a worker's smock. Unlike Degas, who often portrays the singers of *café-concerts*, Manet prefers to paint the members of the audience and the waitress, relegating the stage to the background.

JOHN SINGER SARGENT
The Luxembourg Gardens
1879, oil on canvas,
64.8 × 91.4 cm

Philadelphia Museum
of Art, J.G. Johnson
Collection, Philadelphia

John Singer Sargent is
born January 12, 1856,
in Florence, Italy,
to American parents.
In 1874 he moves to
Paris, where he studies
painting with Carolus-
Duran; in 1878 he is
accepted by the Salon.
He is interested in the
Impressionists and
approaches their style
and sensibility, as is
evident in this paint-
ing, with its soft tones
and pale, luminous
colors. Although he
never participates in
the Impressionist
shows, he performs an
important role for the
movement since he
helps make their art
known in England and
the United States,
contributing to its
diffusion.

GUSTAVE
CAILLEBOTTE
Boatman in Top Hat
1877–78, oil
on canvas,
90 × 117 cm
Private collection

Exhibited at the fourth
Impressionist show as
work Number 8, this
painting does not
escape the ironic eye
of the critics. In par-
ticular, it becomes the
subject of an amusing
caricature by Draner
printed in the maga-
zine *Le Charivari* on
April 23, 1879. The
setting of the paint-
ing is probably Yerres,
the town on the river
of the same name
about twenty kilome-
ters from Paris, where
the painter's father
has a country home.
The identity of the
rower is not known,
but he may well have
been one of the many
friends of the artist
who spend a brief
vacation in his home.

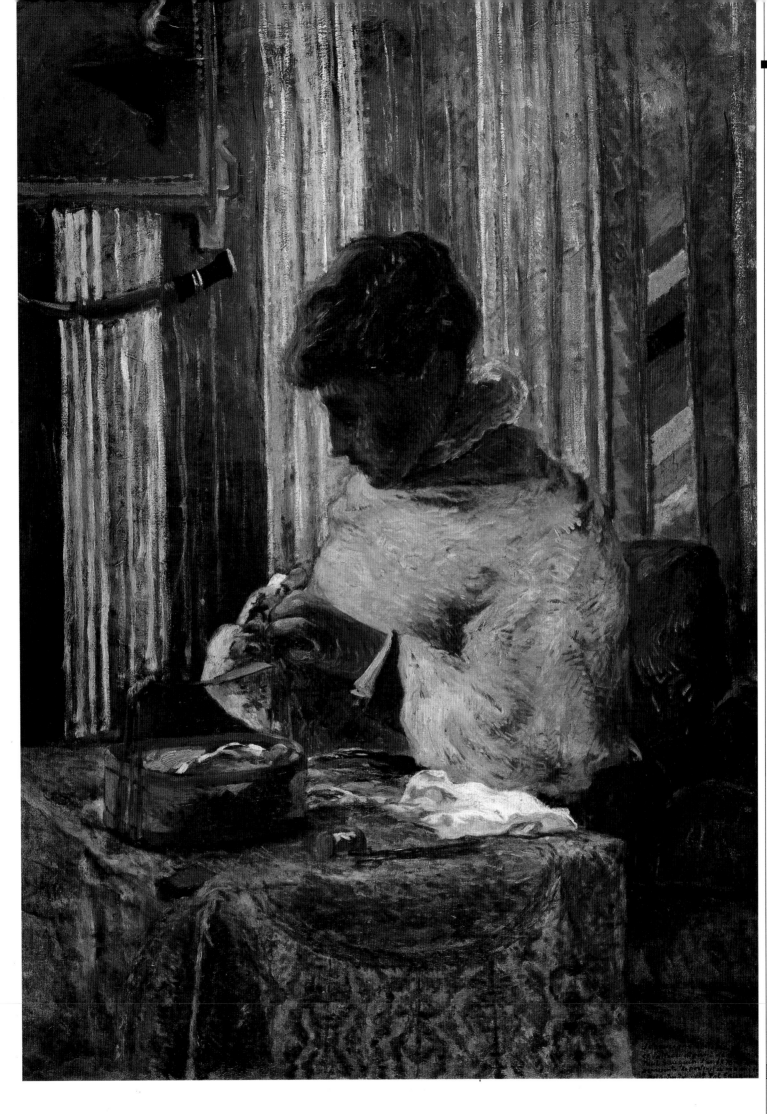

PAUL GAUGUIN
Mette Sewing
circa 1878,
oil on canvas,
115 × 80.5 cm
Bührle Collection,
Zurich

In the fall of 1872 Gauguin meets Mette Sophie Gad, daughter of a Danish judge, who is in Paris on vacation with a friend, Marie Heegard, and is staying in the boardinghouse of Pauline Fouignet. The two are married on November 22 of the next year. In 1874 Emile is born, followed by Aline in 1877, Clovis in 1879, Jean-René in 1881, and Paul in 1883. The first years of the marriage are happy, in terms of both work, which promises to be full of satisfaction, and family life, as reflected in the atmosphere of domestic tranquility that emanates from this painting.

PAUL GAUGUIN
Garden under Snow
1879, oil on canvas,
60.5 × 80.5 cm
Szépmüvészeti
Múzeum, Budapest

Early in 1879 Gauguin
moves his family from
74, Rue des Fourneaux
to a larger apartment
at 8, Rue Carcel, and
there he sets up a room
in which he can paint.
The creation of this
painting begins with
a series of drawings
and sketches made
outdoors, which he
then develops further
in his studio. Almost
without doubt this
painting is among the
landscapes exhibited
at the fifth Impres-
sionist show in 1880.
The artist confronts a
technically difficult
subject that permits
him to display his skill
at rendering the effects
of light on snow.

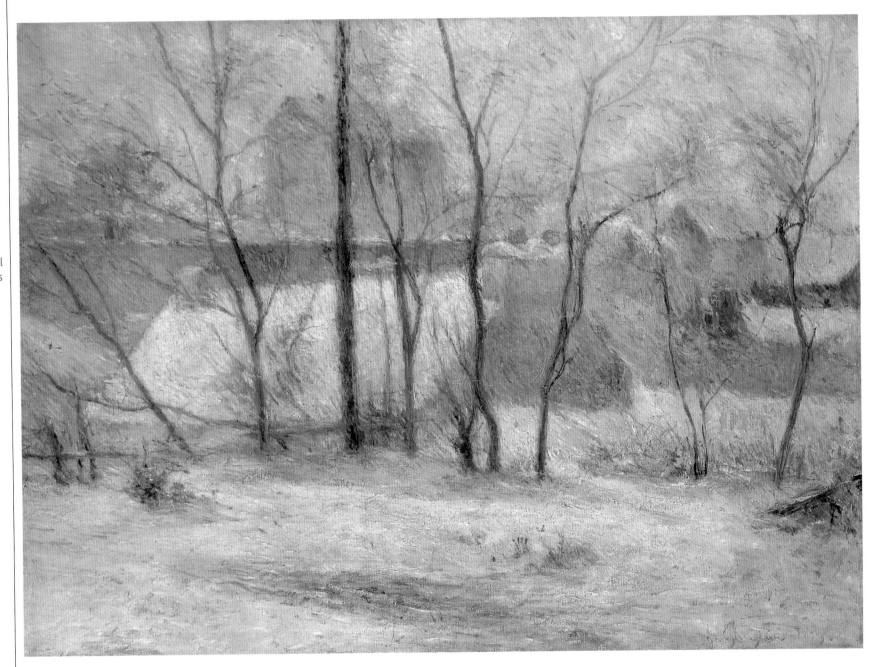

Fourth show

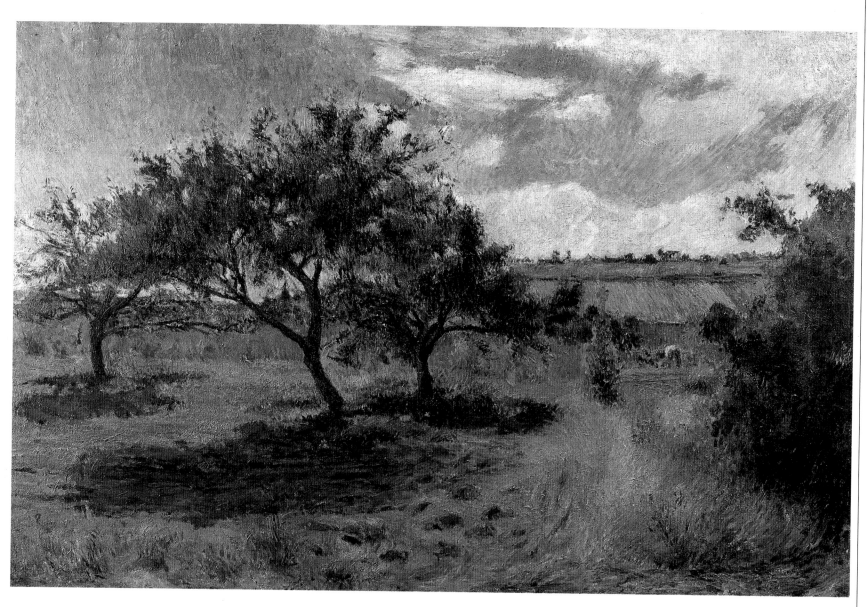

■ PAUL GAUGUIN
**Apple Trees at
the Hermitage
near Pontoise**
1879, oil on canvas,
65 × 100 cm
Aargauer Kunsthaus,
Aarau

Gauguin spends
September 1879 at
Pontoise together
with Pissarro, under
whose guidance he
perfects his rural
landscapes. During
his stay he also has
the chance to meet
Cézanne and compare
their work. The sub-
ject of this canvas is
similar to the many
orchards painted by
Pissarro in the first
half of the 1870s.
The brushstrokes are
more regular than
in Gauguin's earlier
works, the colors
are paler and more
intense, and the
setting is clearly
more realistic.

In February 1880 Degas proposes founding a magazine, *Le Jour et La Nuit*, to be dedicated entirely to lithography. Mary Cassatt, Pissarro, Forain, Bracquemond, Raffaëlli, Rouart, and Caillebotte agree to participate, the latter also offering to finance the venture. For many reasons the magazine never sees the light of day, but it serves the important purpose of stimulating further efforts in the field of lithography. Not all the

Impressionist painters dedicate themselves with equal passion to the creation of numbered lithographs. Monet never makes a single one; Cézanne and Sisley do so only rarely: Cézanne makes nine, Sisley only six. Renoir becomes involved in lithographs only very late, beginning in 1890, and only because of insistent pressure from friends and editors does he eventually become the author of about fifty works. Far and away the largest repertory is that of Degas, who makes a total of 500 monotypes and numerous lithographs; also sizable is Manet's catalog, which comes to include a hundred-odd titles, from etchings to lithographs to woodcuts. Cassatt and Pissarro are also active, with more than 200 sheets from each of them. A great many contemporary critics accuse the Impressionists of being unable to draw, and the etchings and lithographs they make, perhaps even more than their paintings, testify to their true talents and abilities. In reality they do nothing at all to abolish design and instead merely adopt a new way of creating lines, a way that is flexible, allusive, discontinuous. It breaks with the rules taught at the Ecole, but in doing so makes it possible to give more emphasis to light and color. Most Impressionist artists make their initial encounter with engraving after 1862, year of the formation of the Société des Aquafortistes, of which Manet is one of the principal founders. Another significant date is 1889, year of birth of the Société

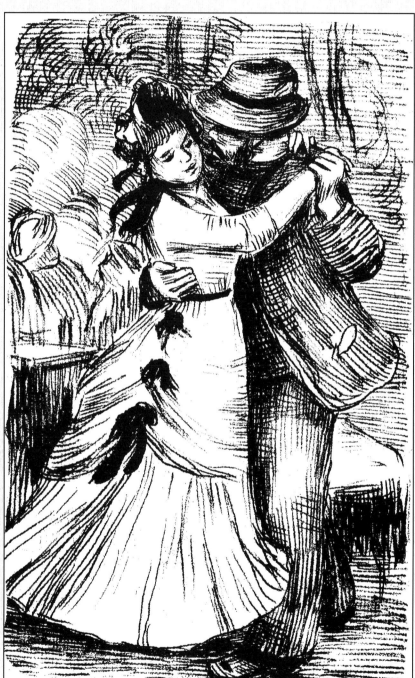

des Peintres-Graveurs: for some this is the crowning achievement of a long activity in the graphic arts; for others it is only the starting point. In general, Impressionist artists turn to numbered graphics as a way of experimenting with new stylistic methods that they can later adapt for use in their paintings, but it also offers a more rapid and less expensive means of making their works known to the public, most of all to buyers who are less well to do. The invention of lithography at the end of the eighteenth century and developments in the technology of typography have made possible the commercial distribution of printed illustrations, such that more than 1,300 periodicals come into being in France between 1830 and 1900. The models to whom the Impressionists turn for inspiration include the many French engravers, such as Honoré Daumier and Charles Meyron, but most of all they draw their inspiration from Japanese prints, which in those very years make their appearance in Paris. From these prints they learn extreme refinement in the use of the line, joining naturalism to decoration. The Japanese prints also tend to break with the traditional rules of perspective and to create instead a new spatial sense, locating objects on overlapping planes separated by different chromatic and luminous values.

It is the graphic activity of Mary Cassatt that most clearly demonstrates the close ties between Japanese prints and Impressionism. A dedicated collector of the creations of the grand masters of Oriental art, the American painter produces a series of ten prints explicitly inspired by Japanese methods, in 1890. In 1880 Degas intensifies his efforts in etching and aquatints together with Cassatt and Pissarro. In a letter to Pissarro he brings him up to date on his progress: "Here are the proofs: the prevailing blackish or rather grayish shade

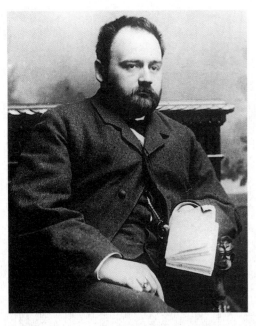

comes from the zinc, which is greasy in itself and retains the printer's black. The plate is not smooth enough. . . . In any case you can see what possibilities there are in the method. It is necessary for you to practice dusting the particles in order, for instance, to obtain a sky of uniform gray, smooth and fine. . . . This is the method. Take a very smooth plate (it is essential, you understand). Degrease it thoroughly with whitening. Previously you will have prepared a solution of resin in very concentrated alcohol. This liquid, poured after the manner of photographers when they pour collodion onto their glass plates (take care, as they do, to

Caillebotte, is again the primary force behind the show, and he succeeds in getting approval of his proposal to do away with the term *Impressionist* and refer to the group of artists by a more neutral title. In the end, however, the name he wants for the show, *Exposition faite par un groupe d'Artistes Indépendants*, appears only on the poster and not on the catalog, indicating that the agreement on the name is not really so unanimous. In a letter of March 1880 Degas writes to Bracquemond: "The posters will be up tomorrow or Monday. They are in bright red letters on a green ground. There was a big fight with Caillebotte as to whether or not to put the names. I had to give in and let him put them up. When on earth will they stop the headlines? Mademoiselle Cassatt and Madame Morisot did not insist on being on the posters. It was done the same way as last year and Madame Bracquemond's name will not appear—it is idiotic. All the good reasons and the good taste in the world can achieve nothing against the inertia of the others and the obstinacy of Caillebotte. In view of the frenzied advertisement made by de Nittis and Monet in *La Vie Moderne* our exhibition promises to be quite inglori-

1880 Fifth show

drain the plate well by inclining it), then evaporates and leaves the plate covered with a coating, more or less thick, of small particles of resin. In allowing it to bite, you obtain a network of lines, deeper or less deep, according as to whether you allowed it to bite more or less. To obtain equal hues this is necessary; to get less regular effects you can obtain them with a stump or with your finger or any other pressure on the paper which covers the soft ground."

During the month of March 1880 the Impressionists get together several times while preparing for their fifth show, although nothing has yet been said about the site for the show or the details of its organization. Degas, together with

ous. Next year I promise you, I shall take steps to see that this does not continue. I am miserable about it, humiliated. Start bringing your things. There will probably be two panel screens, one in the center of the room with the four windows and the other in the entrance room. You will be able to arrange your entire stock of engravings on them." The opening is on April 1, and the show runs until April 30, open from ten to six o'clock; the entrance is one franc. The 232 works are exhibited in a new, inexpensive setting, the half-finished rooms of a palace still in construction at 10, Rue des Pyramides, at the corner of Rue Saint-Honoré. The rooms are dusty and noisy from the ongoing construction work.

Visitors to a Salon. An artist's fate can hang in the balance, the success or failure of his career determined by their judgment, which is quite often more emotional than rational.

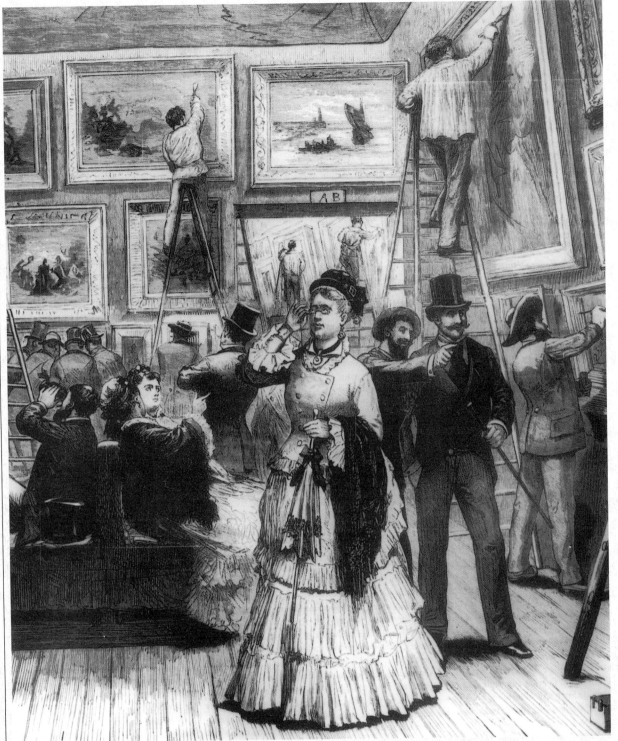

Impressionist show, he presents 25 paintings and several lithographs in the offices of the magazine *La Vie Moderne*, owned by Charpentier. In addition to the artists absent from the preceding year's show, Monet, like Renoir, prefers to send two paintings to the Salon, one of which is accepted: the *Portrait of Antonin Proust*. Unfortunately, Monet's painting as well as the two canvases by Renoir, *Mussel Fishers* and *Girl with Cat*, are displayed in such poor positions that they are wasted. The artists' protests against the organizers in the *Chronique des Tribunaux* of May 23 along with several articles written in their defense by Zola in *Voltaire* fall on deaf ears. In a letter of the same year, Monet writes to Antonin Proust, recently elected to the chamber of deputies: "For three weeks your portrait was exhibited at the Salon, located in an ignoble way, on a panel near a door, and the way it was hung received even less favorable comments. However, it is my destiny to be scorned, and I accept it philosophically." Another possible reason for Monet's absence is that during those same weeks he is reaching an agreement with Charpentier for a show of his own, and in fact in June he exhibits 18 works in the offices of *La Vie*

Nineteen artists take part, including four first-timers: Jean-François Raffaëlli (with 36 works), Jean-Marius Raffaëlli (one), Eugène Vidal (nine), and Victor Vignon (nine). The other artists are Félix Bracquemond (two) and his wife, Marie (three), Gustave Caillebotte (11), Mary Cassatt (16), Edgar Degas (12), Jean-Louis Forain (10), Paul Gauguin (seven paintings and a sculpture), Armand Guillaumin (22), Albert Lebourg (20), Léopold Levert (eight), Berthe Morisot (15), Camille Pissarro (16), Henri Rouart (12), Charles Tillot (14), and Federico Zandomeneghi (eight). Manet is warmly invited to participate and as always refuses. In fact, from April 10 to 30, in direct competition with the

Moderne. Thanks to the editor's help and influence the show is a big success, both critically and in terms of sales. Monet is finally able to pay off his debts, and freed from financial worries he can face the future more optimistically. Among the many visitors to the show is the sixteen-year-old Paul Signac, who sends Monet a long letter expressing his admiration for his works and asking for a meeting to show him his first works and get his opinions and advice. Meanwhile Cézanne has returned to Paris after his long exile at Aix-en-Provence. He resumes the habit of regular get-togethers with his Impressionist friends but remains inflexible in his refusal to exhibit with them, and this even though his works have once

1880

Fifth show

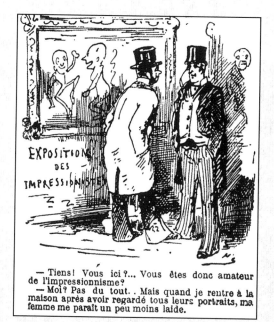

EXPOSITION DES IMPRESSIONNISTES

— Tiens! Vous ici?... Vous êtes donc amateur de l'impressionnisme?
— Moi? Pas du tout.. Mais quand je rentre à la maison après avoir regardé tous leurs portraits, ma femme me paraît un peu moins laide.

Left: Satirical cartoon by Pif on the 1880 show: "What are you doing here? Do you like the Impressionists?" "Not in the least. But when I go home after seeing their portraits my wife looks a little less ugly."

again been rejected by the jury of the Salon. Cézanne's fears are not altogether unfounded, however, for once again the Impressionists' show receives few favorable comments. Indeed, the majority of the critics and the public openly takes sides against them. This phenomena, new to the history of art, interests Emile Zola, who in that year, in his book *Mes Haines (My Hates)*, presents a long analysis of the relationship between artists and their public. "When the crowd laughs it does so almost always for a foolish reason. In the theater, for example, if an actor trips, the public is overcome with hilarity and is still laughing the next day at the memory of the incident. Put ten people of the same intelligence in front of a new and original painting and all ten will behave in an infantile way. Each will call the attention off the others, and all will comment in a facetious way . . . They look at a painting in the same way in which a child flips the pages of a book, only to play. Ignorant people laugh with extreme insolence. Those who believe themselves well informed, those who have studied art at the more conservative schools, are irritated at having to face a new work of art because they see that it does not possess the qualities that until then they believed in and to which their eyes are habituated. No one will make the effort to look at it objectively. The ignorant understand nothing and the educated make too many comparisons. None of them is able to *see* and therefore they are driven to laugh-

Edouard Manet, *Spring*, an etching of 1882.

ter and to anger . . . It is the originality that disturbs them. We are more or less tied to our habits, even if we are not aware of it. We follow well indicated paths that come habitual to us. Every new route alarms us, we avoid that which is unknown and refuse to look ahead. We love to have before us the usual horizon; if we do not understand something, we laugh at it or are irritated by it. We behave like this because we are willing to accept originality only when it is moderate, and we refuse it violently when brings into question our preconceptions. When a truly original personality appears, we become worried and frightened, like a nervous horse that rears when confronted by a tree that has fallen in the street, for it does not understand the nature or the cause of the obstacle and makes no effort to understand it." Yet despite all this, in the words of John Rewald, "Without hesitation the Impressionists continued in complete isolation their daily efforts toward creation, like a group of actors playing night after night to an empty theater."

Alfred Sisley, *Landscape*, an etching of 1890.

PIERRE-AUGUSTE
RENOIR
**Portrait of
Paul Bérard**
1880, oil on canvas,
81 × 65 cm
Private collection

In 1879 Renoir is the guest at Wargemont of Paul Bérard, banker, consular secretary, and art connoisseur. During the summer of the next year, 1880, the several portraits Renoir makes include this one of Bérard. The traditional pose of the portrait is enlivened by the easy naturalness of the sitter's expression and the atmosphere of intimacy. Renoir simplifies the background and the chair, filling them in with a few brisk brushstrokes, to give greater emphasis to the subject, whose face is defined with minute precision.

■ PIERRE-AUGUSTE
RENOIR
**Woman with
White Jabot**
1880, oil on canvas,
46.3 × 38 cm
Musée d'Orsay, Paris

The identity of the
woman is not known;
most probably she is
one of the occasional
models Renoir uses for
practice. During these
months he finds him-
self with commissions
for many portraits,
work that provides
him with both critical
and financial success.
Here he uses a very
close-up frontal pose
with strong, direct
lighting that puts
emphasis on the
details of the face
and dress. The colors
are soft and warm,
particularly around
the flower and the
white jabot, thus
contrasting with
the dark areas of
the dress.

1880

PIERRE-AUGUSTE
RENOIR
**Portrait of Irène
Cahen of Antwerp**
1880, oil on canvas,
65 × 54 cm
Bührle Collection,
Zurich

Through his friendship
with Paul Bérard,
Renoir meets the
banker Louis Cahen
of Antwerp, who com-
missions this portrait
of his eldest daughter,
Irène, and the next
year a painting of his
two younger daugh-
ters, Alice and
Elisabeth. The artist
puts emphasis on the
girl's wonderful hair
and her sweet but
thoughtful expression,
reminiscent of English
portraits, after which
this work seems to be
modeled. The direct
light brightens the
colors, while the way
the garden in the
background is just
sketched in makes it
seem to lack depth.

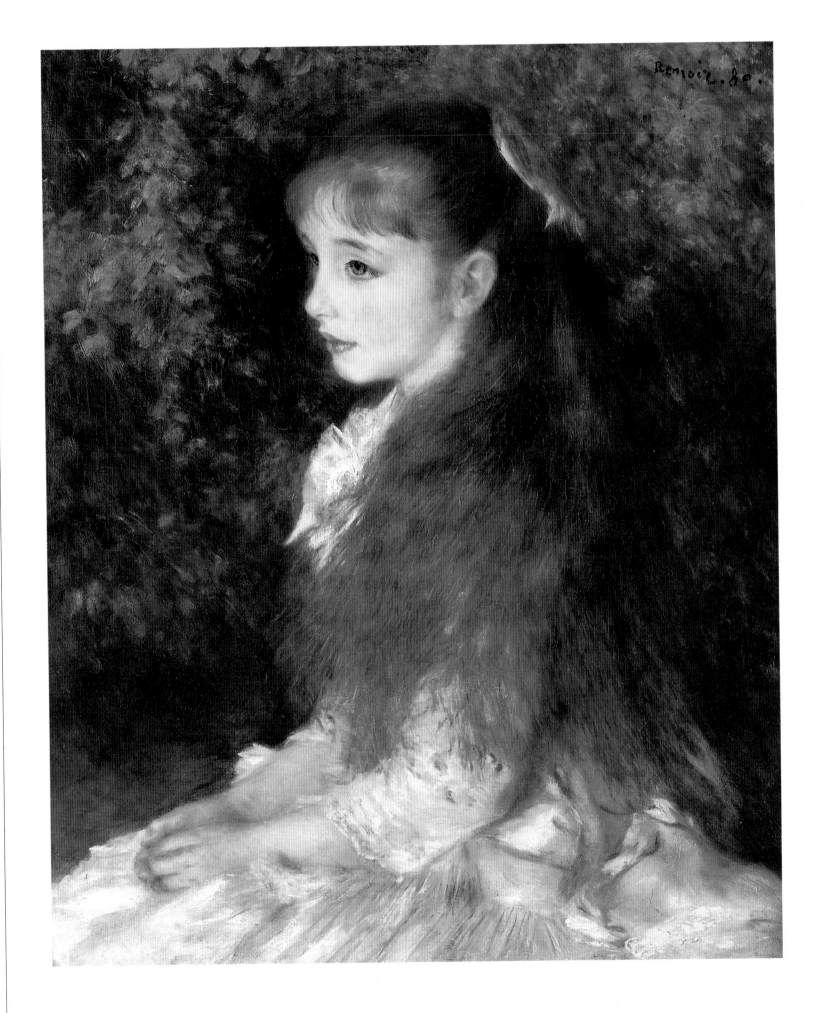

1880

234

Fifth show

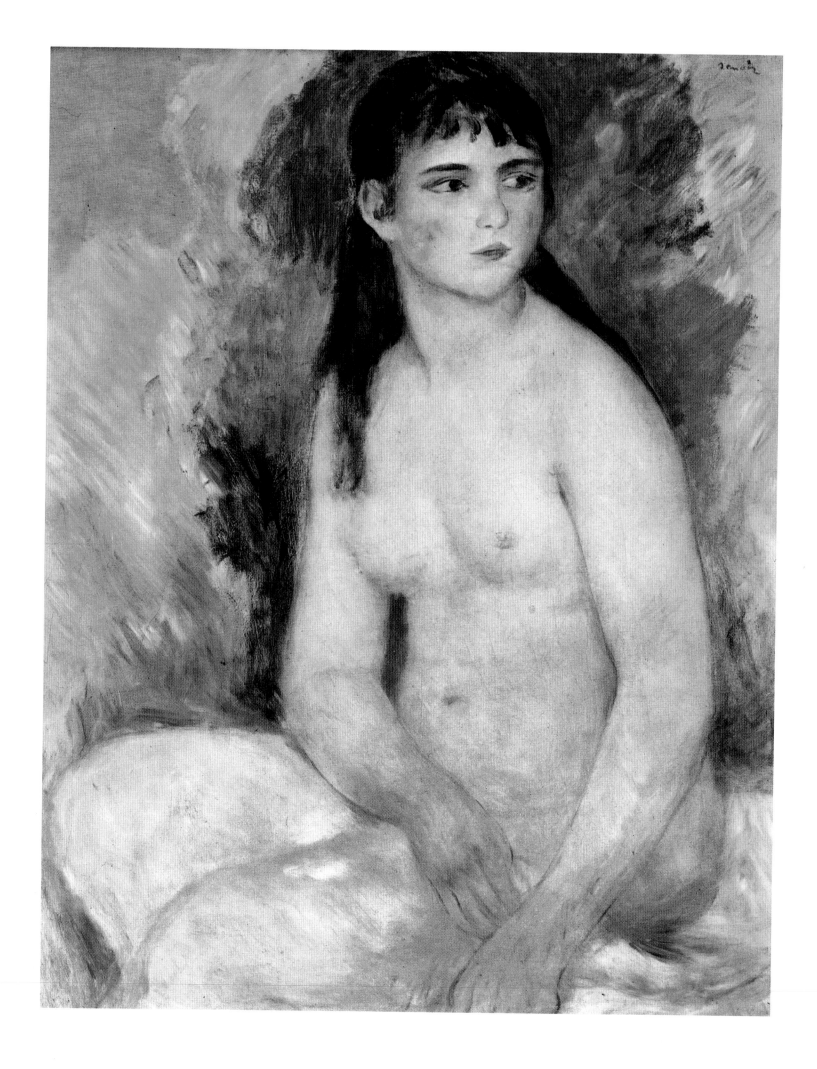

PIERRE-AUGUSTE
RENOIR
Seated Nude
1880, oil on canvas,
80 × 65 cm
Musée Rodin, Paris

This painting is bought
by Maurice Leclanché,
who in turn sells it to
the sculptor Auguste
Rodin, who was struck
by the work, fascinat-
ed by its plastic sense
and the monumental
grandeur of the figure.
Unlike many of the
nudes from preceding
years, here Renoir
struggles to give the
figure movement and
grace, brightening the
colors of her skin to
obtain diaphanous,
almost transparent
tones. Quite different
is the background,
rendered with brusque,
uneven brushstrokes
in darker, stronger
colors, giving spatial
depth to the scene
while also accentuat-
ing its dynamism.

1880

CLAUDE MONET
**Snowy Landscape
at Sunset**
1880, oil on canvas,
55 × 81 cm
Musée Malraux,
Le Havre

On September 5, 1879,
at only thirty-two
years of age, Monet's
wife, Camille, dies. The
painter is at Vétheuil
with his two children
and Alice Hoschedé
and her five children.
That winter is particu-
larly hard; the Seine
often freezes over,
and the town is often
cut off from the out-
side world by snow.
To overcome the death
of his wife, Monet
concentrates on his
work, creating many
landscapes, almost
always set at dawn
or sundown and char-
acterized by a soft,
veiled luminosity.
Marked by a lyricism
of rare poetic inten-
sity, these works are
among the most
beautiful of his
production.

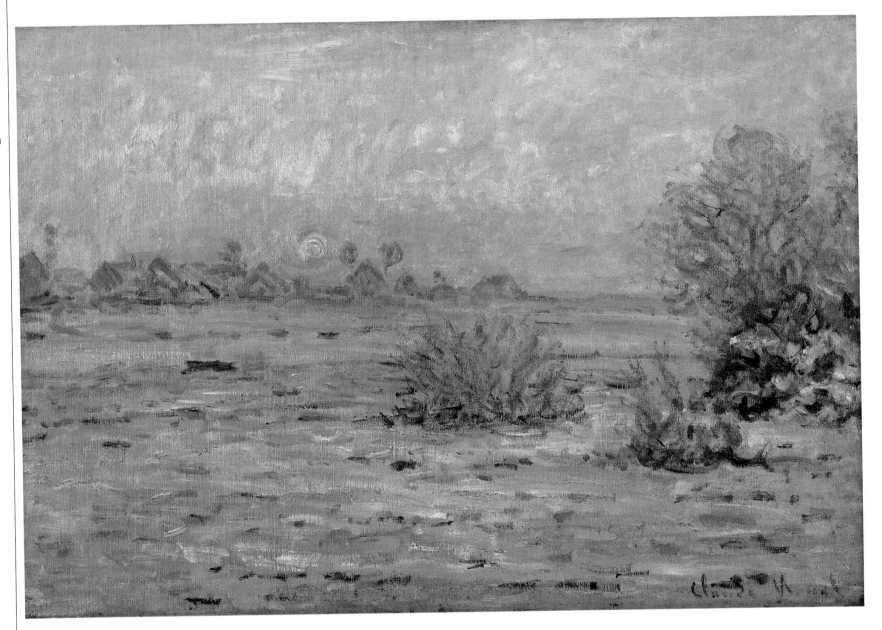

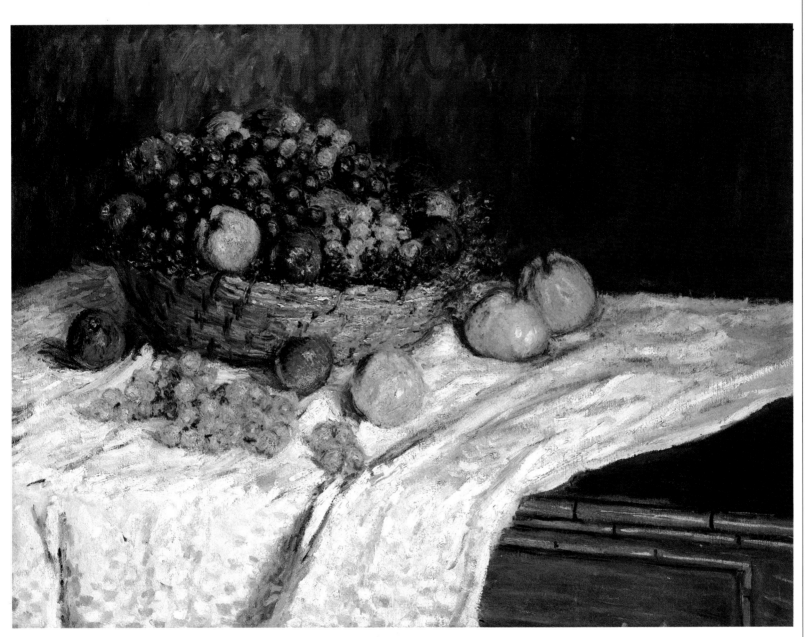

CLAUDE MONET
**Still Life with
Grapes and Apples**
1880, oil on canvas,
70 × 92 cm
Metropolitan Museum
of Art, New York

This is one of three
still lifes with grapes
and apples that Monet
paints during the first
months of 1880; the
other two are slightly
smaller; one is in the
Art Institute of
Chicago, the other
the Kunsthalle of
Hamburg. These
paintings are made
at Vétheuil, most
probably during the
days of that harsh
winter when bad
weather prevents
Monet from painting
outdoors. The arrange-
ment of the still life
seems to recall the
works of the romantic
painters, but the use
of colors and light
anticipates several
of the stylistic
methods of the
Fauvist painters.

**Path in the Isle
Saint-Martin**

1880, oil on canvas,
80 × 62 cm
Metropolitan Museum
of Art, New York

One of Monet's favorite
spots is the little
island of Saint-Martin
near Vétheuil. In the
spring of 1880 he
goes there often to
paint in the open air.
The works of this peri-
od include a series of
landscapes in which
he makes use of very
pale, delicate colors
and softens outlines
to flatten the compo-
sition, techniques he
has drawn from his
study of Japanese
prints. The hushed
melancholy with which
he imbues these works
reflects his state of
mind following his
wife's death—their
sensibility is in stark
contrast to the full,
joyous luminosity of
the paintings of
Argenteuil.

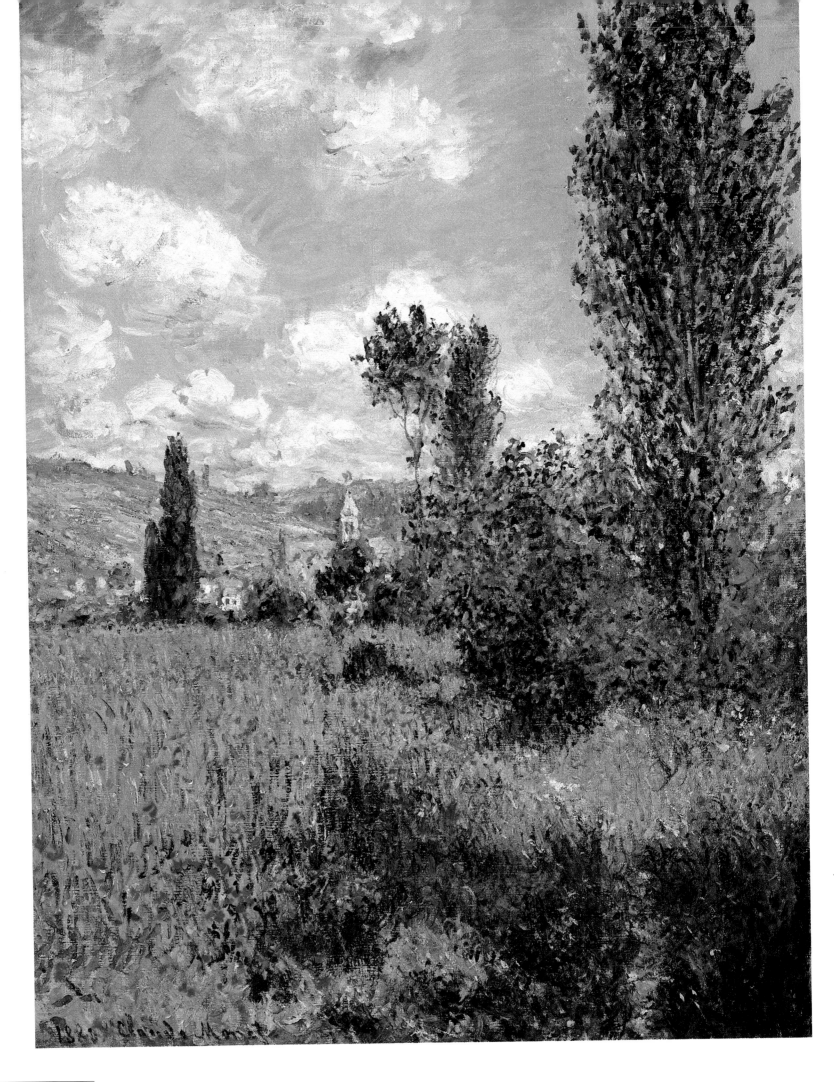

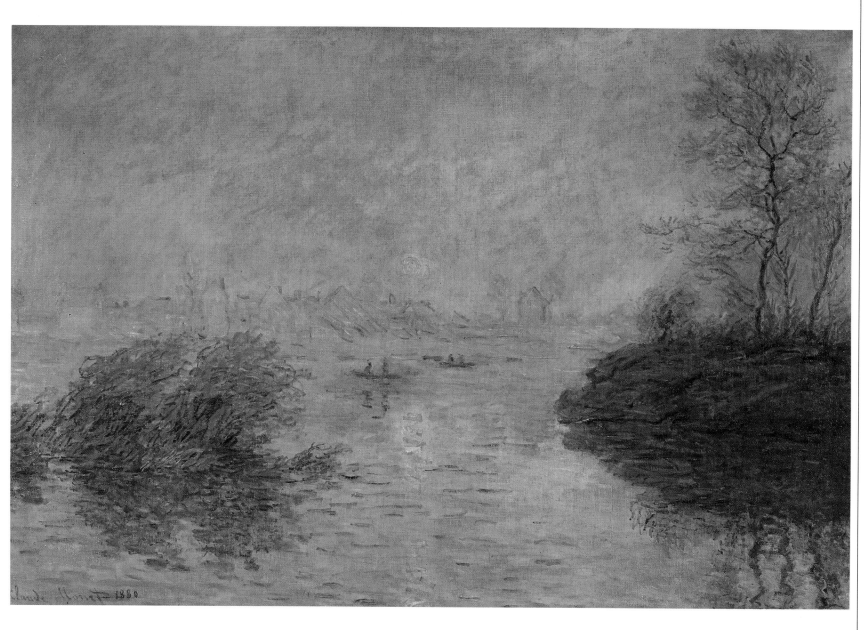

■ CLAUDE MONET
Sunset at Lavacourt
1880, oil on canvas,
101 × 150 cm
Musée du Petit Palais,
Paris

Monet makes this
painting in the autumn
of 1880 at Lavacourt,
near Vétheuil. The
rays of the setting sun
illuminate the sky
with shades of yellow
and orange that are
reflected across the
water of the Seine.
Several boats can
be seen in the back-
ground, but the
houses of the town
are almost hidden
by a wispy fog that
reveals only their out-
lines. The plants in
the foreground recall
the snow-covered
landscapes Monet
made during the pre-
ceding winter and
share the same sense
of sad desolation.

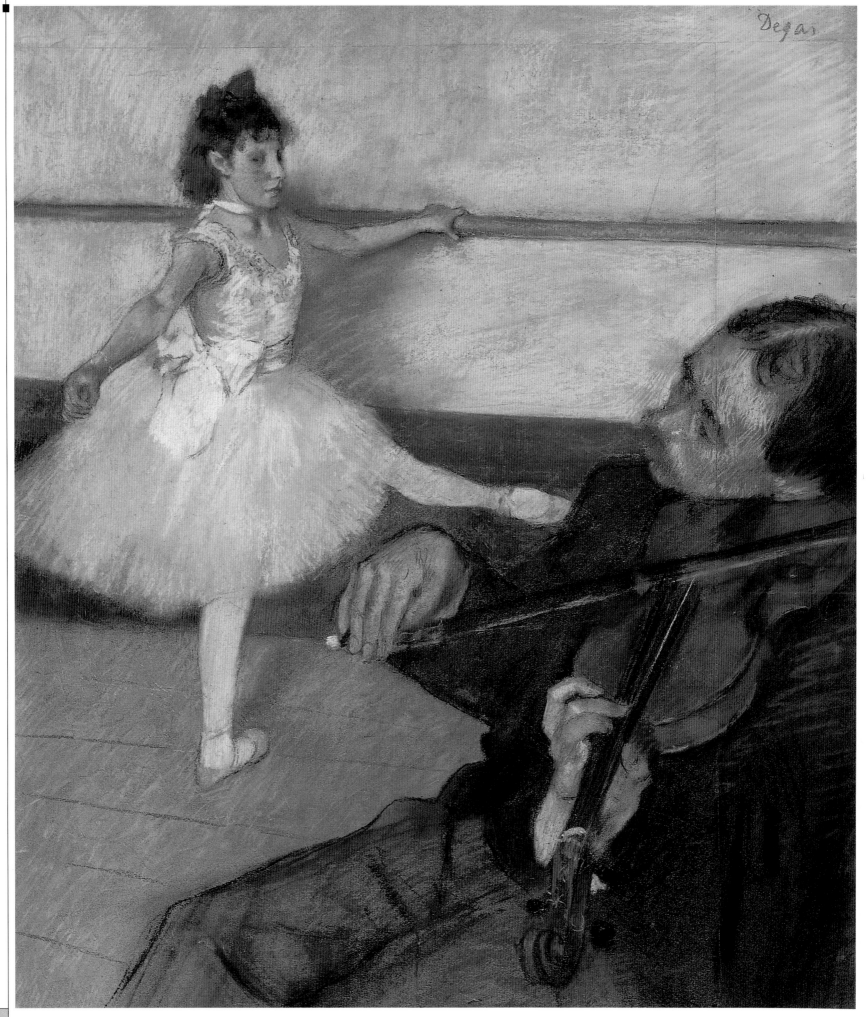

EDGAR DEGAS
The Dance Lesson
circa 1879–80, black chalk and pastel on carbon paper,
63.4 × 56.3 cm
Metropolitan Museum of Art, New York

Before making this work, between the end of 1879 and the first months of 1880, Degas makes a picture of only the violinist using pastels and charcoal on paper. This fact reflects the painter's habit of isolating the individual elements of his compositions and working on them separately, trying out different effects of color and lighting. The slightly raised point of view gives the viewer the sense of actually participating in the scene, perhaps in the role of dance teacher giving a lesson to the young ballerina.

1880

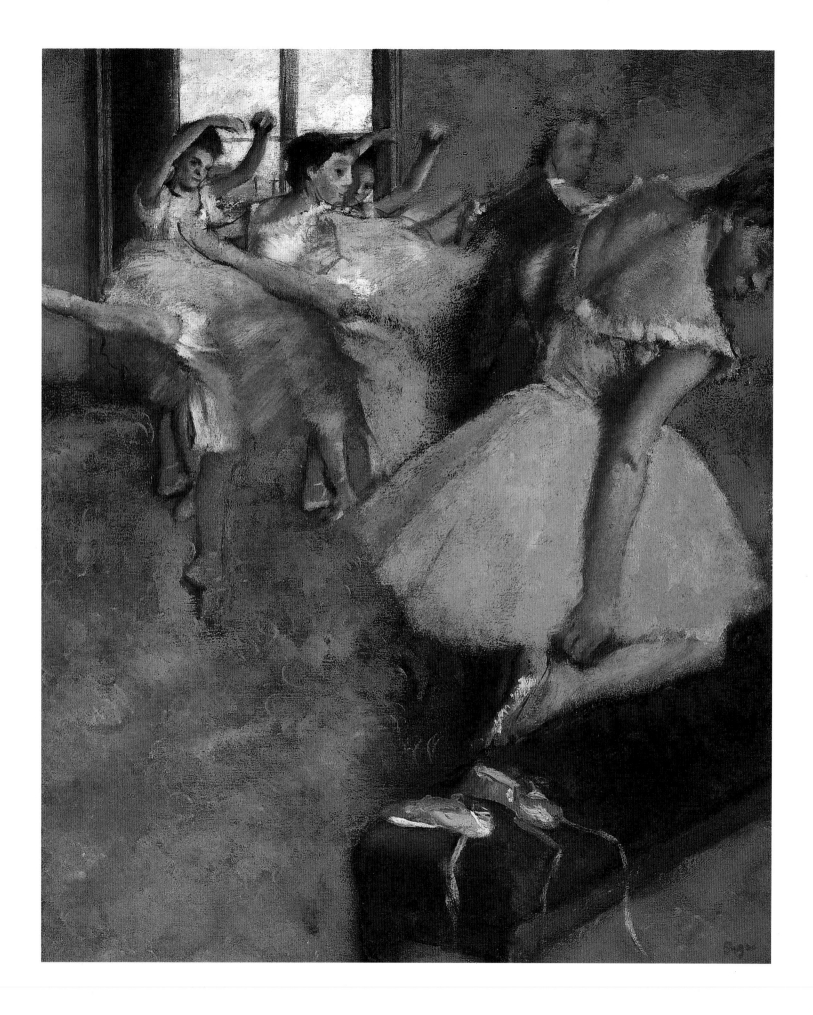

EDGAR DEGAS
The Dance Class
circa 1880, oil
on canvas,
62 × 50.5 cm
Bührle Collection,
Zurich

The theme of move-
ment is of central
importance to many
of the paintings Degas
makes of ballerinas. In
this case the painter
is clearly working to
express the dynamism
of the girls' bodies,
calling attention to
their gestures and
emphasizing them
with the swift brush-
strokes he uses to
render their pale
tutus. The way in
which he distributes
the one color used for
both the floor and
walls contributes to
the sense of a kind
of vortex around the
dancers, as though
our visual perception
of them were affected
by the rapid whirling
of their arms and legs,
eventually giving the
impression that the
entire room is in
movement.

EDGAR DEGAS
Ballerina in Green
circa 1880, pastel and
gouache on paper,
66 × 36 cm
Thyssen-Bornemisza
Collection, Madrid

"They have called me
the painter of dancers.
What they do not
understand, however,
is that for me the
dancer is only an
excuse to paint deli-
cate fabrics and to
express movement."
Degas directs this
statement at those
critics who judge him
by way of broad gen-
eralizations, and the
truth of his words is
made clear in this
painting. The vertical
framing and the very
high point of view
emphasize the light,
vaporous dresses of
the dancers. Their
dynamic movement
is synthesized in
the almost abstract
swirling of their
arms and legs in the
foreground.

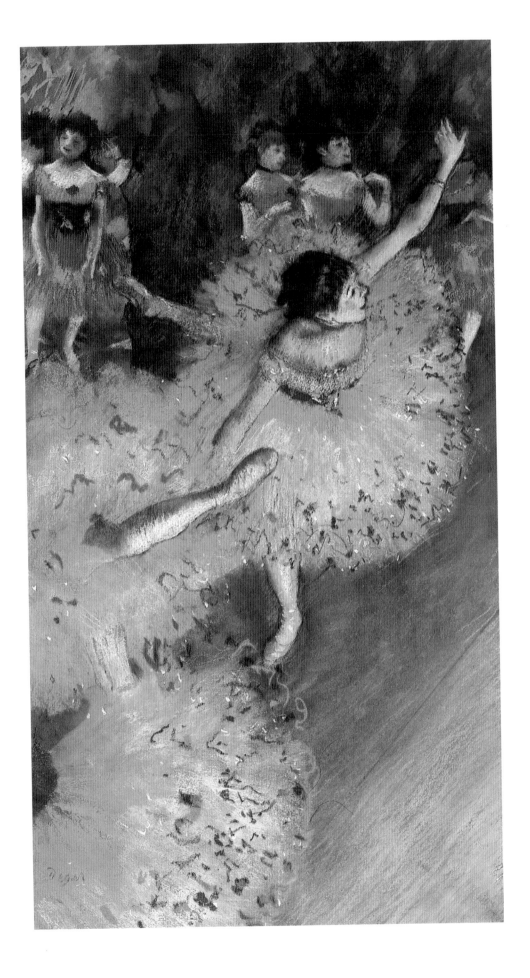

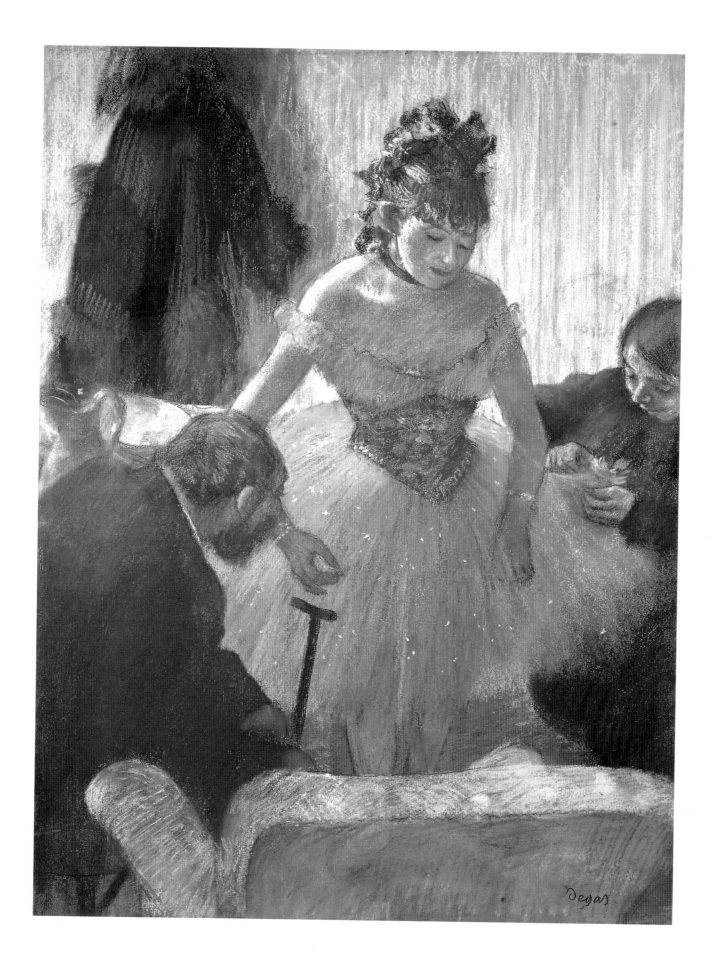

■ EDGAR DEGAS
Ballerina Changing
circa 1880,
pastel on paper,
59 × 45 cm
Private collection

Aside from portraying
ballerinas on the
stage, Degas loves to
"spy" on them while
they practice move-
ments in the exercise
room or, as in this
case, while they are
behind the curtains,
preparing to go on
stage. The painter
does nothing to make
the setting pretty or
elegant; he uses real-
ism and naturalism to
transmit the gestures
of the seamstress who
is putting the final
touches on the girl's
costume while the
seated teacher is prob-
ably giving her some
last-minute advice.
The ballerina's eyes
are lowered; perhaps
she is distracted,
perhaps she is going
over in her mind the
dance steps she will
soon be called on to
perform.

PAUL CÉZANNE
The Bridge at Maincy
1879–80, oil
on canvas,
59 × 72 cm
Musée d'Orsay, Paris

One primary reason for interest in this painting is its geometric reduction of space. The artist contrasts the irregular forms of the trees and leaves with the simple structure of the bridge, presented as a rectangle supported by two arches. A second aspect of the work to which the artist gives much attention is the reflections of the plants on the surface of the river, rendered with brief touches of color, horizontal, in differing intensity, while in the upper area of the painting the brushstrokes are oblique or vertical.

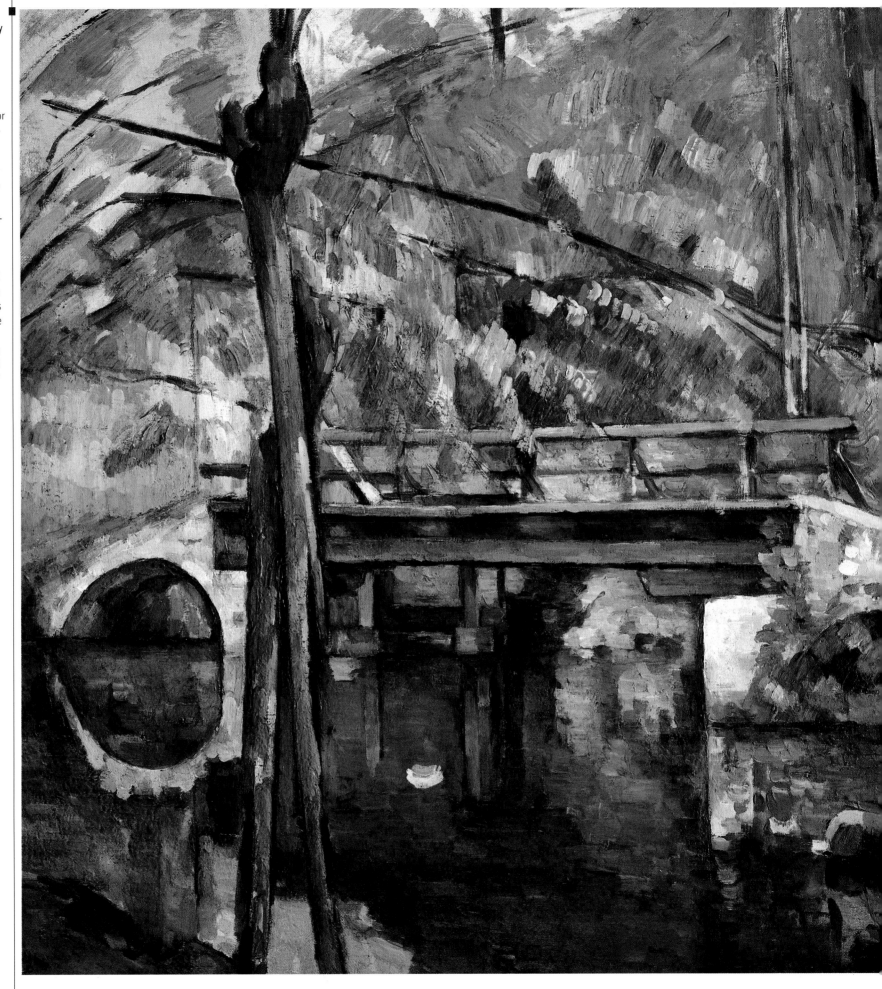

Fifth show

■ PAUL CÉZANNE
**Courtyard of the
Farm at Auvers**
1879–80, oil
on canvas,
63 × 52 cm
Musée d'Orsay, Paris

Many critics, including Lionello Venturi, consider this one of the outstanding examples of Cézanne's "constructive" period, meaning the years between 1878 and 1887. In the landscapes he makes during that decade, Cézanne simplifies forms to the point of pure, simple geometric shapes. In this canvas the procedure is most apparent in the corners of the two buildings to the right and left and in the roof of the building in the center. Only the trees have an irregular shape, as though the painter wanted to represent human rationality so as to contrast it with the irrationality of nature.

PAUL CÉZANNE
Five Bathers
1879–80, oil
on canvas,
35 × 39 cm
Institute of Arts,
Detroit

As we saw in the pre-
ceding chapter (page
216), Cézanne often
turns to the theme of
the nude inserted in
nature, sometimes
alone, sometimes in
groups, sometimes
female, and at other
times, as in this paint-
ing, male. This is a
willfully indefinite
subject, and no one
element permits us to
locate the figures in a
precise historical epoch
or to give them a clear
identity, whether
social or psychological.
They are simply human
beings outside of time
in an unrecognizable
space; they are per-
fectly integrated into
nature, and are at ease
in it, as in a kind of
terrestrial paradise
where the artist him-
self, perhaps, would
like to live.

■ PAUL CÉZANNE
**Auvers from
the Val Harmé**
1879–82, oil
on canvas,
73 × 92 cm
Private collection

Although he has
definitively moved
to Provence, Cézanne
often makes visits to
Paris, both to main-
tain his contacts with
the other Impression-
ist painters and to
visit the outskirts of
the capital to paint
in the open air, as he
did in the preceding
decade. In this land-
scape the few houses
are almost hidden,
surrounded by plants
that the artist works
out of numerous
shadings of green, in
varying levels of light.
Once again the human
figure is banished
so as not to upset
the tranquility of
the scene.

PAUL GAUGUIN
Rural Constructions
1880, oil on canvas,
81 × 116 cm
Sam Spiegel Collection,
New York

Although still considered an amateur, Gauguin is accepted in the Impressionist show of 1880, where he receives flattering reviews that encourage him. The influence of Pissarro is quite clear in this landscape, both in the point of view, which excludes any human presence and gives preference to the compact, almost geometric shapes of the roofs of the houses, and in its organization of light and colors. The way the short brushstrokes join and blend creates a homogeneous and uniform impression, the few contrasts serving to give depth to the scene.

1880

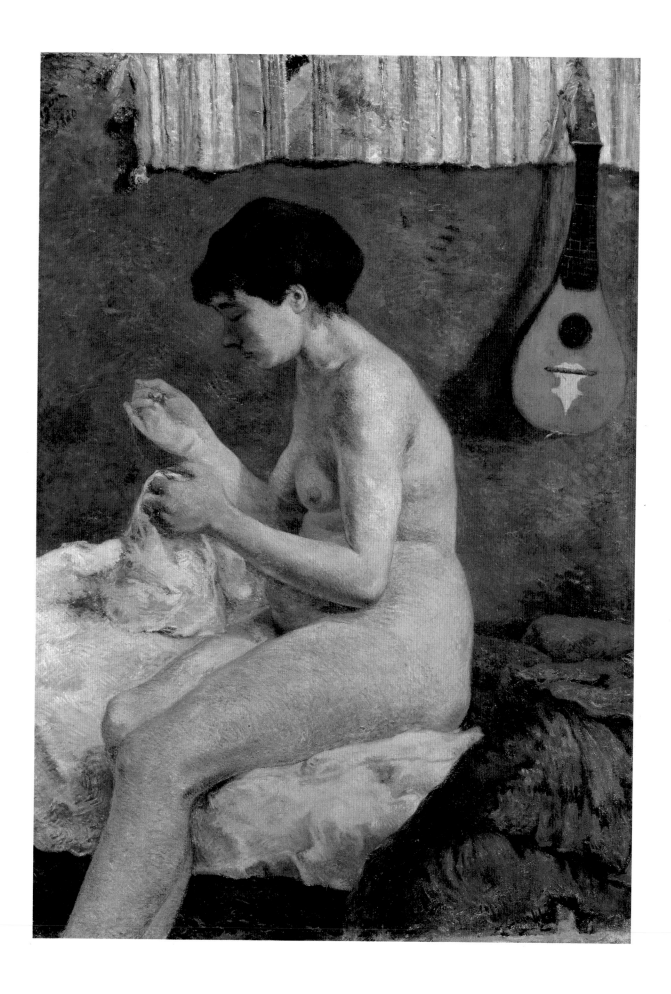

■ PAUL GAUGUIN
**Nude Study
(Suzanne Sewing)**
1880, oil on canvas,
114.5 × 79.5 cm
Ny Carlsberg Glyptotek,
Copenhagen

The model is Suzanne,
the nanny for Gau-
guin's children, and
she is portrayed in a
realistic moment close
to the naturalism of
Gustave Courbet. The
setting is purposefully
simple, almost humble.
The canvas is exhib-
ited at the sixth
Impressionist show,
where it receives
praise from Degas and
is noted by Huysmans.
The writer expresses
admiration for the
work, pointing out its
modernity and at the
same time its ties to
the classical tradition.
In particular he com-
pares it to *Bathsheba*
by Rembrandt.

MARY CASSATT
At the Opera
1880, oil on canvas,
79.9 × 64.7 cm
Museum of Fine Arts,
Boston

The theme of this
painting recalls *The
Loge* by Renoir (page
114). In that work a
male figure points his
opera glass away from
the stage up toward
the public. In this work
a male spectator looks
away from the stage
to boldly study the
woman in the fore-
ground. Unaware of
the attention (or pre-
tending to be unaware
of it) she continues
to concentrate on
the performance. The
framing of the scene
skillfully makes use of
the physical setting
and the distribution
of light.

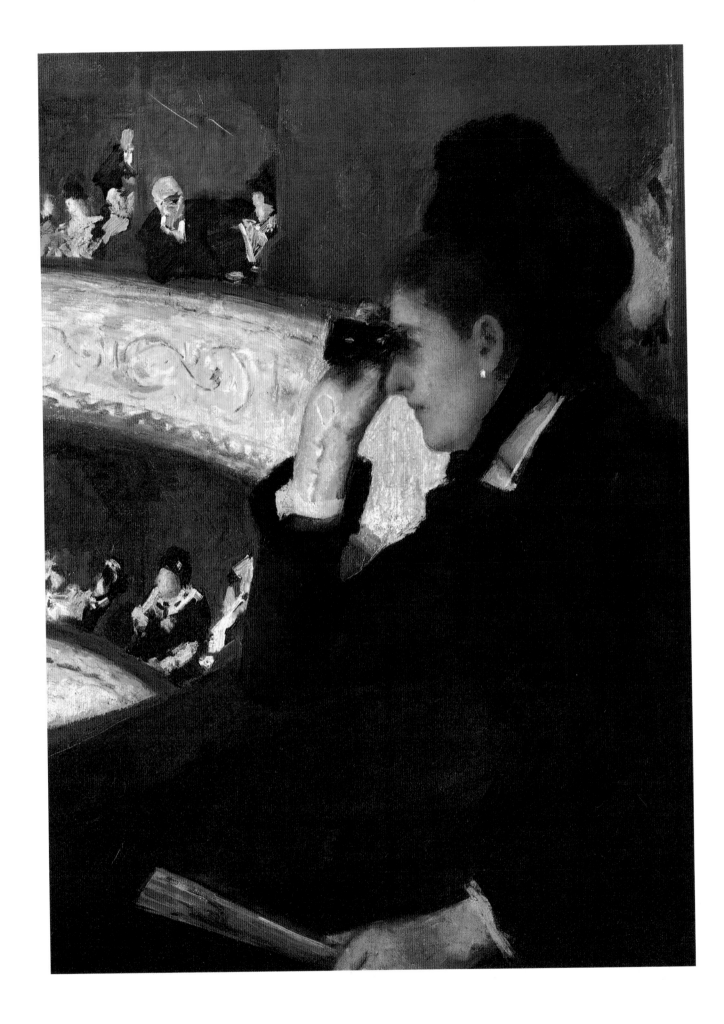

1880

Fifth show

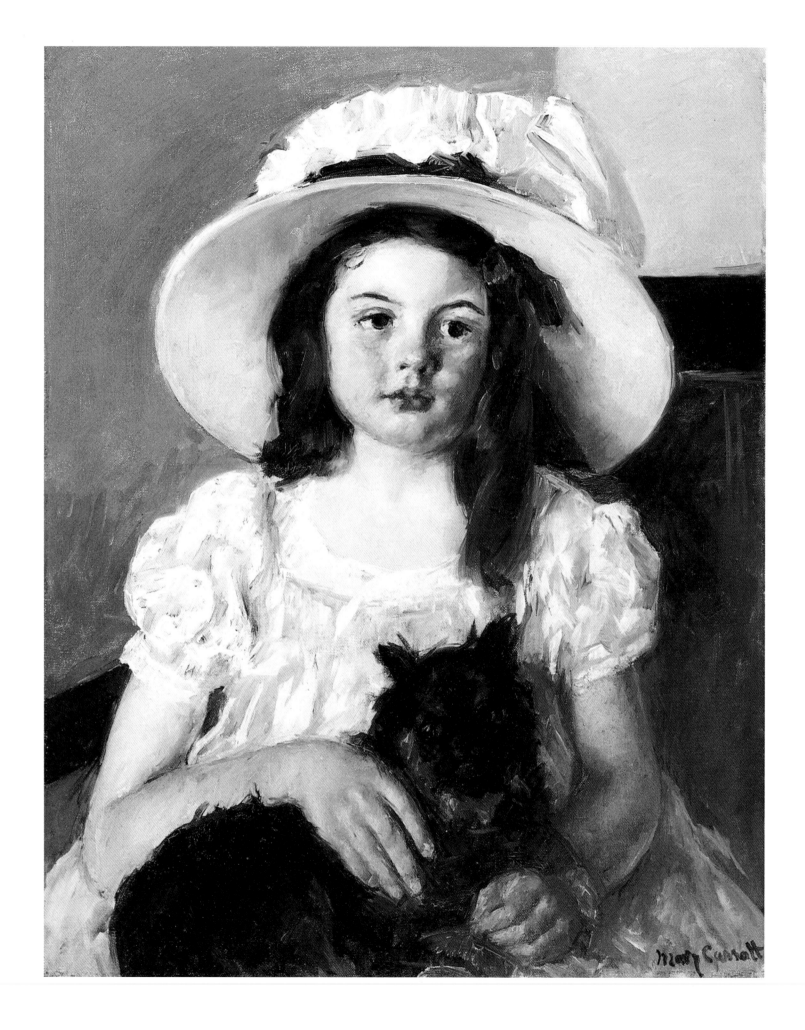

MARY CASSATT
Françoise with a Black Dog
circa 1880, oil on canvas,
75 × 54 cm
Private collection

Born in Pittsburgh, Cassatt studies in Philadelphia and takes a long trip throughout Europe before settling in Paris to study and copy works in the Louvre. She succeeds in being accepted by the Salon of 1874 and meets Degas, who introduces her to the other Impressionists, with whom she exhibits in the shows of 1879, 1880, 1881, and 1886. One can make out the teaching of her friend and master Degas in this portrait, along with signs of the influence of both Renoir and Manet, with whom she shares the choice of pale colors and a soft luminosity with delicate, intimist effects.

ALFRED SISLEY
**Saint-Mammès,
Gray Weather**
circa 1880, oil
on canvas,
54.8 × 74 cm
Museum of Fine Arts,
Boston

In the course of the
1880s Sisley often
stays at Saint-
Mammès, which stands
at the confluence of
the Seine and the
Loing rivers near
Véneux-Nadon. He
works intensely and
makes about fifty
paintings, experiment-
ing with various tech-
nical methods. As is
his habit, he gives
much space to the
sky, which he creates
with broad, regular
brushstrokes like
those used by John
Constable and the
English landscapists.

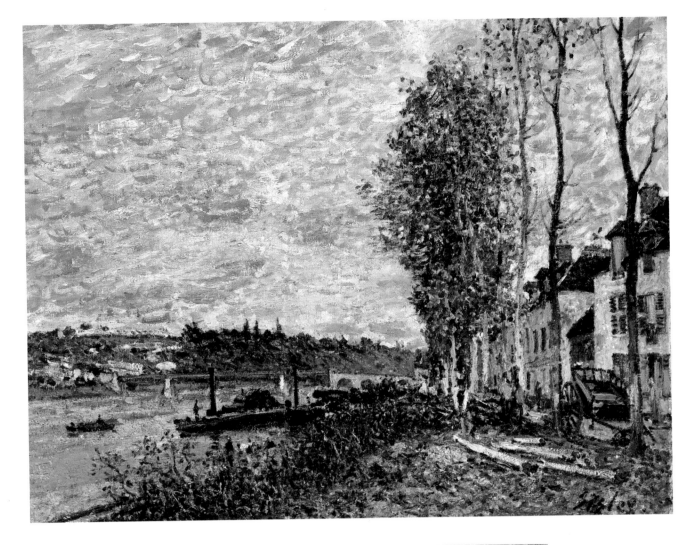

CAMILLE PISSARRO
**Peasant Seated
at Dusk**
1880, oil on canvas,
92 × 71 cm
Private collection

This painting is part of
a series dedicated to
young peasant women,
presented with sim-
plicity and naturalness
while working in the
fields or, as in this
case, while at rest.
From a stylistic point
of view one notes how
Pissarro intensifies the
light and makes it
more diffuse through
the use of small spots
of complementary col-
ors, a use that antici-
pates the works of
Seurat and Signac.

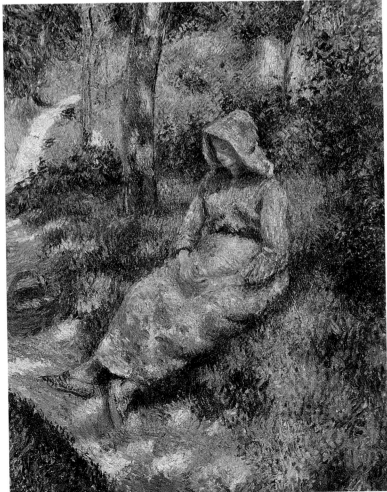

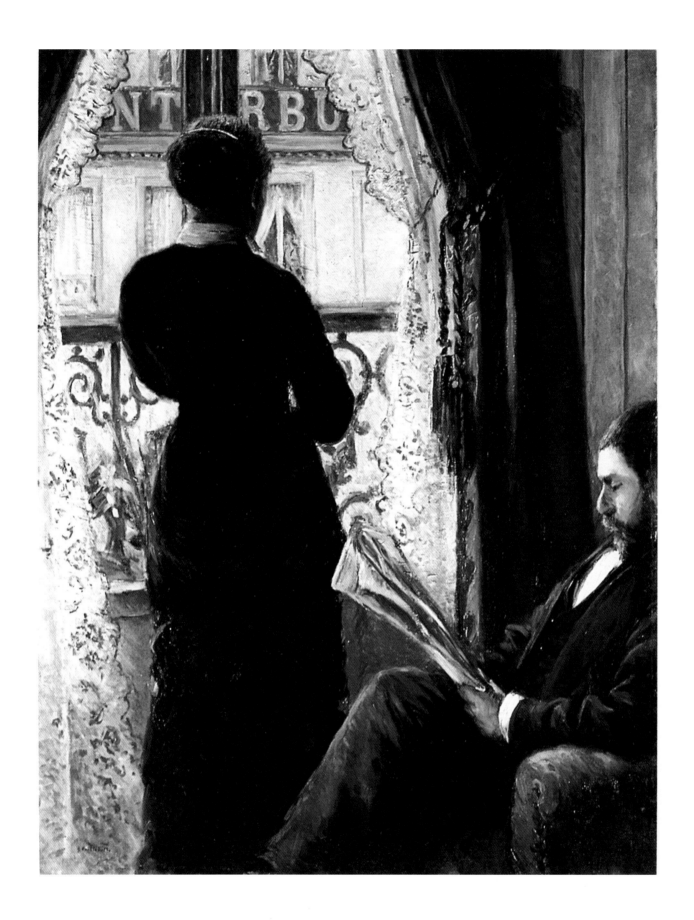

■ GUSTAVE
CAILLEBOTTE
**Interior, Woman at
the Window**
1880, oil
on canvas,
116 × 89 cm
Private collection

This is one of the
two *Interiors* that
Caillebotte presents
at the fifth Impres-
sionist show. The
critics, including
Dalligny in the pages
of the *Journal des
Arts*, Ephrussi in the
Gazette des Beaux-Arts,
and Mantz in *Le Temps*,
give him positive
reviews. Three years
later, in an article
in *L'Art Moderne*,
Huysmans calls the
paintings the most
complete expression
of modern sentiment,
and transcriptions in
paint of the naturalist
novels of Flaubert.
The theme enjoys a
certain fortune and
is repeated several
times, as for example
in the painting by
Paul Signac *A Paris
Sunday*, from 1890.

1880

Early in 1881 the Impressionists get together again, now with the goal of organizing their sixth show, but once again there are heated arguments, and several differences of opinion grow deeper. In two letters, dated January 24 and 28, Caillebotte informs Pissarro of his failed attempts to convince Renoir and Monet to exhibit again and of his own arguments with Degas, following which he has himself decided not to participate in the show. Of the nineteen exhibitors in 1880 only thirteen remain. Aside from Caillebotte, the artists who decide to withdraw include the two Bracquemonds, Lebourg, Leveret, and Jean-Marius Raffaëlli. The exhibitors are Mary Cassatt (with 11 works), Edgar Degas (eight), Jean-Louis Forain (10), Paul Gauguin (10), Armand Guillaumin (16), Berthe Morisot (seven), Camille Pissarro (28), Jean-François Raffaëlli (34), Henri Rouart (15), Charles Tillot (10), Eugène Vidal (one), Victor Vignon (15), and Federico Zandomeneghi (five). The show runs from April 2 to May 1 and is held at 35, Boulevard des Capucines, the same address as the first exhibition but this time in poorly illuminated rented rooms that open onto an inner courtyard. As has become usual, the show is open from ten o'clock in the morning until six in the evening. Along with the

usual satirical cartoons and the many negative reviews in magazines and newspapers, there are also, this time, several articles by Joris Karl Huysmans. The famous writer is one of the few to defend Degas's sculpture of the *Little Fourteen-Year-Old Dancer*. Furthermore, in the periodical *L'Art Moderne* he dedicates a long appreciative essay to the works of Mary Cassatt, writing of having admired "images of fascinating children, tranquil scenes of bourgeois life, painted with a sweet and delicate tenderness, extremely fascinating." Once again there are very few buyers for the

1881•1882

works exhibited, and the earnings from sales are so poor that during their usual meetings at the Nouvelle-Athènes, Manet reminds the other artists of how often he has tried to convince them to take the traditional route of the Salon, which he himself is following. In that year's Salon he presents two portraits, one of Pertuiset and one of Henri Rochefort, and is awarded a medal, although he does not get by without a few sharp comments from academic circles. These comments are repeated a few months later when Antonin Proust, during his brief service as minister of fine arts in the cabinet formed under Gambetta, nominates Manet Chevalier of the Legion of Honor, an honor that also earns him the jealous envy of the painters not nominated. Throughout the year 1881 Caillebotte patiently labors to reassemble the relationships that hold the Impressionists together, trying to heal the divisions. Around February 24, 1882, Pissarro writes to Monet: "For two or three weeks now I have been making great efforts, together with our friend Caillebotte, to arrive at an understanding in order to reassemble our group as homogeneously as possible." Pissarro makes a futile attempt to convince Cézanne, who has spent several months of 1881

Gauguin Portrayed by Pissarro and Pissarro Portrayed by Gauguin. The drawing testifies to the close friendship enjoyed by the two artists.

List of paints and supplies, drawn up by Renoir.

Blanc d'argent.
Jaune de Chrôme
Jaune de Naples, —
Ocre Jaune,
Terre de Sienne Naturelle —
Vermillon,
Laque de Garance
Vert Véronèse
Vert Emeraude
Bleu de Cobaldt
Bleu Outremer.

couteau à palette
grattoir
époussette
à qu'il faut pour peindre

L'ocre Jaune le Jaune de Naples et la terre de Sienne ne sont que des tons intermédiaires. Dont on peut se passer puisque vous pouvez les faire avec les autres couleurs,

Pinceaux de Martin

Brosses plate en soie,

Sixth and seventh shows

at Pontoise, painting with him and Gauguin, to participate. He prefers to send his paintings to the Salon, and this time, after numerous rejections, he is accepted, thanks to the help of Antoine Guillemet (1843–1938), who uses the privilege available to him as a jury member of having work exhibited, without discussion, of one of his students. Cézanne presents a portrait, but the work is ignored by the critics, passing completely unobserved. Cézanne stays in Paris until September in the vain hope of a request for his paintings from dealers or collectors, then, disappointed and embittered, he again exiles himself to Jas de Bouffan, his father's home two kilometers outside Aix-en-Provence. Every one of Pissarro's attempts to reunite the artists for a another big show comes to nothing; the clash of strong personalities makes compromise impossible. The cultural and artistic climate is changing, the revolutionary

ed in a socialistic group. Pissarro even insists on inviting Lavrof [a Russian anarchist] and other revolutionaries. Today the public wants nothing to do with anything that has to do with politics, and at my age I have no intention of becoming a revolutionary. Furthermore they know how much I want to be accepted by the Salon, and I do not want to lose what I have worked so hard to gain." Finally, right on the eve of the opening, even Degas, who has taken part in all six previous shows and has been one of the major inciters, decides not to submit any paintings. Despite all this, Caillebotte and Pissarro, with help from Durand-Ruel, succeed in organizing the seventh show "des artistes indépendants." The show opens March 1 and runs to the end of the month. It is held in rooms of the Salon du Panorama de Reichsoffen, located at 251 Rue Saint-Honoré. Only nine artists are present, with 203 works: Gustave

Sixth and seventh shows

mood stirred up by the Paris Commune has waned, the lively debates with monarchists or with those nostalgic for the empire are no more: few of the artists still believe in the usefulness of those group shows, and they prefer to exhibit their works by themselves or to try the traditional Salon. During these same weeks Renoir exchanges a barrage of letters with the art dealer Durand-Ruel, who possesses some of Renoir's paintings and intends to exhibit them in the next Impressionist show: the painter repeats his firm intention of not taking part in the show, but fails to convince the dealer to withdraw the paintings. The reason for this aversion is the fear that the critics and the public will continue to see them as a group of revolutionary artists. "To exhibit with Pissarro, Gauguin, and Guillaumin," Renoir writes to Monet, "is to risk being includ-

Caillebotte (with 18 works), Paul Gauguin (13), Armand Guillaumin (26), Claude Monet (35), Berthe Morisot (nine), Camille Pissarro (36), Auguste Renoir (25), Alfred Sisley (27), and Victor Vignon (15). The show incurs many expenses, too many to be covered by the poor earnings from sales and from admission tickets, such that midway through March Caillebotte announces to Monet and Renoir that he foresees the loss of about 2,000 francs. Despite the disappointment caused by this umpteenth failure, in the summer of 1882 Durand-Ruel organizes a show in London.

Frederic Wedmore, writing in *The Standard* of July 1: "The show dedicated to the French Impressionists at 13, King Street, while quite small, well merits a visit: first of all, many of the paintings are excellent; furthermore, the

Auguste Renoir, *Portrait of Paul Cézanne*, 1880, pastel on paper; British Railways Collection, London.

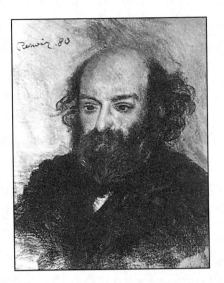

Impressionists are still barely known in England . . . In brief one can say that they like to present that which the human eye sees, not that which the mind reconstructs; furthermore, they boldly and critically take on the problems of modern life and the society in which we live." Both 1881 and 1882 are important for the Impressionists because for almost all of them these years mark the achievement of full artistic maturity, especially in terms of their use of color. More than any other aspect of their technique, it is their use of color that sets the Impressionists apart, in a revolutionary way, from the traditional teaching of the academy. It is this that gives them their original, highly personal style, the style that enrages a majority of contemporary critics and the public but that later comes to be valued for its own merits and enormously appreciated, so much so that Impressionist works will achieve widespread and enduring success throughout the world, a success they still enjoy today.

Since the earliest years of their apprenticeship, the future Impressionists have been aware of the inadequacy of the rules imposed by the Ecole, and they turn instead to the chromatics of Delacroix for their inspiration. When trying to amplify the effects of light, Delacroix

had mixed white into his paints and done so directly on his palette. He had also made frequent use of complementary colors, and when creating shadows preferred not to use black but instead a darker tone of the same color. Beginning in the early 1870s the Impressionists use pale, bright colors; they are able to do so in part because of the rapid progress taking place in the manufacturing methods of paint. The invention, around 1840, of metallic tubes for paint, sold at reasonable prices, provides them with a vast gamut of pigments, with the paint already ground and ready for use. The new process gives oil paints greater durability, permitting the artists to paint in the open air, but most of all it provides them with new tints that better express the effects of light on people and landscapes. From a theoretical point of view, the Impressionists put into practice the scientific studies of light and color carried out since the first half of the seventeenth century. As early as 1666 Isaac Newton had demonstrated that white light passing through a prism separates into a spectrum of many colors, and he had gone on to identify the three primary colors: red, blue, and yellow, through which all the other colors can be created. Newton believed that the "luminous radiations" were composed of "corpuscles." In oppo-

A room in Paul Durand-Ruel's house at 35, Rue de Rome, Paris. On the walls are several paintings by Monet.

sition to Newton's corpuscular theory was the wave theory developed by the Dutch mathematician, astronomer, and physicist Christiaan Huygens. Huygens's theory involved light waves moving through a hypothetical medium he called ether. These studies were the basis for much of the research carried out early in the nineteenth century into the mechanisms by which the human eye perceives color. One of the early works on the subject, read and used by many painters, is *Essai sur les signes inconditionnels dans l'art*, by Humbert de Superville, published in Leiden in 1827, which continues the investigation into the meanings and symbols of lines in relation to colors. No less important are the studies by the Scottish physicist and mathematician James Clerk Maxwell, who formulates the electromagnetic theory of light. Important contributions are also made by David Sutter, who publishes articles in 1880 in the magazine *L'Art*, and the German scientist Hermann von Helmholtz, inventor of the ophthalmoscope and the opthal-

mometer. The text that has the greatest influence on the art of the Impressionists is the treatise by Michel Eugène Chevreul *On the Law of the Simultaneous Contrast of Colors*, published in Paris in 1839. Chevreul (1786–1889) is a chemist, director of the dye department of the Gobelins tapestry works, and from 1860 to 1879 director of the natural history museum in Paris. He sets out to answer the question of why some colors in tapestries look duller than others. To do so, he studies the primary colors—red, blue, and yellow—and the complementary colors, meaning those that can be added to the primary colors—violet for yellow, green for red, and orange for blue. On the basis of his research he presents a law of simultaneous contrast, according to which if two complementary colors are put together their effect on the human eye will be increased—by being together they acquire greater vivacity and intensity. To demonstrate this theory, he publishes in 1864 *Des couleurs et de leur applications aux arts industriels à l'aide des cercles chromatiques*, in which he presents the Cercle Chromatique, a color wheel that explains the precise relationships among colors. Chevreul even suggests that painters use colored frames to amplify the luminous effects of their paintings. The idea seems intriguing to the Impressionists but is immediately rejected by gallery managers and art buyers (only to be revived in the twentieth century and partially adopted by the Futurists). Another

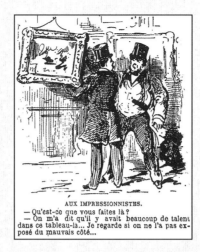

method the Impressionists learn from Chevreul is the theory of optic mixture, according to which small touches of pure pigment applied directly to the canvas will strike the viewer more forcefully than the same colors mixed on a palette. These theories are further developed and amplified by Charles Blanc, art critic and founder of the *Gazette des Beaux-Arts*. In 1876 he publishes his *Grammaire des Arts du Dessin*, in which he holds that "the use of colors follows rules that can be taught in the same way that musicians learn the rules that govern musical notes." Finally, the American physicist Nicholas Odgen Rood (1831–1902) writes *Modern Chromatics* in which he introduces his "scientific" color wheels, rotating disks that can be used to calculate the values of individual colors and of any colors that can be created through their union.

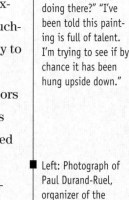

■ Cartoon by Pif from 1881: "What are you doing there?" "I've been told this painting is full of talent. I'm trying to see if by chance it has been hung upside down."

■ Left: Photograph of Paul Durand-Ruel, organizer of the seventh Impressionist show.

■ *A Visit to the Impressionists*, a sort of collage of caricatures of the paintings on display.

The Terrace
1881, oil on canvas,
100 × 80 cm
The Art Institute,
Chicago

Darlaud, the model
for this canvas, is
an actress with the
Comédie Française;
the setting is probably
the terrace of the La
Fournaise restaurant
at Chatou, near
Argenteuil, on the
banks of the Seine.
The restaurant was
once known only to
boating fans, but
thanks to the efforts
of Alphonse Fournaise,
the owner's son, it
gains popularity among
fashionable Parisians,
for whom it becomes
the destination of
Sunday outings. It is
also visited by artists,
intellectuals, and
writers: Maupassant
uses it for his novel
Restaurant Grillon
and Gustave Goetschy
makes it the setting
of his poem "Les
Canotiers."

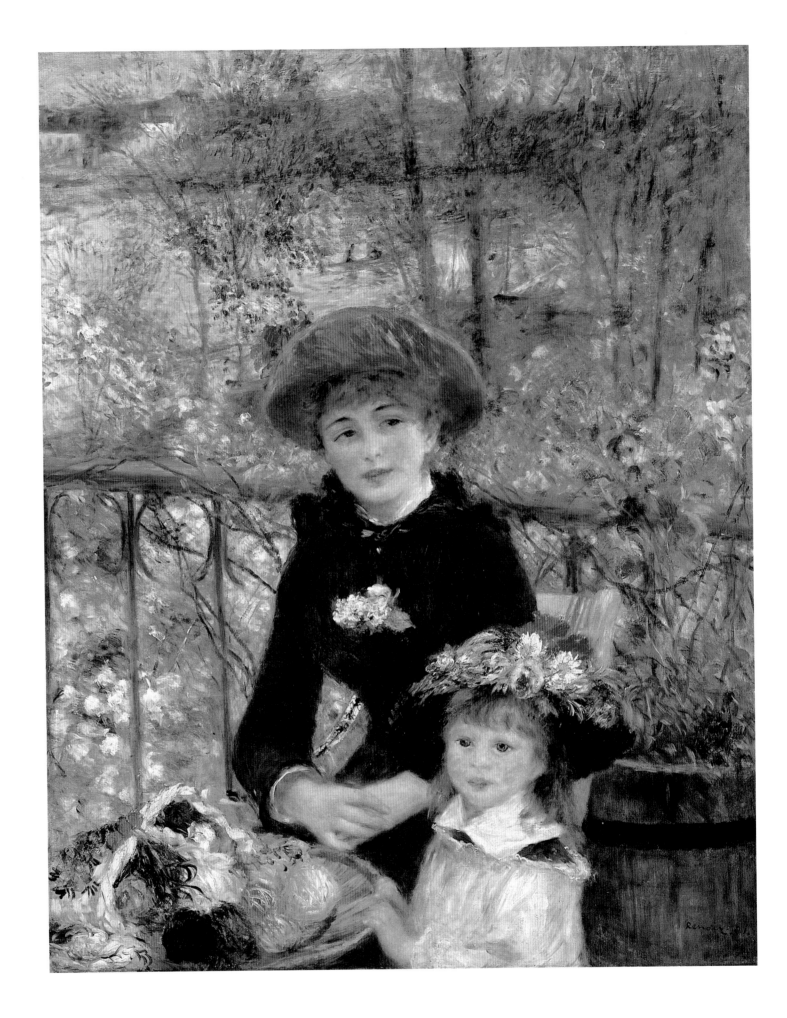

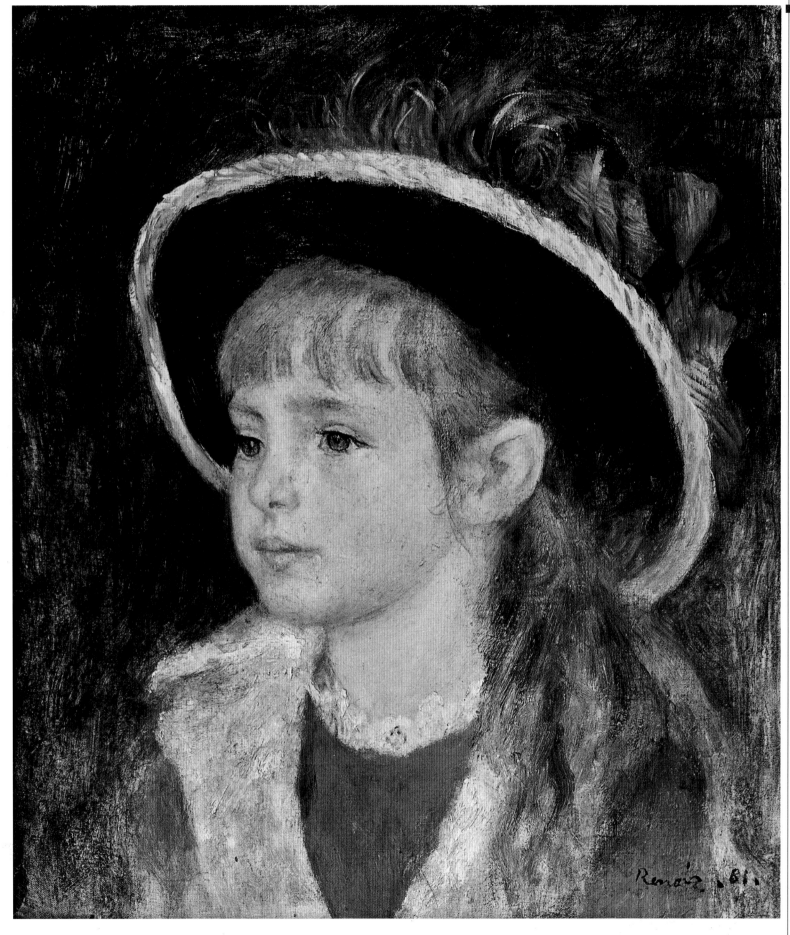

■ PIERRE-AUGUSTE
RENOIR
Child with Hat
1881, oil on canvas,
40 × 35 cm
Private collection

Almost without doubt
the girl in this paint-
ing, made in July
Dieppe, is Jeanne
Henriot, daughter of
the actress Henriette
Henriot, friend and
model of Renoir. Fol-
lowing her mother's
footsteps, the child
seems destined for a
promising career in the
theater. Unfortunately,
a few years later she
will die in a fire at the
Comédie Française.
The big black hat with
yellow rim surrounds
her face like a halo.
Her expression is par-
ticularly intense and
expressive, making her
look far more serious
and mature than her
young age.

PIERRE-AUGUSTE RENOIR
The Luncheon of the Boatmen
(with detail)
1880–81, oil on canvas,
130 × 175 cm
Phillips Collection, Washington, D.C.

This canvas is set on the terrace of the La Fournaise restaurant at Chatou. The man standing to the left is Alphonse Fournaise; seated near him is Aline Charigot. At the center, seated with his back to the viewer, is Baron Barbier; the man in the rear with the top hat is Charles Ephrussi, director of the *Gazette des Beaux-Arts*. The three people in the foreground to the right are the model Angèle (who also poses for the woman drinking from a glass at the center of the canvas), the journalist Maggiolo standing, and Caillebotte, seated. Behind them can be seen the official Lestringuez in the derby, the journalist Lothe, and the actress Jeanne Samary. The detail opposite shows Aline Charigot in profile with a dog. During the four years between this work and *Dancing at the Moulin de la Galette* (pages 154–55) Renoir's hand has become surer, and the character of his figures is sharper, more clearly expressed.

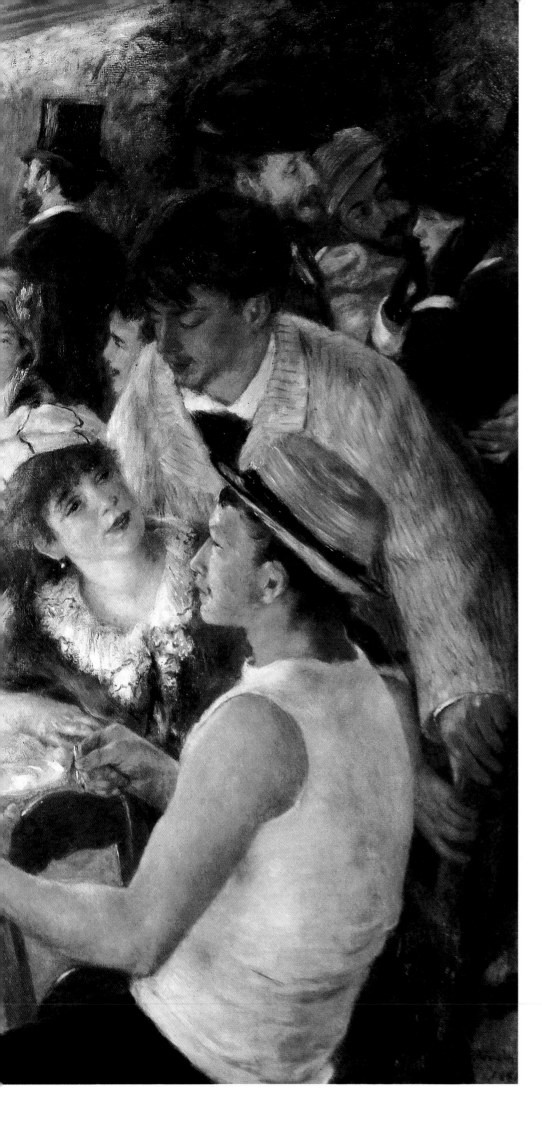

PIERRE-AUGUSTE
RENOIR
Blonde Bather
1881, oil on canvas,
81.8 × 65.7 cm
Sterling and Francine
Clark Art Institute,
Williamstown

At the end of October
1881, Renoir leaves
for an extended trip
in Italy. He has long
hoped to study Italian
art in person, and in
November he visits
Venice, then Padua
and Florence, then
on to Rome, where
he can finally study
the masterpieces of
Raphael and the
works in the Vatican
Museums. He then
goes to Naples,
Pompeii, Sorrento,
and Capri—where he
is joined by Aline—
before leaving for
Calabria. It is in Capri
that the painter sets
this monumental por-
trait of his future
wife, presented in the
guise of a goddess or
sea nymph.

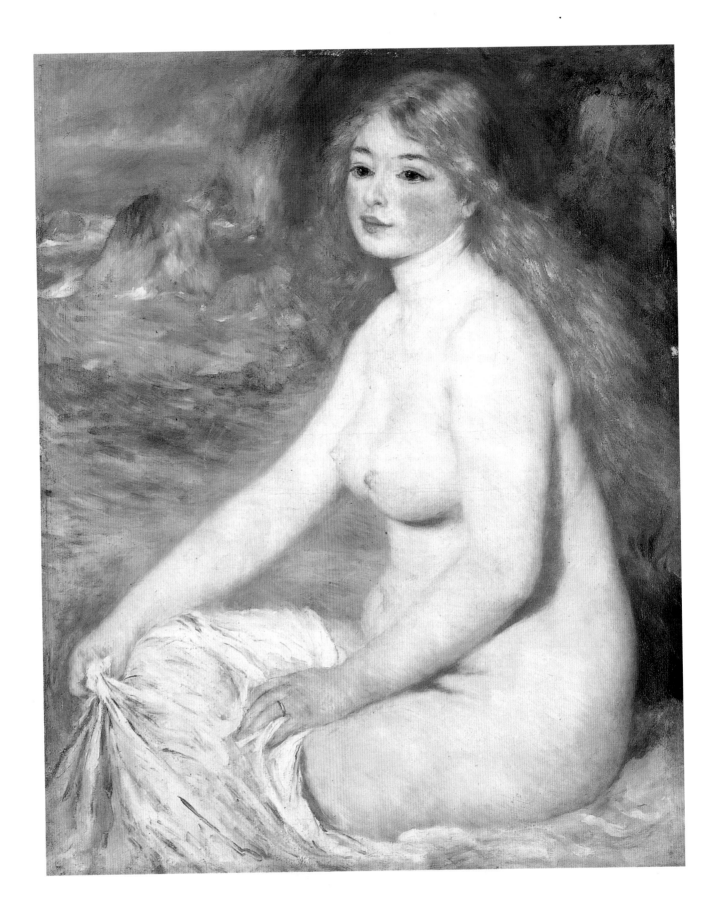

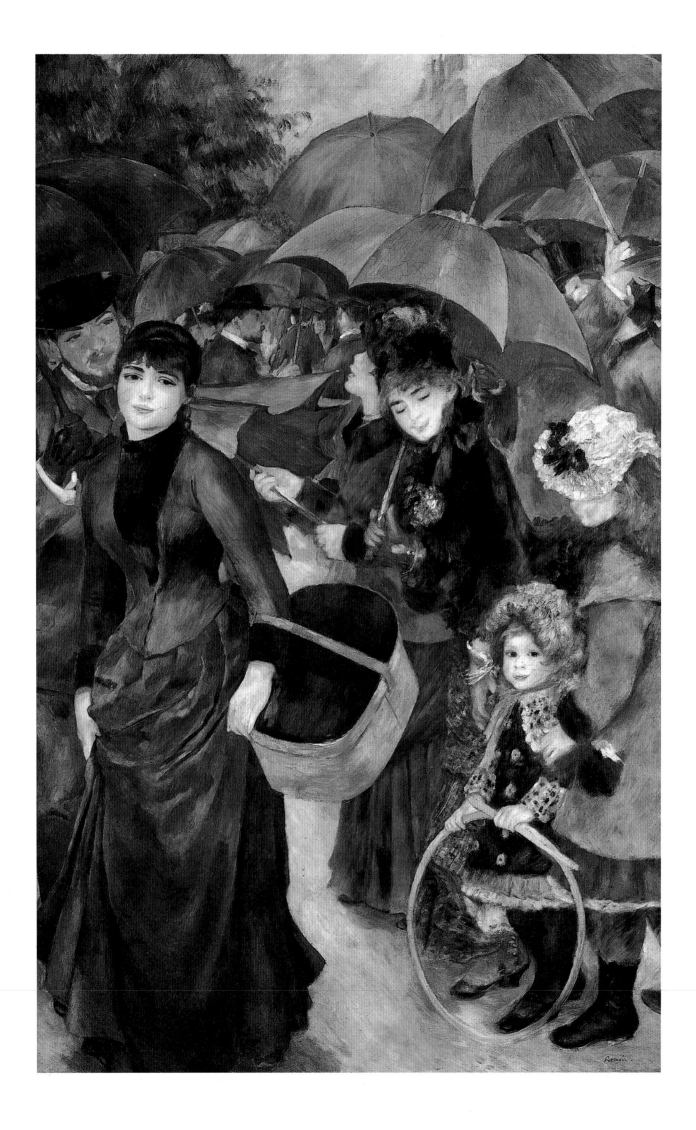

PIERRE-AUGUSTE RENOIR
The Umbrellas
1881–85, oil
on canvas,
180 × 115 cm
National Gallery,
London

X-ray analysis reveals
that Renoir begins
this painting with the
group of women and
children to the right,
applying the paint in
pale tones with soft
outlines. His work on
the painting is then
interrupted, most
probably by his trip to
Italy, to be completed
four years later, around
1885, with the addi-
tion of the couple to
the left and most of
the umbrellas in the
background, all of
which is presented
with far greater
geometric precision
and more delicate
chromatics.

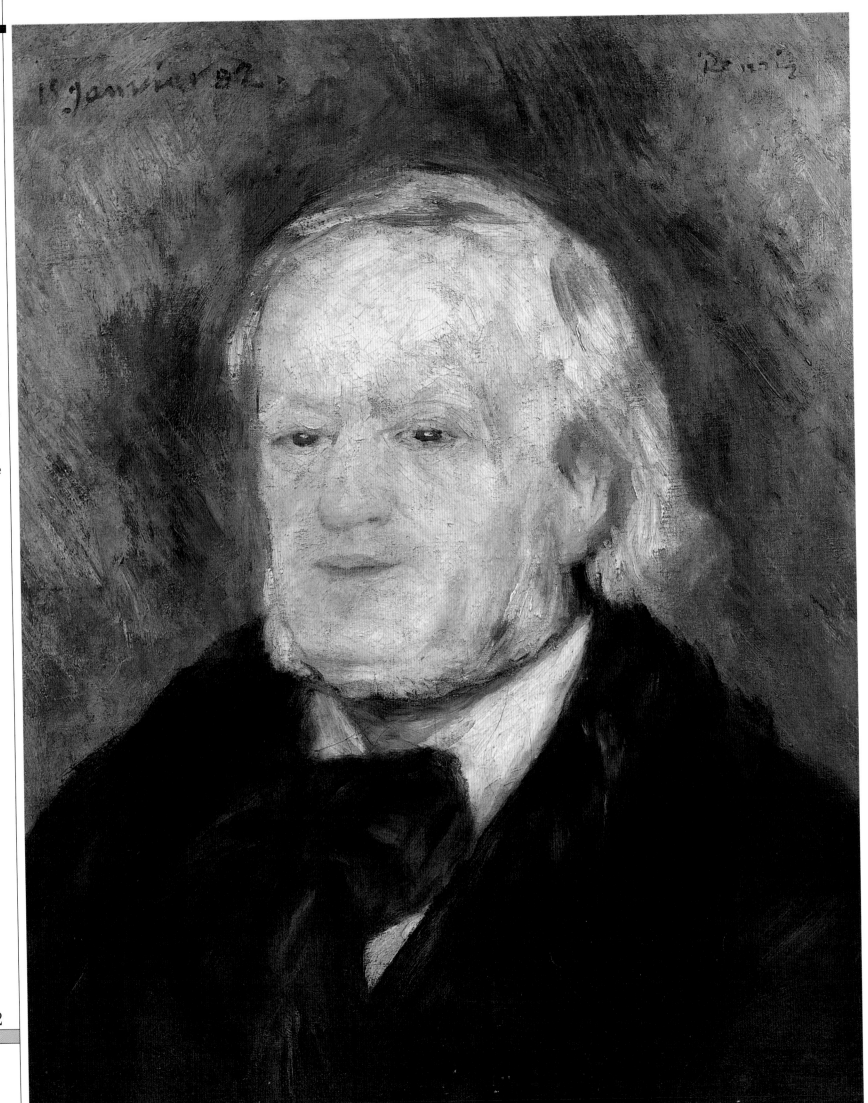

PIERRE-AUGUSTE
RENOIR
**Portrait of
Richard Wagner**
1882, oil on canvas,
53 × 46 cm
Musée d'Orsay, Paris

In January 1882
Renoir and Aline
travel to Palermo,
where they are deeply
impressed by the
cathedral of Monreale.
While there a letter
arrives from a friend,
Jules de Brayer. Pas-
sionate opera fan
and fervent admirer
of Wagner, he asks
Renoir to make a por-
trait for him of the
great German compos-
er, who is then in the
Sicilian capital. The
painter manages to
make an appointment,
and on January 15,
in a single sitting of
little more than half
an hour, he makes the
sketch for this por-
trait, later finished
in his studio.

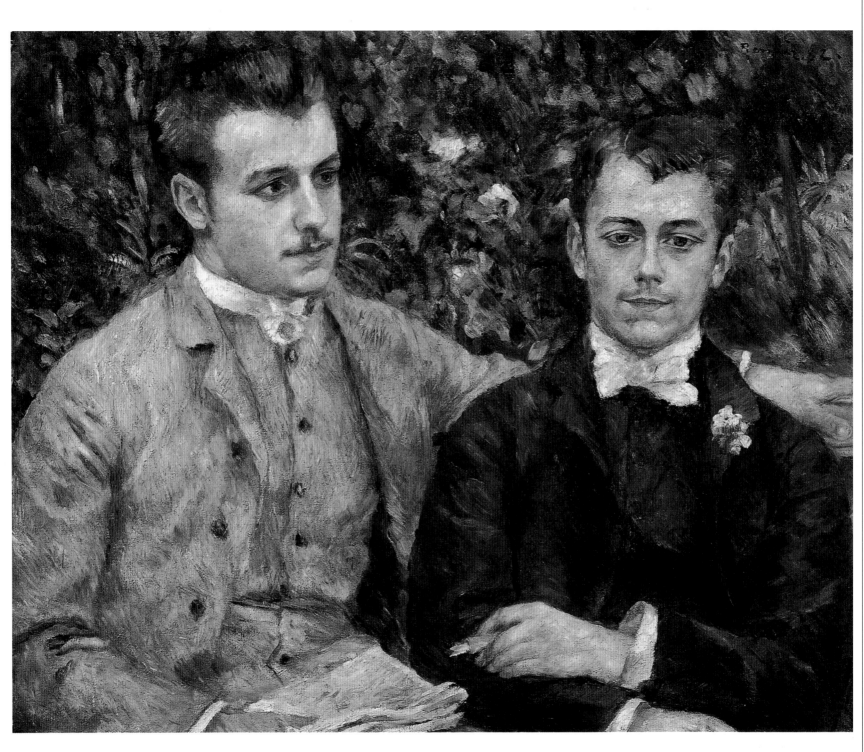

■ PIERRE-AUGUSTE
RENOIR
**Charles and Georges
Durand-Ruel**
1882, oil on canvas,
65 × 81 cm
Durand-Ruel
Collection, Paris

Paul Durand-Ruel
commissions various
portraits of his five
children from Renoir.
Here we see the two
older sons, Charles
and Georges, present-
ed in the garden of
their family's villa at
Dieppe. The tradition-
al layout of the paint-
ing shows traces of
the painter's trip to
Italy, where he stud-
ied from life the mas-
terpieces of classical
art. The background
has neither definition
nor depth; Renoir
concentrates on the
faces of the two boys,
which he presents in
great precision, reveal-
ing traces of their dif-
fering personalities.

PIERRE-AUGUSTE
RENOIR
Rocks at L'Estaque
1882, oil on canvas,
66 × 82 cm
Museum of Fine Arts,
Boston

On January 17, 1882, Renoir and Aline leave Palermo to return to Naples; from there, they take ship to Marseilles, arriving on January 22. The painter decides to make a stop in the nearby locality of L'Estaque, intending to paint in the open together with Cézanne. After only two months their collaboration is cut short when Renoir falls sick with pneumonia; Cézanne patiently takes care of him. This painting shows signs of Cézanne's influence, most of all in the volumetric construction of space and the use of vivid colors, almost in anticipation of Fauvist painting.

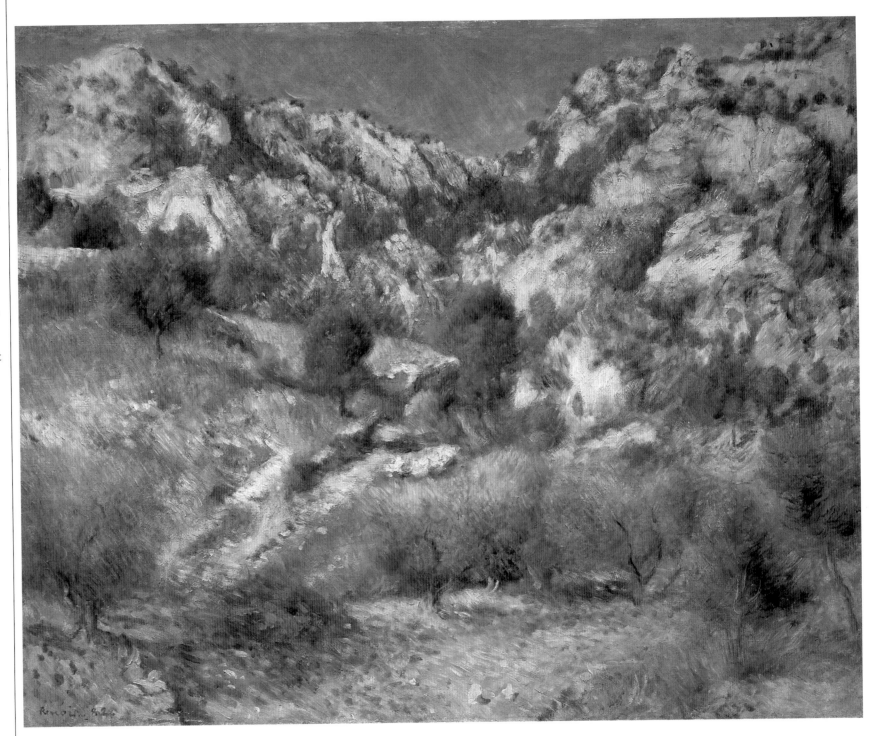

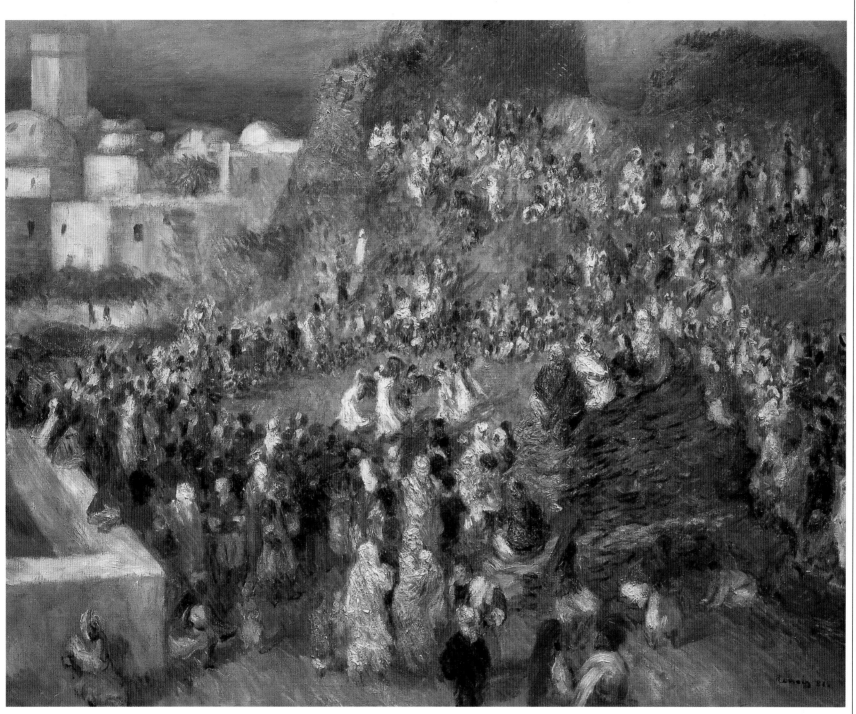

PIERRE-AUGUSTE
RENOIR
**Arabian Feast
(The Mosque)**
1882, oil on canvas,
73 × 92 cm
Musée d'Orsay, Paris

In March 1882, still
recovering from his
bout with pneumonia,
Renoir takes a trip
to Algeria, where he
makes a series of
landscapes. The sub-
ject of this painting is
not clear: in the 1892
painting catalog of
Durand-Ruel, the art
dealer lists it as a
religious scene in a
mosque. The figures
at the center of the
painting, surrounded
by the crowd, seem
more like musicians or
performers putting on
a show or taking part
in a local festival.
Unlike other group
scenes by Renoir, the
artist shows no inter-
est in the individual
personalities of the
many figures and
leaves them indefinite.

ALFRED SISLEY
**The Garden of
Ernest Hoschedé
at Montgeron**
1881, oil on canvas,
56 × 74 cm
Pushkin State Museum
of Fine Arts, Moscow

The house, owned
by Ernest Hoschedé
before the collapse of
his finances, is almost
hidden by the trees,
which are the true
protagonists of this
painting. The artist
dedicates much atten-
tion to the shadows of
the trees on the lawn,
which he creates with
various shades of pale
and dark green. The
bright sky is painted
with long brushstrokes
arranged in an irregu-
lar manner. Durand-
Ruel buys the painting
and then sells it to
the Muscovite collec-
tor Morozov (1871–
1921), one of the first
and most important
Russian collectors of
Impressionist painting.

Sixth and seventh shows

■ CLAUDE MONET
**Lavacourt
under Snow**
1881, oil on canvas,
59 × 81 cm
National Gallery,
London

The canvas is almost
certainly set at
Lavacourt or in the
nearby town of
Vétheuil. Like many
other Impressionist
artists, Monet is
drawn to snowy land-
scapes since they give
him the opportunity
to show off his talents,
as he does here. The
volumes are rendered
using only a few col-
ors, most of all white
and various shades of
gray, brown, and blue.
The clear light is uni-
formly distributed,
although it is clearly
cold. While the plants
are reduced to a few
bare trees, the human
presence is completely
absent.

■ CLAUDE MONET
Spring
1882, oil on canvas,
60 × 79 cm
Musée des Beaux-Arts,
Lyons

Made in May 1882 at
Poissy or in 1880 at
Vétheuil, this canvas
demonstrates Monet's
ability to make colors
literally explode across
a landscape, illumi-
nating it and giving
it a truly evocative
atmosphere. The short
brushstrokes give the
composition a mea-
sured rhythm that
gathers speed in the
contorted branches of
the large tree in the
foreground to then
gradually slow down as
the viewer's eye looks
toward the horizon.

CLAUDE MONET
Vase of Sunflowers
1881, oil on canvas,
100 × 81 cm
Metropolitan Museum
of Art, New York

Between 1881 and
1882 Monet paints
landscapes in the
open air at every
opportunity; when the
weather or his health
prevents him from
going outdoors, he
stays in and paints
floral still lifes, such
as this one, consid-
ered one his finest.
The densely packed
brushstrokes give the
composition a dynam-
ic, lively rhythm that
is accentuated by the
bright colors. Vincent
van Gogh was much
taken by this splendid
bunch of sunflowers
and in 1888 used it as
the model for one of
his own masterpieces.

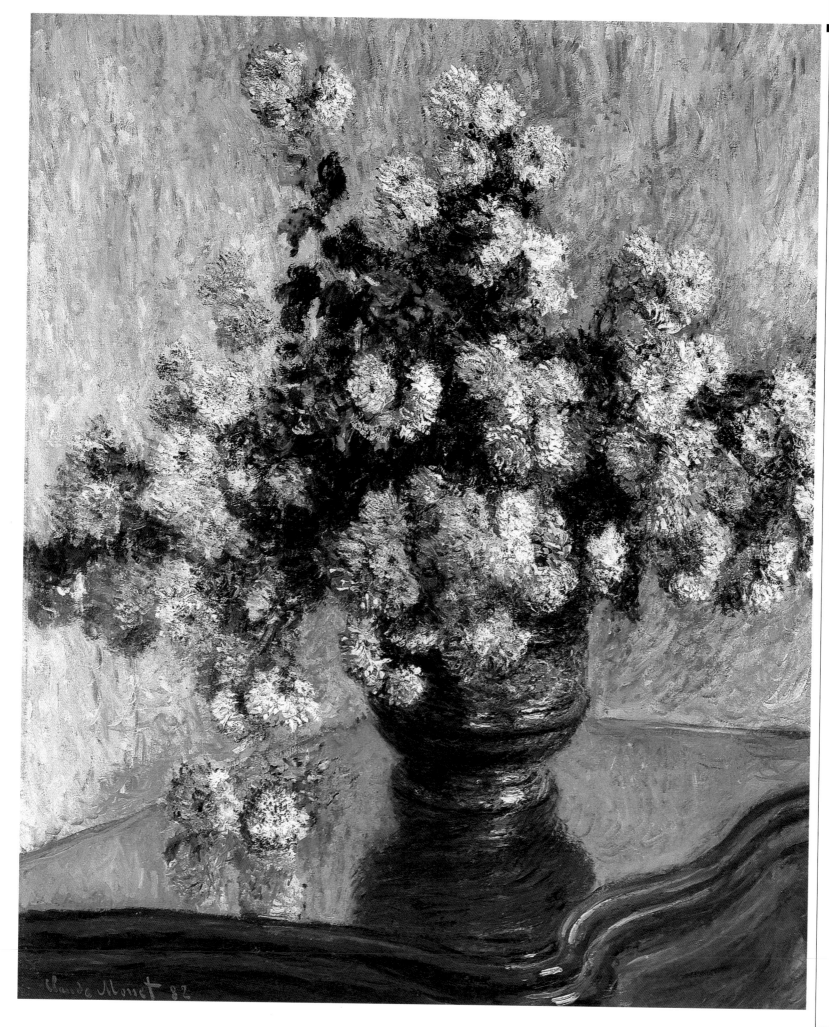

■ CLAUDE MONET
Chrysanthemums
1882, oil on canvas,
102 × 84 cm
Metropolitan Museum
of Art, New York

This vase of flowers is
yet another result of
Monet being forced to
pause in his creation
of *en plein air* land-
scapes. The theme
repeats a similar
composition of 1878,
although in this case
the framing is hori-
zontal and the subject
is chrysanthemums,
imported from China
since the end of the
eighteenth century
and very much in
vogue in France dur-
ing these years. The
little flowers, created
with brief, impalpable
touches of color with-
out depth, stand out
against the neutral
background, made
with long, primarily
vertical brushstrokes,
giving the composi-
tion a particularly
poetic atmosphere.

CLAUDE MONET
**The Church of
Varengeville,
Cloudy Weather**
1882, oil on canvas,
65 × 81 cm
J. B. Speed Art
Museum, Louisville

Monet makes three
paintings of the church
of Varengeville: two
from the sea, using a
daring perspective
from below, and this
one, with its inland
view. The building
occupies only a corner
of the composition,
which is dominated in
large part by the two
trees at the center and
the enormous bush in
the foreground. The
sea is visible in the
distance, its colors as
veiled and transparent
as those of the sky.

CLAUDE MONET
**The Church of
Varengeville,
Cloudy Weather**
1882, pencil on paper,
32 × 42 cm
Private collection,
Paris

In this preparatory
drawing one notes a
third tree, to the left,
and greater emphasis
is given to the shad-
ows of the church
than to the plants.

Sixth and seventh shows

■ CLAUDE MONET
Stroll on the Reef
1882, oil on canvas,
65 × 81 cm
The Art Institute,
Chicago

Monet spends much of the spring of 1882 in Normandy, where despite inclement weather and poor health he makes numerous landscapes in the open air. This is a period of happy creativity and intense pictorial activity. In this canvas the two figures, their clothes blowing in the wind, are presented from such a distance that they almost blend into the plants around them. Even the boats in the background can be barely distinguished from the crests of the waves and resemble the white blotches of the clouds in the sky.

CLAUDE MONET
**The Customs Officer's
Cabin at Varengeville**
1882, oil on canvas,
60 × 78 cm
Museum Boymans-van
Beuningen, Rotterdam

In 1882 Monet makes
three canvases show-
ing the customs house
at Varengeville. In the
first, he shows it from
a distant point of view;
in this version, based
on a charcoal sketch,
it is much nearer;
while in the third
version, today in the
Metropolitan Museum
of New York, it is in
the foreground and
seen from above,
rather than from
below. These works
testify to the artist's
experimentation with
the rendering of color
and light; in making
this painting he gives
no precise definition
to the horizon line,
such that the sky
seems to blend with
the sea.

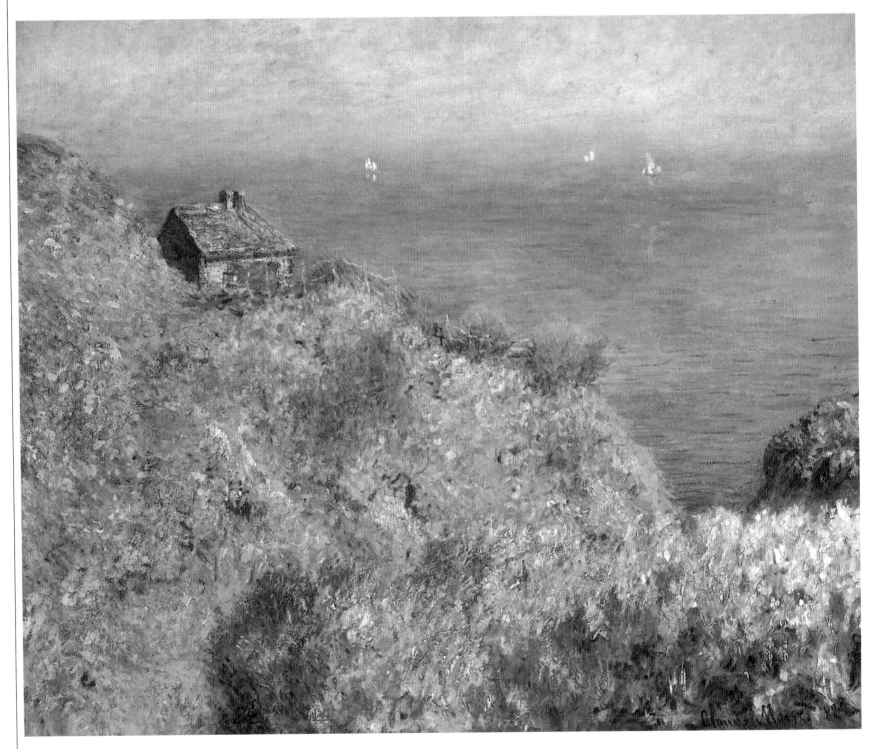

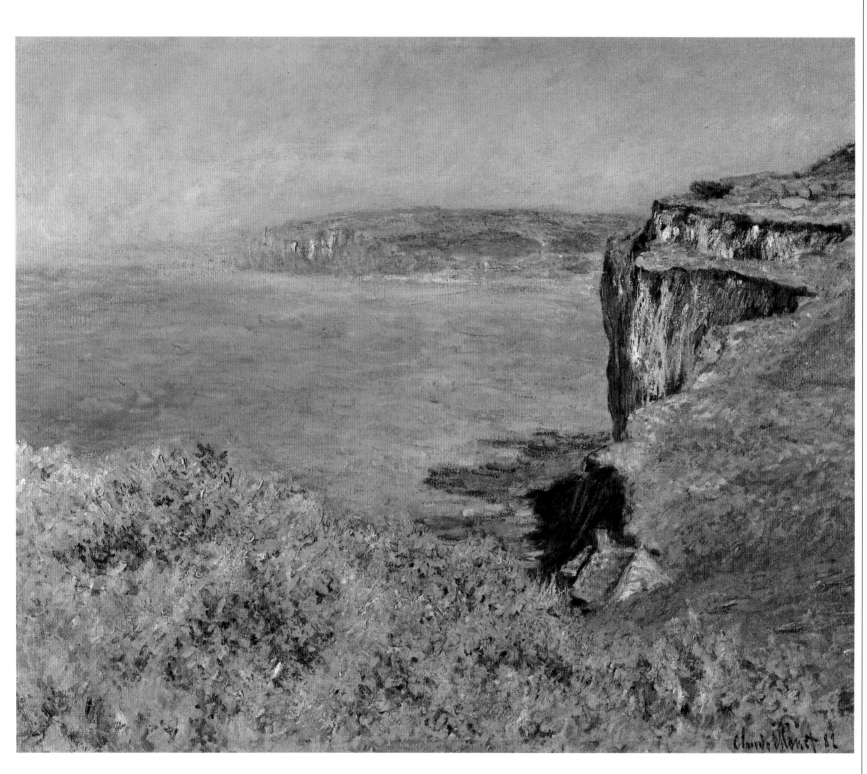

■ CLAUDE MONET
Reef at Varengeville
1882, oil on canvas,
65 × 81 cm
Private collection

The principal subject
of this composition is
the reflections of the
sky and plants on the
sea. The painter cre-
ates these reflections
using alternating dark
and light brushstrokes
to render the ripples
of the water and to
separate the areas in
shadow from those in
the light. In the area
of the foreground,
instead, he makes use
of small touches of
different colors whose
contrast amplifies
and multiplies the
luminous effects.
The small building
to the lower right,
almost hidden, seems
almost squashed by
the imposing weight
and size of the reef.

EDGAR DEGAS
The Dance Lesson
1881, oil on canvas,
81.6 × 76.5 cm
Philadelphia Museum
of Art, Philadelphia

Three ballerinas prac-
tice movements at a
mirror that multiplies
their figures and
amplifies the space
by way of a window
that opens into the
background. To the
right, behind the
instructor, another
pair of dancers per-
forms warm-up exer-
cises, while in the
foreground a woman
quietly reads a news-
paper. Degas thus
divides the space of
the composition in
three distinct parts,
but leaves the center
of the canvas empty.
Doing so gives the
impression that the
scene has not been
posed on purpose for
him and that instead
he has captured it
from life, much like
a snapshot taken
during a regular
day of rehearsals.

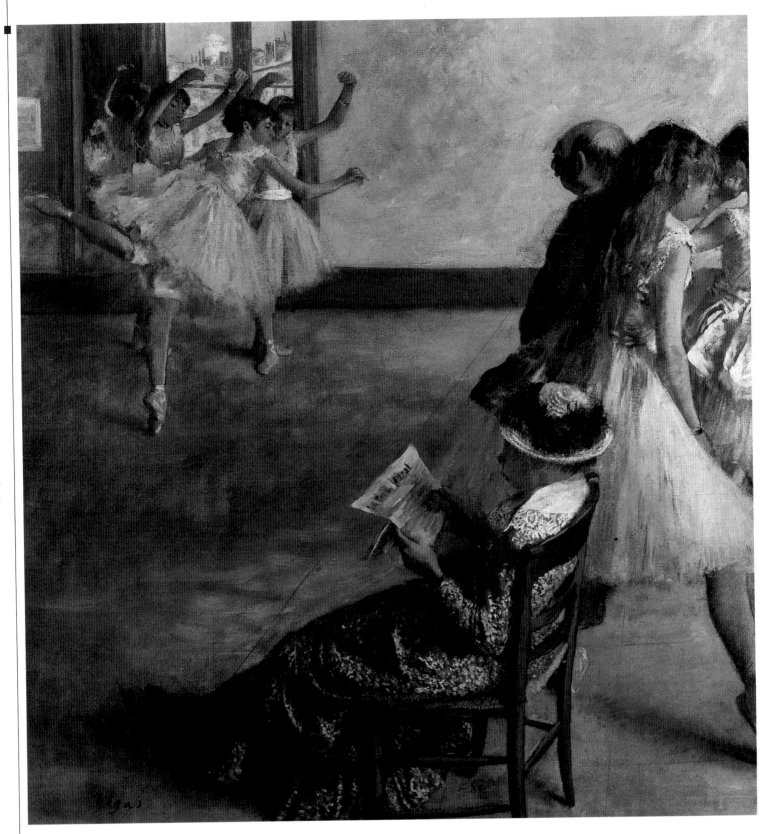

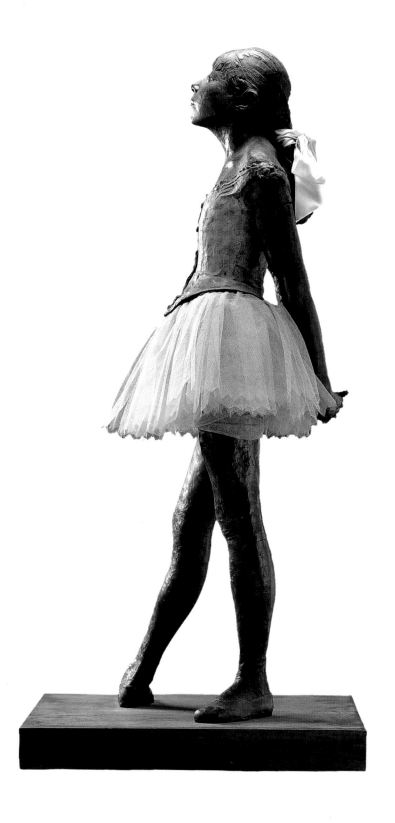
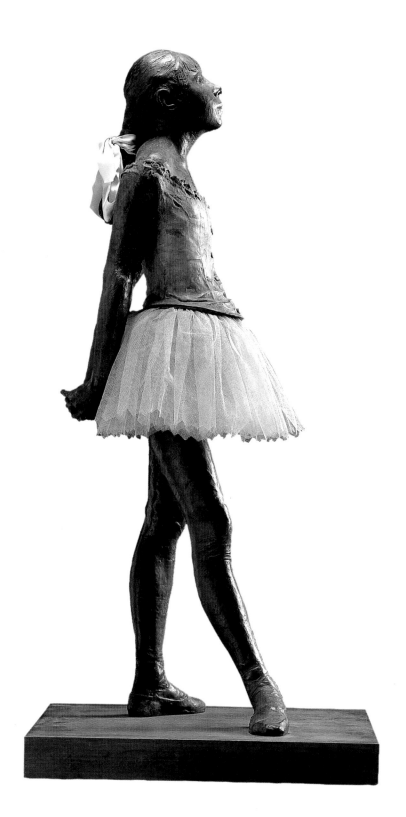

■ EDGAR DEGAS
The Little Fourteen-Year-Old Dancer
1879–81, bronze,
height 99 cm
Musée d'Orsay, Paris

Degas makes the wax model in 1879 and completes it with fabric and a wig found in a doll shop. He originally plans to exhibit it in 1880, but decides to wait until the next year's show. With the exception of Huysmans, who heaps it with praise, the critics are extremely negative, reaching even the point of personal insults. They accuse Degas of being a misogynist, of taking his inspiration from "criminal types," of having presented an aesthetic based on cruelty and ugliness. Paul Mantz, for example, writes that the ballerina "shamelessly extends her bestial face, or rather her little snout." Whereas Huysmans writes that the dancer "comes to life before our eyes and seems ready to step down from her pedestal."

EDGAR DEGAS
Galloping Horse
circa 1881, bronze,
height 27.9 cm
Musée d'Orsay, Paris

Offended and embittered by the critical reception of his dancer, Degas decides not to participate in the 1882 exhibit and to never again show his sculptures in public, which thus come to be known only after his death by way of bronze casts made by Hébrand in 1919. For this reason dating Degas's sculptural works is very difficult, so much so that some critics believe this horse was made at the end of the 1880s, not at the beginning. Notable aspects of this work are its perfect representation of reality, partly a result of Degas's study of the stop-action photographs by Muybridge.

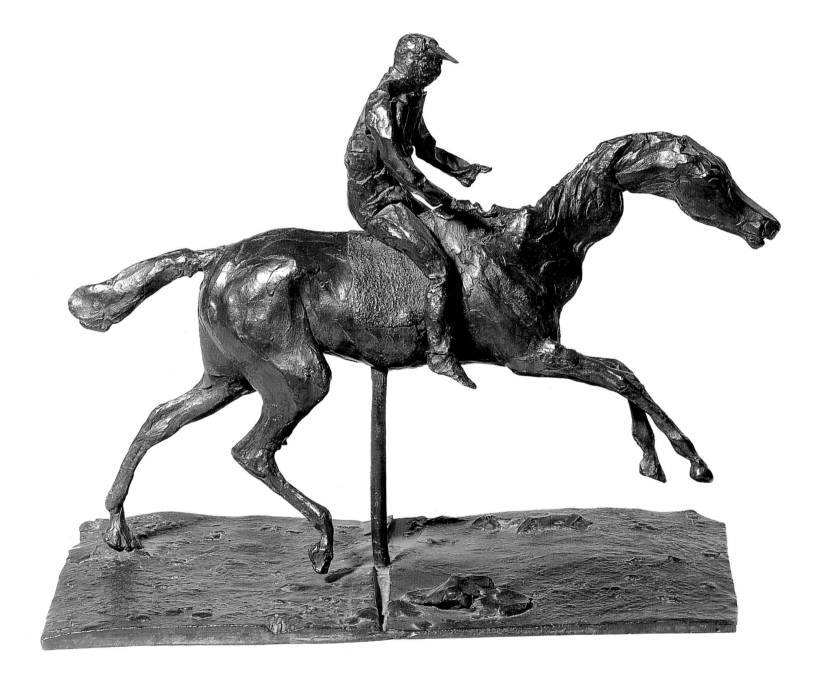

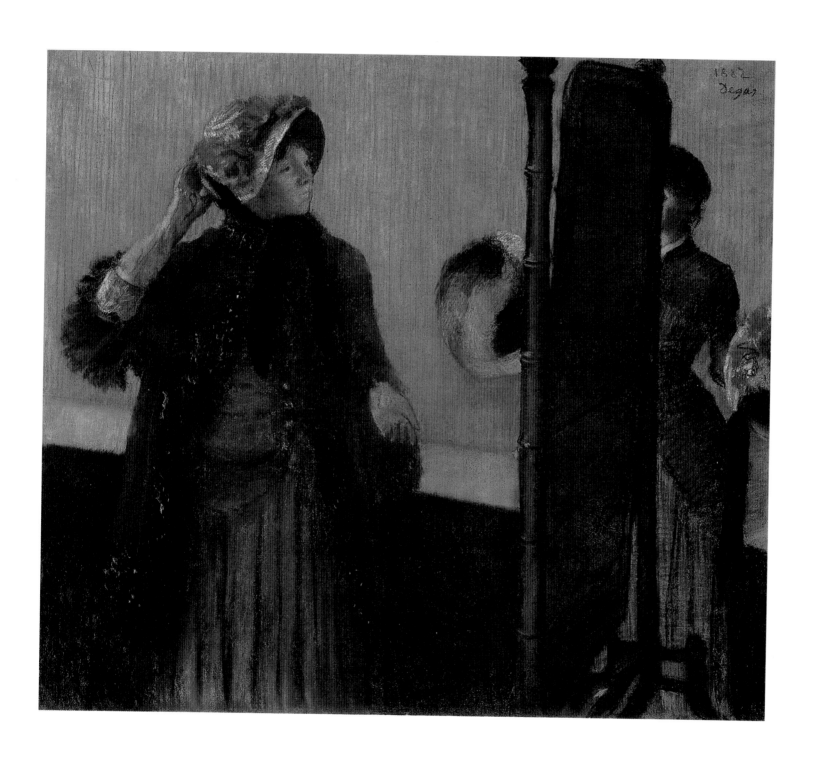

EDGAR DEGAS
Milliners
1882, pastel on paper,
48 × 70 cm
Nelson-Atkins Museum
of Art, Kansas City

The artist observes
these milliners with
the same attentive
and curious eye he
directs on young bal-
lerinas. Almost all
critics of the time
were scandalized
and accused Degas
of misogyny since he
did not present these
young girls in accor-
dance with the ideal-
ized canons of beauty
then in force. Paying
no heed to such objec-
tions Degas perseveres
in his work as a realist,
creating scenes that
achieve a sense of the
anecdotal. There is no
sense in this pastel
that the two women
were posed; they seem
instead to be caught
while performing the
usual day-to-day ges-
tures of their work,
and doing so with
absolute tranquility,
as though no artist
were anywhere near.

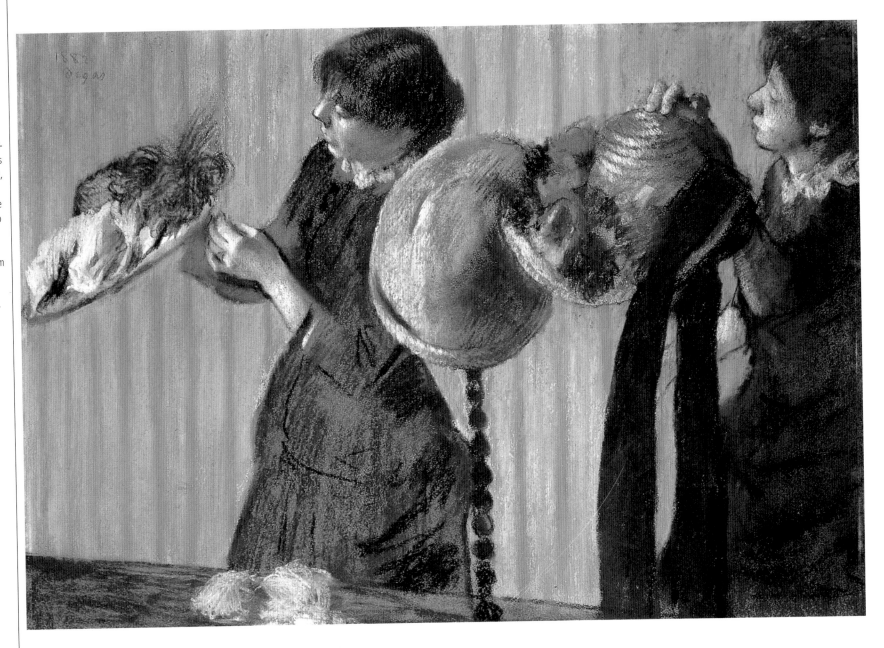

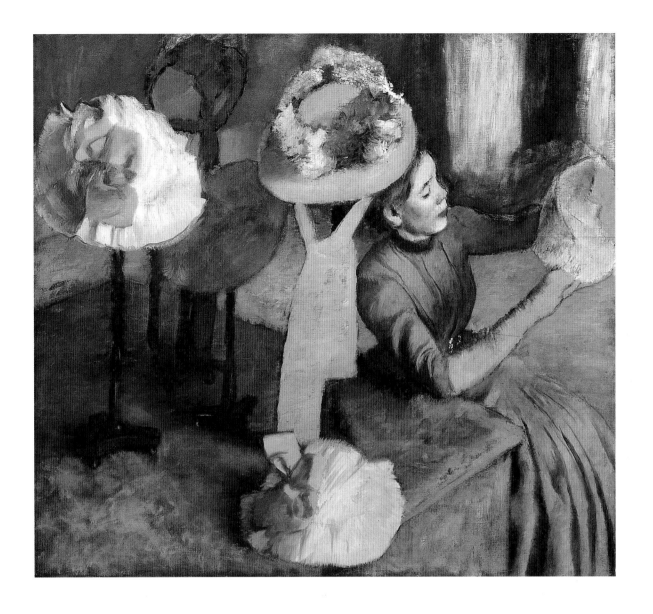

■ EDGAR DEGAS
At the Milliner's
circa 1882–86,
oil on canvas,
100 × 100.7 cm
The Art Institute,
Chicago

In this painting Degas quite deliberately inverts the normal planes of the composition, locating the stylist in the middleground and taking up the foreground with the elaborate, elegant hats. The neutral tones of the display table and the background serve to give greater stress to the other elements in the painting. Once again the artist does not have the young woman look toward him and instead presents her in profile to give the scene a more realistic feeling.

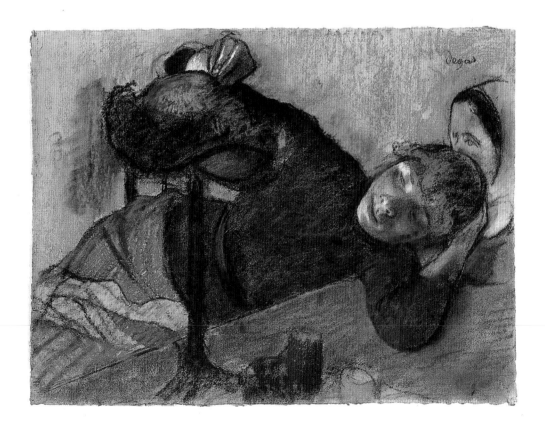

■ EDGAR DEGAS
Milliner
circa 1882, pastel and charcoal on paper,
47.6 × 62.2 cm
Metropolitan Museum of Art, New York

Once again Degas chooses an unusual point of view, also framing the picture in an unusual way. There is nothing traditional about the young woman's pose; in fact, Degas makes her body perform a kind of contortion as she wraps herself around the hat she is working on, which is thus made to occupy the foreground.

PAUL CÉZANNE
**Melting Snow at
Fontainebleau**
1879–82, oil
on canvas,
73 × 102 cm
Metropolitan Museum
of Art, New York

Between 1879 and
1886 Cézanne makes
more than thirty can-
vases dedicated to
trees: the theme has
enormous appeal to
him because it permits
him to rhythmically
mark off space and to
create silent, melan-
choly atmospheres that
express his tormented
state of mind. This
painting is located in
the forest of Fontaine-
bleau, a locale dear to
Corot and the painters
of the Barbizon school.
Cézanne makes use of
very few colors, most
of all black and white,
illuminating them
with a cold light that
creates sharp contrasts
with the dark gray of
the trunks and bare
branches.

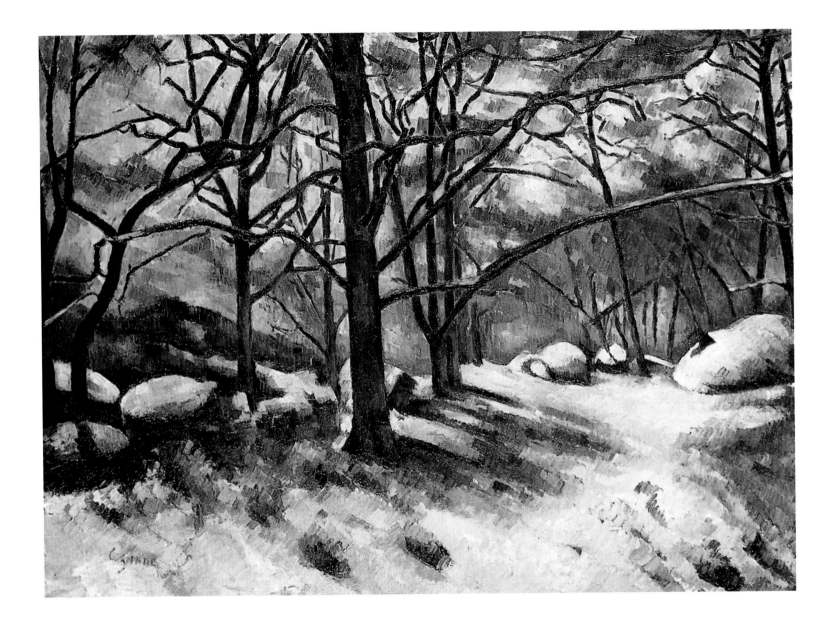

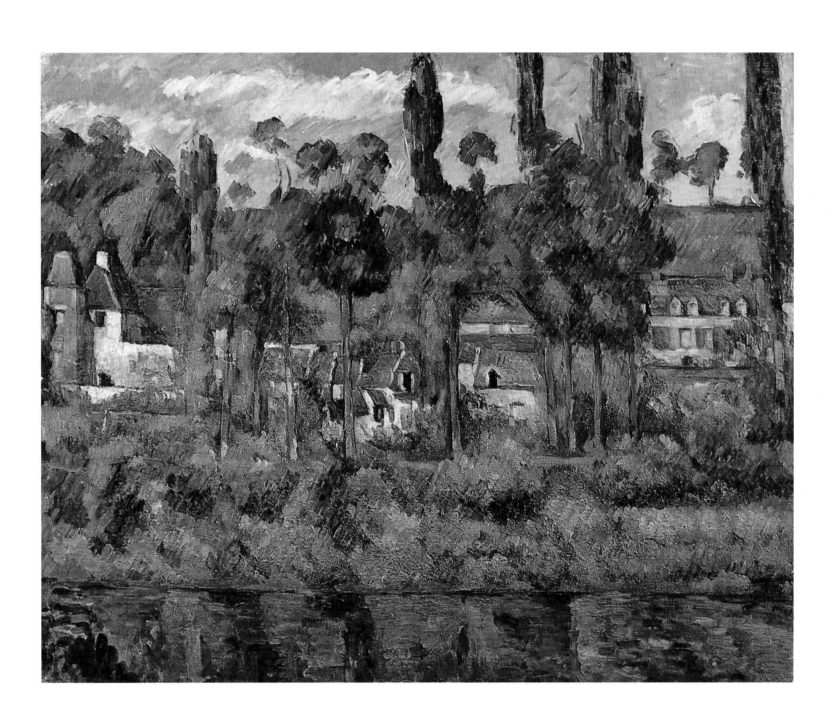

PAUL CÉZANNE
**The Castle of Médan
(The Home of Zola)**
1879–81, oil
on canvas,
59 × 72 cm
Art Gallery and
Museum, Glasgow

In 1878, Emile Zola
buys a house at Médan,
and several times
between 1879 and
1881 Cézanne is his
guest there. It is dur-
ing those same years
of the early 1880s,
however, that Zola
begins distancing him-
self from the Impres-
sionists, although he
continues to consider
himself their friend
and protector. In a
series of articles pub-
lished in 1880 in the
magazine *Le Voltaire*
under the title "Le
Naturalisme du Salon,"
he presents several
reservations concern-
ing the evolution of
the Impressionists'
art, but even more he
openly criticizes them
for continuing with
their group exhibi-
tions, despite the
fact that from the
beginning these
have proven hardly
profitable, if not
absolutely ruinous.

PAUL CÉZANNE
**Containers,
Fruit, Dishcloth**
1879–82, oil
on canvas,
45 × 57 cm
The Hermitage,
St. Petersburg

In the more than fifty still lifes Cézanne makes between 1879 and 1882, he experiments ways of simplifying forms, trying to achieve the kind of absolute geometric purity reached several years later by abstract painters. In these efforts he creates the sense of spatial depth not through the use of geometric line, which has been the method used until then, but instead through the use of color. In this work, he alternates and contrasts the pale tones of the fruit, the bowl, and the dishcloth with the dark tones of the bottle, the table, and the background, setting up their relationships to create a perfect equilibrium.

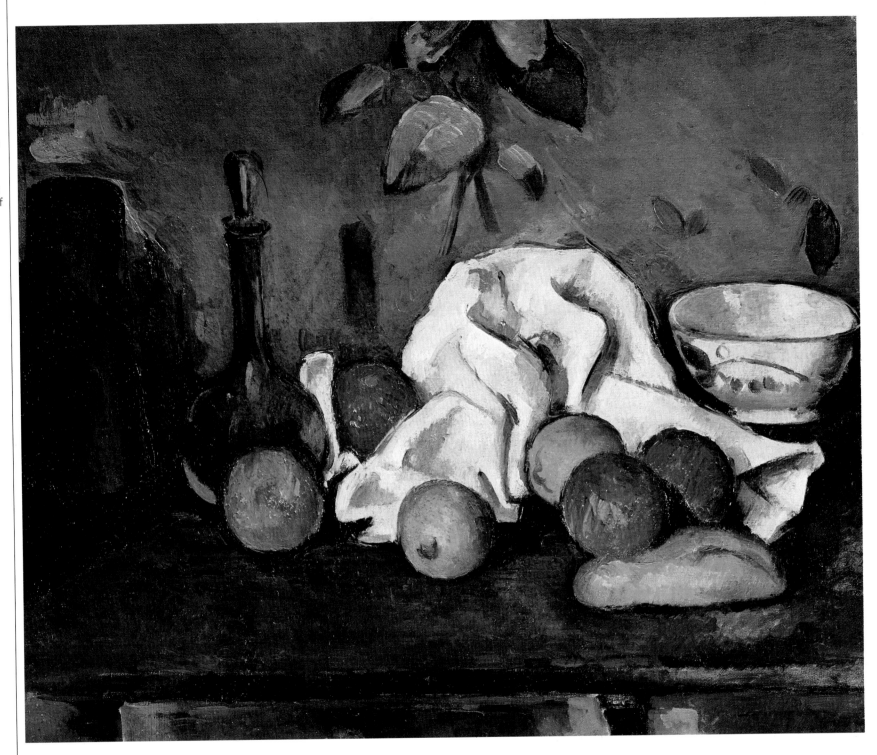

Sixth and seventh shows

PAUL CÉZANNE
**Portrait of
Louis Guillaume**
1879–82, oil
on canvas,
56 × 47 cm
National Gallery of
Art, Washington, D.C.

Louis Guillaume, son
of one of the artist's
neighbors, appears
again later, costumed
as Pierrot, in the 1888
painting *Mardi Gras*
(page 346). In this
canvas the artist uses
a restricted gamut of
colors, preferring dull,
dark tones awakened
only by the neckerchief
at the boy's collar.
The decoration in the
background is very
similar to that in the
still life on the oppo-
site page: "An apple
or a face," Cézanne
writes, "are only a
pretext for a combi-
nation of lines and
colors, nothing more."

PAUL CÉZANNE
**Landscape at
L'Estaque**
1882–83, oil
on canvas,
59.7 × 73 cm
Musée d'Orsay, Paris

Early in 1882 Cézanne
goes to L'Estaque, a
town west of Marseilles
where his mother
owns a house. There
he makes a series of
views of the sea from
different vantage
points. This composi-
tion is divided in three
parts: the sky above,
covered by white
clouds; the middle
area of the sea, with
its violet reflections;
and the foreground
of the small town,
which clearly reveals
the artist's attempts
to render the bright,
intense light of the
Mediterranean.

PAUL CÉZANNE
**L'Estaque Seen
from the Pines**
1882–83, oil
on canvas,
72.5 × 90 cm
Collection of the
Readers' Digest,
Pleasantville,
New York

While in L'Estaque dur-
ing the early months
of 1882, Cézanne is
joined by Renoir, just
back after a long trip
to Italy and eager to
tell him about what he
has seen and learned.
Unfortunately Renoir
falls sick with pneumo-
nia, so the two friends
have little opportunity
to paint together. In
this canvas Cézanne
indicates that he has
assimilated the deli-
cate luminosity typical
of certain works by
Renoir.

This is one of the many paintings Gauguin makes in these years using his children as models. In this example the subject is his second child, a daughter born in 1877, to whom the artist has given his mother's name, Aline. The way in which he applies his broad, regular brushstrokes is very similar to the technique of the Impressionists, especially Sisley and Pissarro. The pale, uniformly distributed light also recalls their influence and shows how well Gauguin has learned and internalized their teachings. It is clear, however, that he is still in his learning phase, with several years to go before he will find a personal, original style.

**Vase of Flowers
at the Window**
1881, oil on canvas,
19 × 27 cm
Musée des Beaux-Arts,
Rennes

The prevalence of
dark colors, the use
of everyday objects,
and the arrangement
of the composition
in horizontal planes
are aspects this can-
vas shares with the
still lifes by Manet
and Cézanne, works
that Gauguin sees
and studies. The
application of the
brushstrokes is still
uncertain, most
of all in the flowers,
which some critics
claim lack both vol-
ume and depth. These
same critics see as
interesting and origi-
nal the view of the
landscape with the
house in the back-
ground, the area
from which light
arrives to weakly
illuminate the scene.

■ PAUL GAUGUIN
**Interior of the
Artist's Home
in Rue Carcel**
1881, oil on canvas,
130 × 162 cm
Nasjonalgalleriet, Oslo

Gauguin, seen from
behind, listens as his
wife plays the piano
in their home in the
Rue Carcel. With this
unconventional and
somewhat daring
arrangement, Gauguin
relegates the two
figures to the back-
ground, all but hiding
them, and puts in the
foreground an empty
chair and a large vase
full of zinnias, made
with short, doughy
brushstrokes. Exhibited
at the seventh Impres-
sionist show, in 1882,
this painting attracts
only moderate criti-
cism; but it strikes the
attention of Huysmans,
who praises its atmos-
phere and highly
courageous chromatics.

PAUL GAUGUIN
Garden at Vaugirard
1881, oil on canvas,
87 × 114 cm
Ny Carlsberg Glyptotek,
Copenhagen

In this painting Gauguin presents his wife, Mette, with three of their four children: Aline, four years old; Clovis, two; and Jean-René, just born. The features of their faces are not defined, only sketched in; Gauguin does not want to present their expressions, trying instead to create the atmosphere of the moment, one of quiet peace. The pale colors are applied with short brushstrokes. In the background, half-hidden by the branches and the wall, is the church of St. Lambert, in the section of Vaugirard where the house was located.

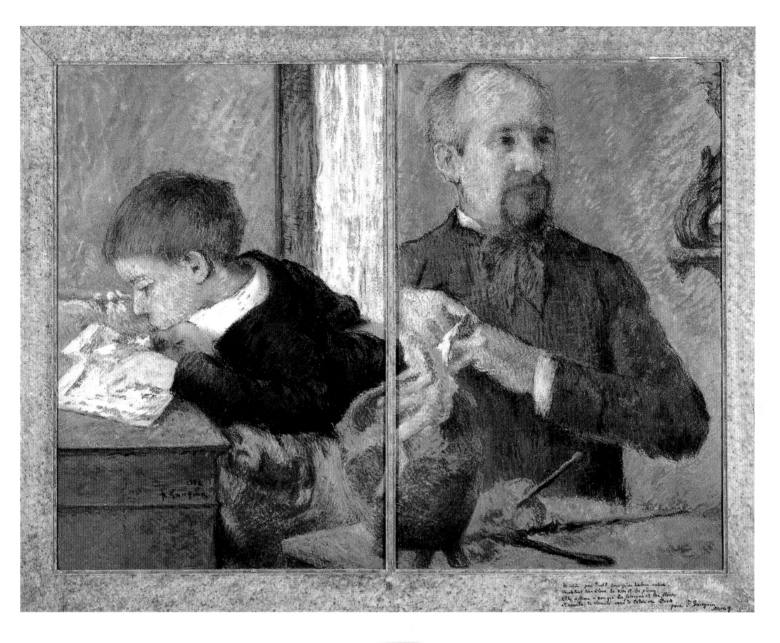

■ PAUL GAUGUIN
**Portrait of the
Sculptor Aubé
with His Son**
1882, pastel on paper,
53.8 × 72.8 cm
Musée du Petit Palais,
Paris

The unusual structure
of this work unites two
very different images.
The ceramic vase at
the center creates the
illusion that the two
images share the same
setting, but this is
immediately belied
by observation of the
background walls and
comparison of the pro-
portions of the two
figures. Paul Aubé
(1836–1916), a highly
esteemed academic
sculptor, meets Gauguin
in 1877. Aubé usually
works in close contact
with several ceramists,
and a few years later
he introduces Gauguin
to his friend Ernest
Chaplet (1835–1909),
who teaches Gauguin
to work in ceramics.

■ PAUL GAUGUIN
**The Singer
(Valérie Roumy)**
1880, wood, plaster,
and paint,
53 × 51 × 13 cm
Ny Carlsberg Glyptotek,
Copenhagen

Gauguin experiments
with several kinds of
sculpture, from ceram-
ics to wood carving. He
bases this large medal-
lion on a pastel by
Degas from 1878, *Café-
Concert Singer*. Gauguin
reworks it, giving it
greater expressiveness,
reinforced by the
alternation of highly
worked areas with
others that are pur-
posely left empty.

GUSTAVE
CAILLEBOTTE
A Hand of Bésigue
1881, oil on canvas,
121 × 161 cm
Private collection

This is one of the 18
works that Caillebotte
exhibits in the sev-
enth Impressionist
show, and it is praised
by many critics. The
figures include
Caillebotte's brother
Martial, presented in
profile in the right
foreground; Richard
Gallo, standing; and
near him Maurice
Brault, an exchange
agent with whom
Caillebotte practices
canoeing. The man
seated on the sofa
in the background,
absorbed in his own
thoughts, is yet
another of Caillebotte's
friends, Paul Hugot.
The other two men
have not been iden-
tified. Appearing
around 1820, *bésigue*
is a variant of *belote*,
a French card game
based on playing for
trumps.

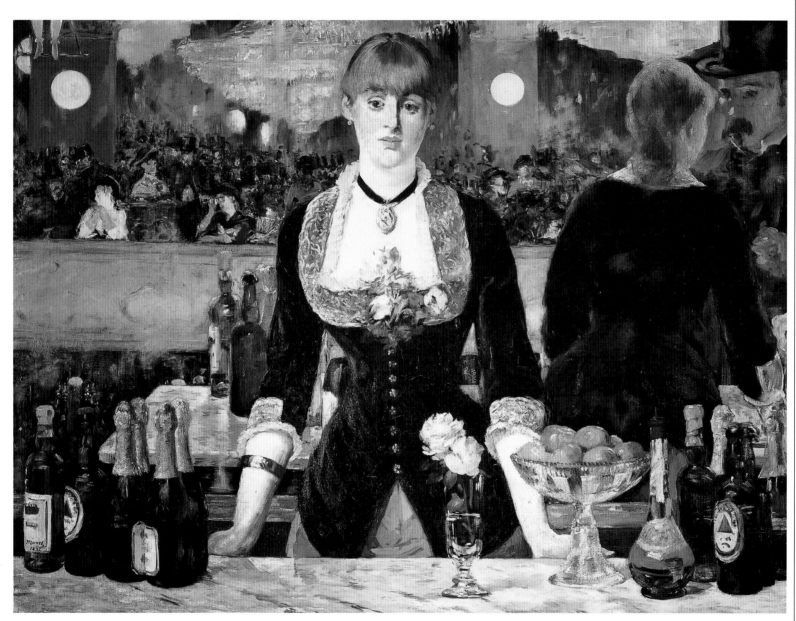

EDOUARD MANET
Bar at the Folies-Bergère
1881, oil on canvas,
96 × 130 cm
Courtauld Institute
Galleries, London

The Folies-Bergère began as a circus that was then transformed into a dancehall and *café-concert*. The locale eventually becomes one of the world's most famous variety theaters. The woman at the center of the composition—her name is Suzon—is really one of the waitresses at the bar, and she agrees to come to Manet's studio to pose for him. Her slightly melancholy expression contrasts with the festive climate that animates the elegant, luxurious scene. Exhibited at the Salon of 1882 the work receives many favorable reviews, although some critics cannot resist noting the absence in the foreground of the client whose reflection appears in the mirror.

E ncouraged by the positive response from so many critics in Great Britain to the exhibit of Impressionist works he organized in the summer of 1882, Paul Durand-Ruel organizes a second Impressionist show in London early in 1883, this time in a larger space, Dowdeswell's Galleries on New Bond Street. Given more room, he presents a larger number of works, including 11 by Camille Pissarro, nine by Pierre-Auguste Renoir, eight by Alfred Sisley, seven each by Edgar Degas and Claude Monet, three each by Berthe Morisot and Edouard Manet, and two by Mary Cassatt. On this occasion too, the reviews are almost universally favorable, but despite the favorable response the art dealer does not succeed in selling even a single painting. It is a fact that even though the Impressionists have been exhibiting their works for more than a decade, the public in Great Britain still looks on them as an avant-garde movement and has not yet fully accepted their art. Between 1883 and 1886, the year of their last group exhibition, the Impressionists as a group fall apart. They remain friends, often spending time together painting, but they are very much aware that their group shows achieve little. Together with Durand-Ruel and the other art dealers who handle their works, they seek new markets, new ways of presenting their creations to the public.

A primary reason for this change in attitude is Manet's death. At the end of March 1882 his health begins to decline rapidly, probably because of a form of circulatory paralysis, and at the end of April his doctors are forced to amputate a leg. A few weeks later, on April 30, after suffering excruciating agony, the artist dies. For more than a decade he has been the guiding light, the source of inspiration, the older brother for the other artists, and his loss deprives them of their basic support and the primary force behind their cohesion. Eight months after his death, the Ecole des Beaux-Arts pays him the tribute of an enormous retrospective exhibit. From January 6 to 28, many of his masterpieces, including works that caused outrage and scandal in Paris on their original appearance, are put on display for the public and critics. The works presented are 116 oils, 31 pastels, 20 watercolors and drawings, 12 lithographs and etchings; they are viewed by 13,000 paying visitors. Hoping to capitalize on the interest awakened by this important exhibit, Manet's brother Eugène sells the works

1883•1886

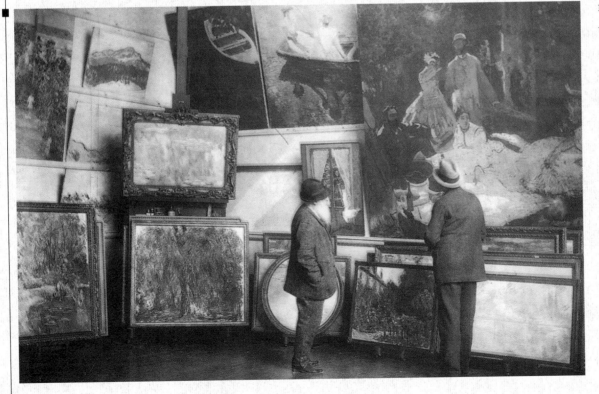

remaining in his brother's studio at an auction at the Hôtel Drouot on February 4 and 5. Paul Durand-Ruel and Georges Petit are on hand as expert consultants; the *commissaires priseurs* are Chevalier and Le Sueur. The catalog of the sale includes 166 works, including 90 paintings, 30 pastels, 14 watercolors, 23 drawings, and nine lithographs. A few days later, in a letter to her sister, Berthe Morisot, Eugène Manet's wife and thus Edouard's sister-in-law, writes: "It's all over, and it was a fiasco. After the victory at the Ecole des Beaux-Arts this auction was a complete failure . . . I'm heartbroken. The only consolation is that these works were bought by true lovers of art and by true artists. In all, the auction made only one

hundred and ten thousand francs when it was expected to reach at least two hundred thousand. These are hard times, and this has been a sad lesson."

A second reason behind the disintegration of the Impressionists as group exhibitors is the gradual reform of the Salon. Since 1881 its organization has no longer been under the aegis of the state but is directed instead by a committee that any artist who has participated in the Salon at least once may join. This committee is responsible for drawing up the statutes for the Société des Artistes Français, founded in 1882 to direct the Salon exhibits. These reform measures come too late, however, and are not enough to put an end to the disputes and polemics among critics and the artists themselves, by

by the jury of the Salon form a new group and, inspired by the name the Impressionists have used for several of their shows, call it the Groupe des Artistes Indépendants. In June 1884 this group is given the new name of Société des Artistes Indépendants. The society's purpose is to display its members' works to the public and to provide an alternative to the Salon. The membership is enormously heterogeneous, both in terms of the members' styles and ideals. Anyone who wishes to participate in one of their shows can do so by paying a modest registration fee as a contribution to the general expenses. Their first show is held in December 1884 in several empty pavilions in the

Eighth show

then divided into openly hostile groups. In 1884 this situation of discontent leads to another desertion, similar to the one that led to the Salon des Refusés in 1863. Numerous artists whose works have been rejected

Tuileries gardens. Among the exhibitors are Georges Seurat, Paul Signac, Armand Guillaumin, Emile Schuffenecker, and Odilon Redon. Redon, in particular, will later play an important role in the organization of the society. In the following years it will present many works by Gauguin, Cézanne, and Henri Rousseau. In 1891 it will dedicate a large retrospective to Van Gogh, and it will form the launchpad for almost all the exponents of so-called post-Impressionism.

Meanwhile Berthe Morisot and her husband, Eugène Manet, finance a new Impressionist show: the eighth and last. Under the official title Exposition de Peinture, it takes place at 1, Rue Lafitte, from May 15 to June 15, with the doors open to the public from ten o'clock to six; the entrance fee is one franc. Seventeen artists

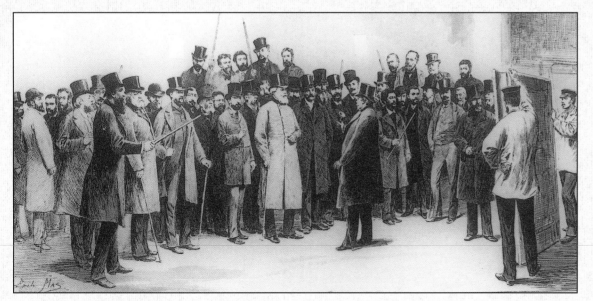

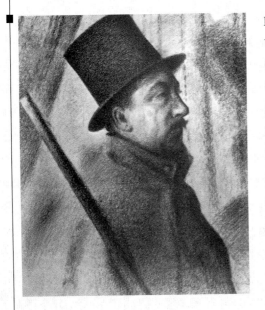

participate, showing 249 works: Marie Bracquemond (showing six works), Mary Cassatt (seven), Edgar Degas (15), Jean-Louis Forain (13), Paul Gauguin (19), Jean-Baptiste Armand Guillaumin (21), Berthe Morisot (14), Camille Pissarro (20), Lucien Pissarro (10), Odilon Redon (15), Henri Rouart (27), Claude-Emile Schuffenecker (nine), Georges Seurat (nine), Paul Signac (18), Charles Tillot (16), Victor Vignon (18), and Federico Zandomeneghi (12). Five of them participated in the first Impressionist exhibit, in 1874: Degas, Guillaumin, Morisot, Pissarro, and Rouart; two are exhibiting for the first time: Lucien Pissarro, Camille's son, and Odilon Redon, invited because of the leading role he has played in the movement to create the Indépendants group. Morisot and her husband do their utmost to get more artists to participate, to drum up favorable reviews of the show from critics, and to convince the few visitors that the paintings on display are valuable works of art and good investments. Once again these efforts come to little, and the show is a failure, as Morisot reports bitterly to Monet—who has decided to have his works exhibited instead by the dealer Adolphe Goupil.

The exhibit's one great novelty is the presence of Signac and most of all Seurat, with his large canvas *A Sunday Afternoon on the Island of La Grande Jatte*. Signac and Seurat have carried forward the research done on color and light by the Impressionists to arrive at what comes to be known as Pointillism. This term is usually taken to refer to a new technique, based on studies of optics published in the first half of the nineteenth century, that consists in breaking up the pictorial surface into small, uniform, separate spots, or points, of pure color. Seen from close up, the canvas gives the impression of being covered by a random distribution of color, but from far enough away the effect becomes surprising: the work acquires movement and depth. After long, heated discussions, the works of Seurat and Signac are presented in a room separate from the other Impressionists. The only other artists to share the space are Camille Pissarro—who is fascinated by their new style and has adopted it in his compositions—and his son Lucien. The public and many of the critics are bewildered and confused by the daring works with their different inspiration and rigorously geometric execution, considered by many to be overly intellectual and cold. The critic Félix Fénéon states that with this exhibit Impressionism is definitely dead and has already been succeeded by a new movement, a new kind of "scientific" art that he calls neo-Impressionism or post-Impressionism. Three months later, on September 18, 1886, in *Le Figaro Littéraire*, Jean Moréas, a poet of Greek origin whose real name is Papadiamantopulos (1856–1910), publishes an article entitled "Le Symbolisme," which becomes the manifesto of the new literary and artistic movement destined to have an enormous importance in coming decades. In those same months yet another event upsets the serenity of the Impressionists while also bringing to an end a long and valued friendship. This event is the publication of *The Masterpiece*, the novel by Emile Zola in which he openly renounces the Impressionists and sharply distances himself from their painting, the very painting he had defended for years from the violent attacks of critics.

As early as 1868, when he first announces his plans for the Rougon-Macquart cycle of novels, Zola makes it clear that he is gathering material for a work to be set in the world of painting. In 1882 Paul Alexis publishes a book on Zola's life and art in which he includes the writer's statement that he is working on the project and that it is already in an advanced stage: "The main character is the painter Claude Lantier, enraptured by the modern ideal of beauty, who appeared briefly in *The Belly of Paris*." Zola's initial idea is to follow the experiences of "an entire group of ambitious young people who come to Paris planning to conquer it. Some fall, others are successful because of the sickness in art, that kind of enormous contemporary neurosis." The story begins in 1863 against the back-

have been betrayed by a man they thought was their friend but who they have seen slowly distance himself from them to the point of now appearing before them in the guise of an accusing enemy. Most of all it is Paul Cézanne whose pride is wounded, for he sees himself in the character of the protagonist, and when Zola summarizes the subject of his book with a sententious statement about "the impotence of failed genius," Cézanne thinks the statement refers to him and his work. Never again does he want to have anything to do with the writer, and nothing ever changes his mind, not even Zola's own expression of regret: "To set off together sharing the same beliefs and the same enthusiasm only to arrive alone, to obtain glory alone, is a great sorrow."

ground of rejections by the Salon and the decision to organize the Salon des Refusés; it goes on to follow the hopes, controversies, and disappointments of the Impressionists' shows, their meetings with dealers and early collectors, all amid the incomprehension of critics and onerous financial difficulties caused by the poor sales of their works. The book reaches its tragic ending as Claude Lantier slowly becomes aware of his inability to achieve his artistic goals. Anguished and depressed by this sense of failure, standing before the work that was supposed to be his masterpiece but that remains dismally unfinished, he takes his own life.

Zola's avowed aim in the work is to bring to light the parallels between naturalistic writers and painters, but at the same time to note that while the first have succeeded in their intentions and have fully achieved what they set out to do, the second have betrayed and trampled upon their initial ideals, and their painting has followed completely different routes than those originally foreseen. As is his habit, the writer makes abundant use of his personal experience in the book, and many of the characters in the novel are based on people he knows, from Paul Durand-Ruel to Cézanne's wife, Hortense Fiquet, from Antonin Valabrègue to Victor Choquet and many others. The protagonist, Claude Lantier, seems an accurate reflection of the personality of Cézanne, with the addition of character traits from Manet, Renoir, Degas, and even Zola himself. When it first appears the novel enjoys moderate success but provokes indignant protests from the Impressionists, who are offended and feel they

Dance in the Country
1882–83, oil
on canvas,
180 × 90 cm
Musée d'Orsay, Paris

The man is Paul
Lhote; the woman,
Aline Charigot. In
this painting, which
is a companion piece
to the painting on
the opposite page,
Renoir perfectly
recreates the festive,
carefree atmosphere
of a dancehall. The
two dancers are iso-
lated from the other
clients of the locale,
who are almost hid-
den, just barely visi-
ble in a corner of the
work near the feet of
the dancing couple.
The woman, her face
framed by a curious
red hat, gazes directly
at the viewer and
smiles with sincere
pleasure.

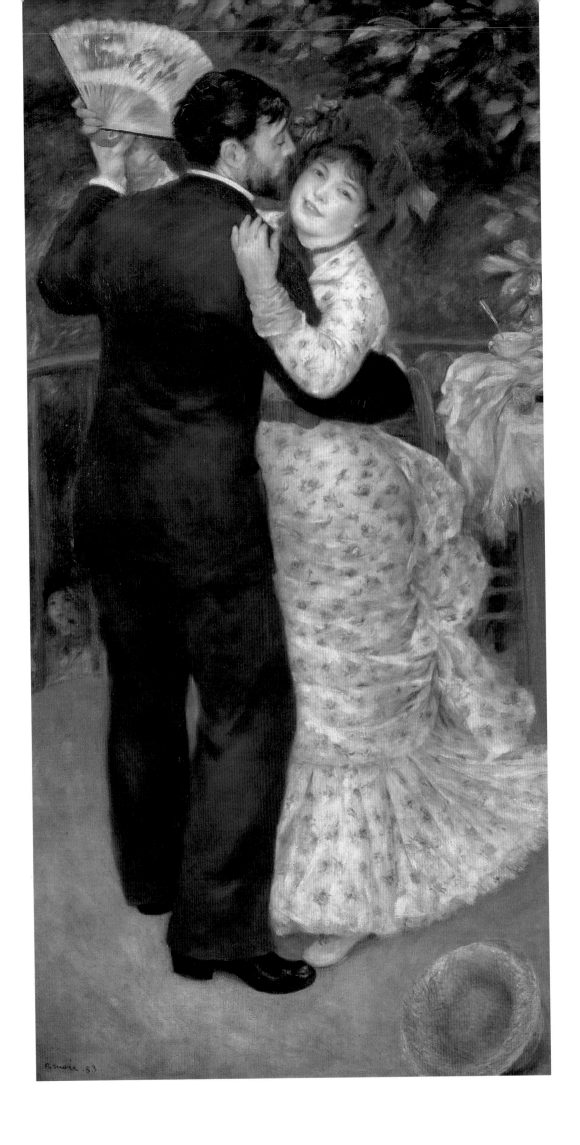

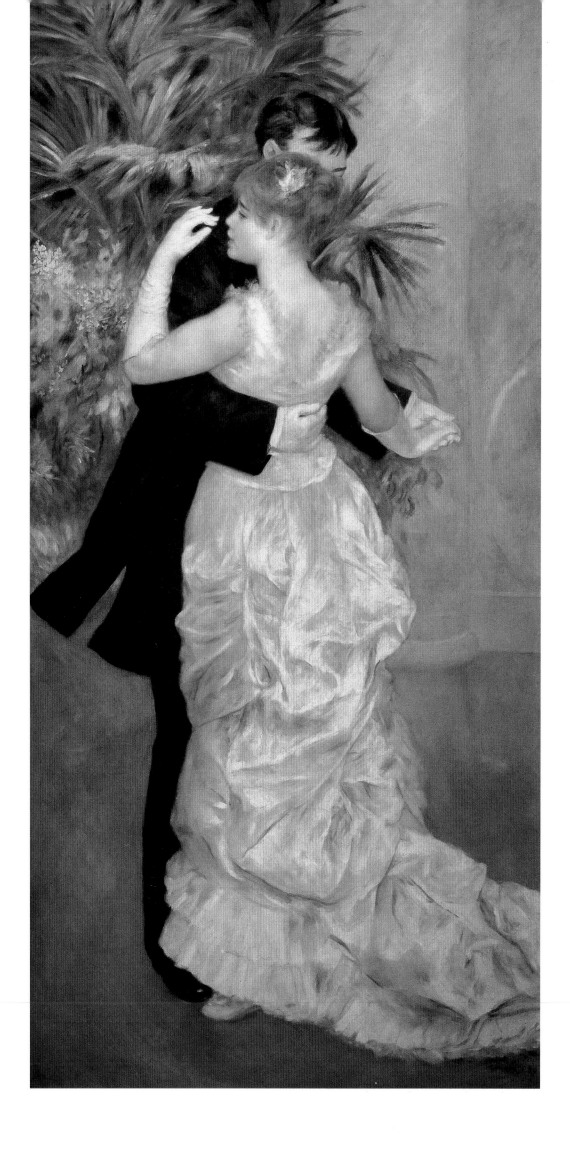

■ PIERRE-AUGUSTE
RENOIR
Dance in the City
1882–83, oil
on canvas,
180 × 90 cm
Musée d'Orsay, Paris

As in the painting on
the opposite page, the
man is Paul Lhote, but
the woman in his arms
is the elegantly allur-
ing Suzanne Valadon.
Only sixteen at the
time she is already a
friend of the Impres-
sionists, used by them
as a model, and is also
a capable painter in
her own right; she will
later be the mother of
Maurice Utrillo. Renoir
accentuates the differ-
ences in the two can-
vases, contrasting the
straightforward sim-
plicity of the country
setting, which he him-
self finds more conge-
nial, with this refined
but cold city setting.
In 1886 Durand-Ruel
buys both large can-
vases and in 1892 puts
them on display in his
own home.

PIERRE-AUGUSTE
RENOIR
Dance at Bougival
1882–83, oil
on canvas,
182 × 98 cm
Museum of Fine Arts,
Boston

The scene is located
in one of the many
locales of Bougival,
the popular spot on
the Seine only a short
distance from Paris.
The man dancing is
Paul Lhote, the woman
is Suzanne Valadon.
This painting was made
several months before
the pair of canvases on
the preceding pages;
it is the same height
but a few centimeters
wider. Whereas the
other two works con-
centrate on a pair
of dancers, here the
painter gives space
to other clients of
the locale, seated at
tables under trees in
the garden. The com-
position is thus more
animated and has
greater depth.

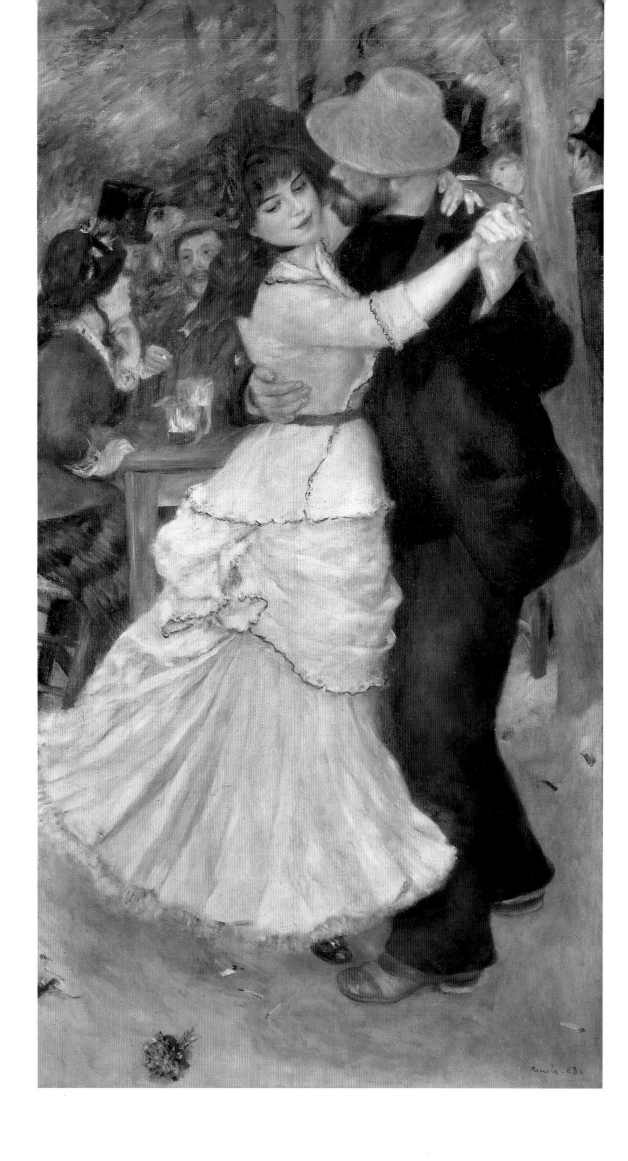

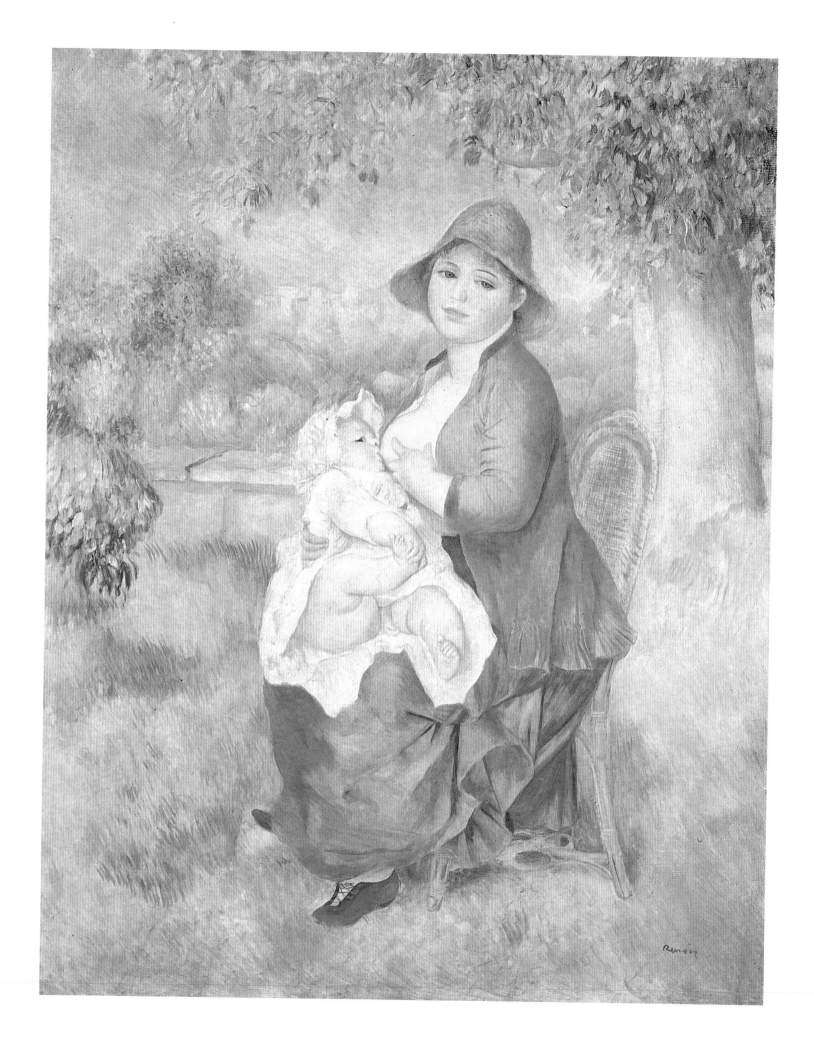

PIERRE-AUGUSTE RENOIR
Maternity
1886, oil on canvas,
81 × 64 cm
Private collection

On March 21, 1885, Renoir's first child is born, his son Pierre. This is one of three paintings in which the painter shows him being nursed by his mother, Aline Charigot. The setting is a garden at Essoyes, the town where Aline was born, the time is the month of June 1886. In making this composition Renoir takes inspiration from classical models, seeking to create a modern Madonna and Child. He makes particular reference to Raphael's *Madonna of the Chair*, which he had been struck by when he had the chance to see it during a visit to the Pitti Palace in Florence.

PIERRE-AUGUSTE
RENOIR
**The Bathers
(Les Grandes
Baigneuses)**
1884–87, oil
on canvas,
115 × 170 cm
Philadelphia Museum
of Art, Philadelphia

For this painting
Renoir takes his
inspiration from the
bas-relief by François
Giradon of *Nymphs
Bathing*, a fountain
decoration at Ver-
sailles. In a more
general sense, his
models are such
eighteenth-century
French painters as
Fragonard and Boucher.
Renoir has been study-
ing those artists at the
suggestion of Edmond
de Goncourt, to whom
he is introduced by
Madame Charpentier.
The painting departs
from the style of the
Impressionists so
much that Pissarro
accuses Renoir of have
betrayed their spirit
and "prostituted" him-
self to classicism in
the hope of obtaining
favors from critics and
attracting buyers.

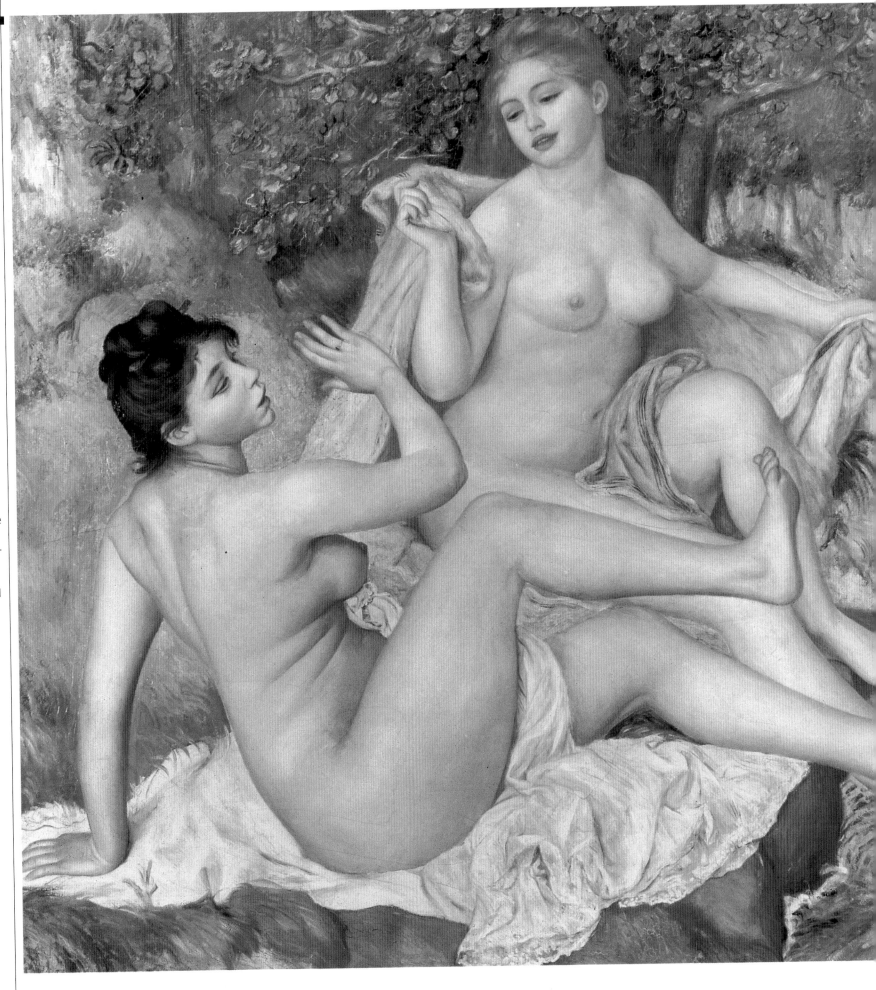

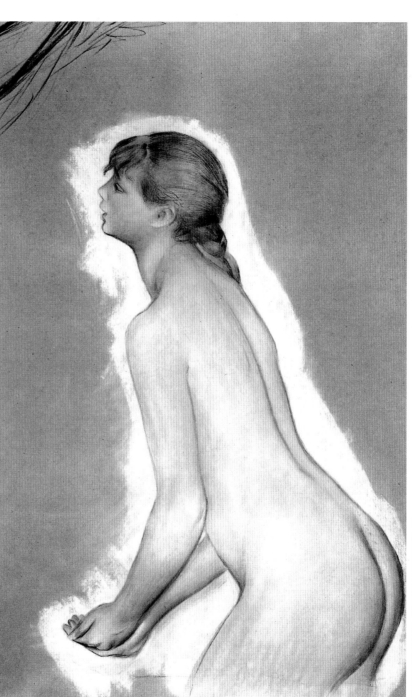

■ PIERRE-AUGUSTE
RENOIR
Study for the Bathers
1886–87, pencil,
sanguine, pastel, and
white chalk on paper,
98.5 × 64 cm
The Art Institute,
Chicago

Preparatory drawings
like this offer us
glimpses of the secrets
behind Renoir's tech-
niques, along with a
sense of his working
method. The highly
precise outlines of
this study for the fig-
ure of the girl to the
right in the painting
recall the purity of
various nudes by
Ingres; at the same
time, the stylistic and
emotive differences
between this work and
the series of *Bathers*
by Cézanne are readily
apparent. On the final
canvas Renoir changes
the position of the
girl's head and arms
and makes her pose
less alluring and sen-
sual, more playful and
natural.

CLAUDE MONET
**The Manneporte
near Etretat**
1886, oil on canvas,
81 × 65 cm
Metropolitan Museum
of Art, New York

Between 1883 and
1886 Monet makes
various paintings of
the reefs near Etretat,
changing the point
of view or time of day
in each work as he
experiments with
different chromatic
methods. In particular
he is drawn to the
contrast between the
rough, massive solid-
ity of the rocks and
the airy lightness of
the clouds in the sky,
between the solid
motionlessness of the
rocks and the dynamic
fluidity of the waves
of the sea. In a letter
to Berthe Morisot dated
November 1, 1886, he
writes that he has
found "a tremendous
landscape, disturbing
but fascinating, which
I've liked from the
first moment."

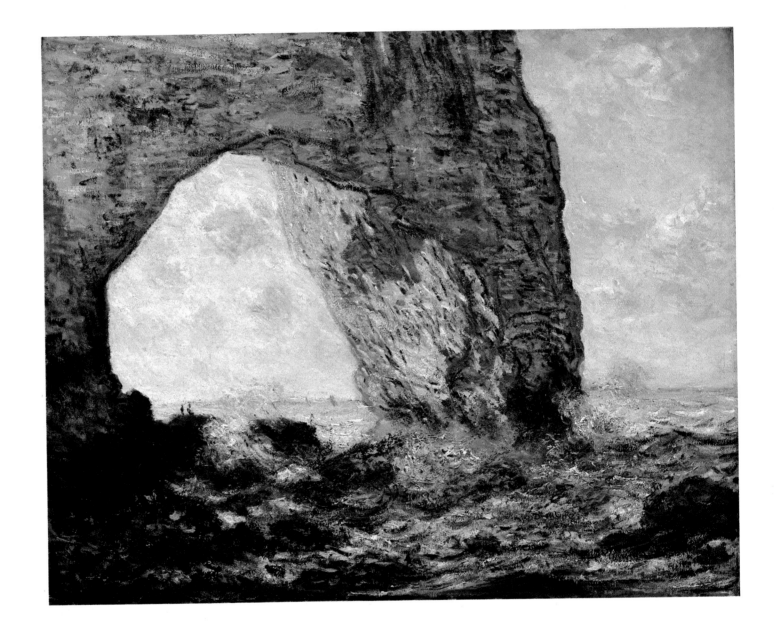

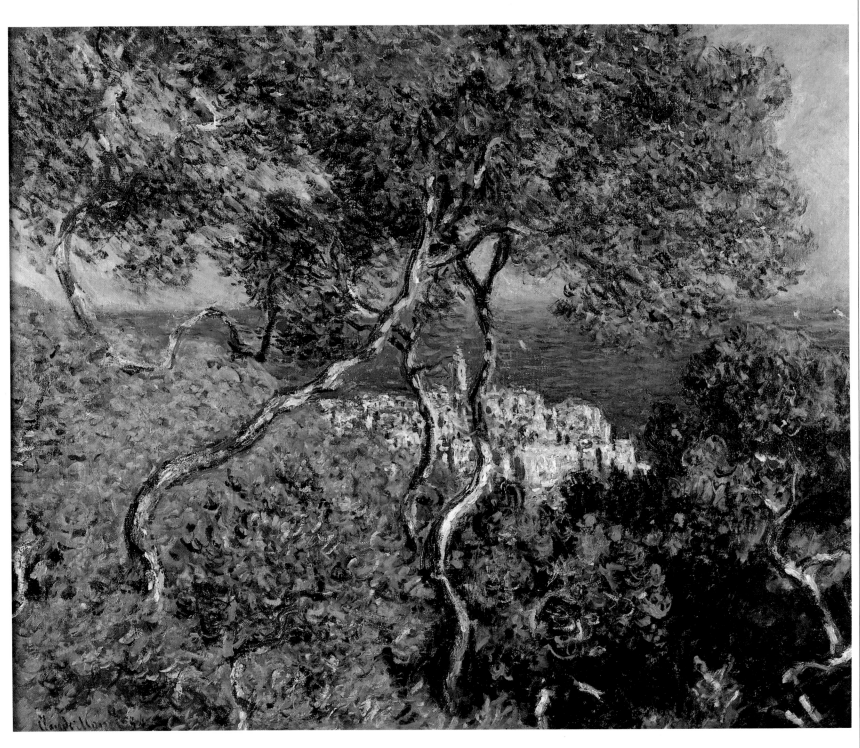

■ CLAUDE MONET
Bordighera
1884, oil on canvas,
64 × 81 cm
The Art Institute,
Chicago

During the last months of 1883, Monet and Renoir take a trip together to Liguria. Renoir leaves for Paris early the next year, but Monet stays behind and visits the seaport of Bordighera, where he remains until April 16, struck by the warm light and lush Mediterranean vegetation. He makes many landscapes, both along the coast and inland, so many that when he returns to Giverny he brings fifty-odd canvases, many unfinished, which he then completes in his studio. The art dealer Georges Petit is much taken by these works and displays a dozen or so in his third "Exposition Internationale."

Woman with Parasol Turned Right

1886, oil on canvas,
131 × 88 cm
Musée d'Orsay, Paris

Here Monet repeats the subject of one of his own paintings, *Woman with a Parasol* (page 119), from 1873. In that work his models were his wife, Camille, and son Jean. The model in this painting—one of two versions made a few days apart—is almost certainly Blanche Hoschedé. The painter presents her from nearby but purposefully leaves the features of her face blurred, treating in the same way her arms, the white dress, and the large red flower at her waist. Both the sky and the plants at her feet are created with rapid, vigorous brushstrokes to visually render the enormous force of the wind.

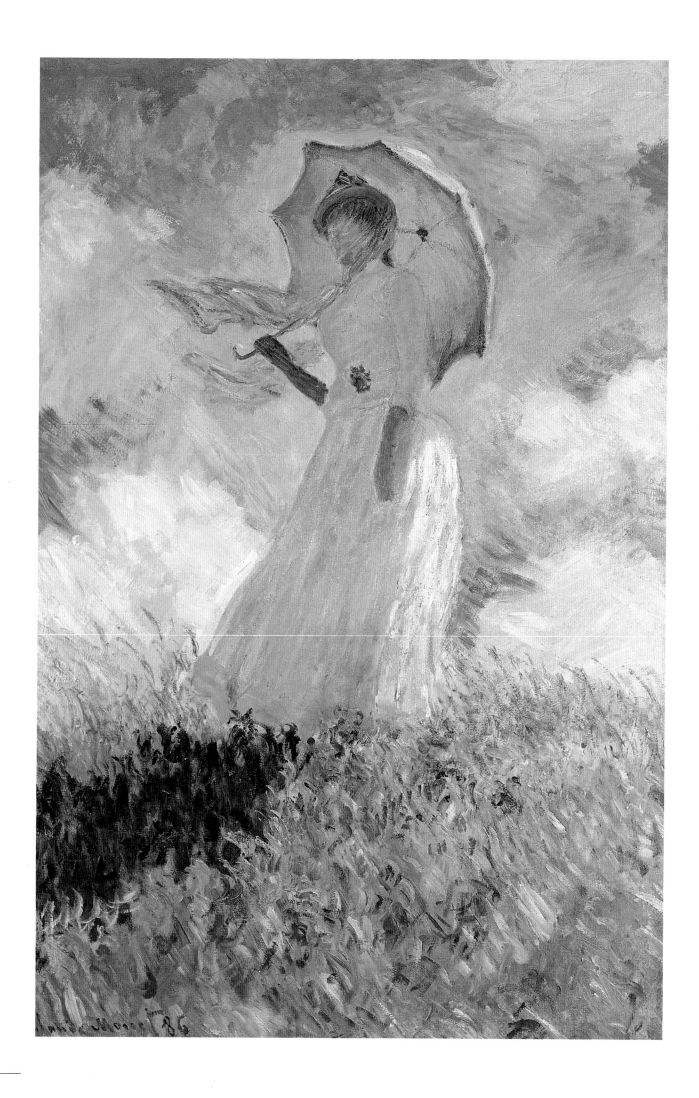

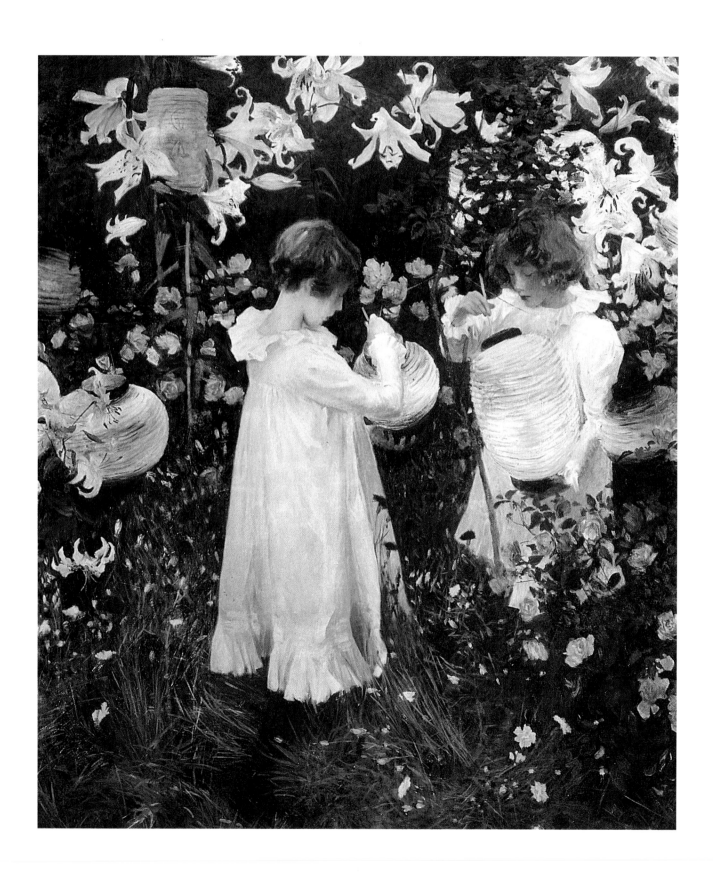

■ JOHN SINGER
SARGENT
**Carnation, Lily,
Lily, Rose**
1885–86, oil
on canvas,
151 × 171 cm
Tate Gallery, London

In 1884, Sargent presents *Portrait of Madame Gautreau* to the Salon, but the critics are ferociously hostile and lump him together with the Impressionists, whose style his work resembles. Embittered, in 1886 he moves to London and opens a studio on Tite Street in Chelsea. He makes frequent visits to the town of Broadway in Worcester, where he meets other American painters and writers who contribute to the formation of his mature style. This painting is considered one of his masterpieces; its title repeats the verse of a song by Joseph Mazzinghi that was then popular.

EDGAR DEGAS
After the Bath
circa 1883,
pastel on paper,
52 × 32 cm
Private collection

Like his ballerinas and
stylish young women,
Degas's nudes never
assume traditional
poses and are instead
presented with utter
naturalness, caught in
an intimate moment
while performing ges-
tures that are ordi-
nary, perhaps even
banal, but also true.
There is neither sensu-
ality nor eroticism in
the unstable position
of this girl; instead
there is a sense of
serene tranquility,
which the painter
records with impartial
objectivity. Without
giving a thought to
how his work might be
interpreted by critics,
he focuses his atten-
tion on the distribu-
tion of light, which
filters into the room
from the window at
right.

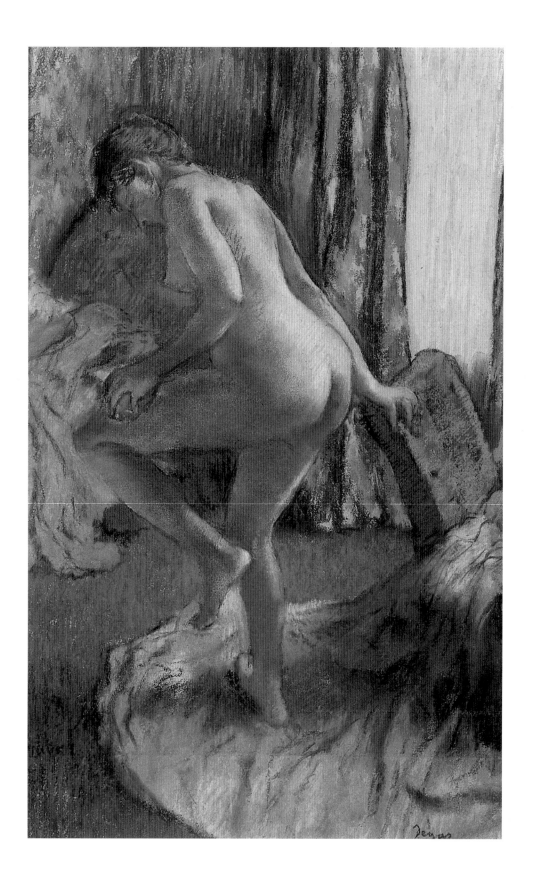

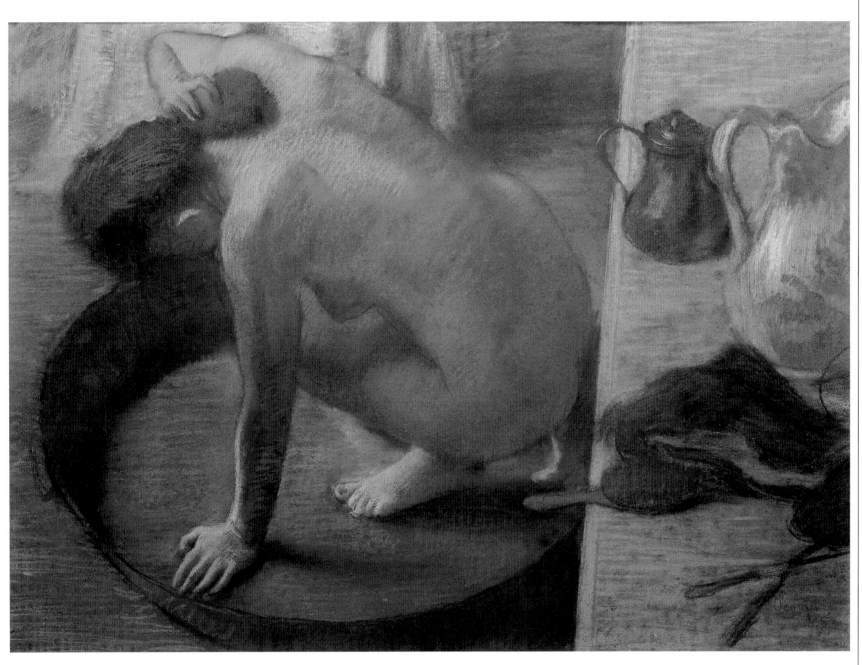

■ EDGAR DEGAS
**Woman Bathing
in a Shallow Tub**
1886, pastel on
heavy wove paper,
60 × 83 cm
Musée d'Orsay, Paris

At the 1886 show
Degas exhibits his
most recent pastels
in a group entitled
*"Series of nude women
bathing, washing,
drying, rubbing down,
combing their hair or
having it combed."*
The public and the
critics are disappoint-
ed because in their
opinion the artist has
lost the delicacy with
which he painted bal-
lerinas and has pre-
sented these women
with too much realism,
in poses that are hard-
ly flattering, almost
like a misogynist.
Although recognizing
Degas's stylistic skills,
some cry out at this
scandal and all on
their own reach the
conclusion that the
artist is presenting
portraits of prostitutes
in brothels.

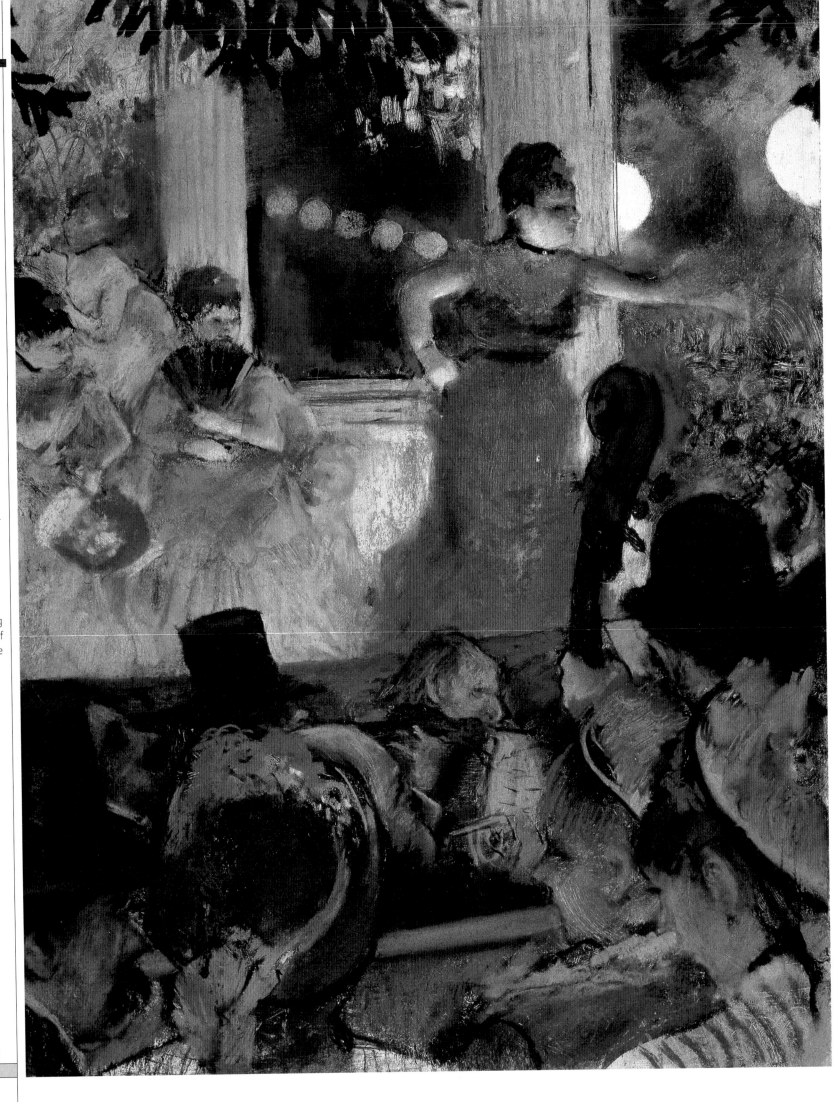

EDGAR DEGAS
Café-Concert at
Les Ambassadeurs
circa 1875–85,
pastel on paper,
37 × 27 cm
Musée des Beaux-Arts,
Lyons

Degas begins this pas-
tel in 1875 and works
on it until 1877; he
then sets it aside only
to pick it up again
eight years later. It is
one of the most com-
plex and far-reaching
of his works dedicated
to the glittery world
of the Parisian *café-
concerts* that were so
popular with the well-
to-do middle class. In
the foreground Degas
places several specta-
tors and the orches-
tra, calling particular
attention to the scroll
of the double bass,
much as he did in *The
Orchestra of the Opéra*
(page 98). In the cen-
ter, standing in front
of the other perform-
ers, and standing out
from them because
of her fiery red dress,
is Emilie Béchat, her
extended arm seeming
to continue the row of
reflected lamps on the
mirror behind her.

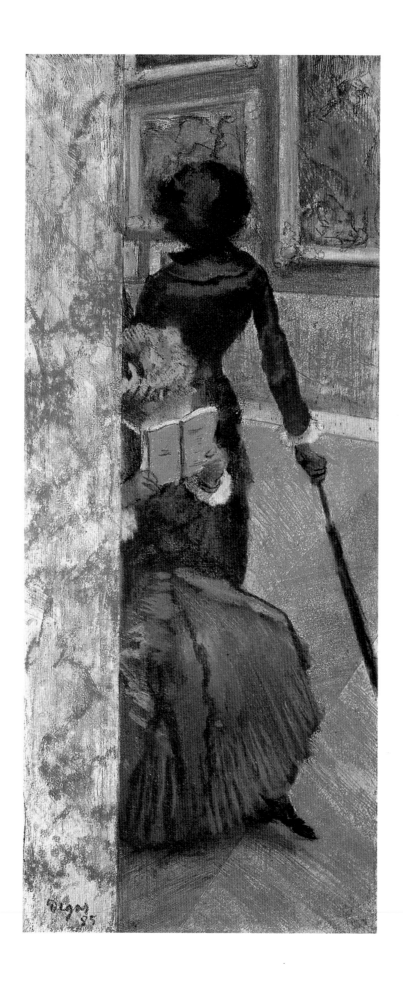

■ EDGAR DEGAS
**Mary Cassatt
at the Louvre:
The Paintings Gallery**
1885, etching,
aquatint, drypoint,
and electric crayon
on wove paper,
31.3 × 13.7 cm
The Art Institute,
Chicago

The narrow format,
the unusual, almost
daring, perspective,
and the techniques
used to create this
colored etching are all
inspired by prints of
such Japanese artists
as Hiroshige and
Hokusai that Degas
has seen and greatly
admired during these
years. In this work too
the principal figure
is not posed for the
viewer but is rather
"spied on" from
behind. The viewer is
denied any sense of
her facial expression
and can only guess
at her state of mind
and the emotions
she is experiencing
during this visit to
the gallery.

EDGAR DEGAS
Women Ironing
1884–86, oil
on canvas,
76 × 81 cm
Musée d'Orsay, Paris

When it first appears
this painting draws
criticism for the
graceless pose—
hardly the classic
ideal of femininity—
of the yawning
woman. Even so,
the atmosphere Degas
creates in this scene
wins the favor of
collectors, and he
ends up making four
versions of the same
subject. The space
in which the two
women are working
is filled with dim
light, and the colors
are purposefully
toned down to
achieve a careful
balance of pale
and dark tints.

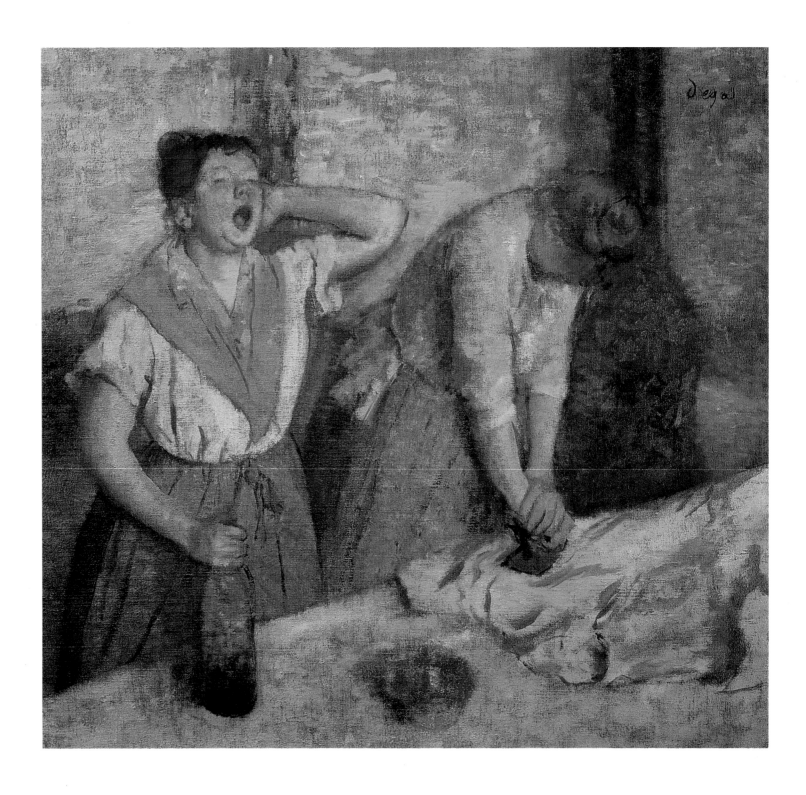

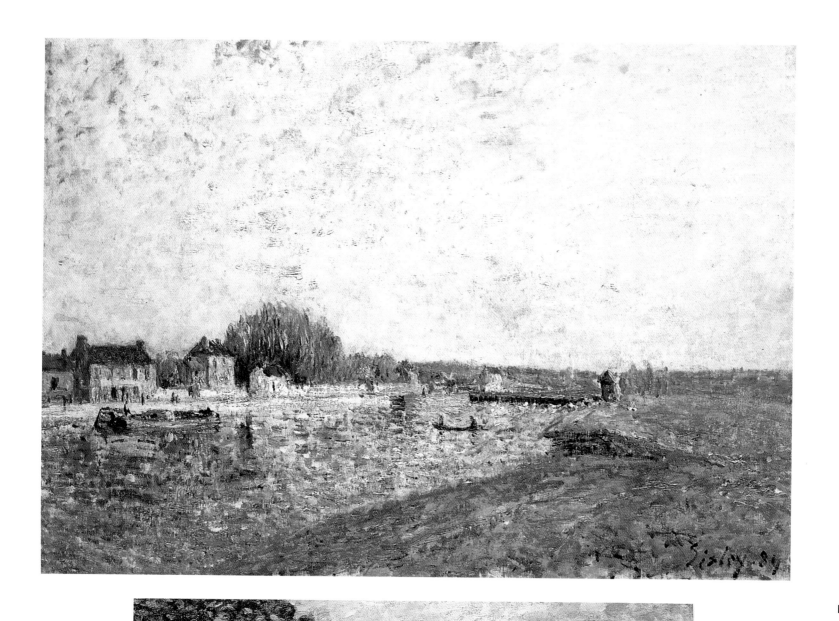

**The Lock and Canal
of the Loing River
at Saint-Mammès**
1884, oil on canvas,
Private collection

Beginning in the fall
of 1883, Sisley makes
frequent trips to the
small town of Saint-
Mammès, located at
the confluence of the
Seine and the Loing
rivers near Véneux-
Nadon. Here he makes
about fifty landscapes,
almost all from life,
and in the process
refines his technique,
further lightening his
palette, enriching it
with the new, delicate
shadings typical of his
maturity.

■ ALFRED SISLEY
**Outskirts of
Les Sablons
(Overcast Day)**
1886, oil on canvas,
Private collection

In this painting, one
of a series of twenty
made near Les Sablons,
the human presence is
reduced to minor fig-
ures just sketched in;
in much the same way
the house at the cen-
ter is nearly hidden by
a large tree. Sisley's
attention is devoted
to nature, to the
shades of the vegeta-
tion, the reflections
of light that filter
through the clouds,
the silvery touches
with which he indi-
cates the water of
the river.

ALFRED SISLEY
**The Banks of
the River at
Saint-Mammès**
1884, oil on canvas,
The Hermitage,
St. Petersburg

In the collections
of the Louvre is an
album of sketches
Sisley made in the
early months of 1884.
Number 22 is the
preparatory sketch for
this painting, one of
the fifty he makes in
that period around
Saint-Mammès. On
March 7 he writes to
Durand-Ruel, report-
ing that he is working
on several landscapes
made from the banks
of the river and
expressing the hope
that the favorable
weather will continue
long enough for him
to complete them. On
March 24 this painting
is consigned to the
gallery, which sells it
in 1907 to the Russian
collector Ivan Morozov
for 20,000 francs.

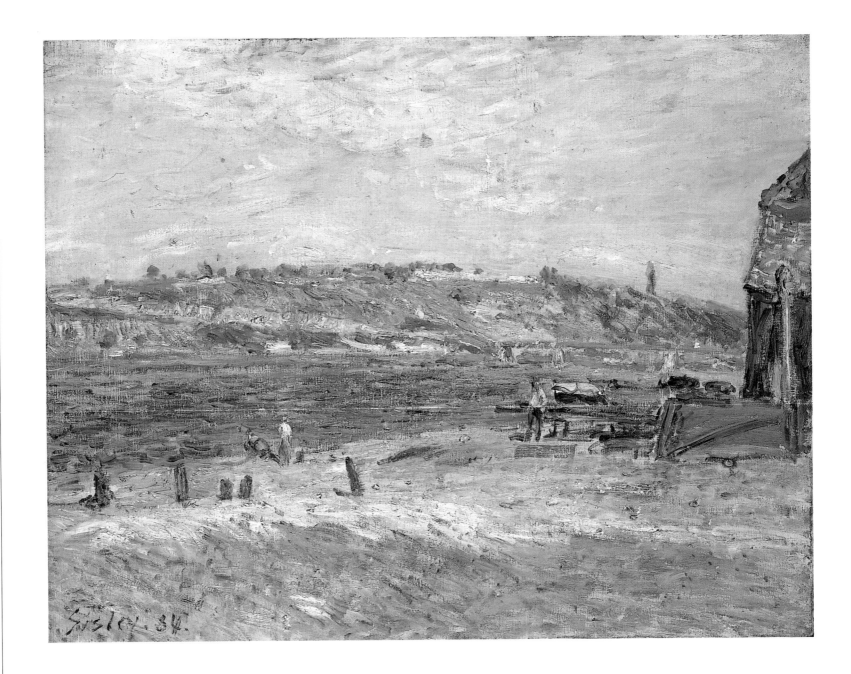

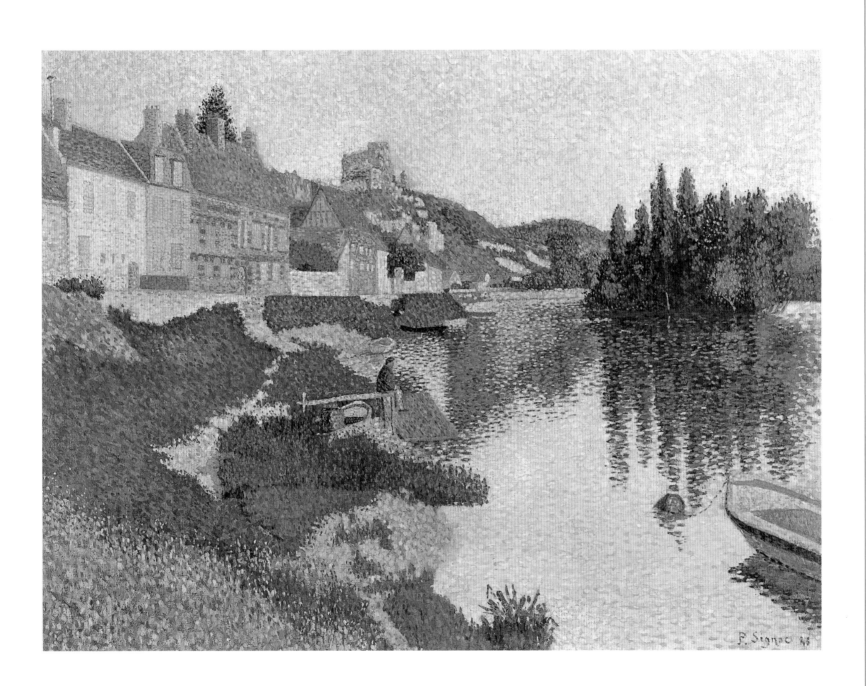

■ PAUL SIGNAC
Les Andelys,
the Embankment
1886, oil on canvas,
65 × 81 cm
Musée d'Orsay, Paris

Between 1883 and
1886 Signac works in
a style similar to that
of Monet, who encour-
ages him to paint
landscapes *en plein*
air. During the same
years, however, he is
powerfully drawn to
the experiments of
Seurat and becomes
his most faithful
disciple. This painting
is one of his nearest
to Pointillism; one
notes immediately the
way the surface of the
canvas is broken up
into small dots of pure
color, each of which is
related to the others,
reinforcing the effect.
At the 1886 show,
the critic Félix Fénéon
praises Signac's works,
finding them among
the most interesting
and modern of the
entire exhibition.

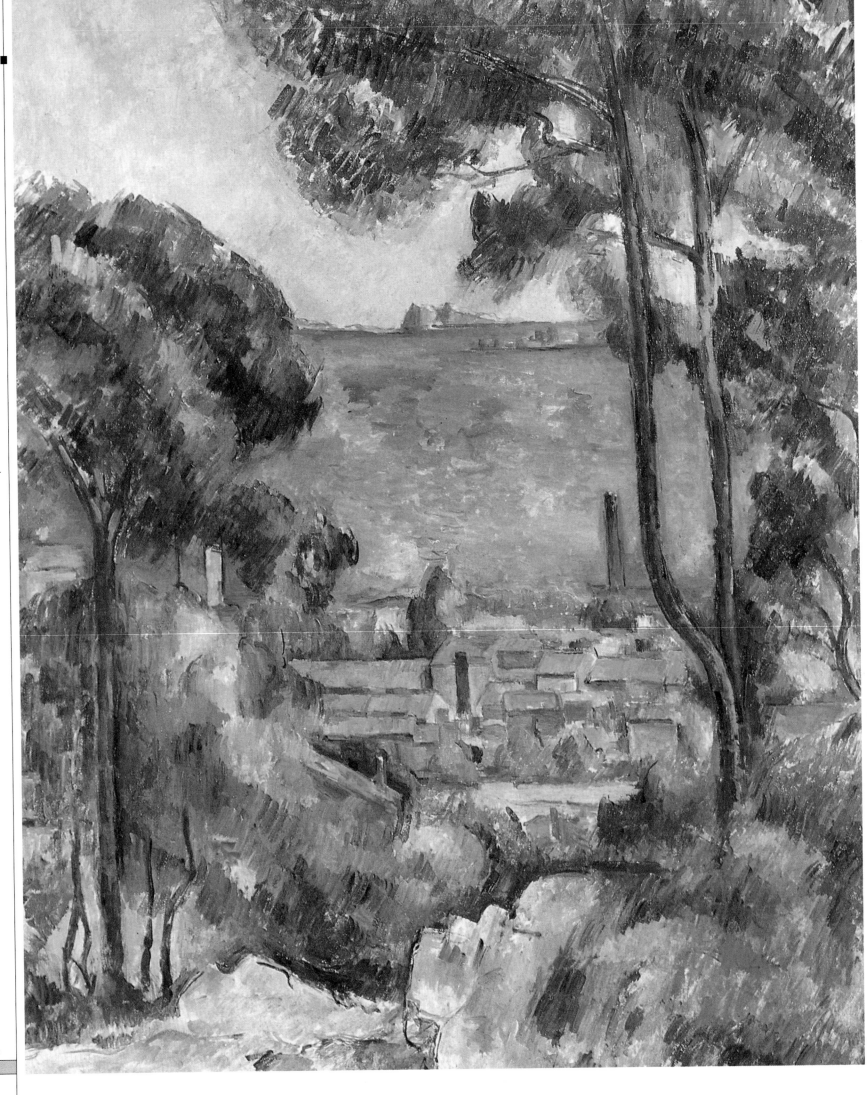

PAUL CÉZANNE
**View through Trees
of L'Estaque**
circa 1882–85,
oil on canvas,
71.5 × 57.7 cm
Private collection

Between 1882 and
1887 Cézanne inten-
sifies his experiments
in space and volume.
In particular, he
simplifies shapes as
they appear in land-
scapes, as is clear
in this painting, in
which he accentuates
the regular, almost
geometric arrange-
ment of the roofs of
the houses in the
town of Saint-Henri
in the foreground.
The various shades of
green are broken up
by touches of yellow
according to the
amount of light reach-
ing them. The sea in
the background is
filled in with brush-
strokes of a different
thickness to better
render the movement
of the water.

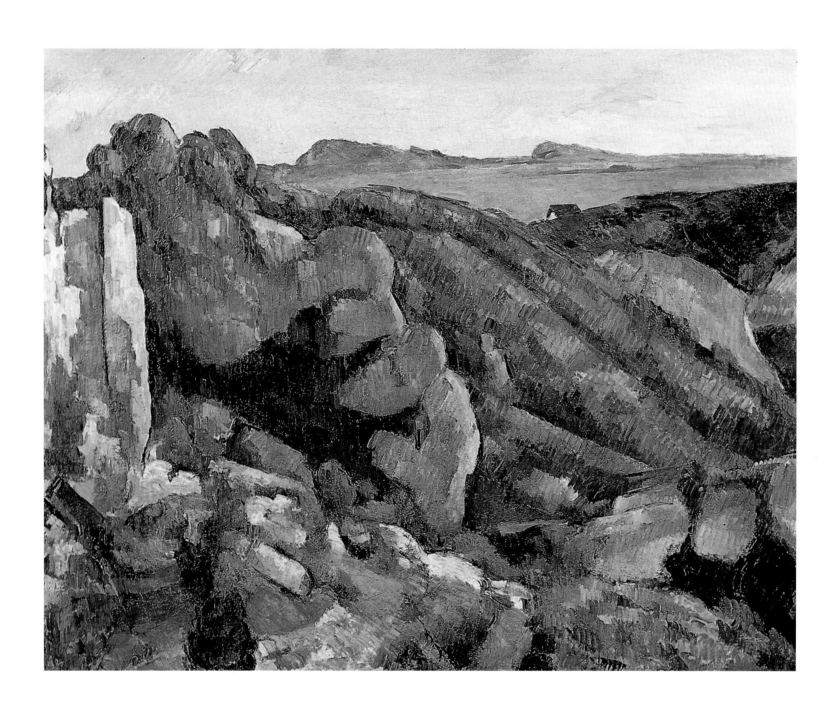

■ PAUL CÉZANNE
Rocks at L'Estaque
circa 1882–85,
oil on canvas,
73 × 91 cm
Museu de Arte,
São Paulo

In this landscape, Cézanne presents rocks on the coast of Provence from so close up that he leaves only a narrow strip at the top of the canvas for the sky and a view of the sea. The short, regular brushstrokes he uses in the central part of the work give the composition a calm, stately rhythm, creating an atmosphere of primitive grandiosity. In the lower part, the paint is applied with greater freedom and irregularity, especially in the thick, reddish areas, which increases the effects of movement and depth.

PAUL CÉZANNE
**L'Estaque and the
Gulf of Marseilles**
circa 1882–85,
oil on canvas,
65 × 81 cm
Philadelphia Museum
of Art, Philadelphia

This painting presents
a blend of Cézanne's
landscape style from
the early 1880s and
methods he develops
later in the decade.
Thus he rhythmically
alternates the vertical
lines of the trees, the
smokestack, and bel-
lower with the hori-
zontal forms of the
roofs, and uses a
similar rhythm to
mark off the pictorial
space with vibrant
brushstrokes in green
and orange. In con-
trast to this is the
rarefied, muted light
of the background,
which creates a sense
of distance; while the
sky and sea seem to
be fashioned out of
the same harmonious
whole, which embraces
the rough cliffs of
the gulf.

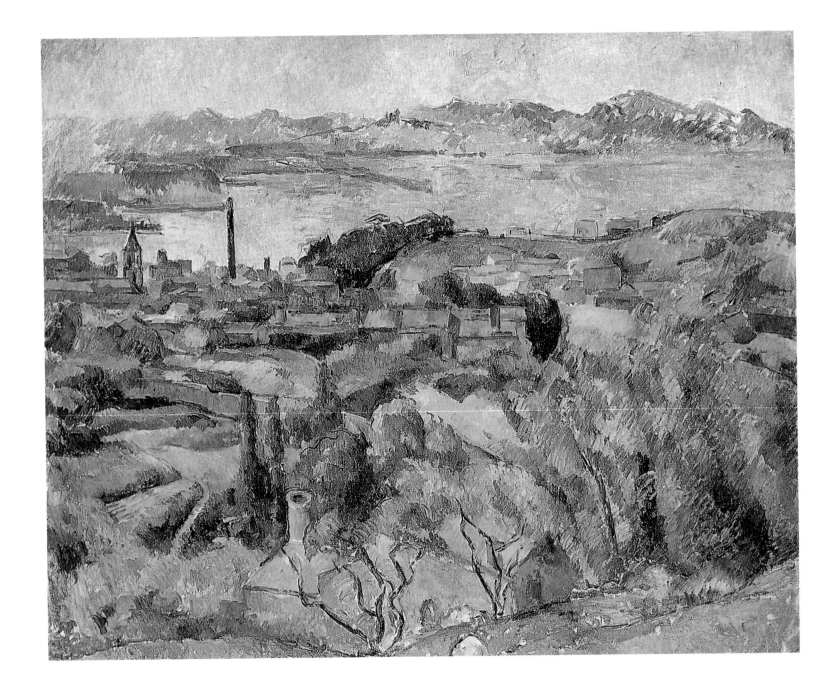

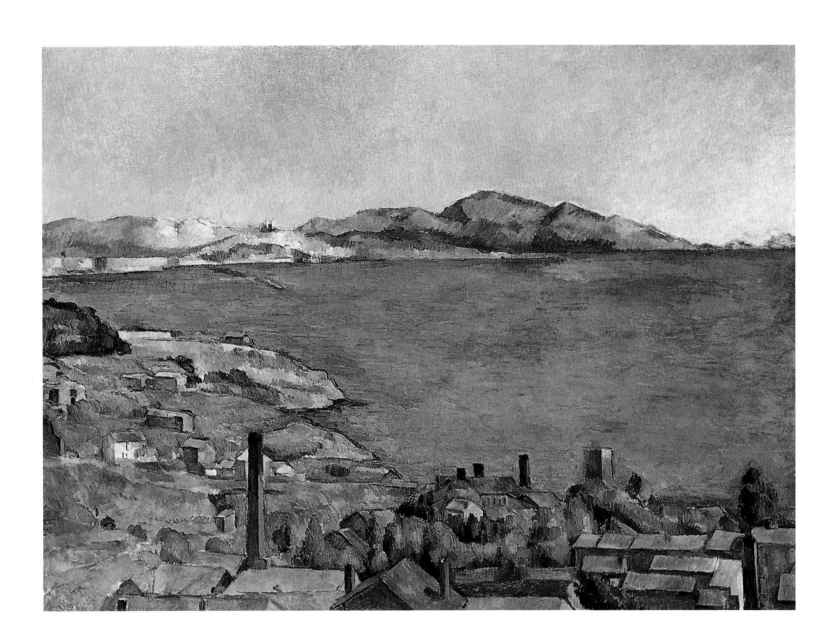

■ PAUL CÉZANNE
The Gulf of Marseilles
circa 1883–85,
oil on canvas,
73 × 100 cm
Metropolitan Museum
of Art, New York

Like the canvas on the facing page, this is a view of the gulf of Marseilles, but in this case the point of view is pulled much farther back, giving greater space to the sea, the sky, and the opposite shore. The town seems compressed and crushed together, so much so that the houses lose their substance, with their roofs transformed into mere geometric shapes. Following this new method Cézanne is gradually but also radically distancing himself from both the traditional French landscape of the early nineteenth century and the Impressionist vision of the world.

PAUL GAUGUIN
Blue Roofs of Rouen
1884, oil on canvas,
74 × 60 cm
Oskar Reinhardt
Collection, Winterthur

In January 1883, Gauguin loses his job when the Union Générale collapses. Despite his wife's misgivings he decides to dedicate himself full time to painting. In November he moves his family to Rouen, in Normandy, partly because living there is less expensive than in Paris and partly because he is following the example set by Pissarro. He arrives full of many hopes for fame and success, but in a short time he is disillusioned: in the provinces, so far from Paris, the citizens do not understand his innovative art and do not buy his paintings.

■ PAUL GAUGUIN
Cattle Drinking
1885, oil on canvas,
81 × 65 cm
Galleria d'Arte
Moderna, Milan

Although acquiring
a style all his own,
Gauguin still reveals
his indebtedness to
Pissarro in the works
from these years. There
are also signs of the
Impressionists, from
whom he learns the
use of broad, flat
brushstrokes, the
preference for sceno-
graphic and decora-
tive effects even when
it means denying the
demands of depth, and
the construction of
uniform compositions
without contrasts or
overly marked chiaro-
scuro. The presence of
animals, unobtrusive
and reassuring, creates
a peacefully serene
atmosphere worlds
away from the unset-
tling symbolism of his
later Tahitian works.

PAUL GAUGUIN
Clovis Sleeping
1884, oil on canvas,
46 × 55.5 cm
Josefowitz Collection,
Lausanne

The subject of this painting is Gauguin's third child, his son Clovis, born in 1879. From a stylistic point of view, the painting shows many similarities to the works of the Impressionists, from the sweet expression of the sleeping child to the splendid still life on the table, from the distribution of light to the application of the brushstrokes. Despite his efforts, Gauguin fails to find new buyers for his paintings, and after eight months Mette, disappointed with her husband's inability to provide a satisfactory standard of living, takes their five children and returns to her family in Copenhagen.

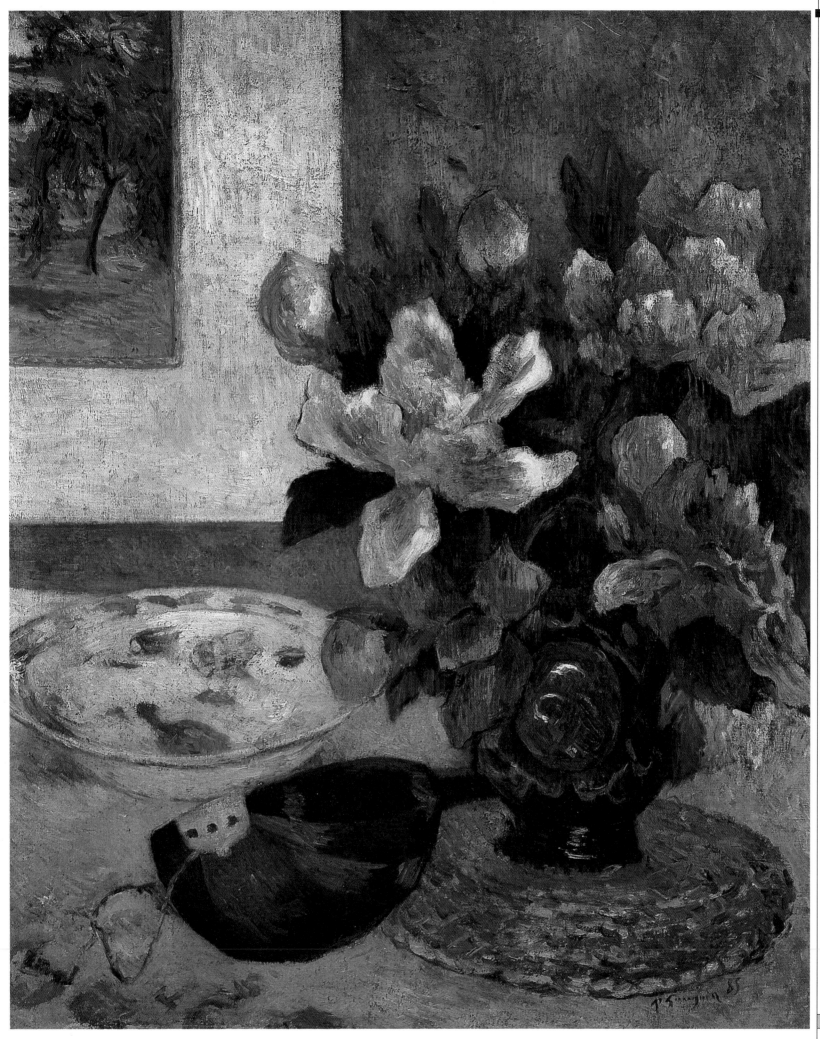

■ PAUL GAUGUIN
Still Life with Mandolin
1885, oil on canvas,
64 × 53 cm
Musée d'Orsay, Paris

This composition, still inspired by the style of the Impressionists, is dominated by the splendid vase of peonies, their colors bright and intense. Among the objects presented are two particularly dear to the artist, the mandolin, which he had learned to play with a certain skill, and, in the background, a painting from his collection by Pissarro or, perhaps, Guillaumin. At the end of 1885, however, Gauguin is forced by his dire financial straits to sell off his collection of paintings, and he resigns himself to working as a billposter at five francs a day.

PAUL GAUGUIN
Four Breton Women
1886, oil on canvas,
72 × 90 cm
Neue Pinakothek,
Munich

In June 1885 Gauguin
leaves most of his
family in Denmark and
returns to Paris with
his son Clovis, aged
six. In July 1886, two
months after taking
part in the sixth
Impressionist exhibi-
tion, he sets off for
Pont-Aven in Brittany
in search of new
sources of inspiration.
Here he makes many
pictures of the local
women in their tradi-
tional costumes, call-
ing attention to their
simple beauty, perhaps
a little coarse but
authentic, far different
from the sophisticated
Parisian models com-
mon in the studios
of painters.

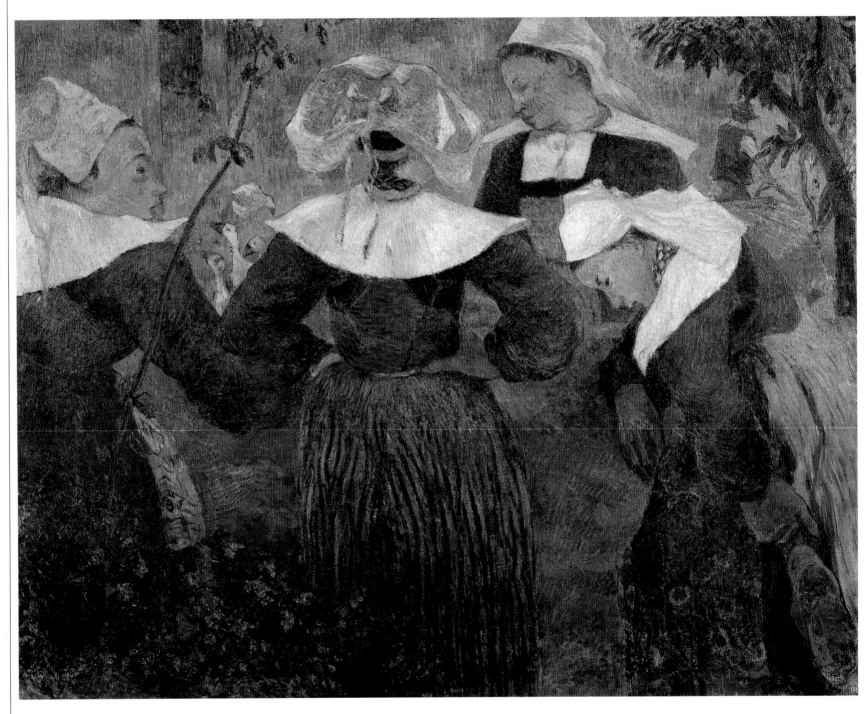

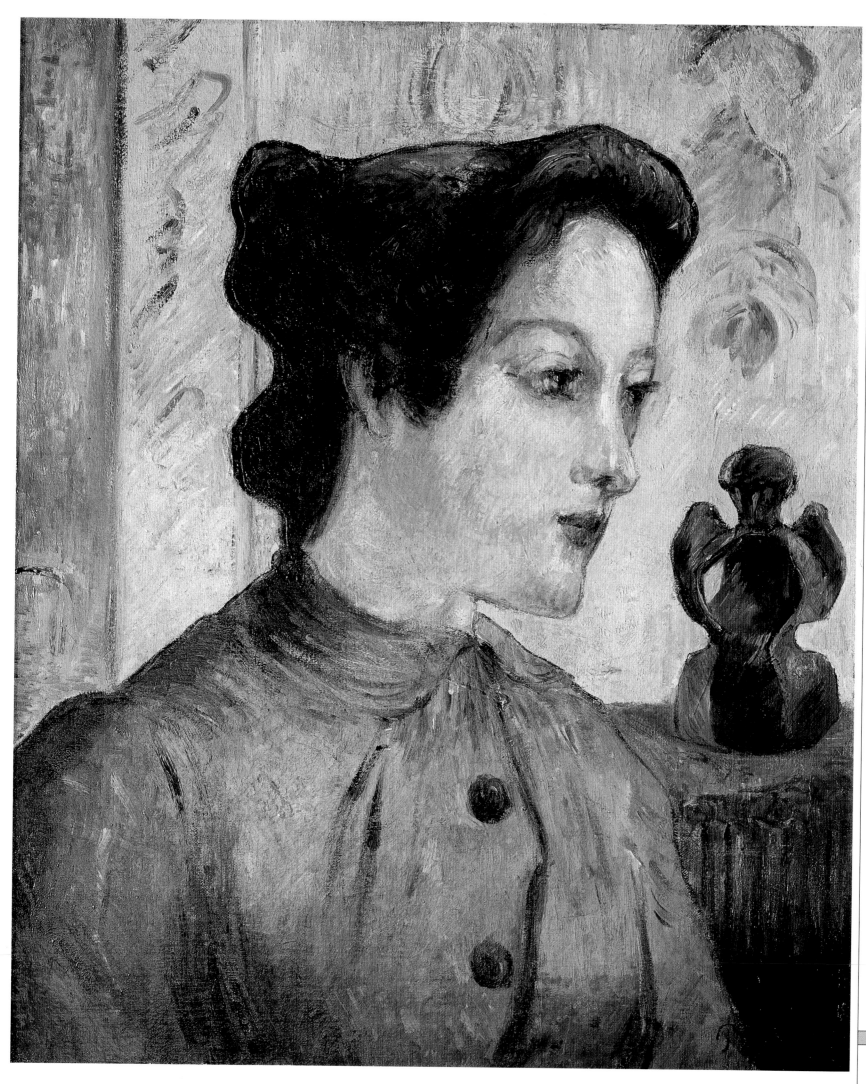

**The Woman
with the Chignon**
1886, oil on canvas,
46 × 38 cm
Bridgestone Museum
of Art, Tokyo

Beginning with his
earliest portraits,
Gauguin reveals great
skill at capturing the
inner emotions of his
sitters. He is able to
put himself in close
harmony with his
models, thus putting
them at ease so that
he can translate to
canvas their feelings
and emotions. Also
portrayed in this
painting is one of
the first ceramic
vases Gauguin makes
(now lost). Particularly
proud of it, he includes
it in his *Still Life with
Profile of Laval* and
makes a sketch of it
in a letter to his wife,
Mette.

MARY CASSATT
**Children Playing
on the Beach**
1884, oil on canvas,
97.6 × 74.2 cm
National Gallery of
Art, Washington, D.C.

The original idea for
this painting almost
certainly takes shape
during a trip to Spain
that Cassatt makes in
1884 together with
her convalescent
mother. Back in Paris
she reworks the theme,
making changes to
the composition of the
canvas, altering the
position of the chil-
dren and the number
of boats in the back-
ground. Displayed in
the 1886 Impressionist
show, the work enjoys
success, praised for
the atmosphere of
idyllic peace with
which Cassatt imbues
the scene. Considered
one of Cassatt's most
beautiful paintings of
children, it is the only
beach scene she ever
paints.

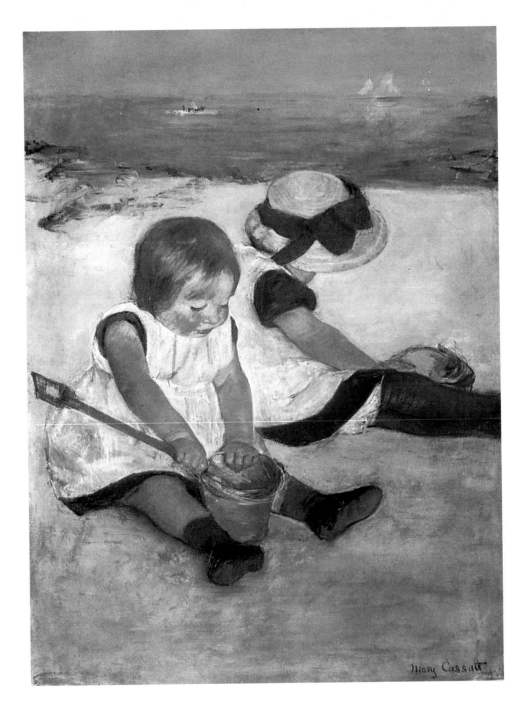

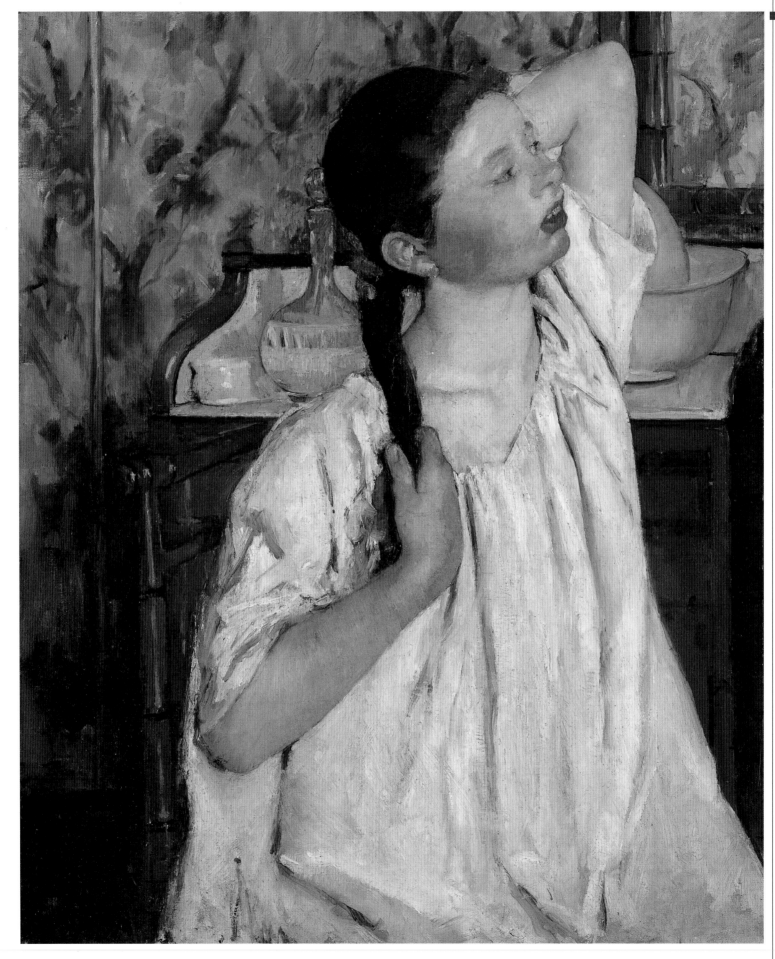

■ MARY CASSATT
**Girl Arranging
Her Hair**
1886, oil on canvas,
75 × 62.3 cm
National Gallery of
Art, Washington, D.C.

Mary Cassatt makes
this painting follow-
ing a discussion with
Degas in which he
challenges her. The
young American artist
makes this canvas
with the deliberate
intention of showing
Degas that she has
learned his methods
and, most of all, to
prove to him that
even a woman can
create paintings of
the same quality as
his. She is successful,
and Degas, astonished
at the quality of her
accomplishment, buys
the painting to add
to his own collection.
Several years after the
deaths of both artists,
the painting, put up
for auction, is mistak-
en for a work by Degas.

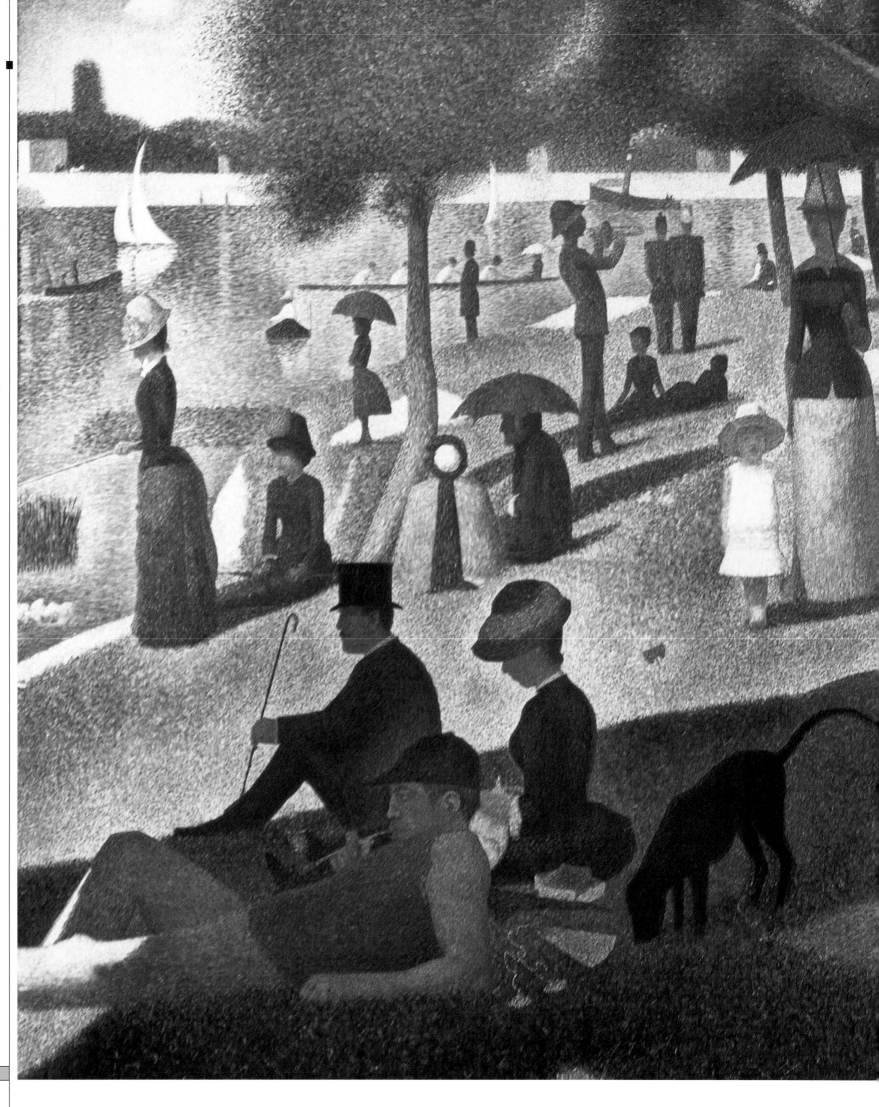

GEORGES SEURAT
A Sunday Afternoon on the Island of La Grande Jatte
1884–86, oil on canvas, 205.7 × 305 cm
The Art Institute, Chicago

This work, Seurat's masterpiece, is one of the radical moments in art at the end of the century. Creation of the work requires much time and effort: the painter wants to put into practice his scientific studies on optics and makes a great many preparatory drawings, both in the open and in his studio. In accordance with the new style, called pointillism, Seurat breaks down the colors into components and applies these to the canvas by means of small individual dots. The painting is presented at the 1886 exhibit where it awakens dismay and clamor because of its powerful visual impact and its undeniable expressive force.

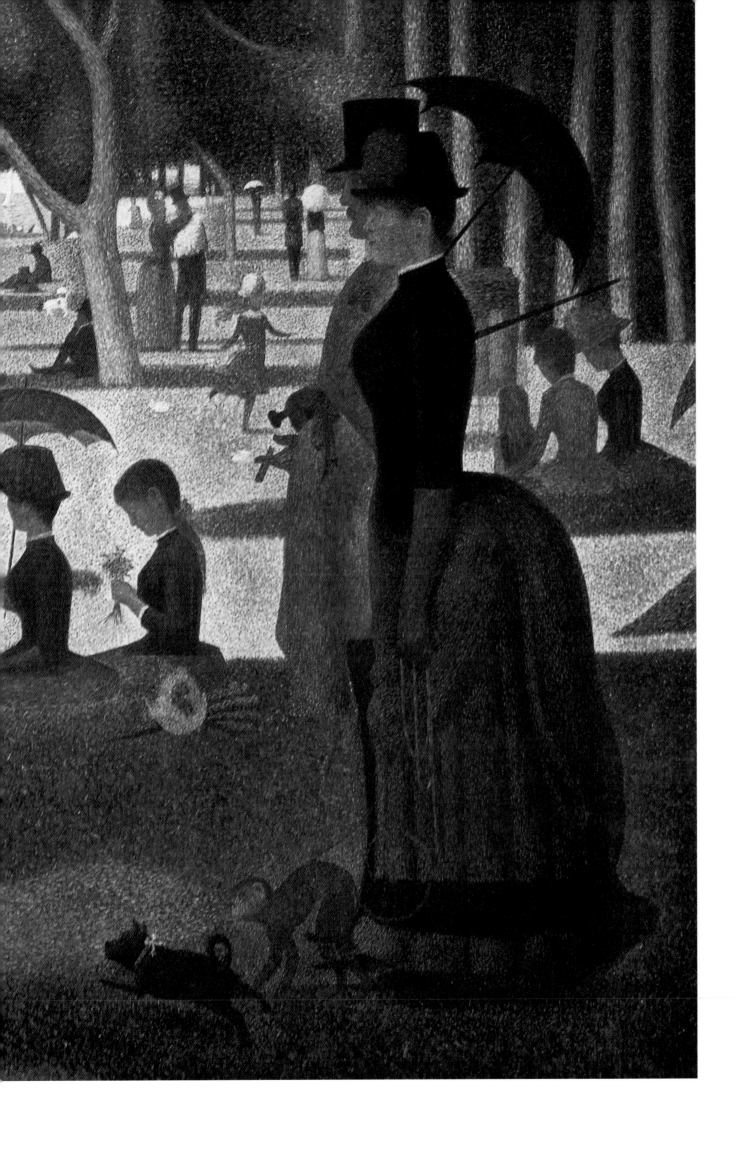

I n 1886, while preparations are going ahead for the eighth and final Impressionist exhibit, another show of their works is taking place, one destined to lay the foundation for far greater success, vast and enduring. In New York, from April 10 to May 25, 1886, in rooms of the American Art Association, Durand-Ruel holds the first show in America entirely dedicated to them, entitled "Works in Oil and Pastel by the Impressionists of Paris." Presented to the American public are 300 works, among them five by Mary Cassatt, six by Caillebotte, 23 by Degas, 17 by Manet, 48 by Monet, 42 by Pissarro, 38 by Renoir, three by Seurat, and 15 by Sisley. The critical reception is in large part favorable, so much so that the show is moved to larger rooms in the nearby National Academy of Design and its length is extended by several weeks. About 20 percent of the paintings are sold,

The building at 315 Fifth Avenue housing Paul Durand-Ruel's gallery in New York.

Title page of the catalog of the Impressionists' 1886 show in New York.

1886•1889 The and the universal

Office in Durand-Ruel's New York gallery. Visible above the desk is a work by Monet, *Japanese Bridge*.

earning all together a little more than $18,000. This commercial success brings relief to Durand-Ruel's financial situation. In May of the next year, in collaboration with James F. Sutton of the American Art Association, the French art dealer presents a second show, and in 1888 he opens a gallery in New York at 315 Fifth Avenue. Standing out among the first American collectors of Impressionist art are the husband and wife Louisine and Harry Havemeyer. Louisine Waldron-Elder

was a childhood friend of Mary Cassatt's in Philadelphia; in 1874 she runs into her again during a trip to Paris, and the next year, on her advice, she buys a pastel by Degas and a painting by Monet. In 1883 Louisine weds Harry Havemeyer, a rich businessman, owner of the American Sugar-Refining Company. He too is a leading connoisseur, passionate about art. The couple often travels to Europe, where they buy important works by Goya, El Greco,

The shows in America and the universal exhibition in Paris

Courbet, and, following Cassatt's suggestions, more paintings by the Impressionists. Durand-Ruel borrows some of their already conspicuous collection for his 1886 show in New York, and they add to the collection during their trip to Paris in 1889 on the occasion of the universal exhibition. To show their collection to better advantage, they have a large home built at 1 East 66 Street in New York. After the death of her husband, in 1907, Louisine continues to buy paintings, including the *Ballerinas at the Bar*, by Degas, for which she pays $500,000 in 1912, at the time the highest price ever paid for a work by a living artist. She dies in 1929, and in accordance with her will, her children bequeath the most important pieces in the collection, including fifty works by

Impressionists increases over the course of the 1890s, thanks in part to essays published in the leading art magazines, such as *Scribner's*, *Modern Art*, and *Art Amateur*, and thanks also to the many American artists who often visit Paris to study art and culture. In doing so they follow in the footsteps of Whistler, Sargent, and Cassatt. Standing out among them is the group of painters led by John H. Twachtmann (1853–1902) and William M. Chase (1849–1916) known as the Ten American Painters.

On May 6, 1889, the universal exhibition opens in Paris. To commemorate the centennial of the French Revolution of 1789 the French set out to amaze the world

shows in America exhibition in Paris

Impressionists, to the Metropolitan Museum of Art. The example set by the Havemeyers is imitated by other rich Americans, including Albert Spencer, who in 1888 sells the antique paintings he owns so as to concentrate his collecting on Impressionists; Desmond Fitzgerald (1846–1928), author of the introduction to the catalog of the show of Monet, Pissarro, and Sisley in New York in 1891 and promoter of a show of Monet at the Copley Society in Boston in 1905; and James S. Inglis and William H. Fuller, both of them among the leading buyers of paintings by Monet and Manet. Included among the ancillary exhibits of the 1893 Columbian Exposition is a show of about twenty canvases by Degas, Manet, Monet, Pisssarro, and Sisley on loan from American collectors; the undertaking is coordinated by Berthe Honoré Palmer, owner of numerous works today in the Art Institute of Chicago. The fame of the

with an enormous, truly stupendous exhibit. The defeat at Sedan and the civil war of the Paris Commune have been buried and forgotten. The well-meaning but utopian ideals of romanticism have been swept aside, their place now occupied by the myth of progress, with well-being guaranteed by science and technology. Colonial expansion is carrying French influence into every corner of the world; modern means of communication are increasing commercial exchanges at a rapid rate. Ever larger and faster ships transport merchandize over the oceans, and the excavation of the Suez Canal, soon followed by those of Panama and Kiel, has brought new seaways, shorter and safer. The domestic rail lines have given new impulse to commerce and industry, and numerous applications are instantly found for each new discovery, each one greeted as further proof of the limitless progress of the new machine-age civiliza-

■ Engraving from the 1889 universal exhibition in Paris showing the entranceway to the Javanese Kampong, the pavilion that so fascinated Gauguin.

1886•1889

331

The shows in America and the universal exhibition in Paris

View from the
1889 universal
exhibition in Paris.

habits and customs different from those in Europe. This part of the exhibition also serves the more serious and purposeful interests of scholars and artists. Gauguin, for example, back in Paris after his brief, unhappy trip to Martinique, visits these sections of the exhibition many times. He is most impressed by the recreation of Tahitian and New Caledonian homes, by the temples of Angkor Wat and Borobudur, and by the spectacle of Javanese dancers. So impressed is he that on April 4, 1891, he decides to take off for Tahiti. The true, great attraction of the 1889 universal exhibition is the Eiffel Tower, tangible proof of the triumph of iron architecture, emblem of industrial civilization, and today, of course, symbol of the city of Paris. Designed by Alexandre Gustave Eiffel, it occupies an area of 100 meters on each side, is 400 meters high, and weighs 8,000 tons. It is erected over 17 months, during which time there are constant clashes and disputes between the enthusiastic supporters of the new architecture and the equally determined defenders of the old-style traditional forms. The peak of this battle comes a few weeks before the opening of the exhibition when the towering structure is covered with a layer of antioxidant varnish. Word spreads that this color, with its bright red and orange glints, is the final color, unleashing the outrage of the opponents. In particular, a large group of intellectuals raises a subscription to send to the government to obtain the immediate destruction of what, in their eyes, is a grave disfigurement of the majestic palaces in the historic center of Paris.

The many smaller exhibitions related to the universal exhibition include a centennial exhibit of French art, a large-scale retrospective show that presents a broad selection of paintings, drawings, sculpture, and engravings by the leading French artists active between 1789 and 1889, from David to the Impressionists. The Impressionists are represented with works by Manet, Monet, Pissarro, and Cézanne, who brings back for the occasion his *House of the Hanged Man*, exhibited to withering reviews at the first Impressionist show in 1874. There is nothing accidental about the decision to exhibit that particular painting, and its choice clearly indicates the change that has taken place in how critics, collectors, and connoisseurs of art view impressionism. The same fate awaits Manet's *Olympia*, which is now honored and venerated every bit as much as it was vilified and insulted on its first appearance. Such is the praise it receives that Monet and Sargent promote a public subscription to buy the painting from Manet's widow and give it with all honors to the state. They succeed in collecting 19,415 francs; in

tion. The only people to harbor doubts about the advantages of this new age are a few socialists and anarchists, concerned as they are about the price paid by the lower classes to the ruling class to make possible this mania for lavishness, which seems to be affecting the entire nation. The pavilions built for the previous exhibitions, in 1867 and 1878, grew steadily larger, designed to astonish foreign visitors and show off the superiority of French technology. This time around the Parisians succeed in outdoing even themselves and erect a true temple of national prestige. The complex, highly elaborate constructions, masterpieces of engineering and architecture, truly astonish the thousands of visitors who come from every part of France and the world during the six months of the exhibition. They are struck in particular by the impressive Galerie des Machines, later taken down, and by the numerous buildings dedicated to the colonies set up in the Champ-de-Mars. The enormous presentation of products and artworks from cultures outside Europe is not only a curiosity but also an excellent learning opportunity, offering visitors the means to see and compare

The shows in America and the universal exhibition in Paris

1890 the painting enters the Musée du Luxembourg and in 1907 it is moved to the Louvre. Only fifteen years have passed since the days when Impressionist art was greeted with sarcastic reviews in almost all newspapers, when it was ridiculed in satirical cartoons, when the vain attempts to sell Impressionist works at auction met only insults. The oldest among the Impressionists, Pissarro, is fifty-nine; the youngest, Caillebotte, has just turned forty-one. Their relationships to art dealers are firm, as are those with collectors, and not only French collectors but, following the success of the shows in London and New York, international ones as well. They have survived the death of Manet, for years their guide and driving force; they have established personal styles that enable them to deepen their art while at the same time moving past the themes that originally gave life to impressionism. Their participation in the centennial exhibition thus marks their official rec-

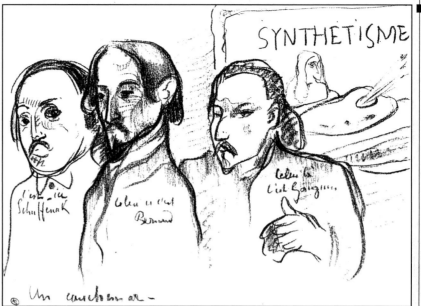

ognition and their complete and undisputed insertion in the history of French art.

During the same occasion the presence is noted of a new generation of artists, destined to have great importance in the coming years. At the eighth Impressionist show, in 1886, critics had already noted the stylistic differences in the works by Seurat and Signac, the exponents of Pointillism, and had begun to speak of post-Impressionism. During the universal exhibition, an Italian named Volpini, owner of the Grand Café, a luxurious Parisian bar, obtains the license to open a café inside the exhibition space. His Café des Arts is located in the external galleries of the fine-arts palace, facing the press pavilion, thus directly beneath the Eiffel Tower. Emile Schuffenecker reaches an agreement with Volpini to decorate the walls of the space with the paintings of a new group of artists, called for this occasion the Impressionist and Synthetism Group. Synthetism, invented by Bernard, Schuffenecker, and Gauguin, does not attempt to reproduce nature but instead the synthetic impression nature awakens in the mind of the viewer. The artist leaves aside perspective, shadings, shadows, and chiaroscuro and applies the colors to flat sur-

faces with sharply defined contours. Because of this final aspect of the style, it also comes to be called Cloisonnism, being similar to that used in medieval stained glass. Exhibited on the walls of Volpini's café are 17 works by Gauguin and others by Schuffenecker, Emile Bernard, Charles Laval, Léon Fauché, Louis Roy, Georges-Daniel de Monfreid, Ludovic Nemo, and Louis Anquetin. Theo van Gogh refuses to send any works by Vincent because he considers it a humiliating alternative to the official exhibition, from which his brother has been excluded. The critics almost completely ignore the exhibit, few members of the public take any note of it, but the paintings are admired by such young artists as Pierre Bonnard, Maurice Denis, and Edouard Vuilland and eventually constitute the reference point for the Nabis group.

■ The Eiffel Tower, the leading attraction of the 1889 universal exhibition, under construction.

EXPOSANTS

Paul Gauguin	E. Schuffenecker	Emile Bernard
Charles Laval	Louis Anquetin	Louis Roy
Léon Fauché	Georges Daniel	Ludovic Nemo

■ Opening page of the catalog of the show held in the Café Volpini in 1889 of the Impressionist and Synthetist Group. The drawing is by Gauguin.

PIERRE-AUGUSTE
RENOIR
Julie Manet with Cat
1887, oil on canvas,
64.5 × 53.5 cm
Rouart Collection,
Paris

Berthe Morisot's
daughter, Julie, is
born in 1878 and at
the time of the paint-
ing is nine years old.
At the death of her
mother, on March 2,
1895, she is put into
the guardianship of
Renoir and Mallarmé.
In this portrait the
painter emphasizes
the tenderness with
which the cat lets
itself be held by the
girl, in whose face
can be seen a shadow
of sorrow and melan-
choly. One cannot
help but note certain
resemblances, as
between the girl's
white dress and the
cat's paws and, most
of all, between the
features of the girl's
face and those of
the cat, most of
all the narrow,
elongated eyes.

The shows in America and the universal exhibition in Paris

PIERRE-AUGUSTE
RENOIR
The Little Gleaner
1888, oil on canvas,
66 × 54 cm
Museu de Arte,
São Paulo

Influenced by the con-
temporaneous works
by Seurat and Signac,
Renoir furthers his
own study of color and
light. In so doing he
approaches a style
called variously
Ingresque, because
of its similarity to the
art of Ingres, or *aigre*,
meaning acidic or
pungent. It is quite
apparent in this can-
vas, in which the
brushstrokes take
on a new energy,
similar to those of
contemporary works
by Cézanne. At the
same time, however,
Renoir skillfully pre-
serves the grace and
delicacy that imbue
this painting with
an uncommon atmos-
phere of intimacy
and tenderness.

CLAUDE MONET
**View of Antibes
from La Salis**
1888, oil on canvas,
65 × 92 cm
Museum of Art,
Toledo, Ohio

Between January and
April of 1888 Monet
paints at Cap Martin,
Juan-les-Pins, and
Antibes, where he
makes several of his
most beautiful land-
scapes. By then
forty-eight years old
he has reached full
artistic maturity and
is in complete control
of his art. Using only
a few thick, dense
brushstrokes he creates
the town in the back-
ground. His attention
is concentrated on the
large tree in the fore-
ground, illuminated
by bright, intense
light that gives the
leaves a variety of
golden reflections.

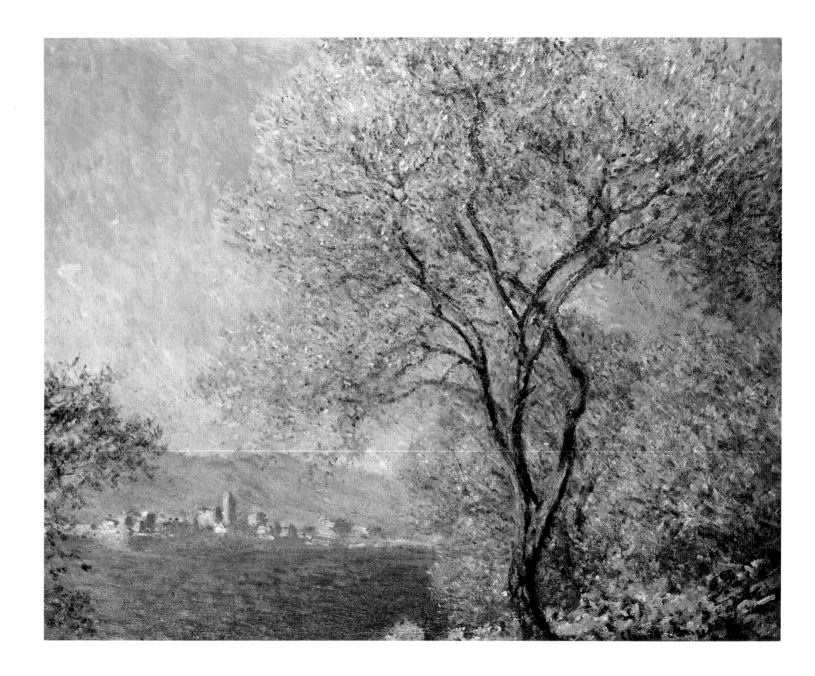

The shows in America and the universal exhibition in Paris

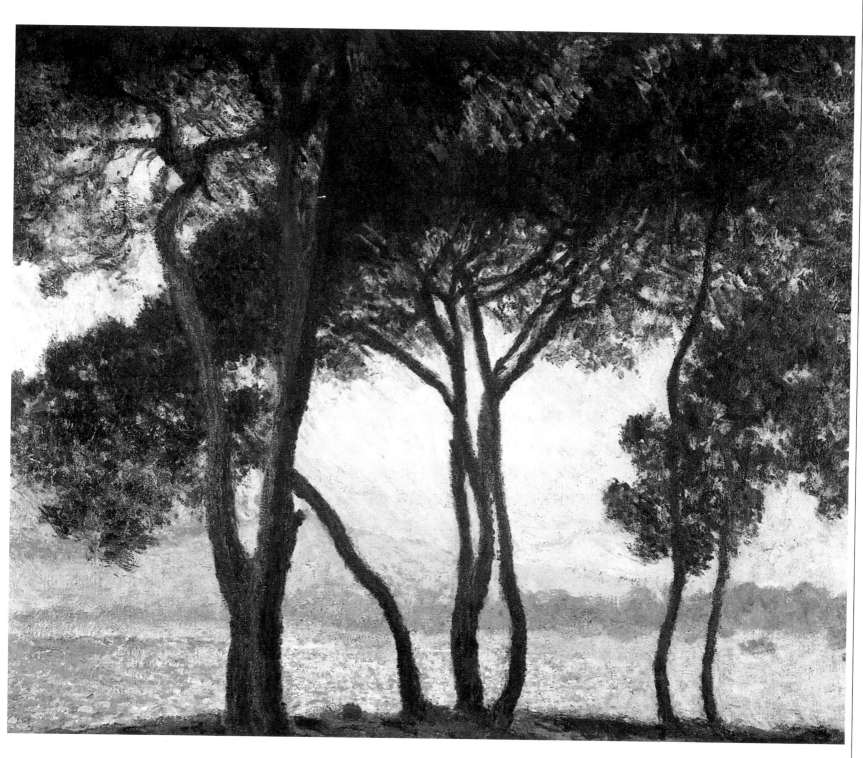

CLAUDE MONET
View of Juan-les-Pins
1888, oil on canvas,
73 × 92 cm
Private collection

This composition, a
true masterpiece of
Monet's art, draws its
force from the contrast
between the trees in
the immediate fore-
ground and the seaside
in the background.
The trees appear in
shadow, with dark,
opaque colors used to
draw in the sinuous
lines of the branches
and the compact
masses of the leaves.
Behind the trees
opens the sea, with
its gilt reflections,
then the hills and the
sky, created with pale,
almost evanescent
colors to create the
sense of a fantastic
vision or a dream
seen with open eyes.
Monet's use of small
brushstrokes of pure
color indicates his
close awareness of
the research into
chromatics of
Pointillism.

CLAUDE MONET
Boating on the Epte
1887, oil on canvas,
133 × 145 cm
Museu de Arte,
São Paulo

This is one of five paintings of girls in boats that Monet makes in the area of Giverny during the summer of 1887. Its delicate tones and visual poetry, sweet but at the same time melancholy, lead critics to compare it to the poetry of Mallarmé or the musical compositions of Debussy. The water of the river, tinted blue, green, and violet by reflections of the plants, is crossed by the narrow, graceful boat, its long oars skillfully handled by one girl while her companion watches attentively.

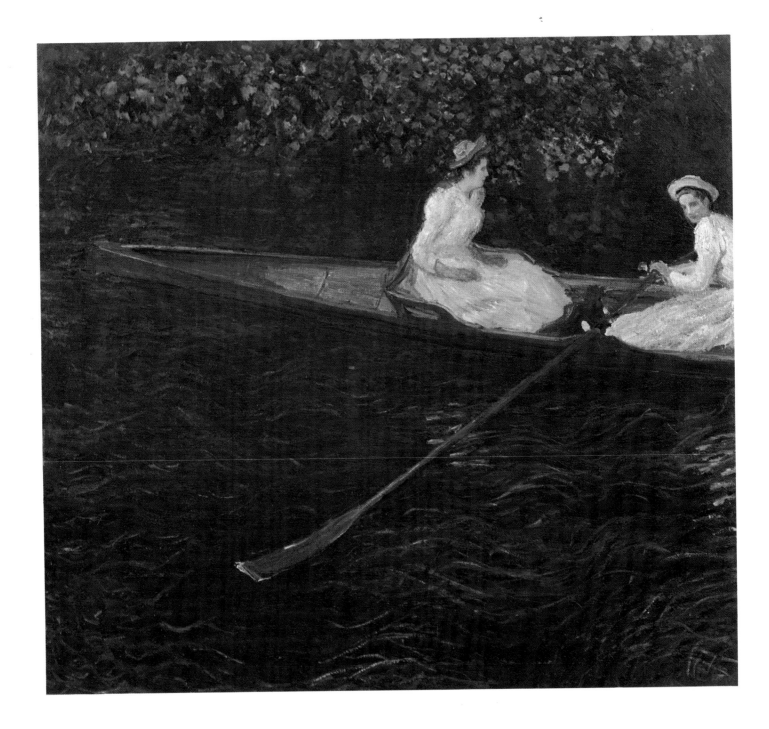

The shows in America and the universal exhibition in Paris

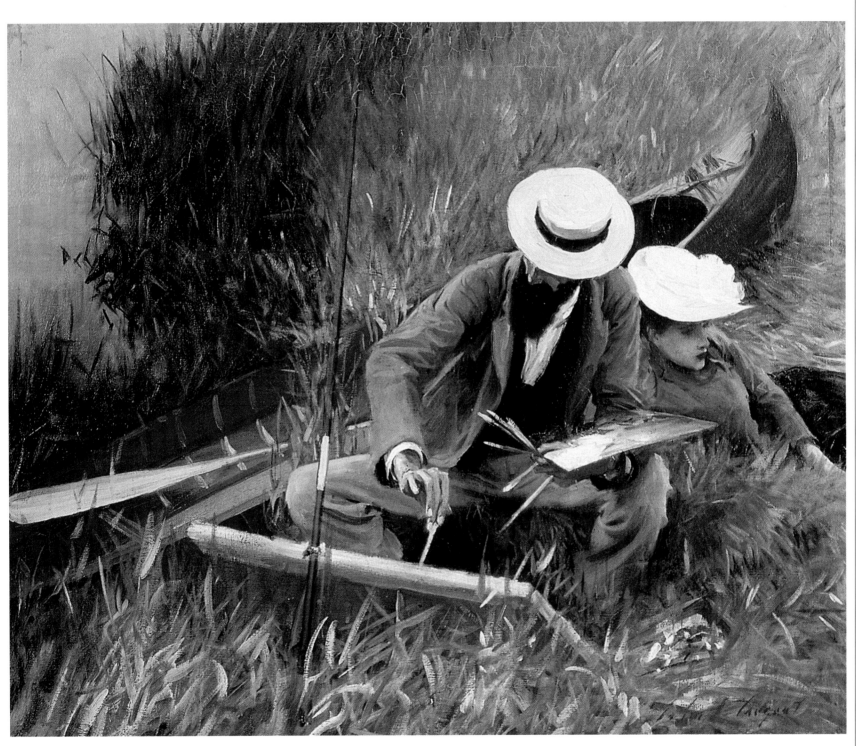

■ JOHN SINGER
SARGENT
**Paul Helleu Painting
with His Wife**
1889, oil on canvas,
Brooklyn Museum of
Art, Brooklyn

The French painter and
engraver Paul César
Helleu has been a
friend of Sargent's
since 1876, when they
frequented Paul
Durand-Ruel's gallery
together with Monet.
The canvas is made in
the summer of 1889
when the Helleu cou-
ple visit the American
artist in Great Britain.
The scene is set on
the banks of the Avon
River near Fladbury
in Worcestershire.
The painting, very
close in style to the
Impressionists, pre-
sents the husband and
wife immersed in tall
grass: the husband's
intense concentration,
absorbed in his paint-
ing, contrasts with
the relaxed, slightly
bored attitude of
the wife.

EDGAR DEGAS
**Woman Combing
Her Hair**
circa 1886–88, pastel
on paper applied to
cardboard,
70.5 × 58.5 cm
Private collection

This work makes an
immediate reference
to the *Valpinçon
Bather* by Ingres,
today in the Louvre,
which Degas had
copied several years
earlier, when it was
still in the collection
of Edouard Valpinçon,
father of his friend
Paul. There are notable
stylistic differences
between the two
works, most of all in
the application of the
colors and the overall
illumination of the
scene: clearly defined
and highly detailed in
Ingres, more fluid and
indefinite in Degas.
The effect is also a
result of Degas's use
of pastels, which give
a softer effect than
oil paint.

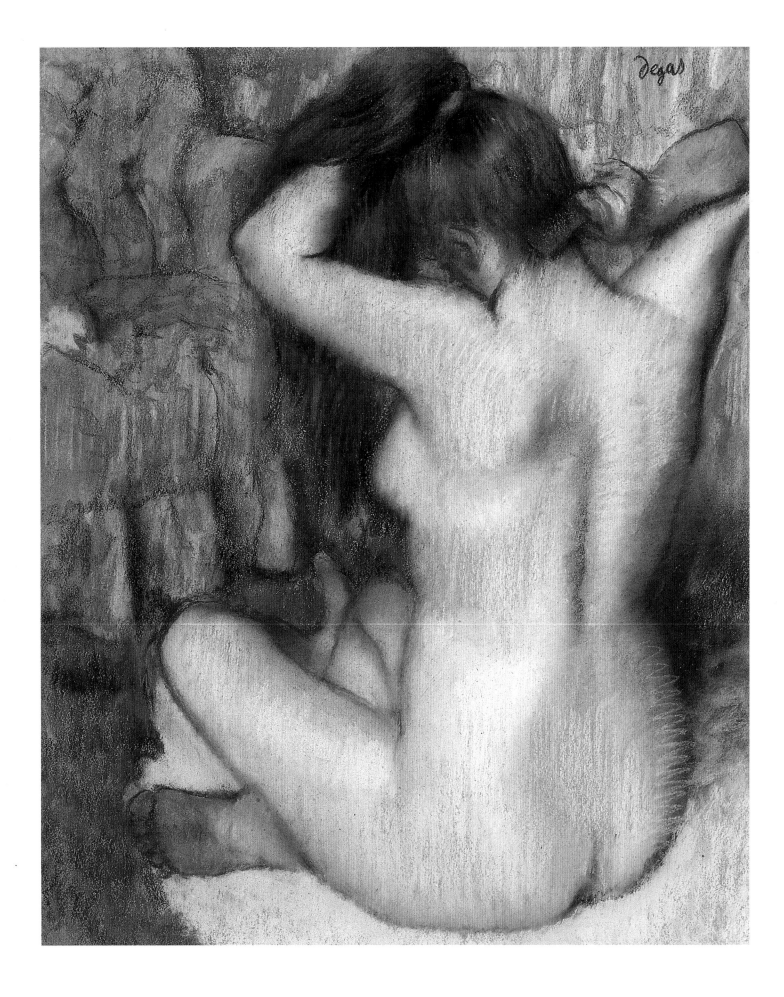

The shows in America and the universal exhibition in Paris

■ FEDERICO ZANDOMENEGHI
The Two Bouquets
1888–89, oil
on canvas,
65 × 73 cm
Private collection

After studying in Venice and Florence, Zandomeneghi moves to France in June 1874. He meets the Impressionists and participates in four of their eight shows, receiving much praise from critics. His studio in Paris is in the same building as those of Toulouse-Lautrec and Renoir, for whom he acts as witness at his marriage to Aline Charigot on April 14, 1890. The center of attention in this painting is the flowers the women hold in their hands. The artist also stresses the chromatic contrasts between the dresses, one pink, the other blue, making them stand out against the green bench.

PAUL CÉZANNE
**Bridge over the
Marne at Créteil**
1888, oil on canvas,
71 × 90 cm
Pushkin State Museum
of Fine Arts, Moscow

Between 1888 and
1890 Cézanne often
paints in the open
air along the banks
of the Marne River,
making fifteen or so
oil paintings of river
views with trees. His
primary interest in
these works is the
reflections of the
plants and sky in the
water. In doing so he
varies the gradations
of the greens and
lightens his brush-
strokes, most of
all when trying to
increase the sense of
transparency or when
rendering the change-
able distribution of
light. At the same
time he is constantly
further simplifying his
line, which almost dis-
appears as he flattens
volumes, anticipating
the later works of
abstract art.

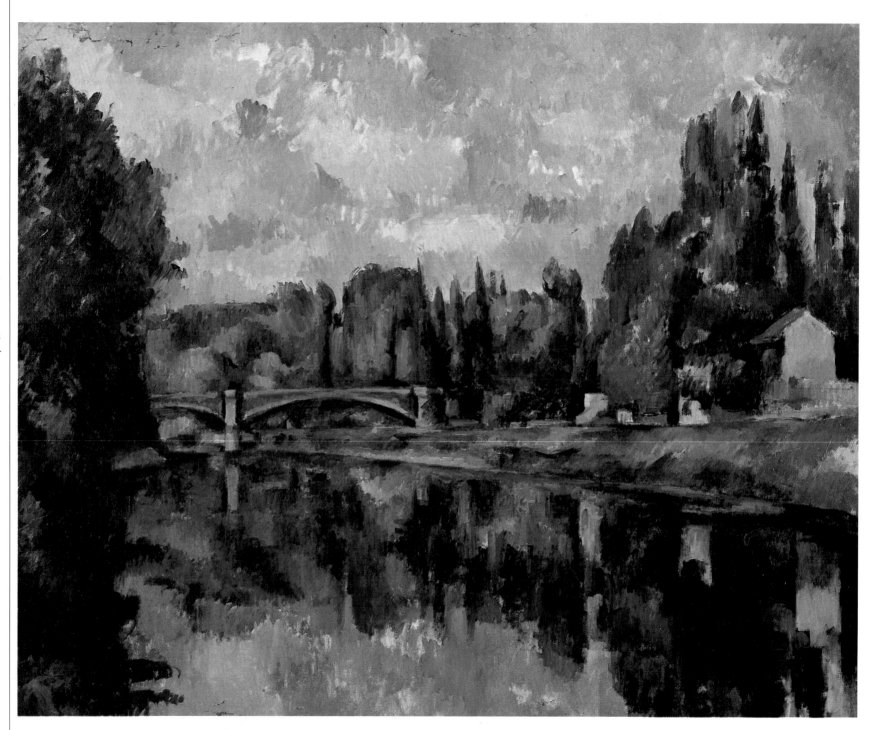

The shows in America and the universal exhibition in Paris

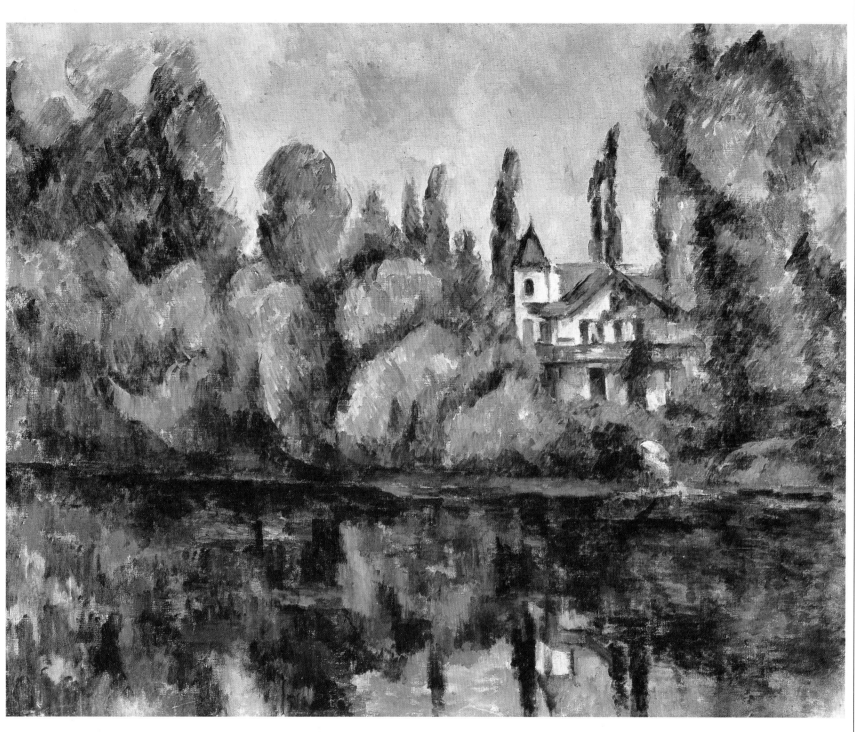

PAUL CÉZANNE
**The Banks of
the Marne**
circa 1888,
oil on canvas,
65 × 81 cm
The Hermitage,
St. Petersburg

As in the painting on the opposite page, here again Cézanne divides the composition into three distinct areas. The sky, with a slight veil of clouds, is touched by violet reflections. The tree-lined banks of the river are without depth, and the dense growth almost completely hides the large white house. The painter's attention is concentrated on the third and last area, the surface of the river, where he makes an obvious effort to render both the transparencies of the water and its slow-moving current.

The shows in America and the universal exhibition in Paris

PAUL CÉZANNE
**Sugarbowl, Pitcher,
and Plate with Fruit**
1888–90, oil
on canvas,
61 × 90 cm
The Hermitage,
St. Petersburg

This painting represents an important and significant step in the still lifes of Cézanne, a genre that he turns to many times in the course of his career. The arrangement of the objects is traditional; in a certain sense, it can be said to repeat the classic style established by Flemish still lifes. The treatment, however, is extremely modern and innovative, so much so that in the decades to come it will influence a great many artists who will endeavor to imitate its extremely efficacious use of color and most of all to give their compositions the same rarefied and meditative atmosphere.

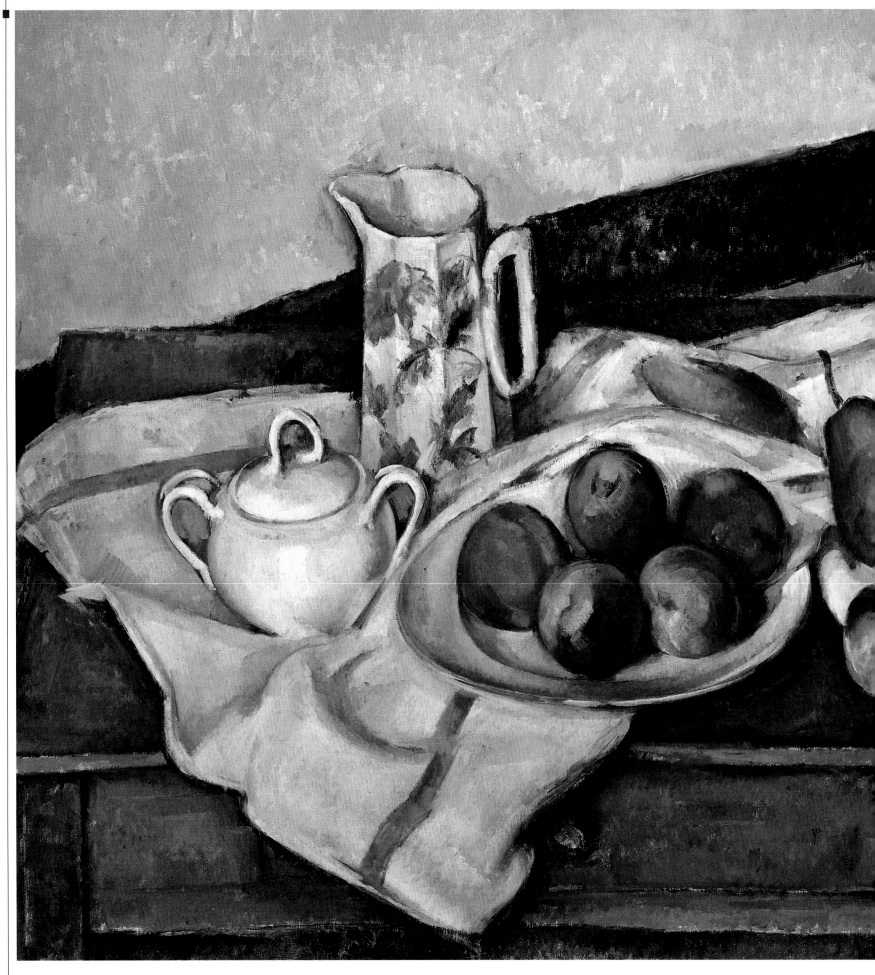

The shows in America and the universal exhibition in Paris

■ PAUL CÉZANNE
Plate with Fruit and Terracotta Vase
1888–89, oil
on canvas,
46 × 55 cm
Courtauld Institute
Galleries, London

In this still life one also notes the very purposeful arrangement of the objects paired with the controlled application of light. The colors, pale and intense, their tones muted and mellow, are without sharp contrasts, and there is no trace of excessive shading. The design is barely indicated, so as to keep to a minimum the volumetric solidity of the objects, which instead seem to be flattened against the background. These explorations of the possibilities of creating a new pictorial space, a space different from that of reality, will constitute a starting point for the experiments of Cubist painters.

PAUL CÉZANNE
Mardi Gras
1888, oil on canvas,
Pushkin State Museum
of Fine Arts, Moscow

For the figure of
Harlequin (on the
right) Cézanne uses
his son Paul as model;
Louis Guillaume poses
in the loose white
outfit of Pierrot. This
composition is unique
in the artist's pro-
duction, and on its
appearance many crit-
ics see it as an alle-
gory in which Cézanne
presents himself
together with Emile
Zola as characters in
the commedia dell'
arte. The publication
of Zola's novel *The
Masterpiece* ends all
contact between the
two men, but it is
not able to erase com-
pletely so many years
of true friendship.

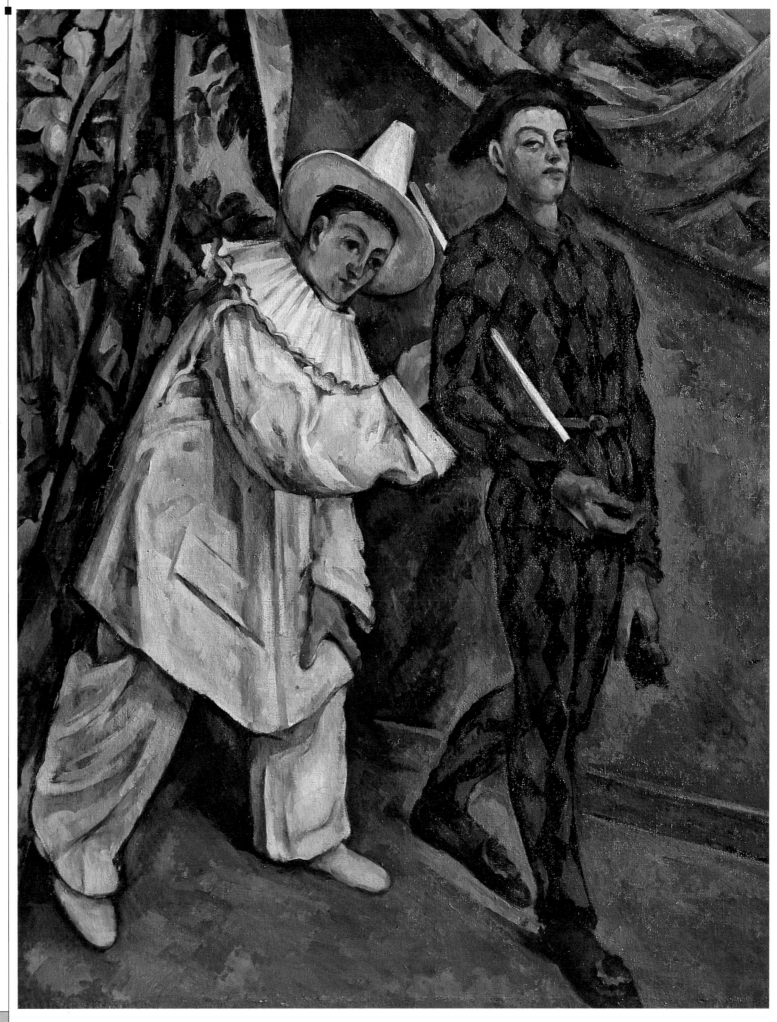

The shows in America and the universal exhibition in Paris

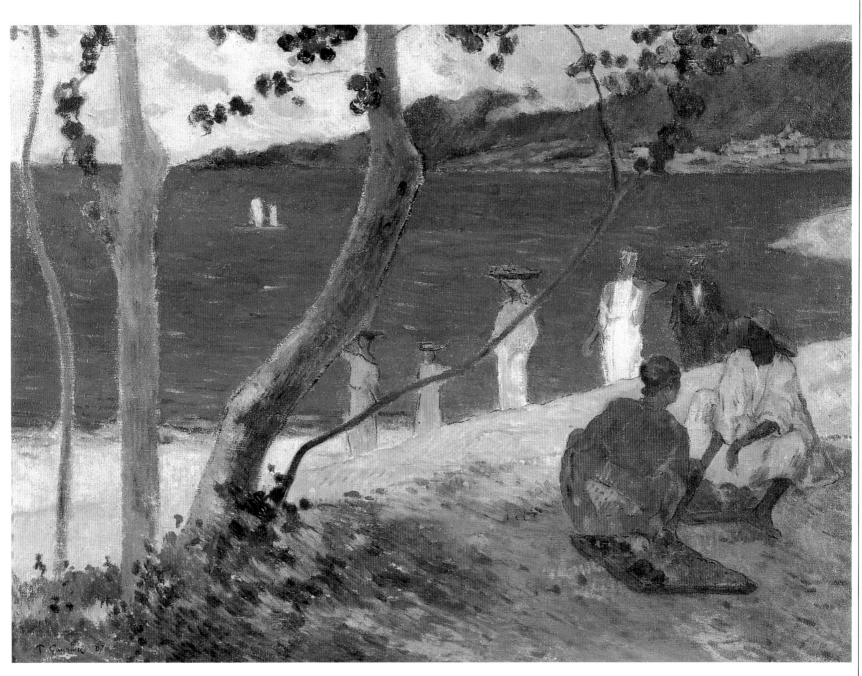

■ PAUL GAUGUIN
**On the Coast
of the Sea, II**
1887, oil on canvas,
46 × 61 cm
Private collection

On April 30, 1887,
Paul Gauguin and
Charles Laval leave
for Taboga, an island
in the gulf of Panama.
Unfortunately, Laval
falls ill with malaria,
and Gauguin, left
without money, is
forced to find work
as a digger in the
Panama Canal to get
by. In the first week
of June the two
friends move to the
nearby island of
Martinique, where
they make several
landscapes, including
this one, in which the
style of the Impres-
sionists blends with
elements from the
local culture. In the
month of July, Gau-
guin too falls victim
to malaria and in
November must
return to France.

PAUL GAUGUIN
Breton Girls Dancing
1888, oil on canvas,
71.4 × 92.8 cm
National Gallery of
Art, Washington, D.C.

Gauguin spends the last months of 1887 in Paris, the guest of his friend Schuffenecker. Here he meets Vincent van Gogh and his brother Theo, director of the Boussod & Valadon gallery. Thanks to Theo, he is able to sell several of the canvases he made on Martinique. On January 26, 1888, Gauguin leaves for his second stay at Pont-Aven. The bell tower and several houses of that Breton village are visible in the background of this painting. The elegant compositional rhythm of the three girls in the foreground demonstrates how well the artist has learned and assimilated the methods of the Impressionists.

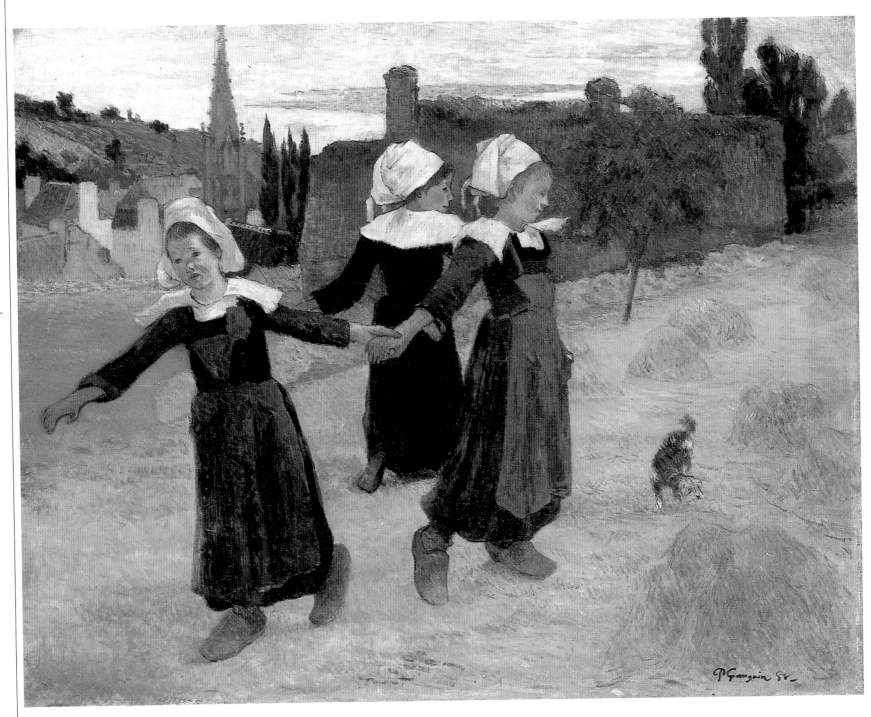

The shows in America and the universal exhibition in Paris

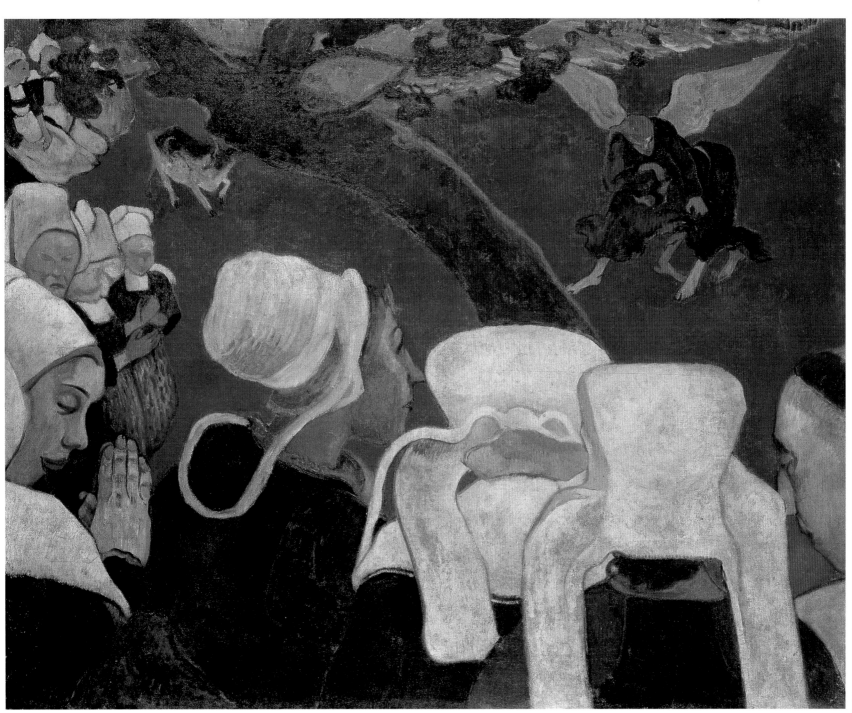

■ PAUL GAUGUIN
The Vision after the Sermon (Jacob Wrestling with the Angel)
1888, oil on canvas, 73 × 92 cm
National Gallery of Scotland, Edinburgh

This work marks a fundamental change in Gauguin's art, which gradually moves away from Impressionism to approach Synthetism and Symbolism. In this work, in fact, what is real exists side by side with the imaginary, as the biblical episode of Jacob's struggle with the angel is given the same solidity as the group of the faithful in prayer. Many aspects of this work show the use of ideas drawn from Japanese prints; there is first of all the position of Jacob and the angel, which repeats a composition by Hokusai; there are then the elevated point of view, the elimination of perspective, and finally the use of colors of a brightness not found in reality.

PAUL GAUGUIN
Self-Portrait
1888, oil on canvas,
45 × 55 cm
Rijksmuseum Vincent
van Gogh, Amsterdam

Gauguin makes this
painting to please
Vincent van Gogh,
who has often asked
him to send him a
self-portrait. As can
be seen in the dedi-
cation at lower right,
Gauguin takes his
inspiration from Victor
Hugo's description of
Jean Valjean, protago-
nist of his novel *Les
Misérables*, with whom
Gauguin identifies
since he too feels
persecuted by society.
At the upper right the
painter adds a portrait
of Emile Bernard—and
Bernard in turn sends
Van Gogh a self-por-
trait, the background
of which includes a
portrait of Gauguin.

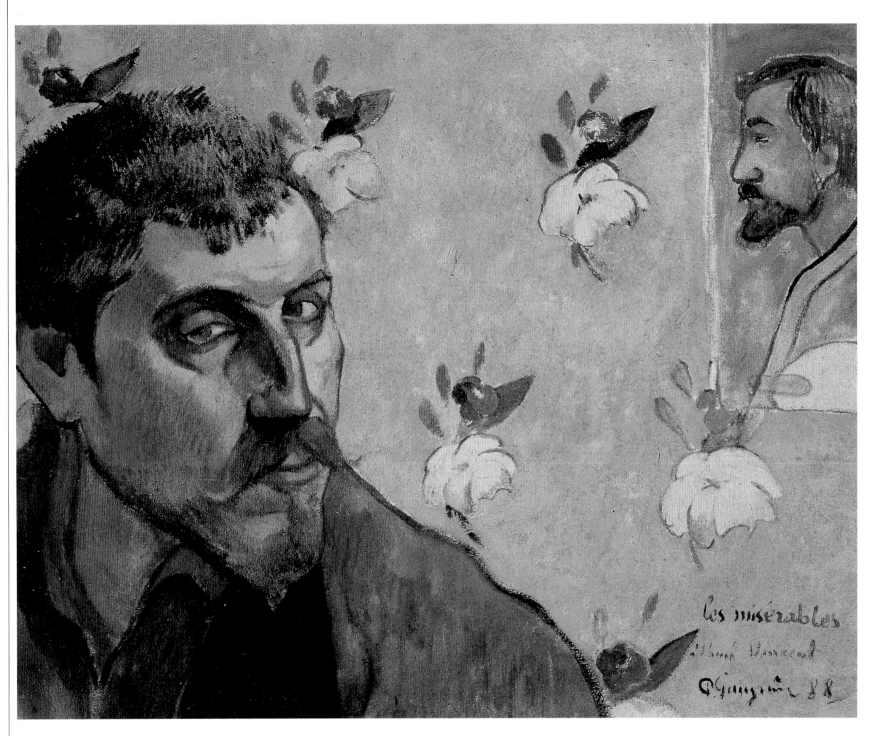

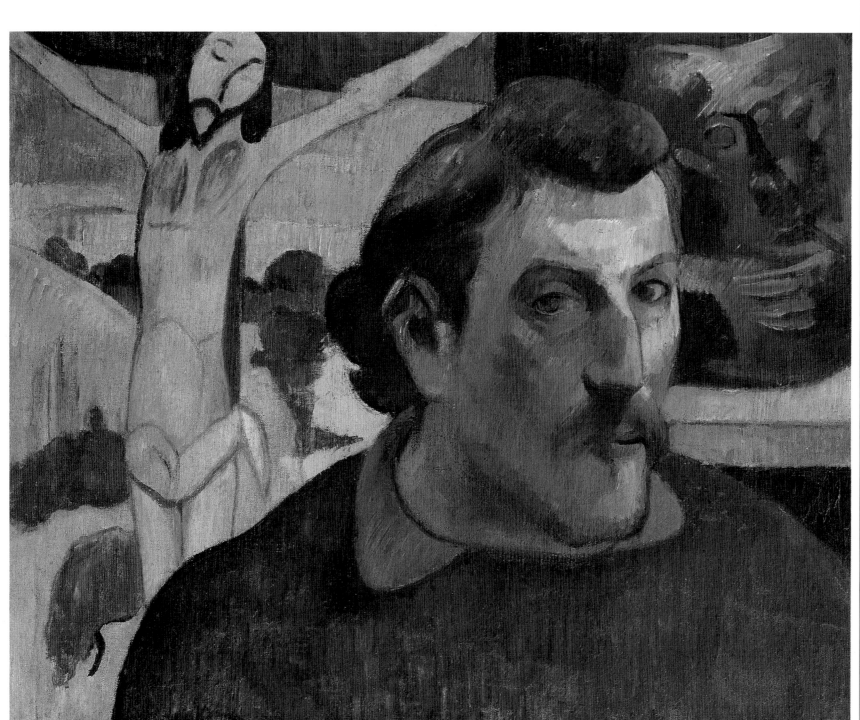

■ PAUL GAUGUIN
**Self-Portrait
with Yellow Christ**
1889–90, oil
on canvas,
38 × 46 cm
Private collection

Gauguin presents him-
self between two works
he makes in those
years, works of which
he is very proud and
that represent his
duplicate nature, part
spiritual, part savage.
To the left is *The
Yellow Christ*, inspired
by a wooden crucifix
displayed in the chapel
at Le Trémalo, near
Pont-Aven. Here it is
reversed because it is
reflected in a mirror.
To the right is his
*Self-Portrait Jug in the
Form of a Grotesque
Head*, a stoneware jug
he makes as a gift for
Madeleine Bernard,
with whom he is in
love; but she, prefer-
ring Charles Laval,
refuses it.

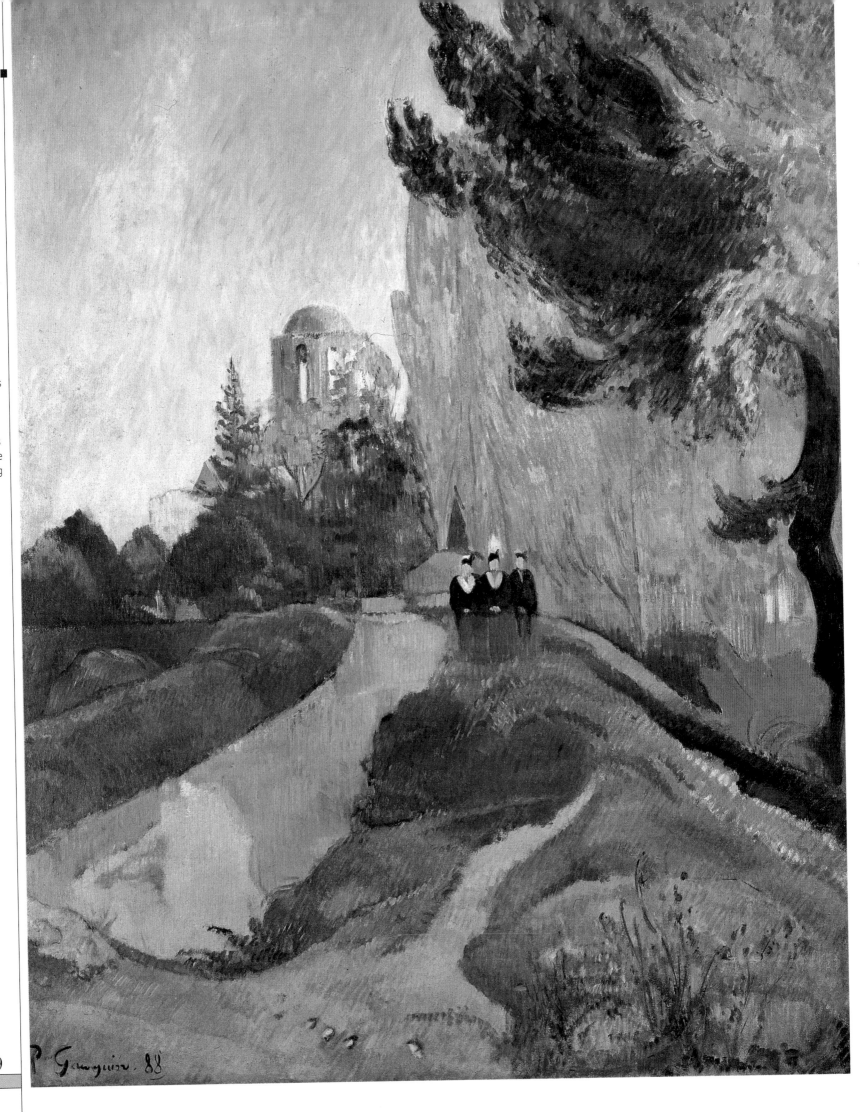

PAUL GAUGUIN
Les Alyscamps
1888, oil on canvas,
92 × 73 cm
Musée d'Orsay, Paris

On October 23, 1888,
Gauguin joins Vincent
van Gogh at Arles, in
Provence. For nine
weeks the two painters
live and work together,
each making about
twenty paintings. One
of their favorite places
is the Christian necrop-
olis of Alyscamps,
where Gauguin makes
two paintings. In the
first of these, with a
horizontal layout, he
presents the sepulchers
along the tree-lined
avenue. In this can-
vas, with its vertical
arrangement, he gives
space to the landscape
and the plants, leaving
the background for
three women and
the dome of the
Romanesque church
of Saint-Honorat.

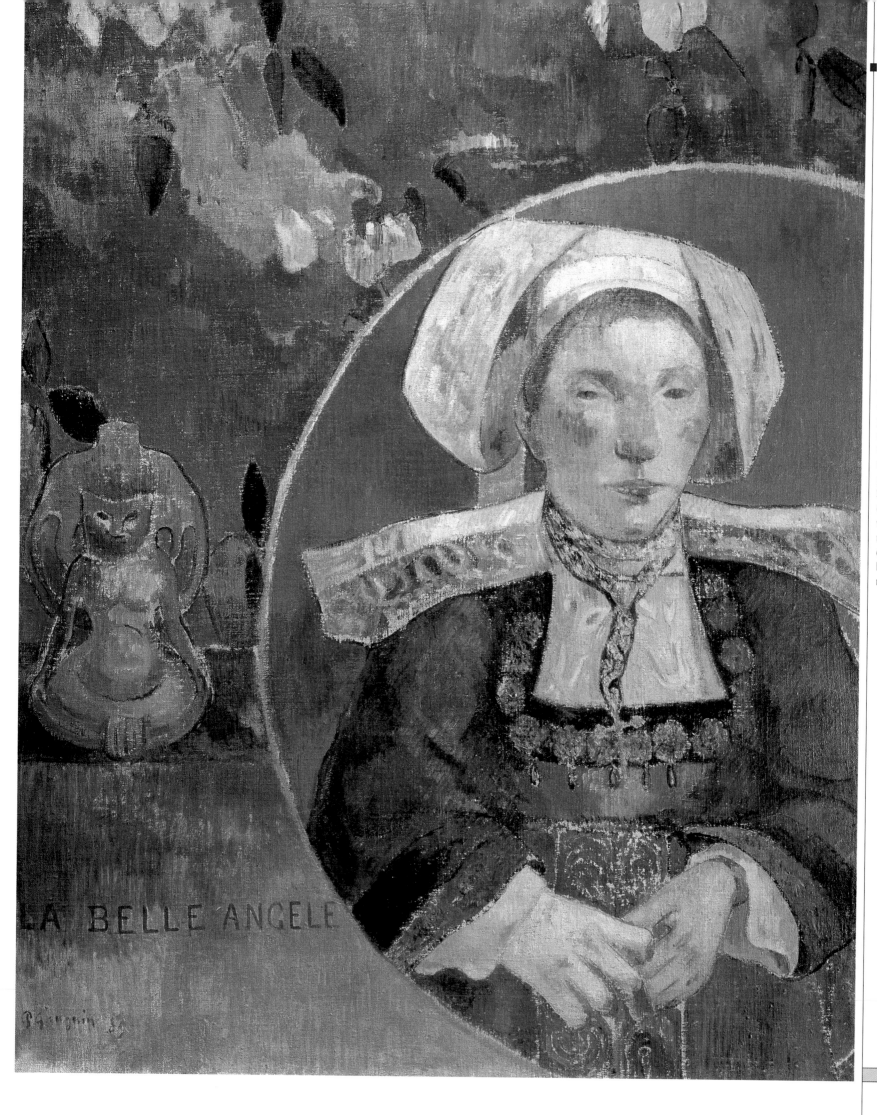

LA BELLE ANGELE

Gauguin 89

Here Gauguin overturns the traditional format of the portrait, locating the figure of the subject in a tondo-icon cut off from the rest of the painting, which has a blue background decorated with stylized flowers, and in which he places one of his ceramic vases in the shape of a primitive idol. Completely satisfied with the result, the painter claims that "no portrait was ever as well done as this." Quite different is the opinion of the woman portrayed, Angélique Satre, wife of a leading citizen of Pont-Aven, who indignantly refuses the painting, convinced it makes her look ugly and ridiculous.

PAUL GAUGUIN
**Self-Portrait
with Halo**
1889, oil on panel,
79.6 × 51.7 cm
National Gallery of
Art, Washington, D.C.

In February of 1889 Gauguin returns for the third time to Pont-Aven; at the end of June, together with Paul Sérusier, he moves to the nearby village of Le Pouldu. The two painters take rooms in the hotel Destais, then move to the Buvette de la Plage, owned by Marie Henry, where they are joined by the Dutchman Meyer de Haan and other painters. With its bright, intense colors, this panel is a companion piece to a self-portrait by De Haan, both works part of a group of paintings and frescoes with which the two artists decorate the dining room of the inn where they're staying.

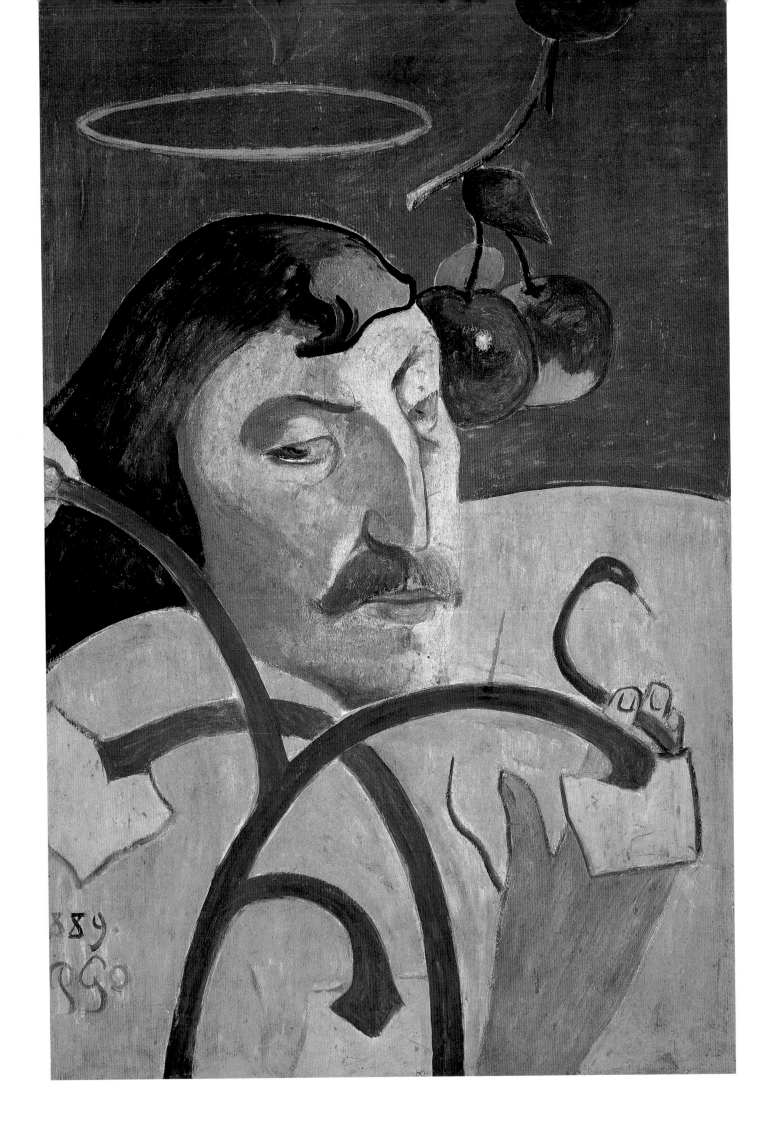

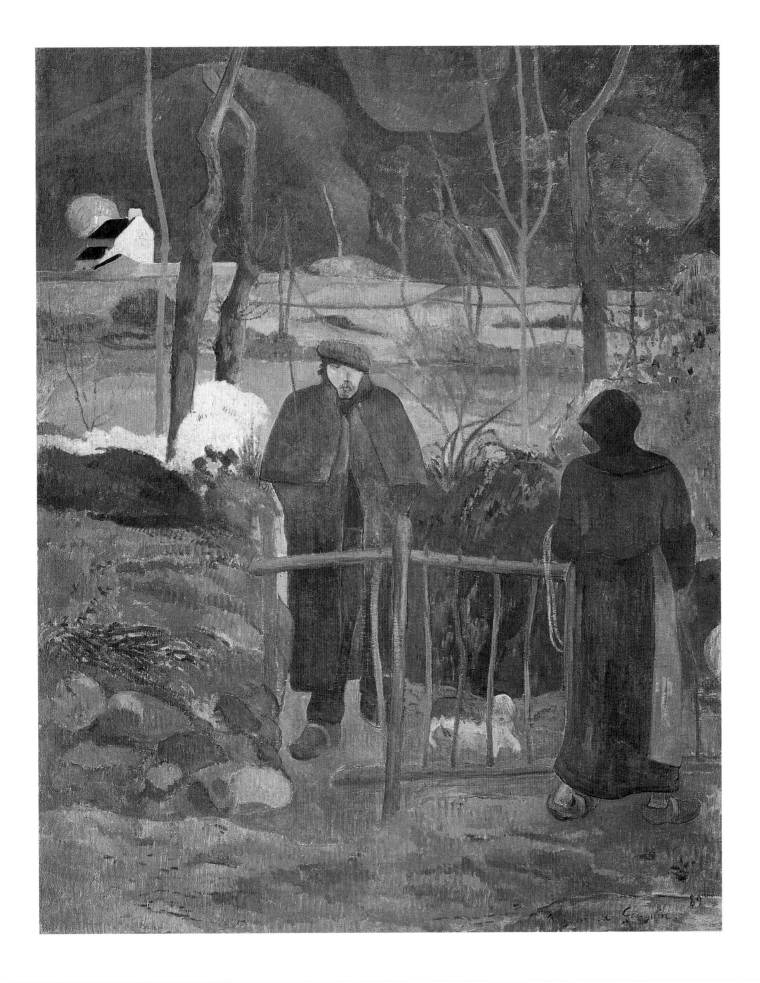

■ PAUL GAUGUIN
**Bonjour,
Monsieur Gauguin**
1889, oil on canvas,
113 × 92 cm
Národní Gallery,
Prague

The title is taken from
a painting by Gustave
Courbet, *Bonjour,
Monsieur Courbet*,
that Gauguin sees at
the Fabre Museum in
Montpelier together
with Vincent van
Gogh. Gauguin, who
loves to present him-
self as a rebellious
nonconformist, iden-
tifies with the role
of the gifted but anti-
social artist and with
the character of Jean
Valjean, the hero of
Hugo's *Les Misérables*.
The canvas, part of
the decoration of the
dining room of the inn
run by Marie Henry at
Le Pouldu, is admired
by the twenty-year-
old André Gide during
a stay in Brittany.

GEORGES SEURAT
Young Woman Powdering Herself
1888–89, oil on canvas, 94.2 × 79.5 cm
Courtauld Institute Galleries, London

The subject of this painting is Madeleine Knoblock, a twenty-year-old model the artist meets on his return from a trip to Belgium and with whom he lives the last two years of his short life. He originally places a self-portrait at the top left of the canvas, but changes his mind and paints it over with a vase of flowers on a table. The woman, her deep neckline revealing her abundant chest, is presented with cold realism in a moment of intimacy, seated at a small makeup table, busy powdering herself, her air both serious and dignified.

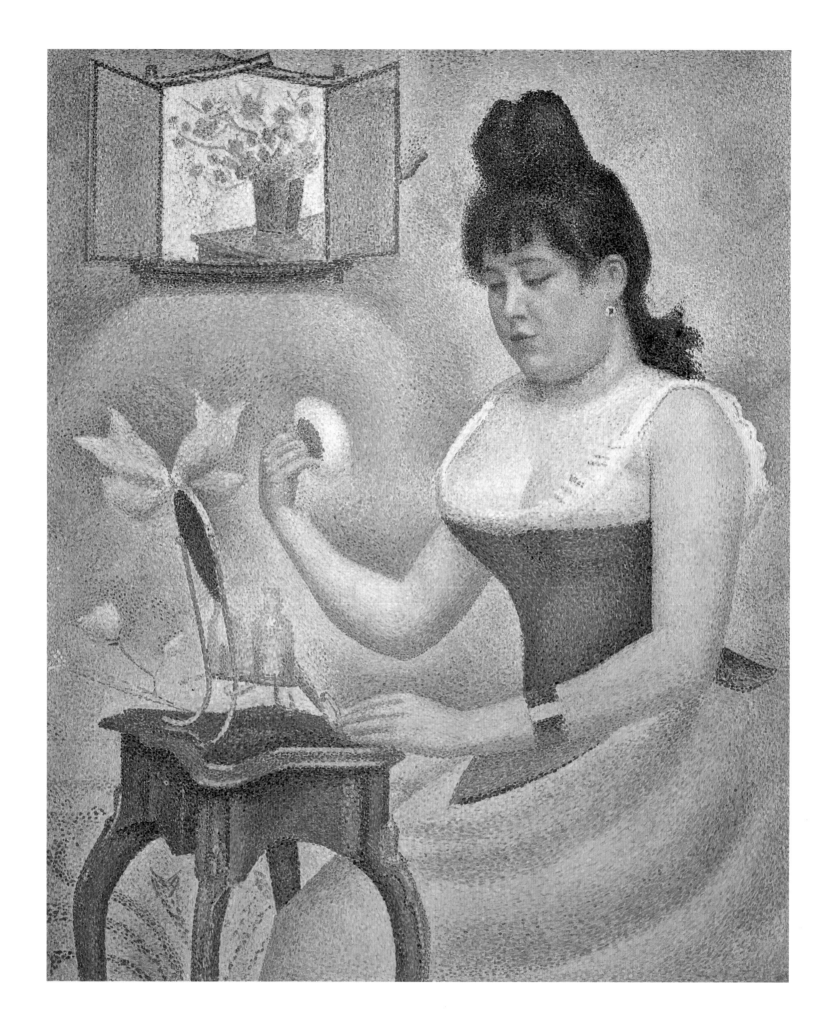

The shows in America and the universal exhibition in Paris

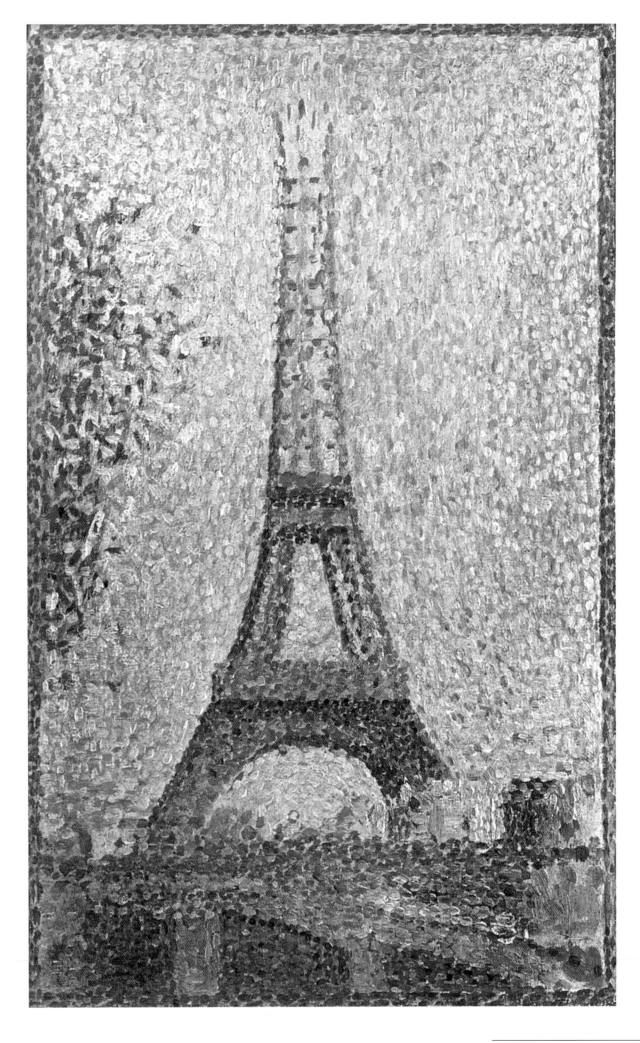

■ GEORGES SEURAT
The Eiffel Tower
1889, oil on panel,
24 × 15.2 cm
Private collection

Heedless of the
ferocious disputes
surrounding the con-
struction of the Eiffel
Tower, erected for the
universal exhibition in
Paris, Seurat takes it
immediately as the
symbol of the capital.
Far from being offend-
ed by the iridescent
reflections caused by
the sun on its iron
structure, he instead
notes a certain resem-
blance to some of his
paintings. He decides
to present the tower
in a painting, as seen
from the Jena bridge,
because he sees it
as an application to
architecture of the
same geometric sim-
plifications he has
spent the last several
years applying to
painting.

CAMILLE PISSARRO
Shepherdess
1887, watercolor
on paper,
Private collection

In the 1880s Pissarro
dedicates much of his
effort to the world
of peasants and their
work in the fields, a
decision placing him
in open contrast with
the comfortable city
life of Parisians. The
use of watercolors
permits him to give
greater luminosity
and transparency to
the colors. Pissarro
often declares his
admiration for and
indebtedness to
Jean-François Millet,
creator of many
paintings celebrating
the life of peasants.
The works of Pissarro,
in turn, serve as the
source of inspiration
for Gauguin, as when
the portrays the
Breton peasants
in Pont-Aven.

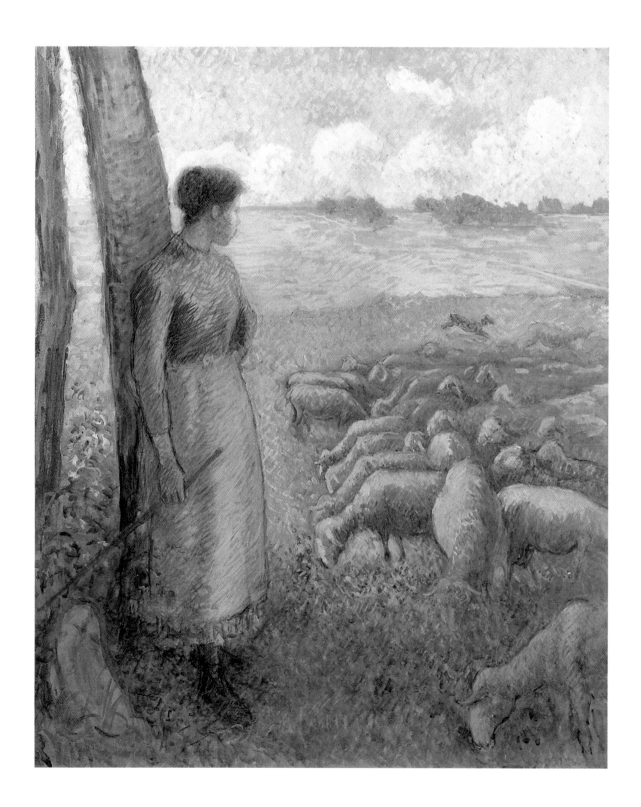

The shows in America and the universal exhibition in Paris

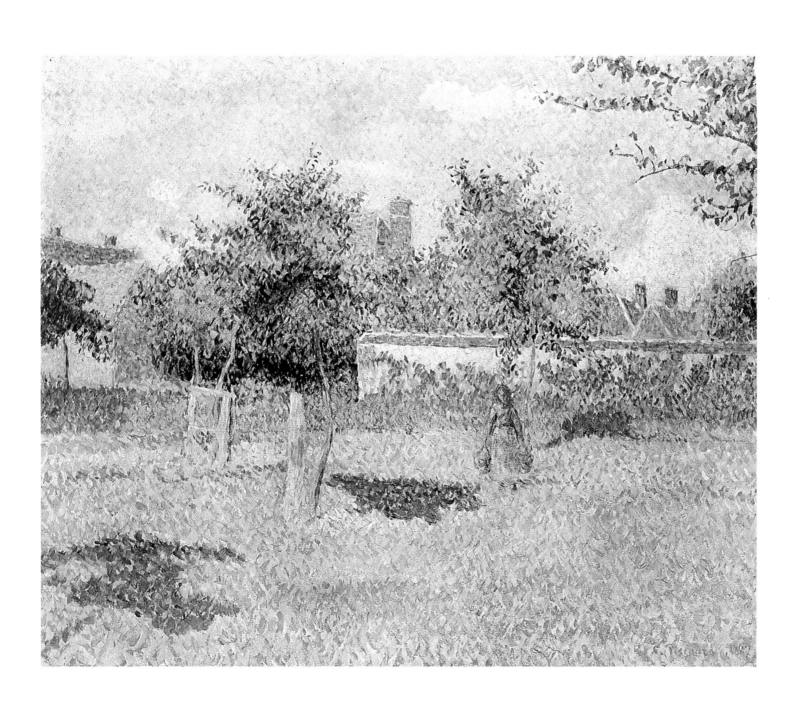

■ CAMILLE PISSARRO
**Woman in a
Meadow, Spring,
Eragny-sur-Epte**
1888, oil on canvas,
Musée d'Orsay, Paris

In 1884 Pissarro
moves from Pontoise
to Eragny-sur-Epte.
A year later he meets
Signac and Seurat,
who introduce him
to the technique of
Pointillism. So taken
is he with the new
method that he adopts
it in his own composi-
tions. As can be seen
in this canvas, he
breaks down the pic-
torial space and fills
it with small colored
points, thereby obtain-
ing a more lively and
intense luminosity,
clearly indicated by
the dark shadows of
the trees. The human
figure is pushed
aside, almost flat-
tened against the
background, so that
greater importance
can be given the
plants.

Vincent van Gogh has not participated in any of the eight Impressionist exhibitions and has had little to do with them; yet their painting is intimately tied to his extraordinary artistic and human story. Vincent Willem van Gogh is born March 30, 1853, in Groot Zundert in the Dutch Brabant, not far from the Belgian border. His parents are Anna Cornelia Carbentus (1819–1907) and Theodorus van Gogh (1822–85), at the time a minister in the Dutch Reformed church. In 1855 his sister Anna is born; on the first of May 1857 his brother Theo, followed by Elizabeth (1859), Wilhelmine (1862), and Cornelius (1867). Vincent attends the local Zundert school for one year, then takes lessons in his parents' home before being sent to the private school of Jan Provily at Zevenbergen, where he studies from 1864 to 1866. He spends the next two years, up to March 1868, at the Rijks Hoogere Burgerschool Willems II at Tolburg. At the end of that period, because of his poor performance and also because of the family's precarious financial situation, his parents decide to send him to serve as an apprentice with his uncle, Cent, who works in the art market and who since 1858 has been associated with the famous Parisian art house of Goupil & Cie. Vincent is first sent to the branch office in the Hague, where he is put to work selling reproductions of artworks. Then he is sent to London. In London he falls in love with Eugenia Loyer, daughter of Ursula, the owner of the boardinghouse where he's staying. She rejects him, the first of a long series of emotional disappointments. In May 1875 he asks to be transferred to

Paris, but his emotional depression is having a negative influence on his work, and on April 1, 1876, he is fired. He finds work in a bookstore in Dordrecht, then decides to follow his father's career and become a minister in Belgium, but again he fails. The council of the Protestant churches in Belgium recognizes his noble and generous spirit but feels he lacks the necessary oratory skills and is concerned about his impulsive temperament. He spends a few months wandering from town to town in Belgium, living in extreme poverty and persisting in his vain plans to become a minister. In the month of August 1880, Vincent decides to dedicate himself to painting and in October of that year he moves to Brussels and enrolls in the Académie des Beaux-Arts. In 1881 he moves to the Hague, opens an atelier, and takes lessons from a cousin, Anton Mauvre, a painter then held in high esteem. During the summer he falls in love with a cousin, Kate Vostricker, recently widowed with a child, but once again he is rejected. Rather than give up, Vincent insists, but his way of doing so

1853 • 1890

only brings further rejection. Desperate, he takes out his frustration on himself. In the fall of 1881 he goes to Amsterdam to meet her and implore her one more time. Faced with another sharp rejection, and perhaps trying to arouse her pity, he holds a hand over the flame of a candle, burning himself until he passes out. This is the first symptom of the serious psychological illness he will suffer from until his suicide. His anguished desire for affection leads him into a relationship with Clasina Maria Hoornick, known as Sien, a prostitute already the mother of one baby and pregnant once again, her face disfigured by smallpox, alcoholic, probably also infected with a venereal disease to which the painter himself falls victim, early in 1882. He portrays her in sixty-odd drawings and watercolors, works of an intense, heartfelt drama that testifies to his sincere feelings for her and to his

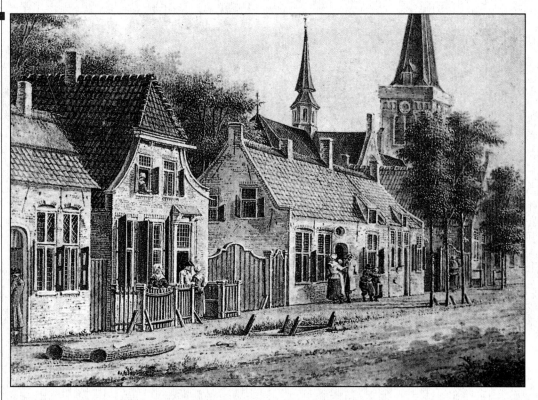

desire, at once romantic and utopian, to achieve her redemption. From September 11, 1883, to November 24, 1885, he returns to live with his parents in Nuenen near Eindhoven, where his father has become the minister of the local parish. Meanwhile his brother Theo has begun his apprenticeship in the art market with Goupil & Cie in the Hague; in 1879 he is transferred to Paris, where he becomes director of the branch gallery on Boulevard Montmartre. Thanks to his new position he can

how "water makes patches of a beautiful emerald and a rich blue in the landscapes. . . . The pale orange setting sun makes the land appear blue. . . . The costumes of the women are pretty, and especially on Sunday one sees on the boulevard very naive and well-found color arrangements." Refreshed in spirit, Vincent throws himself into his painting with renewed vigor and enthusiasm, helped financially by his brother Theo, who sends him—on account, against the sale of his paintings—two hundred and fifty francs a month, in addition to which he makes regular shipments of canvases and paints. Vincent works frequently outdoors, struggling against the wind, which knocks over his easel and blows sand onto his paints. The spring makes him even happier, multiplying the colors of the landscape while the warm Mediterranean sun increases his energy. Indeed, with its life force and creative energy the sun is the most important element in the

Vincent van Gogh

send Vincent money, and in exchange Vincent sends him his works, an arrangement that will continue until Vincent's death. In 1886, after a brief stay in Antwerp, Vincent joins his brother in Paris, living with him there for nearly two years. For a few months he attends the atelier of Fernand Cormon, where he meets Impressionist painters who have a notable influence on his pictorial style. On February 19, 1888, he goes to Arles, in the south of France, to study and work. In that exceptionally cold winter, with abundant snow, the artist is enthralled by the radiant atmosphere and clear sky of Provence, so very different from the oppressive iron-gray skies of the north. In a letter to Emile Bernard in March he confides his emotions at seeing

works Vincent makes in Arles; even when it is not present in the paintings, there is the sense in these works of its luminous power penetrating and vitalizing the colors, giving them strength and increasing their visual impact. More than in any other work, these effects are apparent in his *Sunflowers*, the solar flowers par excellence, which Van Gogh prefers above all others. These are weeks in which he loves to paint flowering orchards, fishing boats pulled up on the beach, the work of peasants in fields, or the Langlois bridge, which reminds him of the bridges of his youth in Holland or of those in the Japanese prints he buys in Père Tanguy's shop. Early in September he leaves the Carrel hotel and rents, at fifteen francs a month, an apartment with two

Theo van Gogh, four
years younger than
his brother Vincent.

rooms with two studios in the Place Lamartine, at the entry to the city. This is the famous Maison Jaune, the "Yellow House," where Vincent will make almost all his masterpieces. Meanwhile, despite his difficult and changeable character, he gets to know several inhabitants of the town, and they pose for him. Among these portraits are those of Madame Ginoux, owner of the Café de la Gare, the postman Joseph Roulin, and his wife.

On the morning of October 23, 1888, after exchanging a flood of letters with Vincent, Paul Gauguin, returning from a brief stay in Brittany, arrives in Arles. The two painters met in the fall of the preceding year, by way of Theo van Gogh. Both have recently experienced great disappointments, and their emotional states make them similar to a pair of shipwreck survivors, each seeking consolation and comfort in the other. By then Gauguin is definitely separated from his wife, who has gone to Copenhagen with their children. Vincent, rejected and humiliated in his attempts to be a preacher, has undertaken the career of painter; but despite the help of his brother he has yet to see any reward for his efforts and his dedication. Even so, during those months of shared financial hardship and solitude, the two artists mature their styles, and the nine weeks they spend together see the creation of many of their enduring masterpieces. Inevitably, having two such distinct individuals under the same roof—men so very different in terms of character and education, each so fiercely proud of his freedom and independence, each so intolerant of all rules and restrictions—proves difficult. No matter what they chance to talk about, whether meaningful or trivial, their discussions tend to drag on for entire days and often lead to violent arguments since neither of the two is willing to give in. Meanwhile Gauguin is

Right: One of the
many drawings Van
Gogh makes of his
prostitute friend
Clasina Maria Hoornik,
known as Sien.

champing at the bit; the anguished situation in Arles has him feeling like a lion in a cage and he can't wait to get away and take off in search of exotic adventures far from Europe. On December 23, in the course of an argument that is no more acrimonious than usual, Van Gogh comes at his friend with a knife in his hand. Gauguin, frightened, spends the night in a hotel in Arles, determined to set off for Paris as early as possible. Vincent, meanwhile, woefully aware that he has once again failed in a relationship with a fellow human, takes out his rage and his frustration on himself.

An item of "local news" appears in the December 30 edition of the *Forum Républicain*, an Arles weekly: "Last Sunday night, at half past eleven, a painter named Vincent van Gogh, a native of Holland, appeared at the *maison de tolérance* No. 1, asked for a girl called Rachel, and handed her his ear with these words: 'Keep this object carefully.' Then he disappeared. The police, informed of these happenings which could

He goes back to painting with renewed vigor and makes various landscapes and several portraits of a very high quality, works that rank among the best of his production.

It is impossible to know how his art would have matured had he lived longer. While in Paris he assimilated the art of the Impressionists, and in Arles he took long strides forward. Holding to symbolism and expressionism he overcame the naturalism of Millet and Pissarro. His colors, strong and bright, expressed his emotions, his state of mind. He completely overturned the use of pictorial space, freeing the line to achieve new balances and create new forms, no longer obliged to be faithful to reality, but capable of tracing the shapes of interior dimensions. Much of modern art is indebted to him, and even today he is seen as the example to follow.

Early in July 1890 Vincent is again in crisis. Both Theo and Gauguin decide not to spend the summer vacation with him, and Vincent senses

be attributed only to an unfortunate maniac, looked the next morning for the individual, whom they found in his bed with barely a sign of life."

Theo gets in touch with Gauguin, and the two of them spend a pair of days caring for Vincent; when it seems that he is out of danger, both of them return to Paris. The convalescence is long and difficult, with frequent relapses; in the month of March eighty of Vincent's neighbors sign a petition asking the mayor to have Vincent sent away to a psychiatric hospital. On May 8, Van Gogh voluntarily enters the Saint-Rémy-de-Provence nursing home, a private-care institute inside a former convent, twenty-five kilometers form Arles. He spends a year there. On May 16, 1890, he leaves the asylum and spends three days in Paris with Theo, who introduces him to his wife, Johanna Bonger, whom he wed on April 17 of the preceding year, and to his son, born January 31 and named in his honor Vincent Willem. At Pissarro's suggestion, Vincent moves to Auvers-sur-Oise, a small town on a tributary of the Seine, forty kilometers outside Paris. He stays in a room over a café run by the Ravoux family, of whom he makes several tormented portraits. He is in the care of Doctor Paul Gachet. Aside from being a doctor who has studied mental illnesses, Gachet is a lover of art, the friend of many artists, and himself a decent painter. He succeeds in winning over Vincent's trust and collaboration, and in fact Vincent shows reassuring signs of a physical and psychological recovery.

himself alone and abandoned. On July 27, while out in the fields where he usually goes to paint, he shoots himself with a pistol. Although seriously wounded he makes it back to his room, but he has lost too much blood and dies, at 1:30. A few months later, on January 25, Theo dies, perhaps heartbroken at not having done enough to save his brother.

VINCENT VAN GOGH
**Peasant Woman
(Portrait of
Gordina de Groot)**
1881, oil on panel,
47 × 34.5 cm
Private collection

When his brother asks
him for paintings,
Vincent turns to the
subjects at hand,
painting nearly fifty
portraits of the local
peasants, who agree
to pose for him. They
stop visiting his stu-
dio when Gordina de
Groot, the subject of
this painting, is found
to be pregnant and
the painter, perhaps
unjustly, is accused
of being responsible.
The artist does noth-
ing to embellish or
beautify the faces of
his models, preferring
to present them in
all their immediate
expressiveness. In
keeping with the style
of the Impressionists
the paint is applied in
bold, decisive strokes
that emphasize the
irregularities of the
nose and lips.

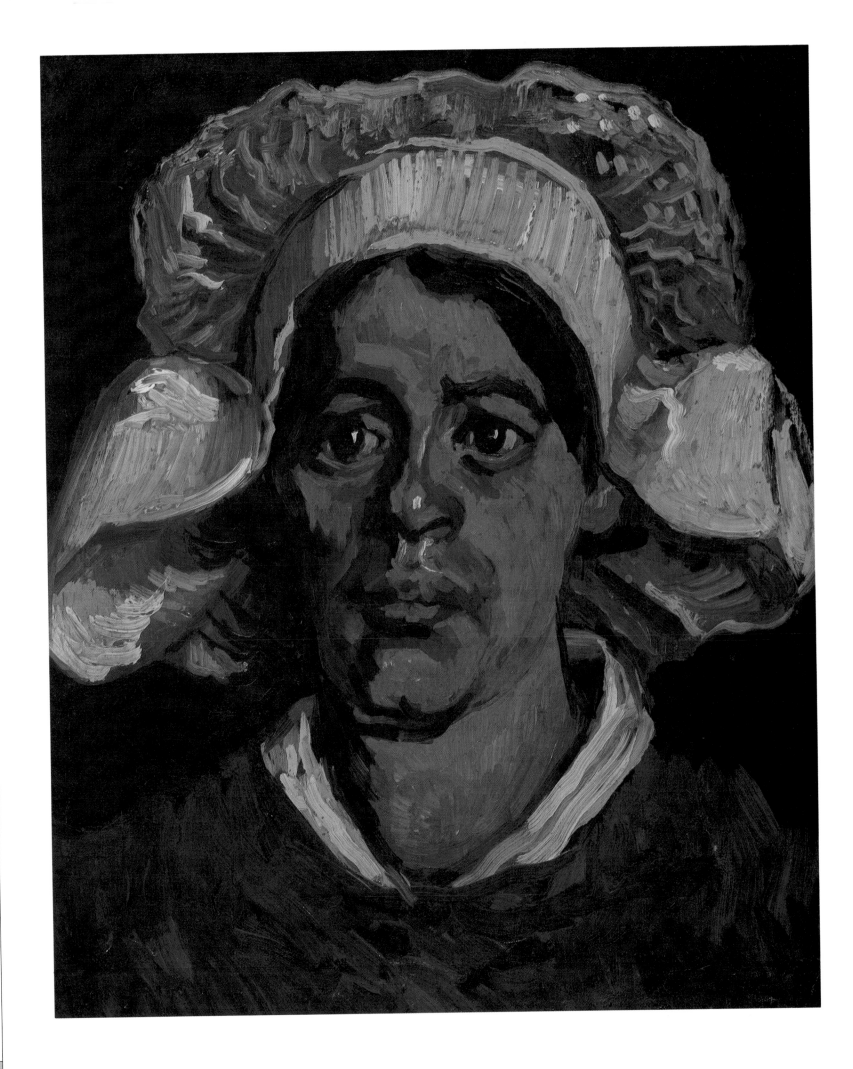

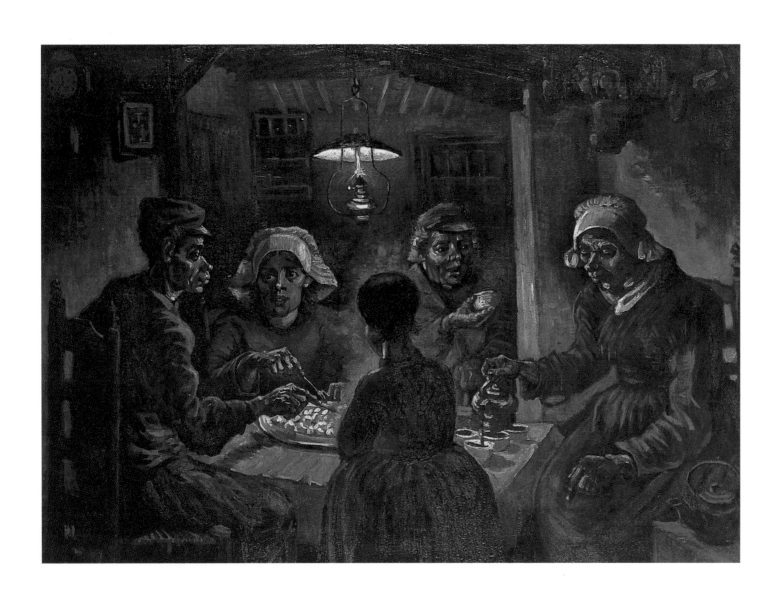

■ VINCENT VAN GOGH
The Potato Eaters
1885, oil on canvas,
81.5 × 114.5 cm
Rijksmuseum Vincent
van Gogh, Amsterdam

This is the most
important and sig-
nificant of the works
Vincent makes at
Nuenen. His original
plan, in which the
peasants would be
seated around a bowl,
involves only four fig-
ures, but his second
version, on which he
begins work a little
after the death of his
father, on March 26,
1885, presents five
peasants seated around
a table in the cramped
interior of their home.
The weak light from
the oil lamp illumi-
nates the faces and
amplifies their expres-
sions, making them
almost theatrical. In
April 1881 Vincent has
a lithograph of this
subject printed at
Eindhoven.

VINCENT VAN GOGH
**Allotments on
Montmartre**
1887, oil on canvas,
81 × 100 cm
Rijksmuseum Vincent
van Gogh, Amsterdam

In 1886 Vincent joins
his brother Theo in
Paris. At first they live
in Rue Laval, today
Rue Victor Massé, near
Pigalle. Soon they
move to 54, Rue Lepic,
near Montmartre.
The painter pays no
attention to the mon-
uments and palaces
in the capital city,
nor does he linger on
the streets crowded
with people, feeling
instead oppressed
and rejected by them.
Instead he paints the
landscapes he can see
from the window in
his apartment and
makes paintings of
various corners of
Montmartre, an area
of the city where
nature is slowly being
fenced in or replaced
by new buildings.

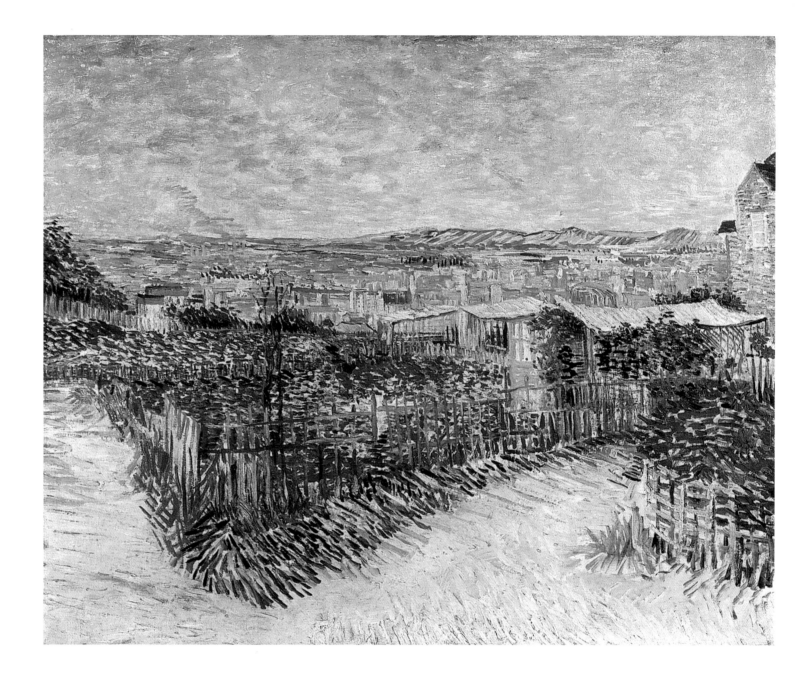

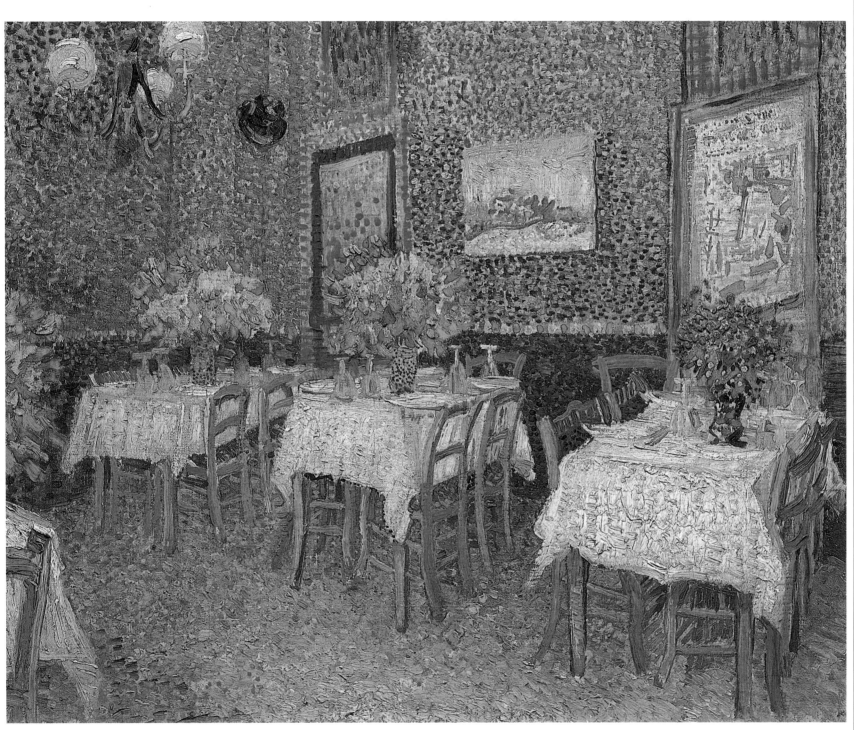

■ VINCENT VAN GOGH
Interior of a Restaurant
1887, oil on canvas,
45.5 × 56.5 cm
Rijksmuseum Kröller-Müller, Otterlo

When Van Gogh arrives in Paris at the end of 1886, echoes of the eighth Impressionist show can still be heard. Still the talk of the town are the works by Georges Seurat and Paul Signac, with their special technique known as Pointillism. Vincent too is struck by the way they break space down into tiny spots of pure color, and he adopts the technique in several paintings, including this restaurant interior, one of the best known and most faithful to the spirit of Pointillism. Compared to the period in Nuenen, his palette is paler and has acquired brighter chromatics.

VINCENT VAN GOGH
**Self-Portrait
with Felt Hat**
1887–99, oil
on canvas,
44 × 37.5 cm
Rijksmuseum Vincent
van Gogh, Amsterdam

Van Gogh's use of the
Pointillism of Seurat
and Signac lasts only
a few months. He is
not pleased with the
results, and after long,
intense discussions
with Signac himself,
he abandons the
technique, adopting
instead broader,
denser, almost parallel
brushstrokes, as in this
famous self-portrait.
The center of the work
is the eyes, acute and
penetrating; the brush-
strokes that form the
face spread outward
from the eyes, rein-
forced by touches of
green and red, almost
as though he were
trying to make clear
the passion in his
troubled soul. Similar
touches of lively color
continue in the back-
ground to form a kind
of halo around the
figure.

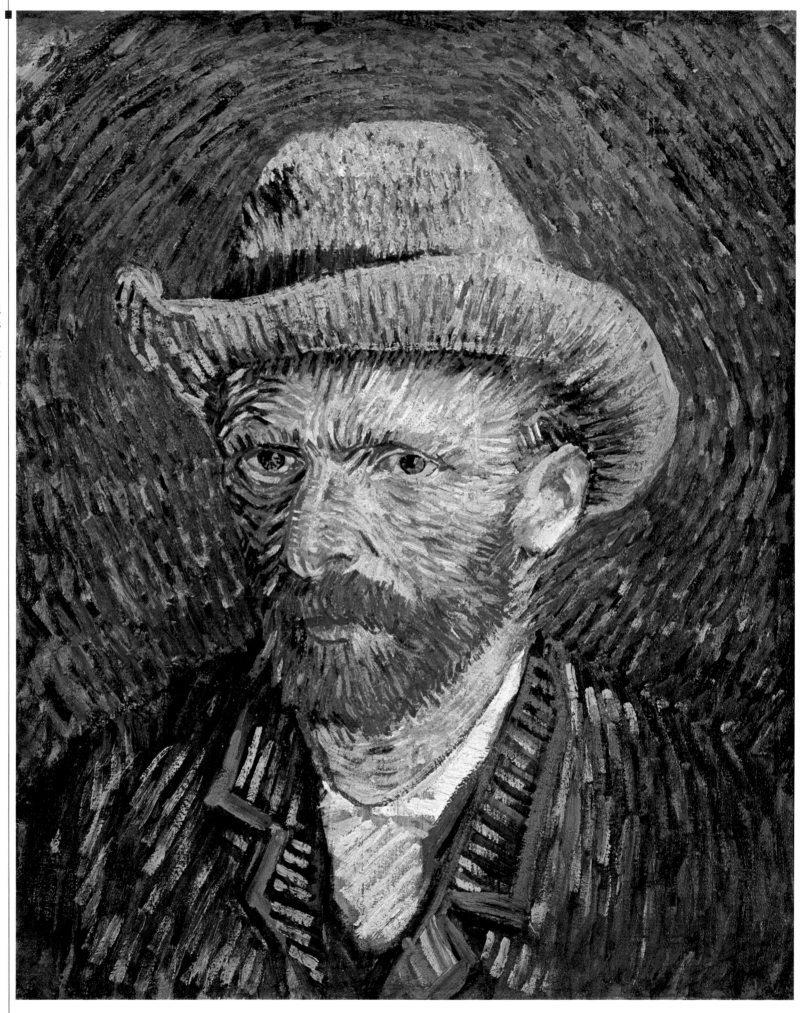

Vincent van Gogh

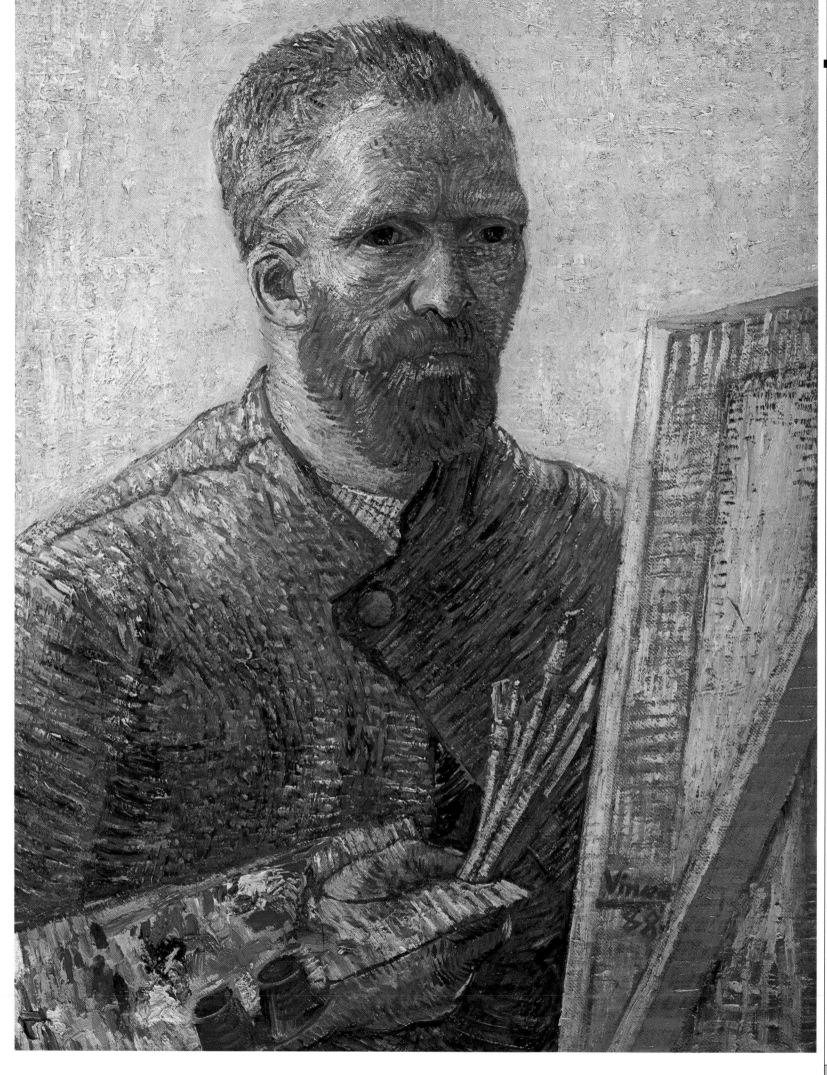

■ VINCENT VAN GOGH
**Self-Portrait
as a Painter**
1888, oil on canvas,
65 × 50.5 cm
Rijksmuseum Vincent
van Gogh, Amsterdam

In this, one of the last
works from the period
in Paris, Van Gogh
presents himself
before his easel,
palette in hand, his
expression absorbed
but at the same time
determined and proud
of his role as a painter.
Critics do not under-
stand his art, collec-
tors ignore it, but he
is convinced that his
artistic vision is valid
and that his works are
valuable. By the time
of this work he has
found a personal, orig-
inal form of expression
and is fully satisfied
with the results he
achieves, regardless of
the opinion of others.

1853•1890

VINCENT VAN GOGH
**Portrait of
Père Tanguy**
1887–88, oil
on canvas,
92 × 75 cm
Musée Rodin, Paris

The paint dealer and
art merchant Julien
Tanguy (1825–94) is
well known to many
Impressionist painters,
whom he takes under
his wing and protects
in an almost paternal
way. They buy their
supplies of canvas,
paints, and brushes
from him and display
their works in his
shop. As indicated by
the background of this
painting, his shop is
also well stocked with
Japanese woodcuts,
on sale at reasonable
prices and popular
with the artists. Père
Tanguy, as he is
called, is fond of this
painting, which Van
Gogh makes especially
for him, and he keeps
it with him until his
death (when it is
acquired by Rodin).

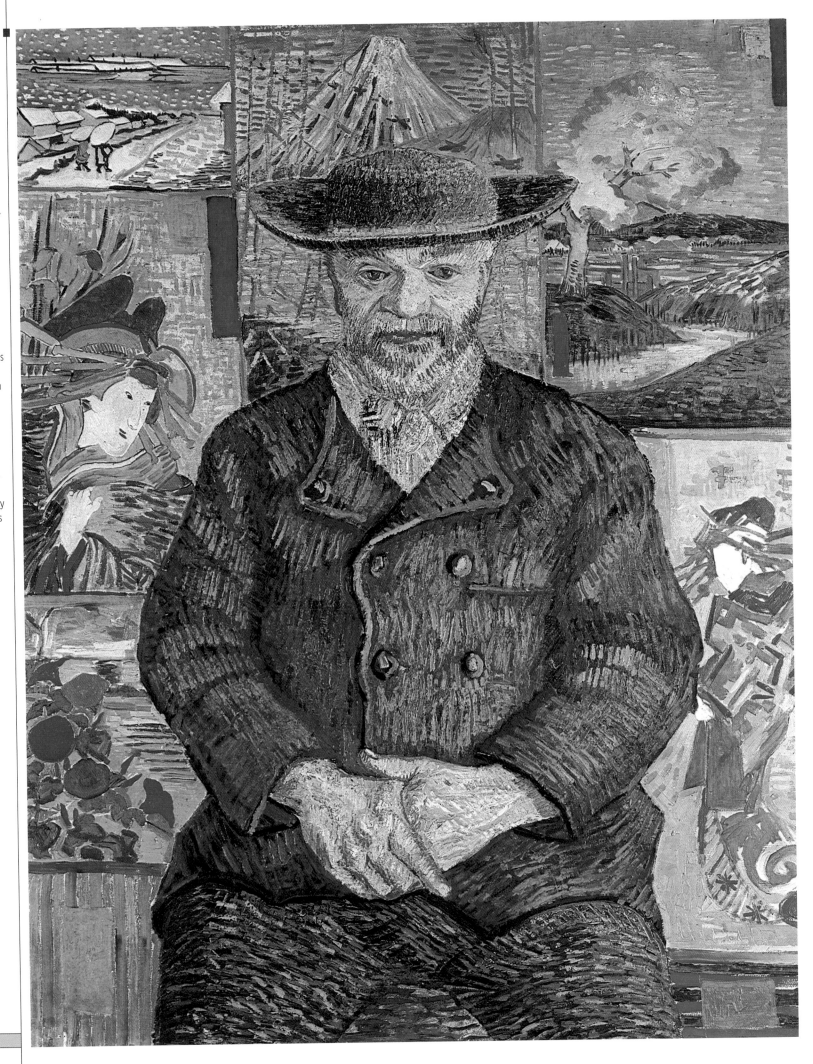

1880

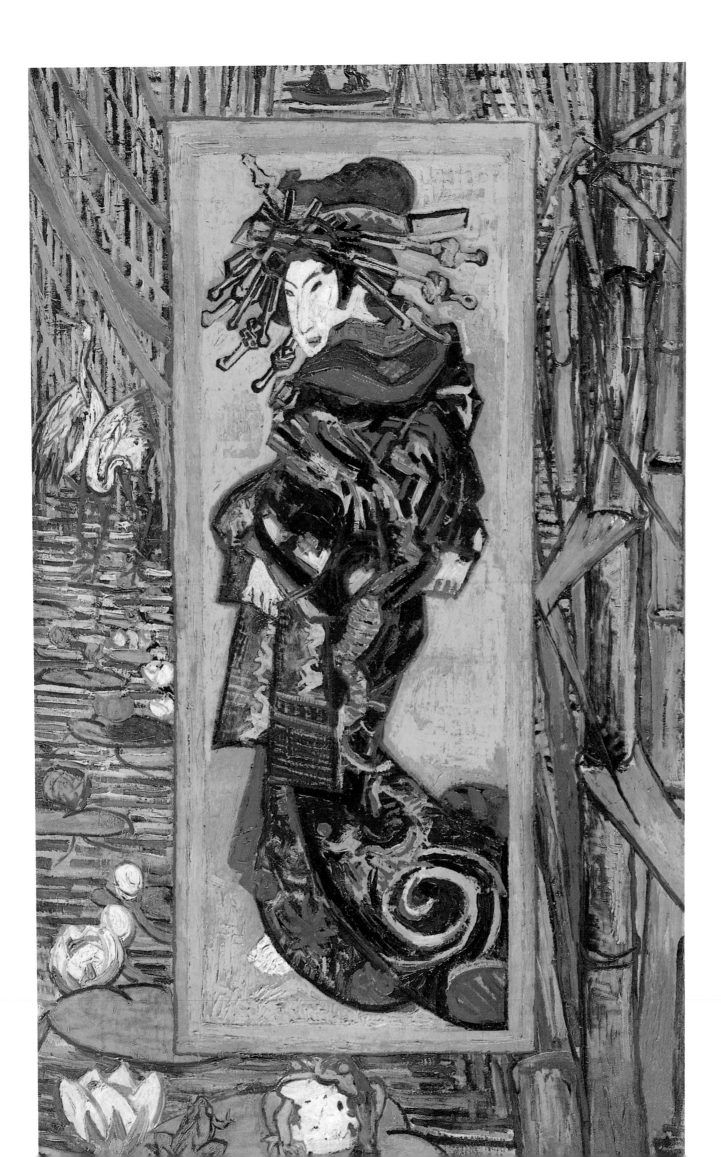

VINCENT VAN GOGH
Japonaiserie: Oiran (after Kesai Eisen)
1887, oil on canvas,
105.5 × 60.5 cm
Rijksmuseum Vincent
van Gogh, Amsterdam

Like many young
French artists, Van
Gogh is fascinated by
Oriental art, which has
only recently become
available in the West.
Vincent discovers it
in the shop of Père
Tanguy, one of the
first to stock Japanese
prints. He studies
and copies the prints
with enthusiasm and
attention. This paint-
ing repeats a work
by Kesai Eisen that
Vincent had seen on
the cover of the mag-
azine *Paris Illustré*.
Not long afterward he
makes a copy of the
famous *Ohashi Bridge
in Rain*, a masterpiece
by Hiroshige.

The White Orchard
1888, oil on canvas,
60 × 80 cm
Rijksmuseum Vincent
van Gogh, Amsterdam

In order to transfer
to canvas the bright
luminosity of the
Provençal landscape,
Van Gogh makes use
of Seurat and Signac's
methods, although he
applies the Pointillist
technique in a less
rigorous and obsessive
manner. This painting
is one of a series of
works dedicated to
orchards in blossom,
symbolic of the rebirth
in him of his enthu-
siasm for life and
painting after the
disappointments
suffered in Paris.
They are works of
extraordinary formal
lightness and enor-
mous emotional
intensity, composed
of limited elements
employed to commu-
nicate deep emotions.

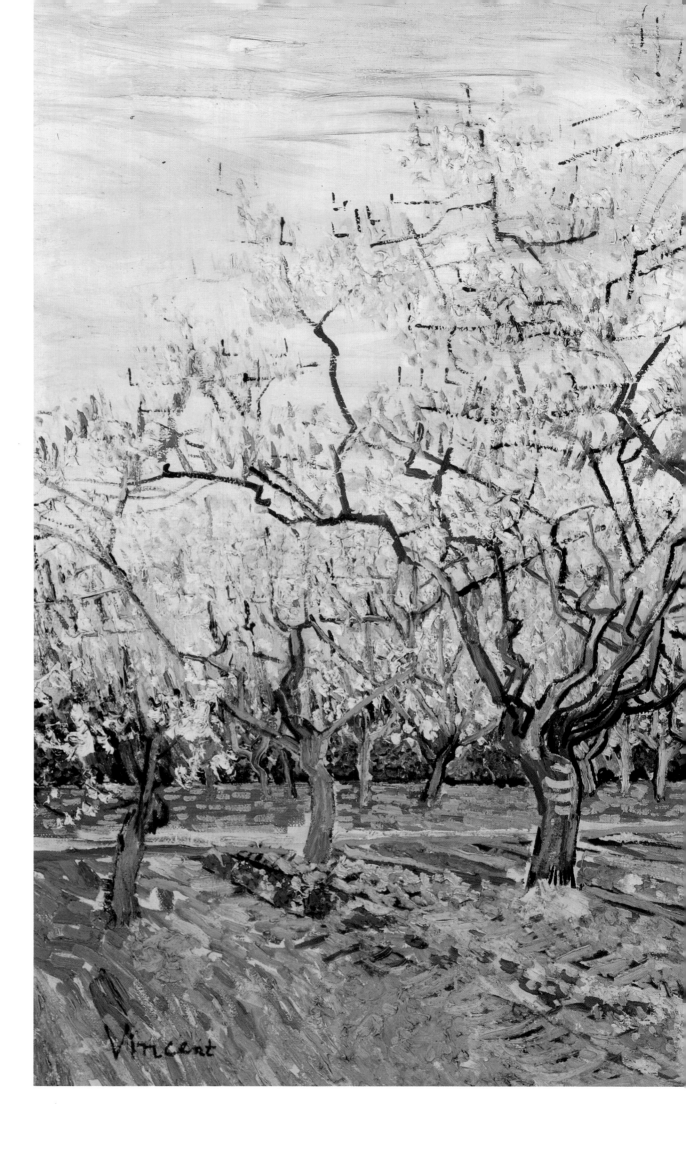

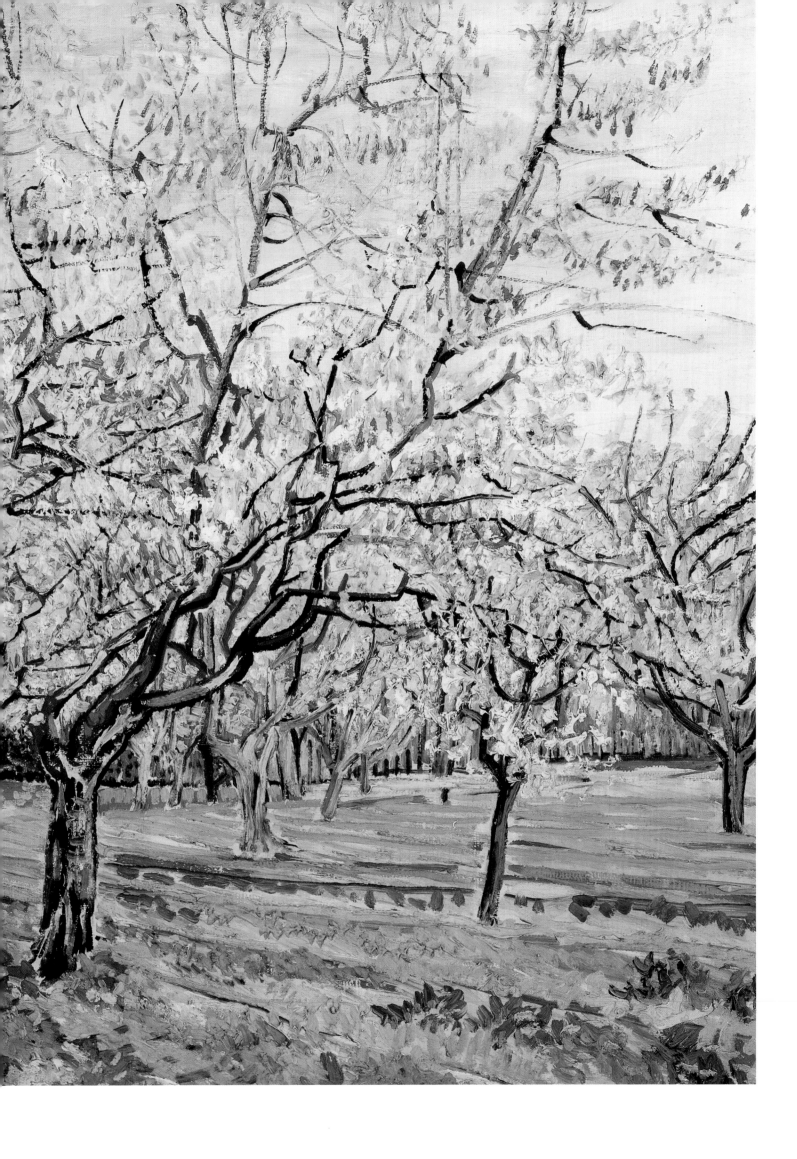

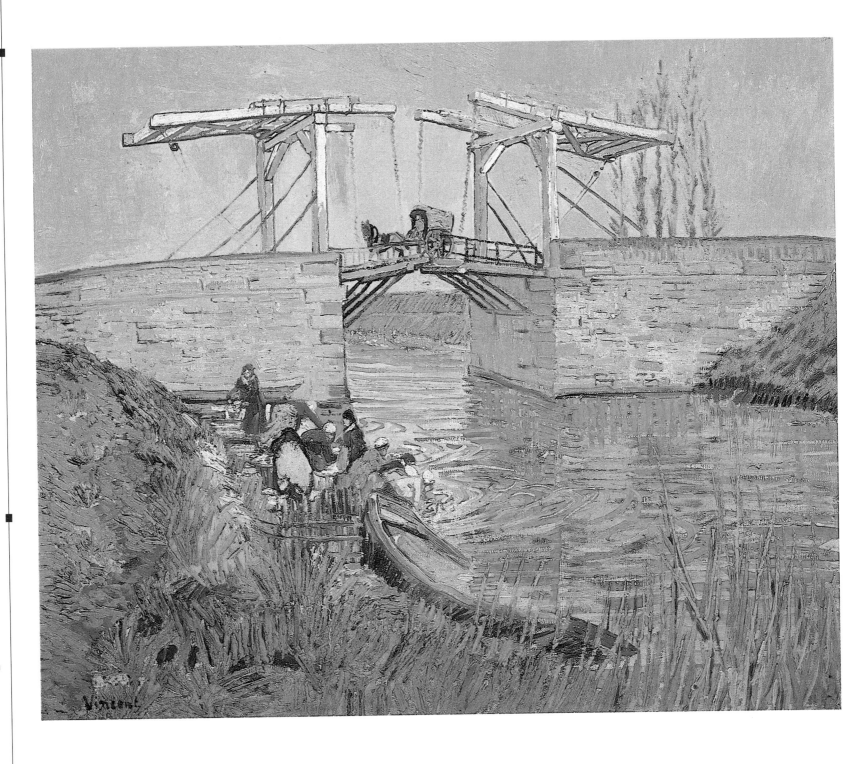

VINCENT VAN GOGH
The Langlois Bridge
1888, oil on canvas,
50 × 65 cm
Rijksmuseum Kröller-
Müller, Otterlo

This is the first of six
views Vincent makes
of the drawbridge he
calls the Langlois
bridge after the name
of its keeper. He uses
different techniques
(oil, watercolor, ink)
and presents it from
different points of
view. Of those works,
this is the version
closest in style to that
of Japanese prints.
The line is sharp and
accurate, the colors
are distributed with
skill, the whole is illu-
minated by an intense
light that infuses the
scene with a sense of
serenity.

VINCENT VAN GOGH
**Sketch from Letter
with Langlois Bridge**
1888, ink on paper,
Private collection,
Paris

To give his friend
Emile Bernard an idea
of the painting he is
working on, Van Gogh
includes this small
sketch in a letter
to him.

VINCENT VAN GOGH
**Langlois Bridge with
Woman with Umbrella**
1881, charcoal
and watercolor
on paper,
45.5 × 30.5 cm
Rijksmuseum Vincent
van Gogh, Amsterdam

Van Gogh's works are
the result of careful
study and are preced-
ed by many prepara-
tory drawings like
this one.

1853•1890

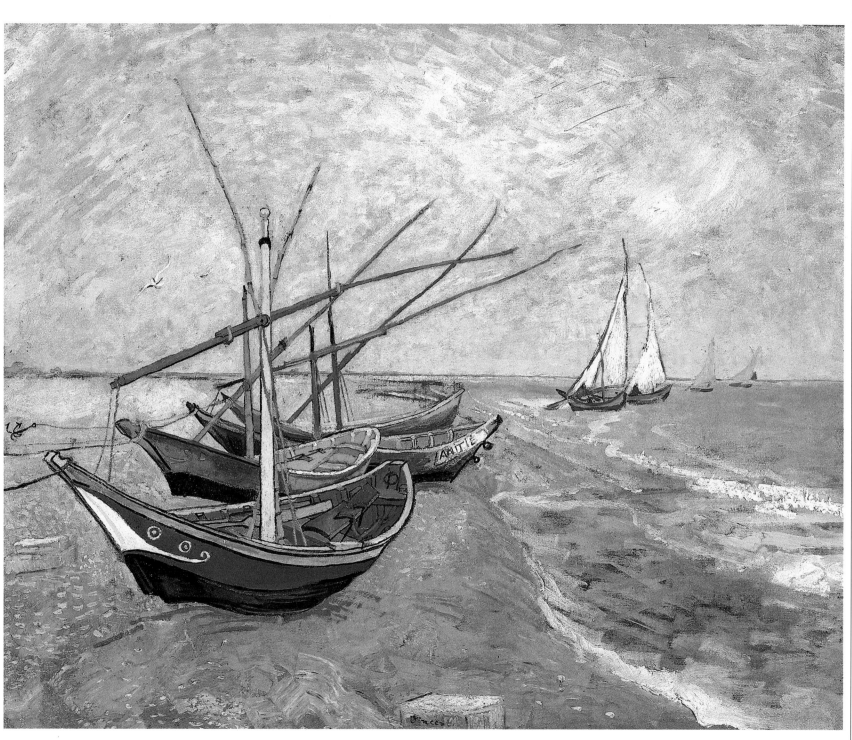

■ VINCENT VAN GOGH
Fishing Boats on the Beach at Les Saintes-Maries-de-la-Mer
1888, oil on canvas, 64.5 × 81 cm
Rijksmuseum Vincent van Gogh, Amsterdam

Van Gogh spends the first weeks of June 1888 in Les Saintes-Maries-de-la-Mer, a fishing village where he makes numerous seascapes, very near the style of the Impressionists. The grayish blue clouds are made with subtle shadings and imperceptible mutations in tone that give the scene movement and depth. The water of the sea is instead made with broader, more visible brushstrokes, giving it a more solid consistency. The square lines of the boats in the foreground, their bright colors, and the elegant interweaving of their masts without sails suggest, instead, the influence of Japanese prints.

The Harvest
1888, oil on canvas,
72.5 × 92 cm
Rijksmuseum Vincent
van Gogh, Amsterdam

This painting, one
of Van Gogh's largest
compositions in terms
of breadth of scale, is
symbolic of his love
for nature and also
emblematic of his
intimate communion
with the life and work
of the fields. In a let-
ter to his brother of
May 29, 1888, he
writes, "I am working
on a new subject,
green and yellow
fields as far as the
eye can reach. I have
already drawn it twice,
and I am starting it
again as a painting.
It is exactly like a
Salomon Konink—you
know, the pupil of
Rembrandt who paint-
ed vast level plains."
A month later Van
Gogh writes, "I have
the sharpness or the
blindness of the lover
for this work, in this
moment. This world of
colors is completely
new to me and thrills
me extraordinarily."

1853•1890

**Portrait of
Joseph Roulin**
1888, oil on canvas,
81 × 65 cm
Museum of Fine Arts,
Boston

The Roulins, husband
and wife, are among
the few people in
Arles with whom Van
Gogh succeeds in
establishing a true
friendship. They often
invite him to their
home for dinner, look
after him, and are the
only ones to stand up
for him in the face of
the gossip of other
inhabitants of the
town, who do not
approve of his disor-
derly style of life.
This is the first and
largest of the portraits
the painter makes of
the postman, who
poses proudly in his
uniform, embellished
by the many shades
of blue and enlivened
by the yellow of the
buttons and the braid
on the sleeves.

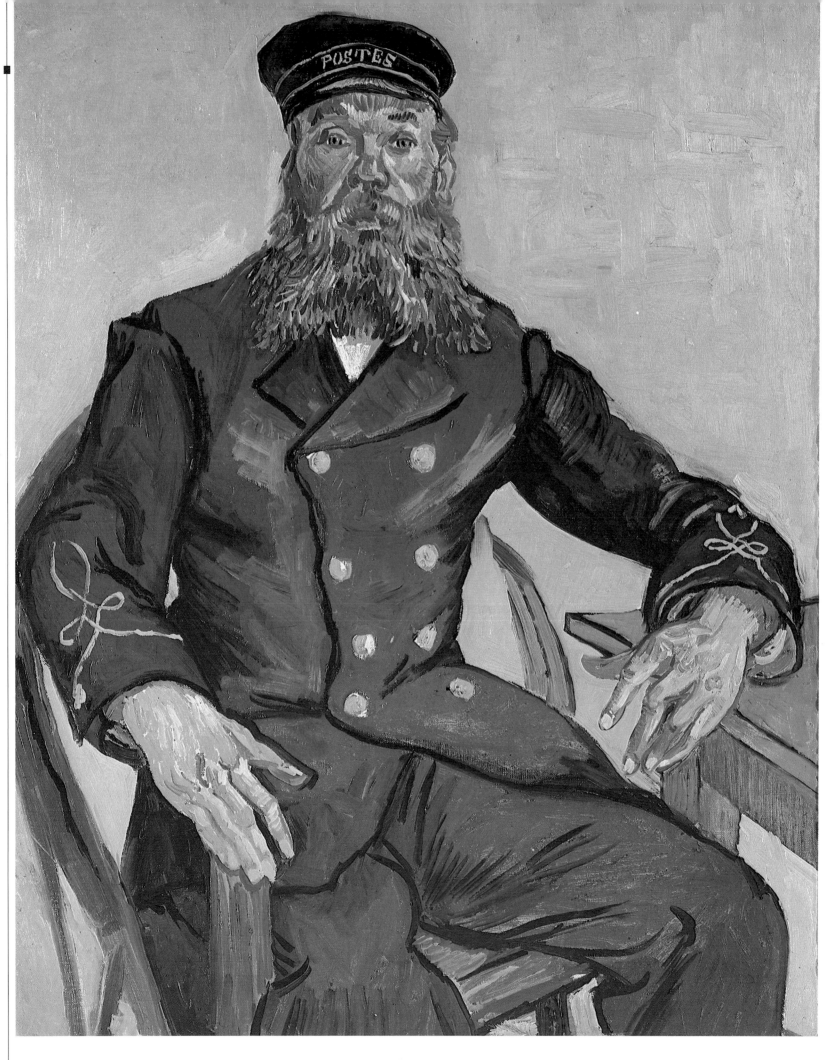

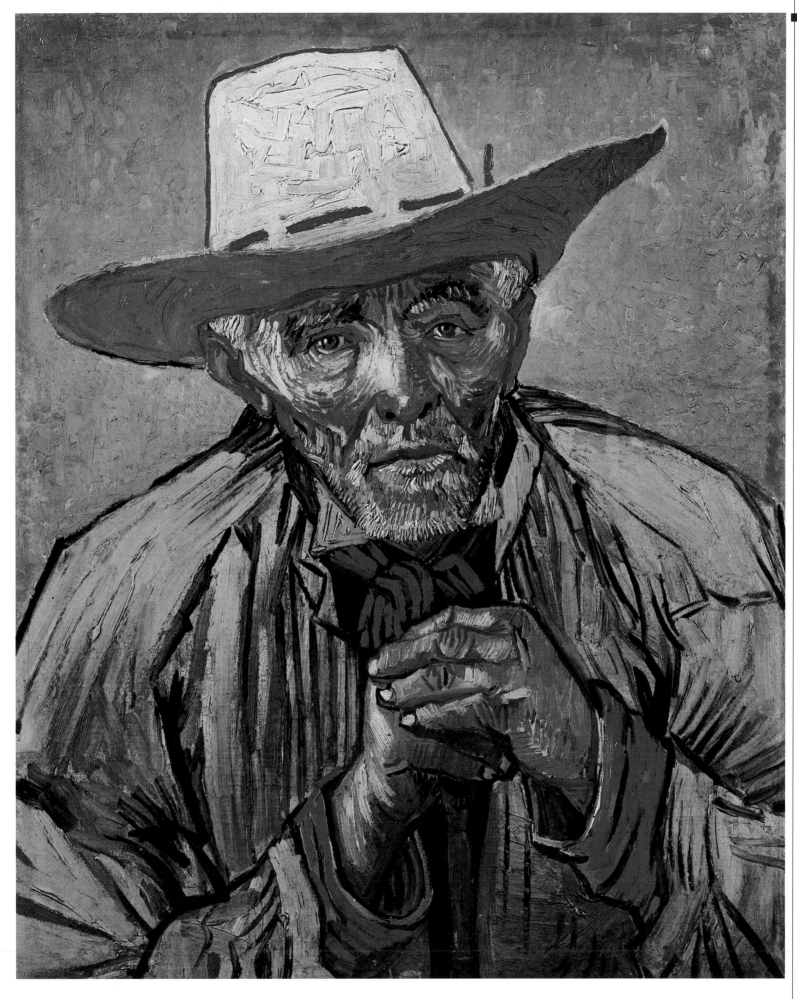

■ VINCENT VAN GOGH
**The Peasant (Portrait
of Patience Escalier)**
1888, oil on canvas,
69 × 56 cm
Private collection

This canvas recalls the
heads of peasants Van
Gogh made at Nuenen,
but the stylistic dif-
ferences between the
two periods are clear.
The dark, earthy colors
of that earlier time
have completely dis-
appeared, giving way
to solar tones, pale
and luminous. The
orange background is
the color of fields of
grain ready for harvest;
the yellow of the hat
is like the bright sun,
as are the yellow
brushstrokes that
heighten the face
or that bring to light
the beard that frames
the man's chin. The
simple work clothes,
alternating green and
blue, contrast with
the bright red of the
handkerchief at his
neck or the red
sleeves of his shirt.

VINCENT VAN GOGH
The Night Café
1888, oil on canvas,
70 × 89 cm
Yale University Art
Gallery, New Haven

Van Gogh here recalls
the Impressionist
paintings set in
Parisian cafés; in
fact, we find the same
air of desolation and
solitude that Degas
put in his *In a Café*
(page 162). As seen
from the clock on the
rear wall, the hour is
past midnight; almost
all the clients have
gone home, and an
air of weariness or
boredom seems to
have spread over the
few holdouts. Only a
couple is intent in
conversation; every-
one else sits in silence
while the owner of
the place stands
beside his billiards
table.

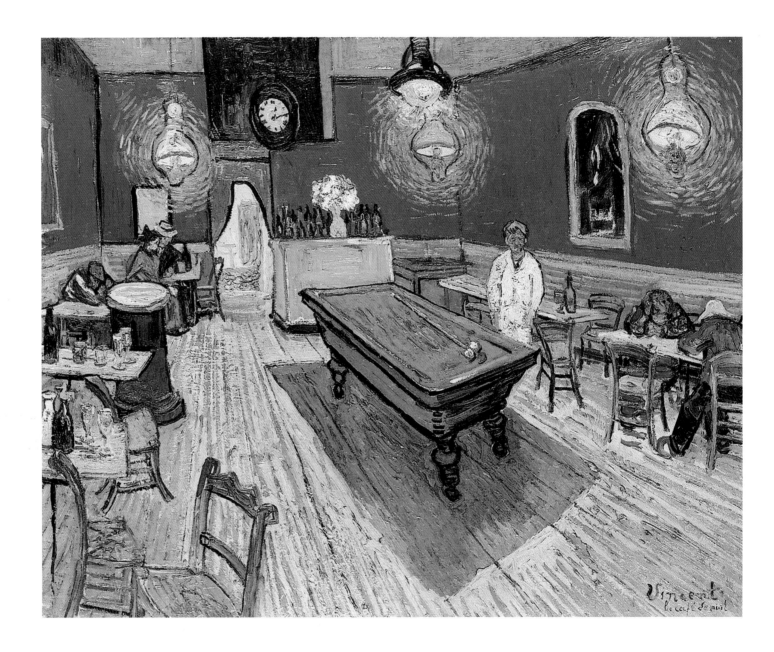

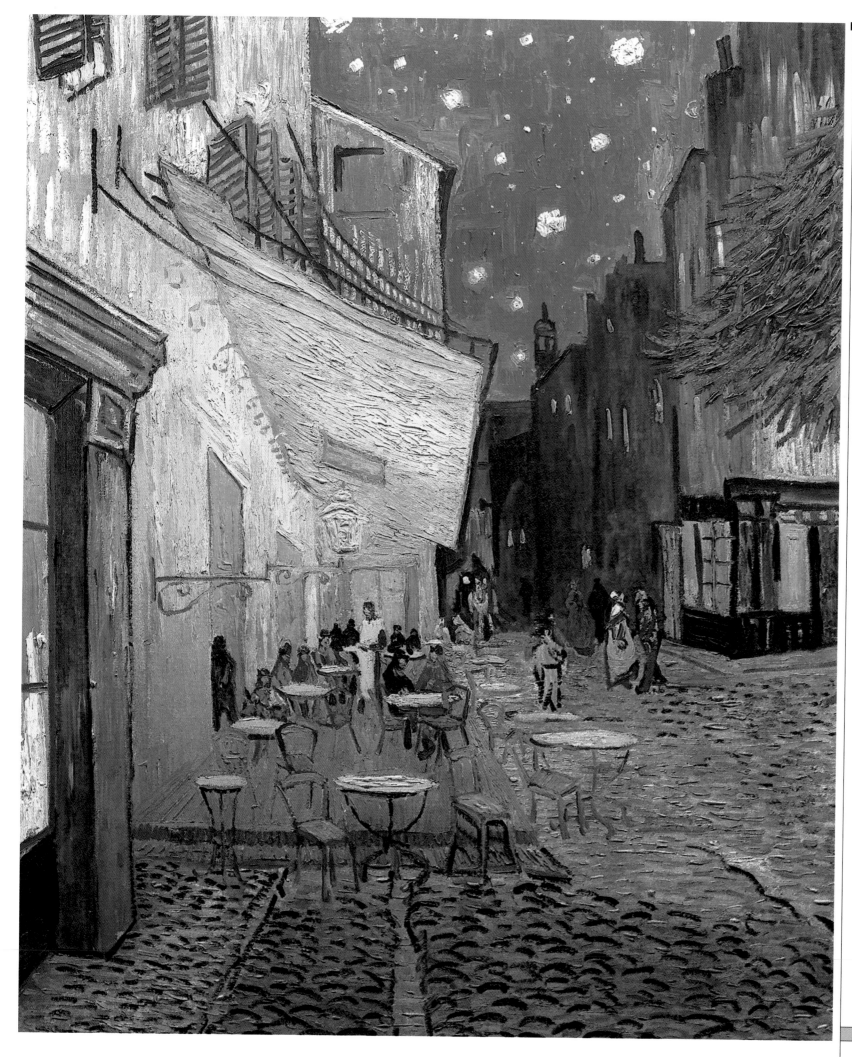

■ VINCENT VAN GOGH
Café Terrace on the Place du Forum
1888, oil on canvas,
81 × 65.5 cm
Rijksmuseum Kröller-
Müller, Otterlo

With the coming of
autumn, Van Gogh
takes up the habit of
painting at night in
the open by the light
of candles. After so
many landscape views
of Arles, this is one of
his first views of the
city itself. The space
is clearly divided into
sections. On one side
is the street and
houses in shadow,
an angle of the sky,
illuminated by stars;
on the other is the
terrace of the café,
its little tables and
clients sharply illumi-
nated. The human
figures, all of them
pushed back to the
rear of the composi-
tion, are very small,
just sketched in, their
features not clearly
defined.

VINCENT VAN GOGH
**The Street
(The Yellow House)**
1888, oil on canvas,
76.5 × 94 cm
Rijksmuseum Vincent
van Gogh, Amsterdam

Early in 1888 Vincent
sends several letters
to his brother Theo
asking him to convince
Gauguin, then in
Pont-Aven, to come
visit him in Provence.
Meanwhile he rents
the right wing of a
small building on
Place Lamartine and
has it made into two
studios, one for him-
self, the other for his
friend. The work is
completed by the
middle of September,
and Vincent leaves
his room in the hotel
Carrel to go live in
the Yellow House,
presented here.
Gauguin arrives a
month later, and
the two are together
nine weeks, a period
of intense emotions
and torments.

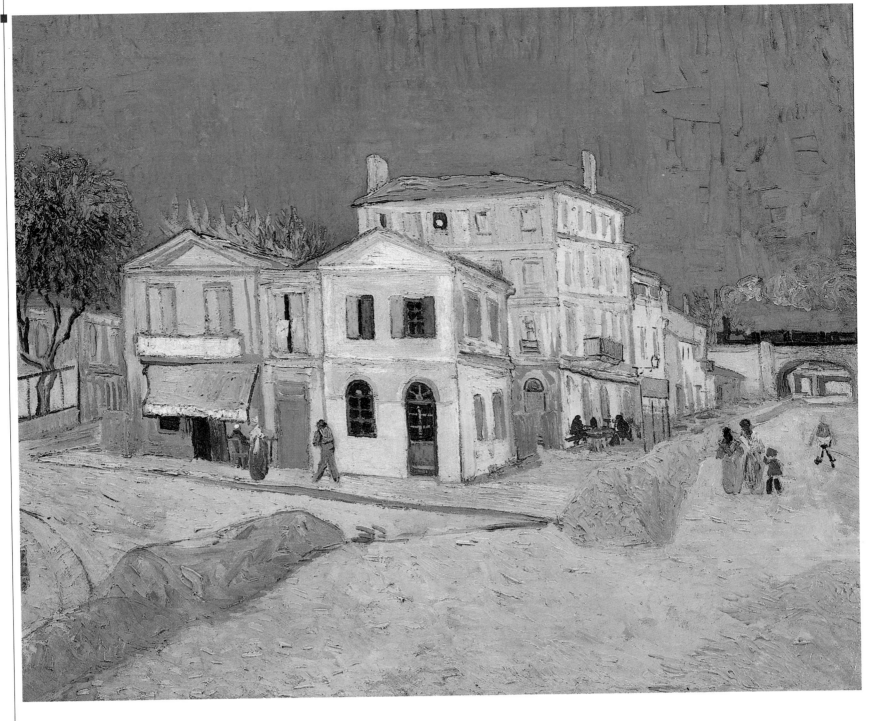

VINCENT VAN GOGH
**The Street
(The Yellow House),
Sketch in a Letter**
1888, ink on paper,
13 × 20.5 cm
N. Dreher Collection,
Brienz

Vincent includes this
sketch of his home
in Arles in a letter
to Theo at the end
of September.

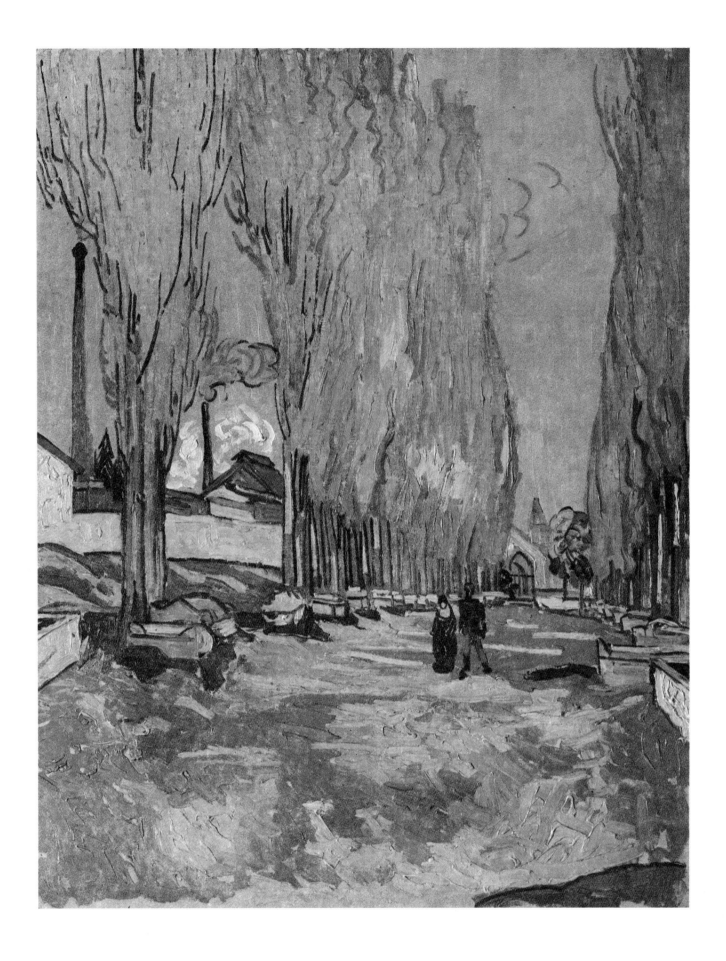

A year before his
birth, Van Gogh's
parents had another
son, baptized with
his name; that first
Vincent died shortly
after birth. Through-
out his life the
painter is extremely
sensitive to the theme
of death, which
appears in many of his
paintings, including
this one, set in the
ancient necropolis of
Les Alyscamps, one
of the historical sites
of Arles. This is the
first subject that
Van Gogh paints
together with Gauguin
(page 352), a few
weeks after his arrival
in Provence, although
each of the two artists
chooses a different
point of view.

VINCENT VAN GOGH
The Bedroom
1888, oil on canvas,
72 × 90 cm
Rijksmuseum Vincent
van Gogh, Amsterdam

By presenting his
own room the artist
presents himself and
his soul; each object
(and its location)
reveals some aspect
of his personality.
The composition's
dominant sentiment
is the almost obsessive
longing for a nest,
a place of shelter from
the difficulties of
other people, a place
where the painter can
feel himself loved and
protected. During his
stay in the sanitarium
Vincent will make
another two paintings
with this subject,
today in the Art
Institute of Chicago
and the Musée d'Orsay
in Paris.

VINCENT VAN GOGH
The Bedroom,
Sketch in a Letter
1888, ink on paper,
Private collection

Vincent sent this
drawing to his brother
Theo to help him
understand where
and how he was living
in Arles.

VINCENT VAN GOGH
The Bedroom,
Sketch in a Letter
1888, ink on paper,
Rijksmuseum Vincent
van Gogh, Amsterdam

The major differences
among the drawings
and the three paintings
of this subject involve
the objects on the
little table and the
painting over the
head of the bed.

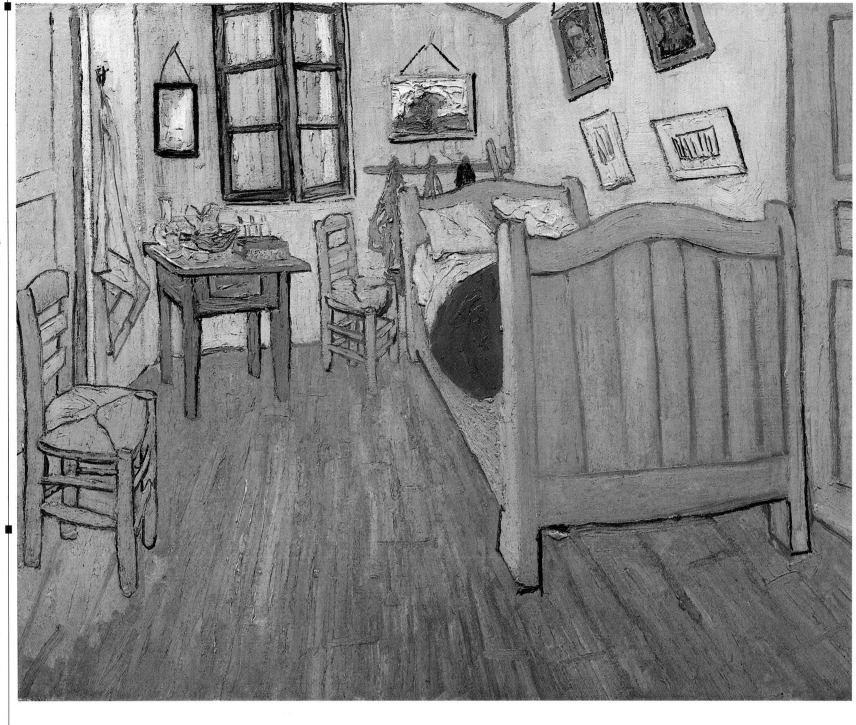

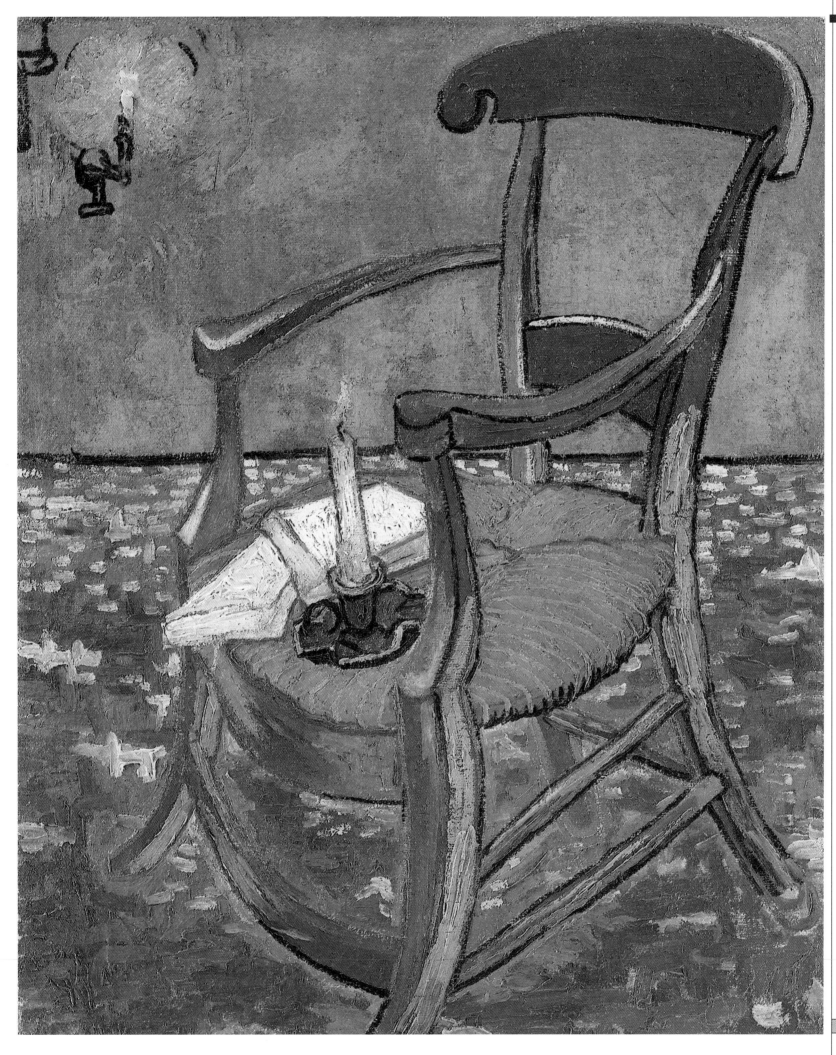

■ VINCENT VAN GOGH
Gauguin's Chair
1888, oil on canvas,
90.5 × 72 cm
Rijksmuseum Vincent
van Gogh, Amsterdam

Even in the painting of
The Bedroom, opposite,
the artist inserts two
chairs, giving them a
symbolic importance.
The meaning is even
more apparent in this
work: the chair for his
friend is empty, he
is not there, and Van
Gogh expresses his
sorrow at having failed
to establish the kind
of strong and honest
artistic and emotional
bonds he had so
longed for. Despite
the efforts made, they
were not able to over-
come their sharp dif-
ferences of character,
their different ways
of life; neither proved
able to surrender even
a small part of his
independence to sat-
isfy the other's needs,
making their separa-
tion inevitable.

VINCENT VAN GOGH
Self-Portrait
1889, oil on canvas,
51 × 45 cm
Private collection

Van Gogh makes this self-portrait in January 1889, shortly after being discharged from the hospital. He makes the work in front of a mirror, as is revealed by the fact that the bandage is on his right ear, instead of his left, which is the one he had injured. The expression on his face still expresses suffering, both physical and spiritual. The eyes, shiny and bloodshot, reveal his tormented state of mind, unable to resign himself to the sad reality.

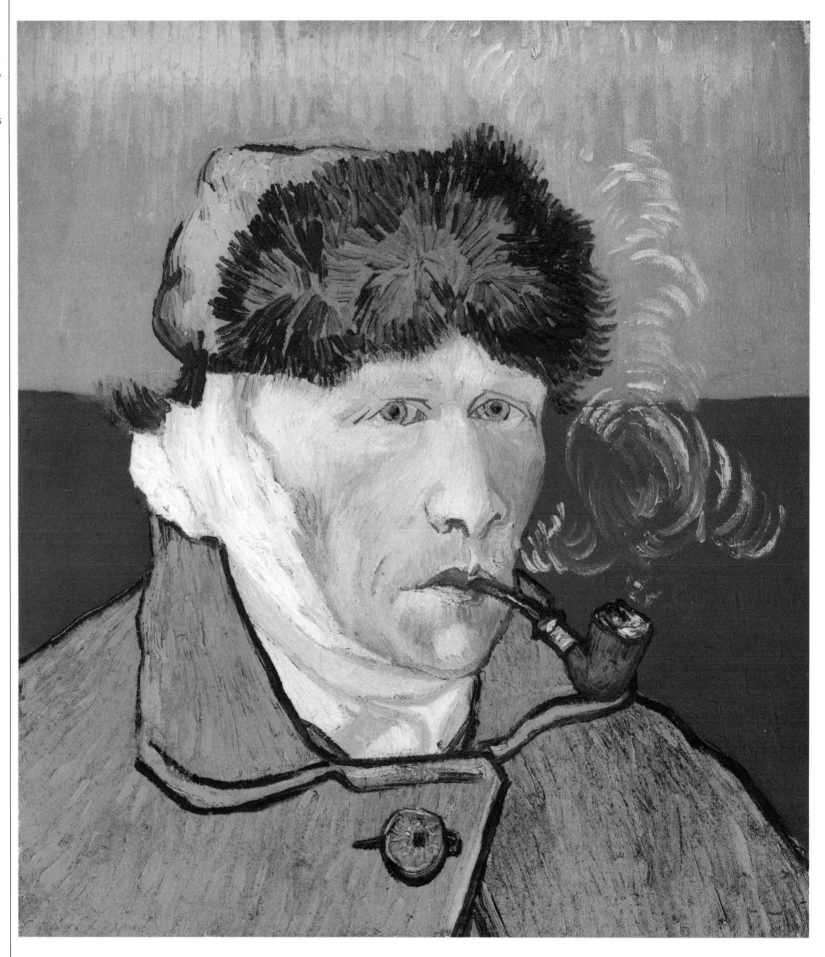

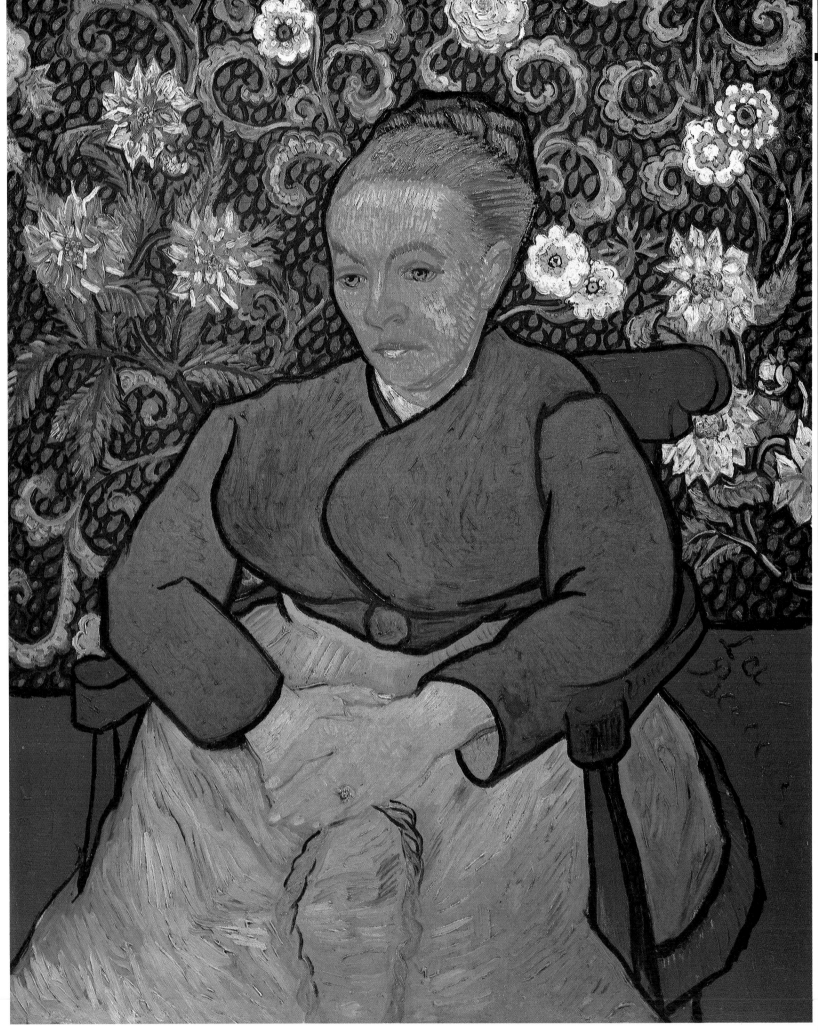

■ VINCENT VAN GOGH
La Berceuse (Portrait of Madame Roulin)
1889, oil on canvas,
92 × 73 cm
Rijksmuseum Kröller-
Müller, Otterlo

This is one of five
versions of the por-
trait of Augustine,
wife of the postman
Joseph Roulin, that
Van Gogh makes.
The painting's title
means "the lullaby,"
and in fact the cord
in the woman's hands
leads to a cradle bear-
ing her newborn son,
Marcelle. The most
striking element of
the painting is the
background decora-
tion of a flowering
garden; later to be
admired by Matisse,
it prefigures the fan-
tasy decorations of
Art Nouveau. Far
different is the dress
worn by Augustine
Roulin, almost too
simple and humble;
her face has so little
expression that she
seems personally
absent from the scene.

PAUL GAUGUIN
Van Gogh Painting Sunflowers
1888, oil on canvas,
73 × 92 cm
Rijksmuseum Vincent
van Gogh, Amsterdam

The presence of his friend Paul Gauguin stimulates Van Gogh's creativity while at the same time bringing to the surface his psychological problems and his difficulties in establishing lasting and meaningful relationships with other people. In this pitilessly honest portrait, Gauguin makes the physical signs of Van Gogh's mental imbalance apparent. In his 1903 diary, *Avant et Apres*, Gauguin will write: "I got the idea of making his portrait while he painted the still life he loved so much, the sunflowers. And when I had finished the portrait he said, 'It is certainly I, but I gone mad.'"

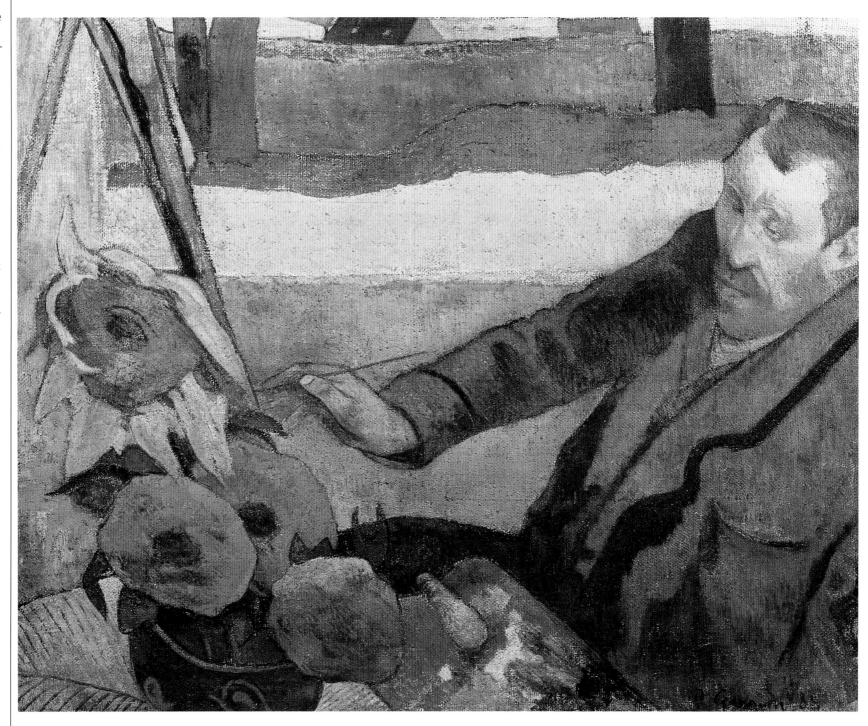

Vincent van Gogh

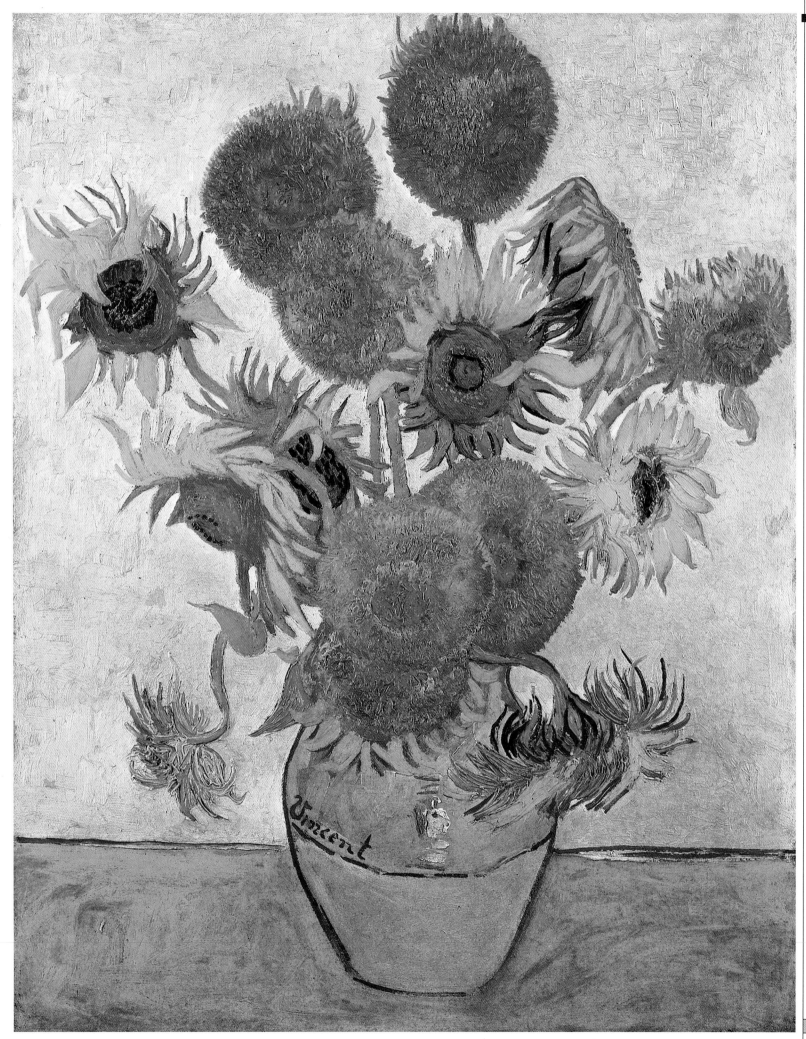

VINCENT VAN GOGH
Still Life with Sunflowers
1888, oil on canvas,
93 × 73 cm
National Gallery,
London

Van Gogh loves flowers, most of all sunflowers. In his eyes they transmit the same vital energy as the sun, they give off their own light, they express a deep and sincere love for life. In this canvas, one of the many versions he makes of the same theme, the artist uses very few colors and develops them in all their possible shadings. The light is intense, without shadow or chiaroscuro; the drawing is rapid, without vagueness or reworkings; the entire composition has so little depth that the vase seems almost flat against the background.

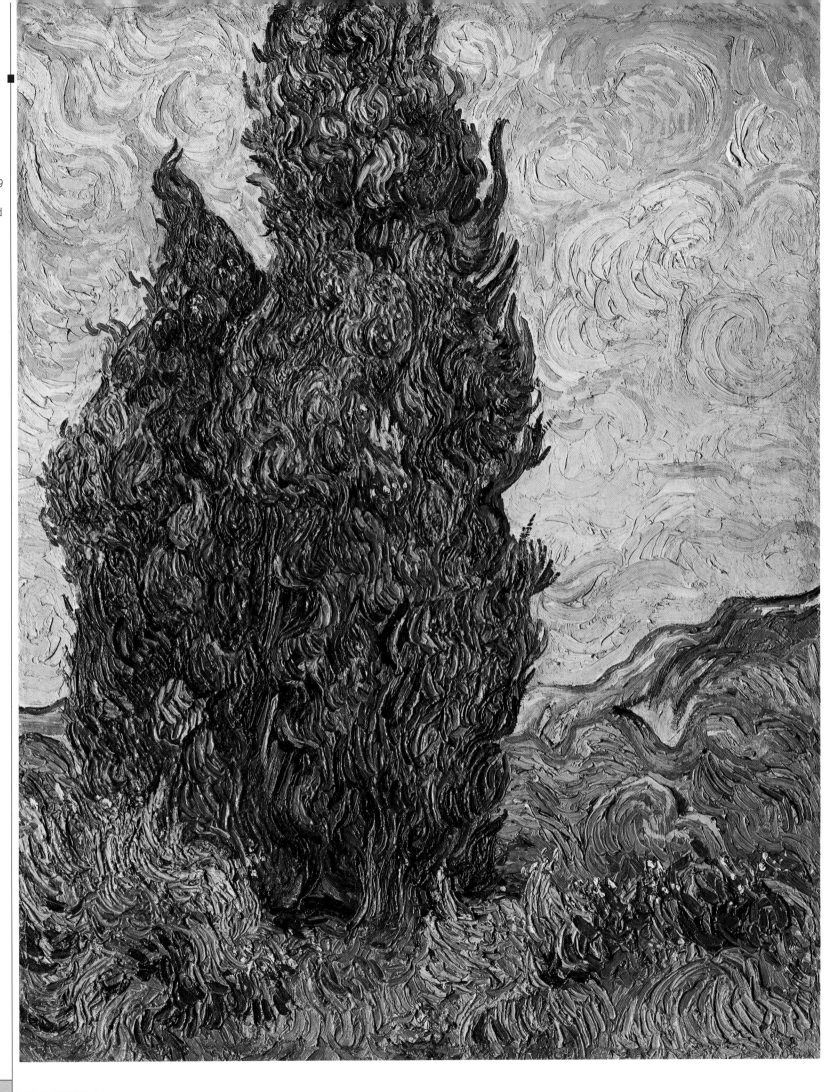

VINCENT VAN GOGH
Cypresses
1889, oil on canvas,
95 × 73 cm
Metropolitan Museum
of Art, New York

In the summer of 1889
Van Gogh returns to
painting with renewed
energy and makes
several paintings of
cypresses. The dark
masses of the trees
stand out sharply
against the paler
colors of the sky
and the surrounding
landscape. Although
the general layout
seems fundamentally
naturalistic and
recalls works by the
Impressionists, his
treatment is very dif-
ferent, both in spirit
and technique. The
space, with little
sense of depth, is
animated by long
brushstrokes, some-
times parallel, some-
times overlapping,
that follow an undu-
lating rhythm.

Vincent van Gogh

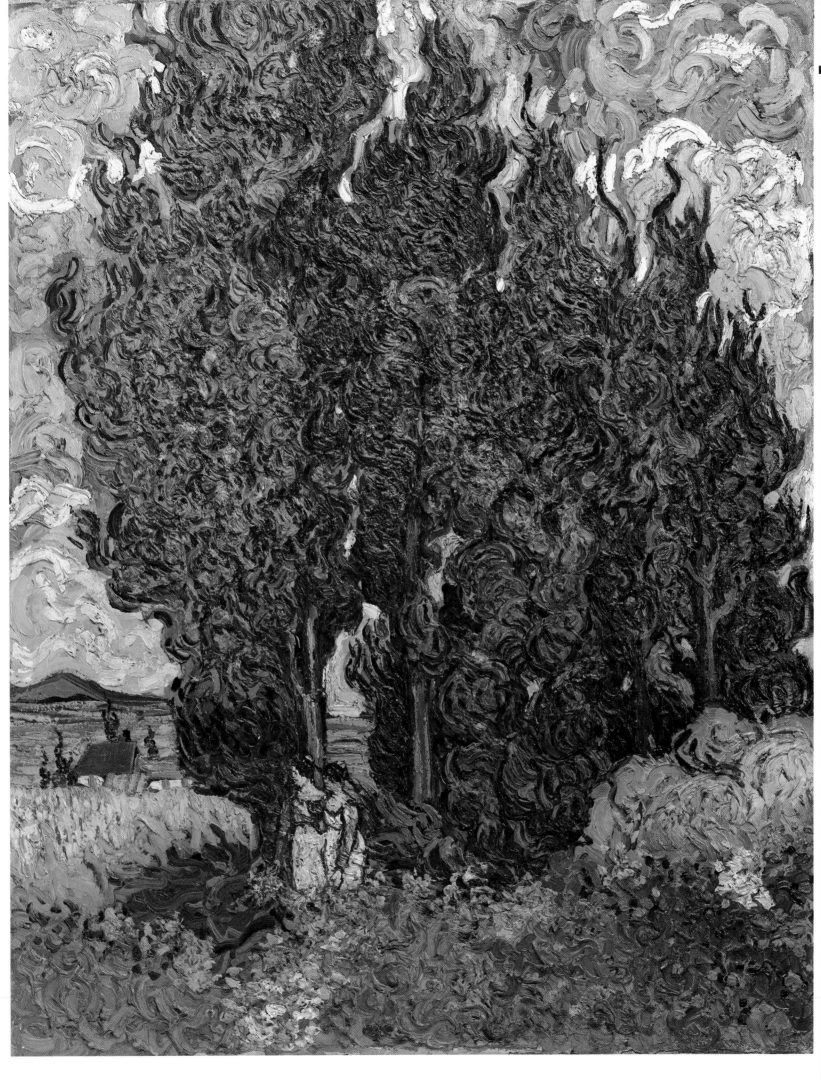

■ VINCENT VAN GOGH
**Cypresses with
Two Women**
1889, oil on canvas,
92 × 73 cm
Rijksmuseum Kröller-
Müller, Otterlo

On May 8, 1889, Van
Gogh lets himself be
taken into a psychi-
atric asylum near
Saint-Rémy-de-
Provence. The director,
Doctor Peyrou, gives
him a private room
and the use of another
room on the ground
floor as a studio.
There he makes rep-
licas of earlier paint-
ings and numerous
landscapes, including
this one. Meanwhile
the universal exhibi-
tion is taking place
in Paris, including the
painting exhibition to
which Van Gogh has
not been invited, along
with the parallel show
of the Impressionists
and Synthetists at the
Café Volpini, organized
by Paul Gauguin,
Schuffenecker, and
Bernard, which he
has refused to partici-
pate in.

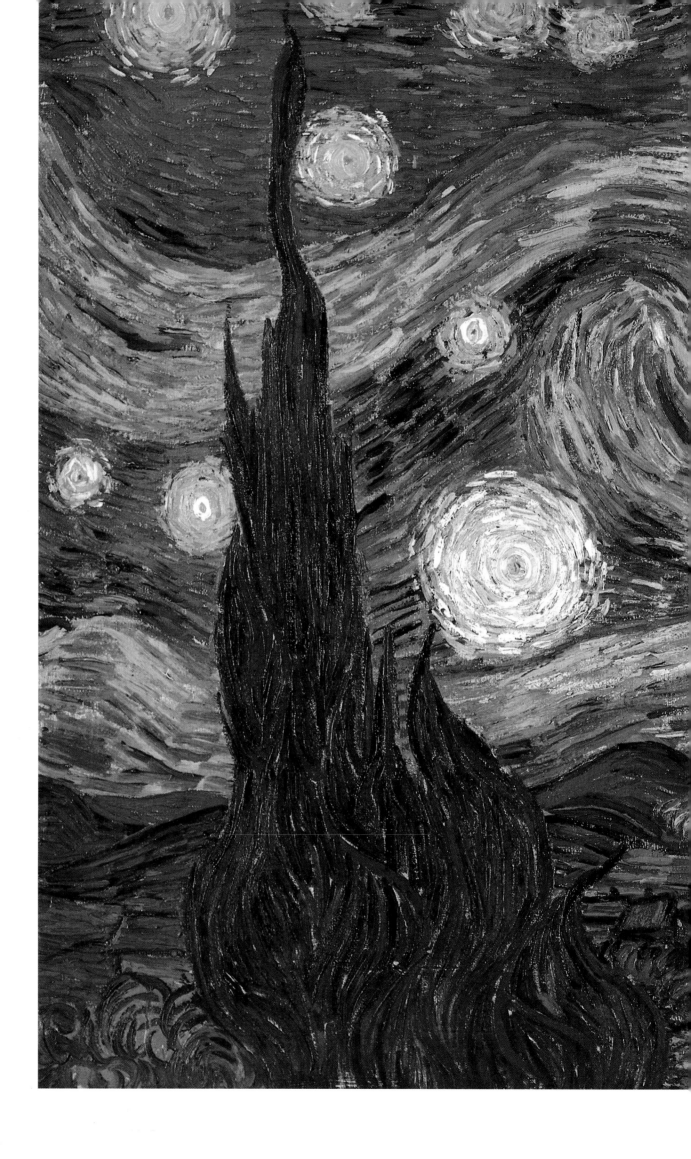

VINCENT VAN GOGH ■
The Starry Night
1889, oil on canvas,
73.7 × 92.1 cm
Museum of Modern
Art, New York

This is perhaps the
most intense and
dramatic of the paint-
ings Van Gogh makes
at Saint-Rémy. His
brushstrokes have
grown longer and
have acquired greater
strength, the result
of an attitude in
painting that has
become increasingly
violent and angry.
The arrangement of
the brushstrokes on
the canvas creates a
kind of vortex that
wraps the sky in a
spiral, taking with it
stars of an extraordi-
nary luminosity. The
cypress trees to the
left resemble tongues
of fire, dark flames
in the night, symbols
of death and despera-
tion. The town to the
right seems to sleep
peacefully, perhaps
unaware of what is
happening.

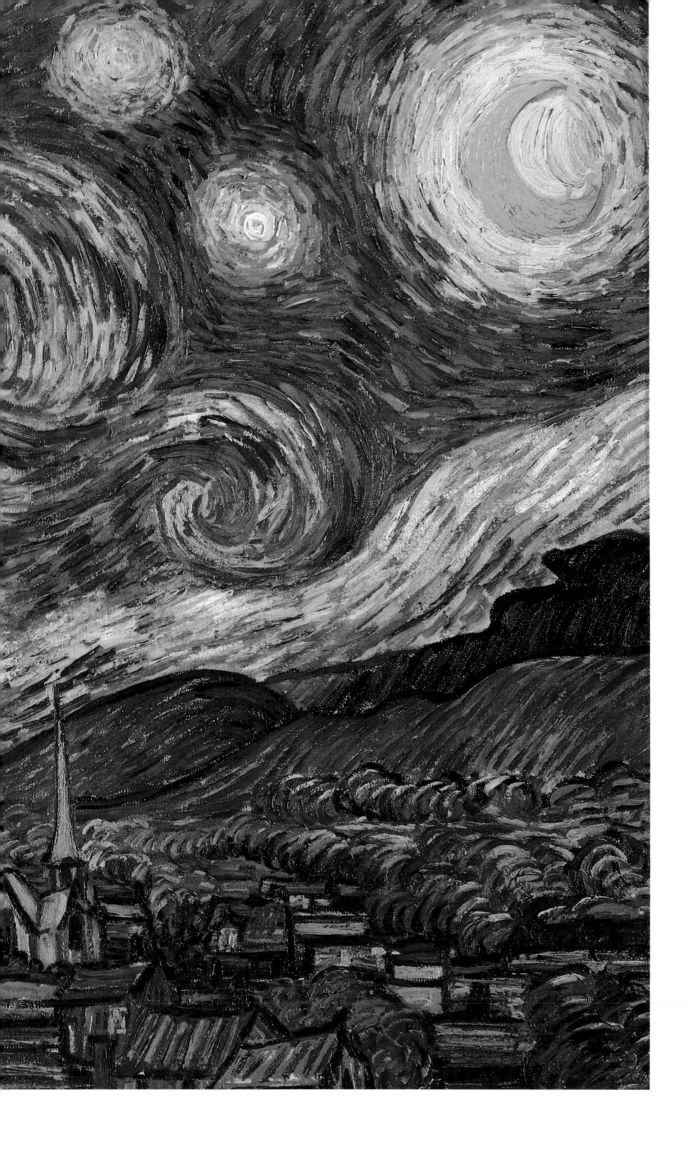

VINCENT VAN GOGH
The Reaper
1889, oil on canvas,
43.5 × 33.5 cm
Rijksmuseum Vincent
van Gogh, Amsterdam

Along with cypresses, fields of grain are a subject dear to Van Gogh, and they appear quite often in his work during his stay in Saint-Rémy. The painter is drawn to the intense yellow of stalks of wheat moved by the wind and tries to recreate this movement with his usual elongated brushstrokes. As is his habit, the background landscape has little depth and serves a primarily decorative function. Although seen from close up, the reaper seems like a small figure, sketched in using a few rapid touches that do not make clear his expression, only his slow, deliberate gesture.

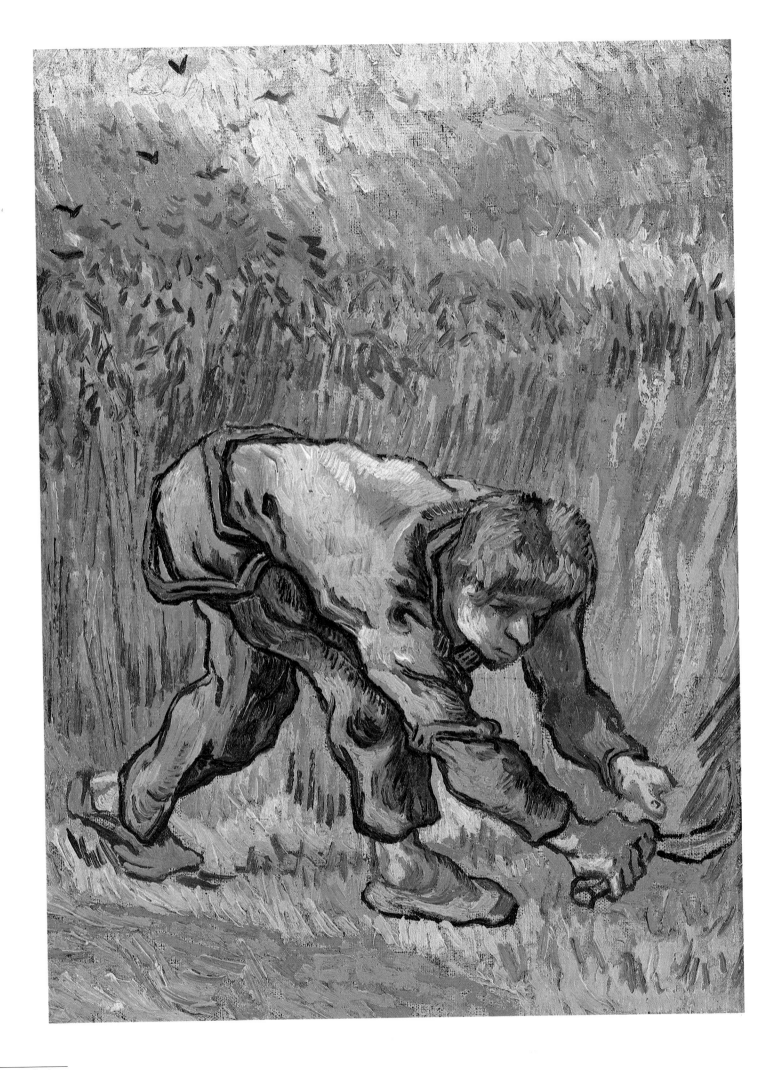

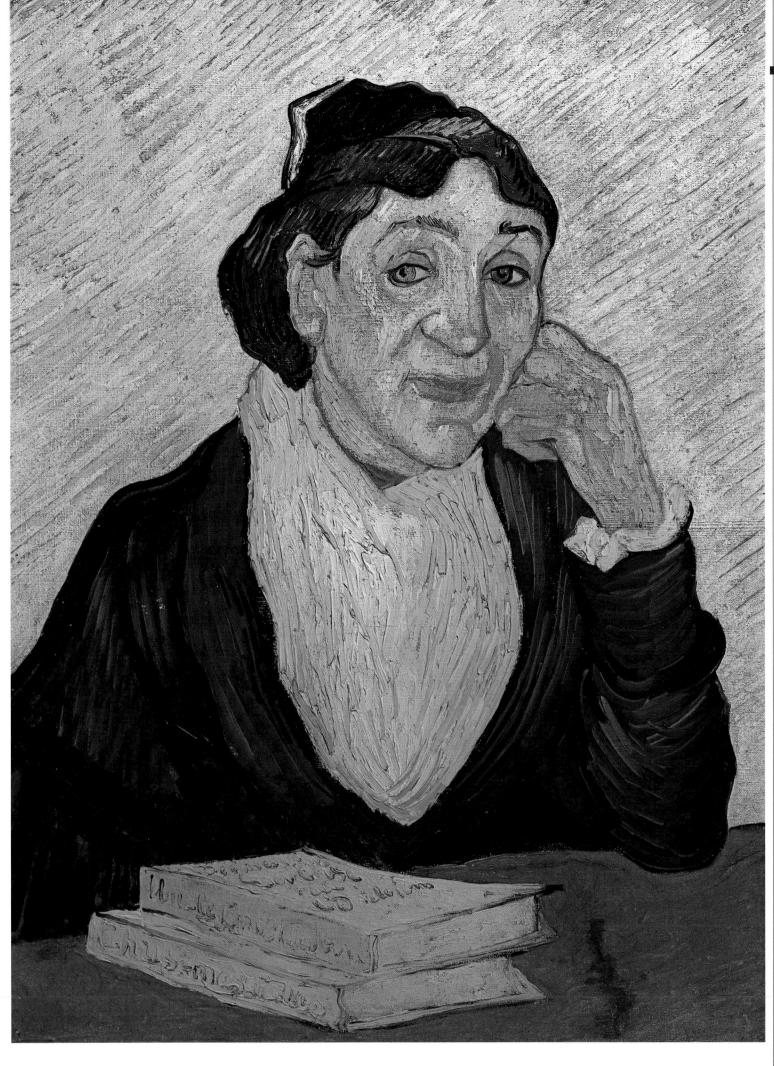

■ VINCENT VAN GOGH
L'Arlésienne (Portrait of Madame Ginoux)
1890, oil on canvas,
65 × 49 cm
Rijksmuseum Kröller-
Müller, Otterlo

The subject of this portrait, Marie Ginoux (1848-1911), ran with her husband the Café de la Gare, near the Yellow House in Arles. Made in the Saint-Rémy asylum, the painting is inspired by two portraits from the November of the preceding year, his own earlier portrait of Madame Ginoux (today in the Metropolitan Museum of New York) and *In the Café* by Gauguin (Pushkin State Museum of Fine Arts, Moscow). In particular he repeats the woman's pose, with the closed hand resting against her cheek, a position at once thoughtful and melancholy.

VINCENT VAN GOGH
**Branches with
Almond Blossom**
1890, oil on canvas,
73 × 92 cm
Rijksmuseum Vincent
van Gogh, Amsterdam

On April 17, 1889,
Theo van Gogh marries
Johanna Bonger. On
January 31 of the next
year a son is born,
and they name him
Vincent Willem in
honor of his uncle,
who is also his god-
father. That February,
as a gift for the new-
born baby, Vincent
makes this splendid
painting, stylistically
among his closest to
Japanese prints. In
May, he spends three
days in Paris with Theo,
where he meets his
nephew and his sister-
in-law. Her affection-
ate welcome does
nothing to placate
his jealousy and his
terror at now being
abandoned even by
his brother, the last
emotional tie remain-
ing to him.

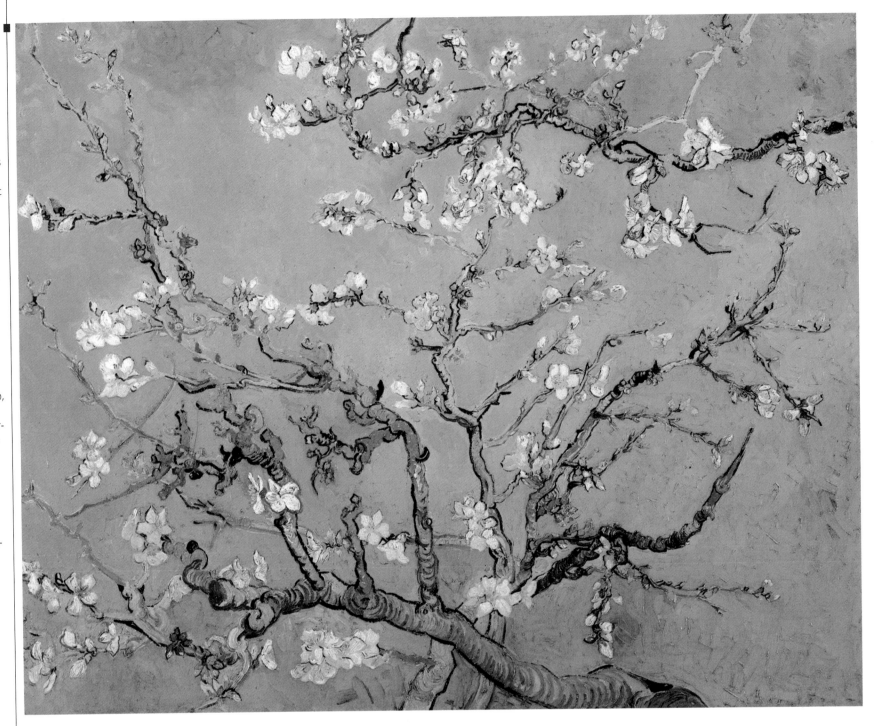

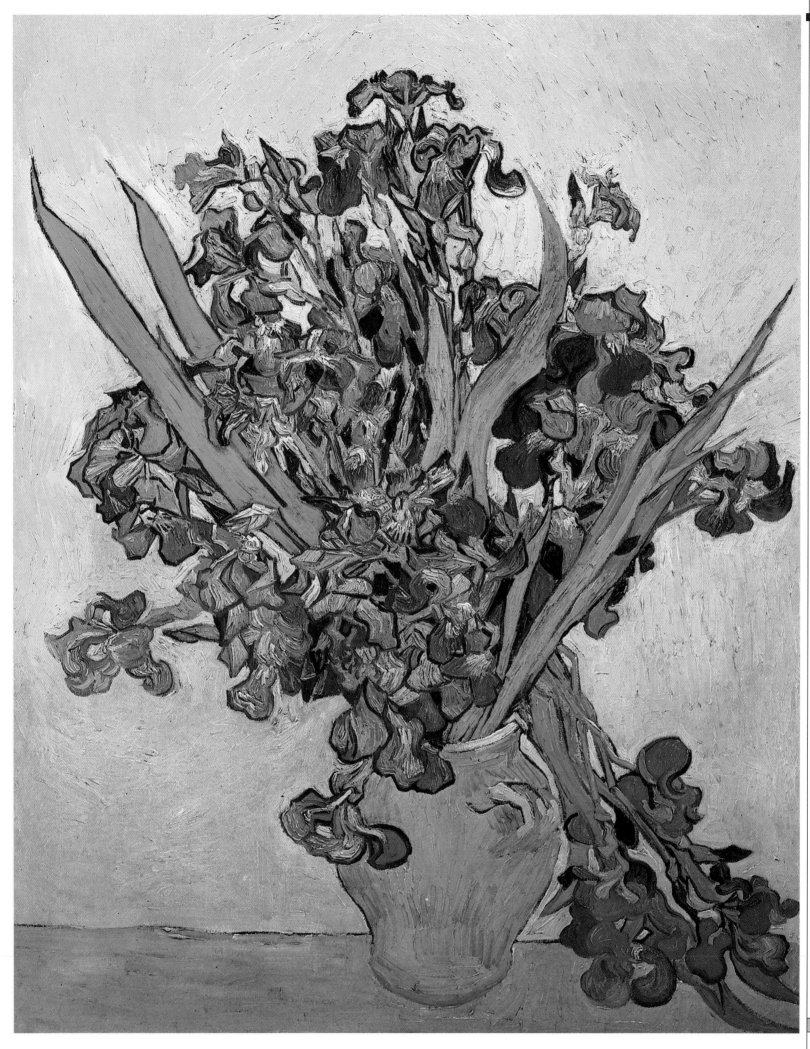

■ VINCENT VAN GOGH
Still Life with Irises
1890, oil on canvas,
92 × 73.5 cm
Rijksmuseum Vincent
van Gogh, Amsterdam

The arrangement of
this painting recalls
that of *Still Life with
Sunflowers* (page 389).
The background is
nearly identical, and
the vase is at least
similar. As in that
painting, the flowers
here are made by
means of shadings of
a single color, yellow
for the sunflowers,
blue for the irises.
The only difference
is the long, swordlike
leaves that brighten
this composition and
give it a sense of
movement. Van Gogh
made four versions of
this, one of which
was sold by Sotheby's
in New York on
November 11, 1987,
for $53.9 million.

VINCENT VAN GOGH
**Prisoners Exercising
(after Gustave Doré)**
1890, oil on canvas,
80 × 64 cm
Pushkin State Museum
of Fine Arts, Moscow

According to various
critics, Van Gogh pre-
sents himself here
in the figure of the
young blond prisoner
at the center of the
composition, the only
one to raise his face
toward the spectator.
In the background,
high against the rear
wall, are two small
white butterflies,
symbolic of Vincent's
longing for freedom.
It seems likely that it
is after seeing this
painting that Theo
decides to seek out
some other arrange-
ment for his brother
and takes Pissarro's
advice to send him
to Auvers-sur-Oise.

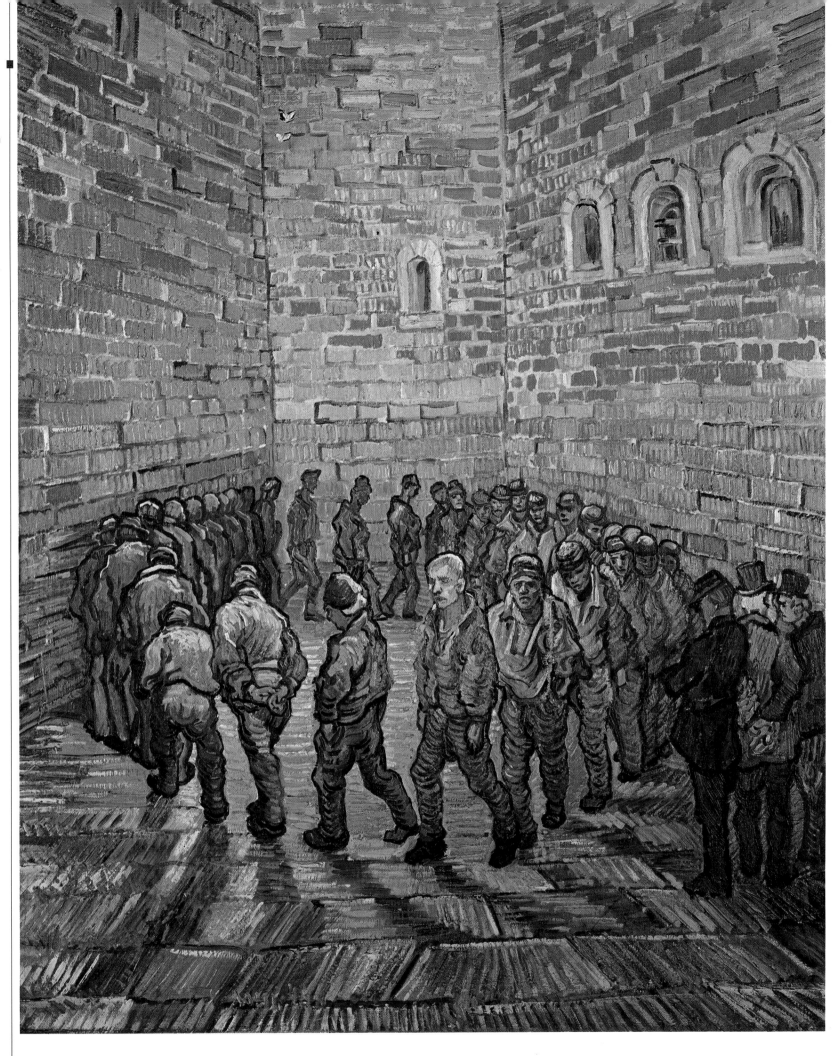

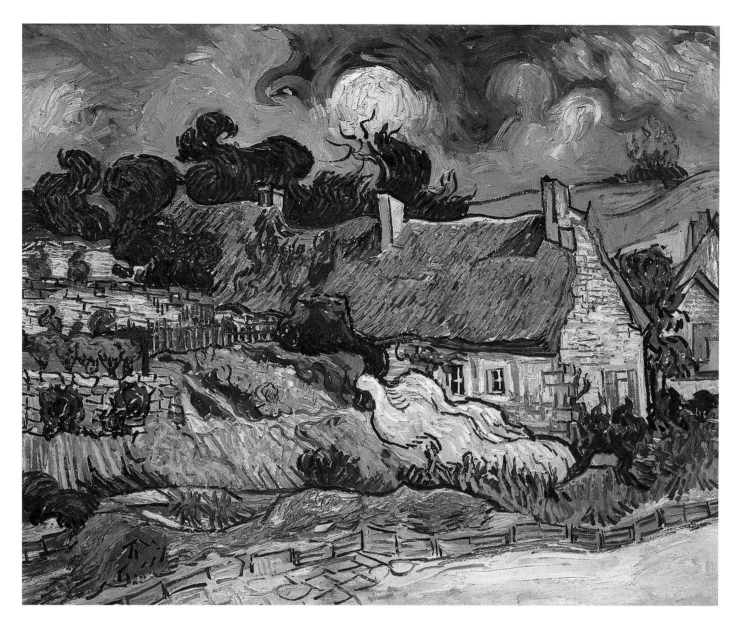

Van Gogh makes this painting at the end of May, after being moved from the asylum of Saint-Rémy to Auvers-sur-Oise. In a letter of that month to Theo he writes, "Here one is far enough from Paris for it to be real country, but nevertheless how changed since Daubigny. Yet not changed in an unpleasant way. There are many villas and various modern bourgeois houses, very radiant and sunny and covered with flowers."

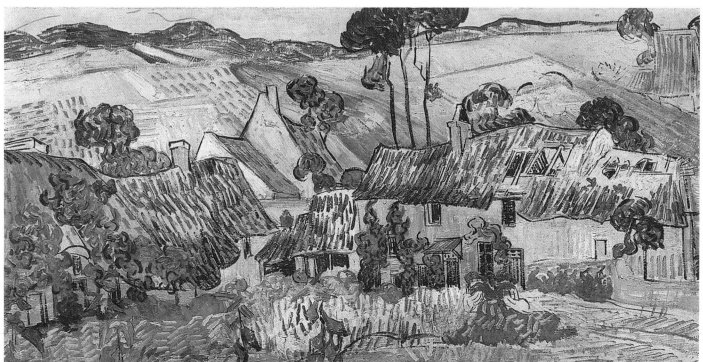

Van Gogh now finds himself in a landscape quite different from that of Provence, nearer in fact to the Dutch countryside of his youth. For this reason he experiments with new stylistic techniques to better render the different structures of the houses and the different illumination of the countryside.

VINCENT VAN GOGH
The Church at Auvers
1890, oil on canvas,
94 × 74 cm
Musée d'Orsay, Paris

Van Gogh's great con-
tribution to modern
art is a new definition
of the pictorial space,
which is no longer
made to suit the
demands of verisimil-
itude but instead
reflects the subjective
state of mind of the
artist. No longer a
mirror of reality, a
painting is a spiritual
dimension on which
the artist expresses
himself and his inner
feelings. The colors
and shapes of this
painting are based
on those found in
reality, but the artist
reforms and rereads
them in a personal
way while also infus-
ing them with other
symbolic meanings.

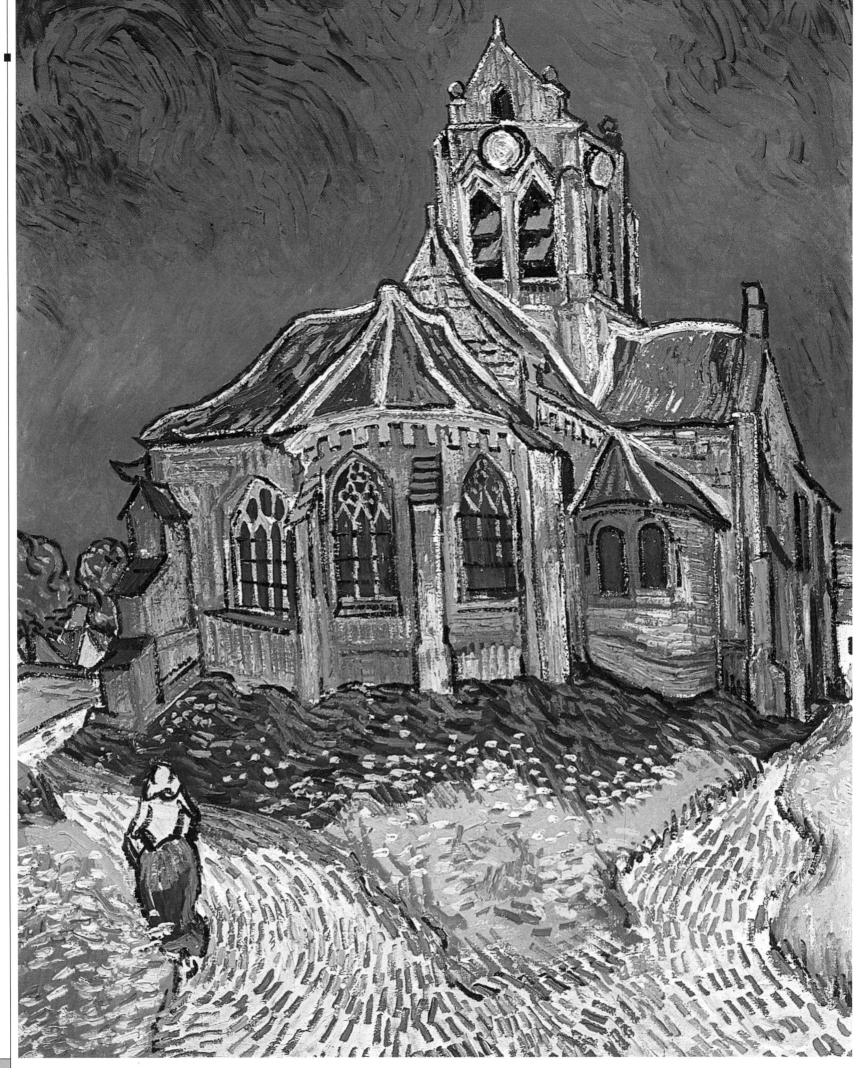

Vincent van Gogh

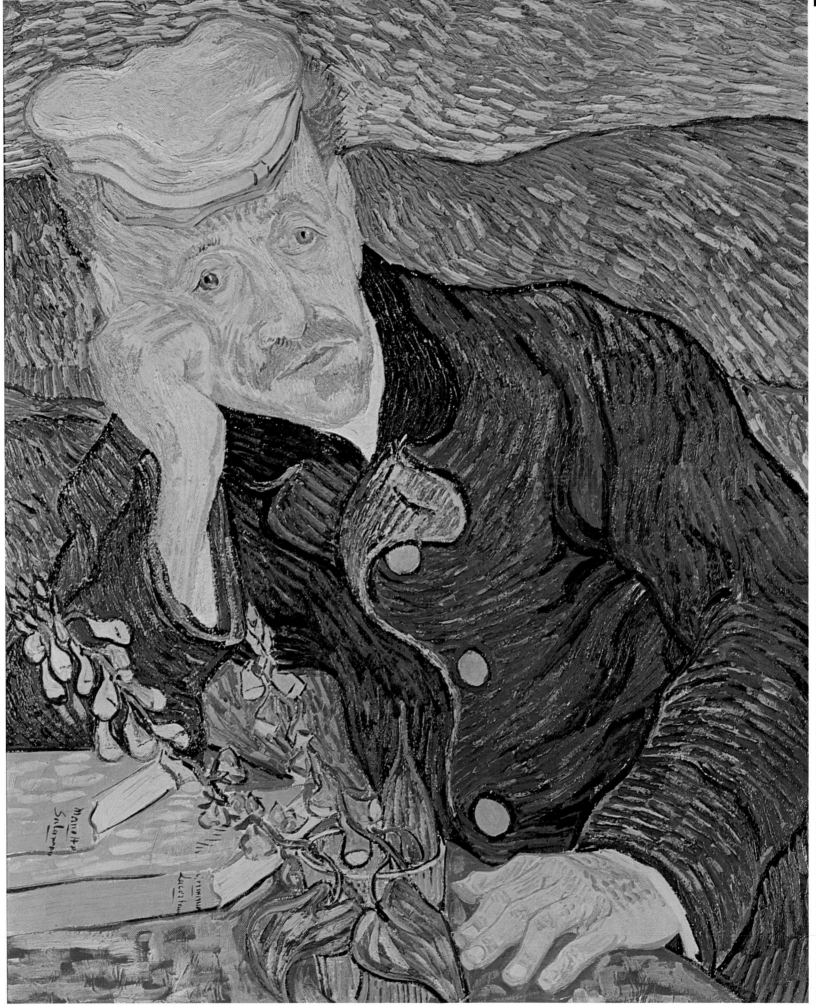

■ VINCENT VAN GOGH
**Portrait of
Doctor Gachet**
1890, oil on canvas,
66 × 57 cm
Private collection

Doctor Paul Ferdinand
Gachet (1828-1909),
a specialist in the
treatment of heart
diseases, is shown
symbolically with a
branch of digitalis.
Familiar with homeo-
pathic medicine,
Gachet has also stud-
ied mental illness.
Passionate about art
and a painter himself,
he has frequented the
Café Guerbois, has
met Impressionist
artists, and numbers
Cézanne, Guillaumin,
Renoir, and Pissarro
among his patients.
This is one of two por-
traits that Van Gogh
makes of him. On May
15, 1990, it is sold at
auction at Christie's
in New York for the
unheard-of sum of
$82.5 million, the
most ever paid for
a painting.

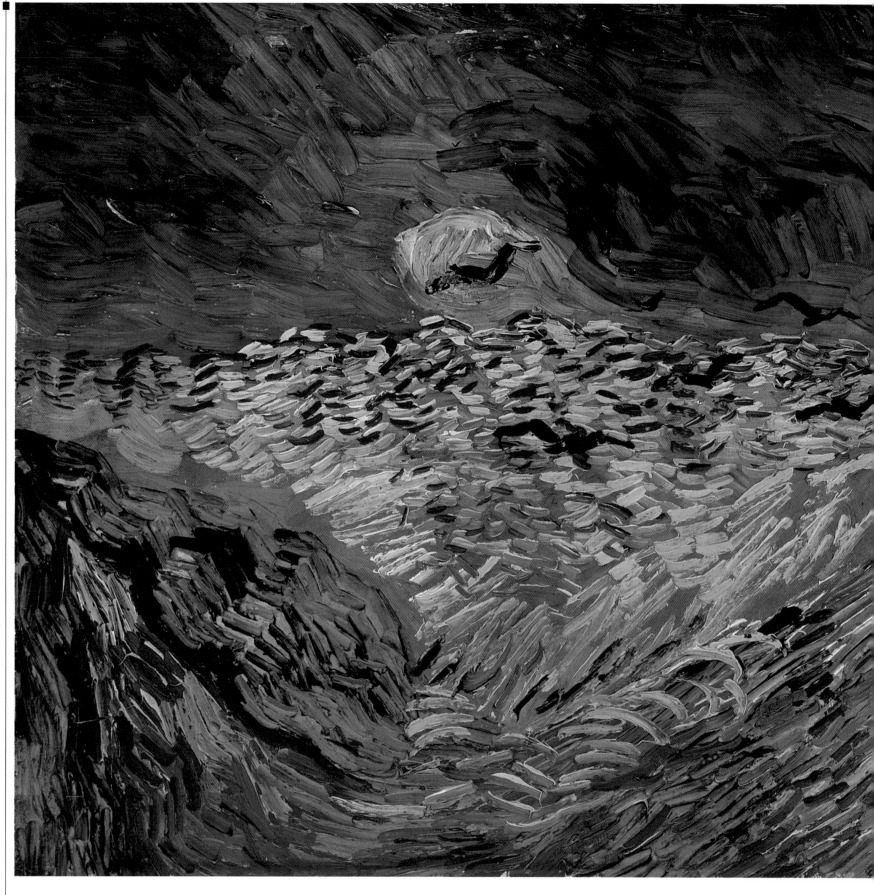

VINCENT VAN GOGH
**Wheatfield
with Crows**
1890, oil on canvas,
50.5 × 100.5 cm
Rijksmuseum Vincent
van Gogh, Amsterdam

This is the last impor-
tant painting Van Gogh
makes before his sui-
cide. From the end of
June into the early
days of July he makes
a series of landscapes
featuring fields of
grain in which delicate
tones predominate in
luminous, solar atmos-
pheres. Here, instead,
the sky is dark and
disturbing; the brush-
strokes, nervous and
angry, convey a sense
of loneliness and des-
peration. The rising
flock of black crows
is a bad omen, a pre-
monition of misfortune
and death. On July 27,
the artist wanders
in these fields, but
instead of shooting at
the crows he directs
the weapon at himself.

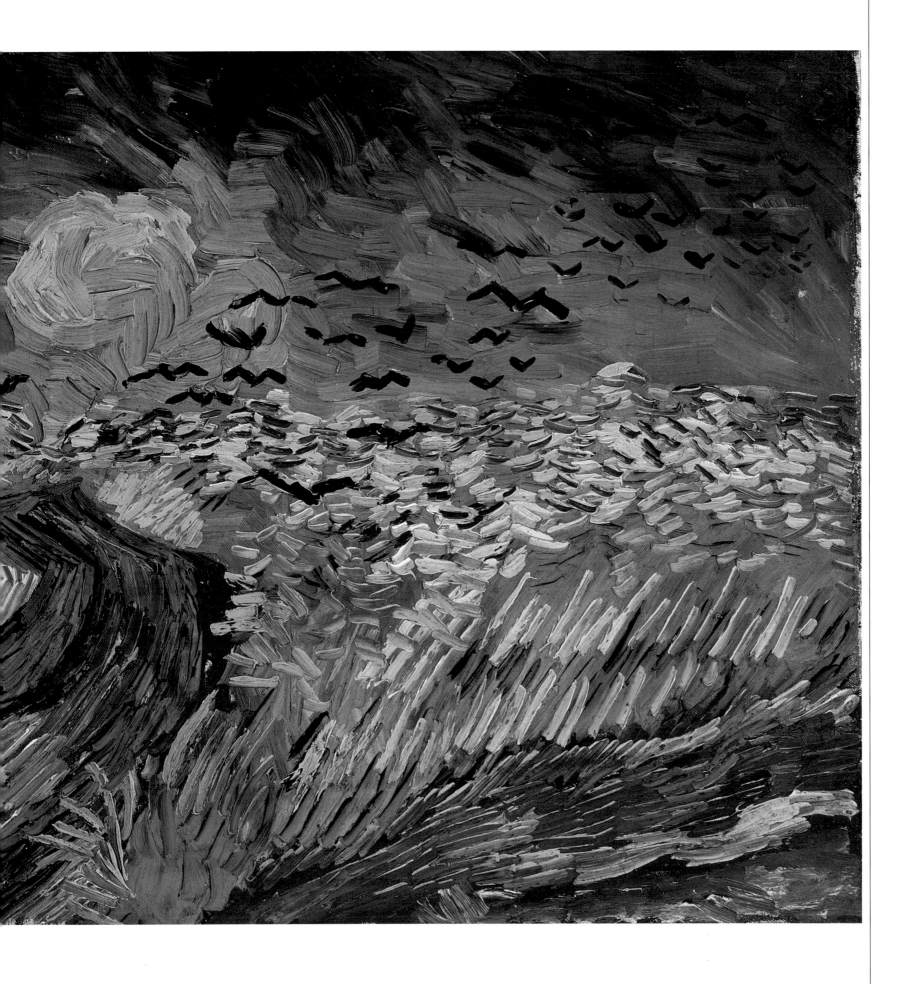

he inclusion of the Impressionists in the commemorative exhibition of nineteenth-century French art during the universal exhibition in Paris in 1889 marks the movement's official consecration. The Impressionists have been accepted by critics and are known to collectors not only in France but throughout the world. The prices paid for their paintings are growing, although not all of them enjoy the same level of commercial success. After 1890, works of Monet, Renoir, and Degas commonly bring 13,000-15,000 francs, but during the same period, landscapes by Sisley or Pissarro do not exceed 1,000. To get an

Pierre-Auguste Renoir in a photo of 1891, at the age of fifty.

Edgar Degas in a self-portrait photograph from the 1890s with his housekeeper Zoe.

Ecole des Beaux-Arts and the Salon. A good example of this occurs in 1889, following a popular subscription organized by Monet and Sargent to buy Manet's *Olympia* and give it to the Louvre; a large number of professors at the Ecole energetically oppose not only the acquisition of the painting by the state but the notion of giving it to the Louvre. Another, even more striking example of this opposition is the long struggle caused by Caillebotte's will. In 1874, following the death of his father, Gustave Caillebotte inherits a very large sum of money, much of which he uses to help his Impressionist friends organize their shows. Over the following years he buys many of their works, assembling an important collection. On November 3, 1876, he draws up his will, and among other clauses he expresses the desire that his collection of Impressionist paintings be given to the state, provided the state makes provisions to display these works in

1890•1900

idea of the buying power of such numbers, it helps to know that in those years a university professor earns a monthly salary of 225 francs; when Gauguin was hired to work in a stock-exchange office not so many years earlier it was at a monthly stipend of 300 francs. One must also bear in mind how other artists were doing. The French painter Jean-Louis Ernest Meissonier (1815–91), whose specialty was large-scale battle scenes or other historical subjects—a famous and powerful man and a bitter enemy of the Impressionists—was getting far higher prices, on average 50,000 francs of more, with an occasional work bringing in even more than that, such as the 336,000 francs paid to him by an American collector in 1887.

Despite a certain level of acceptance, the Impressionists still meet very strong opposition from official academic circles, those tied to the

Gustave Caillebotte photographed in 1891-92 near his home in Petit Gennevilliers.

a manner worthy of their importance, first in the Luxembourg and then in the Louvre. Eight years later, on February 21, 1894, Caillebotte dies, at the age of forty-six. As executors of his will he has named his brother Martial and his close friend Renoir. On March 11, those two men select sixty-five works by eight painters: Millet (two), Cézanne (two), Degas (seven), Manet (three), Monet (16), Pissarro (18), Renoir (eight), and Sisley (nine). These they present to the director of the Musée du Luxembourg, Léonce Bénédite. The plan for the works is looked upon favorably by almost all the specialized press, but it attracts an enraged outcry from the more influential members of the academy, who threaten to quit en masse if the bequest is accepted. Standing out among the most vociferous opponents is Jean-Léon Gérôme (1824–1904), a tireless defender of the academy and a sworn enemy of the Impressionists since their first appearance, so much so that as early

The consecration

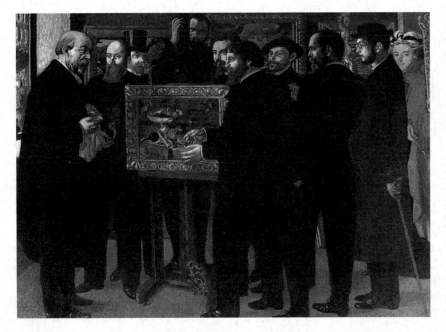

as 1869 Bazille declared: "Gérôme is the source of all our suffering; he treats us like a gang of crazy men and has declared that he sees it as his duty to do everything to prevent us from exhibiting our paintings."

are to be chosen and displayed in the Musée du Luxembourg, along with two other works by Millet, which are to be accepted by the Louvre. On February 9, 1897, the Caillebotte hall in the new wing of the Luxembourg is opened to the public, forming a nucleus of Impressionist paintings in French public collections; but the opening does not pass without protest and rancorous opposition statements. Several conservative deputies try to convince the governor to disassemble the hall and return the paintings, but Henri Roujon, director of the department of plastic arts in the ministry of culture, defends their artistic value and their historic importance, affirming that they "represent a chapter in contemporary art that the state has a duty to display on the walls of its museums."

These fiery disputes between the defenders of the old order and the supporters of the new art reflect the political climate in France during the closing decade of the century. Despite great economic progress made following techno-

Homage to Cézanne, painted by Maurice Denis in 1900 and today in the Musée d'Orsay. This work becomes a symbol of the redemption of the Impressionists.

Claude Monet in a photograph from 1898.

The consecration

Twenty-five years later nothing has happened to alter this stance, which seems in fact to have hardened, making him affirm that "For the government to accept such rubbish would mean we must be fallen very low indeed." The steering committee of the French national museums accepts the Caillebotte bequest, but only of certain paintings; furthermore, fearful of the reaction from academics it makes no effort to display the works, as had been explicitly stated in the will. Martial Caillebotte and Renoir begin long and tedious negotiations that end with a compromise, on February 26, 1896. According to a notary act between the state administrators and the executors of the will, forty works

logical and industrial developments, the country is still sharply divided and agitated, with important issues yet to be resolved, including the quarrel between church and state and the disputes between republicans and monarchists. In 1891, for example, the royalist, ardent nationalist, and would-be dictator Georges Boulanger commits suicide in exile in Brussels. In 1892, Pope Leo XIII intervenes personally to ask French Catholics to collaborate with the republic, this being an attempt to relieve some of the tension between the French church and France's anticlericals. That same year sees the Panama Canal scandal, which reveals corruption among many politicians and financiers; the bankruptcy of the

Camille Pissarro in a photograph by the 1890s.

One of the last
pictures of Cézanne,
working *en plein air*
on a hillside in Aix-
en-Provence.

Right: Pierre-Auguste
Renoir with his son
Jean in a photo
from the last years
of his life.

friends. Many politicians and intellectuals take action in defense of Dreyfus, including Emile Zola, whose famous 1898 article "J'accuse" helps obtain a revision of the case, leading to the rehabilitation of the officer (later exonerated) and marking a victory of civilian power over the military.

At most, these events have very marginal effects on the personal lives of the Impressionists, who by this time pass only brief periods of the year in Paris. For the most part, they move from place to place in France in response to requests from their patrons, whose number grows greater year by year, or in search of new subjects for their paintings. It is during this decade that the creation of series of paintings of the same subject takes on its true importance within their careers; the habit was there in the past, but to a far lesser degree. Ever since they first set up easels outdoors to paint *en plein air*, they have realized that reality varies enormously according to the intensity of light. For this reason they often make many paintings of the same subject at different times of the day or under different weather conditions, creating series of works on the same subject. Among the many examples of this are the almost three hundred city views by Pissarro, works that are divided in eleven series set in four cities: Paris, Rouen, Dieppe, and Le Havre. Better known is the case of Monet. As early as 1883 the writer Guy de Maupassant describes him "setting out along the beach at Étretat followed by children carrying five or six canvases that he has already started with views of the same motif seen at different times and under different conditions. Monet works first on one, then on another, according to the light, lying in wait for a particular gleam or the passage of a cloud, then nabbing it with a few strokes of his brush." During the winter months of 1892–93 Monet works from a studio in Rouen and sets up his easel right in front of a window facing the façade of the cathedral. From this fixed position, he patiently studies the effects of light on the intricate Gothic structure, creating a great quantity of drawings that will serve him as models for oil paintings, which he then completes at Giverny in 1894. One year later, Durand-Ruel organizes a special show in which he displays twenty of the fifty canvas

corporation founded by Ferdinand de Lesseps in 1879 leads to the suspension of work on the canal, which began in 1881. The project is later taken over by the United States and completed in 1914, with serious losses to France in terms of both money and prestige. On June 24, 1894, the president of the Third Republic, Sadi Carnot—one of the few French leaders untainted by the scandals of the time—is murdered by an anarchist. Several intellectuals known for their socialist sympathies are arrested, including the painter Maximilien Luce and the critic Félix Fénéon, and Pissarro takes refuge in Belgium for a few months. Between 1894 and 1895 the socialists create the first forms of organized trade unions, adding tension to their already strained relationship with the government and industrialists.

Most of all, these are the years of the Dreyfus Affair, named for the French staff officer convicted of treason by a court-martial and sentenced to deportation for life. The case becomes a major political issue and divides Frenchmen into two factions, for and against. Since Dreyfus is Jewish, the case involves more than a little anti-Semitism. Pissarro, son of a Portuguese Jew, is among the victims; Degas believes himself forced to break every tie with his Jewish

Monet has made, arranging the works to form a sequence running from dawn to dusk. The critic Clemenceau writes, "The painter gives us the feeling that there could just as easily have been fifty, or a hundred, or a thousand canvases, or as many as there are minutes in a life." Monet himself has this to say of the concept: "For me, the subject is not important; what I want to reproduce is what goes on between me and the subject." This could apply equally well to the ballerinas by

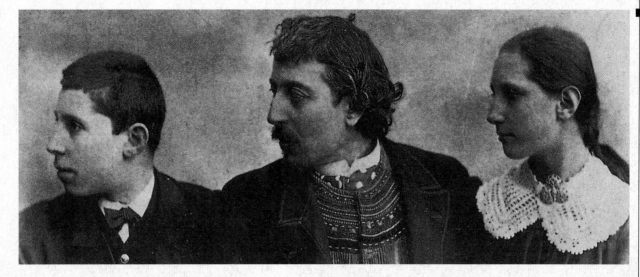

Degas, the bathers by Renoir, the rivers views by Sisley, and the landscapes and still lifes by Cézanne. The painter approaches reality with the intention of presenting it with the greatest possible fidelity. It is in that precise moment, however, that the painter realizes that reality is never the same but changes according to meteorological conditions or the season of the year or the hour of the day. Even the angle of view chosen can cause differ-

ent effects, and even the state of mind of the artist, which can give greater or lesser importance to light or to shadow. In the end, the artist is aware that his painting is not at all a faithful copy of truth but only an "impression" of it, based on how he experienced it and the effect it had on him in the precise moment in which he painted the scene.

By the 1890s, Durand-Ruel is no longer the only art dealer actively trying to increase the popularity of impressionism and increase the value of the works; now there is also Ambroise Vollard. Born in 1868 on the island of Réunion, in the Indian Ocean east of Madagascar, son of a French notary, he moves to France in 1888 to study law at the universities of Montpellier and Paris. He becomes involved in the art market by chance, buying engravings in the shops along the Seine and beginning his apprenticeship as an employee in the gallery of the Unione Artistique. He inaugurates his gallery in Rue Lafitte with a show of drawings by Manet, which is followed by other important shows dedicated to Pissarro, Renoir, Degas, and Rodin, each show increasing the artist's fame and strengthening his relationships with collectors. On the advice of Maurice Denis, Vollard takes an interest in the work of Cézanne, who has spent the last several years living off on his own, very nearly ignored. In 1895, Vollard presents the first large show of Cézanne's works, and it meets with immediate success and attracts the attention of critics. Vollard continues to follow the avant-garde in painting, and in coming years will display the works of Van Gogh, Bonnard, Vuillard, Matisse, and Picasso.

The century ends with another universal exhibition in Paris, once again designed to celebrate the technological and cultural greatness of France. Paintings by the Impressionists are displayed in a special section, admired and praised by almost all the critics. In August 1900 Renoir, who had ten paintings in the exhibition, is made Chevalier of the Legion of Honor. In that same year Maurice Denis makes his *Homage to Cézanne*, a work symbolic of the admiration a new generation of French artists have for the work of the Impressionists.

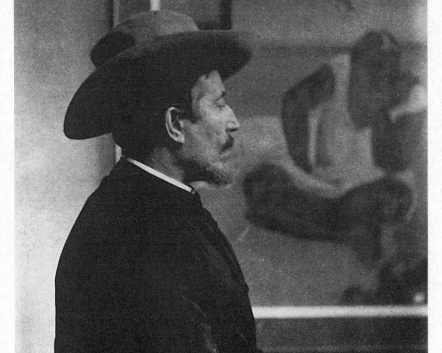

PIERRE-AUGUSTE
RENOIR
**The Children of
Martial Caillebotte**
1895, oil on canvas,
65 × 82 cm
Private collection

The subjects of this
canvas, one of the
sweetest by Renoir,
are Jean and
Geneviève, the son
and daughter of
Martial Caillebotte,
Gustave's brother.
Renoir presents the
children from very
close up, leaving little
space for the vase in
the background and
using a few, quick
brushstrokes to create
the books on the lit-
tle girl's knees. The
work dates to the
months during which
Renoir and Martial are
busy with the difficult
negotiations related
to Gustave's hotly
contested bequest of
his paintings to the
state of France. The
experience cements
their friendship such
that in the summer
of 1896 the two take
a trip together to
Bayreuth and Dresden.

■ PIERRE-AUGUSTE
RENOIR
**Jean Playing with
Gabrielle and a Girl**
1895–96, oil
on canvas,
65 × 80 cm
Norton Simon
Collection, Los Angeles

The little boy is
Renoir's second-born
child, Jean, born
September 15, 1894,
and destined to
achieve fame of his
own as a film director.
He is being held by
Gabrielle Renard
(1879–1959), a dis-
tant cousin of Aline
Charigot, Renoir's
wife, who has been
staying in the Renoir
home to help Aline
through her second
pregnancy. Gabrielle
will be Renoir's
favorite model for
more than twenty
years, until 1914,
when she marries the
American painter
Conrad Hensler Slade.
The young girl offer-
ing Jean the fruit has
not been identified.

PIERRE-AUGUSTE
RENOIR
**Yvonne and Christine
Lerolle at the Piano**
1897, oil on canvas,
73 × 92 cm
Musée de l'Orangerie,
Paris

In 1892 Renoir makes
three paintings of
pairs of girls seated
at a piano. This can-
vas has a horizontal
rather than vertical
layout and instead
of using professional
models it portrays
the two daughters of
Henry Lerolle (1852–
1929), a painter,
collector, and music
lover: Christine (on
the right) and Yvonne.
The girls will soon
marry the sons of
Henri Rouart, while
their brother, Ernest,
will marry Julie,
daughter of Berthe
Morisot and Eugène
Manet. Visible on
the wall are two
paintings by Degas
from Lerolle's
collection.

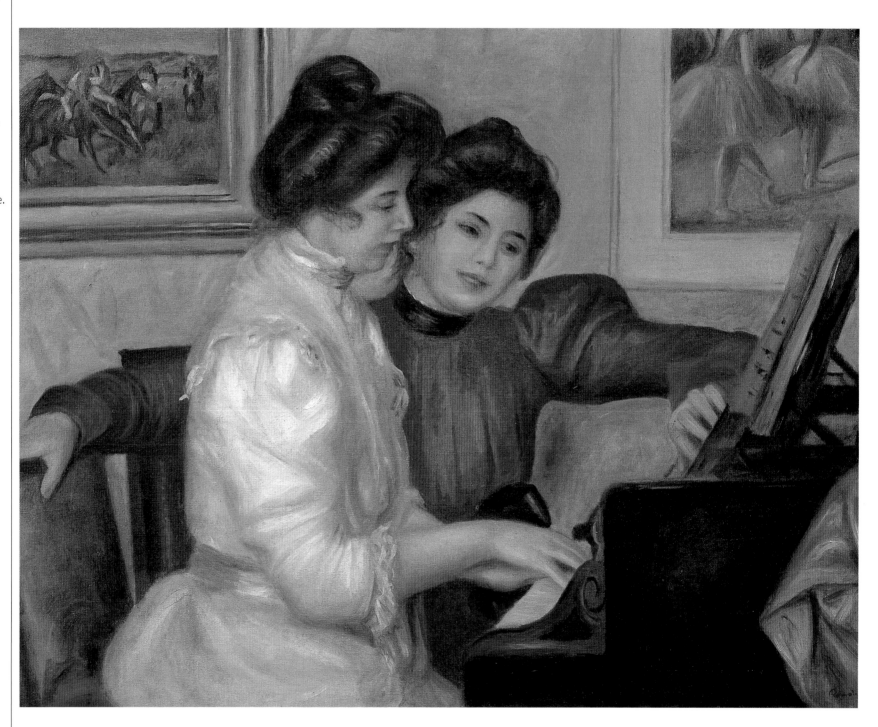

MARY CASSATT
The Boating Party
1893–94, oil
on canvas,
90.2 × 117.5 cm
National Gallery of
Art, Washington, D.C.

In 1892 Cassatt is
busy making a large
mural for the universal
exhibition to be held
in Chicago in 1893.
Although long and tir-
ing, the undertaking
offers her the oppor-
tunity to experiment
with new techniques
and to direct her style
toward a more monu-
mental plasticity. This
is clearly evident in
this composition, both
in the figures and in
the daring perspective
of the boat. Although
she herself never has
children—or perhaps
for that very reason—
Cassatt often portrays
mothers and babies
and does so with a
tenderness that adds
to the extreme fasci-
nation of her work.

CLAUDE MONET
**Haystack
(Snow Effect)**
1890–91, oil
on canvas,
65 × 92 cm
Museum of Fine Arts,
Boston

His series of haystacks permits Monet to call attention to the fundamental importance of light in his paintings. Light is the true protagonist of these works, as it enlivens colors or mutes them, reveals certain details or hides them. Indeed the true subject of Monet's paintings is never the haystacks (or the poplars or the cathedral's façade) but rather the particular moment in which they appear, as he makes clear in the titles he gives the works. In this way he emphasizes the fleeting instant, unique and unrepeatable, and with it the inseparable bond between reality and the painter's eye.

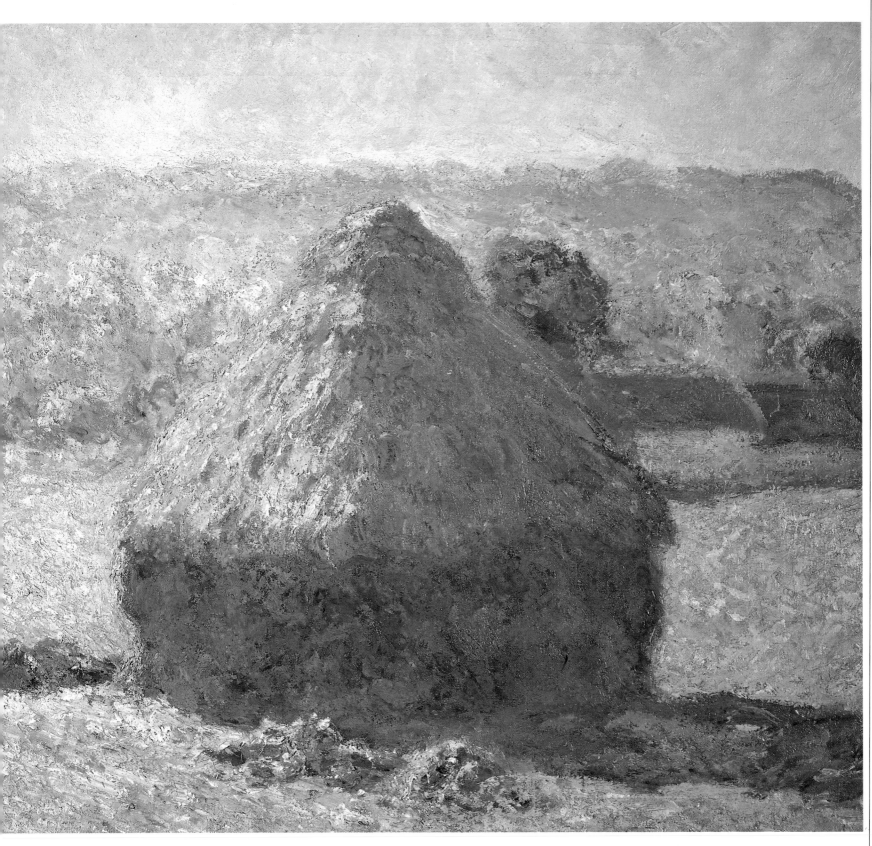

■ CLAUDE MONET
**Haystacks
(Later Summer;
Morning Effect)**
1890–91, oil
on canvas,
60.5 × 100.5 cm
Musée d'Orsay, Paris

Monet is busy with the
series of haystacks
from 1889 to 1893.
He is attracted to them
by their simple shape
and by the infinite
variations in tone that
the hay assumes over
the course of a day
and under different
weather conditions.
He begins work on
most of these paint-
ings in the summer
of 1890 and finishes
them in his studio in
Giverny in the early
months of the follow-
ing year. In May 1891
Paul Durand-Ruel
organizes a show of
twenty-two paintings
by Monet, fifteen of
which are haystacks.
The haystacks are sold
at prices of between
three and four thou-
sand francs each.

CLAUDE MONET
Poplars (Summer)
1891, oil on canvas,
93 × 73 cm
National Museum of
Western Art, Tokyo

Unlike the short,
stumpy haystacks,
poplars are gracefully
tall and thin. Monet
chooses various points
of view and presents
the trees from differ-
ent perspectives so
that their lines vari-
ously converge,
diverge, mirror one
another, run parallel,
or cross. In this way
he seeks to make the
viewer understand
how each different
arrangement changes
the rhythm of the
entire composition,
radically altering the
relationship between
light and color. In
this version he leaves
room for the sky,
trees, and plants to
be reflected on the
surface of the river
water, making use
of a highly effective
technique.

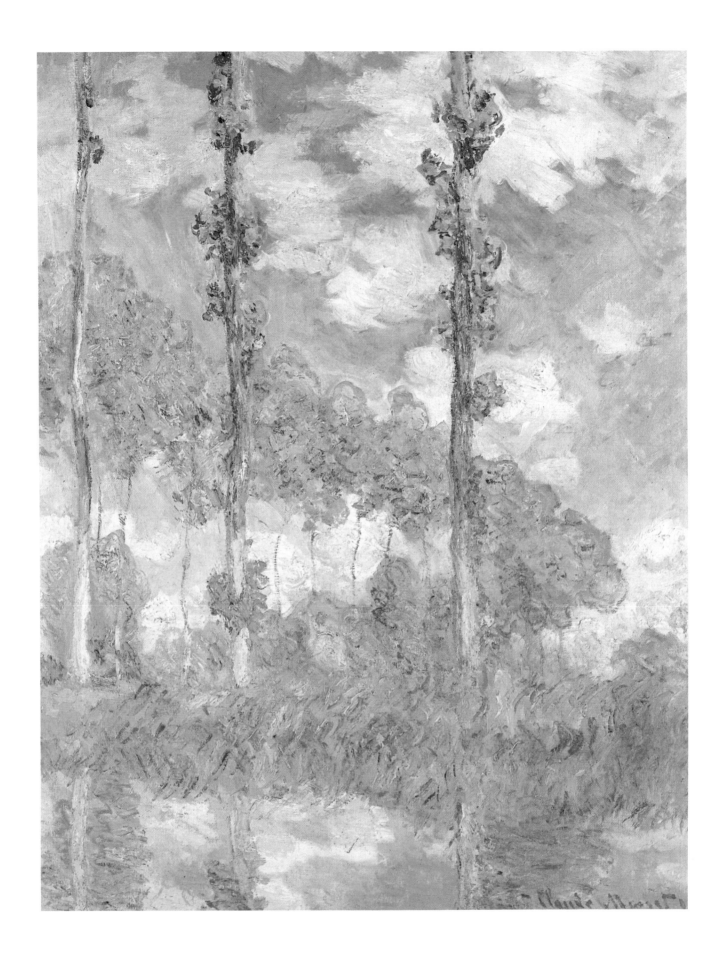

The consecration

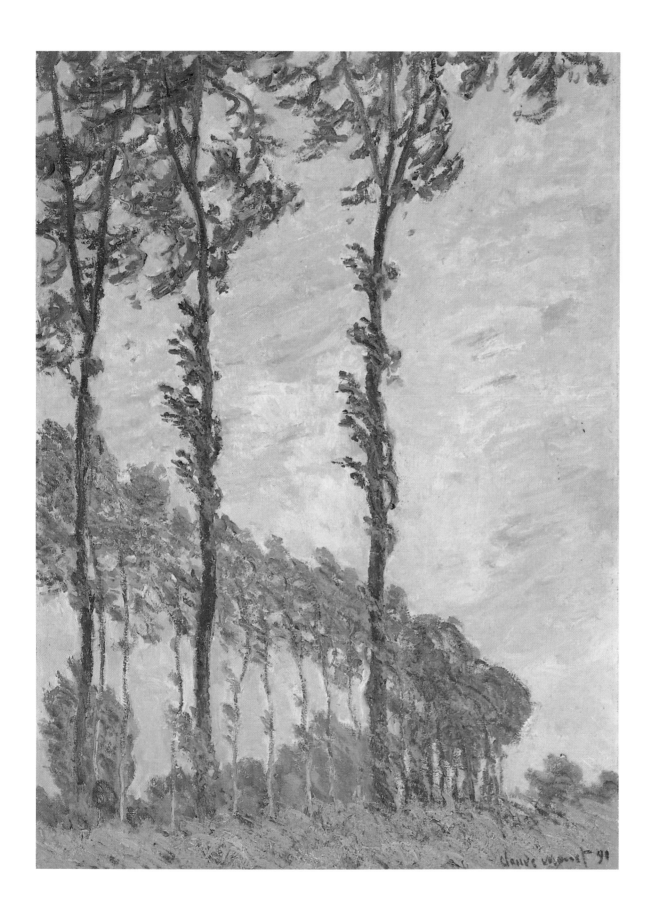

■ CLAUDE MONET
Poplars (Wind Effect)
1891, oil on canvas,
100 × 73 cm
Private collection

As models for his series
of poplars Monet uses
a stand of trees along
the banks of the Epte
River, not far from
Giverny. Just as he
begins work on the
paintings he learns
that the trees are
about to be cut down,
the wood sold at
auction. He goes to
the mayor and asks
him to cancel or at
least postpone the
decision, but the
mayor says there is
nothing he can do.
Monet then contacts
the probable buyers
and asks them to
grant him at least
enough time to finish
his paintings.

**Rouen Cathedral
(Sunset Effect)**
1892–94, oil
on canvas,
100 × 65 cm
Musée Marmottan,
Paris

In the winter months
between 1892 and
1893 Monet rents a
large apartment in
Rouen on the second
floor over the Au
Caprice store in Rue
du Grand Pont,
directly opposite
the western façade
of the cathedral.
With tireless patience
he records the alter-
ations in light and
shadow over the
changing hours of the
day, making a large
number of preparatory
drawings that he then
uses to begin fifty
paintings of almost
identical size, which
he makes all at the
same time and com-
pletes the next year in
his studio in Giverny.

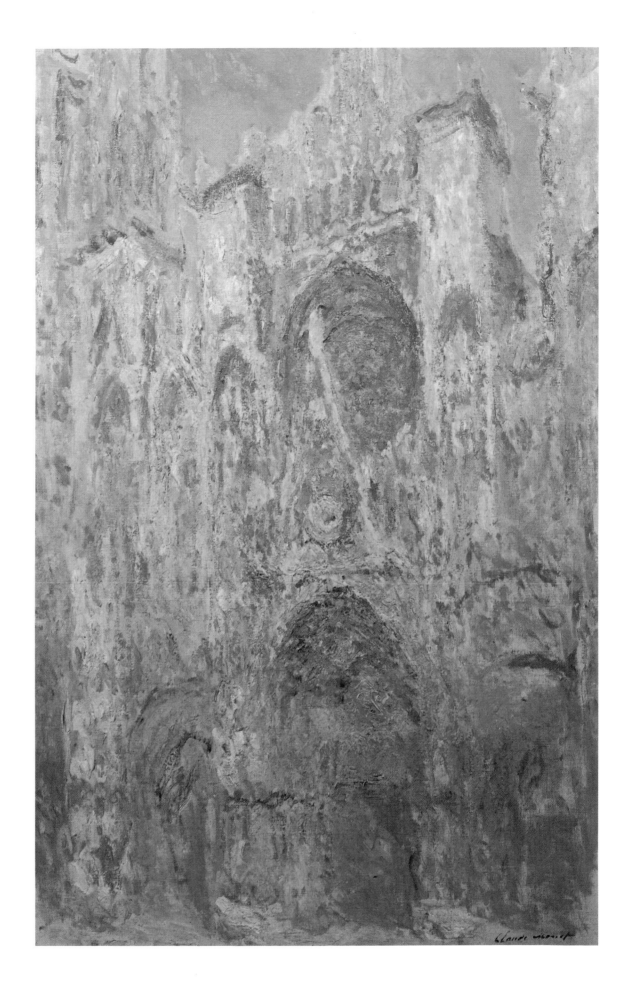

The consecration

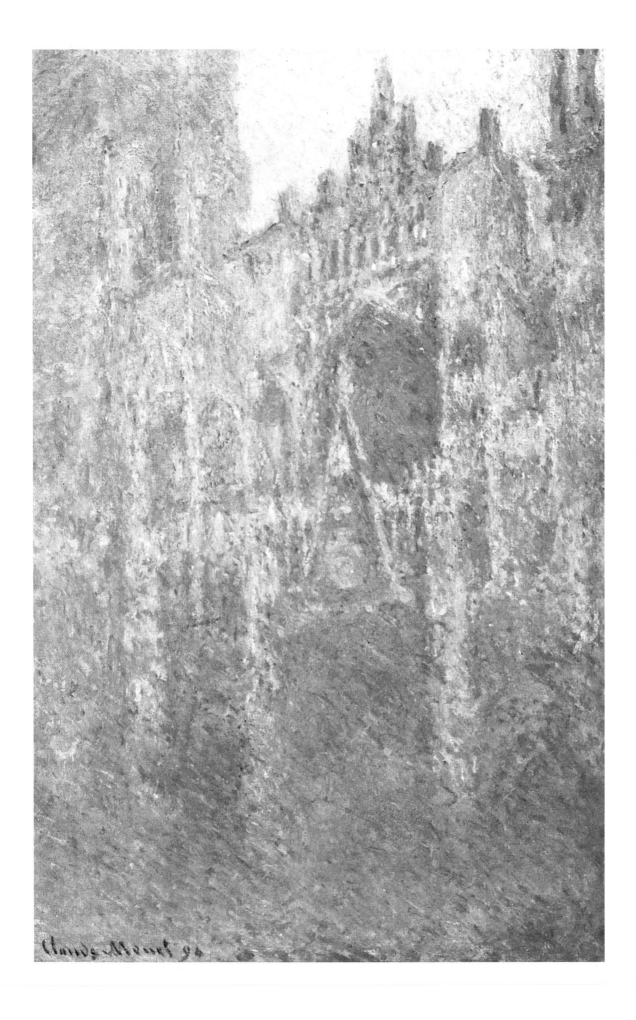

■ CLAUDE MONET
**Rouen Cathedral
(Morning Effect)**
1892–94, oil
on canvas,
100 × 65 cm
Folkwang Museum,
Essen

In 1895 Durand-Ruel
exhibits twenty of
Monet's fifty canvases
showing the cathedral
of Rouen, arranging
them so as to form
a sequence running
from dawn to dusk.
Echoing the "musical"
titles so dear to
Whistler, Monet gives
the series a subtitle:
*Harmony in Blue and
Gold*. The paintings
attract a good deal
of ferocious negative
criticism from several
journalists, in response
to which, on May 20,
1895, writing in the
magazine *Justice,* the
critic Georges Clemen-
ceau defends the
paintings and claims
that they can be divid-
ed into four distinct
pictorial moments
characterized by the
prevalence of a single
color or effect: gray,
white, iridescent,
and blue.

EDGAR DEGAS
**Race Horses
in a Landscape**
1894, pastel on paper,
48.9 × 62.8 cm
Thyssen-Bornemisza
Collection, Madrid

The spectator's attention is drawn to the colors of the jerseys worn by the jockeys and to the carefully rendered bodies of the horses, presented in different positions. Rather than set them inside a racetrack, as he had done several years earlier, Degas prefers to present them against a broad, rolling countryside illuminated by strong, direct light that accentuates the sense of depth. Using pastels enables him to soften the tones and give preference to the emotive effects over the purely descriptive.

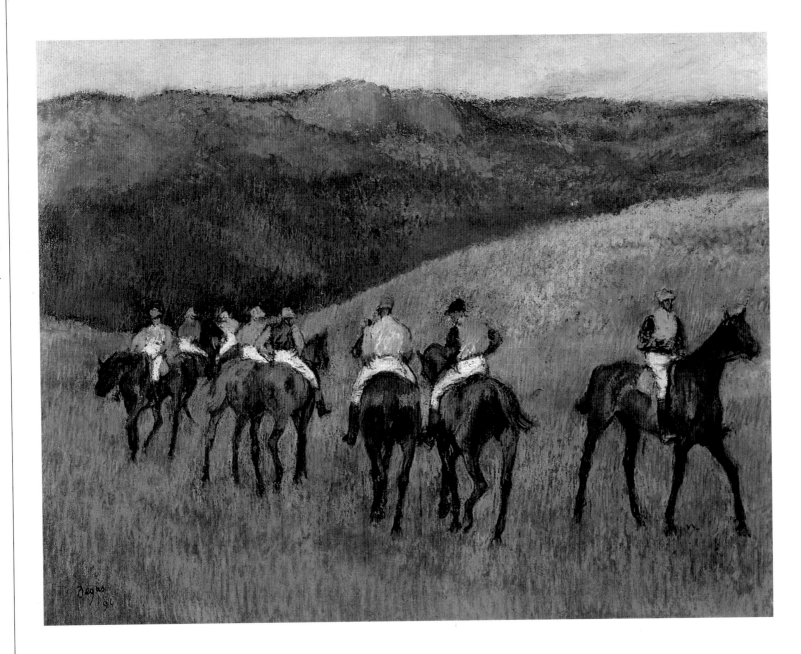

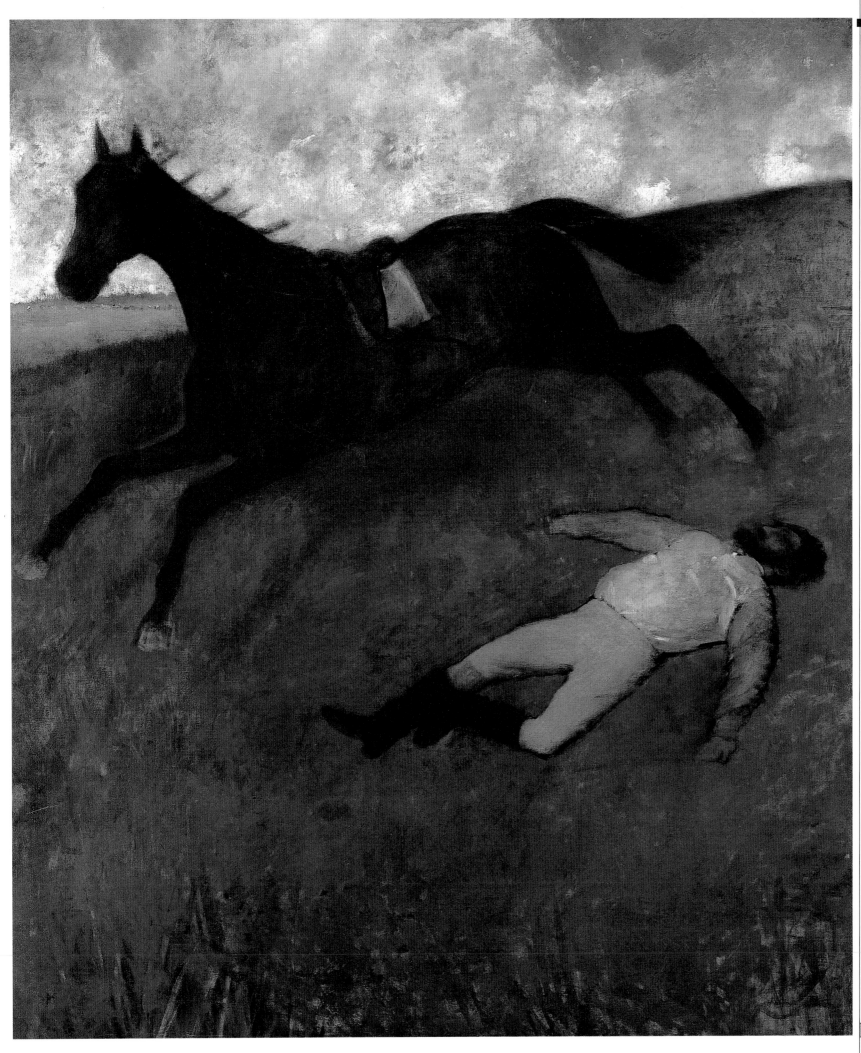

■ EDGAR DEGAS
Fallen Jockey
1896–98, oil
on canvas,
181 × 151 cm
Kunstmuseum, Basel

In this work Degas
repeats a subject
from one of his earli-
est paintings, *The
Steeplechase*, made
thirty years earlier, in
1866. There are many
differences between
the two compositions.
Degas has eliminated
the other horses and
riders, leaving a single
animal and the victim
of a fall, supine on
the ground. He has
also simplified the
landscape and made
use of darker, colder
colors that heighten
the sense of drama in
the scene. The anato-
my of the horse is far
more precise, a result
of the studies he made
during the 1880s, most
of all because of his
interest in sculpture.

EDGAR DEGAS
**Henri Rouart and
His Son Alexis**
1895–98, oil
on canvas,
92 × 72 cm
Neue Pinakothek,
Munich

Although he has par-
ticipated in seven of
the Impressionists'
eight shows, Rouart
has not succeeded in
attaining fame com-
parable to that of the
other artists. Aside
from being a good
painter, he is a pas-
sionate connoisseur
and collector, his
collection including
many works of classi-
cal and modern art.
In this portrait, made
on the basis of a pho-
tograph, Degas does
nothing to disguise
the signs of his friend's
physical decline, while
at the same time suc-
ceeding in commun-
icating his lively
and brilliant intelli-
gence and his warm
humanity.

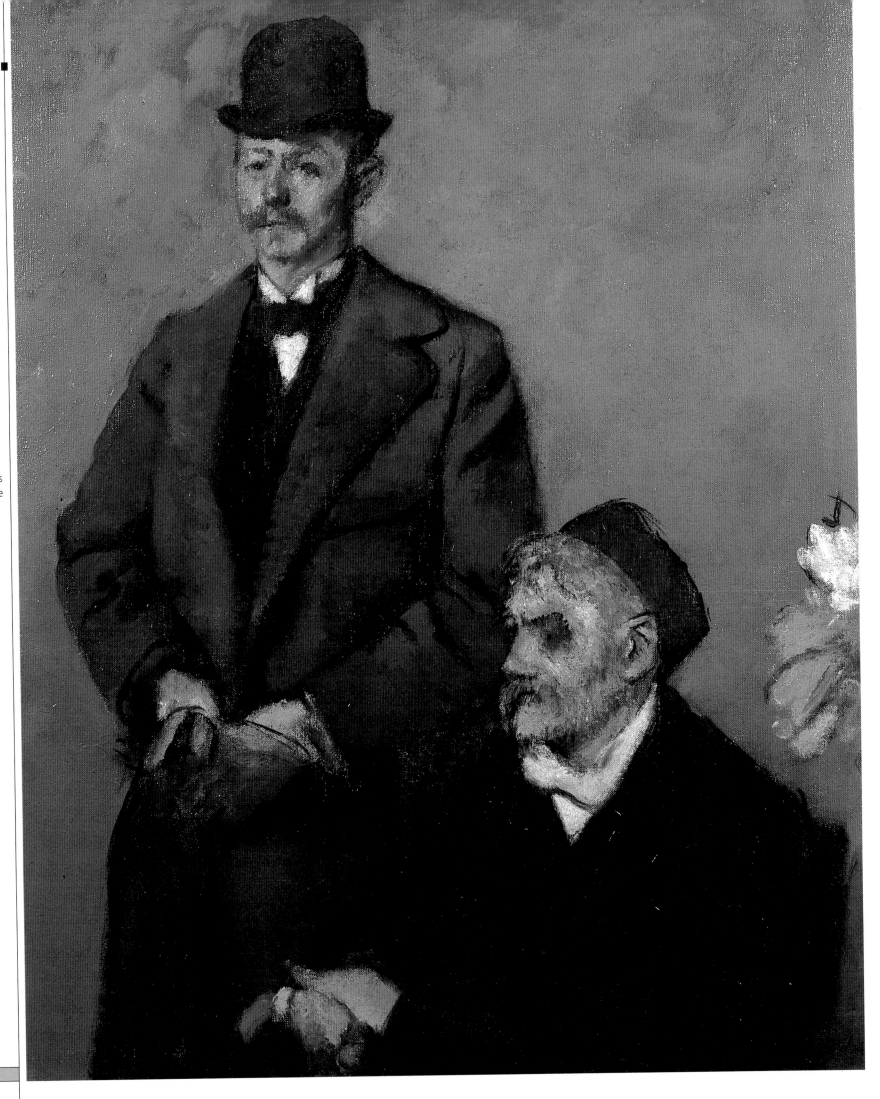

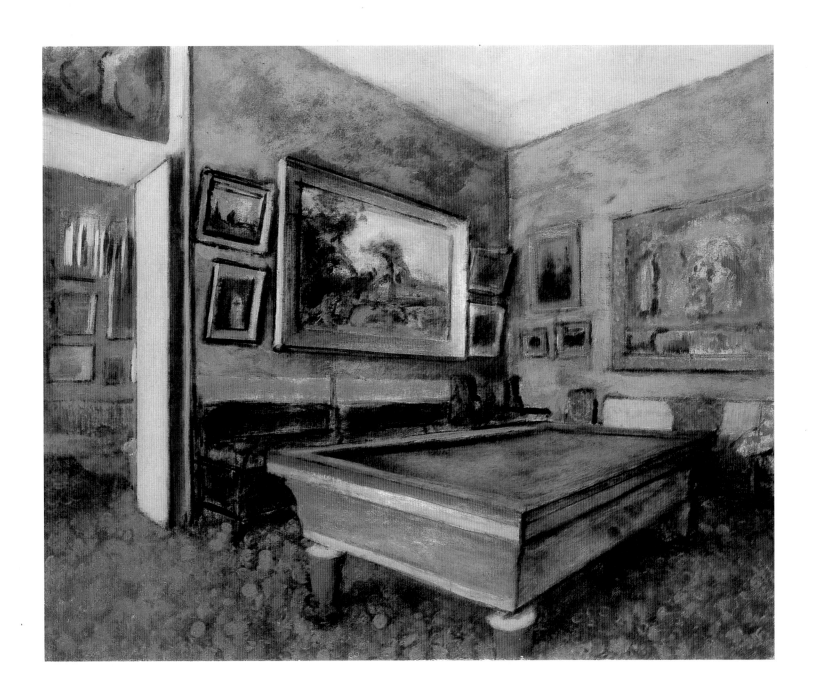

■ EDGAR DEGAS
**Billiards Room
at Ménil-Hubert**
1892, oil on canvas,
65 × 81 cm
Staatsgalerie,
Stuttgart

As he has done many
times in the past,
Degas spends the
summer of 1892 as
the guest of his friend
Paul Valpinçon in his
castle of Ménil-Hubert
in Normandy. While
there he makes several
interior views, notable
for the accuracy of
their line and the
careful use of light.
The diagonal lines
of the billiard table
recall those of the
paintings as well as
those of the benches
along the wall, with
the result that the
room appears far larger
than it is. The absence
of human figures
produces a strangely
absorbed and medi-
tative atmosphere
destined to reappear
decades later in
the works of the
Surrealists.

PAUL CÉZANNE
**Madame Cézanne in
the Yellow Chair**
1890–94, oil
on canvas,
116 × 89 cm
Metropolitan Museum
of Art, New York

This is one of six por-
traits that Cézanne
makes in these years
of Hortense Fiquet, the
woman he is finally
able to marry, over-
coming his father's
last objections, on
April 28, 1886. The
painter opts for a
very simple setting
as background for
his wife: a corner of
their home in Aix-en-
Provence of which we
can make out a small
part of the curtains,
the yellow chair, the
fireplace tongs, frame
of a mirror. Even the
pose and expression
of the woman seem
spontaneous and nat-
ural, communicating a
sense of quiet domes-
tic tranquility.

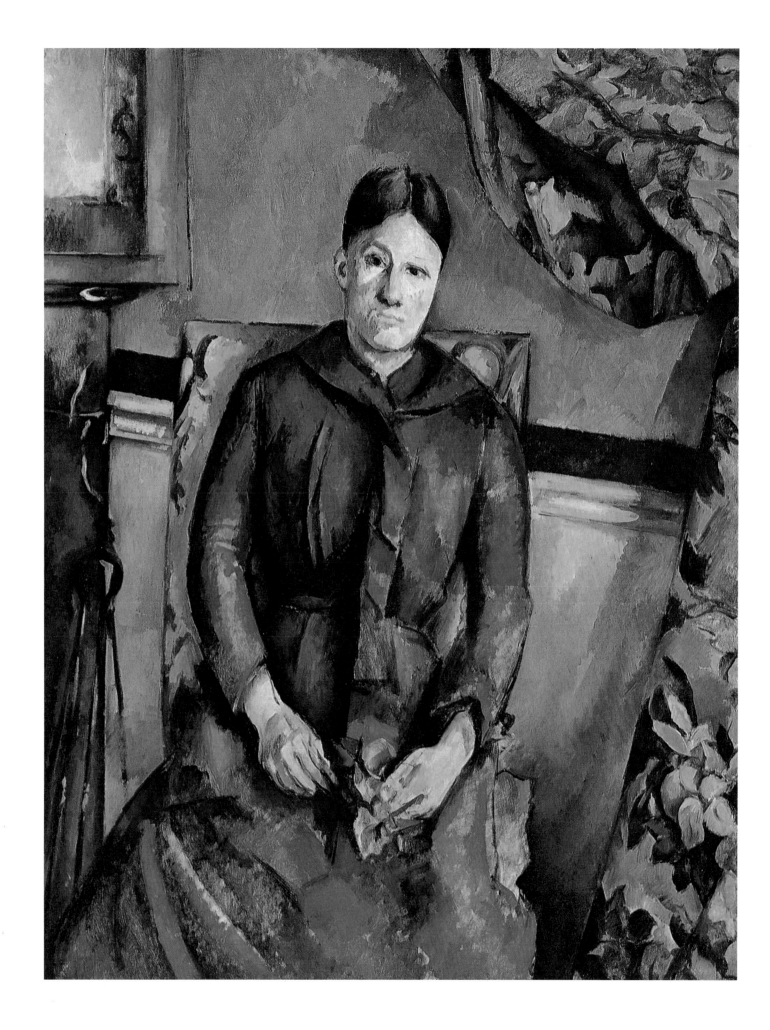

The consecration

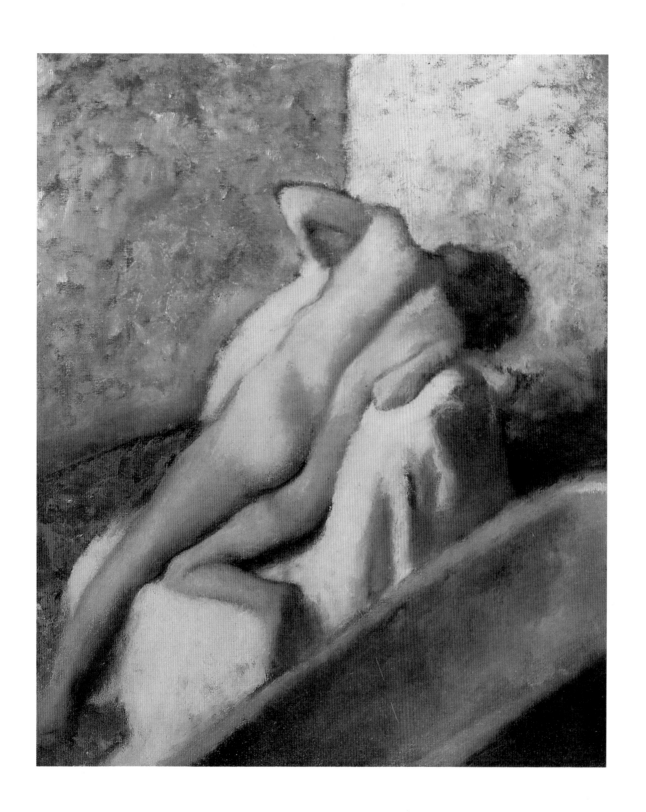

As is his habit, Degas
carefully controls the
layouts of his paint-
ings, making use of
photographs, draw-
ings, and preparatory
sketches. This canvas
is part of a series of
oils and pastels made
between 1894 and
1896 dedicated to
women viewed during
moments of domestic
intimacy, usually while
drying themselves after
a bath. The girl's posi-
tion seems unnatural,
almost forced, but it
permits Degas to show
his skill in the distrib-
ution of light along
with the precision of
his sense of anatomy.

PAUL CÉZANNE
Boy in Red Vest
1890–95, oil
on canvas,
79 × 64 cm
Private collection

Following the death
of their father, on
October 23, 1886,
Cézanne and his two
sisters, Marie and
Rose, inherit more
than 2 million francs.
The painter is finally
able to pay for the
services of profes-
sional models, such
as Michelangelo De
Rosa, an Italian boy
who appears in four
paintings and two
watercolors, always
wearing the same
clothes but presented
from different points
of view. His expres-
sion in this work is
serious if not melan-
choly, an attitude
reflected by the
somewhat abandoned
position of his right
arm, which seems
overly long for the
rest of his body.

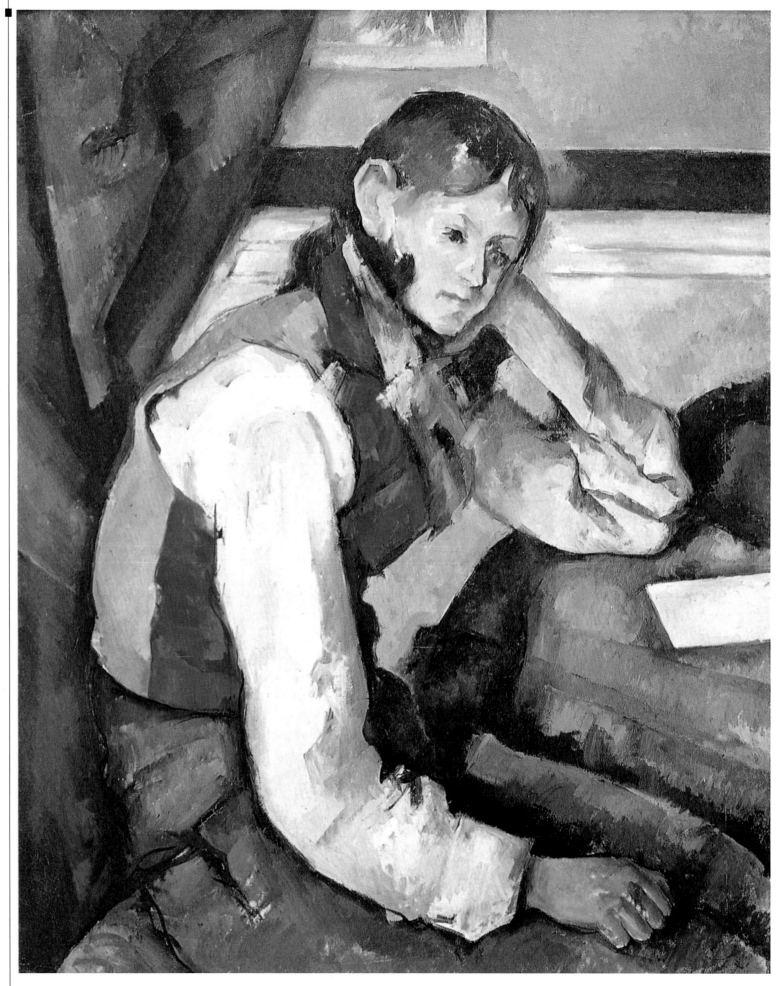

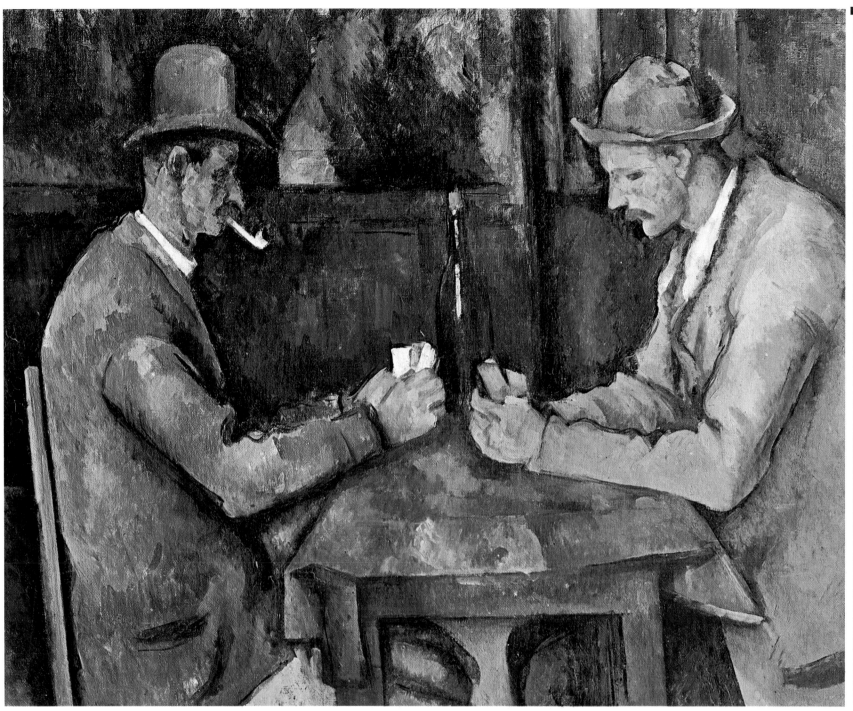

■ PAUL CÉZANNE
The Card Players
1890–92, oil
on canvas,
45 × 57 cm
Musée d'Orsay, Paris

Cézanne takes on the subject of card players between 1890 and 1892, making all told about ten preparatory studies and five oils. The largest of the oil paintings, today in the Barnes Foundation in Merion, has five players; a second version has four; the other three paintings, including this one, are simpler, presenting only two figures. For models the painter uses peasants from his holding in Aix-en-Provence, among them the gardener Alexandre Paulin, known as Père Alexandre, shown here as the man to the left with the pipe.

PAUL GAUGUIN

**Woman with a Flower
(Vahine no te tiare)**

1891, oil on canvas,
70.5 × 46.5 cm
Ny Carlsberg Glypotek,
Copenhagen

On June 9, 1891, fol-
lowing two months
at sea, Gauguin arrives
in Papeete, the main
port of Tahiti. Immedi-
ately upon his arrival,
in an effort to earn
money, he makes por-
traits of the local
European officials,
such as Suzanne
Bambridge. Fluent
in Maori and familiar
with the island, she
serves as his guide,
teaching him about
the island, its inhabi-
tants, and their cus-
toms. For this work,
one of his first por-
traits of Maori women,
Gauguin must first
overcome the girl's
reluctance to pose for
him, but in the end he
succeeds so well he is
even able to convince
her to wear her pretti-
est dress.

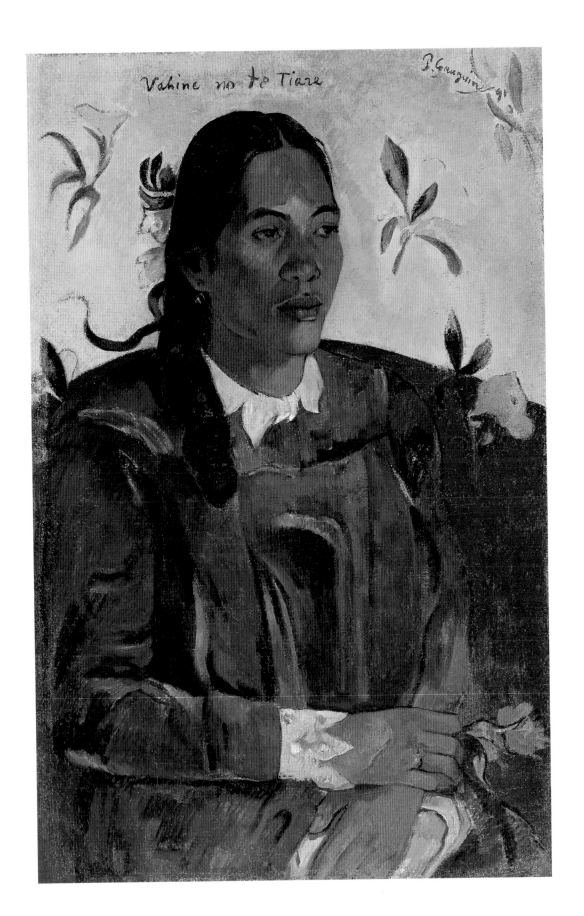

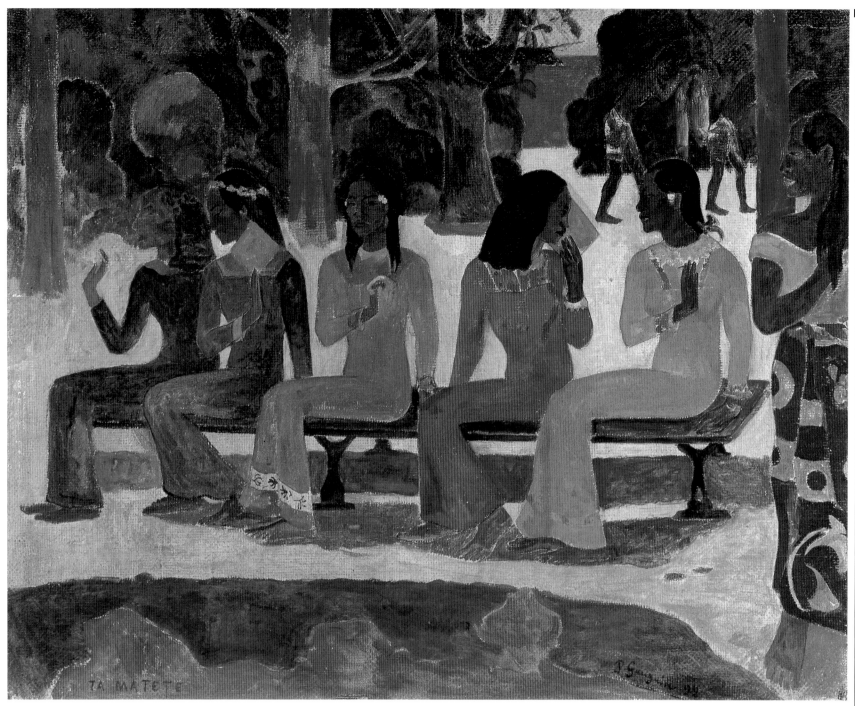

TA MATETE

■ PAUL GAUGUIN
**We Shall Not Go
to Market Today
(Ta matete)**
1892, oil on canvas,
73 × 92 cm
Kunstmuseum, Basel

In this work the artist
takes a scene of daily
Tahitian life and trans-
forms it, loading it
with symbolic mean-
ing. The five seated
women are dressed in
clothes from the local
mission, but their
pose is based on an
Egyptian fresco deco-
rating a Theban tomb
of the XVIII dynasty,
preserved in the British
Museum, of which
Gauguin has a photo-
graph. Their arrange-
ment can also be
compared, although
as a mirror image,
to an Egyptian frieze
in the Louvre that
Gauguin saw during
one of his stays in
Paris.

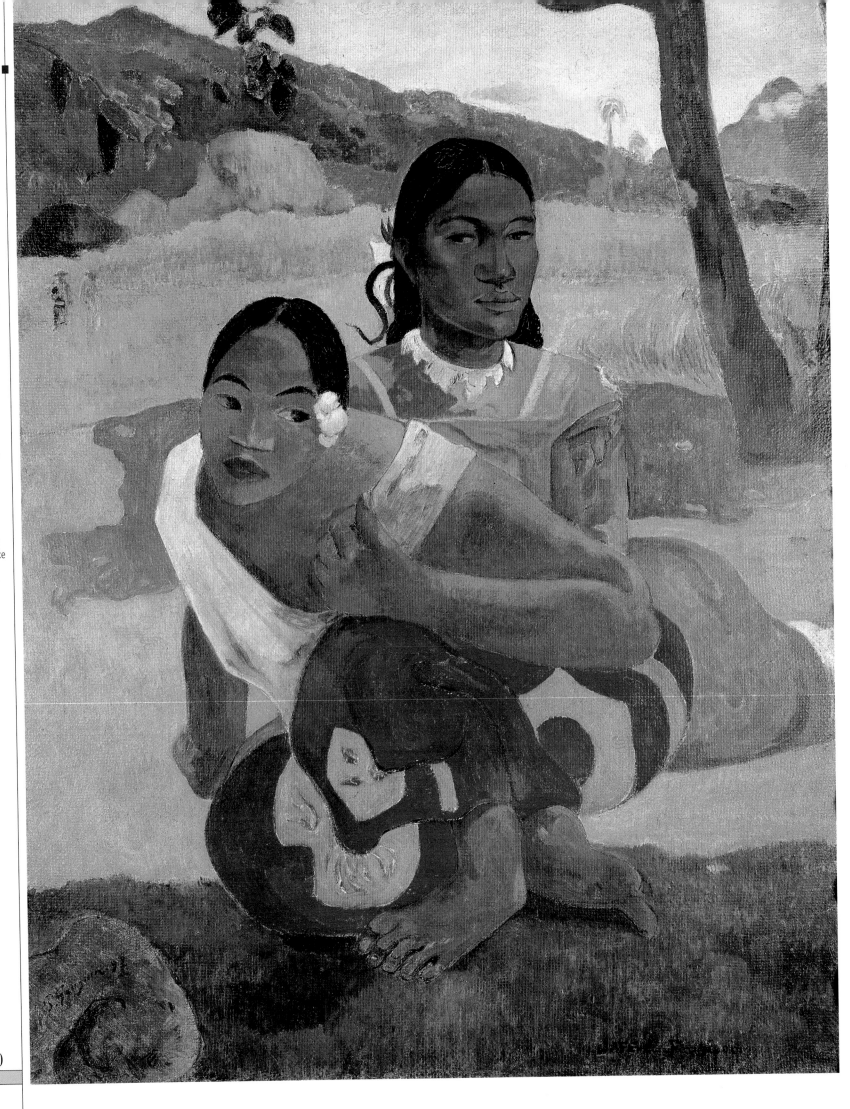

PAUL GAUGUIN
When will you marry?
(Nafea faa ipoipo)
1892, oil on canvas,
105 × 77.5 cm
Rudolf Staechelin
Collection, Basel

Gauguin makes many
paintings during
his stay in French
Polynesia, attracted
by the exotic beauty
of the islands and
their inhabitants. At
the same time, how-
ever, he carries within
him memories of
images from the art
of European culture,
and he often blends
these two realities.
In this painting, for
example, the pose
of the woman in the
foreground, with the
red-and-yellow pareu,
recalls one of the
Women of Algiers by
Eugène Delacroix
(page 22). The girl
behind her, wearing
a mission dress, uses
her right hand to make
the Buddhist sign
meaning "teaching."

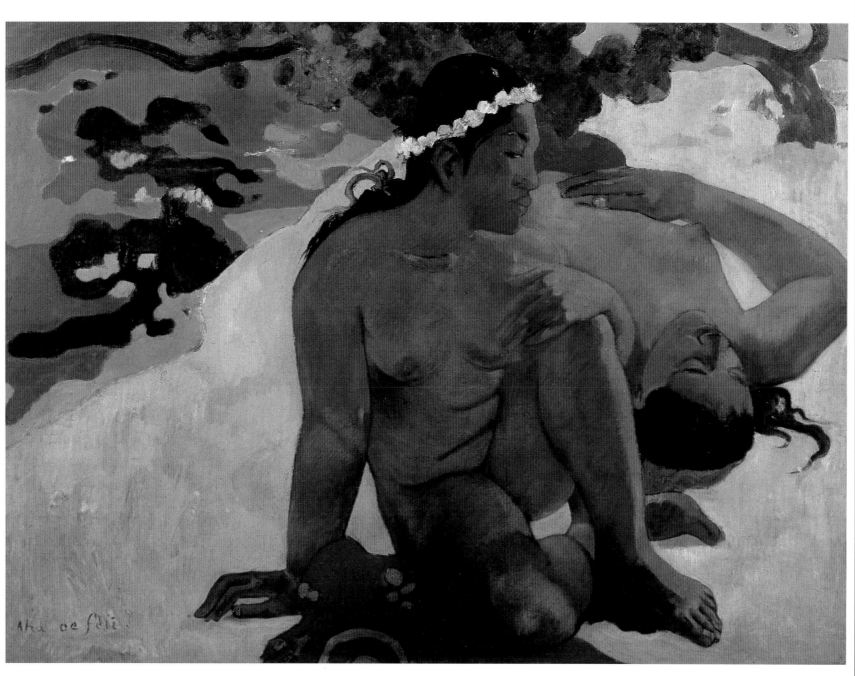

PAUL GAUGUIN
Are You Jealous?
(Aha oe feii)
1892, oil on canvas,
68 × 92 cm
Pushkin State Museum
of Fine Arts, Moscow

There is nothing
accidental about the
arrangement of the
two girls, carefully
orchestrated by Gau-
guin in his search for
new perspectives. At
the bottom left of
the canvas is Maori
writing, which Gauguin
uses in all his Poly-
nesian paintings, an
aspect of his desire to
illustrate the culture
of those islands. The
dialogue to which the
title alludes is not real
but is instead evoked
or suggested by the
calm, reflective atti-
tudes of the two
women. Gauguin
uses bright, intense
colors to stand for
symbolic values in
the composition.

PAUL GAUGUIN
**The Spirit of the
Dead Keeps Watch
(Manao tupapau)**
1892, oil on canvas,
73 × 92 cm
Albright-Knox Art
Gallery, Buffalo

The subject of this
painting is Teha'ama,
the thirteen-year-old
model and lover of
Gauguin (at the time
forty-three). The work's
complex and rich sym-
bolism is based on the
story of a ghost the
girl has seen and her
fear of darkness, which
in her imagination
swarms with threat-
ening and terrifying
phantoms. The artist
uses vivid, dark colors
in cold tones to accen-
tuate the unsettled,
spooky atmosphere,
which is also apparent
in the expression on
the girl's face and
her position across
the bed.

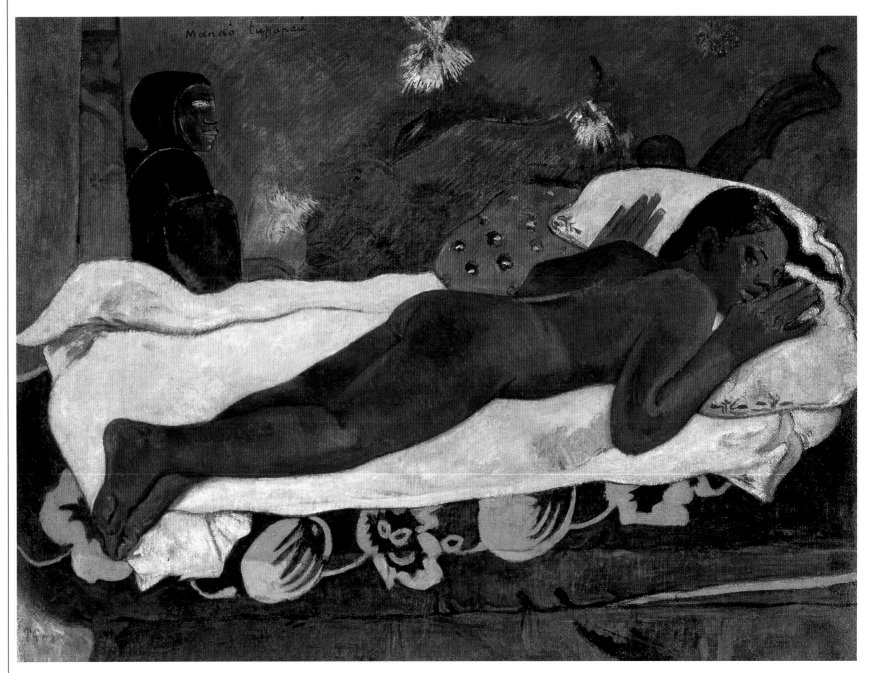

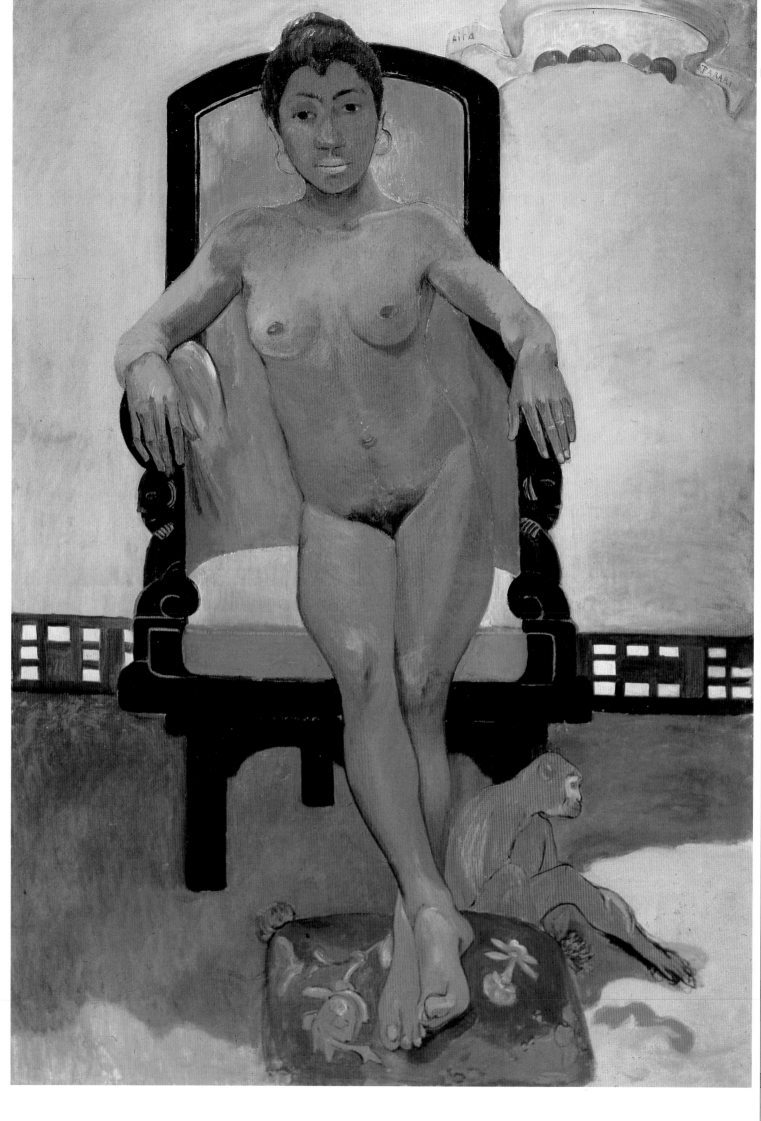

■ PAUL GAUGUIN
**Annah the Javanese
(Aita tamari vahina
Judith te parari)**
1893–94,
oil on canvas,
116 × 81 cm
Private collection

In April 1893 Gauguin
leaves Tahiti to arrive
three months later in
Marseilles, poorer than
when he left, and
also ill. Thanks to an
inheritance left to him
by an uncle, he is able
to pay off his debts
and rent a studio in
Rue Vercingétorix in
Montparnasse, which
he transforms into an
exotic locale, a small
corner of the South
Seas, decorated with
paintings, souvenirs,
wooden sculptures,
and other Polynesian
objects. Here, heed-
less of the disapproval
of his more conserva-
tive neighbors, he lives
with Annah Martin, a
young mulatto, sensu-
al and eccentric, who
poses for this painting
along with her insepa-
rable monkey, Taoa.

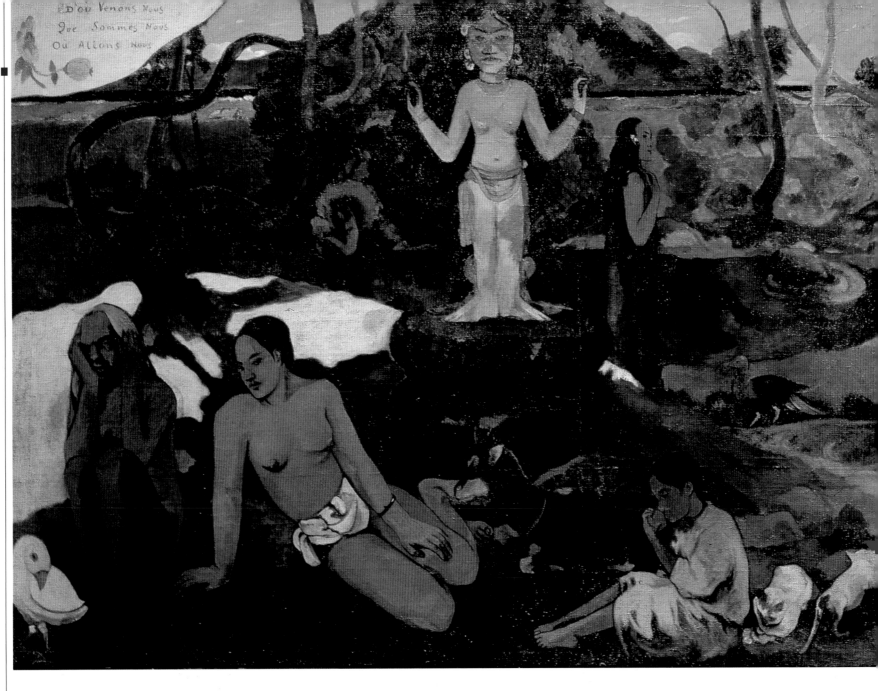

PAUL GAUGUIN
Where do we come from? What are we? Where are we going?
1897–98,
oil on canvas,
139.1 × 374.6 cm
Museum of Fine Arts,
Boston

In the summer of 1895 Gauguin again leaves France to return to Tahiti. By now he is forty-seven, has little money, and is sick. Even so, the final eight years of his life are marked by a burst of extraordinary creativity. This large painting is his masterpiece, his artistic and spiritual testament, a synthesis of the themes in his painting and in his world vision. Exhibited in Vollard's gallery in the fall of 1898, it impresses critics with its innovative stylistic techniques and its rich symbolism. It is interpreted as a metaphor of life and a meditation on the meaning of existence, contrasting nature with civilization, instinct with reason.

PAUL GAUGUIN
Preparatory sketch for Where do we come from? What are we? Where are we going?
1898, pencil, pastel, and watercolors on paper,
20.5 × 37.5 cm
Musée des Arts Africains et Océaniens, Paris

Before every important painting Gauguin makes numerous preparatory sketches, to control the arrangement of the figures and to choose the lighting and the most suitable colors.

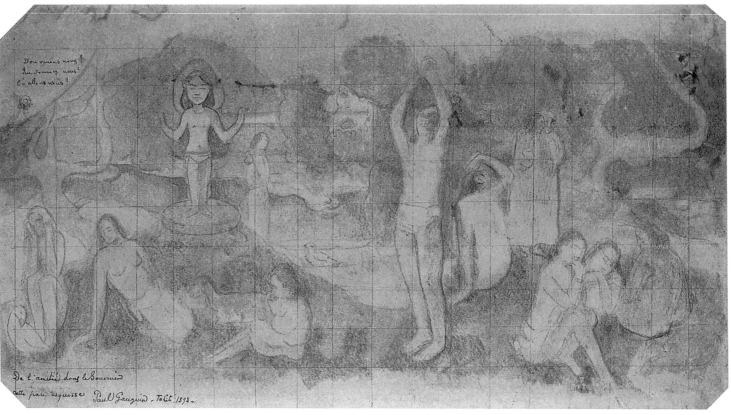

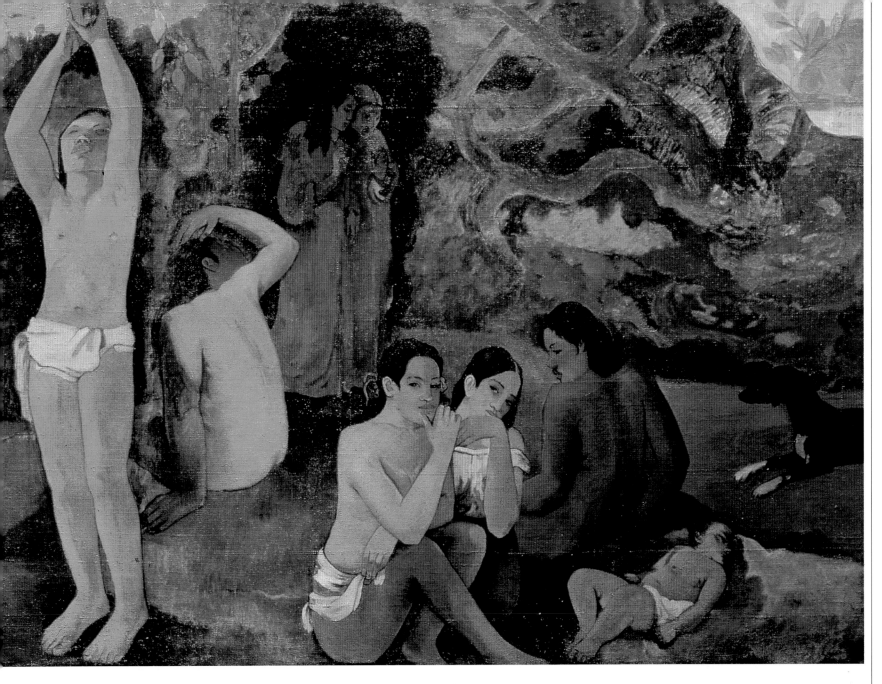

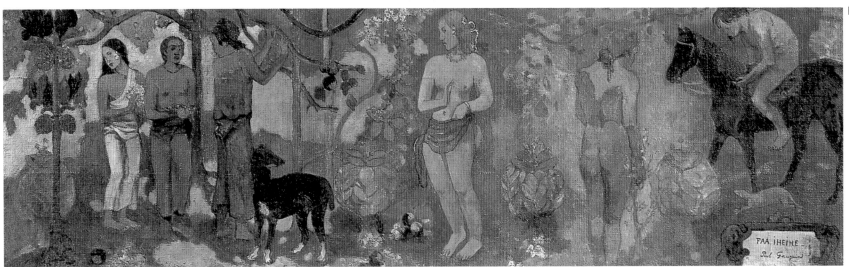

■ PAUL GAUGUIN
Tahitian Pastoral
(Faa iheihe)
1898, oil on canvas,
54 × 169 cm
Tate Gallery, London

Gauguin takes figures
and situations from
earlier paintings and
repeats them in new
narrative contexts.
The arrangement of
these figures against
the landscape recalls
similar scenes in
ancient friezes, in
the large fresco cycles
of Renaissance palaces,
even in the *Sacred
Wood* by Puvis de
Chavannes.

GEORGES SEURAT
The Circus
1891, oil on canvas,
185.5 × 152.5 cm
Musée d'Orsay, Paris

This is George Seurat's
last work, left unfin-
ished at his death at
only thirty-two. He
repeats here the sub-
ject of a painting by
Toulouse-Lautrec,
*Au Cirque Fernando:
L'Equestrienne*, made
three years earlier
and today in the Art
Institute of Chicago.
In both canvases the
horseback rider is per-
forming her evolutions
under the direction
of the trainer while
clowns and acrobats
busily entertain the
audience. Toulouse-
Lautrec's work is hori-
zontal, leaving little
space for the viewers;
this work, vertical,
shows a fair number
of spectators and, in
the upper-right-hand
corner, several mem-
bers of the orchestra.

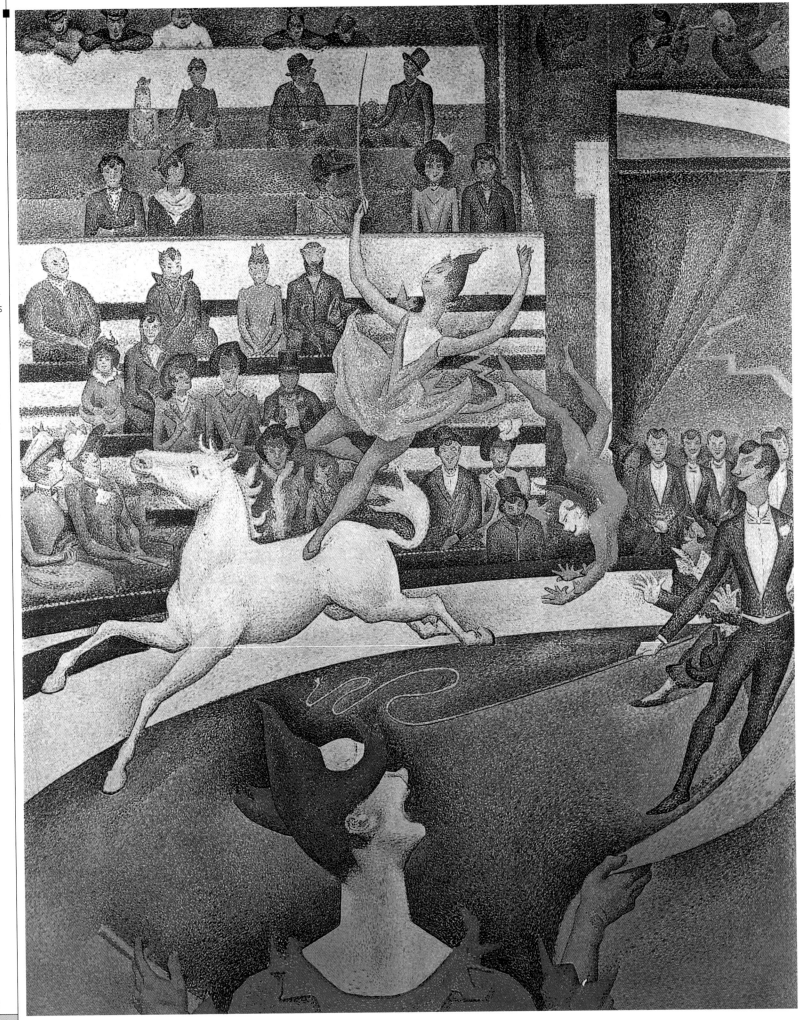

The consecration

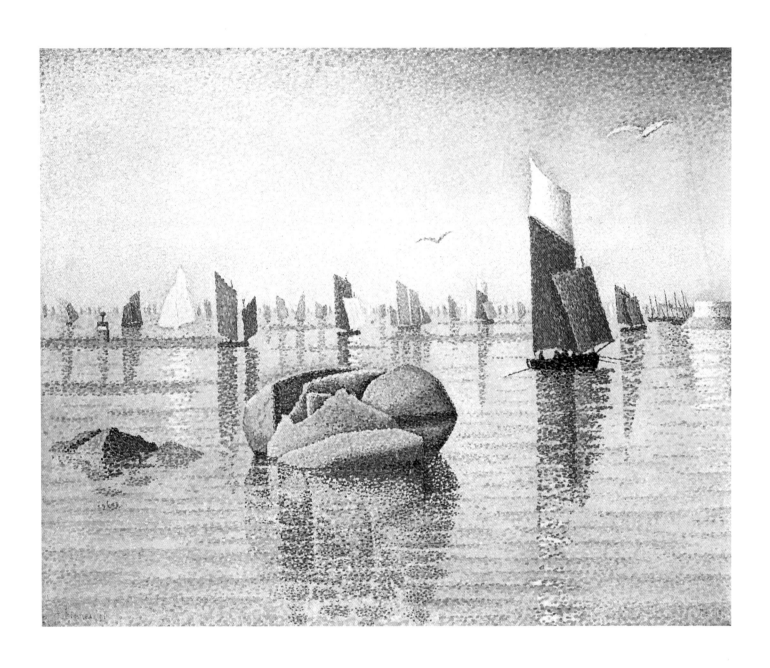

■ PAUL SIGNAC
Morning Calm
1891, oil on canvas,
68 × 85 cm
Private collection

Following Seurat's
death, in 1891, Signac
becomes the leader
and reference point
for the group of artists
that Félix Fénéon calls
"neo-Impressionists" or
"post-Impressionists."
Over the following
decade Signac contin-
ues his experiments
in Pointillism, which
he then presents
in his essay "From
Eugène Delacroix to
Neo-Impressionism,"
published in 1899.
In this painting he
applies the theories
of Pointillism, divid-
ing the pictorial space
into small points of
pure color that ampli-
fy light and enhance
the emotive power
of the composition.

ALFRED SISLEY
Loing Canal
1892, oil on canvas,
Musée d'Orsay, Paris

The painter gives the view ample perspective and depth and marks it off with the vertical measurements of the tall poplars set against the horizontal structures of the houses on the other side of the canal. The pale, luminous colors are distributed on the canvas with broad, regular brushstrokes. Following Sisley's death, in 1899, Monet collects money from among the artist's friends so that this panting can be donated to the Musée du Luxembourg.

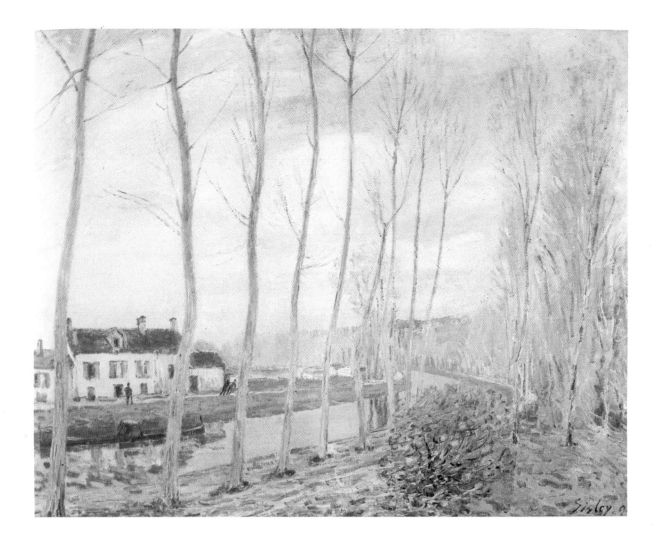

CAMILLE PISSARRO
**Quai Saint-Sever
at Rouen**
1896, oil on canvas,
54 × 72 cm
Private collection

Pissarro goes to Rouen for the first time in 1883, later returning twice, in 1896 and 1898. Unlike Monet, who is struck by the city's Gothic cathedral (pages 416 and 417), Pissarro is drawn to the new industrial sections of the city, the animated port, and the bridges over the Seine. He writes to his son Lucien, "It is as beautiful as Venice, my dear one, it has extraordinary character and is really beautiful! It is true art that corresponds to my way of thinking."

The consecration

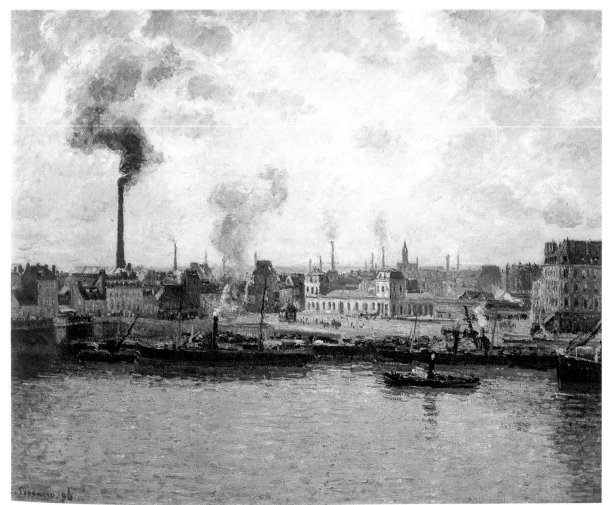

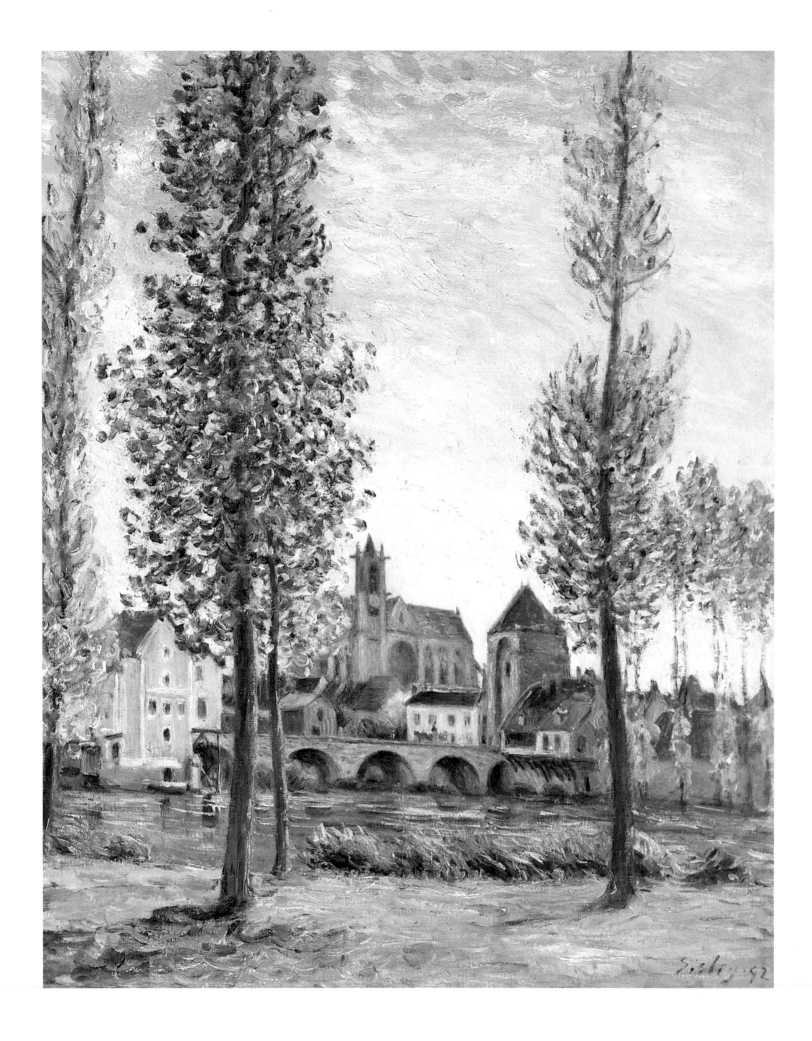

CAMILLE PISSARRO
**Boulevard
Montmartre
(Afternoon Sun)**
1897, oil on canvas,
74 × 92.8 cm
The Hermitage,
St. Petersburg

Problems with his
eyesight prevent
Pissarro from painting
in the open air, and
he finds himself
forced to spend time
in Paris. From February
to April of 1897 he
stays in a room at
the Grand Hôtel de
Russie, the window of
which overlooks the
Boulevard Montmartre,
one of the major
boulevards created
by Baron Haussmann.
Although supposedly
resting, he makes
a large number of
sketches and prepara-
tory drawings that he
later uses, once back
in his studio at
Eragny, to make a
series of city views
that are among the
most pleasing and
striking of his vast
repertoire.

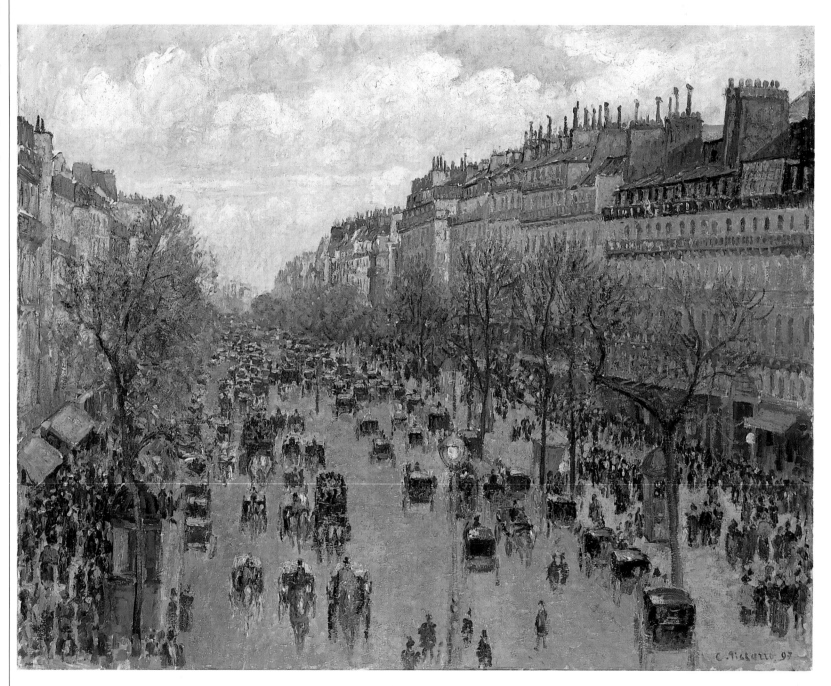

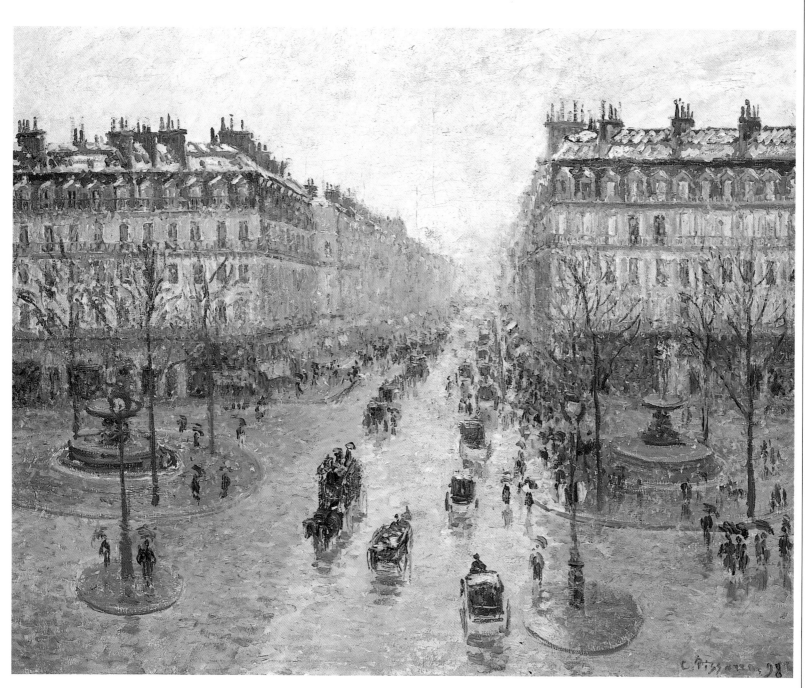

■ CAMILLE PISSARRO
**Avenue de l'Opéra
(Snow Effect;
Morning)**
1898, oil on canvas,
65 × 82 cm
Pushkin State Museum
of Fine Arts, Moscow

As their titles indicate,
the paintings in this
series of urban views
are made at different
times of day. Pissarro
works carefully to
accurately reproduce
the changes in light
caused by variations
in weather conditions.
After his brief experi-
ments with the chro-
matic decompositions
of Pointillism, he has
returned to the real-
ism and naturalism
that lie at the heart
of Impressionism. His
technique is secure,
the application of the
brushstrokes easy and
uniform, recreating
the pale luminosity
of a morning sky.

CAMILLE PISSARRO
Place du
Théâtre Français
1898, oil on canvas,
73 × 92 cm
County Museum of Art,
Los Angeles

Pissarro has made many paintings of the countryside and the work in the fields. In these Parisian views he now seems to contrast the calm, peaceful existence celebrated in his rural landscapes with the frenetic rush of the great French metropolis. With his brusque, cantankerous character, the painter has never felt at home in the middle-class settings of Paris, and never once has he made an effort to win over the attentions of the city's many art collectors. There is also the matter of his political sympathies, which verge on the socialistic; these do much to hold back his career and prevent him from achieving commercial success equal to that of the other Impressionist artists.

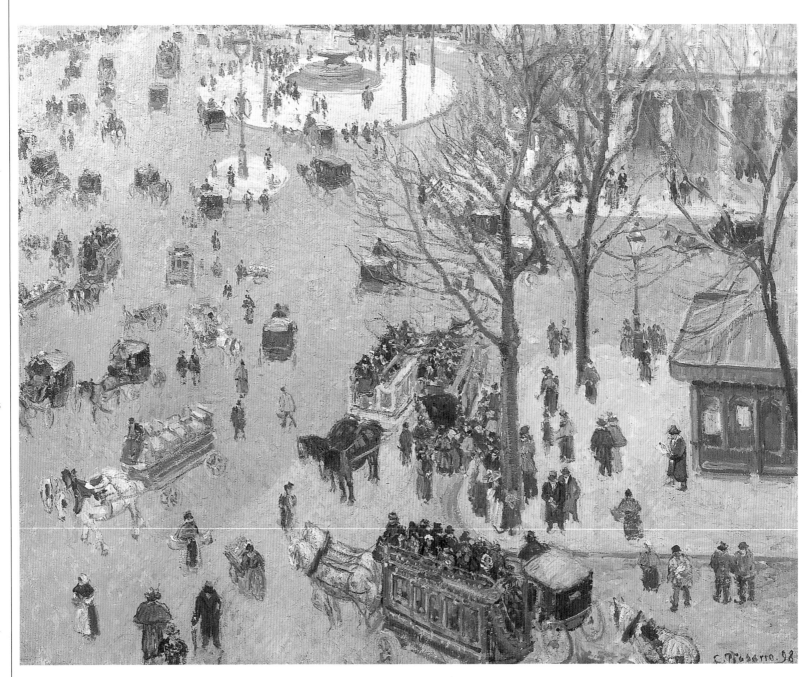

The consecration

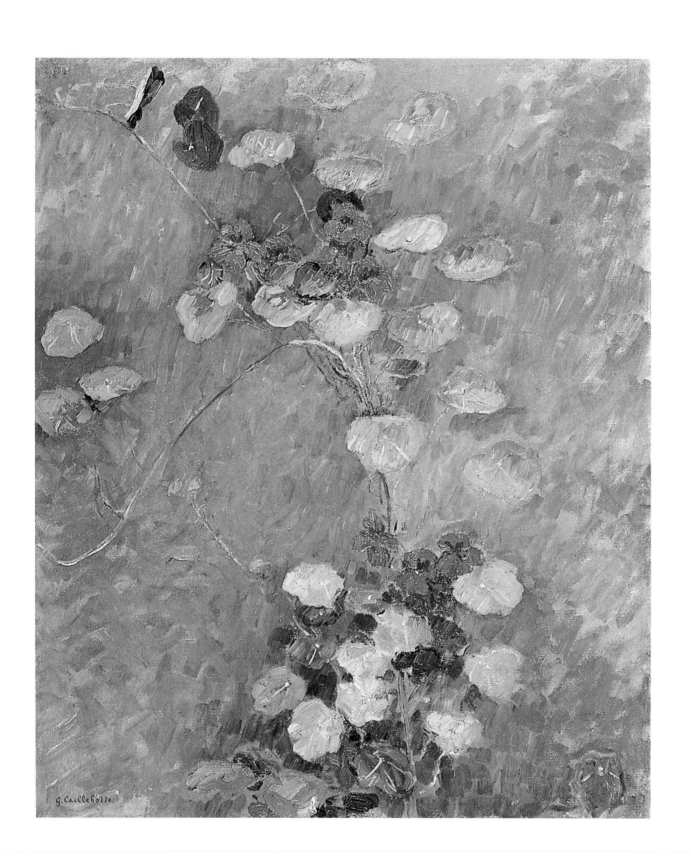

GUSTAVE
CAILLEBOTTE
Nasturtiums
1892, oil on canvas,
65 × 54 cm
Private collection

In 1892 Caillebotte makes two paintings with nasturtiums— this and another, larger work today in the Josefowitz Collection— as decorations for the dining room of his home in Petit Gennevilliers. There on the banks of the Seine opposite Argenteuil, he and his brother Martial create a large garden with a greenhouse in which they passionately cultivate a variety of flowers, including a few rare species of orchid. Caillebotte gives this passion for gardening to Monet, who dedicates his last years at Giverny to that very passion.

The consecration

During the first decades of the twentieth century, the Impressionist artists, still in possession of the energy and will to work, create their final masterpieces. No longer must they face the hostility of critics or the indifference of collectors, but one by one they are called on to confront more powerful enemies.

In August 1901 Gauguin leaves Tahiti, setting sail for the Marquesas, about 1,400 kilometers away. He establishes himself on the southern island of Hiva Oa, buys land in the village of Atuana, and has a hut built, which he calls his Maison du Jouir, "House of Pleasure." Here he lives with Marie Rose Vascho, a fourteen-year-old girl with whom he has a daughter. Although ill and bothered by disputes with the Catholic mission and the local gendarmes, he succeeds in drawing, carving, and painting until death takes him, on May 8, 1903.

In those same years Degas is battling serious vision problems that reduce him almost to blindness. This does not keep him from turning again to subjects dear to him, in particular his beloved ballerinas. He also intensifies his production of sculpture,

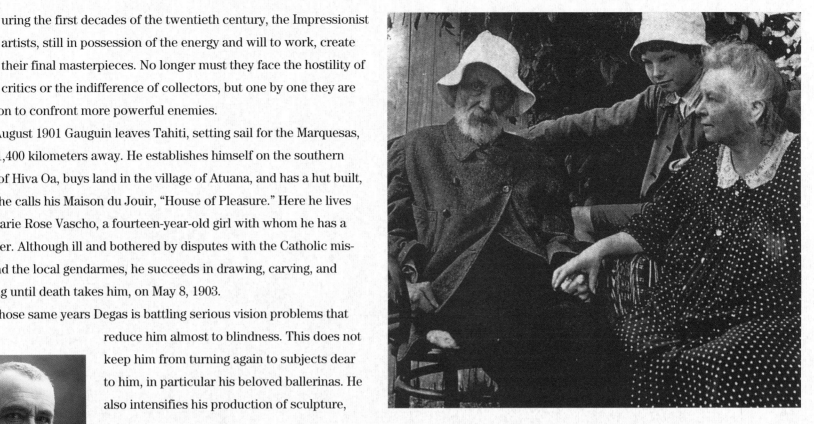

Claude Monet in a photo by Nadar from the early twentieth century.

1901•1920 The legacy

creating works that will become known to the public only after his death, on September 27, 1917.

Renoir's last years are also marked by physical problems, and he too does not let infirmities get in the way of his passion for painting. Since the last decade of the nineteenth century he has suffered sharp pains from rheumatism, but this has not slowed his activity. He moves to Cagnes-sur-Mer in 1903 and has his last home built, part of a large holding at Les Collettes. His health deteriorates further over the next decade, such that he can no longer walk and must be carried from his bed to a wheelchair and then put in place in front of his easel, which is equipped with a special mechanism that allows him to move the canvas to within reach. Only

Paul Cézanne photographed in 1906 by Emile Bernard in front of one of the versions of his *Large Bathers*.

with difficulty can his hands hold a brush, and Gabrielle Renard, a cousin of his wife's, wraps strips of canvas around the palm of his hand to protect the fragile skin. Even so, his spirit remains vigorous, animated by what he calls the *volupté de peindre*, which supports him until his death, on December 2, 1919.

Berthe Morisot dies on June 14, 1926, leaving Claude Monet. He too is anguished at the gradual loss of his vision but shows uncommon strength of character and continues to paint with the same energy he had in his youth. His condition forces him to quit work in 1922, but an eye operation lets him return, and he does his best until his death, which comes on December 6, 1926.

Meanwhile a new generation of artists inherits the legacy of the Impressionists. A

primary element in this legacy is a change in the very meaning of art and artists. As a result of the Impressionists, art is no longer considered the representation of reality but of an *impression* that reality makes on the mind and spirit of the artist, who experiences and interprets it according to his or her character and personality. An immediate result of this change is that artists are freed from the strictures of rules. For centuries, anyone wishing to undertake a career as painter had to submit to long and difficult training in the workshop of a master or in the halls of an academy, passing months or even years copying the works of classical masters to identify, understand, and absorb their techniques. Art manuals left nothing to chance or to the imagination of the artist, setting down precise rules for

every phase of the artist's activity, from the composition of paints to the preparation of the support, whether panel or canvas, from the preparatory drawing to the last layers of varnish. The suitable subjects were strictly divided into genres, each of them controlled by rules and precepts that had to be closely followed. Manet's *Luncheon on the Grass* did not cause a scandal because a naked woman was seated among men, the woman in question being more chaste and modest than dozens of Venuses offered to public view each year at the Salon. What disoriented the critics, leaving them literally speechless, bereft of the means to reach a judgment, was the way Manet broke with the traditional rules, the way he mingled different genres and created a new, more modern way of looking at reality. Which is why

of the Impressionists

Manet was taken as the guide and leader of the Impressionists, just as they in turn become the examples to follow for later generations.

A second element in the legacy of the Impressionists is the priority given to color over design, the preference for rhythm in place of balance. In this instance too, the Impressionists have gone willfully against the longstanding teachings of the Ecole des Beaux-Arts. Students at the Ecole began their apprenticeship restricted to drawing; only much later would they be permitted to make the acquaintance of paints. The Impressionists went about it the other way, moving their brushes freely across the canvas, preferring emotional impact to the descriptive line. They also employ a far brighter palette, from which black is nearly absent, and they apply the optical studies of Chevreul, in particular his "law of simultaneous contrasts," according to which putting two complementary colors together creates a more intense and vibrant effect on the eye of the spectator. They employ these chromatic effects only

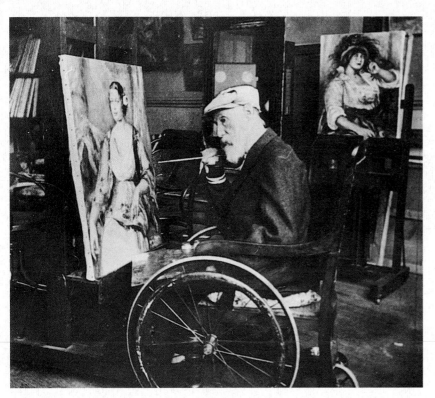

The legacy of the Impressionists

rarely in their first works, using them to
achieve the effects of light on water or to give
depth to the sky. They later use these effects
with greater boldness and assurance, arriving
finally at the series of water lilies by Monet, in
which light and color are the only subjects.
The first new artists to adopt this lesson are
the Fauvists, so-called—from a French word
for "wild animal"—because their composi-
tions are based on the expressive power of
color and the use of direct tonal light without
shading. At the Salon of 1905 the dazzling
splendor of the paintings by Matisse, Derain,
Manguin, Marquet, Puy, Valtat, Vlaminck,
Friesz, and Rouault leaves visitors with their mouths open in shock, but
the more astute critics immediately see the affinity of these works with
those of Van Gogh or Gauguin, Seurat or Signac. In turn the Fauvists are
an example for the members of Expressionism, both the figurative ver-
sion that takes shape in Germany and Austria, and the informal version
that sees its greatest development in the United States.

Yet another important aspect of Impressionist painting destined to have
repercussions through most of the first half of the twentieth century is the
increased importance they give to decorative and symbolic elements.
Almost all of their paintings present reality, but the almost total abolition of

chiaroscuro and the use of broad areas of flat
color give reality a new value that lends itself
to new interpretations. The direct heirs of this
different approach to nature are the Nabis
painters, their name taken from a Hebrew word
meaning "prophets." The Nabis are the direct
descendents of Gauguin. Among the most
important are Paul Sérusier, Pierre Bonnard,
Félix Vallotton, Edouard Vuillard, Paul Ranson,
and Aristide Maillol. Both the Art Nouveau
movement and much of the symbolic painting
of the twentieth century have their beginnings
with the Nabis. It is also true that the
Impressionists change the relationship
between painters and the classics. The Impressionists claim that the oft-
repeated accusation that they are revolting against classical art is untrue;
they are in revolt against the academy and academic thinking, but not
the pictorial tradition. And in fact almost all of them visit the halls of the
Louvre with devotion; as soon as they have the means to do so they take
long trips to Holland, Spain, and
most of all Italy to study ancient art.

The true difference is that the
Impressionists do not allow them-
selves to harden in an empty and
sterile imitation of the classics and
instead reinterpret them and update
their teaching in a modern setting.
As Cézanne writes, "The Louvre is
the book in which we learn to read,
but after seeing the great masters
that are there, one must rush to get
out and revivify in oneself, in con-
tact with nature, one's instincts, the
impressions of art that are in us."

Cézanne's studio
in Aix-en-Provence
in a photo taken
after his death.

Another element in this legacy is the importance given the intuitive
and the conceptual. As discussed in the preceding chapter, the creation
of series paintings, that is, sequences of paintings with the same subject,
calls attention not only to the subject being treated but to the viewer,
meaning the personal and subjective nature of the artist and, even more,
to the special relationship the artist establishes with reality. The impor-
tance attributed to the subjectivity of the artist, along with the impor-
tance given to the moment of inspiration and planning of the final
creation of a work of art, will have an enormous impact on many avant-
garde movements.

Finally, the Impressionists change the relationship between the artist and the buyer. Until the seventeenth century the painter was an artisan whose creations were dependent almost exclusively on the church or the nobility. In the eighteenth century the state was added to this list of patrons, but the true change came in the nineteenth century when the middle class achieved the financial means and the knowledge to buy paintings. A new figure then came into being, that of the art dealer, who performs the role of middleman between artist and buyer. Without Durand-Ruel, Georges Petit, Ambroise Vollard, and the other gallery owners and art dealers, the Impressionists would almost certainly have lived and painted in different ways, and their careers would have followed other routes. The dealers organize their shows, both in France and other countries; the dealers establish contacts with critics and journalists; the dealers sell the works of the artists to clients.

Over the last hundred years the art market has changed continually, its changes effecting the way art is produced and judged; it has revolutionized the values and the criteria of judgment. As we have seen, the first Impressionist paintings are sold at laughably low, almost absurd prices, a hundred or two hundred francs. By the turn of the century their works were obtaining respectable prices, at times comparable to those of academic artists. The true boom on a worldwide scale has occurred over the last twenty years, with the prices of paintings at the leading international auction houses touching astonishing peaks.

Record prices have followed one another at a growing rhythm, and it is most probable that the prices given here as records soon will have been surpassed.

In the category of high prices, which may or may not mean anything, the first place goes by right to Van Gogh. On November 11, 1987, at Sotheby's in New York, a version of his *Irises* was sold for $53.9 million, while on November 19, 1998, at Christie's in New York, a *Self-Portrait without Beard*,

painted in September 1889, went for $71.5 million; but the highest price paid thus far for a single painting is the $82.5 million paid by the Japanese paper magnate Ryoei Saito for a version of the *Portrait of Doctor Gachet* (page 401). In second place is one of the versions of the *Dancing at the Moulin de la Galette* by Renoir, bought on May 17, 1990, at Sotheby's in New York for $78.1 million. There is then the $60.5 million reached for the *Still Life with Curtain, Pitcher, and Compote* of 1893–94 by Cézanne, from the famous collection of John Hay Whitney, offered by Sotheby's in New York on May 10, 1999. The record for a painting by Seurat is $35.2 million for a *Landscape, Island of the Grande Jatte* (Sotheby's, New York, May 10, 1999). One of Monet's *Water Lilies* reached $32.4 million (Sotheby's, London, June 30, 1998); a Degas *Ballerina* got $27 million (Sotheby's, London, June 28, 1999); *La Rue Mosnier* by Manet brought $26.4 million (Christie's, New York, November 14, 1989); *Mata Mua* by Gauguin went for $24.2 million (Sotheby's New York, May 9, 1989), *Man on the Balcony, Boulevard Haussmann* by Gustave Caillebotte reached $14.3 million (Christie's, New York, May 8, 2000). As they did in life, Pissarro, Sisley, Mary Cassatt, and Berthe Morisot must today content themselves with lower numbers, although their top lots, so to speak, fetch between three and four million dollars, and sometimes more.

Monet's funeral. In the foreground to the right is Georges Clemenceau.

Claude Monet in his garden at Giverny a few kilometers from Paris.

PIERRE-AUGUSTE
RENOIR
Blonde Bather
1903–05, oil
on canvas,
92 × 73 cm
Kunsthistorisches
Museum, Vienna

This is most probably
the first of four very
similar versions of a
bather that Renoir
made between 1903
and 1905. The pres-
ence of the modern
clothes gives the
scene a clear sense of
time. Only the hat is
well defined, made to
stand out by the con-
trast of the yellow
with the red of the
band; the other arti-
cles are merely indi-
cated, reduced to a
few spots of indefinite
color. As in other sim-
ilar paintings by
Renoir, the model
pulls back her hair in
a delicate gesture that
is at once modest and
extremely seductive.

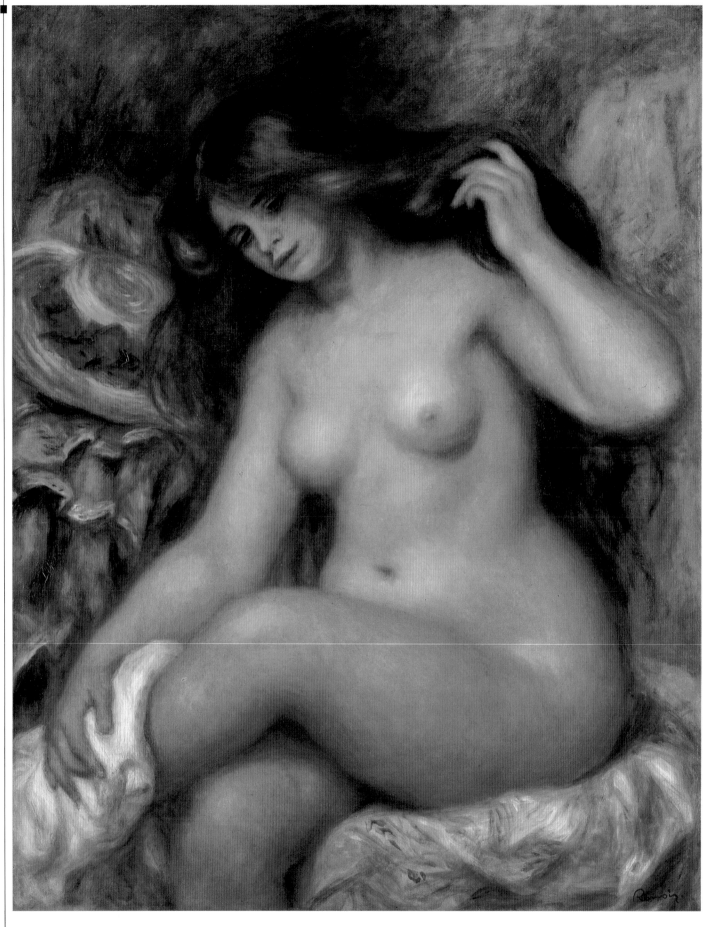

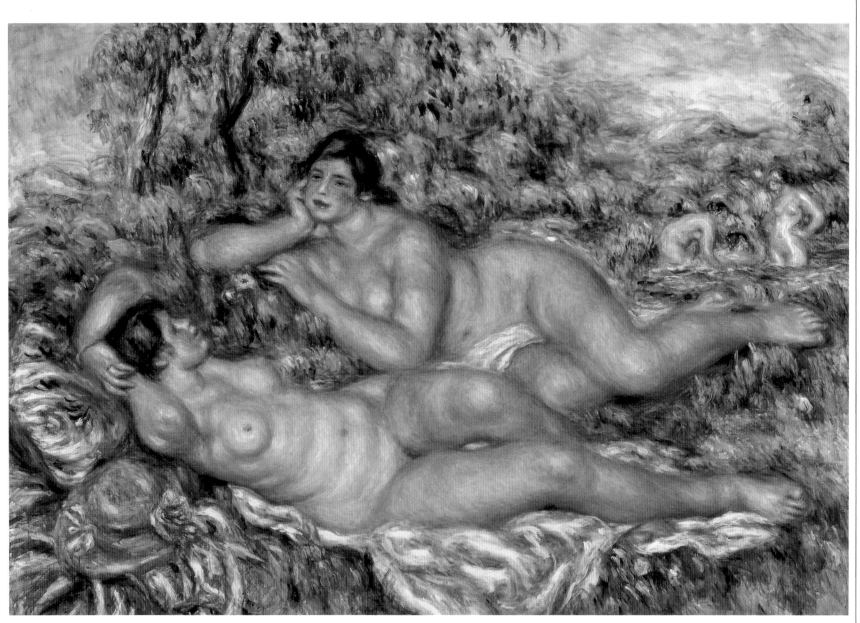

■ Pierre-Auguste
Renoir
Bathers
1918–19, oil
on canvas,
110 × 160 cm
Musée d'Orsay, Paris

In order to make this
large painting, Renoir
has a special easel
built in the garden of
his house in Cagnes;
the canvas can be
made to wind around
cylinders, allowing
him to work on every
part of it without
moving from his chair.
Henri Matisse visits
him during this period
and reports that Renoir
is proud of this work,
considering it the high
point and synthesis of
his art. For this reason,
in 1923, Renoir's chil-
dren decide to donate
it to the French nation.
The model for both
women in the fore-
ground is almost cer-
tainly Andrée (Dédée)
Hessling, who marries
Jean Renoir and has a
son with him, Alain,
born in 1921.

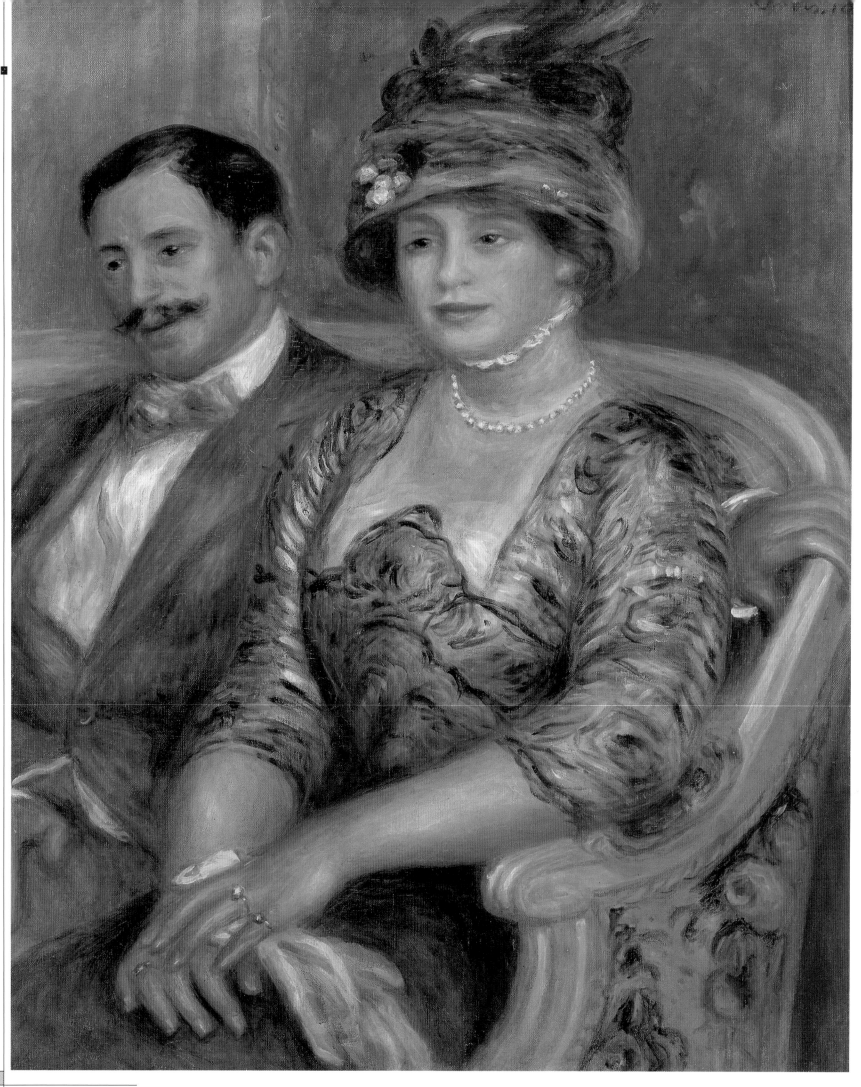

PIERRE-AUGUSTE
RENOIR
**Portrait of Monsieur
and Madame
Bernheim de Villers**
1910, oil on canvas,
81 × 65.5 cm
Musée d'Orsay, Paris

Gaston Bernheim de
Villers, one of the
best-known gallery
owners in Paris,
assembles a sizable
collection of works by
Renoir, most of all
from 1900 on. He is
shown here in the
company of his pretty
wife (of whom Renoir
had already made a
portrait, in 1901),
who assumes a pose
modeled on that of
Leonardo's *Mona Lisa*.
The couple is present-
ed from very close up,
but rather than look
in the direction of the
viewer, as is usually
the case with people
in portraits by Renoir,
they look away. In
1910 Renoir makes
a portrait of their
daughter Geneviève,
today in the Musée
d'Orsay in Paris.

The legacy of the Impressionists

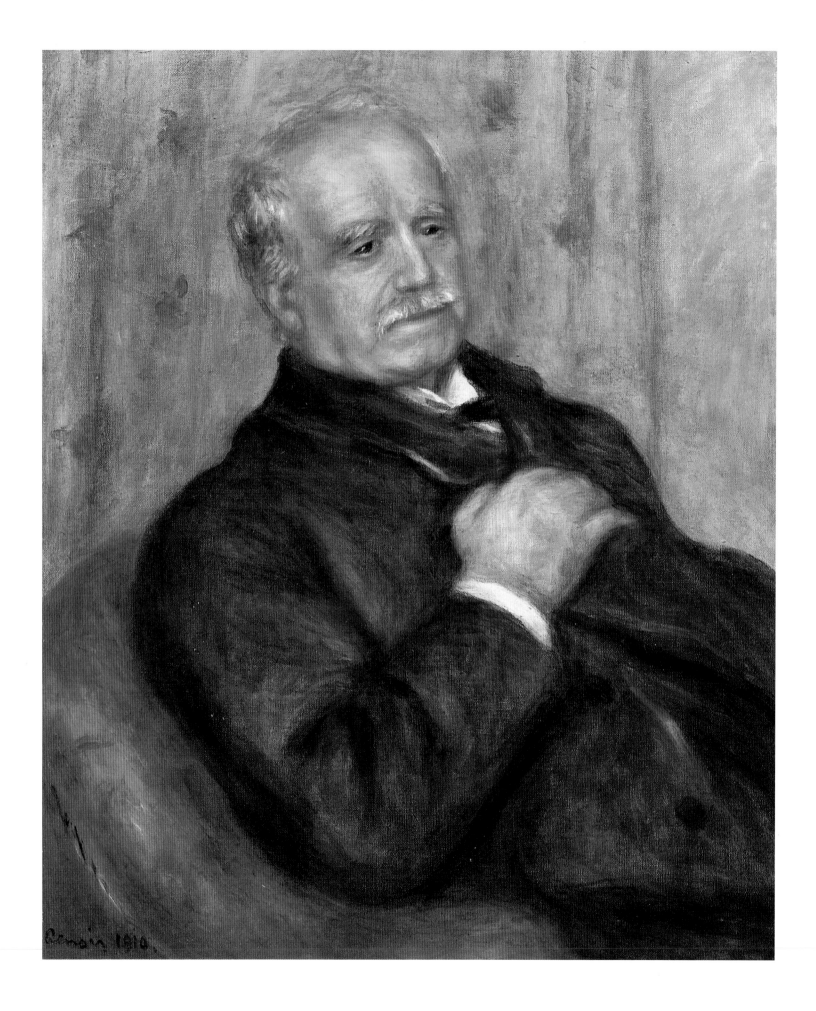

PIERRE-AUGUSTE
RENOIR
**Portrait of
Durand-Ruel**
1910, oil on canvas,
65 × 54 cm
Durand-Ruel
Collection, Paris

This is the only portrait Renoir makes of the art dealer who performs such an important role for the Impressionists. The gallery owner is seventy-nine years old when he poses for this portrait and is particularly pleased with the result. He says in fact that he wants to always have it nearby. He is especially happy about Renoir's decision to present him in an unofficial pose, seated in the intimacy of his own home. The indefinite nature of the chair he sits in and the background serves to call further attention to the expression on his face, which is peaceful and relaxed, with just the slightest touch of melancholy.

Parliament (Sunlight Effect in the Fog)
1904, oil on canvas,
81 × 92 cm
Musée d'Orsay, Paris

From 1900 to 1903 Monet spends the winter months in London, where he makes views of the city along the Thames that he then completes, all together, in his studio in Giverny. He often expresses his love for the English city, most of all when it is wrapped in fog, "with that sense of grandiosity, under that cloak of mystery." In this work, so extraordinarily evocative, the lines of the drawing have completely disappeared, such that the buildings in the background are reduced to simple shadows, evanescent and immaterial. In 1904 Durand-Ruel displays thirty-seven of these views, and in praising them critics compare them to the works of Turner.

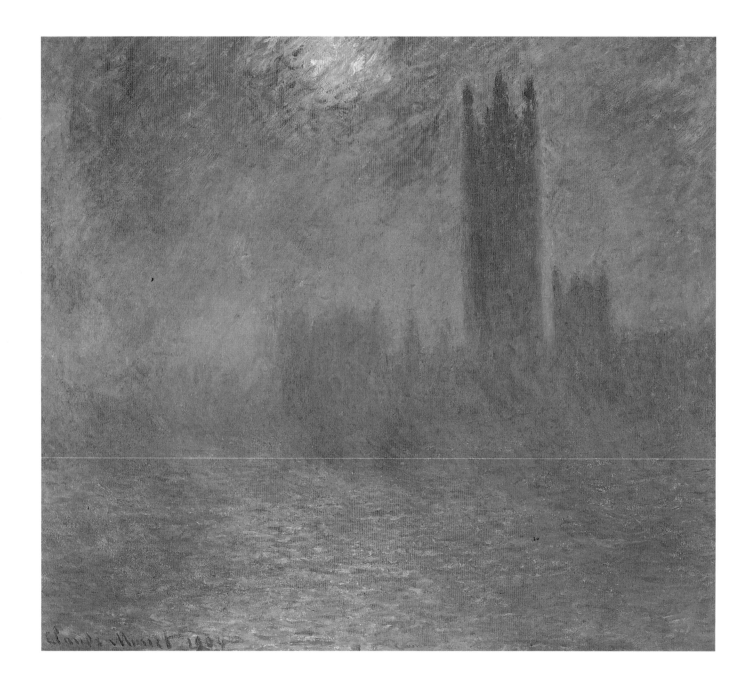

The legacy of the Impressionists

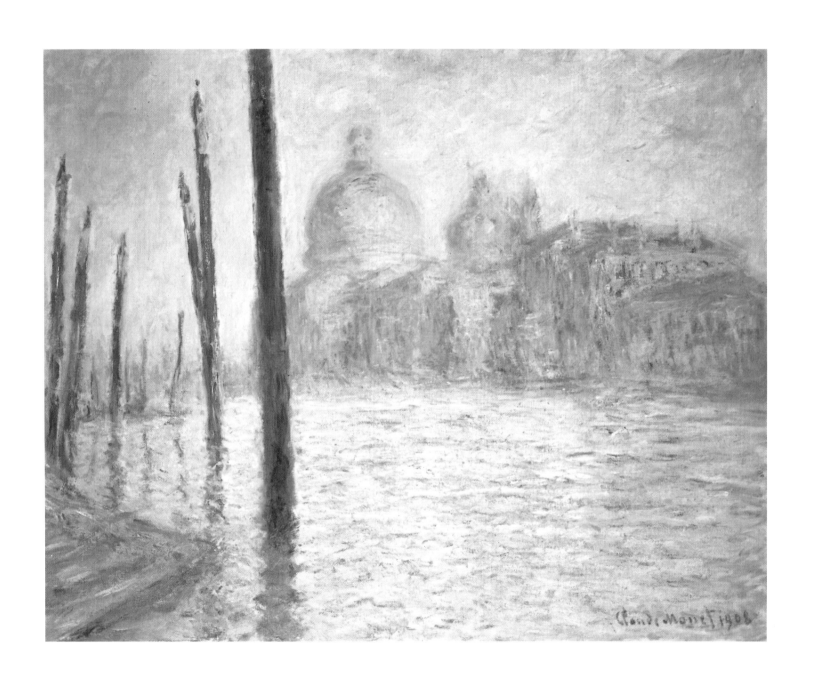

■ CLAUDE MONET
The Grand Canal
1908, oil on canvas,
73 × 92 cm
Private collection

In September 1908
Monet and his wife,
Alice, take a trip to
Venice, spending three
months there in the
Grand Hotel Britannia.
They go back in the
fall of 1909, and two
years later are plan-
ning a third trip, but
these plans are can-
celled by Alice's death,
on May 19, 1911.
Monet pays little
attention to the
works by Venetian
artists in museums,
but he is so fascinated
by the special atmos-
phere of the city and
its lagoon, with the
palaces reflected on
the water of the
canals, that he says,
"Venice is Impres-
sionism in stone."

CLAUDE MONET
**Water Lilies
(Water Landscape)**
1905, oil on canvas,
90 × 100 cm
Private collection

Beginning in 1883
Monet's home is in
Giverny, site of a vast
garden that he culti-
vates with passion.
Ten years later he has
water deviated from
the Epte River to turn
part of the garden
into a lily pond. Views
of that pond become
his last large series of
paintings, a synthesis
of his artistic endeav-
ors as well as his spir-
itual testament. In
the background to the
left can be seen the
little bridge he has
built to recreate the
sense of a Japanese
print. Over time he
has come to value
and appreciate such
prints for the impor-
tance they give to
color and light.

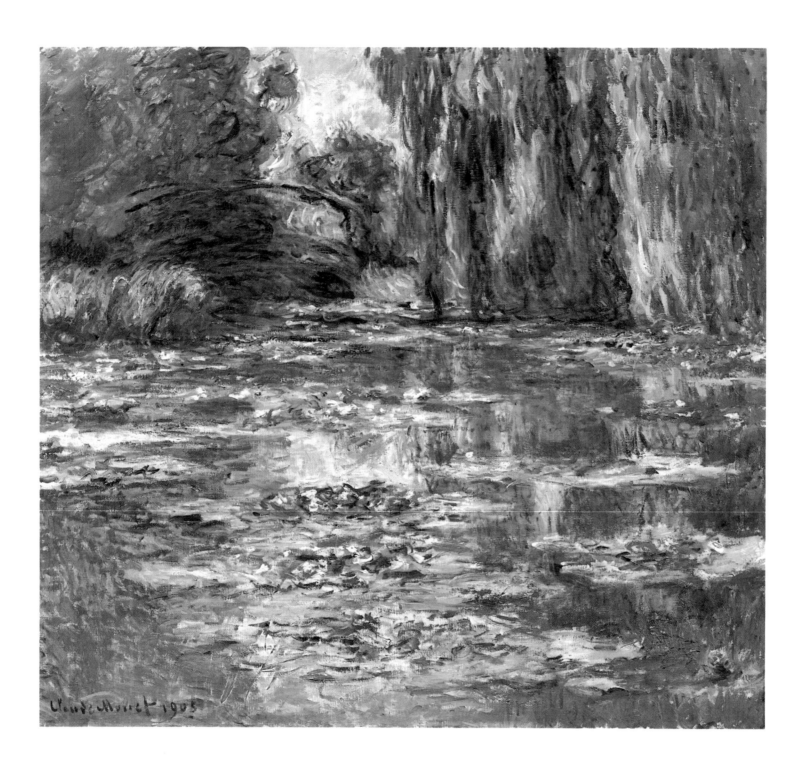

■ CLAUDE MONET
**Water Lilies
(Water Landscape)**
1907, oil on canvas,
92 × 73 cm
Private collection

Monet makes his first
group of paintings of
water lilies between
1900 and 1907. In this
work the point of view
is so close up that the
Japanese bridge is
gone; like the banks
of the pond and any
other elements of the
landscape, it cannot
be seen. The painter's
attention, along with
that of the spectator,
is absorbed by the
play of light and color
of the flowers and
the water, giving the
impression of a limit-
less expanse. Monet
writes in a letter, "I
am obsessed by this
landscape of water
and reflections. So
much of this is beyond
my aging powers, but
I want to show what
I feel."

CLAUDE MONET
Landscape:
Weeping Willows
1918, oil on canvas,
130 × 110 cm
Private collection

In 1916 Monet has a
third, far more spa-
cious atelier built in
his home at Giverny to
enable him to work on
large-scale canvases.
The artist repeats the
theme of water lilies,
stressing the chromatic
values and varying the
subjects of the compo-
sitions, as in this work,
in which he presents a
weeping willow. The
arrangement of the
brushstrokes no longer
responds to any crite-
ria of verisimilitude
but instead reflects
the painter's state of
mind, his feelings, his
spiritual sensibility.
These works take Monet
to the extreme limits
of Impressionism while
at the same time lay-
ing the basis for much
nonrepresentational
abstract art.

■ CLAUDE MONET
**Path in the Rose
Garden at Giverny**
1920–22, oil
on canvas,
73 × 107 cm
Private collection

By 1920 Monet is
almost completely
blind; during a visit
to a specialist he
learns that the vision
in his left eye, the
better of the two, is
about one-tenth of
what would be normal.
This notwithstanding,
he insists on painting,
driven by his great
willpower. To com-
memorate the end
of the world war he
makes a special series
of twelve enormous
canvases—two meters
high, more than four
long—with his beloved
water lilies. As in this
painting, color has
definitely won out over
design, and the brush-
strokes pulsate off the
surface of the canvas
precisely as they do
during these same
years in the first works
of abstract artists.

EDGAR DEGAS
Two Ballerinas Resting
circa 1910, pastel and
charcoal on paper,
78 × 98 cm
Musée d'Orsay, Paris

During the last years
of his life, tormented
by serious problems
with his vision that
make him almost com-
pletely blind, Degas
often returns to the
subject of ballerinas,
the subject he loves
more than any other.
Here the drawing
seems to disintegrate,
and with it the human
figures, as though the
shapes were losing
their material consis-
tency to become phan-
toms evoked in the
mind of the painter
rather than perceived
by his diseased eyes.
Even the colors seem
to be losing their
adherence to reality,
contributing to the
work's sense of
unreality.

■ EDGAR DEGAS
At the Milliner's
circa 1905–10,
pastel on paper,
91 × 75 cm
Musée d'Orsay, Paris

Degas's last works,
most of all the pas-
tels, have a thick,
pasty consistency
with powerful chro-
matic contrasts that
serve as models for
the parallel efforts
of the Nabis painters.
The features of the
faces of the two
women are almost can-
celled by the artist's
vigorous gestures.
We cannot make
out their expressions
but sense them from
their attitudes and
the positions of their
bodies. Compared to
paintings of the same
subject made in earli-
er years, we see here
a greater emotional
involvement owing to
the extreme liberty
with which the artist
combines colors.

PAUL SIGNAC
**Constantinople,
the Gold Coast**
1907, oil on canvas,
62 × 80 cm
Private collection

In 1907 Signac and his painter friend Henry Person take a long train trip from Venice to Constantinople, where they are fascinated by the remains of ancient Ottoman civilization. Signac draws inspiration from the seascapes of Turner, also full of color and light, and applies the pointillism technique less strictly, giving more attention to visual effects, to create highly evocative atmospheres, as in this work.

CAMILLE PISSARRO
**Port of Dieppe,
Rainy Morning**
1902, oil on canvas,
68 × 83 cm
Private collection

In his last ten years of life Pissarro makes a little over three hundred urban views. These are divided in eleven series set in four different cities: Paris, and three Normandy ports: Rouen (where he stays in 1896 and 1989), Dieppe (1901), and Le Havre (1903). In these cities he chooses his hotels with great care, selecting places where he will be able to work in his room and thus avoid overtaxing his troubled eyes.

The legacy of the Impressionists

■ PAUL GAUGUIN
**Sunflowers
on a Chair**
1901, oil on canvas,
73 × 91 cm
The Hermitage,
St. Petersburg

Early in 1900 Gauguin
has his friend Daniel
de Monfreid send him
seeds from France,
which he then plants
in Tahiti in the gar-
den of his hut, trans-
forming it into an
unreal spot of Medi-
terranean color. This
painting is one of four
in which he repeats
the subject of sun-
flowers, which remind
him of the months
spent in Arles togeth-
er with Van Gogh. The
presence of the eye
at the center of the
flower, and the Maori
portrait to the right,
give the composition
a mystical feel, more
like the transcription
of a dream than a
representation of
reality.

PAUL GAUGUIN
Ford (Running Away)
1901, oil on canvas,
73 × 92 cm
Pushkin State Museum
of Fine Arts, Moscow

By now sensing the
approach of the end
of his life, Gauguin
meditates on the
mystery of death.
The figure on the
white horse, a color
associated in those
islands with mourning,
resembles a *tupapau*,
a Polynesian demon,
and is presented
accompanying to the
afterlife a young man
on a black horse, with
whom the artist most
probably identified.
Critics have noted
similarities between
this work and the
famous Dürer engrav-
ing of the *Knight,
Death, and Devil*, of
which the painter
owned a reproduction
that he glued to the
back of his diary, enti-
tled *Avant et Apres*.

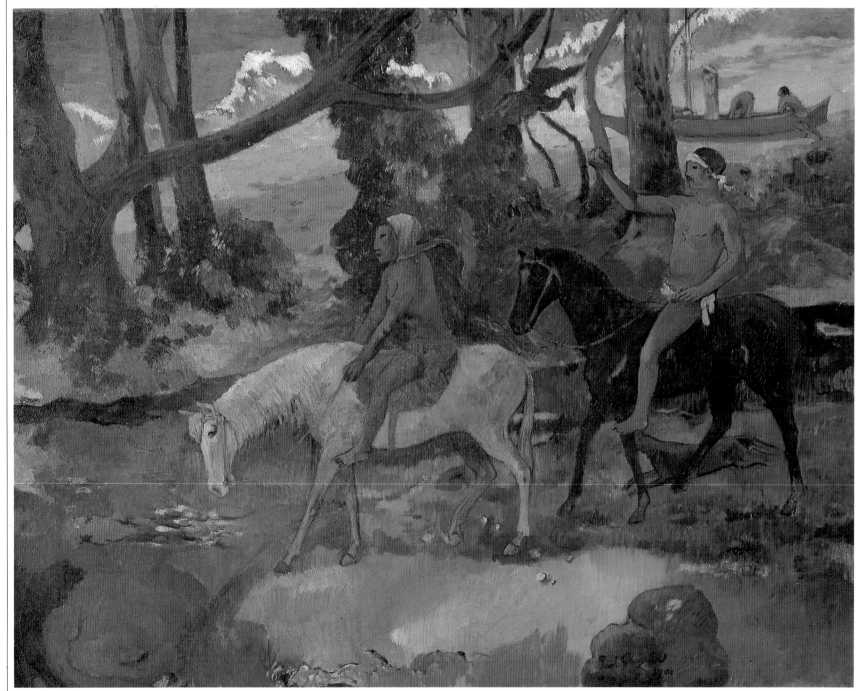

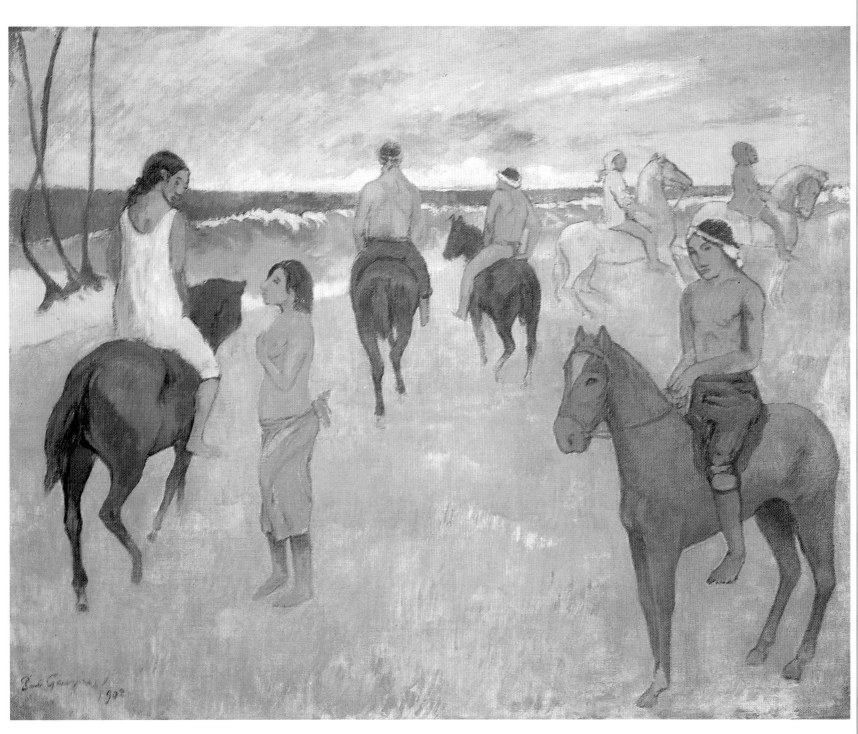

■ PAUL GAUGUIN
Riders on the Beach
1902, oil on canvas,
73 × 92 cm
Private collection

In August 1901 Gauguin leaves Tahiti and sets sail for the Marquesas, an archipelago of twelve volcanic islands located about 1,400 kilometers away. This painting recalls the works by Degas showing the racecourse of Longchamp, but the naturalism of those works is replaced here by symbolism. Not only has the location of the scene changed, a tropical beach in place of a suburban racecourse, but even the meaning of the work is different. In place of jockeys there are two mysterious hooded figures, similar to the *tupapau* demons of Polynesian mythology, leading the other horsemen into the unknown.

PAUL GAUGUIN

Marquesan with Red Hat (The Witch of Hiva Oa)

1902, oil on canvas, 92 × 73 cm
Musée d'Art Moderne, Liege

The figure at the center in the red cloak is most often identified as Haapuani, a former local witch who became a sort of master of ceremonies after the arrival of the missionaries. There are also those who see the figure as a *mahu*, meaning a man with female features, long hair, and a woman's costume, like one Gauguin met on the island of Hiva Oa. The two animals to the lower right, part real, part fantasy, are associated with the ancient religion of the Marquesas to which Gauguin is strongly attracted.

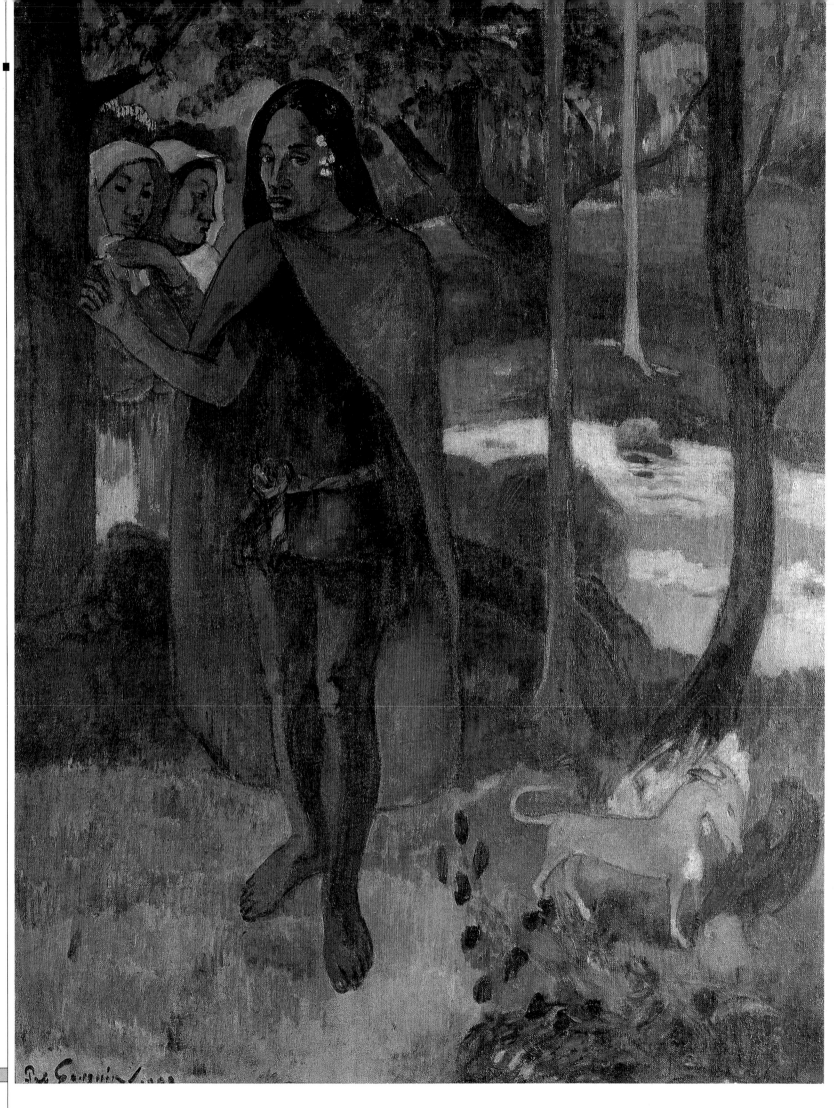

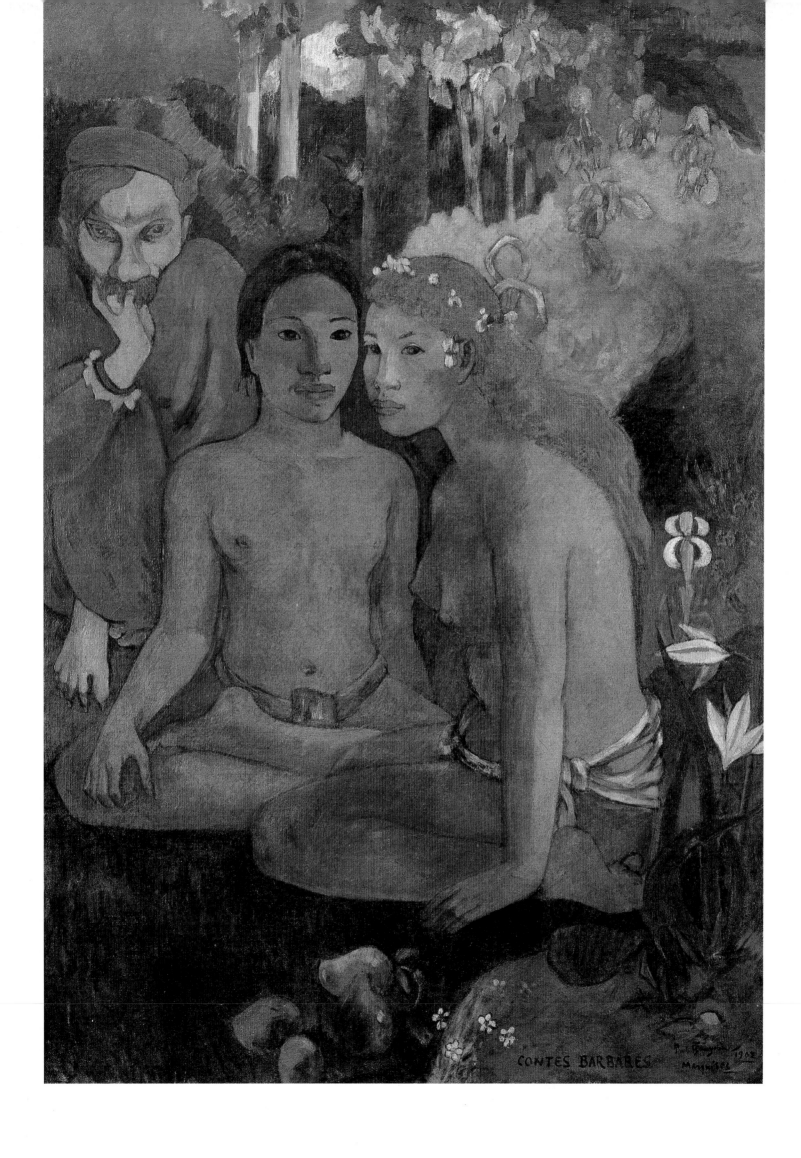

PAUL GAUGUIN
Barbarous Tales
1902, oil on canvas,
131.5 × 90.5 cm
Museum Folkwang,
Essen

Gauguin dies on May
8, 1903, probably as
the result of a heart
attack; this painting
is one of his last
works. The male figure
is Meyer De Haan, his
Dutch painter friend
with whom he had
many long discussions
of literature and phi-
losophy. Here is he
transformed into a
strange diabolical and
evil figure, symbolic
of the heartless ratio-
nality of the West that
threatens the purity of
the two girls, who are
themselves symbolic of
an existence that is
vital and instinctive,
in perfect harmony
with nature.

PAUL CÉZANNE
Mont Sainte-Victoire
1902–06,
oil on canvas,
65 × 81 cm
Nelson-Atkins Museum
of Art, Kansas City

Mont Saint-Victoire, which dominates the plain to the east of Aix-en-Provence, is one of Cézanne's favorite subjects, and he repeats it many times in the works of his last years. He finds himself drawn to the places where he spent the happy, carefree years of his youth. When he was a child he loved to have the local peasants tell him the folk tales set in those very woods; then there was the period when he and Emile Zola (back when they were still friends) went hunting together there, or if the weather permitted dared each other to dive into the cool waters of Provençal streams.

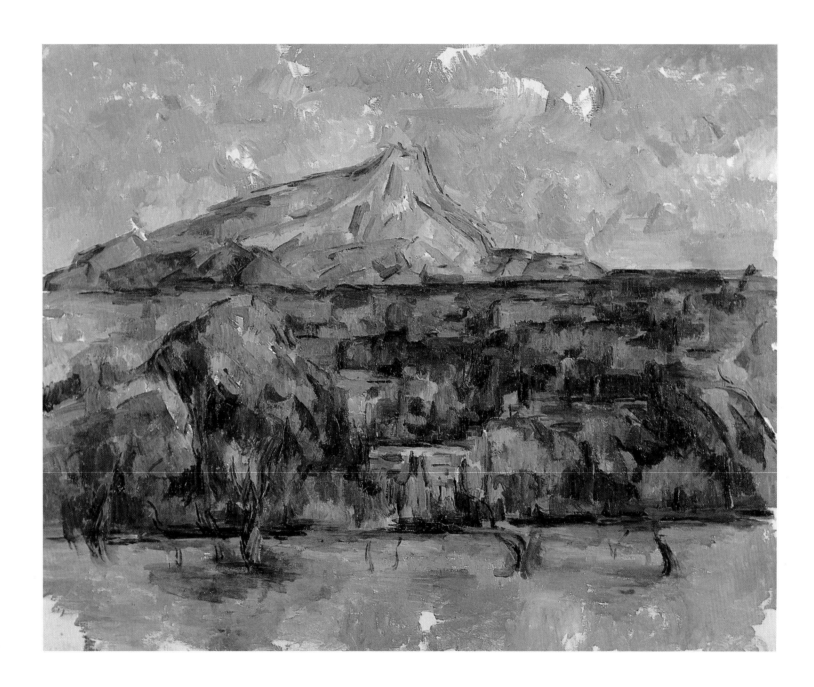

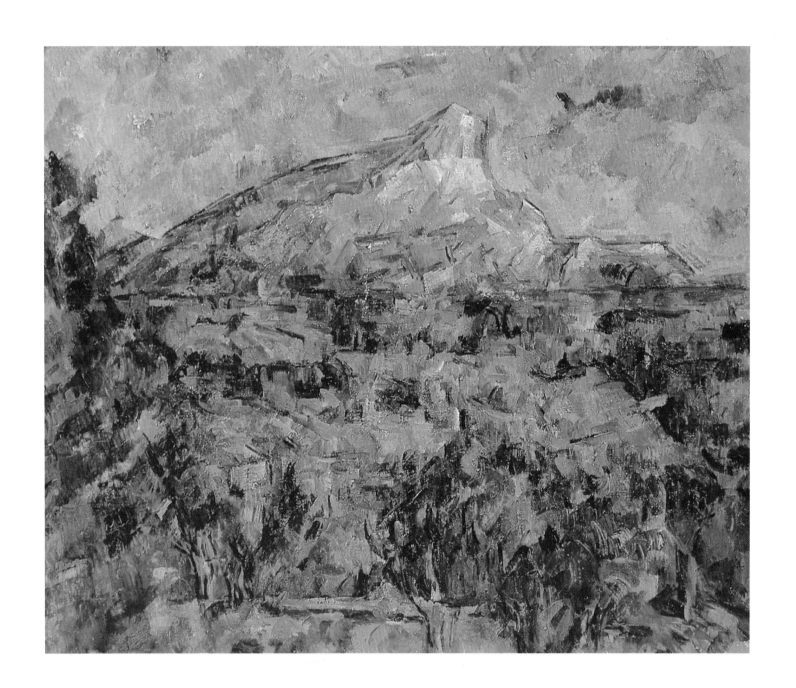

PAUL CÉZANNE
**Mont Sainte-Victoire
Seen from Lauves**
1905–06,
oil on canvas,
60 × 73 cm
Pushkin State Museum
of Fine Arts, Moscow

The mountain's characteristic outline, the way its blocky peak rises straight up from the surrounding plain, provides a good means of tracing the stylistic route Cézanne follows during the last years of his life. He increasingly simplifies the forms and flattens the volumes, which lose their consistency to the point of appearing two-dimensional. He applies the paint to the canvas in an increasingly looser and dynamic way, ultimately distancing himself from the faithful rendering of the landscape and bringing his art to the boundaries of abstract painting.

PAUL CÉZANNE
Bathers
1900–05,
oil on canvas,
51.3 × 61.76 cm
The Art Institute,
Chicago

This is one of the pre-
liminary sketches for
the three final canvas-
es dedicated to the
subject of bathers,
works that are today
divided among the
National Gallery of
London, the Barnes
Foundation in Merion,
and the Philadelphia
Museum of Art (oppo-
site page). The first
series of bathers, made
in 1873–76, are in a
naturalist style based
on the Barbizon
school; in the second
group, which dates to
the period between
1879 and 1887, the
colors take on a more
accentuated, rhythmic
cadence; here, finally,
Cézanne achieves a
synthesis of his art,
presenting one of the
absolute peaks of his
artistic development.

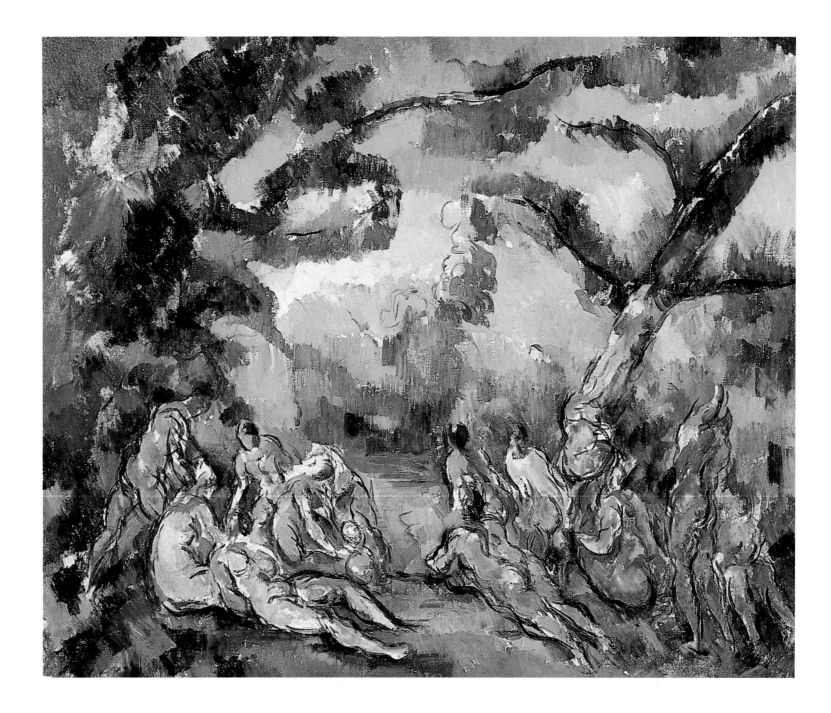

The legacy of the Impressionists

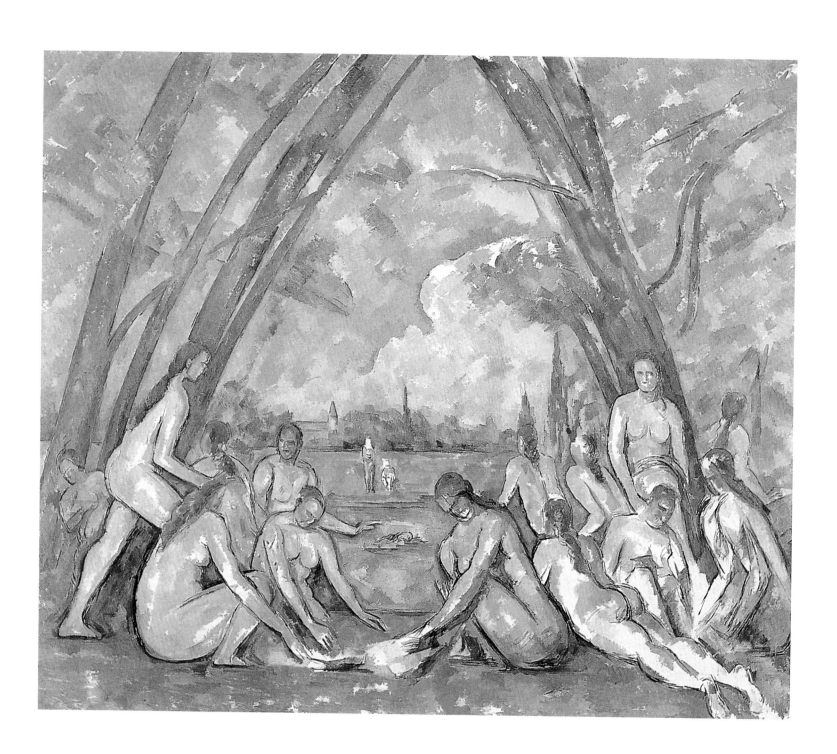

■ Paul Cézanne
The Large Bathers
1906, oil on canvas,
208 × 249 cm
Philadelphia Museum
of Art, Philadelphia

Long, meticulous
preparation helps
Cézanne create his
absolute masterpiece,
his spiritual testament
in which color becomes
the rhythmic pulsation
of emotion. The arcing
shape of the plants
serves to link the two
groups of figures, tying
them into the planes
of the composition
while drawing the
eye of the spectator
toward the luminous
landscape in the back-
ground. We have come
far from the quiet nat-
uralism of the late
nineteenth century
and are making our
way directly into the
dynamic vortex of
twentieth-century art.

References

Participants in the group shows

●

Biographies

●

Bibliography

●

Index of names and places

●

Index of works

Participants in the group shows

This table presents the artists who took part in the eight Impressionist shows, from 1874 to 1886, indicating which shows each artist participated in.

ARTIST		1874	1876	1877	1879	1880	1881	1882	1886
ASTRUC, ZACHARIE	1835–1907	■							
ATTENDU, ANTOINE-FERDINAND	1845–1905	■							
BÉLIARD, EDOUARD	1835–1902	■	■						
BOUDIN, EUGÈNE	1824–1898	■							
BRACQUEMOND, FÉLIX	1833–1914	■			■	■			
BRACQUEMOND, MARIE	1841–1916				■	■			■
BRANDON, EDOUARD-EMILE	1831–1897	■							
BUREAU, PIERRE-ISIDORE	1827–1880	■							
CAILLEBOTTE, GUSTAVE	1848–1894		■	■	■	■		■	
CALS, ADOLPHE-FÉLIX	1810–1880	■	■	■	■				
CASSATT, MARY	1845–1926				■	■	■		■
CÉZANNE, PAUL	1839–1906	■		■					
COLIN, GUSTAVE	1828–1910	■							
CORDEY, FRÉDÉRIC	1854–1911			■					
DEBRAS, LOUIS	1820–1899	■							
DEGAS, EDGAR	1834–1917	■	■	■	■	■	■		■
DE NITTIS, GIUSEPPE	1846–1884	■							
DESBOUTIN, MARCELLIN	1823–1902		■						
FORAIN, JEAN-LOUIS	1852–1931				■	■	■		
FRANÇOIS, JACQUES	/		■	■					
GAUGUIN, PAUL	1848–1903				■	■	■	■	■
GUILLAUMIN, JEAN-BAPTISTE-ARMAND	1841–1927	■		■		■	■	■	■
LAMY, FRANC	1855–1919			■					
LATOUCHE, LOUIS	1829–1884	■							
LEBOURG, ALBERT-CHARLES	1849–1928				■	■			
LEGROS, ALPHONSE	1837–1911		■						
LEPIC, LUDOVIC-NAPOLÉON	1839–1889	■	■						
LÉPINE, STANISLAS	1835–1892	■							
LEVERT, JEAN-BAPTISTE-LÉOPOLD	1828–?	■	■	■		■			
MAUREAU, ALPHONSE	1830–1883			■					
MEYER, ALFRED	1832–1904	■							
MILLET, JEAN-FRANÇOIS	1814–1875		■						
MOLINS, AUGUSTE DE	1821–1890	■							
MONET, CLAUDE	1840–1926	■	■	■	■			■	
MORISOT, BERTHE	1841–1895	■	■	■		■	■	■	■
MULOT-DURIVAGE, EMILIEN	1838–?	■							
OTTIN, AUGUSTE-LOUIS-MARIE	1811–1890	■							
OTTIN, LÉON-AUGUSTE	1836–?	■	■						
PIETTE, LUDOVIC	1826–1877			■	■				
PISSARRO, CAMILLE	1830–1903	■	■	■	■	■	■	■	■
PISSARRO, LUCIEN	1863–1944								■
RAFFAËLLI, JEAN-FRANÇOIS	1850–1924					■	■		
RAFFAËLLI, JEAN-MARIUS	/					■			
REDON, ODILON	1840–1916								■
RENOIR, PIERRE-AUGUSTE	1841-1919	■	■	■				■	
ROBERT, LÉON-PAUL	1849–?	■							
ROUART, STANISLAS-HENRI	1833–1912	■	■	■	■	■	■		■
SCHUFFENECKER, CLAUDE-EMILE	1851–1934								■
SEURAT, GEORGES	1859–1891								■
SIGNAC, PAUL	1863–1935								■
SISLEY, ALFRED	1839–1899	■	■					■	
SOMM, HENRI	1844–1907				■				
TILLOT, CHARLES	1825–1895		■	■	■	■	■		■
VIDAL, EUGÈNE	1847–1907					■	■		
VIGNON, VICTOR	1851–1909					■	■	■	■
ZANDOMENEGHI, FEDERICO	1841–1917				■	■	■		■

Biographies

GUSTAVE CAILLEBOTTE

Born in Paris on August 19, 1848, son of a wealthy textile manufacturer. Studies law, getting his degree in 1870. In July 1870 he enrolls in the national guard and fights in the Franco-Prussian War. Admitted to the Ecole des Beaux-Arts in 1873, presented by Léon Bonnat, and places forty-second out of eighty candidates. On the death of his father, in 1874, he receives a large inheritance, thanks to which he can dedicate himself full-time to painting. Through Giuseppe De Nittis and Degas he meets the Impressionists and exhibits in five of their shows, beginning with the second. Uses his inheritance to finance the shows, also providing generous help to other painters, loaning them money and buying their works. In 1880 he moves with Charlotte Berthier to Petit-Gennevilliers, near Argenteuil, where he paints, gardens, and takes part in sailing regattas. He dies on March 2, 1894, leaving his large collection of Impressionist paintings to the French nation. The works form the core collection of the Musée d'Orsay in Paris.

MARY CASSATT

Born in Pittsburgh on May 22, 1844, daughter of a wealthy businessman. Against her family's wishes she studies at the Pennsylvania Academy of the Fine Arts. Between 1865 and 1870 travels in Europe, visiting museums and studying classical art. She attends the studio of the academic painter Chaplin, takes lessons from Couture and Gérôme, and in 1874 succeeds in having a painting accepted by the Salon. She is noted by Degas, who introduces her to the other Impressionists. She participates in four of the Impressionist shows, becoming known for her portraits of young mothers with their babies and for her use of colors with intimist effects. She buys works by Impressionists and introduces their works to her friends, including Louisine Elder Havemeyer. She has a great passion for Japanese art, which has an important effect on her production of etchings. Her official recognition comes with a personal show in 1891 organized by Durand-Ruel. She dies at Mesnil Théribus June 14, 1926.

PAUL CÉZANNE

Born in Aix-en-Provence on January 19, 1839. His father, Louis-Auguste, owner of a hat factory, is one of the founders of the Cézanne & Cabassol bank. In 1852 Paul begins studies at the Bourbon college, where he makes friends with future writer Emile Zola. In 1859 he enrolls in the law school of the university of Aix-en-Provence, but in 1861 he finally obtains his father's permission to go to Paris to study painting. In 1869 he meets Hortense Fiquet, with whom he has a son in 1872 and whom he marries in 1886. He paints with Pissarro at Pontoise, and in 1874, at Pissarro's invitation, he exhibits in the first Impressionist show and also participates in the third show, in 1877. Disappointed by negative criticism, he isolates himself from the other painters and withdraws to L'Estaque, in the south of France. After the death of his father, in 1887, he returns to Aix-en-Provence, alternating his time in Provence with trips to Paris and other spots in France. In 1895 Vollard organizes a first one-person show, and it meets with great favor. He dies in Aix-en-Provence on October 22, 1906.

EDGAR DEGAS

Born in Paris on July 19, 1834. His father, descendent of a noble family of Breton origin, moved to Naples during the French Revolution and returned to Paris, where he directs a branch of the family's bank. In 1855 Degas abandons law studies to dedicate himself to painting. He attends the studio of Louis Lamothe and is admitted to the Ecole des Beaux-Arts. Between 1856 and 1861 he makes a long trip to Italy. In 1862, he meets Manet and the other Impressionists, with whom he frequents the Café Guerbois and the Café La Nouvelle-Athènes. He participates in all the shows except that of 1882. He first experiences problems with his eyesight in 1880; by the time of his death the problems have rendered him almost completely blind. In 1893 Durand-Ruel organizes the first and only one-man show. Because of his poor health he spends his last years increasingly isolated from the other artists, and lives apart until his death, in Paris, on December 26, 1917.

GIUSEPPE DE NITTIS

Born in Barletta, Italy, on February 25, 1846. Studies in the workshop of Giovambattista Calò, then in the academy of Naples, but is expelled in 1863 for disciplinary reasons. Dedicating himself to working *en plein air*, he debuts as a landscapist in 1864 at the show of the Salvator Rosa Fine Arts Society of Naples. In 1867 he goes to Florence and meets the Macchiaioli artists. He moves to Paris and in 1869 marries Léontine Gruville. He goes to Italy during the Franco-Prussian War, returning to France in 1872. After two years of difficulties and studies he is admitted to the Salon, also exhibiting in the first Impressionist show. The next year he is in London, where he makes city views. He continues to exhibit with success at the Salon and frequently participates in international shows, including the Venice biennale, until his death at Saint-Germain-en-Laye, on August 21, 1884, only thirty-eight years old.

PAUL GAUGUIN

Born in Paris on June 7, 1848. Following the death of his father, he spends his childhood in Peru with the parents of his mother. In France he first tries to become a sailor, then is taken on by the Bertin exchange firm. A colleague, Emile Schuffenecker, infects him with the love of art. In 1873 he marries the Dane Mette Gad, with whom he has five children. In January 1883, having lost his job, he decides to dedicate himself full-time to painting, although he meets with scant success; he then meets Camille Pissarro, thanks to whom he takes part in the last five Impressionist shows. While his wife returns to her family in Copenhagen, Gauguin paints in Pont-Aven, in Martinique, and at Arles, guest of Vincent van Gogh. Between 1891 and 1893 he makes his first trip to Tahiti. In December 1893 Durand-Ruel organizes the first one-man show of his work in Paris, but it fails to attract a favorable response from critics and collectors, who do not understand his exoticism. On June 28, 1895, he leaves Paris for good, living first in Tahiti and finally in the Marquesas, where he dies on May 8, 1903.

EDOUARD MANET

Born in Paris on January 23, 1832. His father is a magistrate, personnel director of the ministry of justice. From 1850 to 1856 he studies painting in Thomas Couture's academy, visits the Louvre, and takes trips to Italy, Holland, Germany, and Austria. On October 23, 1863, he marries Suzanne Leenhoff; that same year the jury of the Salon rejects his *Luncheon on the Grass*. When the artist presents it at the Salon des Refusés, it causes a scandal and attracts fierce criticism that only increases two years later when the Salon shows his *Olympia*. These two works, often cited as the beginning of modern art, make him enormously popular with certain young artists, those unhappy with the traditional teachings of the Ecole des Beaux-Arts, who meet at the Café Guerbois and the café La Nouvelle-Athènes. Although he never participates in any of their shows, and although he prefers paintings of figures, portraits, and genre scenes to landscapes, he is considered the leader of the Impressionist group. He dies in Paris on April 30, 1883.

CLAUDE-OSCAR MONET

Born in Paris on November 14, 1840, second-born of Claude Auguste, owner of a drugstore, and Louise Justine. In 1856 he meets Eugène Boudin who teaches him to paint outdoors. Following the death of his mother, in 1857, he is entrusted to an aunt. Two years later he returns to Paris and takes lessons in Gleyre's academy; there he meets Renoir, Sisley, and Bazille, with whom he paints in the forest of Fontainebleau. In 1865 he is accepted by the Salon for the first time. On June 26, 1870, he marries Camille Léonie Doncieux,

who dies in 1879. During the Franco-Prussian War he goes to London, where he meets Pissarro and Durand-Ruel. Back in France he is among the promoters of the first Impressionist show and goes on to participate in another four of their shows. In 1883 he moves to Giverny; in 1892 he marries Alice Hoschedé, a widow who dies in 1911. His vision grows increasingly poor from 1908 on, such that he is finally almost blind, but he continues to paint until his death at Giverny, on December 6, 1926.

BERTHE MORISOT

Born in Bourges on January 14, 1841, the daughter of an official with the state audit board who teaches her to draw and passes on to her his passion for painting. Being a woman she cannot attend the Ecole des Beaux-Arts and takes private lessons from the academic painter Joseph Guichard, who presents her to Jean-Baptiste-Camille Corot, under whose guidance she learns to paint in the open air. She is finally admitted to the Salon in 1864 and participates regularly until 1873. In 1867 she meet Edouard Manet and becomes his model and student. On December 12, 1874, shortly after the death of her father, she marries Eugène Manet, Edouard's brother, and in 1878 gives birth to a daughter, Julie. She participates in all of the Impressionists' shows except that of 1879, which she misses because she is giving birth. She is without doubt among the outstanding personalities of the group, and the Thursday meetings at her home are animated by musicians, painters, and writers, including Stéphane Mallarmé and Emile Zola. She later displays her works with great success in the galleries of Petit, Durand-Ruel, and Boussod & Valadon in France and the United States. She dies in Paris on March 2, 1895.

JACOB-ABRAHAM-CAMILLE PISSARRO

Born in Saint Thomas in the Virgin Islands on July 10, 1830, son of a Portuguese Jew and a creole. He studies at the Ecole des Beaux-Arts and the Académie Suisse, where he meets Monet, who introduces him to Cézanne and Guillaumin. Although his works are routinely admitted to the Salon from 1859 to 1869, he is hostile to official settings and in 1863, as a show of solidarity, he joins the painters in the Salon des Refusés. During the Franco-Prussian War he takes refuge in London, where he meets Paul Durand-Ruel, who begins to handle his paintings as well as those of the other Impressionists. In 1874 he participates in the first Impressionist show and is the only artist to take part in all the other shows. He spends most of his life in Louveciennes, Pontoise and, beginning in 1884, Eragny. In 1885 he meets Seurat and Signac with whom he experiments in the divisionistic method called Pointillism, which he abandons in1890 to return to the Impressionist style. He dies in Paris on November 13, 1903.

PIERRE-AUGUSTE RENOIR

Born in Limoges, in central France, on February 25, 1841, the sixth of seven children born to Léonard Renoir, tailor, and Marguerite Merlet, laborer. In 1844 he moves to Paris and find works as a decorator in a porcelain factory. Admitted to the Ecole des Beaux-Arts, he studies under Emile Signol and Charles Gleyre, also attending the latter's atelier, where he meets Bazille, Sisley, and Monet, the so-called Batignolles group. He participates in four of the Impressionists' shows even though after 1882,

following a trip to Italy, his style turns toward the classical. At the end of December 1889 he is struck by severe rheumatic pains and will suffer from them for the rest of his life. On April 14, 1890, he marries Aline Charigot, with whom he has three sons, Pierre, Jean, and Claude (known as Coco). From 1899 on he lives in Cagnes-sur-Mer, halfway between Nice and Antibes. In 1907 he buys a large holding, Les Collettes, in Cagnes, where he continues to paint despite poor health until his death, on December 2, 1919.

JOHN SINGER SARGENT

Born in Florence on January 12, 1856, to American parents who have moved to Italy, the doctor Fitzwilliam Sargent and Mary Newbold Singer. Showing precocious artistic talent he takes lessons at the fine arts academy in Florence in 1873. The next year he moves to Paris and studies at the Académie des Beaux-Arts and takes lessons from Carolus Duran, who introduces him to the painting of the Impressionists. In 1878 he is accepted by the Salon for the first time, but in 1884, following the negative criticism of one of his paintings, *Portrait of Madame Gautreau*, he moves to London, where he sets up a studio in Chelsea. He is already famous for his portraits. In 1889 he is awarded the grand prize at the universal exhibition and is made a chevalier of the Legion of Honor. In 1894 he is nominated to the Royal Academy of London, later becoming a member. His fame as a portraitist grows, and he enjoys enormous success painting the aristocracy and the well-to-do of both Europe and America. When the United States enters World War I, he goes to the front lines in France to paint the war and its horrors, staying there four months. He dies in London on April 15, 1925.

GEORGES-PIERRE SEURAT

Born in Paris on December 2, 1859, the third of four children in a well-to-do family. In 1878 he is admitted to the Ecole des Beaux-Art; in 1879, together with his friends Edmond Aman-Jean and Ernest Laurent, he rents a studio at 32, Rue de L'Arbalète. In 1883 the jury of the Salon accepts one of his drawings, but the next year his painting *Une Baignade à Asnières (Bathers at Asnières)* is refused. Along with other "refuseés" artists he founds the Société des Artistes Indépendants, which on May 15 at the Tuileries opens the first Salon des Artistes Indépendants, with works by 450 painters admitted without a selection committee. He participates in the March 1886 Impressionist show in New York and in the last Impressionist show in Paris. Meanwhile he finishes his painting *Sunday Afternoon on the Island of La Grande Jatte*, his masterpiece and the manifesto of the new Pointillist painting based on studies of optics. In 1889 he meets the model Madeleine Knoblock, with whom he has two children. On March 29, 1891, he dies of diphtheritic influenza or pneumonia at age thirty-two.

PAUL SIGNAC

Born in Paris on November 11, 1863, to a family of shopkeepers. Following the death of his father he moves to Asnières and begins to paint in the open. Through friendships with Pissarro and Seurat he participates in the first Salon des Artistes Indépendants in 1884 and in the last Impressionist show in 1886. Working in close collaboration with the critic Félix Fénéon and Seurat, he experiments and further develops the method and theory of Pointillism.

After Seurat's death he becomes the leader of the post-Impressionist movement, and from 1908 to 1934 is president of the Société des Artistes Indépendants, participating in all nine shows of that group. During his final years he continues his experiments with the divisionist style, along with intense activity as an engraver. He backs away from the scientific rigor of his chromatic methods, giving space in his later works to light and emotional values. At the same time he remains open to ideas from the avant garde, most of all in terms of the use of color of the Expressionist painters. He dies in Paris on August 15, 1935.

ALFRED SISLEY

Born in Paris on October 30, 1839, the son of a rich English businessman in France for business reasons. His father tries to get him started in business studies in London but surrenders in the face of his determination to dedicate himself to painting. In 1862 he attends the studio of Charles Gleyre, where he makes friends with Bazille, Monet, and Renoir and with whom he frequents the famous Café Guerbois. The Franco-Prussian War causes the complete financial ruin of his father, and from then on he lives in difficult financial straits. He participates in the first three shows of the Impressionists and in the 1882 show. His landscapes and views draw most of their inspiration from the painting of Corot, Courbet, Daubigny, and the English landscape tradition, particularly Turner. Although his works are highly appreciated by the other painters as well as by most of the critics, Sisley is almost completely ignored by collectors and, much like Pissarro, never succeeds in achieving a level of fame anywhere near that of the other Impressionists. He dies at Moret-sur-Loing on January 29, 1899, as the result of a throat tumor.

VINCENT WILLEM VAN GOGH

Born in Groot Zundert in the Dutch Brabant on March 30, 1853. In 1868 he is taken on by the Goupil company and works in the Hague office, then in London, and finally in Paris before being fired, in April 1876. Gripped by powerful religious fervor he attempts to follow his father's career as a preacher but fails. In October 1880 he goes to Brussels and enrolls in the academy of fine arts. In 1886 he joins his brother Theo, director of an art gallery in Montmartre, in Paris; until the end of his life Theo will do what he can to take care of him. He enrolls in the atelier of Fernand Cormon and meets the Impressionist painters, who have a strong influence on his art. He makes friends with Gauguin, who visits him in Arles, where he moves in February 1888. The two artists spend two anguished and tormented months together, ending in the dramatic gesture of Van Gogh cutting off part of his left ear. He spends several months in an asylum at Auvers-sur-Oise, under the care of Dr. Gachet. On July 27, 1890, he shoots himself with a pistol.

JAMES ABBOTT MCNEILL WHISTLER

Born in Lowell, Massachusetts, on July 10, 1834. His father, an engineer, moves the family to Russia in 1843, where he works on the St. Petersburg-Moscow rail lines. Following his father's death, in 1849, James returns to America with his mother. In 1851 he enters the West Point military academy but is dismissed three years later and turns to the study of drawing and engraving. In 1844 he moves to Europe, first Paris, where he takes lessons from Gleyre, then London, where he spends almost the rest of his life. From 1864 to 1865 he paints in Trouville with Courbet, coming to approach his realism. In 1866 he goes to Valparaiso to participate in Chile's war of liberation against Spain. During those same years he is passionately interested in Japanese prints, aspects of which enrich his art. Through Baudelaire, Mallarmé, Degas, and Manet, the art of the Impressionists also has an effect on his style. In 1877 he presents several of his *Nocturnes* at the Grosvenor Gallery, but they are poorly received by critics. In 1884 he becomes a member of the British Artists Society, serving as its president from 1886 to 1888. Whistler dies in London, on July 17, 1903.

FEDERICO ZANDOMENEGHI

Born in Venice on June 2, 1841, to a family of sculptors. His training begins in his father's studio and continues at the Venetian academy (1856). A fervent patriot, he joins the followers of Garibaldi and is one of the famous Red Shirts. Prevented from returning to Venice, still in Austrian hands, he moves to Florence, where he meets the artists of the Macchiaioli group. In June 1874 he moves to Paris and meets Toulouse-Lautrec and Renoir, serving as Renoir's witness when he marries Aline Charigot, on April 14, 1890. He also makes friends with Pissarro and Degas, who convince him to participate in four of the Impressionists' shows. Durand-Ruel takes him on as a client, exhibiting his works in his gallery and thus guaranteeing him steady income. During the last years of the century his style approaches that of Renoir, although he is also attentive to the Pointillism of Seurat and Signac. He specializes in female portraits, in which he shows an exceptional sensitivity in the use of colors. He dies in Paris on December 30, 1917.

Bibliography

The following titles have been chosen from the vast literature on the Impressionists to give the interested reader a sense of the variety of works available. Note that a catalogue raisonné is an annotated catalogue, usually including all of an artist's known works.

Adams, Steven. *The World of the Impressionists*. London-New York: Thames and Hudson, 1989.

Adhémar, Jean, and Françoise Cachin. *Degas: The Complete Etchings, Lithographs, and Monotypes*. Trans. by Jane Brenton; foreword by John Rewald. London-New York: Thames and Hudson, 1986.

Adler, Kathleen. *Camille Pissarro: A Biography*. New York: St. Martin's Press, 1977.

———. *Unknown Impressionists*. Oxfordshire: Phaidon, 1988.

Adler, Kathleen, and Tamar Garb. *Berthe Morisot*. London: Phaidon, 1995.

Adriani, Gotz. *Degas: Pastels, Oil Sketches and Drawings*. London-New York: Thames and Hudson, 1985.

Barnes, Albert C., and Violette De Mazia. *The Art of Renoir*. New York: Minton, Balch, 1935.

Barskaya, Anna, Marina Bessonova, and Eugenia Georgievskaya. *Impressionist and Post-Impressionist Paintings in Soviet Museums*. New York: Facts on File, 1985.

Bazin, Germain. *Impressionist Painters in the Louvre*. Trans. by S. Cunliff-Owne. London-New York: Thames and Hudson, 1958.

Bérhaut, Marie. *Caillebotte: The Impressionist*. Lausanne: International Art Books, 1968.

———. *Gustave Caillebotte, sa vie et son oeuvre*. Paris: Fondation Wildenstein, 1978.

Blunden, Maria and Godfrey, and Jean-Luc Daval. *Impressionists and Impressionism*. Geneva: Skira, 1970.

Boggs, Jean Sutherland. *Portraits by Degas*. Berkeley: University of California Press, 1962.

Boggs, Jean Sutherland, et al. *Degas* (exhibition catalog). The Metropolitan Museum of Art, New York, and the National Gallery of Canada, Ottawa, 1988.

Boggs, Jean Sutherland, and Anne Maheux. *Degas Pastels*. London-New York: Thames and Hudson, 1992.

Breeskin, Adelyn Dohme. *Mary Cassatt: A catalogue raisonné of the graphic work*. Washington, D.C.: Smithsonian Insitution Press, 1979.

———. *Mary Cassatt: A catalogue raisonné of the oils, pastels, watercolors, and drawings*. Washington, D.C.: Smithsonian Institution Press, 1970.

Brettell, Richard. *Pissarro and Pontoise: The Painter in a Landscape*. New Haven: Yale University Press, 1990.

Brettell, Richard, and Christopher Lloyd. *Catalogue of Drawings by Camille Pissarro in the Ashmolean Museum, Oxford*. New York: Oxford University Press, 1980.

Brettell, Richard, et al. *The Art of Paul Gauguin*. Washington, D.C.: National Gallery of Art, 1988.

Brooks, Van Wyck, trans. *The Intimate Journals of Paul Gauguin*. London: W. Heinemann, 1930.

Browse, Lillian. *Degas Dancers*. London: Faber and Faber, 1949.

Burnett, Robert. *The Life of Paul Gauguin*. London: Cobden-Sanderson, 1936.

Carson, Julia Margaret Hicks. *Mary Cassatt*. New York: D. McKay, 1966.

Chase, Edward T. *The Etchings of the French Impressionists and Their Contemporaries*. New York: Crown Publishers, 1946.

Clairet, Alain, et al. *Berthe Morisot: Catalogue raisonné*. Montolivet, France: CERA, 1997.

Cogniat, Raymond. *French Painting at the Time of the Impressionists*. New York: Hyperion Press, 1951.

Couldrey, Vivienne. *Alfred Sisley: The English Impressionist*. Newton Abbot: David & Charles, 1992.

Courthion, Pierre. *Impressionism*. New York: Harry N. Abrams, 1977.

Daulte, François. *Alfred Sisley: Catalogue raisonné de l'oeuvre peint*. Lausanne: Durand-Ruel, 1959.

———. *Auguste Renoir*. London: Cassell, 1972.

———. *Auguste Renoir: Catalogue raisonné de l'oeuvre peint*. Lausanne: Durand-Ruel, 1971.

———. *Frédéric Bazille et Son Temps*. Geneva: P. Cailler, 1952.

De Leiris, Alain. *The Drawings of Edouard Manet*. Berkeley: University of California Press, 1969.

Denvir, Bernard. *The Chronicle of Impressionism*. London-New York: Thames and Hudson, 1993.

———. *Encyclopedia of Impressionism*. London-New York: Thames and Hudson, 1990.

———. *The Impressionists at First Hand*. London-New York: Thames and Hudson, 1987.

———. *Paul Gauguin: The Search for Paradise*. London: Collins & Brown, 1992.

Dunlop, Ian. *Degas*. New York: Harper, 1979.

———. *The Shock of the New*. New York: American Heritage Press, 1972.

Duret, Théodore. *Manet and the French Impressionists*. Trans. by J. E. Crawford Flitch. New York: J.P. Lippincott, 1912.

Faille, Jacob-Baart de la. *L'oeuvre de Vincent van Gogh: catalogue raisonné*. 4 vol. Paris: G. van Oest, 1928.

Fletcher, John Gould. *Paul Gauguin, His Life and Art*. New York: N.L. Brown, 1921.

Gauguin, Paul. *Avant et Apres*. Paris, G. Crès et cie, 1923.

Gaunt, William. *Impressionism: A Visual History*. New York: Praeger, 1970.

Gordon, Robert, and Andrew Forge. *Degas*. New York: Harry N. Abrams, 1988.

Gray, Christopher. *Armand Guillaumin*. Chester, Conn.: Pequot Press, 1972.

Guérin, Marcel, ed. *Degas Letters*. Trans. by Marguerite Kay. Oxford: Cassirer, 1947.

Gwynn, Stephen Lucius. *Monet and His Garden*. London: Country Life, 1934.

Halévy, Daniel. *My Friend Degas*. Trans. and ed. by Mina Curtiss. Middletown, Conn.: Wesleyan University Press, 1964.

Hammacher, Abraham Marie. *Van Gogh: A Documentary Biography*. London-New York: Thames and Hudson, 1982.

———. *Vincent Van Gogh: Genius and Disaster*. New York: Abradale Press, 1985.

Hanson, Lawrence. *Mortal Victory—A Biography of Paul Cézanne*. New York: Holt, Rinehart and Winston, 1959.

Harris, Jean C. *Edouard Manet: Graphic Works, A definitive catalogue raisonné*. New York: Collectors Editions, 1970.

Havemeyer, Louisine W. *Sixteen to Sixty: Memoirs of a Collector*. New York: Metropolitan Museum of Art, 1961.

Hulsker, Jan. *The New Complete Van Gogh: Paintings, Drawings, Sketches*. Amsterdam: J. J. Meulenhoff, 1996.

Jamot, Paul, Georges Wildenstein, Marie-Louise Bataille. *Manet*. 2 vols. Paris: Les Beaux-Arts, 1932.

Kelder, Diane. *The Great Book of French Impressionism*. New York: Abbeville Press, 1980.

Kennedy, Edward G. *The Etched Work of Whistler*. San Francisco: Alan Wofsy Fine Arts, 1978.

Lemoisne, Paul-André. *Degas et son oeuvre*. 5 vol. New York: Garland, 1984.

Leymarie, Jean. *Van Gogh*. Trans. by James Emmons. New York: Rizzoli, 1977.

Lindsay, Jack. *Cézanne—His Life and Art*. Greenwich, Conn.: New York Graphic Society, 1969.

Lloyd, Christopher. *Camille Pissarro*. Geneva: Skira, 1981.

Loyrette, Henri. *Degas: The Man and His Art*. New York: Harry N. Abrams, 1993.

Mack, Gersetle. *Paul Cézanne*. New York: Knopf, 1935.

McMullen, Roy. *Degas: His Life, Times and Work*. Boston: Houghton Mifflin, 1984.

Millard, Charles W. *The Sculpture of Edgar Degas*. Princeton: Princeton University Press, 1976.

Moore, George. *Reminiscences of the Impressionist Painters*. Dublin: Maunsel, 1906.

Mount, Charles Merrill. *Claude Monet—A Biography*. New York: Simon and Schuster, 1967.

Nochlin, Linda, ed. *Impressionism and Post-Impressionism, 1874-1904, Sources and Documents*. Englewood Cliffs, N.J.: Prentice-Hall, 1966.

Orienti, Sandra. *The Complete Paintings of Manet*. New York: Harry N. Abrams, 1967.

Parry, Eugenia. *Degas Monotypes*. Cambridge: Fogg Art Museum, 1968.

Pickvance, Ronald. *Gauguin and the School of Pont-Aven*. London: Apollo, 1994.

———. *Van Gogh in Arles*. New York: Metropolitan Museum of Art, 1984.

———. *Van Gogh in Saint-Rémy and Auvers*. New York: Metropolitan Museum of Art, 1986.

Pissarro, Joachim. *Camille Pissarro*. New York: Rizzoli, 1992.

———. *Monet's Cathedral: Rouen, 1892-1894*. London: Pavilion, 1990.

Pissarro, Ludovico Rodo, and Lionello Venturi. *Camille Pissarro, son art, son oeuvre*. 2 vol. Paris: P. Rosenberg, 1939.

Pool, Phoebe. *Degas*. London: Spring Books, 1967.

———. *Impressionism*. London-New York: Thames and Hudson, 1967.

Rachman, Carla. *Monet*. London: Phaidon, 1997.

Rewald, John. *Camille Pissarro, Letters to His Son Lucien*. With the assistance of Lucien Pissarro. New York: Pantheon Books, 1943.

Rewald, John. *Cézanne: A Biography*. New York: Harry N. Abrams, 1986.

———. *Degas, Works in Sculpture: A Complete Catalogue*. New York: Pantheon Books, 1944.

———. *Georges Seurat*. New York: Wittenborn and Company, 1946.

———. *The History of Impressionism*. 4th rev. ed. New York: Museum of Modern Art, 1973.

———. *Paul Gauguin*. New York: Harry N. Abrams, 1954.

———. *Post-Impressionism: From Van Gogh to Gauguin*. New York: Museum of Modern Art, 1978.

———. *Studies in Impressionism*. New York: Harry N. Abrams, 1986.

Rewald, John, ed. *Paul Cezanne: Letters*. 4th ed. New York: Hacker Art Books, 1976.

Roskill, Mark. *Van Gogh, Gauguin, and the Impressionist Circle*. Greenwich, Conn.: New York Graphic Society, 1970.

Roskill, Mark, ed. *The Letters of Vincent Van Gogh*. New York: Atheneum, 1987.

Rubin, James. H. *Impressionism*. London: Phaidon Press, 1999.

Serret, Georges, and Dominique Fabiani. *Armand Guillaumin, 1841-1927, catalogue raisonné*. Paris: Mayer, 1971.

Seitz, William C. *Claude Monet—Seasons and Moments*. Garden City, NY: New York Museum of Modern Art and Los Angeles County Museum, 1960.

Sterling, Charles. *Great French Painting in the Hermitage*. New York: Harry N. Abrams, 1958.

Stone, Irving, ed. *Dear Theo: The Autobiography of Vincent Van Gogh*. New York: Doubleday & Company, 1937.

Stuckey, Charles F., and William P. Scott. *Berthe Morisot, Impressionist*. New York: Hudson Hills Press, 1987.

Sweet, Frederick. A. *Miss Mary Cassatt, Impressionist from Pennsylvania*. Norman, Okla.: University of Oklahoma Press, 1966.

Tabarant, Adolphe. *Manet et ses oeuvres*. Paris: Gallimond, 1947.

Terrasse, Antoine. *Edgar Degas*. Garden City: Doubleday. 1974.

Thomson, Belinda. *Gauguin*. London-New York: Thames and Hudson, 1987.

Thomson, David Croal. *The Barbizon School of Painters*. London: Chapman and Hall, 1890.

Uitert, Evert van, Louis van Tilborgh, Sjraar van Heugten. *Vincent van Gogh: Paintings*. Milan: Arnoldo Mondadori Arte, 1990.

Venturi, Lionello. *Cézanne, son art, son oeuvre*. 2 vol. San Francisco: Alan Wofsy Fine Arts, 1989.

Venturi, Lionello. *Impressionists and Symbolists*. Vol. II of *Modern Painters*. Trans. by Francis Steegmuller. New York: Scribners, 1950.

Venturi, Lionello. *Modern Painters*. Trans. by Francis Steegmuller. New York: Scribners, 1947.

Verdi, Richard. *Cézanne*. London-New York: Thames and Hudson, 1992.

Vollard, Ambroise. *Degas: An Intimate Portrait*. Trans. by Randolph T. Weaver. New York: Greenberg, 1927.

———. *Paul Cézanne, His Life and Art*. Trans. by Harold L. Van Doren. New York: N.L. Brown, 1927.

———. *Renoir: An Intimate Record*. Trans. by Harold L. Van Doren and Randolph T. Weaver. New York: Knopf, 1925.

Wadley, Nicholas. *The Drawings of Van Gogh*. London-New York: Feltham, Hamlyn, 1981.

Weekes, C.P. *The Invincible Monet*. New York: Appleton-Century-Crofts, 1960.

Wildenstein, Daniel. *Claude Monet: Biographie et Catalogue Raisonné*. Lausanne, Paris: La Bitliothèque des Arts, 1974.

Wolk, Johannes van der; Ronald Pickvance; E.B.F Pey. *Vincent van Gogh: Drawings*. Milan: Arnoldo Mondadori Arte, 1990.

Young, Andrew McLaren, Margaret MacDonald, Robin Spencer. *The Paintings of James McNeill Whistler*. New Haven: Yale University Press, 1980.

Index of names and places

Numbers in *italics* refer to captions.

Aix-en-Provence, 56, *78, 79, 80, 81, 101, 105,* 200, 230, 255, *294, 406, 422, 425, 444, 464*
Alexis, Paul, 296
Amiens, 84
Amsterdam, 360
Andrée, Ellen, 162
Angkor-Vat, 332
Anquetin, Louis, 333
Antibes, 336
Antwerp, 361
Argenteuil, 108, *112, 118, 120, 121, 135, 136, 137, 143, 144, 158, 182,* 200, *238, 258, 441*
Arles, *352,* 361, *361,* 362, 363, *378, 381, 459*
Arosa, Gustave, 138
Astruc, Zacharie, *39, 40,* 41, 109
Attendu, Antoine-Ferdinand, 109
Atuana, 442
Aubé, Paul, 291
Auvers-sur-Oise, 109, *126, 127, 128, 129, 130,* 361, *363, 398, 399*

Baldus, Edouard, 202
Balleroy, Albert, comte de, *37,* 38, *43*
Ballu, Roger, 175
Barbizon, 8, 17, *25, 29, 32,* 59, *65, 79,* 138, *143,* 149, *170, 282, 466*
Barletta, *139*
Barrias, Félix, *74*
Bartholomé, Albert, 444
Bartolini, Lorenzo, 16
Barye, Antoine Louis, 17
Baudelaire, Charles, 7, 15, *36, 37,* 38, 40, 43, *48, 106,* 203
Bazille, Jean-Frédéric, 10, *39,* 41, *49,* 58, *58,* 59, *62, 66, 70,* 109
Beauharnais, Ortensia, 82
Béliard, Edouard, 109, 150
Bellelli, Gennaro, *73*
Bellio, Georges de, 176, *177,* 177
Bellot, Emile, *134*
Bénédite, Léonce, 404
Bérard, Paul, *206, 232, 234*
Berck-sur-Mer, *164*
Bernard, Emile, 333, *333, 350,* 361, *363, 391, 442, 443*
Bernard, Madeleine, *351*
Bismarck, Otto von, 83, 84
Blanc, Charles, *53, 255,* 257
Blémont, Emile, 150, 177
Bonaparte, Louis, king of Holland, 82
Bonger, Johanna, 363
Bonnard, Pierre, 333, *333, 350,* 361, *363, 391, 442, 443*
Bordeaux, 84
Bordighera, 305

Borobudur, 332
Boucher, François, *302*
Boudin, Eugéne, *60, 65, 92,* 109, *139, 211*
Bougival, *64, 300*
Boulanger, Georges, 405
Boulogne, Bois de, 10
Boulogne-sur-Mer, *51, 52,* 82, 108
Bracquemond, Marie, 11, 41, 202, 229, 230, 254, 296
Bracquemond, Félix, *37,* 41, 59, 109, 202, 228, 229, 230, 254
Brandon, Emile, 109, 111
Brière de L'Isle, Georges, *87*
Broglie, Jacques-Victor-Albert, 176
Brunelleschi, Filippo, 12
Bruyas, Alfred, 62
Bulthuis, Jan, *360*
Bureau, Pierre-Isidore, 109
Burty, Philippe, 110, 148

Cagnes-sur-Mer, 442, *447*
Cahen, Louis, of Antwerp, 234
Caillebotte, Gustave, 7, 8, 9, 11, 108, *143,* 148, 150, *158,* 174, 175, 200, 202, 228, 229, 230, 254, 255, *260,* 330, 333, *404,* 405, *408,* 445
Cals, Adolphe-Félix, 109, 150, 174, 202
Canova, Antonio, *18, 19*
Cap Martin, *336*
Capri, *262*
Caravaggio, 7
Carbentus, Anna Cornelia, 360, 360
Cardon, Emile, 110
Carnot, Marie-Françoise-Sadi, 406
Cassatt, Mary, 10, 11, *11,* 202, 228, 229, 230, 254, 294, *295,* 296, 330, 331, 445
Castagnary, Jules, 110, 148
Cavour, Camillo Benso, conte de, 83
Cézanne, Paul, 8, *9,* 10, 11, 38, 41, 56, *56,* 58, 59, 108, 109, *109,* 111, 148, 150, *152,* 174, 175, *180,* 200, 202, *227,* 228, *229,* 230, 231, 255, *256, 266, 288, 294,* 295, *296,* 297, 332, *335, 401,* 404, 405, 406, 407, *442, 443,* 444, *444,* 445
Cézanne, Paul (son), *196,* 200
Chabrier, Emmanuel, *98*
Chailly-en-Brière, *58, 66, 67*
Cham (Amédée de Noé), 15, 111, 175, 176
Champfleury, Jules Husson, *37*
Champsaur, Félicien, 38
Chaplet, Ernest, *291*
Charenton-Saint-Maurice, 16
Charpentier, Georges, 10, 177, *177, 178,* 200, 230
Charpentier, Gervais, 177, *205*
Charpentier, Marguerite, 177, *204, 205, 302*
Chase, William Merritt, 331
Chatou, *64, 207*
Chesneau, Ernest, *42,* 111

Chevreul, Michel Eugène, 8, 257, 443
Chocquet, Victor, 10, *152,* 177, *190, 191,* 297
Claretie, Jules, 174
Claus, Fanny, *52*
Clemenceau, Georges, 148, *407, 417, 445*
Colbert, Jean-Baptiste, 14
Colin, Gustave, 109, 111
Constable, John, *26, 94, 252*
Copenhagen, *322,* 363
Corday, Frédéric, 174
Cordier, Charles, *37*
Cormon, Fernand, 361
Corot, Jean-Baptiste-Camille, 8, 15, 16, 57, 59, *65, 79,* 110, *143, 147,* 149, *282*
Courbet, Gustave, *36, 65, 66,* 85, *86, 92, 93, 102, 106,* 148, 149, *249,* 331, *335*
Couture, Thomas, 38, *46,* 57
Cross, Charles, 201, 203

Daguerre, Louis-Jacques Mandé, 202
Dali, Salvador, *31*
Darras, Paul, *91*
Daubigny, Charles-François, 17, *94, 137,* 148, 149, *399*
Daumier, Honoré, 15, *29, 30, 102,* 228
David, Jacques Louis, 15, 332
Debras, Louis, 109
Debussy, Claude, *338*
Décamps, Alexandre Gabriel, 17
De Gas, Achille, 108, 125
De Gas, Auguste, *100*
Degas, Camilla, *163*
Degas, Edgar-Hilaire-Germain, 9, *9,* 10, 11, *11,* 38, 41, 56, 57, *57,* 59, *72, 106,* 108-09, 148, 149, 150, 151, *168,* 174, 201, 202, 203, 222, *228,* 229, 230, *249, 251,* 254, 255, *291,* 294, *295,* 296, 297, *297, 327,* 330, 331, *380,* 404, *404,* 406, 407, 442, *443,* 444, 445
Degas, Elena, *163*
Degas, Hilaire, *73,* 75
Degas, René, *125,* 202
Degas, Stefanina, *163*
De Haan, Meyer, *354, 463*
Delacroix, Eugène, 12, 15, *15,* 16, *20, 23, 76, 87,* 88, *149, 152,* 256, *428*
Denis, Maurice, *333, 405,* 407
De Nittis, Giuseppe, 41, 109, 111, *169,* 229
Dépeaux, Félix-François, 177
Derain, André, 444
Desboutin, Marcellin, 148, 150, 162
Diaz de la Peña, Narcisse Virgile, 17, 59
Dieppe, *265,* 406, *458*
Dihau, Desiré, 98
Dijon, 84
Disdéri, A.E., 201, 203, *203*
Dordrecht, 360
Dreyfus, Aldred, 406
Dumas, Alexandre, 15

Du Maurier, George, 58
Dupré, Jules, 17, *32*
Duran, Carolus, *223*
Durand-Ruel, Charles, *265*
Durand-Ruel, Georges, *265*
Durand-Ruel, Jean-Marie-Fortuné, 149
Duran-Ruel, Paul, *94,* 108, 149, *149,* 150, 174, *178, 184,* 255, *256, 257, 265, 267, 268,* 294, 297, *299, 314,* 330, *330,* 331, *331, 339,* 406, 407, *413,* 445, *450*
Duranty, Louis Edmond, *37,* 41, 150, *213, 215*
Dürer, Albrecht, *460*
Duret, Théodore, 41, 175, 176
Durieux, Tilla, *443*
Duval, Jeanne, *43*

Eiffel, Gustave Alexandre, 332
Eindhoven, 361
Emperaire, Achille, *101*
Enault, Louis, *168*
Ephrussi, Charles, *260*
Eragny-sur-Epte, *359*
Essoyes, *301*
Estaque, 200, *217, 286*
Étretat, *34, 304,* 406
Eugenia Maria de Montijo de Guzmán, 82

Fantin-Latour, Henri de, *36,* 38, 39, *39, 43, 106*
Fauché, Léon, 333
Faure, Jean-Baptiste, *134, 146,* 177, 200
Favre, Jules, 84
Féneon, Félix, 296, *315,* 406, *435*
Feydeau, Georges, *211*
Feyen-Perrin, 109
Fiocre, Eugénie, 203
Fiquet, Hortense, *196,* 200, 297, *422*
Fitzgerald, Desmond, 331
Flaubert, Gustave, *253*
Florence, 16, *18, 27, 73, 260*
Fontainebleau (forest), 17, *25, 29, 32,* 59, *61, 67,* 201, *282*
Forain, Jean-Louis, 148, 202, 228, 230, 254, 296
Fournaise, Alphonse, *258, 260*
Fournier, Edmond-Edouard, 38
Fournier, Eugénie-Désirée, 38
Fragonard, Jean-Honoré, *302*
François, Jacques, 150, 174
Friesz, Emile-Othon, 444
Fuller, William H., 331

Gachet, Paul Ferdinand, *127, 129, 362, 363, 401*
Gallo, Richard, *292*
Gambetta, 84, 85, 148, *198,* 254
Garibaldi, Giuseppe, 84

Garnier, Charles, 9
Gaugain, Paul-Octave, 177
Gauguin, Aline, *287, 407*
Gauguin, Clovis, *322, 324*
Gauguin, Emil, *407*
Gauguin, Jean-René, *290*
Gauguin, Mette Sophie (Gad), *138, 225, 290, 297, 322*
Gauguin, Paul, 12, *12*, 148, 202, 230, 254, *254*, 255, 295, 296, *297, 331*, 332, 333, *333, 358, 361*, 362, 363, *382, 383, 388, 391, 395*, 404, *407*, 442, 444, 445
Gautier, Théophile, 15
Gennevilliers, *136, 441*
Genoa, *27*
Géricault, Théodore, 16, *24*, 203
Gérôme, Jean-Léon, *139*, 404, 405
Gide, André, 355
Ginoud, Marie, 395
Girardon, Françoise, 302
Giverny, *180, 294, 305, 338*, 406, *413, 415, 416, 441, 444, 445, 450, 452, 453*
Gleyre, Charles, 58, *60*, 62, *106, 142*
Goetschy, Gustave, *258*
Goncourt, Edmond, and Jules, 15, *213, 302*
Gonzales, Emmanuel, 54
Gonzales, Eva, *54, 55, 220*
Goupil, Adolphe, 296
Goya, Francisco, 39, *42, 47, 50*, 331
Grandville, 15
Greco, El, 331
Grevy, Jules, 85
Groot Zundert, 360, *360*
Guérard, Henri, *54, 220*
Guérin, Pierre Narcisse, 16
Guichard, Joseph, 57
Guillaume, Louis, *285, 346*
Guillaume, Paul, *346*
Guillaumin, Jean-Baptiste-Armand, 58, *78*, 109, 111, 174, *180*, 202, 230, 254, 255, 295, 296, *323, 401*
Guillemet, Antoine, *52*, 255

Hague, the, 360
Hals, Frans, *134*
Hampton Court, *144*
Hauser, Henriette, *197*
Haussmann, Georges-Eugène, 9, 59, 83, *83*, 176, *438*
Havemeyer, Harry, 330, 331, *332*
Havemeyer, Louisine, 330, 331, *332*
Helleu, Paul César, *339*
Helmholtz, Hermann von, 257
Henriot, Henriette, *259*
Henriot, Jeanne, *259*
Henry, Marie, *354*, 355
Hervilly, Ernest d', 110
Hiroshige, 201, 311, *371*
Hirsch, Alphonse, *133*
Hiva Oa, 442, *462*

Hokusai, 201, *311, 349*
Honfleur, 70
Hoornik, Clasina Maria (Sien), 360, *362*
Hoschedé, Alice, 210, *236*
Hoschedé, Ernest, 109, 177, *181, 183*, 200, *210, 268*
Houssaye, Arsène, *88*
Hugo, Paul, *292*
Hugo, Victor, 84, *350, 355*
Hunt, Holman, 151
Huygens, Christiaan, 257
Huysmans, Joris-Karl, *213, 249, 253*, 254, *277, 289*

Inglis, James S., 331
Ingres, Jean-Auguste-Dominique, 12, 15, 16, *23*, 40, *47, 74, 179, 295, 303, 335, 340*

James, Henry, 148, 151, 174
Jongkind, Johann Barthold, *60, 65, 95*, 110, 211
Jouy, Jules de, *136*
Juan-les-Pins, *336*
Julian, Rodolphe, 58

Knoblock, Madeleine, *356*
Koëlla, Léon Edouard, 51, *52*
Konink, Salmon, *376*

Lamothe, Louis, 74
Lamy, Franc, *155*, 174
Langlois, 361, *374*
Latouche, Louis, 109
Laurent, Méry, 41, 149
Laval, Charles, 333, *347, 351*
Lebourg, Albert, 202, 230, 254
Lecadre, Paul Eugène, *69*
Leclanché, Maurice, *235*
Le Coeur, Charles, *115*
Le Coeur, Jacques, *61, 91*, 177
Le Coeur, Jules, *115*
Le Coeur, Marie, *115*
Leenhoff, Ferdinand, 44
Leenhoff, Rudolph, *135*
Leenhoff, Suzanne, 38, *42, 44, 135*
Legrand, Alphonse, 174, 175
Legrand, Marguerite, *155*
Le Gray, Gustave, 202
Legros, Alphonse, *37, 106*, 110, 150
Le Havre, 8, 56, *65*, 69, 406, *458*
Leo XIII, pope, 405
Lepic, Ludovic-Napoléon, 109, 150
Lépine, Stanislas, 109
Lerolle, Henri, 410
Leroy, Louis, 15, 110, *116*
Les Collettes, 442
Lesseps, Ferdinand de, 406

Levert, Jean-Baptiste-Léopold, 109, 150, 174, 230, 254
Lhote, Paul, *298, 299, 300*
Limoges, 56
London, 15, *94, 95*, 108, 149, 255, 333, 360, *450*
Longchamp, 10
Lopez, Nini, *114*
Lorrain, Claude, 287
Louis Philippe, duc d'Orleans, 14, *22, 33*, 82,
Louveciennes, 108, *142, 146*
Lowell, *106*
Loyer, Eugenia, 360
Luce, Maximilien, 406
Lyons, 85

MacMahon, Edmé-Patrice-Maurice, conte de, 84, 85, 176
McNeill, Anna Matilda, *107*
Maillard, Georges, 175
Maître, Edmond, *39*, 41, *63*
Mallarmé, Stéphane, *36*, 41, *106*, 149, 151, *157*, 202, *213, 334, 338*
Manet, Auguste, 38
Manet, Edouard, 9, 10, 11, *37*, 38-41, *39*, 56, 57, 59, *63, 67*, 85, *100, 102, 103, 106*, 110, *139, 141*, 148, 149, 150, *152, 158, 169*, 174, 177, *198*, 200, 202, 203, 228, 230, *231, 251*, 254, *288*, 294, 297, 330, 331, 332, 333, 404, 407, 443, 445
Manet, Eugène, 38, 39, *164*, 294, *296*
Manet, Gustave, 38, *44*
Manet, Julie, 202, *334*
Manet, Suzanne, *164*
Manguin, Henri-Charles, 444
Mantz, Paul, *277*
Marquesas, 442, *461*
Marey, Etienne-Jules, 203
Margot, Estelle, *155*
Margot, Jeanne, *155, 156*
Marlotte, 56, 59, *61*
Marly-le-Roi, *171*
Marquet, Albert, 444
Marseilles, 85, *105, 217, 266, 286, 319*
Martelli, Diego, *214*
Martin, Annah, *431*
Martin, Père, *114*, 201
Martinet, Louis, 39, *42, 46*
Martinique, 332, *347, 348*
Maximilian, emperor of Mexico, *50*, 83
Matisse, Henri, 11, *387*, 407, 444, *447*
Mattling, 109
Maupassant, Guy de, *258*, 406
Maureau, Alphonse, 174
Maus, Octave, *218*
Mauve, Anton, 360
Maxwell, James Clerk, 257
May, Ernest, 174, 177
Mazzinghi, Joseph, 307

Mazzini, Giuseppe, 82
Médan, *283*
Meissonier, Jean-Louis-Ernest, 404
Menotti, Ciro, 82
Meryon, Charles, 228
Meurent, Victorine Louise, 39, *44, 46, 133*
Meyer, Alfred, 109
Millais, John Everet, 151
Millet, Jean-François, *358*, 363, 404, 405
Molins, Auguste de, 109
Moltke, Helmuth Karl Bernhard von, 84
Monet, Camille Léonie (Doncieux), *66, 67, 70, 92, 118, 119, 135*, 200, *210, 236, 306*
Monet, Claude, 8, *8*, 17, 38, *39*, 41, 56, 58, 59, *59, 61, 62, 63, 64, 76, 78, 108*, 109, 110, 111, *112, 135, 137, 139, 142, 143*, 148, 149, 150, *152, 169*, 174, 175, 177, *180*, 200, 202, 203, 228, 229, 230, 254, 255, *256*, 294, *294*, 296, 330, *330*, 331, 332, 333, *339*, 404, 405, 406, *436, 441*, 442, *442*, 444, *444*, 445, *445*
Monet, Jean, *118, 119, 135, 306*
Monet, Michel, 200
Monfreid, Georges-Daniel de, 333
Monginot, Charles, *51*
Monreale, 264
Montauban, 16
Montgeron, *182*
Montpellier, *62, 407*
Montifaud, Marc de, 110
Moore, George, 41
Moréas, Jean (Papadiamantopulos), 296
Moret-sur-Loing, *437*
Morisot, Berthe, 10, *10*, 11, 38, 39, *52, 54, 55*, 56, 57, 109, 111, 148, 149, 150, 151, *152*, 174, 202, 229, 230, 254, 255, 294, 296, *304, 334*, 442, 445
Morisot, Edma, *140, 141*
Morot, Aimé Nicolas, *7*
Morozov, Ivan, *178, 268, 314*
Mulot-Durivage, Emilien, 109
Muraieva, Martha, 201
Murer, Eugène, *87*, 177, *180, 181*
Murer, Marie, *181*
Musson, Mathilde, *125*
Musson, Michel, *125*
Muybridge, Eadweard, 202, 203, *278*

Nadar (Gaspar-Félix Tournachon), 41, 108, 109, 110, *114, 116*, 201, 203, *442*
Naples, *73, 75, 262, 266*
Napoleon I, 14, 82, 83, 85
Napoleon III, 16, 39, *43*, 59, 82, 83, 84, *84*, 148
Narbonne, 85
Nemo, Ludovic, 333
New Orleans, 108, *125*, 202
Newton, Isaac, 256
New York, 15, 330, *330*, 331, 333

Niepce, Joseph-Nicéphore, 202
Nieuwerkerke, Emilien, 80
Nuenen, 361, *365*, *367*, *379*

Ottin, Auguste-Louis-Marie, 109
Ottin, Léon Auguste, 109, 150
Oudinot, Nicolas-Charles-Victor, 82

Padua, *262*
Pagans, Lorenzo, *100*
Palermo, *264*, *266*
Palmer, Berthe Honoré, 331
Panama Canal, 332, *347*, 406
Person, Henry, *458*
Petit, Georges, 200, 294, *305*, 445
Philadelphia, 330
Philipon, Charles, 15
Picasso, Pablo, 7, 11, *50*, 407
Piette, Ludovic, 174, 202
Pillet, Charles, 148, 200
Pissarro, Camille, 8, 9, *9*, 10, *10*, 38, 41, 56,
 58, 59, *61*, *78*, *94*, 108, 109, *109*, 111, *126*,
 128, *130*, *138*, *146*, 148, 149, 150, 151,
 152, *166*, 174, 175, 176, 177, *180*, *181*,
 192, *193*, *194*, *195*, 200, 201, 202, *227*,
 228, 230, *248*, 254, *254*, 255, *287*, 294,
 296, *302*, *320*, *321*, *323*, 330, 331, 332,
 333, 363, *398*, *401*, 404, 405, 406, 407,
 445
Pissarro, Lucien, 296, *436*
Pius IX, pope, 82
Pocheron, Emile, 150
Poe, Edgar Allan, *157*
Poissy, *269*
Pompeii, *262*
Pont-Aven, *324*, *348*, *351*, *353*, *354*, *358*,
 382
Pontoise, 108, *126*, *127*, 174, *227*, 255,
 359
Pontormo, Jacopo da, *76*
Port-Marly, *171*
Pothey, Alexandre, *160*
Poussin, Nicolas, *25*
Praxiteles, 38
Proudhon, Pierre Joseph, *35*
Proust, Antonin, *198*, 230, 254
Prouvaire, Jean, 110
Provily, Jan, 360
Puvis de Chavannes, Pierre, *57*, *103*, *433*
Puy, Jean, 444

Raffaëlli, Jean-François, 148, 228, 230, 254
Raffaëlli, Jean-Marius, 230, 254
Raimondi, Marco Antonio, *44*
Randon, Georges, 40
Ranson, Paul, 444
Raphael, *24*, 38, *44*, *301*
Redon, Odilon, 295, 296

Rembrandt, *249*, *376*
Renard, Gabrielle, *409*, 442
Renoir, Aline (Charigot), 254, *260*, *298*,
 301, 442
Renoir, Claude, *442*
Renoir, Edmond, *61*, 110, *113*, *114*
Renoir, Jean, 203, *406*, *409*, *447*
Renoir, Pierre, *301*
Renoir, Pierre-Auguste, 8, *8*, 10, 11, *11*, 12,
 13, *13*, *22*, 38, *39*, 41, 56, 57, 58, 59, *59*,
 63, *81*, 108, 109, 110, 111, *135*, *142*, *143*,
 148, 149, 150, 151, *151*, *152*, 174, 175,
 176, 177, *180*, 200, 202, *202*, 228, *228*,
 230, *251*, 254, *254*, 255, *256*, *286*, 294,
 296, 297, *305*, 330, *401*, 404, *404*, 405,
 406, 407, 442, *443*, 445
Réunion, 407
Rewald, John, *113*, 231
Rheims, 84
Rivière, Georges, *155*, 175, *195*
Robert, Léon-Paul, 110
Robespierre, Maximilien de, 85
Rodin, Auguste, *235*, 407
Rome, 14, 16, *18*, *26*, *262*
Rood, Ogden Nicolas, 255, *257*
Rouart, Henri, *99*, 109, 110, 150, 174, 175,
 177, 201, 202, 228, 230, 254, 296, *420*
Rouault, Georges, 444
Rouen, *180*, *320*, 406, *416*, *417*, *436*, *458*
Roujon, Henri, 405
Roulin, Augustine, *387*
Roulin, Joseph, 362, *378*, *387*
Rousseau, Henri, 295
Rousseau, Jean, *136*
Rousseau, Théodore, 17
Rousselin, Auguste, 51
Roy, Louis, 333
Rubens, Pieter Paul, 11
Ruskin, John, *185*

Saint-Etienne, 85
Saintes-Maries-de-la-Mer, *375*
Sainte-Victoire, 8, *167*
Saint-Henri, *316*
Saint-Mammès, *252*, *313*, *314*
Saint-Paul-de-Mausole, *363*
Saint-Rémy-de-Provence, 363, *363*, *391*,
 392, *394*, *399*
Saito, Ryoei, *155*, 445
Samary, Jeanne, *178*, *260*
Sargent, John Singer, 331, 333, 404
Satre, Angélique, *353*
Scholderer, Otto, *39*
Schuffenecker, Emile, *138*, 295, 296, 333,
 333, *348*, *391*
Sedan, 84, 331
Sérusier, Paul, *354*, 444
Seurat, Georges-Pierre, *252*, 295, 296, *296*,
 315, 330, 333, *335*, *359*, *367*, *368*, *372*,
 435, 444, 445

Signac, Paul, 230, *252*, *253*, 295, 296, *296*,
 333, *335*, *359*, *367*, *368*, *372*, 444
Simon, Jules, 176
Silvestre, Armand, 41
Sisley, Alfred, 8, 10, 38, 41, 56, 58, 59, *61*,
 62, 109, 110, 111, 148, 149, 150, *152*, 174,
 175, 177, 200, 202, *228*, *231*, 255, *287*,
 294, 330, 331, 404, 407, 445
Solari, Philippe, 108
Somm, Henri, 202
Sorrento, 262
Spencer, Albert, 331
Stanford, Leland, 203
Stevens, Alfred, *133*
Strasbourg, 82, 84
Superville, Humbert de, 257
Sutter, David, 257
Sutton, James F., 330

Tahiti, *332*, *426*, *427*, *431*, *432*, 442, *461*
Talbot, William Fox, 202
Tanguy, Julien (Père), 201, 362, *370*, *371*
Tarbes, *91*
Thiebault-Sisson, 149
Thiers, Adolphe, 84, 85, 201
Thoré-Bürger, Théophile William, 40
Tillot, Charles, 150, 174, 202, 230, 254, 296
Tissot, James, 110
Titian, 11, *44*, *47*
Tolouse, 16, 85
Toulouse-Lautrec, Henri de, 9, 59, *341*, *434*
Tours, 84
Tréhot, Lise, *87*, *88*
Trochu, Louis Jules, 84
Trouville, *92*, *106*
Troyon, Constant, 17
Turner, Joseph Mallord William, 94, *450*
Twatchman, John W., 331

Utamaro, 201
Utrillo, Maurice, *299*

Valabrègue, Antonin, *80*, 297
Valadon, Suzanne, *299*, *300*
Vallotton, Félix, 444
Valpinçon, Paul, *71*, *96*, *421*
Valtat, Louis, 444
Van Gogh, Anna, 360
Van Gogh, Cornelius, 360
Van Gogh, Elizabeth, 360
Van Gogh, Theo, 333, *348*, 360, *360*, 361,
 362, *362*, 363, *366*, *382*, *384*, *396*, *398*
Van Gogh, Theodorus, 360, *360*
Van Gogh, Vincent, 12, *31*, *127*, *270*, 295,
 333, *348*, *350*, *352*, *355*, 360-63, 407, 444,
 445, *459*
Van Gogh, Vincent Willem (Theo's son), 363
Van Gogh, Wilhelmine, 360

Varengeville, *272*, *274*
Vedel, Pedro, *155*
Velázquez, Diego, 39, *42*, *49*, *53*
Venice, *27*, *262*, *436*, *451*, *458*
Venturi, Lionello, 245
Versailles, 85
Vétheuil, 210, *236*, *237*, *238*, *239*, 269
Vibert, Edouard, *219*
Vic-en-Bigorre, *91*
Vidal, Eugène, 230
Vignon, Victor, 230, 254, 255, 296
Villeneuve-la-Garenne, *142*, *146*
Vincent, Joseph, 110
Victor Emmanuel II, 83
Vlaminck, Maurice de, 444
Voisins, *142*
Vollard, Ambroise, *406*, 407, 445
Vostricker, Kate, 360
Vuillard, Edouard, 333, 407, 444

Wagner, Wilhelm Richard, *176*, *264*
Wargemont, *232*
Wedmore, Frederic, 256
Whistler, James Abbott McNeill, *37*, 58,
 331, *417*
William I, 84
Wolff, Albert, 150, 175

Zaandam, *95*
Zandomeneghi, Federico, 148, 230, 254, 296
Zevenbergen, 360
Zola, Emile, 15, *36*, *39*, 40, 41, *42*, *49*, *53*,
 61, *63*, *81*, *104*, 177, *197*, *204*, *213*,
 229, 230, 231, *283*, *294*, 296, 297, *346*,
 406, *464*

References

Index of works

Bazille, Jean-Frédéric
The Studio in Rue La Condamine, 63

Boudin, Eugène
The Port of Portrieux, 139

Caillebotte, Gustave
Aimé Nicolas Morot in His Studio, 7
Boatman in Top Hat, 224
Floor Scrapers (Paris), 168
Floor Scrapers (private collection), 168
A Hand of Bésigue, 292
Interior, Woman at the Window, 253
Nasturtiums, 441
Paris Street, 199
The Pont de L'Europe (Geneva), 169
The Pont de L'Europe (Fort Worth), 169

Cassatt, Mary
At the Opera, 250
The Boating Party, 411
Children Playing on the Beach, 326
Françoise With a Black Dog, 251
Girl Arranging Her Hair, 327
A Kiss for Little Anna (N. 1), 11

Cézanne, Paul
Apples, Bottle, and Tureen, 194–95
Auvers from the Val Harmé, 247
The Banks of the Marne, 343
Bathers (Chicago), 466
Bathers (New York), 165
Bather with Raised Arm, 216
The Black Clock, 104
Boy in Red Vest, 424
The Bridge at Maincy, 244–45
Bridge over the Marne at Créteil, 342
The Card Players, 425

The Castle of Médan (The House of Zola), 283
Containers, Fruit, Dishcloth, 284
Courtyard of Farm at Auvers, 245
Dahlias, 128
L'Estaque and the Gulf of Marseilles (Paris), 216–17
L'Estaque and the Gulf of Marseilles (Philadelphia), 318
L'Estaque Seen from the Pines, 286
Five Bathers, 246
Flowers in a Small Delft Vase, 129
The Gulf of Marseilles, 319
The House of Dr. Gachet at Auvers, 127
The House of Père Lacroix at Auvers, 130
Houses (Roofs), 192
The Judgment of Paris, 78
Landscape around Aix-en-Provence, 79
Landscape at Auvers (etching), 229
Landscape at L'Estaque, 286
The Large Bathers (Chicago), 467
Madame Cézanne in the Yellow Chair, 422
Madame Cézanne Leaning on a Table, 196
Mardi Gras, 346
Melting Snow at Fontainebleau, 282
A Modern Olympia, 102
Mont Sainte-Victoire, 464
Mont Sainte-Victoire Seen from Lauves, 465
On the Banks of the Seine at Bercy, 193
Pastoral (Idyll), 102
Plate with Fruit and Terracotta Vase, 345
Portrait of Achille Emperaire, 101
Portrait of Achille Emperaire (charcoal), 101
Portrait of Antonin Valabrègue, 80
Portrait of Louis-Auguste Cézanne, 81
Portrait of Louis Guillaume, 285
The Road (The Boundary Wall), 167
Rocks at L'Estaque, 317
Self-Portrait, 126
Self-Portrait with Hat, 166
Self-Portrait with Red Background, 218
Still Life with Green Pot and Pewter Jug, 104
Still Life with Open Drawer, 195
Still Life with Pitcher, Bread, Egg, and Glass, 79
Sugarbowl, Pitcher, and Plate with Fruit, 344–45
Vase, Bottle, Cups, and Fruit, 105
Victor Chocquet (private collection), 191
Victor Chocquet (Upperville, Va.), 190
View of Auvers, 9
View through the Trees of L'Estaque, 316
Young Girl at the Piano (Overture to Tannhäuser), 103

Corot, Jean-Baptiste Camille
Agostina, 28
Chartres Cathedral, 26

The Forest of Fontainebleau, 25
Horseman, Setting Sun, 27
Windswept Landscape, 27
Woman in Blue, 28

Courbet, Gustave
The Proudhon Family in 1853 (with detail), 35
Small Seascape, 34
The Wave, 34

Daumier, Honoré
The Washerwoman, 33

Degas, Edgar-Hilaire-Germain
After the Bath (Paris), 423
After the Bath (private collection), 308
At the Milliner's (Chicago), 281
At the Milliner's (New York), 279
At the Milliner's (Paris), 457
At the Races in the Countryside, 71
Ballerina Changing, 243
Ballerina in Green, 242
Ballerina in Pose for a Photographer, 161
Ballerina with Bouquet, 187
The Beach, 164
Billiards Room at Ménil-Hubert, 421
Café-Concert at Les Ambassadeurs, 310
Café-Concert Singer, 212
The Dance Class (New York), 99
The Dance Class (Paris), 123
The Dance Class (Zurich), 241
Dance Class at the Opéra, 122
The Dance Lesson (New York), 240
The Dance Lesson (Philadelphia), 276
The Duchessa di Montejasi with Her Daughters Elena and Camille, 163
L'Etoile (The Star; Dancer on Stage), 186
Fallen Jockey, 419
Family Portrait (The Bellelli Family), 72–73
Galloping Horse, 278
Henri Rouart and His Son Alexis, 420
Hortense Valpinçon, 96
In a Café (The Absinthe Drinker), 162
The Little Fourteen-Year-Old Dancer, 277
Lorenzo Pagans and Auguste De Gas, 100
Mary Cassatt at the Louvre: The Paintings Gallery, 311
Milliner, 281
Milliners, 280
Miss La La at the Cirque Fernando, 213
Orchestra Musicians, 97
The Orchestra of the Opéra, 98
The Pedicure, 124
Portrait of Diego Martelli, 214
Portrait of Hilaire Degas, 75
Portrait of Louis-Edmond Duranty, 215
Portrait of Zacharian, 11
Portraits in an Office (New Orleans), 125
Preparing for the Lesson, 9

Race Horses in a Landscape, 418
Self-Portrait, 74
The Song of the Dog, 188
Two Ballerinas Resting, 456
Woman Bathing in a Shallow Tub, 309
Woman Combing Her Hair, 340
Women Ironing, 312
Women on the Terrace of a Café in the Evening, 189
Young Spartans Exercising, 76-77

Delacroix, Eugène
Arab about to Saddle His Horse, 23
Jacob's Fight with the Angel, 24
Women of Algiers in Their Apartment, 22

De Nittis, Giuseppe
The Ducks' Repast, 139

Dupré, Jules
Autumn, 32

Fantin-Latour, Henri
Homage to Delacroix, 37
Scene from Tannhäuser, 36
Strawberries and Wine Glass, 37
A Studio in the Batignolles Quarter, 39

Gauguin, Eugène-Henri-Paul
Les Alyscamps, 352
Annah the Javanese (Aita tamari vahina Judith te parari), 431
Apple Trees at the Hermitage near Pontoise, 227
Are You Jealous? (Aha oe feii), 429
Barbarous Tales, 463
La Belle Angèle, 353
Blue Roofs of Rouen, 320
Bonjour, Monsieur Gauguin, 355
Breton Girls Dancing, 348
Cattle Drinking, 321
Clovis Sleeping, 322
Ford (Running Away), 460
Four Breton Women, 324
Garden at Vaugirard, 290
Garden under Snow, 226
Hina, 12
Interior of the Artist's Home in Rue Carcel, 289
Landscape, 138
Marquesan with Red Hat (The Witch of Hiva Oa), 462
Mette Sewing, 225
Nude Study (Suzanne Sewing), 249
On the Coast of the Sea II, 347
The Pond with Ducks, 287
Portrait of the Sculptor Aubé with His Son, 291
Preparatory Sketch for Where do we come from? What are we? Where are we going?, 432

Riders on the Beach, 461
Rural Constructions, 248
The Seine near the Jena Bridge, 170
Self-Portrait, 350
Self-Portrait with Halo, 354
Self-Portrait with Yellow Christ, 351
The Singer (Valérie Roumy), 291
The Spirit of the Dead Keeps Watch (Manao tupapau), 430
Still Life with Mandolin, 323
Sunflowers on a Chair, 459
Tahitian Pastoral (Faa iheihe), 433
Van Gogh Painting Sunflowers, 388
Vase of Flowers at the Window, 288
The Vision after the Sermon (Jacob Wrestling with the Angel), 349
We Shall Not Go to Market Today (Ta matete), 427
When will you marry? (Nafea faa ipoipo), 428
Where do we come from? What are we? Where are we going? 432–433
Woman with a Flower (Vahine no te tiare), 426
The Woman with the Chignon, 325

Géricault, Théodore
Portrait of a Kleptomaniac, 21

Goya, Francisco
Maya Naked, 47

Ingres, Jean-Auguste-Dominique
The Forestier Family, 72
Madame Moitessier, 19
Oedipus and the Sphinx, 18
The Turkish Bath, 20

Manet, Edouard
Argenteuil, 136
At the Café, 220
The Balcony, 52
Bar at the Folies-Bergère, 293
The Barricade (sketch), 85
Berthe Morisot, 132
Boating, 135
La Bon Bock, 134
Boy with a Sword, 42
The Café Guerbois (sketch), 38
A Café in Place du Théâtre Français, 189
Civil War (lithograph), 85
The Dead Christ with Angels, 48
Dead Toreador, 48
The Execution of the Emperor Maximilian, 50
The Fifer, 49
Luncheon on the Grass (Le Déjuner sur l'Herbe), 44–45
Lunch in the Studio, 51
Masked Ball at the Opéra, 131

The Monet Family in Their Garden at Argenteuil, 135
Monet Painting in His Floating Studio, 137
Music in the Tuileries Gardens, 43
Nana, 197
Olympia, 47
On the Beach, 164
Plum Brandy, 221
Portrait of Antonin Proust, 198
Portrait of Emile Zola, 53
Portrait of Eva Gonzales, 54
Portrait of Jeanne Duval, 43
Portrait of Stéphane Mallarmé, 157
Racecourse in the Bois de Boulogne, 131
The Railway, 133
Repose (Berthe Morisot), 55
Self-Portrait with Palette, 219
Spring (etching), 231
Street Singer, 46
The Waitress, 222

Millet, Jean-François
Angelus, 30-31
Gleaners, 29
The Sheepfold, Moonlight, 29
Spring, 30

Monet, Claude-Oscar
Argenteuil under the Snow, 158
Bazille and Camille (The Stroll), 67
Beach at Honfleur (Shipyards near Honfleur), 65
Boating on the Epte, 338
Boats in the Port of London, 95
Bordighera, 305
Boulevard des Capucines, 117
Bridge at Argenteuil (Munich), 121
Bridge at Argenteuil (Paris), 121
Camille on the Beach at Trouville, 68
The Church at Varengeville, Cloudy Weather (Louisville, Kentucky), 272
The Church at Varengeville, Cloudy Weather (private collection), 272
The Customs Officer's Cabin at Varengeville, 274
Chrysanthemums, 271
The Corner of the Garden at Montgeron, 182
Field of Poppies, Argenteuil, 118
The Gare Saint-Lazare, 184
The Grand Canal, 451
La Grenouillère, 64
Haystack (Snow Effect), 412
Haystacks (Late Summer; Morning Effect), 412–13
Highway Bridge at Argenteuil, 120
Hotel des Roches Noires, Trouville, 92
Impression: Sunrise, 116
The Jetty at Le Havre, 93
Landscape: Weeping Willows, 454

Lavacourt under Snow, 269
The Luncheon on the Grass (Moscow), 67
The Luncheon on the Grass (Paris: fragments), 66
Madame Monet in a Japanese Costume (La Japonaise), 160
The Manneporte near Etretat, 304
Monceau Park, 209
Parliament (Sunlight Effect in the Fog), 450
Path in the Isle Saint-Martin, 238
Path in the Rose Garden at Giverny, 455
Pleasure Boats at Argenteuil, 159
Pond at Montegeron, 183
Poplars (Summer), 414
Poplars (Wind Effect), 415
Railway Bridge at Argenteuil, 120
Reef at Varengeville, 275
Road to Vétheuil in Winter, 210
Rouen Cathedral (Morning Effect), 417
Rouen Cathedral (Sunset Effect), 416
Rue Montorgueil, Paris, Festival of June 30, 1878, 208
Snowy Landscape at Sunset, 236
Spring, 269
Still Life with Grapes and Apples, 237
Stroll on the Reef, 273
Sunset at Lavacourt, 239
The Thames and Westminster, 94
Vase of Sunflowers, 270
View of Antibes from La Salis, 336
View of Juan-les-Pins, 337
Water Lilies, 8
Water Lilies (Water Landscape) (1905), 452
Water Lilies (Water Landscape) (1907), 453
Woman in Garden, 68-69
Woman with a Parasol—Madame Monet and Her Son, 119
Woman with Parasol Turned Right, 306
Women in the Garden, 70
The Zaan at Zaandam, 95

Morisot, Berthe
The Cradle, 140
Hide-and-Seek, 141
In a Park (On the Grass), 141
Lady at Her Toilet (detail), 172
Portrait of Julie Manet, 10
The Psyché (The Cheval Glass), 173
Reading: The Mother and Sister Edma of the Artist, 103

Pissarro, Jacob-Abraham-Camille
Avenue de l'Opéra (Snow Effect Snow; Morning), 439
Boulevard Montmartre (Afternoon Sun), 438
Factory near Pontoise, 147
Gardens of the Tuileries and the Louvre, 10

Peasant Seated at Dusk, 252
Place du Théâtre Français, 440
Port of Dieppe, Rainy Morning, 458
Quai Saint-Sever at Rouen, 436
Self-Portrait, 147
Shepherdess, 358
View of Pontoise, 9
Woman in a Meadow, Spring, Eragny-sur-Epte, 359

Raimondi, Marcoantonio
Judgment of Paris, 45

Renoir, Pierre-Auguste
Algerian Woman (Odalisque), 88-89
Arabian Fest (The Mosque), 267
At the Inn of Mother Anthony, 61
Bathers, 447
The Bathers (Les Grandes Baigneuses), 302
Bather with a Griffon, 86
Bazille at His Easel, 62
Blonde Bather (Vienna), 446
Blonde Bather (Williamstown), 262
Captain Darras, 91
Charles and Georges Durand-Ruel, 265
Charles Le Coeur in His Garden, 115
The Children of Martial Caillebotte, 408
Child with Hat, 259
Dance at Bougival, 2, 300
Dance in the City, 299
Dance in the Country, 298
Dance in the Country (etching), 228
Dancing at the Moulin de la Galette, 154–55
Girl with Straw Hat, 6
La Grenouillère, 64
Jean Playing with Gabrielle and a Girl, 409
Julie Manet with Cat, 334
The Little Gleaner, 335
The Loge (The Box), 114
Lunch on the Banks of the River, 207
Luncheon of the Boatmen, 260–61
Madame Charpentier and Her Children, 204–05
Maternity, 301
Monet Reading, 112
Parisian Women in Algerian Dress, 87
The Pont Neuf, 113
Portrait of Durand-Ruel, 449
Portrait of the Countess of Pourtalès, 179
Portrait of Eugène Murer, 180
Portrait of Irène Cahen of Antwerp, 234
Portrait of Jeanne Samary, 178
Portrait of Madame Charpentier, 205
Portrait of Marguerite Bérard, 206
Portrait of Marie Murer, 181
Portrait of Monsieur and Madame Bernheim de Villers, 448
Portrait of Paul Bérard, 232

Portrait of Paul Cézanne (pastel), 256
Portrait of Richard Wagner, 264
Portrait of Victor Chocquet, 152
The Reader, 153
Reclining Odalisque, 11
Return from a Boat Outing, 60
Rocks at L'Estaque, 266
Seated Nude, 235
Still Life with Fruit, 8
The Stroll, 90
*Study for Dancing at the Moulin de la
 Galette*, 154
Study for the Bathers, 303
The Swing, 156
The Terrace, 258
The Umbrellas, 263
Woman with Parrot, 90
Woman with White Jabot, 233
The Young Mother, 13
*Yvonne and Christine Lerolle at the
 Piano*, 410

Sargent, John Singer
Carnation, Lily, Lily, Rose, 307
The Luxembourg Gardens, 223
Paul Helleu Painting with His Wife, 339

Seurat, Georges-Pierre
The Circus, 434
The Eiffel Tower, 357
Portrait of Paul Signac (sketch), 296
*Sunday Afternoon on the Island of La
 Grande Jatte*, 238–39
Young Woman Powdering Herself, 356

Signac, Paul
Constantinople, the Gold Coast, 458
Les Andelys, the Embankment, 315
Morning Calm, 435

Sisley, Alfred
*The Banks of the River at Saint-
 Mammès*, 314
The Bridge at Villeneuve-la-Garenne,
 143
Flood at Port-Marly (Madrid), 171
Flood at Port-Marly (Paris), 171
Foot Bridge at Argenteuil, 143
*The Garden of Ernest Hoschedé at
 Montgeron*, 268
Landscape (etching), 231
*The Lock and Canal of the Loing River at
 Saint-Mammès*, 313
Loing Canal, 436
Misty Morning, 146
Outskirts of Les Sablons (Overcast Day),
 313
Regatta at Molesey, 146
Road at Hampton Court (detail), 144–45
Saint-Mammès, Gray Weather, 252
Snow at Louveciennes, 211

View of Moret-sur-Loing, 437
Villeneuve-la-Garenne on the Seine, 142

Titian
Concerto Campestre, 45
Venus of Urbino, 47

Van Gogh, Vincent Willem
Allotments on Montmartre, 366
Les Alyscamps, 383
*L'Arlésienne (Portrait of Madame
 Ginoux)*, 395
The Bedroom, 384
*The Bedroom, Sketch in a Letter
 (Amsterdam)*, 384
*The Bedroom, Sketch in a Letter
 (private collection)*, 384
*La Berceuse (Portrait of Madame
 Roulin)*, 387
Branches with Almond Blossom, 396
Café Terrace on the Place du Forum, 381
The Church at Auvers, 400
Cypresses, 390
Cypresses with Two Women, 391
*Fishing Boats on the Beach at Les
 Saintes-Maries-de-la-Mer*, 375
Gauguin's Chair, 385
The Harvest, 376–77
Houses with Thatched Roofs, Cordeville,
 399
Interior of a Restaurant, 367
Japonaiserie: Oiran (after Kesai Eisen),
 371
The Langlois Bridge, 374
*Langlois Bridge with Woman with
 Umbrella*, 374
The Night Café, 380
*The Peasant (Portrait of Patience
 Escalier)*, 379
*Peasant Woman (Portrait of Gordina de
 Groot)*, 364
Portrait of Doctor Gachet, 401
Portrait of Joseph Roulin, 378
Portrait of Père Tanguy, 370
The Potato Eaters, 365
Prisoners Exercising (after Doré), 398
The Reaper, 394
Self-Portrait, 386
Self-Portrait as a Painter, 369
Self-Portrait with Felt Hat, 368
*Sketch from Letter with Langlois
 Bridge*, 374
The Starry Night, 392-93
Still Life with Irises, 397
Still Life with Sunflowers, 389
The Street (The Yellow House), 382
*The Street (The Yellow House), Sketch in a
 Letter*, 382
Thatched Houses against a Hill, 399
Wheatfield with Crows, 402–03
The White Orchard, 372–73

Whistler, James Abbott McNeill
*Arrangement in Gray and Black No. 1
 (The Artist's Mother)*, 107
*Nocturne in Blue and Gold: The Old
 Bridge at Battersea*, 185
Variations in Violet and Green, 106

Zandomeneghi, Federico
The Two Bouquets, 341